TEXTILE
TRADITIONS
OF MESOAMERICA AND
THE ANDES

Greene

TEXTILE TRADITIONS
OF MESOAMERICA AND THE ANDES:
An Anthology

Edited by
Margot Blum Schevill
Janet Catherine Berlo
Edward B. Dwyer

UNIVERSITY OF TEXAS PRESS
AUSTIN

First University of Texas Press edition, 1996

Requests for permission to reproduce material from this work should be sent to Permissions, University of Texas Press, Box 7819, Austin, TX 78713-7819.

♾ The paper used in this publication meets the minimum requirements of American National Standard for Information Sciences—Permanence of Paper for Printed Library Materials, ANSI Z39.48-1984.

Library of Congress Cataloging-in-Publication Data

Textile traditions of Mesoamerica and the Andes : an anthology / edited by Margot Blum Schevill, Janet Catherine Berlo, Edward B. Dwyer.
 p. cm.
 Originally published: New York : Garland, 1991.
 ISBN 0-292-77714-0 (pbk. : alk. paper)
 1. Indian textile fabrics—Mexico. 2. Indian textile fabrics—Guatemala. 3. Indian textile fabrics—Andes Region. 4. Indians of Mexico—Costume. 5. Indians of Central America—Costume—Guatemala. 6. Indians of South America—Costume—Andes Region. I. Schevill, Margot. II. Berlo, Janet Catherine. III. Dwyer, Edward Bridgman.
F1219.3.T4T49 1996
746'.089'97—dc20 96-10252

Contents

I
Introduction

II
Mesoamerica

III

Central Andes of South America

IV
Weaving and Dyeing Technology

V
The Marketing of Textiles

VI
Conclusion

Illustrations

xiii

Preface to the 1996 Edition

The reprint of *Textile Traditions of Mesoamerica and the Andes: An Anthology* makes available to a larger audience a wide-ranging volume that explores theory and concept, cultural meaning and material culture, as well as specific traditions. The audience includes scholars and students in disciplines such as Latin American studies, art and textile histories, material culture, anthropology, women's studies, and the interested general public. Some articles include uncharted regions on the textile map; others offer information that has not been recorded elsewhere.

Updated biographies of contributors illustrate how scholars have developed ideas presented in this volume over the past decade. A list of additional references covers recent publications in relevant areas. There remains a need for more textile studies in all areas covered by this volume, including:

- in-depth fieldwork-based studies like Ackerman's work in Abancay, Peru, and Hendrickson's study in Tecpán, Guatemala;
- ethnohistoric and iconographic studies such as Wilson's essay on colonial and historic textiles in Cuzco, Peru, and McCafferty and McCafferty's essay on late pre-Hispanic Central Mexican textile ideologies;
- and broadly synthetic and interpretive studies like Berlo's contribution, "Beyond *Bricolage*."

The studies published here fill a gap in the textile literature. Yet they also point out how many more research questions there are to explore.

These include the role of indigenous textiles in the world market, transnational and global exchanges through cooperatives and alternate trading organizations, local impact of market expansion, dress and gender, and dress and ethnicity.

Grateful thanks from all contributors for this new edition are due to Theresa May, Assistant Director and Executive Editor of the University of Texas Press.

Margot Blum Schevill,
Janet Catherine Berlo,
Edward B. Dwyer
January 10, 1996

Contributors

Raquel Ackerman received her Ph.D. at Cambridge, England. She is Associate Professor of Anthropology at California State University, Los Angeles. She teaches linguistics and anthropology and continues her research in Peru on political rhetoric.

Linda Asturias de Barrios (Ph.D., State University of New York, Albany) is Director of ESTUDIO 1360, a Guatemalan private organization devoted to social and educational research, and consultant for the Asociación de Investigación y Estudios (ASIES) and the Museo Ixchel del Traje Indígena in Guatemala City. Her publications as author, coauthor, and editor include more than fifteen books and articles and two video scripts.

Janet Catherine Berlo is Professor of Art History at the University of Missouri–St. Louis. She has also taught at Yale University and the Rhode Island School of Design. Trained as a historian of pre-Columbian art, Berlo is increasingly interested in women's historic and contemporary arts in the Americas.

Robert S. Carlsen is Research Associate at the University of Colorado Museum in Boulder. He teaches at the University of Denver. He was coauthor with Martin Prechtel of "Weaving and Cosmos amongst the Tzutujil Maya" in *RES*. Forthcoming from the University of Texas Press is *Bibles, Bullets, and the "Venerable Grandchild."*

Virginia Davis works with *ikat* weaving and other resist techniques, both as an internationally exhibited studio artist and from a technical, historical, and ethnographic point of view. She has an M.A. in sociology from the University of Illinois, Urbana. In 1995, as a recipient of a joint National Endowment for the Arts and Fondo Nacional para la Cultura y las Artes award, Davis, working with Dr. Irmgard W. Johnson, researched Mexican stitch-and-tie resist skirts.

Edward B. Dwyer is Associate Provost at the Rhode Island School of Design. He was trained in anthropology at the University of California at Berkeley (Ph.D., 1971) and has done extensive fieldwork, mainly archaeological, in southern Peru. His interests include the development of Early Inca culture in Cuzco, the technical and iconographic analysis of ancient Peruvian textiles, and the relationship of material culture to myth and world-view in specific Peruvian settings.

Blenda Femenias received her Ph.D. in cultural anthropology from the University of Wisconsin–Madison in 1996. From 1982 to 1988 she was Curator of the Helen Allen Textile Collection at the same university. Her research in South America addresses artisanal production of clothing and media images of indigenous people. Femenias' dissertation, *Ambiguous Emblems*, treats the politics of gender and representation through dress in contemporary Peru. She also published the 1987 catalogue *Andean Aesthetics: Textiles of Peru and Bolivia.*

Ed Franquemont is an anthropologist and a handweaver who has been involved in field studies in the Andes since 1966. He was trained as an archaeologist at Harvard College (B.A., 1967) and has many publications in professional and popular journals. Since 1976, Franquemont has been engaged in a broad-based and long-term study of the Inca weavers of Chinchero, Peru, and their products. He regularly lectures and conducts workshops about Andean weaving across the United States and has served as a consultant for several museums.

Carol Hendrickson has studied *traje* and weaving in the context of social life in the central Guatemalan highlands since 1980. She is author of *Weaving Identities* (University of Texas Press, 1995), which focuses on the Kaqchikel Maya community of Tecpán. Recent work has explored marketing Guatemalan textiles in U.S. markets. She teaches anthropology at Marlboro College, Vermont.

Guisela Mayén is a researcher at the Museo Ixchel del Traje Indígena in Guatemala. She is author of *Tzute y jerarquía en Sololá.*

Geoffrey G. McCafferty is Adjunct Assistant Professor of Anthropology at Brown University and a former Mellon Fellow in Latin American Art and Archaeology. He continues to do archaeological research at Cholula and joint research with Sharisse McCafferty on gender in pre-Columbian Mesoamerica.

Sharisse McCafferty is an archaeologist, ethnohistorian, and illustrator, negotiating the "real world" as a speech pathologist, school teacher, and mother of three. She is currently researching costume styles of the pre-Columbian Mixtec codices.

Mary Ann Medlin first became interested in Andean weaving at Cornell in John V. Murra's "Ethnography of the Andes" course in 1973. Her dissertation fieldwork was with the Calcha ethnic group in highland Bolivia from 1978 to 1981, and she received her Ph.D. from the University of North Carolina at Chapel Hill in 1983. She teaches at Barber-Scotia College in Concord, North Carolina.

Lynn A. Meisch has conducted extensive fieldwork in Ecuador, Peru, and Bolivia. Her early research and publications on the importance of cloth and costume in Andean societies focused on the significance of costume as an ethnic marker. Current research explores the construction of gender, ethnic, and national identities in transnational contexts, and she has taught on the anthropology of tourism, globalization and ethnic arts, and the indigenous rights movement in Ecuador. She will obtain her Ph.D. in anthropology from Stanford University in June 1996, with dissertation research on Otavalo (Ecuador) weavers, merchants, and musicians in the global arena.

Laura Martin Miller (B.A., Wesleyan University, 1984; M.D., Harvard Medical School, 1993) conducted costume and weaving research in highland Ecuador from 1984 to 1986 under the auspices of the Ecuadorian Fulbright Commission. She continued this research with Lynn Meisch and Earthwatch volunteers in the summers of 1988 and 1989. This work will appear in *Cloth and Costume in Highland Ecuador*, edited by Ann P. Rowe (forthcoming). She is currently finishing residency in Internal Medicine— Primary Care at the University of California, San Francisco, and anticipates clinical practice in rural California.

Walter F. Morris, Jr. is Projects Director at Na Balom in San Cristóbal de las Casas, Chiapas, Mexico, and Research Associate at the Science Museum of Minnesota. Since the early 1970s, he has worked extensively with the Maya weavers of Chiapas, and his research was supported by the Smithsonian Institution, the National Geographic Society, and the MacArthur Foundation. Morris has organized exhibitions of Chiapas textiles and written several books based on his research. The most recent is *Hand Made Money: Latin American Artisans in the Marketplace.*

Cherri M. Pancake (B.S. cum laude, Cornell University; Ph.D., Auburn University) was Curator of the Museo Ixchel del Traje Indígena, the ethnological textile museum in Guatemala. She is now Professor in the College of Engineering at Oregon State University, where she applies ethnographic techniques to the study of how engineers and scientists learn and apply high-performance computing. She also serves as Associate Editor of *Mesoamérica*, a journal devoted to historical and anthropological research in Central America and southern Mexico.

Pamela Scheinman is a visiting specialist in the Department of Fine Arts at Montclair State University in New Jersey. An artist and photographer interested in popular art, she curated exhibitions based on recent Fulbright research and now is working on *mestizo* embroidery. Her articles have appeared frequently in *American Craft, Craft International, Fiberarts, Surface Design Journal,* and *Threads* magazines.

Margot Blum Schevill is an anthropologist, weaver, educator, and musician. Currently she is Textile Consultant and Research Associate at the P. Hearst Museum of Anthropology, University of California at Berkeley, and Guest Curator for the Appleby Andean Textile Collection at the M. H. de Young Memorial Museum, The Fine Arts Museums of San Francisco. Schevill has curated several exhibitions of Maya textiles and returns to Guatemala annually to continue her research on "Costume as Communication."

Lynn Stephen is Associate Professor of Anthropology at Northeastern University. She is the author of *Zapotec Women* (University of Texas Press, 1991), *Hear My Testimony* (South End Press, 1994), and *Power from Below* (University of Texas Press, forthcoming). She currently is researching the movement for indigenous autonomy in Mexico and the impact of economic

restructuring and changes in land reform policy in rural Chiapas and Oaxaca.

David A. Wenger is Professor of Medical Genetics and Professor of Biochemistry and Molecular Biology at Jefferson Medical College in Philadelphia. He has more than eighty publications, mostly in the area of genetic disorders. His publications have appeared in such journals as *Science* and *Proceedings of the National Academy of Sciences*.

Lee Anne Wilson is Professor of Art History at Central Michigan University and Chair of the Art Department. She has published articles on the indigenous arts of both North and South America and coedited *The Arts of Africa, Oceania, and the Americas: Selected Readings* with Janet Catherine Berlo. She also is the founder of the Native American Art Studies Art Association.

PART ONE

INTRODUCTION

The Communicative Power of Cloth and Its Creation

Margot Blum Schevill

*Tantos símbolos, cábalas, sabidurías,
astrales y cálculos se urden en sus telas.*

So many symbols, spells, sayings,
stars and conjectures are warped in their cloth.
Miguel Angel Asturias (1974)

Introduction

The creation of cloth for clothing and other purposes has always been a main concern and occupation of human beings. What we wear transforms our appearance. We speak silently, signaling layers of meaning through our clothing. Unfortunately the study of the textile systems and clothing of indigenous peoples worldwide has been largely overlooked by anthropologists, archaeologists, and art historians except for a handful of important works. Andean scholarship has focused on the brilliant and technically complex archaeological fabrics from coastal Peru and not on cloth created by people living in the present and not too distant past. In the past ten years, however, there has been increased interest in looking at the material culture of indigenous peoples. Researchers have begun to view clothing, body adornment, textiles, and cloth production as powerful indicators of social structure, ritual patterns, economic networks, and a commitment to the traditional life—what the Maya of Mexico and Guatemala call *costumbre*. This new interest may reflect what a textile dealer said at a recent conference: "That's all that's left: no more sculpture, pottery, paintings!"

3

Linguist and structural ethnographer Petr Bogatyrev, ethnohistorian John V. Murra, and semiotician Roland Barthes have made important contributions to a theoretical framework for ethnographic textile studies. Bogatyrev (1971), in his work on folk costume in Moravian Slovakia, found that folk costume conveyed rank, class, status, region, religion, and age. Thus clothing functioned as practical, aesthetic, erotic, and even magical phenomena. Murra (1962) defined the complex role that cloth played for the Inca. Stored in large warehouses, cloth reflected wealth, served as a medium of exchange, provided tribute, and was used in sacrificial and funerary contexts as well. Barthes explored "the transformational myth which seems attached to all mythic reflection on clothing" (1983:256). A garment can magically transform the person, but the person also transforms the garment and is expressed through it. There is a dialectical exchange between person and garment, an awareness of self and the transformed self simultaneously.

Although Barthes contended that fashion trends remained out of history, I have suggested that evolution in dress reflects the nature of the times (Schevill 1986:3-4). Jane Schneider (1987) commented on the effect that political and economic shifts in great transregional systems of interaction have on centers of art and their styles. It follows that the rhythm and nature of clothing evolution may be responsive to these shifts as well.

In 1985 Annette B. Weiner and Schneider organized a conference, sponsored by the Wenner-Gren Foundation, entitled "Cloth and the Organization of Human Experience." Participating scholars expressed multiple views of cloth as "an economic commodity, a critical object in social exchange, an objectification of ritual intent, and an instrument of political power" (Schneider and Weiner 1986:178). In their recent publication, an outgrowth of the conference, Weiner and Schneider comment on "the properties of cloth that underlie its social and political contributions, the ritual and social domains in which people acknowledge these properties and give them meaning, and the transformations of meaning over time" (1989:1).

Patricia Anawalt, through her explorations of pre-Hispanic, Mesoamerican clothing, has developed a model for the study of the basic pan-Mesoamerican male and female costume based on construction and classification of garments (1981). She gleaned information from all available sources, including painted books or codices, sculptures and paintings, chronicles of the Spanish explorers, priests, and travelers, and the small body of archaeological textiles available. Anawalt's model has proved useful for hypothesizing the pre-Columbian clothing utilized in areas of Mesoamerica, like the highlands of Guatemala, that lacks the richness of visual sources

found in Mexico. Ethnographic fieldwork in Puebla has provided Anawalt with contemporary costume information, which confirms the persistence of certain prehistoric dress forms over a four-hundred-year period.[1]

The contributors to this volume, as well as the symposium participants, have carried forward many of the ideas presented above. They have developed their own interpretations of the communicative power of cloth and clothing, thus enriching the study of ethnographic textile systems. Walter F. Morris, Jr., proposes that, for the Maya, cloth is memory and that Maya cosmology is symbolized by the designs on their clothing. Elayne Zorn argues that, while cloth may be read as a text, it also serves as a meaningful object with social functions that are communicative, poetic, economic, and political.[2] For the Quechua and Aymara, Ed Franquemont finds that the creation of cloth served as a link to their pre-Columbian ancestors: cloth functioned as historical homage. John Cohen observes that the textile system remains an integral part of Andean cultural patterns: "Tradition for its own sake is the outstanding cultural determinant for weaving in the sierra today."[3]

Walter F. Morris, Jr., and Lynn Stephen focus on the commoditization of textiles, consumer-producer relations, and the political economy created by a public eager to buy and collect textiles. And Janet Catherine Berlo perceives textile systems as part of intercultural systems of exchange, not merely a syncretization of indigenous and nonindigenous traditions but as a continuing creative process.

Textile studies of the past emphasized several research approaches: broad overviews, the one-costume-one-town taxonomy, or comparative studies of neighboring villages or regions. The scholarship presented here is indicative of a shift of the pendulum towards material culture studies while utilizing methodologies from other disciplines. The direction in Andean and Mesoamerican anthropological studies has been away from chronology to a more holistic interpretation combining art historical, ethnohistorical, and archaeological methodologies with those of anthropology.

One of the purposes of this volume is to show that the study of cloth, clothing, and the creation of cloth can be an important index for understanding human culture and history. The diversity of subject matter and the diversity in analytical approaches to the data offer a rich blending of information. The essayists are symbolic, social, and cultural anthropologists as well as art historians, archaeologists, and textile artists. Methodologies range from structural, art historical, ethnohistorical, symbolic, and reflexive analyses to synchronic and diachronic, etic and emic, ethnoaesthetic, and

technical analyses. Although broad and diverse topics are presented in these papers, certain themes recur frequently.

The Nature of Change

Indigenous, traditional communities have been viewed as rooted in the past, with little historical change occurring from within. The assumption was that the lives of the inhabitants were mediated by cultural patterns or *costumbre*. Innovation was not encouraged. Contemporary researchers have found this premise to be misleading. Instead, the non-static, receptive response to new ideas, an ongoing process in village life, is a major topic in contemporary writings. Sometimes change is imposed from without. Mary Ann Medlin finds that when the men from Calcha, Bolivia, go to work outside of their communities or on trading trips, village clothing sets them apart from the non-Indian world. The resulting discrimination became a motive for change to western clothing when traveling.

Change is often initiated by the community itself. Carol Hendrickson and Laura Miller explore the relationship between tradition and conservatism exemplified by what women choose to create and wear. Local fashions are an important consideration. Both Pamela Scheinman and Walter F. Morris, Jr., discuss traditional dress as a form of display, and they comment on women's admiration for fresh interpretations of traditional patterns and of their desire to wear the latest styles of dress for special occasions like fiestas.

Innovative techniques are discussed by Virginia Davis and Laura Miller. They analyze contemporary shawls woven with tie-dyed threads from Mexico, Ecuador, and Peru. This process, known as ikat or *jaspe,* may have been developed independently in the New World, or it may have been copied from Philippine textiles brought to Latin America on the Manila galleons from the mid- sixteenth century to the early nineteenth century.

In contrast, some archaic weaving techniques are still practiced in the Andes. Ed Franquemont concludes that dual-lease weaving was an indigenous, ancient, and probably widespread Andean technology. This form of weaving necessitates double heddles, which create four sheds. Pre-Columbian weavers solved design problems by adding a forked stick and a second stick to create classic, complex Andean weaves. This method is still in use by contemporary weavers.

In recent years, handicrafts have become desirable commodities throughout the world. Artisans are responding to outside influences and creating innovative as well as traditional forms. Overwhelmed by the

proliferation of manufactured items, the Western industrialized public, however, is buying the "old ways" along with the items of contemporary design. Concerning Teotitlán del Valle, Mexico, Lynn Stephen comments on the flexibility of the skilled weavers in adapting to changes in textile designs. In response to the growth of this village's export market, there is a variety of styles reflecting American and European taste. Traditional designs are not those of the Zapotec of Oaxaca but of the Navajo of the Southwestern United States. These skilled weavers are able to reproduce on the loom any design that the customer wants, including works by Picasso, Miro, and Escher.

Does the act of wearing traditional dress imply conservatism and isolation? On the contrary, argues Blenda Femenias. For the wealthy inhabitants of the Colca Valley of Peru "it (*ropa bordado* or traditional clothing) seems to indicate an awareness of various roles individuals must play to survive and prosper in a changing world." Femenias also shows how change in cloth and costume production can be analyzed from an historical perspective. She traces the historical development of the cloth production system known as the *obraje* or workshop system. While most Inca weavers were women, the Spanish introduced the treadle loom and conscripted men to weave under oppressive and crowded working conditions. Some Mesoamerican and Andean communities still have small workshops in which men weave wool and cotton yardage on treadle looms. This cloth is bought by indigenous peoples and used for skirts, pants, and other tailored garments.

Lynn Meisch looks at the development of traditional dress in Otavalo and Saraguro, Ecuador. She suggests the term "survivals" for older costume elements that continue to be worn with modern clothing. Gradual changes take place as a new style or garment becomes traditional, and the traditional style or garment becomes archaic and eventually disappears.

Local Distinctions and Concepts

The development of distinctive regional or town-specific clothing may be due to the geographic isolation created by the mountains inhabited by the majority of indigenous peoples. The Andes and the mountain ranges of Guatemala and Mexico physically separate communities from their neighbors. Styles become codified and are repeated with slight innovations due to the personal whim of the weaver. Stylistic changes evolve as a result of trade networks that bring geographically distant groups together, and new techniques and materials are exchanged and eventually assimilated.

Cherri Pancake defines Guatemalan clothing as "locative: graphic elements (that) symbolically describe 'spaces' as would a map." In addition to design motifs, shapes, and colors, another indicator is the way a garment is worn or constructed. Clothing is not always town specific, for a weaver may admire the *huipil* of a nearby town and create one for herself, indicating her knowledge of the world outside the town.

Linda Asturias de Barrios studies the pan-community styles of one Guatemalan municipality, Comalapa. By eliciting the criteria that the women themselves use to evaluate fine *traje*, she learned that clothing functions as a semiological code that conveys socially relevant information. Guisela Mayén analyzes male *traje* in another Guatemalan community, Sololá, where rank in the predominantly male civil-religious hierarchy, which governs the indigenous population, is indicated by certain costume elements and how they are worn.

Although there may be two or more textile systems—indigenous and nonindigenous—functioning simultaneously in the towns and regions covered in these essays, only Carol Hendrickson and Raquel Ackerman discuss the hierarchical ordering of nonindigenous dress. For Guatemalan *vestido* or *ladino* dress, the most desirable clothing is imported from the United States; next might be clothing from Guatemala City, and least desirable are products sold locally. In the Andes, the city dweller, the *mestiza*, and the peasant all have specialized clothing expressing differences in wealth, orientation, and the desire for social status.

Lee Anne Wilson and Ed Franquemont integrate the concept of Andean complementary dualism into their analyses. The dual structure of village organization, with reciprocal exchanges between both parts, developed from an Inca worldview and is mirrored in the act of weaving. The loom is set up with positive-negative, two-thread sets of balanced pairs. The weaver holds in her mind the reverse image of what she is weaving. The two halves of the textile are arranged symmetrically. Two-ply yarns are utilized because all elements require a mate.

Wilson reports that myths recall mock battles between *ch'unchos*, the naked wild inhabitants of the dark jungle, and *collas*, clothed llama and alpaca herders from the altiplano. The image of the *ch'uncho* is woven into textiles and is a reminder of the Andean dialectic of the opposing yet combining forces of *hanan* —the right side, masculinity, and superiority—and *hurin*—the left side, femininity, and inferiority.

Ritual Uses of Cloth and Its Creation

Sharisse and Geoffrey McCafferty study Post-Classic spindle whorls from Cholula, Mexico, and combine their archaeological data with historical information. They find that, for the Aztec, spinning and weaving symbology were connected with pre-Columbian goddesses. Spindle whorls were elaborately decorated with motifs related to deities responsible for sexuality, childbirth, and major events in the female life cycle. The attendant priestesses knew herbal and magical methods for conception and contraception. Therefore, through female discourse, women learned to control fertility and childbirth. Spinning and weaving helped to define femininity. A woman who spun but never wove was equated with infertility.

In Abancay, Peru, Raquel Ackerman observes that cloth is central to the definition of self. It may replace the individual and be used in witchcraft to harm the owner. To pacify the virgins and saints, their statues are periodically dressed and re-dressed either physically or metaphorically. Each rite of passage requires a new set of clothes. For death rituals, the best clothes of the deceased are placed on top of the shoulder cloth to reproduce the dead body.

Social Uses of Cloth and Its Creation

Mary Anne Medlin finds that the creation of textiles and the wearing of traditional dress at fiesta time is fundamental to Calcha ethnic identity. The acquisition and creation of fiesta dress indicate that the young woman is interested in the opposite sex and looking for a lover. Wearing fiesta dress represents adulthood and integration into local political and economic groups. Although ethnic clothing was customary in the past, now it is reserved for marriages, baptisms, and fiestas. Handwoven cloth is given at social events such as marriages, hamlet plantings of corn, and group celebrations.

At the Indian Queen contest in Tecpán, Guatemala, Carol Hendrickson notes that the contestants are not limited to wearing their own village-specific *traje típico*. Instead, the winner usually dons fine, older style *traje*, sometimes from another village in the municipality, demonstrating both *preparación*, knowledge of what is correct, and pan-Indian ethnic pride.

Commoditization of Textiles

For the Zapotec women of the Isthmus of Tehuantepec, traditional clothing is a financial investment and signals the wealth of the wearer. Pamela Scheinman looks at the production of traditional blouses by seam-

stresses working on old model, miniature Singer treadle machines. Novelty confers status on the wearer and new colors and designs appear each year. These blouses are sold in stores and market stalls but the finest ones, worn at fiestas and special events, are commissioned.

Backstrap weaving is a labor-intensive occupation. Materials are costly and often difficult to obtain. Weavers seldom receive compensation for time invested. Walter F. Morris, Jr., writes that, when a fine Maya weaving from Chiapas was marketed like an art object, a fair price was forthcoming. The middleman in a store or market situation needs to buy a textile cheaply in order to add on a percentage for profit. Since art collectors pay premium prices, gallery owners and dealers can sell fine textiles for more and still earn a commission. One approach that has helped Maya weavers in Chiapas is the development of the co-op Sna Jolobil through which the weaver gets paid directly for her work. She may receive materials in advance without paying for them. Older textiles are available for study purposes. Classes in natural dye technology and conservation are available. This co-op has contributed to the fine quality of weaving being produced in Chiapas, and a reciprocal relationship between *traje* and *costumbre* persists.

Suzanne Baizerman explores the paradox of "authentic" traditional art. Traditional, for the nonindigenous public, seems to imply something handmade and therefore superior to a machine-crafted object. "Authentic" refers to older-style native art forms and production methods. Criteria include one-of-a-kind products, use of natural dyes, and handwoven. The nonindigenous emphasis on "authentic" art led to a revival of the Indian Arts and Crafts movement spearheaded by Anglos who have become collectors. However, these collectors pay little attention to the social realities and values of the artists, who are no longer weaving for home production but for an elite few or for a market meant to satisfy Western popular tastes and budgets. Middlemen play important roles in defining traditional or "authentic" textile art and tourist textile art. The latter category, for which Baizerman proposes the term "boundary" art, includes small, portable, inexpensive items which are produced in quantity and marketed as craft items rather than art objects.[4]

When the Mexican government initiated a marketing campaign that expanded national and foreign markets of native crafts, it assumed an entrepreneurial role. Lynn Stephen studies the effect on the production of wool blankets and rugs in Teotitlán del Valle, an historic weaving town. The local craft industry depends on family and *compadrazgo* or godparent relationships. Merchants have control over the materials and give the work to weaving families with whom they have kinship ties; these weavers produce

only for them. Business negotiations between local merchants and importers take place in Teotitlán. Therefore, control of resources, capital, and labor remains within the community. Ethnic pride is expressed through textiles, for the weavers think of themselves as "the original Zapotecs" who continue to weave in the tradition of their ancestors.

Gender Roles

Both men and women are involved in Mesoamerican and Andean textile systems. Pre-Columbian weavers were predominantly women. As discussed above, under Spanish domination, treadle-loom weaving became men's work. Janet Catherine Berlo points out that, through contact with the Spanish, men learned their language. Women, however, continued to weave clothing and cloth on their backstrap looms in the home environment and did not learn Spanish. Women became the conservators of weaving lore and continued to wear *traje*, while men, dressed in western-style clothing, interacted with the Spanish and other foreigners. Both men and women, however, were involved in the marketing of textiles.

Lynn Stephen finds that, with the growth of the textile market in Teotitlán and the availability of prespun wool, women also began to weave on the treadle loom, formerly restricted to men. Households became a kind of production unit with specific tasks allocated to each member. In the highlands of Guatemala, if the woman is a well-known weaver, all the members of her family, including the young boys, learn backstrap weaving.

Virginia Davis comments that, in the past, tie-dyed *rebozos* or shawls were woven on backstrap looms by women in Teotla and Tenancingo, Puebla. When textile production became specialized in the 1930s, men began producing *rebozos* utilizing a two-harness foot-loom, while women specialized in textile finishing.

Andean men, women, and children all spin, an occupation that can be accomplished while tending animals. What they weave, however, may be gender and age specific. In Chinchero, Peru, men produce slings and cords for llama halters. Women weave shoulder cloths or *llikllas* and other clothing elements, while young girls create narrow ties or *hakimas* as their first textile.

Textiles as Text

Technical analyses of red, purple, and blue dyes in Guatemalan textiles have made it possible to read, or what Robert Carlsen and David Wenger call "fingerprint," documented weavings in museum and private

collections. Provenience and date of manufacture are correlated with data derived from ethnohistorical sources, concerning the economic and political conditions that prevailed during the production period. By reading the textiles from these various perspectives, a more holistic picture emerges that may be useful for cross-cultural studies.

One image, the *ch'uncho* or wild man from the jungle, serves Lee Anne Wilson as a means of looking at Andean symbolic values. Utilizing historical chroniclers and contemporary ethnographies, she focuses on several possible interpretations of this motif, which has been woven into textiles over the past centuries. Wilson concludes that the *ch'uncho* image is of Inca origin and relates to pre-contact, culture-hero mythology. It continues to reflect the survival of a pre-conquest world view: textiles function as narrative.

If textiles can be read as a text, we must learn the language. Barbara and Dennis Tedlock emphasize the important role that cloth and its creation played for the ancient Maya (Tedlock and Tedlock 1985). They suggest that the key to understanding Quiché Maya symbolic modes may be through intertextuality. By relating the arts of weaving, writing, oratory, architecture, and agriculture, it is possible to achieve a holistic perception of this symbolic system from the distant past. In this volume, Janet Catherine Berlo looks at the links between weaving, agriculture, and writing. She points out that, in *The Popol Vuh*, the ancient sacred book of the Maya, the words "to brocade" (which means to add supplementary weft threads to the basic web) and "to plant" are synonymous. Weaving and agriculture are linked to birth and procreation: maize is born from seeds which men place in the earth with planting sticks. For the Quechua of Chinchero, Peru, the word *pampa* describes the agricultural plain of the altiplano and also the solid color sections of a weaving.

In conclusion, we may reflect again on the words of Miguel Angel Asturias, as he describes a Maya *huipil* and consider the inevitability of change. In order to penetrate the symbols, spells, sayings, stars, and conjectures woven in cloth, textile systems must be studied in context and in relation to other systems in operation. The written word is one possibility, but the power of the visual image must not be ignored. The photographs and drawings accompanying the papers in this volume will help us to synthesize our impressions.

Why do we study textiles? Whose questions are being answered? Is it sufficient to pursue knowledge for its own sake, or is there a broader purpose which must be taken into account? Virginia Dominguez writes of the

paradoxes of ethnological collecting (Dominguez 1986). By representing indigenous cultures in our museums, are we trying to complete a vision of ourselves? Why do we concentrate on peoples whom we perceive to be without history? Are we endeavoring to connect with our own lost past through the possession of objects of the other?

Certainly, the study of cloth and its creation, as revealed in these essays, displays the multifaceted dimensions of textiles as artistic and cultural achievements. Through textiles we see ourselves in mirrors that reflect the history of changing civilizations.

Endnotes

1. Anawalt presented the Jane Dwyer Memorial Lecture, which was part of the Haffenreffer Museum symposium mentioned in the preface. She met two textile artists—Virginia Davis and Pamela Scheinman—who were presenting papers and are included in this volume. Anawalt informally presented recent research on the cloak of an Aztec emperor during the symposium. Davis and Scheinman questioned the surface-decorative technique that could produce two such distinct patterns. Upon Anawalt's request, the textile artists experimented with various techniques and eventually succeeded in replicating these designs. The research was included in the published article. See Anawalt 1990.
2. Zorn's symposium paper, "Andean Textile Systems: Reflections on Their Multiple Meanings" is not included in this volume. Consult the bibliography for her numerous publications cited by the authors.
3. John Cohen presented these comments in the symposium. His paper, "The Study of Ethnographic Textiles in Peru: A Personal View," is not included here.
4. Baizerman was also a symposium participant. In her paper "Textile Tourist Art: Can We Call it 'Traditional'?" and in her dissertation (1987, see bibliography), she addresses the topic of tourist or "boundary" art.

Bibliography

Anawalt, Patricia Rieff
 1981 Indian Clothing before Cortes. Norman: University of Oklahoma Press.
 1990 The Emperors' Cloak: Aztec Pomp, Toltec Circumstances. American Antiquity 55 (2):291-307.

Asturias, Miguel Angel
 1974 Leyenda de la mujer de ceniza. Américas 26(1):2-7.

Baizerman, Suzanne
 1987 Textiles, Traditions and Tourist Art: Hispanic Weaving in Northern New Mexico. Ph.D. dissertation, Department of Design, Housing and Apparel, University of Minnesota.

Barthes, Roland
 1983 The Fashion System. Trans: Mathew Ward and Richard Howard. New York: Hill and Wang.

Bogatyrev, Petr
 1971 Function of Folk Costume in Moravian Slovakia. The Hague: Mouton Publishers.

Dominguez, Virginia R.
 1986 The Marketing of Heritage. American Ethnologist 13(3): 546-555.

Murra, John V.
 1962 Cloth and Its Function in the Inca State. American Anthropologist 64 (4):710-728.

Schevill, Margot Blum
 1985 Evolution in Textile Design from the Highlands of Guatemala. Occasional Papers No. 1. Berkeley: Lowie Museum of Anthropology, University of California.
 1986 Costume as Communication. Studies in Anthropology and Material Culture: Volume IV. Bristol, Rhode Island: Haffenreffer Museum of Anthropology, Brown University.

Schneider, Jane
 1987 The Anthropology of Cloth. Annual Review of Anthropology 16:409-448.

Schneider, Jane, and Annette B. Weiner
 1986 Cloth and the Organization of Human Experience. Current Anthropology 27(2): 178-184.

Tedlock, Barbara, and Dennis Tedlock
 1985 Text and Textile: Language and Technology in the Arts of
 the Quiché Maya. Journal of Anthropological Research
 41(2):121-146.
Weiner, Annette B., and Jane Schneider, editors
 1989 Cloth and the Human Experience. Washington, D.C.:
 Smithsonian Press.

PART TWO

MESOAMERICA

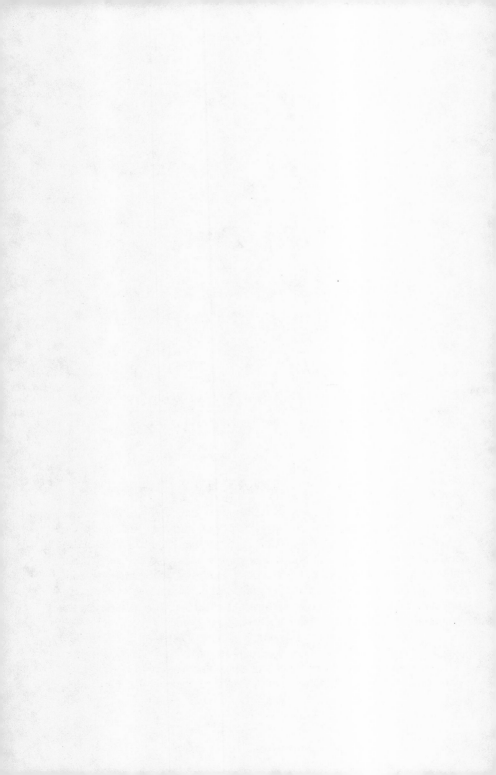

Chapter One

Spinning and Weaving as Female Gender Identity in Post-Classic Mexico

Sharisse D. McCafferty and Geoffrey G. McCafferty

Introduction

Spinning and weaving are traditional activities specific to the female domestic sphere in indigenous Mexican society. Evidence from ethnohistoric sources, including Spanish accounts and pre-Columbian codices, indicates that spinning and weaving were also important in Central Mexico immediately prior to the Spanish Conquest as both functional and symbolic activities. Finished textiles played an important role in the economy and tribute of Post-Classic Mexico. As costumes, they also served to communicate status, rank, ethnic affiliation, and gender.[1]

In addition to these functional qualities, spinning and weaving acted symbolically in defining and reifying female identity. In this chapter we discuss how spinning and weaving acted as metaphors for sexuality, childbirth, and female life-cycles in Post-Classic Mexico; and how these

activities served as a means of initiation into female ideologies. Finally, we suggest that the symbolism surrounding spinning and weaving defined female identity as one source of control over reproduction and thus as a basis of female power. The changing symbolic role of these activities during the Late Post-Classic and Early Colonial periods allows interpretations of the construction and transformation of female gender ideologies and the negotiation of gender relations.

Symbolic Archaeology and the Study of Gender

Spinning and weaving were traditionally considered women's work in pre-Columbian Central Mexico (Hellbom 1967). Although functional aspects of these activities have been described by anthropologists, the possibility of a symbolic significance has been largely overlooked. In Mesoamerica, Cecilia Klein (1982) has addressed the relationship between spinning and weaving symbolism and the metaphor of the loom as a structuring principle of the Mesoamerican worldview. For the Aztecs of Central Mexico, June Nash has interpreted spinning and weaving in gender terms as a "metaphor for subordination and humility" (1978:356). She supports this with the example of Tezozomoc, king of Azcapotzalco, who sent a shipment of cotton to the king of Texcoco in 1410, allegedly as an insult to his masculinity (see also Bernal 1976). Nash goes on to suggest diachronic changes in gender relations during the Post-Classic period, emphasizing specific arenas of female participation but concluding that male monopoly of military and bureaucratic spheres limited female access to wealth and prestige (1978:361) and was supported through a state ideology of male dominance.

In contrast to the paradigm of male dominance, this chapter employs a model in which the symbolism of spinning and weaving acted within an alternative, female discourse, operating apart from, even in resistance to, the dominant male ideology. Symbols helped to define female identity and delimit an arena within which female power could be negotiated. While evidence supports Nash's contention of a dominant socio-political position for Aztec males, it must not be assumed that other groups were without access to power. Several recent studies have addressed the issue of pre-Columbian gender relations from the perspective of women as an active interest group negotiating status through strategic decision-making (Brumfiel 1990; Kann 1989; Kellogg 1988; G. McCafferty and S. McCafferty 1989a, b; S. McCafferty and G. McCafferty 1988; see also Silverblatt 1978, 1987 for examples from South America).

A comparable use of symbolism in female discourse has been illustrated in the ethnoarchaeological studies of the Ilchamus of Baringo, Kenya (Hodder 1982, 1986), where women decorate calabash gourds used for feeding milk to children. While the ethnographic study of the Ilchamus indicated that women had little overt power in the public arena, "covertly, ... the decoration defines and emphasizes the reproductive importance of women in a society in which reproduction (of children and of the cattle that produce milk) is the central pivot of male power" (Hodder 1986:109). Women have adopted a strategy of emphasizing the source of their power in resistance to the pattern of male behavior. We assert that a comparable female discourse existed in pre-Columbian Mexico, as women expressed their control over reproduction and domestic production through symbolic representations of spinning and weaving.

Recognizing gender differences in the past is complicated by the androcentric bias that permeates anthro-pological research (Conkey and Spector 1984). The male bias that characterizes Western science has traditionally emphasized male activities while peripheralizing female activities. This is particularly true of the documentary records from the Spanish conquest (Brown 1983; Leacock and Nash 1977). The inherent androcentrism of early Colonial period ethnohistoric records—written by priests and *conquistadores* using a medieval mind-set—conforms to the culture historical model used in anthropological convention: an emphasis on political history, economics, technology, and the masculine elements of the native religious pantheon. Women, women's activites, and female cultural elements were dealt with superficially and stereotypically.

To study past gender relationships it is necessary to critically appraise potential biases that affect interpretation at every stage of analysis. In our investigations of pre-Columbian Mexican spinning and weaving we have used a variety of sources.[2] However, in addition to relying on literal textual references, this study also considers the pictorial representations of spinning and weaving and their associated tools in different contextual situations. In so doing we adopt methodologies from historical archaeology and material culture studies, which indicate that biases existing in textual records are often less pronounced when referring to material culture (Deetz 1977). An example of this principle in Colonial Mexican texts is found in the *Florentine Codex*, where the Spanish priest Bernardino de Sahagun noted that women had little influence in the marketplace; yet in the accompanying illustrations women are shown selling an assortment of goods (Hellbom 1967:134; Sahagun 1950-1982, Book 10:61-62, cf. plates 119 and 120).

The approach we use presumes an active role for material culture and its encoded symbols in the creation and transformation of society (Hodder 1982). On one level, symbols act as a form of communication, mediating social relationships while establishing group identity and maintaining boundaries (Wobst 1977). On another level, meanings vary depending on situational contexts, and symbols help to create those contexts (Bourdieu 1977; Hodder 1986). For instance, material culture—in this case spinning and weaving implements—will have different meanings within the different contexts in which it appears. These contexts can vary widely, based on who and what other factors are involved, when and where the activity takes place, and how all of the factors are integrated into the total context.

Another critical factor is the identification of historical antecedents, or traditions, for particular types of behavior. When contextual patterns are culturally prescribed, elements of material culture acquire symbolic properties that can evoke meaning regardless of context. The symbols are meaningful to those participants familiar with the patterned behavior. In this way symbols can be transmitted, but as symbolic information becomes invested in material culture it can also be controlled and manipulated. By studying symbols diachronically, we have a means of monitoring relationships not otherwise observable in the historical record.

The Ethnoarchaeology of Spinning and Weaving

Central Mexico had a well-developed weaving industry incorporating a wide range of materials, motifs, colors, and forms. This was noted by the early Spanish chroniclers (Cortes 1986; Diaz del Castillo 1963; Duran 1971; Motolinia 1951; Sahagun 1950-82) and has been well documented by Patricia Anawalt (1981).

Pre-Columbian weaving was done on the backstrap loom, a highly portable device where one end is attached to a tree or post, while the other end is wrapped around the weaver who maintains tension on the warp using body weight (figure 1a). [3] Spinning techniques included both drop- and supported spinning methods, depending on the material being spun and the desired quality of the thread (Hochberg 1980). Drop-spinning is done with a heavy whorl on the spindle shaft, where the rotating spindle is repeatedly dropped to draw out and twist the raw fiber. Drop-spinning can be done virtually anywhere, and ethnographic accounts describe women spinning with this technique as they walk to the fields or in the marketplace (Granberg 1970:13-16; Starr 1908). Supported spinning is done with the tip of the spindle shaft resting in a small bowl or on a flat surface. It provides greater control over

the spinning process and results in a finer-quality thread (figure 1b). Drop-spinning can only be done with relatively long staple fibers, such as maguey, while cotton is best suited for supported spinning.

Cotton in particular was a valuable trade and tribute commodity associated with elite status (Berdan 1982:30-31; Rodriguez Vallejo 1976). Maguey fiber was another commonly spun material, and depending on the species used and the number of production steps, it could produce either coarse or high-quality thread. Additional materials used for spinning included human and animal hair (rabbit and dog), feathers, and vegetable fibers such as milkweed and *chichicastle*, a fibrous nettle native to Southern Mexico, also known as *mala mujer* (Garcia Valencia 1975:61-62).

Education in spinning and weaving techniques began at an early age, and by adolescence girls were learning the rudiments of weaving (Codex Mendoza, plates LIX-LXI, described in Hellbom 1967:110-115) (figure 2). The primary weaver in a household was the wife, who had the responsibility of making clothing and other woven goods for the household (Duran 1971:423). Thread was often spun by other family members, especially young girls and old women, and occasionally by males depending on production needs and end use.

In addition to domestic use, spinning and weaving provided a means for women to participate in the market economy (Sahagun 1950-82, Book 8:69; Hellbom 1967:299). Woven goods produced in the household could be sold in the market or used as tribute. Capes and blankets were regularly presented as gifts at different ceremonies and were an important means for gaining social status (Sahagun 1950-82, Book 6:196). A woman's skill as a weaver was considered a positive asset in this pursuit. The practice of polygamy by the Aztecs was credited in part to the need for the elite to maintain a large labor pool of women for producing textiles for ritual gift-giving (Motolinia 1951: 202, 246). In temple compounds, spinning and weaving of fine textiles produced costumes, cotton armor, and incense bags for distribution as emblems of rank and for religious and state ceremonies (Anawalt 1981; Motolinia 1951). Finally, capes and *quachtlis* (small woven cloths) were used as standards of value in the pre-Columbian economy and were exchanged at a rate regulated by the Aztec state administration (Sahagun 1950-82, Book 9:48; Book 3:6-7; Berdan 1982:44).

Spinning and weaving were important functional tasks in Mesoamerican society, but it is our contention that they were equally important ideologically in structuring patterns of female identity. The female experience could be described as an analogue of spinning and weaving

activities, "interwoven" throughout daily practice by myth, folklore, gossip, and jokes. The metaphor of spinning and weaving is used in many cultures to explain the world (Eliade 1975:45-46; Klein 1982; Schaefer 1989; Wilbert 1974). There is ample evidence that this was the case in Post-Classic Central Mexico, as has been noted by Thelma Sullivan (1982:14):

> Spinning goes through stages of growth and decline, waxing and waning, similar to those of a child-bearing woman. The spindle set in the spindle whorl is symbolic of coitus, and the thread, as it winds around the spindle, symbolizes the growing fetus, the woman becoming big with child Weaving, too, the intertwining of threads, is symbolic of coitus, and thus spinning and weaving represent life, death, and rebirth in a continuing cycle that characterizes the essential nature of the Mother Goddess.

The metaphor of spinning and weaving is demonstrated in the Nahuatl riddle "What is it that they make pregnant, that they make big with child in the dancing place?" Answer: "Spindles" (Sahagun 1950-82 Book 6:240; paraphrased in Sullivan 1982:14). The "dancing place" was the bowl in which the spindle was set. Contemporary spinners in Mexico still refer to the spindle as dancing (*bailando*) in a bowl during supported spinning (Garcia Valencia 1975:60).

Indoctrination into female ideology began at an early age in a dedication ceremony involving spindles, fiber, whorls, looms, needles, and cooking utensils as symbols of female gender identity (Sahagun 1950-82, Book 6:201) (figure 3). The Aztec ceremony involved the presence of a midwife/priestess of the Mother Goddess, who read the astrological destiny and gave the child its calendrical name (Hellbom 1967:39). The priestess then took the umbilical cord of the girl child and buried it by the hearth, and "thus she signified that woman was to go nowhere. Her very task was the home life, life by the fire, by the grinding stone ... She was to prepare drink, to prepare food, to grind, to spin, to weave" (Sahagun 1950-82, Book 6:171).

Spinning and weaving were an essential part of the moral upbringing of young girls. They were associated with high status, but were taught as desirable skills for all "good" girls. Young girls began learning to spin by the age of four and learned to weave clothing by the age of fourteen (Hellbom 1967:167; Codex Mendoza; Zorita 1963:137). Since spinning and weaving were activities practiced predominantly in the household, it was taught that this was the female domain, with weaving ability a characteristic of a "proper wife" and thus a favorable trait for obtaining a husband:

Pay heed to, apply yourself to, the work of women, to the spindle,
to the batten.
Watch carefully how your noblewomen, your ladies, our ladies, the
noblewomen, who are artisans, who are craftswomen,
dye [the thread], how they apply the dyes [to the
thread], how the heddles are set, how the heddle
leashes are fixed ...
It is not your destiny, it is not your fate, to offer [for sale] in people's
doorways, greens, firewood, strings of chiles, slabs of
rock salt, for you are a noblewoman.
[Thus], see to the spindle, the batten ...
[Sahagun 1950-82, Book 6:96, quoted in Sullivan
1982:13-14]

The combined tasks of spinning and weaving were symbolic of the
changes in the female life cycle, with spinning an activity of young girls and
old women, while a married woman had the responsibility of weaving to
supply clothing for the family, especially her husband and children. A
common metaphor for infertility was one who spun but never wove (Sullivan
1982:19), as in the myth of *cihuapipiltin*, deified women who died in
childbirth. A contemporary myth from the state of Chiapas relates how
witches in the mountains spend their time endlessly spinning, with the
implication that "spinning without weaving is a futile and unproductive
occupation" (Cordry and Cordry 1968:42).

The sexual symbolism of spinning and weaving is also incorporated
into the Christmas ceremony of the Tzotzil Maya of Chiapas (Bricker
1973:19). Men dressed as "grandmothers" give the young women a lesson
in spinning and weaving full of sexual metaphors on the importance of
pleasing their husbands by fulfilling their female duties.

The symbolism of spinning and weaving as an emblem of female
identity is richly demonstrated in ethnohistory and folklore. In addition, its
significance pervades the mythology surrounding the Central Mexican
goddesses.

Mythology and Gender Identity

Symbols of female gender identity were transmitted through reli-
gious beliefs incorporating the female deities to create active social roles. In
pre-Columbian Mexico religion was not an abstract set of norms but an active
factor in prescribing behavior. The myths that surrounded the goddesses

were a means for enculturation, as mythology was used to transmit and justify gender ideologies (Taggart 1983). The metaphors expressed in mythology served to transform the natural into the supernatural, creating an ideological mystification of gender relationships and defining a female identity.

Mesoamerican religion was complex, and the Aztec pantheon in particular incorporated deities from neighboring lands as a result of imperial conquest and diverse cultural composition. As a consequence, isolating a specific deity associated with spinning and weaving is difficult. The traits extend beyond any one goddess and blend into many, until we see an archetypal pattern with multiple identities. The three main deities associated with spinning and weaving were Tlazolteotl, Xochiquetzal, and Mayahuel. A fourth, Toci, was also closely linked to the patterns embodied by the Mother Goddess and, by extension, to female identity. A brief description of each will present their individual traits and will demonstrate their overlapping attributes.

Tlazolteotl was known as the "Great Spinner and Weaver," and probably originated among the Huaxtecs of northern Veracruz (Sullivan 1982). She was associated with childbirth, the moon, menses, and purification; sexuality, witchcraft, and healing. She was also the *Tlaelquani*, "Eater of Filth," who absolved the sins of both men and women before death. Since it was believed that a child came into the world coated in the sins of its parents, Tlazolteotl (in the guise of her priestesses/midwives) received and purified the new-born (Sahagun 1950-82, Book 6:175). Another name for Tlazolteotl, Ixcuina, is a reference to her relationship to cotton (*ixcatl*), used in spinning but also important as an abortive, a lactogenic, and for absorbing menstrual flow (i.e.,"eating filth") (Sullivan 1982:19). Tlazolteotl was often depicted in the four-part nature of the female life cycle: first young and immature, then in full sexual bloom, later as a mother and center of the household, and finally as an old woman wise with experience (Sahagun 1950-82, Book 1:23; Sullivan 1982:12).

Tlazolteotl was often portrayed in the codices wearing a headband of unspun cotton and with cotton draped from her earspools (figure 4). Spindles with whorls were thrust into her hair as decoration or carried as a staff or weapon. Black bitumen (*chapopote*) was used to decorate her face as further indication of gender identity.[4] Another diagnostic emblem of Tlazolteotl was the crescent shape, which signified the moon, and which decorated her clothing and *yacametztli* nose ornament. Tlazolteotl's skirt

and/or *quechquemitl* were occasionally divided into red and black halves, symbolic of the structural oppositions incorporated in her character.

Tlazolteotl was associated with snakes, dogs, and centipedes (Sullivan 1982:17-18), all symbolic of fertility and the earth. Dogs were regarded as "eaters of filth" because they were commonly found foraging in garbage dumps. Centipedes are also found in areas of decomposing trash and were associated with the transformation of waste into productive humus. The essence of female ideology was embodied in Tlazolteotl, with the metaphor of spinning and weaving symbolic of the ongoing process of generation and regeneration.

Xochiquetzal, or "Precious Flower," was in many ways the Nahua equivalent of Tlazolteotl and shared many of her attributes. She was associated with flowers, artisans, and sexuality, both as the goddess of the marriage bond and as patroness of harlots (Brundage 1982; G. McCafferty and S. McCafferty 1989a). Xochiquetzal was reputed to have introduced the knowledge of spinning and weaving and to have provided the creative initiative for painting, carving, and music (Heyden 1985). These were occupations of the elite, especially of the children of the nobility who would not succeed to political posts (Sahagun 1950-82, Book 8:45). Humming-birds, butterflies, and flowers were glyphic elements identifying her as protector of the earth and its vegetation and the souls of the dead. The quetzal bird, dual locks of hair or twin upright tassles, a gold butterfly nose ornament, and a blue dress were other visual means of identifying Xochiquetzal (Duran 1971). In another aspect of the goddess, Itzpapolotl, or "Obsidian Butterfly," was a goddess of war and death in combat (Berlo 1983). While she was a protector of male warriors, Xochiquetzal was especially sensitive to women in labor, "since childbirth itself was likened to death and to battle" (Klein 1972:40).

Mayahuel was known as Lady Maguey because of her association with the agave plant, one of the fundamental elements of Mexican culture. Virtually every portion of the plant was used, including fiber for weaving, juice for the fermentation of *pulque*, and spines for ritual blood-letting (Goncalves de Lima 1956; Sullivan 1982:24-25). Although spun *maguey* did not have the elite status of cotton, it was more versatile in many ways and thus was more widely used. Mayahuel was a goddess of weaving; she was also associated with healing, female productivity, and reproduction. *Pulque*, the fermented juice of the maguey, was used ceremonially throughout Central Mexico. Like Tlazolteotl, Mayahuel shared the characteristic headband of

unspun fiber, in this case probably maguey, with spindles thrust into it (Sullivan 1982). Mayahuel was the embodiment of female productivity, often depicted with bare breasts as a symbol of her nurturing character. In the *Codex Vaticanus A* (21v) she is portrayed with 400 breasts (a metaphor for "prolific") in reference to her fecundity (Sullivan 1982:24; another possible example of this is found in the *Codex Nuttall* 27:I).

Finally, the goddess Toci, or Teteo-innan, was associated with the bath house, an area of healing, illicit sexual union, and childbirth. She was referred to as "Our Grandmother," a protector of women and source of wisdom. Her symbols were the broom and the shield, relating to her role in women's work and healing, and also as a warrior and protector. Toci was also known as Ilamatecuhtli, "the Mother of the Gods," and as such was a central figure in Mesoamerican mythology (Nicholson 1971). As part of the ritual calendar, the "Feast of the Sweeping" (*Ochpaniztli*) was dedicated to Toci, in which a goddess impersonator was sacrificed after performing her symbolic roles as a woman (Duran 1971:232-3):

> [The impersonator] was delivered to the old women who brought her a bundle of maguey fiber. They made her comb it, wash it, spin it, and weave a cloth of it. At a certain hour she was led out of the temple to a place where she was to perform the act [of weaving]....
> When the eve of the feast arrived, the woman, who had finished her weaving (which was a skirt and blouse of maguey fiber), was led by the old women to the marketplace. They made her sit there and sell the things she had spun and wove, thus indicating that the mother of the gods had been engaged in that occupation in her time to make a living, spinning and weaving garments of maguey fiber, going to the markets to sell them, thus providing for herself and her children.

As spinning and weaving were attributes of the Mother Goddess complex, they were linked symbolically to the authority of the goddesses and metaphorically to fertility and reproduction. Priestesses of the female deities were skilled midwives and adept at herbal and magical methods for inducing conception and contraception (Sahagun 1950-82, Book 1:4-5; Hellbom 1967:36). This implies control over reproduction, one of the most important sources of female power, and therefore a potential arena for gender competition.

Evidence for the multiplicity of symbolic meanings surrounding spinning and weaving can be found in the pre-Columbian codices, where the

presence of spindles and spindle whorls were characteristic traits for identifying the female deities and their priestesses. In the *Codex Nuttall* (e.g., pages 43:III and 48:IV) they were used to denote place names, perhaps as a means of identifying female domains or specific activity areas. Spindles, with or without whorls or thread, were also used as hair adornments in the codices, serving as an emblem of gender identity. Spindles are still worn in the hair in weaving communities of the Mixteca de la Costa, Oaxaca, where they are diagnostic of *malacateras*, or "spinners."[5]

An additional use of spinning and weaving symbolism in the codices was the use of weaving tools, especially battens, as weapons or as staffs of authority to represent female power (G. McCafferty and S. McCafferty 1989b; Sullivan 1982). In the feast of *Atemoztli*, images of mountain fertility deities were made out of amaranth dough, sacrificed using weaving battens, and then eaten (Sahagun 1950-82, Book 2:29; Anawalt 1981:14). This suggests that the weapons of the female deities were the same domestic tools that served to define female identity.

Conclusion

The symbolism of spinning and weaving served to define female identity in the sense that it created a set of meaningful associations that united women as an interest group. Spinning and weaving were gender specific activities that took place in the household, an area in which female power was concentrated. They were tasks that were practiced by virtually all women, regardless of class or age, and were taught as a fundamental part of the female gender role. The primary female goddesses associated with spinning and weaving were also linked with reproduction, and this theme was related metaphorically in the folklore surrounding spinning and weaving. The relationship between weaving materials (such as cotton and maguey) and fertility further reinforces the concept that female power was closely related to control over reproduction. The tools of spinning and weaving (spindles, whorls and battens) acted as symbols of this power, with the women represented in the codices that bore these tools—be they goddesses, priestesses, sacrificial impersonators, or mortals—identified as women with access to resources of female power.

The Archaeology of Gender Identity

This chapter has developed out of our study of archaeological spindle whorls from Cholula, Puebla. Spindle whorls were usually made of baked clay and acted as fly-wheels to maintain inertia for the rotating spindle

while twisting fiber into thread (Hochberg 1980; Smith and Hirth 1988). In Post-Classic Mexico (A.D. 900-1520) spindle whorls were often decorated with mold-made or incised designs, and occasionally they were painted or coated with bitumen. Interestingly, whorls are rare from earlier and later time periods, suggesting that permanent baked clay whorls may have had a symbolic role in addition to their functional utility. In contrast to highland Mexico, at the site of Matacapan in central Veracruz, spindle whorls *were* found in Classic period contexts (Hall 1989) and can possibly be related to increased status of women associated with textile production (Kann 1989).

In comparing archaeological assemblages from Post-Classic Cholula, striking differences are apparent in the decorative motifs on spindle whorls that probably relate to cultural changes through time. From an excavated household compound (the UA-1 site on the campus of the Universidad de las Americas) dating to the Early Post-Classic period (ca. A.D. 1000-1200) (G. McCafferty n.d., 1986), whorls displayed diverse decorative motifs, including complex geometric and zoomorphic patterns (figures 5a-f), and many have a bitumen coating over the mold-impressed designs (14%, n = 51).

Bitumen-covered whorls have been associated with the Gulf Coast region based on archaeologically recovered examples from sites in Veracruz (Ekholm 1944; Parsons 1972:57). Functional explanations for bitumen as a covering are unsatisfactory, and instead we suggest a symbolic interpretation, particularly as it relates to the cult of Tlazolteotl. While the Gulf Coast affiliation of the goddess would support the identification of bitumen-covered whorls as trade goods, it is not conclusive. At the UA-1 excavation at Cholula, five whorls were found with identical molded patterns, suggesting that they were produced in the same mold, and two were covered with bitumen. This suggests that the bitumen covering was probably applied on-site.

In another assemblage from the same area (UA-79), dating to the Late Post-Classic period (ca. A.D. 1350-1520), many of the previous motifs are nearly absent as is the use of bitumen. Instead, the whorls are often decorated with floral patterns, possibly depicting marigolds (figures 5g-j). Flowers were closely associated with the Mother Goddess complex, especially Xochiquetzal and Toci, and the marigold was used in special rituals by priestess/midwives (Sahagun 1950-82, Book 2:19; Heyden 1985).

The stylistic differences between the two assemblages occurred over a period of about 200-400 years, during which time the documentary sources record the conquest of Cholula by the Tolteca-Chichimeca ethnic

group (Historia Tolteca Chichimeca; Olivera and Reyes 1969). The histori-
cal evidence for ethnic change, from the original Olmeca-Xicallanca group
(with ties to the Gulf Coast) to the Tolteca-Chichimeca, is supported by
changes in the material culture (McCafferty 1989a, b). The evidence from
this spindle whorl analysis suggests that spinners were initially affiliated
with the cult of Tlazolteotl, using symbolic elements such as bitumen to
identify with her power. By the Late Post-Classic period this affiliation had
been transferred to the cults of Xochiquetzal and Toci as evidenced by the
predominance of floral motifs. What effect this religious change may have
had on gender relations remains to be explored further, although the similari-
ties between the goddesses suggest that the structural differences may have
been minimal.

Another symbolic association relates whorl patterns and shield
decorations.[6] Decorated shields are represented in the pictorial manuscripts,
with different motifs relating to regional identity and military rank (Penafiel
1985). Patterns identical to those found on shields were also found on spindle
whorls, particularly those from the UA-1 household context. Whorls deco-
rated with hatched semicircles, for example, may relate to the *teueuelli*
("sacrificial shield") carried by the goddess Toci and the Aztec patron
Huitzilopochtli. Susan Kellogg (1988) has discussed the conceptual similari-
ties between warfare and childbirth as a "structural equivalence" linking
male and female genders. This may be one explanation for the use of shield
patterns on whorls, relating to the exhortation of the midwife to "take up the
little shield" during childbirth (Sahagun 1950-82, Book 6:154, 161; G.
McCafferty and S. McCafferty 1989b). On a more practical level, it can be
speculated that a sharp spindle through a whorl would have been a formi-
dable female weapon, the Mesoamerican equivalent of a long hat pin.

Spindle whorls *do* play a functional role in spinning, but they do not
need to be as elaborately made as the Post-Classic Cholula whorls. Contem-
porary spinners often use spindles with sun-baked clay whorls applied
directly to the shaft, resulting in an efficient system that would rarely leave
a trace in the archaeological record. Since whorls are not recovered from
Classic period contexts, yet woven garments are depicted in mural paintings,
it is likely that a similar, impermanent spindle whorl was used.

We suggest that the symbolic importance of decorated spindle
whorls emphasized affiliation with the female deities and therefore pro-
moted a group identity. Spindles with whorls worn in the hair may have been
an emblem of status as is still the case among the Mixtecs of the Oaxaca coast.
As a talisman of the deity, spindle whorls may have been used in fertility rites

(Duran 1971: 264-5, 269). The act of spinning itself, which was practiced throughout the day in varied situations, could almost be interpreted as a form of worship in the sense of symbolic bonding with the Mother Goddess(es).

Based on ethnohistoric evidence and supported by the archaeological spindle whorls from Cholula, female power during the Post-Classic period was expressed through the metaphor of spinning and weaving. Following the Spanish Conquest, the ideological system of Mesoamerica was fundamentally altered and consequently so were gender relationships (Nash 1980). The authority of the female deities was transferred to the cult of the Virgin and any overt control over reproduction was discouraged by the Church. Effectively, female power rapidly declined. And although techno-logical change did not alter the indigenous weaving industry, the use of decorated and baked spindle whorls was quickly abandoned.

The use of archaeological methods to study ideology, through symbols and material culture, provides a methodology for studying change in the relations between and within social groups. Group relationships are continuously redefined as strategies for control over power are negotiated. Changing symbols of group identity can relate to these changing relation-ships and thereby indicate the arenas of interaction. In the example from Post-Classic Mexico, control over reproduction was one focus of gender competition, symbolized in the myths of spinning and weaving. That these symbols were abandoned following the Spanish Conquest does not necessar-ily mean that the competition was also abandoned but only that gender identities were redefined with other symbols of identity taking their place.

Endnotes

1. This paper has been revised from a seminar paper entitled "Mesoamerican Myth, Material Culture and Female Gender Ideology" for Sym-bolic and Structural Archaeology taught by Dr. Ian Hodder at SUNY Binghamton in the spring of 1986. Earlier drafts of this paper have been read by Lon Bulgrin, Margaret Conkey, Ian Hodder, James W. McCafferty, Randall McGuire, Susan Milbrath, and Susan Pollock. Additional comments were made by members of the "Feminist Theory in Archaeology" discussion group, Dept. of Anthropology, SUNY Binghamton. We gratefully acknowledge the constructive advice that has been offered and take full respon-sibility for the end result.

2. To illustrate the activities of spinning and weaving we have drawn data from throughout the Mesoamerican area, and from a long historical

sequence. This is not meant to imply that we consider Mesoamerica as a homogeneous unit, as certainly there are important cultural differences within the area. Instead, we see the symbolism of spinning and weaving as a cross-cutting theme that was prevalent in the Post-Classic period (A.D. 900-1550), albeit with informative regional and cultural variations. The core area from which we derive most of our examples, and hence for which the conclusions are most appropriate, is Central Mexico, especially the valleys of Mexico, Puebla/Tlaxcala, Tehuacan, and Oaxaca; and the Gulf Coast and the Mixteca of Oaxaca.

3. Illustrations were drawn by Sharisse D. McCafferty.

4. Bitumen is a natural tar that was available in the Gulf Coast. It was believed to have curative and magical properties, especially when applied to pieces of bark paper. Mixed with *axin*, an oily substance derived from ground insects, bitumen became *chicle* and could be chewed like gum (Sahagun 1950-1982, Book 10:89). It was the "preference" of girls and unmarried women to chew publicly. Married women, widows, and old women also enjoyed chewing but never in public. Harlots chewed *chicle* "quite publicly, ... clacking like castanets" (ibid.). Men chewed *chicle* "very secretly —never in public," with exception of homosexuals: "the men who chew *chicle* achieve the status of sodomites" (ibid.:90). This suggests that the use of bitumen was an overt indicator of the sexual as well as gender status, with the application of bitumen paint on the face an emblem of female identity.

5. Our thanks to Dr. Patricia Anawalt for providing illustrations of shield patterns from her study of the Codex Mendoza.

6. Female weavers from the weaving community of Jamiltepec (Oaxaca) are known as *malacateras* and continue to wear spindles in their hair.

Bibliography

Anawalt, Patricia R.
 1981 Indian Clothing Before Cortes: Mesoamerican Costumes from the Codices. Norman: University of Oklahoma Press.
Berdan, Frances F.
 1982 The Aztecs of Central Mexico: An Imperial Society. New York: Holt, Rinehart and Winston.
Berlo, Janet Catherine
 1983 The Warrior and the Butterfly: Central Mexican Ideolo-

gies of Sacred Warfare and Teotihuacan Iconography. *In* Text and Image in Pre-Columbian Art, edited by J.C. Berlo. Pp. 79-118. Oxford: BAR International Series 180.

Bernal, Ignacio
 1976 Tenochtitlán es una isla. Mexico, D.F.: Utopia, Companía Editorial.

Bourdieu, Pierre
 1977 Outline of a Theory of Practice. Cambridge: Cambridge University Press.

Bricker, Victoria
 1973 Ritual Humor in Highland Chiapas. Austin: University of Texas Press.

Brown, Betty Ann
 1983 Seen but not Heard: Women in Aztec Ritual—The Sahagun Texts. *In* Text and Image in Pre-Columbian Art, edited by J.C. Berlo. Pp. 119-154. Oxford: BAR International Series 180.

Brumfiel, Elizabeth
 1990 Weaving and Cooking: Women's Production in Aztec Mexico. *In* Women and Pre-History, edited by J. Gero and M. Conkey. Oxford: Basil Blackwell. (in press).

Brundage, Burr Cartwright
 1982 The Phoenix of the Western World: Quetzalcoatl and the Sky Religion. Norman: University of Oklahoma Press.

Codex Mendoza
 1964 Codex Mendoza, Bodleian Library, Oxford. *In* Antigüedades de México basadas en la recopilación de Lord Kingsborough, edited by Jose Corona Nuñez. México, D.F.: Secretaría de Hacienda y Crédito Público.

Codex Nuttall
 1975 The Codex Nuttall. A Picture Manuscript from Ancient Mexico. The Peabody Museum Facsimile, edited by Zelia Nuttall (introduction by A.G. Miller). New York: Dover Publications, Inc.

Codex Vaticanus A
 1964 Codex Vaticanus A (3738), Biblioteca Apostolica Vaticana, Rome. *In* Antigüedades de México basadas en la recopilación de Lord Kingsborough, edited by Jose Co-

rona Nuñez. México, D.F.: Secretaría de Hacienda y Crédito Público.

Conkey, Margaret, and Janet Spector
1984 Archaeology and the Study of Gender. *In* Advances in Archaeological Method and Theory, Vol. 7, edited by M.B. Schiffer. Pp. 1-38. New York: Academic Press.

Cordry, Donald, and Dorothy Cordry
1968 Mexican Indian Costumes. Austin: University of Texas Press.

Cortés, Hernán
1986 Letters from Mexico (translated and edited by A. Pagden). New Haven and London: Yale University Press. (Originally written from 1519-1526.)

Deetz, James
1977 In Small Things Forgotten. New York: Doubleday.

Diaz del Castillo, Bernal
1963 The Conquest of New Spain (translated by J.M. Cohen). Middlesex: Penguin Books. (Originally written in the 1560s.)

Duran, Diego
1971 The Book of the Gods and Rites and the Ancient Calendar (translated by F. Horcasitas and D. Heyden). Norman: University of Oklahoma Press.

Ekholm, Gordon F.
1944 Excavations at Tampico and Panuco in the Huasteca, Mexico. Anthropological Papers 38(5). New York: American Museum of Natural History.

Eliade, Mircea
1975 Rites and Symbols of Initiation: The Mysteries of Birth and Rebirth (translated by W.R. Trask). New York: Harper and Row.

García Valencia, Enrique Hugo
1975 Textiles: Vocabulario sobre materias primas, instrumentos de trabajo, y técnicas de manufactura. Cuadernos de Trabajo, No. 3, Museo Nacional de Antropología, Seccion de Etnografía. México, D.F.: INAH.

Goncalves de Lima, Oswaldo
1956 El maguey y el pulque en los Códices mexicanos. México, D.F.: Fondo de Cultura Económica.

Granberg, Wilbur J.
 1970 People of the Maguey: The Otomi Indians of Mexico.
 New York: Praeger Publishers.
Hall, Barbara
 1989 Spindle Whorls and Textile Exchange at Matacapan,
 Veracruz. Paper presented at the Annual Meeting of the
 American Anthropological Association, Washington, D.C.
Hellbom, Anna-Britta
 1967 La participación cultural de las mujeres: Indias y mestizas
 en el México precortesiano y postrevolucionario. Mono-
 graph Series, Publication No. 10. Stockholm: The Eth-
 nographical Museum.
Heyden, Doris
 1985 Mitología y simbolismo de la flora en el México pre-
 hispanico. Mexico, D.F.: Universidad Nacional Autónoma
 de México.
Historia Tolteca-Chichimeca
 1976 Historia Tolteca-Chichimeca (edited and translated by P.
 Kirchoff, L. Odena G., and L. Reyes G.). México, D.F.:
 Instituto Nacional de Antropología e Historia.
Hochberg, Bette
 1980 Handspindles. Santa Cruz: B. and B. Hochberg.
Hodder, Ian
 1982 Symbols in Action. Cambridge: Cambridge University
 Press.
 1986 Reading the Past. Cambridge: Cambridge University Press.
Kann, Veronica
 1989 Late Classic Politics, Cloth Production, and Women's
 Labor: An Interpretation of Female Figurines from Mata-
 capan, Veracruz. Paper presented at the Annual Meeting
 of the Society for American Anthropology, Atlanta, GA.
Kellogg, Susan
 1988 Cognatic Kinship and Religion: Women in Aztec Society.
 In Smoke and Mist: Mesoamerican Studies in Memory of
 Thelma D. Sullivan, edited by J.K. Josserand and K.
 Dakin. Pp. 666-681. Oxford: BAR International Series
 402.
Klein, Cecilia
 1972 The Face of the Earth: Frontality in Two-Dimensional

Mesoamerican Art. New York: Garland Series, Outstanding Dissertations in the Fine Arts.

1982 Woven Heaven, Tangled Earth: A Weaver's Paradigm of the Mesoamerican Cosmos. *In* Ethnoastronomy and Archaeoastronomy in the American Tropics, edited by A.F. Aveni and G. Urton. Pp. 1-35. New York: Annals of the New York Academy of Sciences, vol. 385.

Leacock, Eleanor, and June Nash

1977 Ideology of Sex: Archetypes and Stereotypes. New York: Annals of the New York Academy of Sciences, vol. 285.

McCafferty, Geoffrey G.

n.d. Archaeological Interpretations of the Post-Classic Material Culture from the UA-1 Excavations, San Andres Cholula, Puebla, Mexico. Ph.D. dissertation, SUNY Binghamton. (in preparation.)

1986 The Material Culture of Early Post-Classic Cholula and the "Mixteca-Puebla" Problem. Paper presented at the Annual Meeting of the Society for American Archaeology, New Orleans, LA.

1989a Ethnic Boundaries and Ethnic Identity: Case Studies from Post-Classic Mexico. Unpublished M.A. thesis, Dept. of Anthropology, SUNY Binghamton, Binghamton, NY.

1989b Ethnic Identity in the Material Culture of Post-Classic Cholula. Paper presented at the Annual Meeting of the Society for Historical Archaeology, Baltimore, MD.

McCafferty, Geoffrey G., and Sharisse D. McCafferty

1989a Xochiquezal: Images of the Goddess in Aztec Society. *In* Collected Papers from the Conference "The Goddess as Muse to Women Artists," edited by Mary Kelley, SUNY Cortland.

1989b Weapons of Resistance: Material Metaphors of Gender Identity in Post-Classic Mexico. Paper presented at the Annual Meeting of the American Anthropological Association, Washington, D.C.

McCafferty, Sharisse D., and Geoffrey G. McCafferty

1988 Powerful Women and the Myth of Male Dominance in Aztec Society. Archaeological Review from Cambridge 7:45-59.

Motolinia, Toribio de
 1951 History of the Indians of New Spain (translated and
 annotated by F.B. Steck). Washington, D.C.: Academy of
 American Franciscan History. (Originally written ca. 1536-
 1543.)
Nash, June
 1978 The Aztecs and the Myth of Male Dominance. Signs:
 Journal of Women in Culture and Society 4(2):349-362.
 1980 Aztec Women: The Transition from Status to Class in
 Empire and Colony. *In* Women and Colonization: An-
 thropological Perspectives, edited by M. Etienne and E.
 Leacock. Pp. 134-148. New York: Praeger Publishers.
Nicholson, Henry B.
 1971 Religion in Pre-Hispanic Central Mexico. *In* Handbook of
 Middle American Indians, Vol. 10: Archaeology of North-
 ern Mesoamerica, Part 1, edited by R. Wauchope, G.F.
 Ekholm, and I. Bernal. Pp. 395-446. Austin: University of
 Texas Press.
Olivera, Mercedes, and Cayetano Reyes
 1969 Los Choloques y los Cholultecas: Apuntes sobre las
 relaciones etnicas en Cholula hasta el siglo XVI. Anales
 del INAH, Epoca 7a, Tomo I, 1967-68, México, D.F.
Parsons, Mary H.
 1972 Spindle Whorls from the Teotihuacan Valley, Mexico. *In*
 Miscellaneous Studies in Mexican Prehistory, edited by
 M.W. Spence, J.R. Parsons, and M.H. Parsons. Pp. 45-80.
 Anthropological Papers, No. 45. Ann Arbor: Museum of
 Anthropology, University of Michigan.
Penafiel, Antonio
 1985 Indumentaria antigua: Armas, vestidos guerreros y civiles
 de los antiguos Mexicanos. México, D.F.: Editorial Inno-
 vación.
Rodriguez Vallejo, Jose
 1976 Ixcatl: El algodon mexicano. México, D.F.: Fondo de
 Cultura Económica.
Sahagun, Bernadino de
 1950-1982 Florentine Codex: General History of the Things of
 New Spain. Trans. C.E. Dibble and A.J.D. Anderson. Salt

Lake City and Santa Fe: University of Utah Press and School of American Research. (Originally written by 1569.)

Schaefer, Stacy B.
1989 The Loom as a Sacred Power Object in Huichol Culture. Paper presented at the Annual Meeting of the American Anthropological Association, Washington, D.C.

Silverblatt, Irene
1978 Andean Women in the Inca Empire. Feminist Studies 4:36-61.
1987 Sun, Moon, and Witches: Gender Ideologies and Class in Inca and Colonial Peru. Princeton: Princeton University Press.

Smith, Michael E., and Kenneth G. Hirth
1988 The Development of Pre-Hispanic Cotton-spinning Technology in Western Morelos, Mexico. Journal of Field Archaeology 15:349-358.

Starr, Frederick
1908 In Indian Mexico. Chicago: Forbes and Company.

Sullivan, Thelma
1982 Tlazolteotl-Ixcuina: The Great Spinner and Weaver. *In* The Art and Iconography of Late Post-Classic Central Mexico, edited by E.H. Boone. Pp. 7-36. Washington, D.C.: Dumbarton Oaks.

Taggart, James
1983 Nahuat Myth and Social Structure. Austin: University of Texas Press.

Wilbert, Johannes
1974 The Thread of Life: Symbolism of Miniature Art from Ecuador. Studies in Pre-Columbian Art and Archaeology 12. Washington, D.C.: Dumbarton Oaks.

Wobst, Martin
1977 Stylistic Behavior and Information Exchange. *In* Papers for the Director: Research Essays in Honor of James B. Griffin, edited by C.E. Cleland. Pp. 317-342. Anthropological Papers, No. 61. Ann Arbor: Museum of Anthropology, University of Michigan.

Zorita, Alonso de
 1963 Life and Labor in Ancient Mexico Trans. B. Keel. New Brunswick: Rutgers University Press. (Originally written in 1570s or 1580s.)

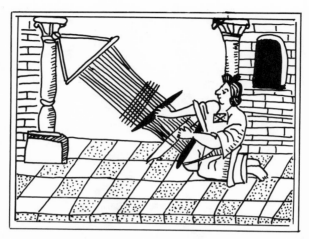

Figure 1a. Aztec noblewoman weaving on backstrap loom in patio of house (after Sahagun 1950-1982, book 10: figure 58). Drawing by Sharisse McCafferty.

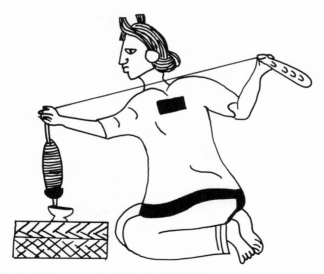

Figure 1b. Aztec woman spinning with spindle supported in small bowl (after Codex Mendoza, vol. 3, folio 68r). Drawing by Sharisse McCafferty.

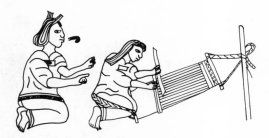

Figure 2. Aztec woman instructing daughter in weaving technique (after Codex Mendoza, vol. 3, folio 60r). Drawing by Sharisse McCafferty.

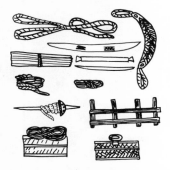

Figure 3. Spinning and weaving implements (after Sahagun 1950-1982, book 8: figure 75). Drawing by Sharisse McCafferty.

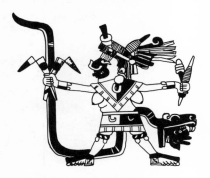

Figure 4. Mexican goddess, Tlazolteotl, with spindles in headband and hand (after Codex Laud:39). Drawing by Sharisse McCafferty.

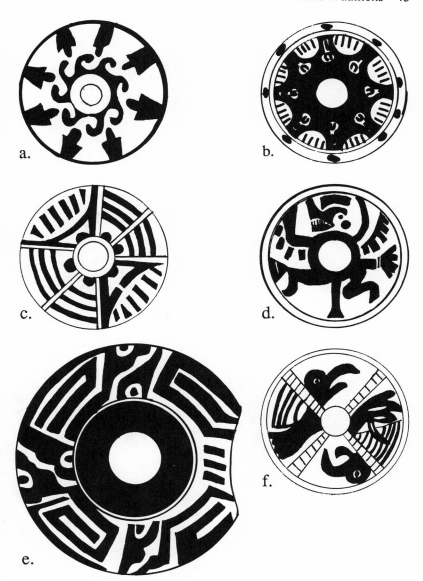

Figures 5a-f. Archaeological spindle whorls from UA-1 (Cholula, Puebla) showing complex geometric and zoomorphic design motifs. Drawings by Sharisse McCafferty.

Figures 5g-j. Archaeological spindle whorls from UA-79 (Cholula, Puebla) showing floral motifs. Drawings by Sharisse McCafferty.

Chapter Two

Communicative Imagery in Guatemalan Indian Dress

Cherri M. Pancake

Social parameters or codes governing dress are found to a degree in all societies. Some, such as the sumptuary laws of ancient Rome or Mesoamerica, are formally defined and stringently enforced by the governing class, while other restrictions are dictated simply by public opinion. Because unofficial dress codes are imposed by the general public upon itself, anthropologists and sociologists have become increasingly aware of their value as sources of information on aesthetic and social values. In this chapter, we explore the concept of textile imagery by assessing the role of Guatemalan Indian dress as a communicative medium.[1]

It is rare that clothing traditions are as clearly defined and accessible for study as among the Indian communities of Guatemala. Highland Guatemala is densely populated and a majority of its inhabitants are of Indian descent. Although there is a certain degree of cultural amalgamation and intermingling between the Indian and non-Indian sectors, many Indian

communities preserve what is effectively a cultural autonomy. Each has its own language, costume, ceremonial calendar, civil-religious hierarchy, agricultural and cottage industry specializations, oral traditions, and aesthetic traditions, and each is isolated from its neighbors—if not in a physical sense, then by equally real cultural barriers.[2]

For more than a century, clothing traditions have provided the most visible evidence of cultural autonomy in many Indian communities. Prior to the political and social upheaval of the late 1970s, more than a hundred and twenty Indian communities retained distinctive styles of clothing. These costumes differ radically from one another in construction, color, design, materials, and even the manner in which individual garments are worn. The study of Guatemalan Indian dress as an indicator of societal attitudes and values is possible precisely because these traditions are so pervasive and so clearly delimited.[3]

Apart from its role as a purveyor of warmth and modesty, clothing serves to convey information. In this sense, dress may be seen as symbolic "text" or "message," a visual means of communicating ideas and values. In its purely graphic aspect, clothing is a collection of design elements: form, color, texture, and pattern. The human mind and eye selectively focus on particular elements or sets of these elements. Although the process is largely subconscious, it provides an initial plane of perception. Some of the design elements have, through use and tradition, taken on meaningful associations. Each viewer interprets the dress he observes according to his visual perceptions and his understanding of the symbolism inherent in the design components and the ways in which they are combined.

Locative Information

One illustration of the communicative symbolism of dress is its capacity for providing locative information. The term locative refers to the fact that the graphic elements of clothing symbolically describe spaces, as would a map. This spatial categorization can be physical (e.g., geographic areas) or social (i.e., action domains established by class or race). In its broadest sense, locative imagery goes beyond the simple delimiting of a space; it locates the wearer within the space, defining where the individual feels he or she belongs *vis-a-vis* attitudes and personal preferences.

For example, in Guatemala the overall form of Indian clothing—distinctive wrapped garments very unlike the fitted clothing worn by non-Indians—instantly marks the wearer as being "of Indian space," a first order of spatial organization. Geographically, this means that the wearer is from

the highlands of Guatemala. More importantly, since Guatemalan society is highly stratified by race and class, it implies an acknowledgment of the Indian/non-Indian ethnic boundary and an explicit association with one group.

The construction and shape of particular garments and the ways in which they are worn serve to further locate the individual. For example, most Indian skirts are long lengths of fabric wrapped about the body in various ways. Wrapping styles that incorporate a double, inverted pleat at the front indicate that the wearer is from the Cakchiquel or Quiché linguistic area; women from the neighboring Mam region use a simpler wrapping technique. A very wide skirt gathered at the waist identifies the wearer as being from a Kekchí, Pocomchí, or Pocomam community. Geographic region thus constitutes a second order of spatial organization. In similar fashion, general pattern composition serves to distinguish garments from specific subregions. The traditional garments of the eastern Cakchiquel area (San Raimundo, San Juan Sacatepéquez, Santo Domingo Xenacoj, San Pedro Sacatepéquez, Santiago Sacatepéquez, and Santa María de Jesús) are characterized by complex, finely detailed bird and animal figures woven in horizontal bands.

Additional details, such as the placement of design elements appearing on specific garments or the textile techniques used to produce them, locate the wearer with even more precision, usually signaling the particular community to which he or she belongs. Indian clothing functions as a medium of communicative imagery primarily because of the strong design traditions characteristic of the Indian communities. Local norms, collectively referred to as *costumbre* (tradition), guide the overall form of the costume and the use of its component parts. Any serious deviation exposes the trespasser to ridicule by fellow community members. It is difficult to generalize about which specific costume features are most likely to be dictated by local standards. In some communities seemingly trivial details, such as the precise way in which a shawl is folded on the head or the sequence of colors in a striped background fabric, are predictable while more obvious elements, like the selection and placement of design motifs, are irrelevant.

The outsider is unlikely to be able to predict which items of communicative text a community member will find most significant. Taken as a whole, however, the local costume is generally so recognizable that it serves as an identification badge indicating the community affiliation of the wearer (figure 1). Even the casual observer can learn to identify the origins of Indians who wear traditional clothing. Communicative imagery of this sort is a valuable tool. The evolution of traditional textiles over the last

hundred years has been gradual and comprehensible, so much so that historical illustrations from the nineteenth century may be identified solely on the basis of the costumes depicted. Community members recognize and often admire the dress of other villages, but for their personal use—and for the images with which they associate their community—they conserve local styles as an expression of cultural affiliation.

Locative symbolism at this third spatial order can be of economic as well as social importance. Certain communities and regions (e.g., the Zunil/Almolonga valley or the area around Lake Atitlán) are renowned for the high quality of their agricultural produce. Most Indian farmers retail their own products in the many local and regional markets characteristic of Guatemala's Indian economy. A vendor gains instant credibility in the marketplace by wearing the village's distinctive costume (figure 2). The dress of Todos Santos Cuchumatán, for example, is familiar to Indians and non-Indians throughout Guatemala. Shoppers who prefer to buy potatoes from that area seek out merchants who wear the community costume. Indians from villages which specialize in pottery or other crafts also journey to area markets to sell their products; here, a distinctive village dress serves to immediately "label" the wearer as being from that community and therefore presumably skilled in its craft specialty. In an economy that is largely dependent on cottage industries and small-scale agricultural production, Indian costumes play as important a role in establishing product quality as do brand names in more technologically advanced markets.

The badge of community affiliation is equally important outside of the marketplace. Agricultural agents are well aware that some communities are known for workers skilled in certain tasks (such as coffee picking or plant nursery work) and prefer to hire seasonal laborers from these areas. Similarly, the large textile mills prefer to hire Indian women from the Cantel or Quezaltenango areas, where mill work has for decades been an acceptable female occupation; women from other areas are considered difficult to train. In cases such as these, recognizable community dress plays an essential role in establishing an individual's background and potential worth. Finally, the use of a village costume instills a certain amount of confidence in the mind of the prospective purchaser or hirer. The community affiliation made explicit by the use of village costume implies the existence of relatives and friends to whom grievances may be directed should problems arise.

At a fourth spatial order, of even greater locative specificity, a perceptive observer can identify subcommunity units such as *barrios* (town precincts), *cantones* (rural subareas), or *aldeas* (rural settlements) based on

locale-specific variants of the basic coloration or composition of village dress.[4] For most viewers, this difference is irrelevant and thus goes unnoticed. Anyone for whom the subcommunity distinction is significant, however, can instantly read, interpret, and mentally file the graphic code.

Not all Indian dress functions on all levels of locative imagery. Many of the traditional distinctions have been obscured by the emergence of pan-community styles in the past four decades. In these cases, fabrics woven in mills or produced in quantity on handlooms are used as the basis for regional garments that replace the community and subcommunity locative orders. Women in many communities of the central highlands have adopted what may be termed the "Totonicapán style," which combines a tie-dyed skirt with a decorated sash and any of a variety of blouse styles. Short filmy tops and full skirts characterize the increasingly popular "Alta Verapaz style."

Social Information

Locative symbolism is only one illustration of the range of communicative possibilities presented by traditional Indian dress. Within the community another spectrum of variation reflects the individual's status: gender, age group, socioeconomic position, marital status, ceremonial role, and so on (figure 3). The distinctions may be minor in the case of informal stratifications such as age and marital status. In San Juan Sacatepéquez, for example, unmarried women traditionally wear a narrow sash with embroidered designs, while their married counterparts use a wider sash with woven patterns similar to that of their husbands. In Todos Santos Cuchumatán, single women wear their skirts shorter and more precisely folded. In Sacapulas, single women wear large, exotic headdresses, while married women effect a more conservative style. The *huipil*, a blouse-like garment worn throughout Guatemala, is particularly rich in this type of message. In many communities, the style of *huipil* a woman wears reveals as much about her age as do her hair and skin.

Membership in formal groups is signaled by even more distinctive variations in style. The attainment of certain ranks in the local civil-religious hierarchy is reflected by changes in the garments constituting a person's costume. Town officials are recognizable by their use of special woolen overgarments as well as by the silver-tipped staffs of office they carry. Specialized patterns and colors also identify the clothing worn by members of local *cofradías* or religious confraternities. Each *cofradía* is charged with the care and protection of the church in general and of one locally venerated

saint in particular. Although not directly imbued with political powers, the members of the *cofradías* often exercise a certain control over the conduct of fellow community members and command their respect. This status is communicated in the text of their clothing: while carrying out religious duties, *cofradía* members wear a distinctive variant of the local costume.

Garments used for ceremonial occasions communicate information on role as well as event. In general, they are more elaborate and more finely worked than their everyday counterparts. For example, the daily *huipil* traditionally worn in Patzicía is of simple striped fabric, the *huipil* worn by principals in baptisms and weddings has a single horizontal pattern band, while the *cofradía huipil* has many rows of motifs across the shoulder area.[5] In some communities specific design motifs are reserved for use on ceremonial garments. Aesthetic strictures such as these often are considered inviolable. Consequently, in some towns the only distinction between daily and ceremonial *huipiles* is the occurrence of a particular motif (e.g., the double-headed eagle motif in Palín *huipiles* prior to 1975). Other communities utilize specific types of garments to indicate ceremonial status; the loosely-wrapped male *cofradía* costumes from Nahualá, for example, are totally unlike the clothing worn for everyday work. Most towns also reserve particular categories of accessory cloths for ritual occasions, such as the embroidered textiles used to carry ceremonial standards. Rank, occasion, role, and authority are eloquently expressed through the symbolic imagery of ceremonial textiles.

Creating Woven Text

The extraordinary diversity of Guatemalan Indian dress reflects the rich and varied textile techniques used to produce traditional clothing. Many garments are woven on the Maya stick loom,[6] which has remained remarkably unchanged since the neolithic origins of handweaving. The loom is composed of a handful of sticks, a rope, and a strap and is held together only by the threads being woven. Two wooden bars are used to keep the lengthwise threads taut for the weaving process. One bar is tied to a tree or secure post, while the second is bound to the weaver's hips with a strap or belt.

The stick loom is uncomplicated and portable and has the great advantage of permitting the weaver to exercise complete control over her work. The weaver sits, kneels, or stands so that she may regulate the tension of the threads by changes in body position. Tension is loosened when she leans forward and tightened when she leans back, permitting subtle vari-

ations in spacing and texture. A skilled stick-loom weaver can produce combinations of techniques in a single piece—such as alternating sections of dense warps with light openwork—that would be difficult or impossible on a more modern loom. The stick loom is traditionally used by women weavers, while men generally weave on rustic floor looms similar to those first introduced by the Spaniards four hundred years ago.[7]

Guatemalan weavers introduce pattern elements in a variety of ways. The simplest is the alteration of the fabric's background color to create striped or plaid designs. Two threads of contrasting colors may also be twisted together and then woven as a single yarn to create subtle shadings. Another source of color variation is the use of *ikat* -patterned threads. This technique, called *jaspe* (marbleized) in Guatemala, involves the binding of yarns prior to their dyeing. When the ties are removed, what were the bound portions show as light patterns against the darker dyed sections. A skillful use of bindings results in an intricate design which appears to be painted on the woven cloth.

Variations in the relative thickness of the threads and the closeness with which they are woven are used to produce a broad range of textures and weights of fabrics. Embroidery, tapestry, knotting, fringing, and other decorative techniques are also popular. However, it is with the technique of brocading that Guatemalan weavers have achieved the richest variation. The concept of brocading is simple: extra design threads are laid across the main fabric as it is being woven. An incredible variety is achieved through subtle changes in the weight of the design threads, the way in which they are attached to the main fabric, and the patterns formed by combining different thread types and colors.

Each community has a repertory of traditional designs and techniques used to produce the handwoven garments that make up the local costume. When a girl learns to weave (generally from her mother or grandmother), she is taught the local design motifs and their names as well as any restrictions such as which colors may or may not be used for specific patterns. In some communities, design traditions are so stringent as to preclude all but minor variations in coloration or the use of personal "signature" motifs. Other communities have such broad repertories of patterns and techniques that the individual weaver can exercise considerable latitude in her choice of design elements. In any case, local tradition dictates at least the overall composition of garments. Although deviation from these aesthetic norms is not strictly forbidden, it does leave the weaver open to ridicule or gossip. Most weavers, when asked why they don't simply produce

whatever designs they please, answer that "it is tradition" to weave certain styles and that "people would laugh" if local custom were violated.

Personal Information

The intelligibility of local costumes is primarily the result of two factors: first, the techniques and patterns found in traditional textiles are varied enough that they may be categorized into distinguishable groups; and second, the use of particular styles is so firmly entrenched in community tradition that we can deduce the one from the other. Nevertheless, like any dynamic tradition, Guatemalan Indian dress undergoes a constant process of modification, adaptation, and refinement. As tastes and available materials change, new styles are slowly introduced, gain popularity, and eventually supplant the old.

The result is yet another spectrum of clothing variation, this time reflecting the personal attitudes of the wearer. This attitude spectrum coexists simultaneously with the variations due to status or locative imagery, and each to a great extent operates independently. In Chichicastenango, for example, only a ranking official wears a headcloth that has a gridwork of small animal motifs. But although the cloths worn by most men are limited to stylized geometric patterns, appearance varies widely from one garment to another according to individual preferences.[8] The composite degree of variation found in a particular village depends on such factors as the range of raw materials available locally, design strictures imposed by the community's aesthetic construct, the pattern repertory recognized by the community and the subset of it known to the individual weaver, and the degrees of innovation countenanced by the community and attempted by the individual.

As materials, techniques, and tastes change over time, the long-term variation can grow to overwhelming proportions. The past forty years have witnessed a startling degree of change in communities like Santa Catarina Palopó and Santiago Atitlán, where very simple and sparse motifs were rapidly supplanted by multiple patterns, which in turn evolved into dense geometric bands. Although most villagers wear the recent style, some older Indians continue to produce and wear the garments popular during their youth and young adulthood. A full range of evolving styles may often be found in use within a single family. This continuing flux of change and modification in response to changing needs and desires provides the final and richest level of communicative symbolism.

The weaver picks and chooses the components of her textile from the range of local patterns. The selected designs may include those which most appeal to her own aesthetic judgment, exemplify her perception of what others like, present some sort of technical challenge, simply strike her fancy, or represent any combination of these and myriad other personal factors. The finished textile is a graphic representation of these choices and decisions, and it is their complex interrelationship that imbues the garment with its communicative imagery. Although particular design elements cannot be said to reflect individual qualities or decisions, the resulting composition taken as a whole reveals such traits as relative progressiveness or conservatism, innovativeness, notions of aesthetics, and self-expressiveness (figure 4).

Like the locative and status symbolism discussed earlier, personal imagery may be interpreted on several planes. Since girls learn to weave from older family members, the stylistic elements popular among the weaver's extended family provide a first level of identification. Although this categorization may not be known to the community at large—and almost certainly is not recognized outside of the local setting—it is often the case that weavers can identify the work of other family groups. Women in San Antonio Aguas Calientes, San Lucas Tolimán, and San Miguel Chicaj, for example, were able to immediately recognize textiles woven by other family groups on the basis of relationships between color and pattern composition. Within the extended family, of course, individuals are intimately familiar with each other's technical skills and aesthetic sensibilities. It comes as no surprise that subtle differences in the use of color, the selection of design motifs from the repertory, and slight variations in technique distinguish generation from generation and weaver from weaver.

Field studies reveal that many of the design decisions which a weaver must make in producing a garment are spontaneous.[9] Often the only conscious decision made prior to beginning the weaving process is the selection of the colors for the background fabric. The weaver also makes certain that her thread-basket includes a variety of colors that, in her opinion, go with the background. Decisions about which design motifs to weave and which colors to combine for each motif are determined as weaving progresses. Asked in advance which patterns or colors will be used, the weaver usually expresses uncertainty unless she has been commissioned by someone else to weave specific combinations. She may draw inspiration from her surroundings (e.g., planning a bird motif when a chicken walks by), but it is much more likely that she will defer many choices as long as possible and

then select whatever feels right at the moment. This spontaneity underscores the role of textile design as a reflection of personal attitudes, taste, and judgment.

Table 1. Levels of Communicative Imagery

locative information	first level: ethnicity
	second level: linguistic region and subregion
	third level: community
	fourth level: subcommunity
status information	gender, marital status, age group, socioeconomic position
	membership in community groups
	ceremonial roles
personal information	family affiliation
	personal aesthetics
	technical skills
	progressiveness, self-expressiveness

Conclusion

Table 1 summarizes the types and levels of communicative imagery discussed in the preceding sections. Guatemalan Indian dress furnishes a rich vocabulary. In particular, traditional garments provide much more than the simple locative information with which they are usually attributed. Taken individually, garments reveal much about the origin and position of both the weaver and the wearer; collectively, the combination of textiles and accessories that makes up an individual's apparel is a rich source of information on personal and cultural values.

Variations in Guatemalan textiles, from one community to another and from one generation to the next, have been a popular theme for discussion and study in the past. But despite the fact that the production and use of local costumes form an integral part of the economic, social, and artistic life of most Indian communities, the attitudes and opinions of the persons who produce and wear Indian clothing—the individuals who collectively shape local textile traditions—are largely ignored. The outward characteristics of community costume have been recorded, but they have not as yet been interpreted satisfactorily.

The time has come to explore the expressive semantics of Indian dress, with special attention to those factors that serve as an impetus for

change. In the past few years, many ethnographic and ethnohistorical studies of the Guatemalan area have been criticized for sustaining the attitude that the Indian has withdrawn into traditionalism as a means of surviving the incursion of outside influences. The view of the Indian as an object of historical pressures is inadequate to explain the persistence of some traditions and ephemerality of others and has led to a series of general misconceptions.[10] That approach is now being challenged with the argument that the Indian is also an agent of change. The strength and the richness of Guatemalan textile traditions speak eloquently of an active evolutionary process such as this.

Although we can recognize and categorize the specific techniques and design motifs used to create Guatemalan textiles, we have little understanding of the messages latent in the rich melange of Guatemalan Indian dress.[11] It is certain that, through the sensitive medium of personal style, the weaver records an explicit identification that can be interpreted on a number of levels, from attitude and sense of aesthetics to subcommunity and social occasion. This subjective group identification should, when properly interpreted, permit an objective group attribution by observers. The details of the communicative symbolism will remain elusive, however, until we can more fully analyze and comprehend the internal logic of textile imagery.

Endnotes

1. The information presented was derived from field observations and interviews conducted in collaboration with Sheldon Annis from 1974 to 1981, with the assistance of Wendy Kramer, Lydia Parks Pérez, and Marinus Pérez. The fieldwork interpretation was supplemented by the examination of several thousand museum specimens dating from 1880 to 1986. Although an attempt is made to describe collectively the communicative characteristics of Guatemalan clothing traditions during the past century, space constraints limit the examples to a selected few. The reader is cautioned against too literal an extrapolation from the particular to the general.
2. The persistence of the Guatemalan Indian community has intrigued researchers for the reason encapsulated by Sol Tax fifty years ago: "From the point of view of the Indians themselves, the people of each *municipio* constitute a unique group, united by blood and tradition, and differing from all others in history, language and culture" (Tax 1937). This is not to say that Indian communities are

simple or particularly unified in makeup. As Sheldon Annis recently demonstrated, religious and political factionalism has profound effects on village life: "The cultural stability of the past ... has been fractured ... by population pressure, growing landlessness, environmental deterioration, and military repression,... by land windfalls, new technology, development programs, and expanding primary education. Both kinds of pressures have contributed to a surprisingly skewed distribution of wealth within the ostensibly homogeneous Indian community" (Annis 1987).

3. Publications focussing on the production and use of ethnic costume as an expression of ethnic identity include the following: Annis 1987, Barrios 1985, Castellanos 1986, Maynard 1963, Morrissey 1983, Pancake 1988, Rodas and Polanco 1987.

4. The historical basis for subcommunity distinctions and their importance in present day Indian life has been dealt with by some anthropologists and ethnohistorians. See, for example, Colby and Berghe 1969, Hill and Monaghan 1987, Hunt and Nash 1967, Castellanos 1986.

5. It is not always true that ceremonial garments are elaborate. The *cofradía huipil* of neighboring Patzún, although embroidered with silk rather than cotton threads, is less densely patterned than many everyday garments.

6. The stick loom is also referred to as the backstrap, hipstrap, waist, belt, or girdle loom. Only one published study has attempted to deal with the symbolic and communicative significance of the loom itself. See Prechtel and Carlsen 1988.

7. For a discussion of the implements used to produce Guatemalan textiles and recent changes in traditional gender roles. See Pancake 1989.

8. The headcloths of Chichicastenango have been particularly well documented. See, for example: Bunzel 1952, Rodas 1938, Rowe 1981, Schevill 1985.

9. See Pancake and Annis, 1982.

10. A striking example of this is the popular and totally unsubstantiated notion that distinctive village costumes were mandated by Spanish colonial officials so that they could monitor population migrations.

11. For a review of progress in this area, see Pancake 1988.

Bibliography

Annis, Sheldon
 1987 God and Production in a Guatemalan Town. Austin: University of Texas Press.
Barrios, Linda Asturias de
 1985 Comalapa: Native Dress and Its Significance. Guatemala: Museo Ixchel del Traje Indígena.
Bunzel, Ruth
 1952 Chichicastenango. New York: American Ethnological Society.
Castellanos, Guisela Mayén de
 1986 Tzute y jerarquía en Sololá. Guatemala: Museo Ixchel del Traje Indígena.
Colby, Benjamin N., and Pierre van den Berghe
 1969 Ixil Country. Berkeley: University of California Press.
Hill, Robert M., II, and John Monaghan
 1987 Continuities in Highland Maya Social Organization: Ethnohistory in Sacapulas, Guatemala. Philadelphia: University of Pennsylvania Press.
Hunt, Eva, and June Nash
 1967 Local and Territorial Units. *In* Handbook of Middle American Indians, Vol. 6, Robert Wauchope ed. Pp 253-282. Austin: University of Texas Press.
Maynard, Eileen
 1963 The Women of Palin: A Comparative Study of Indian and Ladino Women in a Guatemalan Village. Ph.D. dissertation, Cornell University.
Morrissey, Ruth Claus
 1983 Continuity and Change in Backstrap Loom Textiles of Highland Guatemala. Ph.D. dissertation, University of Wisconsin-Madison.
Pancake, Cherri M.
 1989 Gender Boundaries in the Production of Guatemalan Ethnographic Textiles. *In* The Anthropology of Dress and Gender, Ruth Barnes and Joanne Eicher eds. In press.
 1988 Nuevos métodos en la interpretación de textos gráficos: aplicaciones de la "teoría del lenguaje" a los tejidos autóctonos de Guatemala. Mesoamérica 16: 311-334. An

English version (Systematizing the Deconstruction of Graphical Text: Lessons from Formal Language Theory) was presented at the centennial meeting of the American Folklore Society, Philadelphia, 1989.

1988 Interpreting the Text of Guatemalan Ethnographic Dress: Syntax and Semantics. Paper presented at the 46th International Congress of Americanists, Amsterdam.

Pancake, Cherri M., and Sheldon Annis

1982 El arte de la producción: Aspectos socio-económicos del tejido a mano en San Antonio Aguas Calientes, Guatemala. Mesoamérica 4: 387-413.

Prechtel, Martin, and Robert S. Carlsen

1988 Weaving and Cosmos amongst the Tzutujil Maya of Guatemala. Res 15: 122-132.

Rodas, Flavio N.

1938 Simbolismos (Maya Quiché) de Guatemala. Guatemala: Tipografía Nacional.

Rodas, Idalma Mejía de, and Rosario Miralbés de Polanco

1987 Cambio en Colotenango: traje, migración y jerarquía. Guatemala: Museo Ixchel del Traje Indígena.

Rowe, Anne Pollard

1981 A Century of Change in Guatemalan Textiles. New York: Center for Inter-American Relations.

Schevill, Margot Blum

1985 Evolution in Textile Design from the Highlands of Guatemala. Occasional Papers No. 1. Berkeley: Lowie Museum of Anthropology, University of California.

Tax, Sol

1937 The Municipios of the Midwestern Highlands of Guatemala. American Anthropologist 39: 423-444.

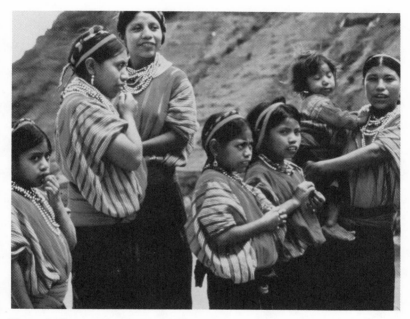

Figure 1. Guatemalan Indian dress provides locative information identifying not only ethnicity but also linguistic group and community affiliations. The form of these garments and the way they are worn identify the women as being from the central Cakchiquel area. Patterning, color, and weaving techniques reveal that they are from the town of San Antonio Palopó. Photo by Cherri M. Pancake 1977.

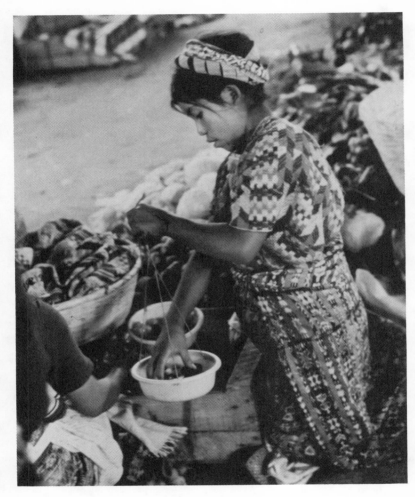

Figure 2. Indian dress—the badge of community affiliation—plays a unique role by establishing product quality in the marketplace. This vendor's dress identifies her as being from the Zunil/Almolonga Valley, a region famous for the quality of its produce. Girl from Almolonga. Photo by Cherri M. Pancake 1980.

a.

b.

Figures 3a-b. The graphical composition of a garment varies according to the social status and role of the intended wearer. Both these textiles were woven as headcloths for ceremonial occasions, but Figure 3 a was used by a man and Figure 3b by a woman. Palín *tzutes* from the collection of the Museo Ixchel del Traje Indígena. Photo by Cherri M. Pancake 1981.

62 *Mesoamerica*

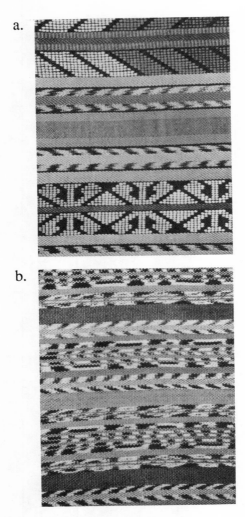

Figures 4a-b. Garment styles also reveal information about the personal attitudes of the weaver. These cotton skirt lengths from Zunil contrast the brocaded style worn by conservative older women (a) with the *ikat* style in favor with their more progressive contemporaries (b). Younger women prefer patterns that make heavy use of bright synthetically dyed wools. Zunil *cortes* from the collection of the Museo Ixchel del Traje Indígena. Photo by Cherri M. Pancake 1980.

Chapter Three

A Line at a Time: Innovative Patterning in the Isthmus of (Isthmian) Mexico

Pamela Scheinman

Introduction

Contradictory as it might seem in a traditional, predominantly agrarian country like Mexico, fashion reigns in the Isthmus of Tehuantepec. Zapotec women in the principal towns of Tehuantepec, Juchitan and Ixtepec—as well as in outlying Mixe and Huave villages—constantly update the patterns decorating the clothing for which they are famous.[1] The "Tehuana" is known throughout Mexico as a legendary beauty, her legend perpetuated in song, poetry, film, plastic arts, and even advertising goods.[2] Mention of the region summons a romanticized image of women erect in stature, gloriously attired in embroidered velvets and silks, bedecked in gold jewelry, fiercely proud, independent, and shrewd in business. In fact, the strong regional identity and gracefulness of the costume led the painter Frida Kahlo to adopt the traditional skirt and blouse of the Isthmus for travel abroad with her husband, the muralist Diego Rivera. This choice, in part, reflected her larger commitment to symbolize Mexican nationalism through its Indian heritage.[3]

It is ironic that travel writers mention little of interest in this fly-infested and windswept stretch lying along the Pan American highway, where Mexico narrows between the Pacific Ocean and Gulf of Mexico. Most guidebooks urge the tourist to pass on to the state of Chiapas and the Guatemalan border. Yet historically the Isthmus has figured as an important trading center, located southeast of the city of Oaxaca and forming an isosceles triangle with the ports of Veracruz and Acapulco. It was in Veracruz that first Hernan Cortez (1519) and later Maximilian von Hapsburg (1864) disembarked to rule Mexico. Following the Spanish occupation, the Isthmus was a major trans-shipping point in the trade between Europe and the Orient; and at the turn of this century it gained renewed prominence when British concessionaires raced to complete a cross-Isthmian railroad against Americans constructing the Panama Canal (Covarrubias 1946:163-73).

The fortunes of the Isthmus continue to ebb and crest. The port of Salinas Cruz, which was developed in 1901-05, experienced a shipping boom with Mexican oil exploitation in nearby Coatzalcoalcos in the 1970s. The 1980s brought years of economic crisis throughout Mexico, but the national government, in an effort to win back eroded political support, particularly in Juchitan, undertook several public works projects in this area to stimulate investment. Prosperity and foreign influences have affected local dress, bringing coins transformed into jewelry, imported fabrics and notions, new motifs, and accessories to a female population passionate for style.

A review of the literature suggests that little systematic documentation has been undertaken since publication of *Mexico South*, an exhaustive study of Isthmian culture by Miguel Covarrubias. His detailed description of "Costume" (1946:246-66) includes not only line drawings and colored plates, but a supplementary "Album of Photographs" taken by his wife Rose, a native of Tehauntepec.[4] My own study, based on field research over a seven-year period, attempts to update existing information on garments, embroidery patterns, and the complex economic, social, and ceremonial relationships that are reflected in this distinctive local dress.[5]

Daily Costume
In the absence of artifacts or records, empirical evidence has been used to hypothesize the appearance of specific garments. Covarrubias traces the evolution of present-day costume from the wrapped skirt (*enredo*), large overdress (*huipil*), and mass of cotton hair cords worn by Indian women prior to the Spanish Conquest (1946:262-63). An 1828 engraving by Claudio

Linati published in Brussels in a collection titled *Costumes civils, militaires et religieux du Mexique* (reproduced in Sayer 1985:98) is the earliest document showing a Tehuana. She is dressed only in an *enredo* (two widths of backstrap-loomed fabric seamed together), wrapped from hips to ankles and secured with a belt, and a headpiece resembling a blouse of thin, transparent gauze, worn with a ruffled neckline encircling the face and the bottom edge falling down over the shoulders like a cape. This upper garment most probably represents the common ancestor of the Isthmian *huipil grande* (to which a ruffle was added at the lower edge), now used ceremonially, and the Zoque *huipil de tapar*, a short top of handwoven gauze worn in the vicinity of Tuxtla Gutierrez, Chiapas (Cordry 1968:280). In hot coastal areas it was common practice to go topless at home and to don a loose blouse or triangular shawl (*quechquémitl*) when going out to market, a habit still observed around Pinotepa Nacional, Oaxaca (Sayer 1985:216).[6]

Covarrubias describes women over fifty clinging to the conservative *enredo* of red or purple striped cotton for household wear in the 1940s (1946:253). In contrast I have seen only one *enredo*, worn by a very old woman in the remote village of San Juan Guichicovi, and I suspect that the wrapped skirt, along with the embroidered cotton belt used to secure it at the waist, has virtually disappeared. Further evidence that the *enredo* in 1985 has become a symbolic or "folkloric" garment was suggested when a parade of bridesmaids marched through the *jardín* (town center) of Juchitan one Saturday morning in 1985 dressed in identical wrap-skirts. They carried lacquered gourds (*jicalpextles*) stuffed with tiny paper flags, traditional in the "fruit throwing" (*tirada de fruta*) ceremony. The bride and groom wore costumes dating to the Revolution of 1910 (Meisch, this volume).

Most items of clothing described by Covarrubias persist, however. These include a shirt, underskirt, blouse, shawl, and *huipil grande* (figure 1). Beginning with Frederick Starr's *In Indian Mexico* (1908:40), photographic documentation of twentieth-century Tehuana dress is ample, enabling comparative study. The everyday skirt, for example, is full-length, usually of three widths of fabric gathered into a waistband that ties at the back. It is a style that permits freedom of movement and relative comfort in the hot climate. Called *enagua*, this skirt heightens the impression of a graceful gait and erect posture, often attributed to the custom of carrying parcels on the head. The 1940s version was made of cotton, whereas today bold floral prints in bright-colored polyester or nylon are the rule. Younger women add darts or tucks around the waist to taper the fullness. Alternately, they might choose an A-line skirt with gored panels. Married women may add a deep gathered

ruffle at the hem of the same fabric as the skirt, a style Covarrubias refers to as *rabona* (1946:247-48). Except for the ruffle or two-to-three horizontal tucks below the knee resembling a Victorian petticoat, the skirt is unadorned for daily wear. An underskirt (*refafo*) of white fabric, slightly shorter and less full than the outerskirt and similarly gathered at the waist, is worn underneath as a slip and is the only form of underwear (Covarrubias 1946:247).

The everyday *huipil* is a short blouse with a rounded, scoop neck. It is made of the single length of fabric (about one and one-quarter yards) fully lined and folded in half, with the finished side seams sewn to leave narrow arm openings (five to six inches deep) that fit the upper arm tightly, forming a cap sleeve. Hand-loomed native cottons were replaced by machine-woven cloth during Victorian times. A preference existed for luxurious fabrics: fine cottons, as well as silk velvets (*charmès*), brocades, and satins. Manchester cotton, specially printed in England with tiny leaf and flower motifs, predominated in the early part of this century,[7] along with silk (and later rayon) taffeta. Traditional blouse colors are dark purple, red, deep crimson, vermillion, and black. In 1979 rayon velvet (*terciopelo*, or "third skin") and brocaded satin still were common, although polyester (*piel de angel*, or "angel's skin") was beginning to gain popularity. Because of its light weight, ease of washing, and the availability of a spectrum of vivid colors, polyester now is the fabric choice for everyday blouses.

Cotton linings imported from England were replaced by Mexican-manufactured cloth (Covarrubias 1946:249). The traditional, virtually exclusive lining is red, blue, or black cotton printed with tiny white polka dots. In 1985 red cotton lining printed with a pattern of small fruits (pears, apples, and cherries) appeared inside a few blouses for sale at the Juchitan market. Navy blue nylon with large (nickel-size) white polka dots lined a piece a seamstress was machine-embroidering in her home. These, however, are exceptional examples. In general, lining adds comfort and extends the wear of a blouse against rubbing of the breasts.

Often the side seams are left unstitched so that the buyer can adjust the blouse for size. She folds back excess fabric and makes a tuck at the sides if necessary. Isthmus women tend to be larger and taller than women in other parts of Mexico. For that reason today's *huipiles* fit the wearer rather tightly, pulling into folds and binding across the body if a woman bends or twists. They are short, falling to an inch or so below the waist. Photographs from the 1930s and 1940s from the Jimenez Studio (now in the collection of the Casa de la Cultura in Juchitan and published in an undated volume edited by Carlos Monsivais), show the earlier style which was much fuller and longer. The

blouse drapes into soft folds, and the hem falls slightly below the hips. Necklines also were deeper, more scooped.

For daily wear a shawl or scarf of cotton or acrylic fiber may be worn around the shoulders or tied around the head. Terrycloth towels are sometimes used in this manner. Hair usually is worn long, dressed in two braids plaited down the back with bright-colored satin ribbons that are looped together with bows at the ends or tied up across the crown of the head. Flowers often are pinned in the hair as are plastic barrettes. Younger women wear loosely twisted hair, pony tails, and short, bobbed cuts. Plastic sandals or rubber thongs (*chanclas*) have been adopted in major towns, while in smaller villages, some women continue to go barefooted.

Fiesta Dress

It is in dressing for Mass, saint's days, baptisms, weddings, anniversaries, funerals, or the balls orchestrated by social cooperatives that Isthmus women indulge their love of display. These events fall in a regular sequence throughout the year and provide numerous occasions for showing off new clothes and jewelry (see Coss n.d). Fiesta dress consists of a blouse and skirt similar in form to the ones worn daily (figure 2). The skirt is lined and embellished with one or a combination of embroidery techniques to match the blouse. This matching set is known as *traje* ("suit" or "outfit") and traditionally is black, or, more rarely, a deep red shade of velvet. Since *traje* can cost a few hundred dollars, contemporary fiesta dress varies as does street wear. Many outfits are made of polyester, or a blouse paired with a contrasting skirt of lace, brocade, or sheer printed fabric. In 1979 elaborate cut-velvet skirts woven with metallic threads were the rage, whereas, more recently, filmier, light-colored fabrics were popular, as were voiles with flocked sprigs or lurex brocades.

For fiestas, a ruffle of heavily starched lace or tulle, the *holán*, is worn at the hem of the skirt, which becomes *enagua de holán*. This ruffle is detachable for washing. In the 1940s the ruffle was made of cotton lace and had to be starched and finely knife-pleated by hand after each wearing. Today the *holán* tends to be of synthetic lace, permanently pleated in Mexico City factories and cut so the bottom edge is zigzagged. The depth of the ruffle varies by locale: Tehuanas wear their *holánes* a long twelve to eighteen inches, while in Juchitan the length varies from eight to twelve inches. The *holán* is shown to advantage in dancing the *Sandunga*, the traditional dance of the region, in which women circle slowly, lifting and swooping their lacy hems.

The most famous article of fiesta garb is the *huipil grande*, a blouse or miniature dress of white lace with starched and pleated ruffles at the hem, sleeve cuffs, and neckline. It is worn as a headdress. Because of its form and tiny vestigial sleeves, theories exist that the *huipil grande* originated as a priest's surplice or christening dress donned by a vain Isthmus woman. It is more likely an offspring of the gauze-weave *quechquémitl* (Covarrubias 1946:262 and Cordry 1968:250). For Mass the neckline is worn like a hood, framing the face. The body of the garment encompasses the shoulders and bodice, and one sleeve is positioned to hang center front and back. For fiestas and processions it may be worn with the starched ruffle of the bottom hem over the head, like a mantilla, and the body and sleeves dangling down the back. Women still wear the *huipil grande*. It is certainly in evidence at important ceremonial occasions like wedding processions and parades but no longer used by every woman. There also is a contemporary preference for washable machine-manufactured lace and for bright colors: one example available for rental was bright orange!

Even rarer is the use of a cape-like netted garment edged with gold fringe that rests on the shoulders, modeled on epaulets worn by French soldiers during the Intervention in the 1860s. Because of a bitter political rivalry dating to that period, Juchitecas reported that they do not wear this garment, though it is still used for fiestas in Tehuantepec.[8] In 1985, grandmothers *(madrinos)* in Juchitan wore in a wedding procession large open-work shawls crocheted of gold and silver metallic yarn with fringes. Lace scarves, however, as well as *ikat*-striped cotton or rayon shawls *(rebozos)* with tiny white and black dots, imported from Mexico City, frequently are wrapped across the shoulders for fiestas. Black lace or yellow-black combinations are most common. Red and black striped *rebozos* also are sold and constitute traditional colors. Since politicization of the population over municipal elections in 1981, women loyal to the National Revolutionary Party (known as the "PRI," Mexico's majority party) refuse to wear red and proudly flaunt green shawls or the more neutral purple.[9]

No fiesta dress is complete without jewelry, and the gold of the Isthmus, like its women, is legendary. Filigree work and casting are gold-smithing crafts of long-standing tradition (Rouillion 1954:32-33). When currency flowed from railroad and port commerce at the turn of the century, coins were converted into earrings, necklaces, and chains hung with large medallions of gold. Covarrubias recorded thick, solid ropes of *monedas* that included U.S. gold pieces, Mexican *centenarios*, Guatemalan, and English coins. Gold jewelry still is produced in the area and sold at stalls in the

municipal markets. Most of it is cast in molds to resemble old coins. Besides those featuring *monedas*, there are several distinctive styles of earrings fashioned into woven miniature baskets, clusters of leaves, various flowers, and life-size houseflies. Link bracelets and gold watchbands also are popular.

Much of the jewelry worn today is costume jewelry. Robberies and a series of publicized murders in the early 1980s made women fearful of wearing their real gold. While the political climate has somewhat stabilized,[10] the flashy glitter of copies and their relative cheapness are attractive. The better-quality costume jewelry is gold plated (*baño de oro*). Twenty *centavo* pieces, the small coins used for pay telephones, were dipped for use as *monedas* until 1984, when the minting of new coinage (and the conversion of pay phones to a *peso*) created a sudden shortage. One entrepreneur mentioned the possibility of dipping U.S. pennies, which are smaller than the new *peso* and thinner than the tiny new ten-*peso* coins. There also has been an influx of cheap costume jewelry (*fantasia*) bought from wholesalers in Mexico City. This inexpensive metal and plastic jewelry probably will have less impact on fiesta costume than on street wear because, although the array of styles and colors is endless, it bears no resemblance to traditional jewelry.

Hair is braided with ribbons and/or decorated with flowers for formal wear. Young girls wear braids down the back, while older women secure them across the crown of the head, sometimes with the addition of combs and clips or barrettes. To camouflage short hair cuts, women purchase falls of natural hair through purveyors in Mexico City. They pay dearly for hairpieces that are long, thick, and a good color match. The tendency is to conform to traditional styles at fiestas out of respect. Modern styles are curled, or the hair caught in a back twist or ringlets. Make-up is used on eyes, lips, and cheeks, even on young girls, as no Isthmus woman is fully dressed till she is "painted."

Embellishment

The decoration of blouses and fiesta outfits is the distinguishing feature of Isthmus dress. It adds characteristic gaudy color and bold design. Four specific techniques are used, alone or in combination: appliqué, machine-embroidery, punch-needle embroidery, and hand-embroidery. The decorated area on blouses extends in a square down from the shoulders and across the bottom edge. A band of plain fabric approximately two to four inches wide is placed at the side seams and hem, and a small unadorned rectangle appears at the center below the neckline. On fiesta skirts, the entire

surface may be decorated below the hip-line (where the *huipil* falls). Alternatively, three to five horizontal bands of embroidery will be stitched parallel to the hem. Each band is slightly wider, and the pattern is in proportionately larger scale. Both the front and back of the garment are decorated identically. The neckline of the blouse is finished last, by cutting out the circular hole, turning the edges, and overstitching the neckline with embroidery.

 Ribbons (listónes): Thin rayon ribbons or seam binding, approximately a quarter-inch wide, are stitched to the surface of the blouse in parallel rows spaced one to two inches apart. Blouses with ribbon appliqué often have floral-printed muslins or nylon lace as the ground fabric. Cotton rickrack and commercial braid recently have been applied in the same manner. This is the least expensive *huipil* for daily wear, and the color and trimmings may match or contrast with the blouse fabric. Traditionally, ribbon-trimmed blouses may serve as mourning attire, in which case they are made of dark fabrics—navy, black, or chocolate brown—with ribbons to match.

 Sewing Machine Chain-Stitch (cadeneta): This technique produces geometric patterns. As early as 1898, Frederick Starr photographed examples of blouses with narrow bands of machine embroidery along the lower edge (Sayer 1985:159). Archives from the studio photographer Sotero Constantino Jimenez Gomez contain formal portraits of the 1930s and 1940s showing blouses decorated with many of the same machine-stitched patterns catalogued by Covarrubias (1946:250-51) and still worked today. The earlier blouses are embroidered in a single band extending down from either shoulder and across the stomach, which frames the edges of the blouse. Contemporary styles favor three concentric squared bands, two to three inches wide each and spaced one-quarter to one-half inch apart. Fabric shows only around the margins. As a rule, the inner and outer bands are identical in pattern, while the middle band contrasts in pattern and/or scale. Another contemporary style resembles a bib, with the stitching filling the squared area solidly, rather than in bands.

 The machine used is a miniature Singer (*máquina de gasa*) in a treadle model that is no longer made. These machines, described as *antiguas* (old ones) pass from woman to woman through private sale, costing about three hundred dollars.[11] Why or when the machine was imported into the Isthmus is unknown. Whether it was destined originally for another purpose, such as sealing off the tips of cargo sacks (*costales*), (chain-stitch finish is common on feed bags or flour sacks) or specifically for dressmaking pur-

poses, is subject to speculation. The fine gauge of stitch and thread argues for the latter.

All stitching is done on the lining side, with the chain appearing on the "right" side. Frequently guidelines are ruled on the lining fabric in pencil, dressmaking crayon, or ballpoint pen. They serve as boundaries of the designs, or as grids for more elaborate patterns. The traditional thread color combinations are yellow and black for red grounds and yellow and red for black fabric. The choice of thread affects the quality and price of the garment. The cheaper *hilo*, a mercerized cotton sewing thread, tends to be dull in appearance. The high-gloss, hundred-percent rayon two-ply thread is referred to colloquially as *seda* ("silk"), which may be a carryover from earlier times when silk floss was used. Brand-conscious Juchitecas rate Iris over Armida thread; formerly the two brands available were Iris and Carmencita, but the preferred Carmencita is no longer sold.

The simplest pattern imitates ribbon applique. It is three to five rows of side-by-side chain stitch and makes a solid narrow band. A second basic machine-embroidered pattern is the lattice or net (figure 3). It is executed by zigzagging parallel and intersecting lines about three-quarters to one inch apart to form openwork diamonds. Very inexpensive daily *huipiles* often are decorated with a rough version of this lattice pattern. Variations are achieved by working single, double, or multiple rows of stitching and by altering the spacing between rows. Further variations result from alternating bands of straight chain-stitch and net pattern or superimposing lines over a lattice to make fine triangles.

Intricate patterns are built up by superimposing networks of chain stitch, one on top of another, and by alternating dark and light threads until a section is completely covered with intersecting rows of stitching. These patterns closely resemble weave structures of the interlaced details of Moorish architecture. Several patterns bear descriptive names, such as *trencillas*, (braids), (figure 4), *uñitas* (fingernails), *jaguar* (spotted cat), *copa* (wineglass), *estrella* (star), *maguey* (century plant), *cadena a ocho* (chain-of-eight), and *galleta* (cookie) (figure 5). The elements seem universal—checks, triangles, diamonds, eight-pointed stars, etc.—but their elaboration in chain-stitched thread is unique. There seem to be conventions about using specific patterns for the matching inner and outer bands with groups of three or five bands. The more complex interlacing of *galleta* and *cadena a ocho* occur exclusively in this border position, as does the less utilized pattern of interlocking diamonds called *charly*.

The origin of names and the names of some patterns are lost. When I showed copies of Covarrubias' renderings of patterns to seamstresses, they readily identified several by name for me. The *jaibera* design, (Chart I), which he describes as an extremely complicated pattern developed in Juchitan and the rage in Tehuantepec (1946:250), was unknown, at least by name. Nor is the mechanism for naming patterns clear. In some cases there is a perceived resemblance to natural phenomena, for example, the undulating zigzag of *culebra* (snake) or straight rows of alternating dark and light triangles of *reja* (ruler).[12]

Exactly how these patterns evolved also is a mystery. Clearly, the simplest lattice looks like a fishing net, and fishing is a major industry of the area. The complex superimpositions suggest European models, perhaps in imitation of plaids or bird's-eye twills, such as those seen on table linens and tea towels. Intricate patterns which appear on straw mats (*petates*) might be a source. Or, possibly, the process is self-generating, yielding a finite number of patterns that are determined by the sequence of superimposed lattices, by spacing, and by color change (i.e., counterchange).

In 1979 traditional machine-embroidered patterns were sewn in multicolor thread combinations rather than the standard yellow-red or yellow-black combinations. At first a few experimentally-patterned cloths appeared for sale in the market at slightly higher prices. The popularity of these multicolored versions has steadily increased to the point where now approximately half the blouses available for sale are of this type. Yellow thread is the ground color for red-green, violet-green, or orange-green combinations, sometimes with several shades of each hue to achieve an optical effect. Space-dyed (*ombré*) threads may also be used to add color. Although these multicolored innovations might appear garish to some purists, they exemplify the local predilection for eye-dazzling color and a search for fresh interpretations of traditional patterns.

Since 1983 a few geometricized floral patterns have appeared that originated with seamstresses in the Mixe town of Guichicovi, which is a center for machine-embroidery work and the source for much innovation. One pattern of large diamonds resembles Huichol god's eyes. Another features diamonds fitted to form five-pointed stars. A third pattern has four elliptical petals radiating, like windmill blades, from a diamond-shaped center. Identified generically as floral patterns, none has a more specific name. Typically, these new patterns are executed in the bib format, although bands of elliptical four-petalled "flowers" also are used to frame a "plaid"

(*cadenía bandera*) band in the three-band format. These new patterns depend on boldness and variegated color (against a yellow field) for impact.

It is important to note that much of the inventiveness associated with machine embroidery results from playing with all the variables: scale, color, and placement of pattern bands. While a design might be very popular one year and less in demand the next, the basic vocabulary of patterns remains constant. What makes the geometricized florals from Guichicovi look innovative is the large scale and balanced placement of motifs in quadrants, which probably is borrowed from the arrangement of hand-stitched floral designs (a kind of cross-over of traditions).

Punch-Needle Chain-Stitch Embroidery (*tejido*): Fine floral and leaf patterns are chain-stitched, using a hooked tool to perforate the cloth and interloop stitches to create curved and coiled lines of embroidery that resemble filigree. These designs are worked in rayon thread. They occur either in narrow squared bands, often juxtaposed with bands of machine embroidery, or drawn over the entire surface of a garment in a delicate tracery. I have not observed this process firsthand, although I have examined *huipiles* and *traje* executed in the technique in both two-color and multicolor combinations.

Hand-Embroidered Satin-Stitch (*bordardo*): Lavishly embroidered silk shawls (*mantónes de Manila*) imported from China and the Philippines in the nineteenth century probably inspired the large floral patterns satin-stitched by hand throughout the Isthmus (see Miller, and Davis, this volume). Full-blown blooms of every variety are incorporated into these designs—lilies, roses, orchids, pansies, or poinsettias. The effect is theatrical and dazzling. Designs are rendered freehand or copied from earlier examples. Doña Ofélia Valdivieso Ruiz purchases floral-printed gift-wrappings at the stationery store to stimulate new ideas for her dense compositions, which she renders in pencil on large sheets of manila paper. These patterns, then, are painstakingly punched with a sewing needle along the pencil lines, and the preforations are spaced approximately every sixteenth of an inch.

The fabric to be embroidered is pre-lined and stretched taut on a rectangular wooden frame or *bastidor* set on legs, similar to a frame for hooking rugs. The long sides of the fabric panel are basted to lengths of cloth, which are wrapped around and stitched secure to the sides of the wooden frame. Several strips of cloth, each about three inches wide, are sewn to the shorter ends of the fabric panel, and these are knotted around the wood frame

at opposite (short) ends to maintain tension. Alternately, if a woman's schedule requires, a large wooden embroidery hoop, which has the advantage of portability, can be used.

One panel is required for a blouse, while three separate panels are embroidered then sewn together for a fiesta skirt. The skirt design is planned to be slightly larger in scale than the blouse. If hand-embroidery is to be used in conjunction with machine-embroidery, the machine work is done first to define the placement of the satin stitch. The paper pattern is secured on top of the stretched panel. Talcum powder is poured through the needle holes to transfer the design, which appears on the cloth as a series of tiny white dots. A white marking crayon (*crayon marcador*) is used to connect the dots and reinforce the pattern lines.

Seated in a low wooden sling chair, the woman begins embroidering from the edge of one panel, covering the rest of the fabric with a sheet or towel to protect it from dust. She works in a continuous direction, stopping to roll the finished work on the pole and re-anchor the corners of the frame. Because of the space occupied by the frame, several women work side by side in the courtyard. Using prethreaded needles that lie stuck around the work area, each petal and leaf will be shaded with up to five colors of thread and outlined. The preferred thread is a glossy two-ply pearl cotton or *ancla* sold in balls and manufactured in Mexico under Clark's "Anchor" brand. Occasionally six-strand embroidery floss is used, but this thread bleeds and is considered inferior.

Taste rather than realism dictates color placement. Leaves always are green, but the color ranges from lime to yellowy-olive to deep emerald. Shading is calculated by the code numbers of thread colors. Doña Ofélia bought threads by the boxful, storing them by color code in a large wooden chest of drawers. When commissioning a seamstress to hand-stitch a panel, she selected several gradations of each hue. She also could examine a piece of embroidery and call out the manufacturer's dye numbers, while criticizing the choice of color or faulty steps in a gradation. Conversations between seamstresses might sound like quarterback's signals in football.

A small area is shaded at a time. The stitch actually is a false satin stitch, worked by passing the needle from one hand on top of the work to the other below the frame with rapid stabbing movements that are audible. The women I watched working were so precise that they had neither needle marks nor callouses on their fingers; they used thimbles on the index or middle finger to jab a needle through. French knots provide accents in the center of petals simulating pistils. Stylistic differences between Juchitan and Tehuan-

tepec are easily detected and a source of mutual disdain: Tehuanas draw larger, gaudier flowers and shade their leaves with spaced parallel stitches, while Tecas (Juchitecas) embroider in a solid style.

Economic Aspects

The sewing of *huipiles* and *trajes* is a cottage industry, which is spurred by a full calendar of religious and civic celebrations, family events, and parties that require new clothes. A woman can sew for herself, commission a garment, buy from a retailer, or even rent a costume by the hour or the day. Business is especially brisk in Juchitan in the spring in anticipation of the month-long May fiestas that culminate in a week of nightly balls (*velas*) and again in August. Clothes are a constant topic of female conversation anywhere in the Isthmus. The municipal market in Juchitan is crowded from early morning until long past dark and swells into the surrounding streets on Tuesdays and Saturdays. Most women engage in some kind of work such as selling vegetables, flowers, *totopos* (a crisp *tortilla* riddled with round holes that is the local bread), coal, live iguanas (a delicacy), prepared foods, fruit drinks, or smoked fish. The money earned is theirs to spend. Clothing and jewelry represent huge investments.

At the age of twelve or thirteen a girl might apprentice herself to a skilled seamstress to learn embroidery design. She brings her own machine, thread, lining, and fabric and pays a negotiated monthly fee. In 1979 I was asked to pay ten dollars a month. A good sewer can finish a *huipil* in fifteen days, if she works constantly and doesn't divide her time up with too many household responsibilities. If she is slow to learn or must perform chores, it can take a month or longer (Paulina Robledo Lopez, pers. com. 1985). Whether machine-stitched or hand-embroidered, the average time spent on a *traje* is a month and a half. A skilled apprentice can learn several patterns in four to six months' time, whereas an untalented girl can struggle for a year or more in training.

Interest and pride in workmanship are deemed important qualities. Workmanship is judged by the fineness and consistency of stitching, complexity of the pattern, harmony of the color scheme, and value of the materials used. While much teaching is of the learn-by-watching kind, one frequently overhears critical appraisals of workmanship in assessing specific examples. In two instances, a woman admired a blouse I had purchased and sent her servant out to order one for herself.

Seamstresses produce designs on order for individual clients or under contract to merchants. Usually a client supplies the cloth and lining.

Contracts for the pattern and price of the finished garment in advance include a payment schedule. It would seem that enterprising seamstresses also produce a small number of garments on speculation for itinerants who buy for resale or for the occasional tourist. Some seamstresses employ girls to sew for them in their homes. It appears that these interrelationships are governed by social convention, and dealings are circumscribed by extended families and godparents, who are "people who are known to us." Sewing is a livelihood for women of the poorer sections of town, with concentrations in the eighth and fifth sections of Juchitan. Sewing also is taught on the secondary school level, but the course is geared toward conventional dressmaking from commercial printed patterns.

Small inventories of finished blouses are sold directly through fabric stores in the main towns. Stalls in municipal markets display huge piles of blouses, along with skirts, hair-ribbons, shawls, and manufactured clothing for men. At last count there were six retailers on the second story of the Juchitan market who dealt in traditional costume. Shops in Juchitan and Salina Cruz, owned by Doña Ofélia Valdivieso Ruiz, specialize in costume rental, with racks of inventory for all ages and sizes. They are hung inside out to preserve the embroidery. A *mayordomo* (ceremonial host) or family representative might contract the rental of a dozen to twenty *trajes* for a three-day fiesta in one of the smaller towns or barrios. Or, a woman might rent a costume for an hour or two in order to have her daughter pose for a portrait at a local photographic studio.

As in other parts of Mexico, the local textile trade is dominated by Lebanese merchants. Covarrubias explains this phenomenon in terms of the strict divisions of sex roles: since only women engage in commerce, foreigners have cornered some retail trades (1946:283). At least three shops display bolts of fabrics, threads and accessories manufactured in Mexico. Their displays are supplemented by street vendors on Tuesdays and Saturdays. It is not uncommon, however, for women to make the thirteen-hour bus trip to Mexico City to acquire machines, buy supplies wholesale, or seek a larger selection of fabrics and colors. Imported cloth, especially from the United States and Japan, is expensive, in limited supply, and is spoken of as having superior qualities.

Change

An example of how change comes about occurred in late 1984, when two Juchitecas imported sewing machines with cams for satin stitch and began to produce machine-embroidered blouses. This type of machine

is used to embroider floral neckbands and hems in the state of Yucatán. This purchase started a bandwagon effect among the few entrepreneurs in an economic position to acquire the new machines, so that they, too, could provide customers with the latest style. One would expect a machine-process to cost less than a hand-process. The rarity, however, of these machines, which requires considerable training to master tension problems and time consumed in constantly rethreading the machine for color gradation and change, have meant that costs have stayed high. In addition to the high price, novelty confers status. This is the first new tool to be introduced in nearly fifty years. In retrospect, it seems a logical move, since Yucatecan embroideries bear a stunning resemblance to Isthmian false satin-stitch work. Both garments are thought to trace to Manila shawl prototypes.

It is unclear whether this new machine will displace punch-needle and/or hand embroidery or merely add to the choice of embellishments. Just as there has been a recent proliferation of machine-embroidered *huipiles*, especially colored-thread combinations, there may be a transition from hand to machine products as experience in using these machines increases. The smaller-scale motifs and thinner rayon thread more closely approximate the appearance of *tejido*. The machine operates more easily for smooth fabric points, which suggests that punch-needle work is more likely to be displaced.

One immediate consequence of the new machine is a reduction from five or more to only three shades used within each petal and leaf due to the inconvenience of rethreading. Since careful shading is an aesthetic value, there may be a decline in this aspect of work. New methods, such as the use of several machines threaded with different colors or space-dyed threads, may be sought to accommodate shading. Past experience indicates that pattern change has been subtle and incremental rather than drastic.

A more important issue is the transition from Indian costume to contemporary Western-style clothing. To some degree change is taking place throughout Mexico as a result of education and efforts to shed the low status associated with Indianness. Although women are an important force in the Isthmian economy, and fierce pride is bound up with the wearing of *enagua* and *huipil*, many school-age children wear *traje* only for fiestas. Virtually from birth, girls are integrated into social custom and taught their responsibilities. Around the age of six, a girl is expected to host a fiesta (in late June or early July to coincide with the flowering of the brilliant red *framboyan* trees). She performs the obligations of a hostess: greeting her guests by sprinkling them with confetti, serving them generously with food and drink, inviting guests to dance, dancing the traditional *Sandunga*, and

participating in a ceremonial transfer of responsibility to a future hostess. For this and other fiestas a girl will acquire and wear her own costume, usually sewn or bought by her mother. Girls "paint" themselves liberally with make-up for these occasions and adeptly pose with the skirt held wide in either hand to show off the embroidery and an expanse of white lace ruffle. This generation will most certainly continue to wear traditional dress for fiestas and to observe ceremonials that are the center of Isthmian life. A few girls of wealthier families have expressed interest in celebrating their fifteenth birthdays (*quinze años*), the Mexican equivalent of a Sweet Sixteen and Coming-Out party, with trips to Disney World, rather than the traditional fiesta. That is a small minority, and the final decision rests with older members of the family. The fact that Zapotec is still the predominant language spoken, the *lingua franca* of the marketplace, would tend to support the preservation of traditions.

The question of daily wear is more complex. Young children tend to be dressed in manufactured clothing, which is readily available in markets and shops. Still, the prevalent "look" of Isthmian towns is Indian. Despite ease of travel, it is still a five-hour bus ride to Oaxaca City and thirteen hours to Mexico City. This relative isolation works for tradition. The trend toward refining and elaborating decoration on local dress suggests a deep-seated interest in preserving costume. One could argue that the new machine-embroidered patterns represent a simplifying and coarsening of design that might be an early sign of decline, but I doubt that this is true.

Fine workmanship is expensive, which has led some middlemen to seek commercial opportunities outside the community, exporting blouses to Mexican craft stores and beyond. To date, these attempts have not produced big orders, nor has traditional costume been adapted for other commercial products, such as napkins or wall hangings, as it has in nearby San Mateo del Mar, an Huave village. Wealthier families in the commercial centers of towns have adopted Western dress. I suspect, however, that change will not occur within a single generation but filter down slowly. The fact that Juchitecas constantly create their own "new" fashions helps to circumscribe the community and allows for individual expression within a broader framework of conformity.

Endnotes

1. The full names of these Zapotec towns are: Santo Domingo Tehuantepec, San Vicente Juchitán, and San Jeronomio Ixtepec. Salina Cruz and Matias Romero, two other major Isthmian centers, are mestizo.

Mixe towns include Mogoñé, San Juan Guichicovi, and Coatlán. Huave villages are San Mateo del Mar, Santa María, San Francisco del Mar, San Dionisio, and Huasuntlán. A full listing of towns, villages, and barrios celebrating fiestas is given by Julio Antonio Coss in *Fiestas tradicionales del istmo de Tehuantepec Oaxaca*, n.d. (Mexico City: FONADAN).

2. A segment of the Sergei Eisenstein film "Que Viva Mexico," shot in the early 1930s features a Tehuana love interest. Local ceramics take female form both in water-storage jars from San Blas Atempa and in figurines made for the New Year, called *tanguyú*. Romanticized images are numerous and are found even on beer trays sold in the La Lagunilla flea market in Mexico City.

3. Kahlo frequently painted herself in *traje*, for example in "The Two Fridas" of 1939 (Plate XIV in Herrera 1983), a self-portrait in the permanent collection of the *Museo de Arte Moderno* in Mexico City.

4. Miguel Covarrubias (1902-57), the painter, author, illustrator, and pre-Columbian collector, arrived in New York from Mexico in 1923 and began a career sketching drawings, and caricatures for *Vanity Fair*, *The New Yorker*, *Vogue* and other publications. His interest in ethnology and art history led him to write and illustrate several important books on Mexican art and a book on Bali. His work is widely cited in other sources on Isthmian costume.

5. In 1979 I surveyed the markets at Tehuantepec, Juchitan, Ixtepec, Matias Romero, and Salina Cruz. During this trip I attended the Fiesta of Santa Cecilia in Guichicovi and interviewed a seamstress and her assistants. Guichicovi is a center for machine embroidery. In May 1981 I attended the Velas of San Vincente and Angelica Pipi, two of the annual balls that take place during the last week of the month-long Fiestas del Mayo, and also travelled to San Mateo del Mar. In January 1983 I retuned again, this time by the southern route along the Oaxaca coast from Acapulco (alternate routes are through Oaxaca City or through the state of Veracruz, roughly parallel to the railroad line, which is slightly faster and less mountainous than the Oaxaca road). During a year's residence in Mexico City (1984-85) I met Juchitecas in Mexico City, where a large community is socially active and holds a September ball. Through this group I contacted Doña Ofélia Valdivieso Ruiz and her daughter Marilu Valdivieso, who arranged visits to seamstresses in Cheguigo, the eighth section of Juchitan, and acted as my translators and infor-

mants in February and July 1985. In July I photographed the fiesta celebrating the sixth birthday of Marilu's daughter Yazmín and also worked with photographic archives of the Casa de la Cultura in Juchitan, courtesy of Director Macario Matus.

6. I observed this practice in Pinotepa de Don Luis, Jamiltepec, and Huazolotitlán in 1983.

7. An example of this type of cloth is exhibited on a mannequin in the Museo Nacional de Antropología in Mexico City in the ethnographic section on the second floor (see also Covarrubias 1946:249).

8. In 1866 Juchitecos and residents of the San Blas and Shiwi wards of Tehuantepec took arms against Remigo Toledo, an army captain sympathetic to Maximilian von Hapsburg, the Austrian archduke who had been declared Emperor of Mexico in 1864 with support from Napoleon III (his French troops were defeated and Maximilian executed in 1867). Reinforced by the French army and Catholic patriots, Toledo retreated beyond Tehuantepec when his attack on Juchitan was repulsed. Juchitecos celebrate the victory September 4. This treason by Tehuantepec created a rift between the two towns, doubtless exacerbated by economic rivalry (Covarrubias 1946:228-29). Today, there is a racial strain of blue-eyed, fair-skinned Isthmus people referred to by locals as *"frances,"* descendants of French soldiers.

9. A coalition of workers, farmers, and students (COCEI) seized the Municipal Building to seat the popularly elected candidate for mayor, but this attempt ended in the army intervening to reinstate the PRI candiate two years later.

10. PRIists attribute the instability to the presence of outsiders: political refugees from Central America who were granted asylum in the Municipal Building and opportunists drawn by stories of local gold. With a PRI mayor back in power, the party has initiated public works to re-enlist local support that include refurbishing of the town center and a new indoor marketplace (under construction).

11. A search through the sewing machine district in the center of Mexico City confirmed that these very old models do not come on the market outside the Isthmus, where they are bought and sold through word of mouth.

12. This apparently straight forward naming procedure contrasts with the rather interesting description in Ruth Nielsen's article on "African Wax Prints," where vendors bestow names that originate in per-

sonal associations or dreams to printed patterns that often gain fame
and longevity through the naming (1980:10).

Bibliography

Brasseur, Charles
1981 Viaje por el istmo de Tehuantepec 1859-1860. Mexico
 City: Fonda de Cultura Económica, Vol. 18, Lecturas
 Mexicanas.
Cordry, Donald B., and Dorothy M. Cordry
1968 Mexican Indian Costume. Austin: University of Texas
 Press.
Coss, Julio Antonio
n.d. Fiestas tradicionales del istmo de Tehuantepec Oaxaca.
 Mexico City: FONADAN.
Covarrubias, Miguel
1946 Mexico South: The Isthmus of Tehuantepec. New York:
 Alfred A. Knopf.
De Paalen, Isabel Marin
1974 Etno-artesanía & arte popular. Mexico City: Editorial
 Hermes. *In series,* Historia General del Arte Mexicano.
Doniz, Rafael
1983 El ayuntamiento popular de Juchitan: Fotografías de Rafael
 Doniz. Mexico. Preface by Carlos Monsivais.
Herrera, Hayden
1983 Frida: A Biography of Frida Kahlo. New York: Harper &
 Row.
Lechuga, Ruth D.
1982 La indumentaria en el Mexico indígena. Mexico City:
 FONART.
Kolko, Bernice
1968 Semblantes mexicanos. Text by Fernando Camara Bar-
 bachano. Mexico City: Instituto Nacional de Antropol-
 ogía e Historia.
Linati, Claudio
1978 Trajes civiles, militares y religiosos de México. Mexico
 City: Editorial Innovación S.A. (First ed. Brussels 1831).
Mompradé, Electra, and Tonatiúh Gutiérrez
1981 Indumentaria tradicional indígena: Tomo II. Mexico City:

Editorial Hermes. *In series*, História General del Arte Mexicano.

Monsivais, Carlos, ed.

n.d. Foto estudio Jimenez: Sotero Constantino, fotógrafo de Juchitan. Juchitan, Oaxaca: Ediciones Era (Cronicas).

Nielsen, Ruth

1980 African Wax Prints. Corvallis, Ore. Oregon State University, Horne Museum. Reprinted from 1979, The History and Development of Wax-Printed Textiles Intended for West Africa and Zaire. *In* The Fabrics of Culture, Justine M. Cordwell and Ronald A. Schwartz, eds. Pp. 467-98. The Hague: Mouton.

Rouillon, M.C.

1954 Goldsmiths Follow in Footsteps of Early Indian Craftsmen. Craft Horizons 14:32-33.

Sayer, Chloë

1985 Costumes of Mexico. Austin: University of Texas Press.

Starr, Frederick

1908 In Indian Mexico: A Narrative of Travel and Labor. Chicago: Forbes & Company.

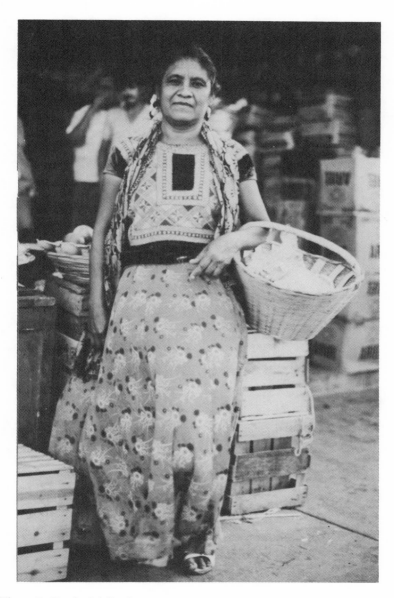

Figure 1. Typical daily dress, Juchitan market. Photo by Pamela Scheinman 1980s.

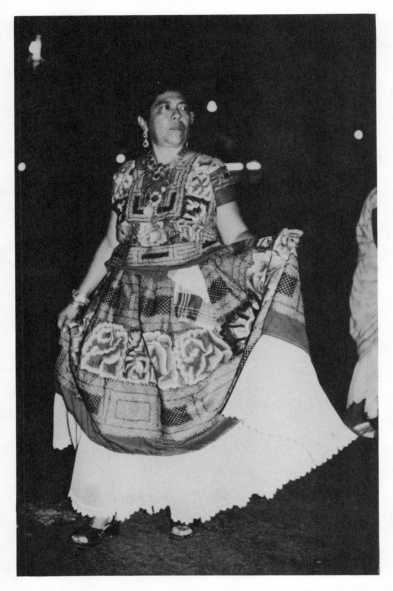

Figure 2. Dancing the *Sandunga* in fiesta dress, Juchitan. Photo by Pamela Scheinman 1980s.

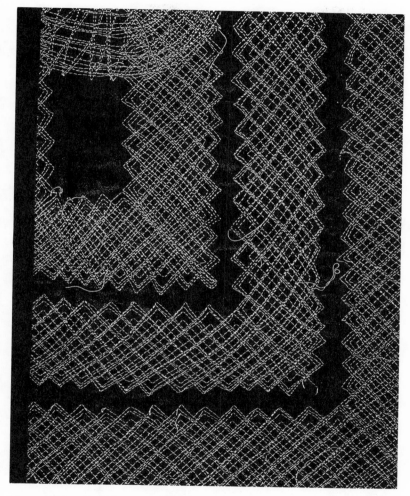

Figure 3. Detail of blouse, lining side; simple net or lattice pattern in machine chain stitch. Drawing by Pamela Scheinman.

Figure 4. Detail of machine chain stitch bib style; *trencillas* (alternating lines in large open diamond or lattice); *copa* (inverted triangles in squares).

Figure 5. Detail of machine chain stitch 3-band style. Drawing by Pamela Scheinman.

Chart I. Diagrams of machine-embroidered designs (after Covarubias 1946:250-1). Names supplied by Roselia Robledo Lopez and Paulina Robledo Lopez of Juchitan, 1985. Drawings by Pamela Scheinman.

1. Unita

2. Cadenia Bandera

3. Reja or Rejita

4. Maguey

5. Copa Estrella Estrella

6. Trencilla (with Estrella Copa) (with Unita)

7. Culebra

8. Cuadro Baraja

9. Cuadro Galleta

10. Cuadros y Cadenia

11. Bitalla con Cuadros

12. Charly

13. Unidentified

Jaguar (?)

Chapter Four

Dress and Civil-Religious Hierarchy in Sololá, Guatemala

Guisela Mayén

Introduction

Contemporary Guatemalan Indian culture is the product of the contact between pre-Hispanic communities and the Spanish conquerors.[1] One of its main characteristics is its syncretic form. The native dress and the political-religious organization, also called the civil-religious hierarchy, are two examples of such cultural syncretism. Generally both have been studied separately. The purpose of this article is to show that rank within the civil-religious hierarchy of Sololá is encoded in ceremonial dress. Separate descriptions of clothing and the civil-religious hierarchy are followed by an analysis of the ceremonial garments denoting each office.

This investigation concentrates on the municipality of Sololá, a Cakchiquel Maya community with a population of 29,000, located in the midwestern highlands of Guatemala. This community was selected because it is one of the few Guatemalan municipalities where men still wear native clothing and where the form of social organization mentioned above also exists.[2]

89

Dress and Its Construction

The dress of the municipality of Sololá is composed of two types of garments: some made with fabric woven on a backstrap loom and others with fabric woven on a treadle loom. The former type of garment includes *huipiles* (women's blouses), *tzutes* (square or rectangular cloths used by Indian men and women), trousers, and shirts. The latter includes fabrics for skirts. Some garments leave the loom ready to use, such as the sash, which is woven on a backstrap loom, and the *rodillera* (rectangular woolen cloth worn by men wrapped around the hips over trousers), which is woven on a treadle loom.

Generally, Sololá textiles, woven on backstrap looms, are warp-faced plain weavings with warp stripes. The materials in the ground weaving are commercial cotton, acrylic, wool, tie-dyed yarns, metallic yarns, and natural handspun brown cotton. Some weavings have two-faced or double-faced brocading. The brocading materials are *sedalina* (a two-ply mercerized cotton yarn usually sold in 5-gram balls), *lustrina* (embroidery or brocading mercerized cotton yarn, which is sold in small hanks), and acrylic and metallic yarn.

The outstanding feature of backstrap-woven fabric is a design of red and tie-dyed patterned warp stripes. Although all the weavings appear similar, people from Sololá, especially weavers, distinguish different combinations of several elements of design. Several weavers interviewed for this study explained that they can identify more than ten elements. These elements are divided into two types, according to their function. The first consists of units of stripes, differing in their distribution, color, or material. The second is characterized by single-colored stripes or by units of a prevailing color in which narrower lines are interpolated. The elements of the second type are separators of the units of the first type (Mayén de Castellanos 1986: 54-56). These two types of elements of design are used in specific combinations according to kind of garment. In addition, some textiles have brocaded designs that represent animals, plants, and geographic, meteorologic, or sidereal elements.

Sololá women use hand or machine embroidery. Hand embroiderers join breadths, shirr material, sew appliqué, or decorate garments. The stitches are stem, cross, backstitch, Cretan, Rumanian, and hemstitch. Machine embroidery is done with cotton or metallic yarn over the *randa* (hand-embroidered joinings) of the skirts and *tzutes*. Soutache and piqué, bands of imitation jewelry, and castile tape form designs on men's jackets and shirts.

Everyday Dress

Women's everyday dress includes a *huipil*, skirt, sash, and *tzutes* for different uses. The Sololá *huipil* is characterized by a gathered collar and set-in sleeves. It is worn tucked into the skirt, with the sleeves rolled up above the elbow and adjusted to the arm. The traditional wrap-around cotton skirt is blue with units of vertical white weft stripes. In modern acrylic skirts, these weft units have been replaced by brocaded or tie-dyed patterned bands. The sash may have brocaded designs at one or both ends.

The *tzutes* (head or carrying cloths) are square or rectangular cloths formed by joining two breadths. They have multiple, specialized uses. Women's *tzutes* are distinguished by their white and brown narrow warp stripes. The types of *tzute*, according to their function, include: 1) the covering or carrying *tzute*, in which a woman carries children on her back or wears it as a shawl; 2) the *tanatero* (bundle) *tzute*, for carrying things at the market, making bundles, covering baskets, and also to cover the head at church or to provide shade against the sun; 3) the *tortillero* (for *tortillas*) *tzute* resembles the *tanatero*, but it is smaller and is for wrapping *tortillas* and covering small baskets; and 4) the large *tzute*, which is similar to the men's large *tzute* described below.

The man's everyday dress in Sololá includes a shirt, trousers, a sash to hold the trousers in place, a *rodillera*, a leather belt to hold it in place, a hat, a jacket, and a *morral* (man's knitted shoulder bag to carry food, personal documents, etc.). The modern shirt, which has a Western cut, is made of fabric woven on a backstrap loom. It is cut and sewn by machine in specialized tailor shops. The shirt may be decorated with appliqué designs on the collar, chest, and back. Trousers are also made with fabric woven on a backstrap loom and may include brocade. Trousers are now sewn by machine; the legs are joined by a gusset in the crotch. The everyday sash has a warp design but no brocading. The *rodillera*, a rectangular breadth of fabric woven on a treadle loom in Nahualá, has a checked design achieved by alternating natural white and black wool in the weft and the warp. This garment is wrapped around the hips over the trousers.

Woolen jackets are made locally by specialized tailors from industrial fabrics or material woven in other communities. The jackets for everyday wear may be black, gray, or white, and are open in the front. All have three or four pockets, black lapels, and a decoration usually made of black soutache braid in a traditional design called *murciélago* (bat). This design has recently changed to butterflies, hawks, or *quetzal* birds, which are incorporated according to the wearer's taste.

Ceremonial Garments

Women hold only secondary positions within the civil-religious hierarchy, and their ceremonial garments are correspondingly fewer than those for men. The large *huipil* or *sobrehuipil* (overblouse) is a garment for ceremonial use. It is made with three breadths of woven cloth with multicolored joinings. The collar is formed by cutting a round opening in the central breadth. The opening is bound with pink taffeta appliqué. This appliqué is surrounded by embroidery with another appliqué in the shape of a rosette. The *sobrehuipil* is worn over the *huipil* or folded in quarters over the left shoulder, so that the collar design may be seen. The large or ceremonial *tzute* (described below) is worn over the *sobrehuipil* by the *texeles* only.

The ceremonial garments for men are a blue jacket, a *sobrepantalón rajado* (black woolen overtrousers split to the thigh), the *jerga*, a *gabán* (woolen overcoat), a sash with two brocaded ends, a head *tzute*, and a shoulder or large *tzute*. The blue jacket is locally made from a blue-and-white striped fabric woven in Momostenango and is generally closed at the front. The *sobrepantalón rajado*, also called *estameya*, is made in local tailor shops of black woolen commercial material. It is open at the sides from the hip down, so that the trousers can be seen. The *jerga* is a rectangular breadth of fabric with the same structural and design characteristics as the *rodillera*, except that it is larger and has longer fringes on both ends. The *gabán*, which is made like a cloak with false sleeves, is a black woolen garment made in local tailor shops; it is worn ceremonially over the blue jacket. The ceremonial sash is worn over the *sobrepantalón rajado*, and it is tied so that the ends hang loose in front.

Tzutes for men are distinguished from those for women by the absence of brown and white warp stripes and by their distinctive design, which consists of red warp stripes, alternating with units of green or blue, and tie-dyed patterned stripes. Men's *tzutes* may have brocade and are woven and constructed in the same manner as women's. There are two types: one worn on the head and other parts of the body and the other over the shoulders. The latter is larger than the former and therefore is also called the *tzute grande* (large *tzute*).

In addition to the ceremonial garments, several objects are part of the ceremonial costumes: a black hat, a municipal staff of office, a wooden club, a monstrance, a *chachal* or silver necklace, and large and small candles. The black hat, as opposed to the everyday white hat, is ornamented with a decorated ribbon. The municipal staff of office, which is made of wood and has a silver end, is carried under the arm. The wooden club hangs from a

shoulder. The silver monstrance bears the image of a religious confraternity's saint. The silver necklace is made of old coins. The large candle weighs twelve pounds and is about one meter long. The small ones are about thirty centimeters long and are carried in pairs.

The Political-Religious Hierarchy

The political-religious hierarchy in Sololá has as its base an organization of pre-Hispanic origin known today as the *chimital*. A *chimital* is a group known by the surname of a powerful family that protects its members, who may be kin. In Sololá, there are eighteen *chimitales*, each of which has a political-religious leader and a *calpul*, who represents the *chimital* in community affairs. Each *chimital* includes families with different surnames, but is known by the name of the most powerful family. These groups are ordered by rank and maintain a close relationship with the political-religious hierarchy, as each *chimital* has the right to certain offices, which at the same time assert its position.

The political-religious hierarchy includes two institutions in a single structure: the *cofradía* (religious confraternity devoted to the care and veneration of a particular saint) and the *alcaldía* (town council directed by an *alcalde* or mayor). Both institutions were introduced by the authorities of the Spanish colony—the first for religious functions and the second for administrative ones. The system is known in Sololá as *servicio comunitario* (community service); men alternate their service in the offices or positions of both institutions. Approximately fifteen years are required for a man to reach the top of the system and to achieve the position of *principal* (elder) in the community.

The Indian *alcaldía* in Sololá is a relatively autonomous political-administrative entity that is tied to the country's municipal system through the auxiliary *alcaldes*. It derives its power by controlling the flow of official information to the Indian population. Until some years ago, it was made up of the following public officials:

2 *alcaldes* (mayors), first and second
1 *síndico* or third *alcalde*
10 *regidores*
20 *alguaciles*
4 *mayores*
and auxiliary *alcaldes*, or community representative, for each
 canton or hamlet in the municipality.

In recent years, the Indian *alcaldía* had difficulties in completing its lists of public officials, because the pool of available men shrunk as a result of such factors as conversion to Protestantism, recruitment to the military, and economic pressures. Therefore, some of the offices such as *chajal*, *ajtzalam*, and *fiscal* are not now filled.

The *cofradía* system is made up of twelve *cofradías* in a hierarchic structure of four major, four intermediate, and four minor *cofradías* (figure 1). This system is undergoing the same problems as the *alcaldía*. Only eight are now organized. The four remaining *cofradías* are kept in force only through celebrations of their patron saints' days by the other *cofradías*, whose *cofrades* carry the images to mass. The hierarchic order from the most to the least important *cofradía* and the dates on which they celebrate their festivals are:

1. The Virgin Mary August 15
2. The Virgin of the Rosary October 7
3. The Holy Cross May 3
4. The Sacrament Corpus Christi (movable)
5. Saint Nicholas September 10
6. Saint Anthony June 13
7. Saint Bartholomew August 24
8. Saint Francis October 4
9. Saint Michael November 1
10. Saint James November 12
11. The Guardian Angel February 7
12. Saint Isidore May 15

The public officials who make up each cofradía are one *cofrade* or *alcalde* of the *cofradía*, four *mayordomos* and their wives, and two *texeles* (female members of the *cofradía*).

Dress and Hierarchy

In Sololá dress reveals an individual's status within the community. The local social stratification system is encoded in the different garments or in the way they are worn. The information encoded in the dress is: geographic origin, age, sex, economic level, and office within the political-religious hierarchy. One or several garments and the way these are worn symbolize the offices or positions. This encoding is illustrated in figure 2 . In the vertical axis are the offices or *cargos*, and in the horizontal axis are the garments, the

ways in which they are worn, and accessories that are significant in relation to the hierarchy. In each row one or several squares are marked to indicate the elements of clothing that, taken together, denote a *cargo*. The numbers that appear in a few squares refer to notes that clarify how a garment is worn on specific occasions. It should be clear that any member of the civil-religious hierarchy can wear a special garment as required by his *cargo* or he can dress as a common Sololateco. The choice between one or the other depends on the role he is playing. For example, Don Margarito Chiyal dresses as a Sololateco to perform his domestic activities, and, as *cofrade mayor*, to discharge the functions assigned to that *cargo*.

The blue jacket, the *sobrepantalón rajado*, the brocaded sash, the *tzute* tied on the head, and the black hat are associated with the most important positions: *camol bey, alcalde, cofrade,* and *regidor* (figures 3, 4). The only exception is that the *camol bey* wears a white hat, which may denote his retirement from active duty.

Only *cofradía* members wear the *gabán* and the large *tzute*. The former is part of the basic dress of the *cofrades*. Wearing the latter is a privilege of the *cofrade mayor* and the first *texeles*. The rest of the *cofrades* wear the large *Tzute* only when they receive or hand over their offices. When a *cofrade* wears the large *tzute*, he arranges the head *tzute* with three visible corners placed in the back (figure 5), instead of the usual arrangement with two corners placed in front (figure 3).

The *jerga*, and the way it is carried, are important elements in denoting several positions: *camol bey, regidor, alcalde auxiliar, calpul,* and *mayordomo*. In addition, this garment has other ritual meanings. For example, the attending *mayordomo* is responsible for spreading the *jerga* on the floor before the *cofrade* kneels, thus preventing direct contact with the floor.

In several cases, only a single garment or a pair of details distinguish one office from another. The difference between the dress of the *alcalde* and the *regidor* is that the first carries a magistrate's staff and the second wears a *jerga*. On the day that the *cofrade* is initiated into his office, his apparel is differentiated from that of the *cofrade mayor* only by the absence of the *chachal* (necklace). The *alcalde auxiliar* wears the fringes of the strap of the *morral* over his left shoulder, and the *calpul* wears it over his right shoulder; the former carries a staff of office and the latter does not.

On a feast day, the first *mayordomo* is differentiated from the other three because he does not wear a *tzute* tied around his waist. In addition, as he has to help the *cofrade* on this occasion, he carries the *cofrade*'s *morral*, *jerga*, and hat. In the *morral* he carries the liquor and cigarettes for the rest

of the *cofrades* and the glass and plate to serve the liquor. When it is not a feast day, the *mayordomo* on duty wears the *tzute* tied around his waist and carries the *cofrade*'s possessions. In addition to the meanings related to the civil-religious hierarchy, the *morral* also transmits other kinds of information about the user, as it generally has the owner's name and the canton where he lives woven into it.

The head *tzute* is worn, depending on the office, between the waist and the head. Because the positions of *alguaciles* and *mayores* are now unoccupied, there is doubt about the way the *tzute* was worn by these officials. Sources indicated that they wore it wrapped around the neck. In general terms, the *tzute* is worn higher on the body as the individual attains higher positions within the hierarchy. It ascends from the waist, to the neck, and to the hat, and finally to the head, reflecting the man's ascent of the scale of positions from *regidor* to *alcalde* and *cofrade* and finally, *camol bey*.

Men dominate the political-religious hierarchy. The participation of women is very limited; they can only fill two positions: *texel* or wife of one of the officials (*cofrade, alcalde, regidor,* or *mayordomo*). Consequently the number of ceremonial garments for women is smaller than the number for men. Two ceremonial garments, the *sobrehuipil* and the ceremonial *tzute*, and large and small candles distinguish the women's positions (figure 6). The ceremonial *tzute* diferentiates the first *texel* from the second. Candles differentiate the second *texel* and the *cofrade*'s wife, the former carries a large one and the latter two small ones. The wives of the *alcaldes* and the *regidores* do not wear a *sobrehuipil* as described above, but instead carry it folded on their left shoulders.

Conclusions

The Guatemalan Indian culture has preserved many pre-Hispanic features, but unquestionably it has changed with time. Many syncretic elements exist among them the civil-religious hierarchy. Dress symbolizes office within the hierarchy. Distinctive garments, a combination of them, and specific ways of wearing them, express an individual's position within the political-religious hierarchy. In this way dress identifies the position of a public official. The community can interact with him in accordance with his rank.

Men's Indian dress associated with the hierarchy reflects a greater richness of garments and ways of wearing them than does women's dress. This institution is basically controlled by the men; the women can only

participate in secondary roles and in almost exclusively ceremonial activities.

Endnotes

1. This study was sponsored by Museo Ixchel del Traje Indígena and Tabacalera Centroamericana S.A., Guatemalan affiliate of Philip Morris Companies Inc. Fieldwork was conducted by the author, Idalma Mejía de Rodas, Linda Asturias de Barrios and Rosario Miralbés de Polanco.
2. The procedures used to collect data were direct observation, participant-observation, interviews, and analysis of textiles and photographs. The dress is described by combining two approaches. The etic approach is used for aspects related to the elaboration of the garments, and the emic, for their design and use. The former approach is based on criteria and categories imposed by the investigator, in this case, those used in museums; the latter, on those used by the members of the community. The analysis of the distinctive dress worn by the members of the political-religious hierarchy is based on the theoretic framework used by Asturias de Barrios (1985) in her book, *Comalapa: Native Dress and its Significance*. Figures 3, 4, 5 and 6 show several members of the political-religious hierarchy of Sololá wearing ceremonial clothing.

Bibliography

Asturias de Barrios, Linda
 1985 Comalapa: Native Dress and Its Significance. Guatemala: Museo Ixchel del Traje Indígena.
Mayén de Castellanos, Guisela
 1986 Tzute y jerarquía en Sololá. Guatemala: Museo Ixchel del Traje Indígena.

The Political-Religious Hierarchy of Sololá.

LEVEL	OFFICE OR POSITION	FUNCTIONS
1	*Ajtzalam* and *Chajal*	Servants of the church
2	*Alguacil*	Servants of the Indian and *Ladino* (non-Indian) municipalities
	Mayor	Assistants of *regidores*
3	*Mayordomo*	Servants of the *cofradía*
4	*Calpul*	Representatives of the *chimitales*
	Alcalde Auxiliar	Representatives and highest authorities of the cantons
5	*Cofrade*	Heads of minor or intermediate *cofradías*
6	*Regidor*	Municipal authorities
7	*Cofrade*	Heads of intermediate or major *cofradía*
8	*Alcalde Segundo*	Substitute for the first *alcalde*
	Síndico	Similar to the second *alcalde*
	Fiscal	Servant of the church
9	*Cofrade Mayor*	Chief of all *cofrades*
10	*Alcalde Primero*	Highest municipal authority
11	*Camol Bey* or *Principal*	Elder, community leader
	Texel I and II	Widows whose husbands performed community service, who are servants of a *cofradía*

Figure 1. The political-religious hierarchy of Sololá.

Figure 2. Distinctive garments and accessories worn by the political-religious hierarchy of Sololá. In this chart the vertical axis lists the cargos, and the horizontal axis identifies the garments, the ways in which they are worn, and accessories that are significant in relation to the hierarchy. In each row one or several squares are marked to indicate the elements of clothing that, taken together, denote a cargo. The numbers that appear in a few squares refer to notes that clarify how a garment is worn on specific occasions.

NOTES: 1. FESTIVE OCCASIONS. 2. RECEIVING AND DELIVERING RESPONSIBILITIES OF OFFICE. 3. WEEK OF SERVICE. 4. COFRADE'S GARMENT. 5. HANDING OVER AN OFFICE, HOLY WEEK AND THE DAY OF THE BLACK KING.

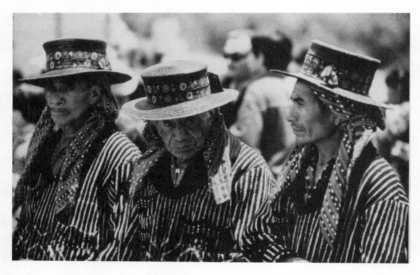

Figure 3. *Alcaldes* of Sololá wearing blue jacket, head *tzute*, and black hat. Photo by Maureen Treacy c. 1980.

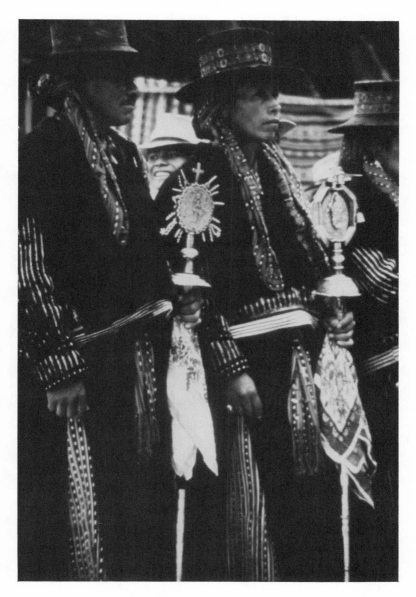

Figure 4. *Cofrades* of Sololá wearing black hat, head *tzute*, blue jacket, *gabán*, and brocaded sash. Photo by Otto Tinshert 1978.

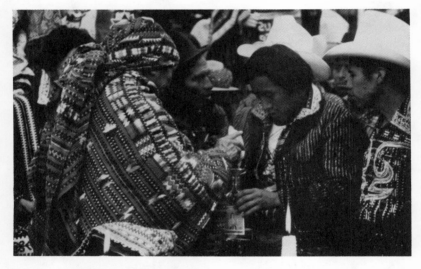

Figure 5. *Cofrade mayor* wearing shoulder or large *tzute* and head *tzute* with three corners in back. A *mayordomo* assists the *cofrade mayor*. Photo by Thierry Delrue 1986.

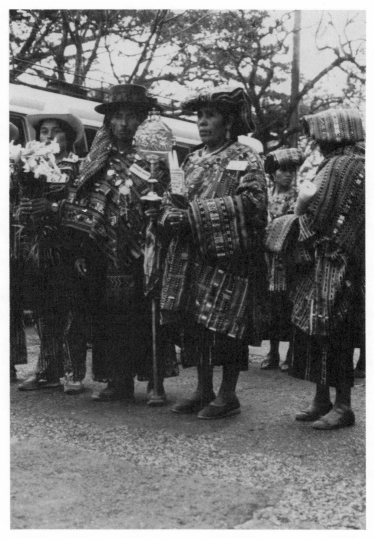

Figure 6. A *cofrade mayor* and his wife accompanied by a *mayordomo* (left) and a *texel* (right). The *cofrade mayor* wears a large or shoulder *tzute* and a silver necklace. His wife wears a *sobre huipil*. The *texel* wears a large or shoulder *tzute* over her *sobre huipil*. Photo by Linda Asturias de Barrios 1988.

Chapter Five

Dress and the Human Landscape in Guatemala: The Case of Tecpán, Guatemala

Carol Hendrickson

The belief that one can tell the municipal origin of a particular item of Maya Indian clothing simply by looking at it is, perhaps, the most commonly known "truth" about *traje*, or indigenous dress, of Guatemala. Tourist books on the region inform travelers of this local phenomenon; ethnographic literature on the highlands routinely mentions the connection, although usually at the beginning of a book and then never again; whole pictorial volumes have been organized around this theme; and Guatemalans—both Indians and non-Indians (or *ladinos*)—are keenly aware of and regularly talk about this social fact. But what, more precisely, can we say about the tie between *traje* and the geographical units with which it is traditionally associated? And how does the cultural information mirrored in this connection compare to and contrast with that found in other spheres of Guatemalan society? In short, what more, beyond the mere mention of the link between *traje* and highland town units, can we say about the geographic associations embodied in the dress worn in Guatemala?

In order to get at some sort of answer to these larger questions, I will examine the two major systems of dress found in Guatemala: *traje* or *vestido*

tradicional ("indigenous dress" or "traditional dress") and *vestido* or *ropa corriente* (literally "dress" or "common clothes," but what I will call "Western dress"). More than simply describing the ties between *traje* and municipal units, this project calls for a wide-ranging examination of the cultural construction of space in light of the two distinct but related systems of clothing.

I start in familiar territory by examining, first, the relation between *traje* and town units. In light of this highland-specific relationship, some of the other functional dimensions of indigenous dress are examined so as to convey a sense of the complexity of the cultural statements people communicate visually by means of *traje*. From there, the discussion is expanded to include non-Indian or Western dress as it relates symbolically to the world in which is it used. In the end, two very different systems of social relations are seen as being reflected through the ordering of *traje* and *vestido* across the human landscape. The former mirrors the ideal of egalitarian relations within the Indian community, while the latter reflects a hierarchical ordering of people based on an individual's place of origin and/or access to goods from home and abroad.

While these conclusions can be generalized for all of Guatemala, the bulk of my ethnographic data comes from fieldwork conducted in the highland municipality of Tecpán Guatemala in the Department of Chimaltenango.[1] Located fifty miles to the west of Guatemala City on the Pan American Highway, Tecpán lies in the heart of the central highlands and in a region known for expert weavers. The town itself has a strong weaving tradition though it is not mentioned often in the literature on Guatemalan indigenous dress. Another point to note is that Tecpán is judged locally to be a very modern town—*"el municipio vanguardista"* ("the avant-garde municipality"), as one local writer put it (Ajozal Xuya 1977:13). What this means, in part, is that Tecpanecos (or the people of Tecpán) have a knowledge of and participate in national and international trends, events, and policies to a notable degree. This expanded vision of the world is also reflected in the local knowledge of and reactions to dress.

The Municipal Function of Dress [2]

Writers have stated and Guatemalans would agree that "each [highland] community has a distinctive *traje* which is distinguished from those of its neighbors by color, style, design patterns and the manner in which it is worn" (*La Nación* 1977:16, my translation). It is with a notion such as this in mind that Tecpanecos describe the clothing of Indians from neighbor-

ing highland municipalities (women's *traje*, largely) by specifically noting what are considered to be the maximally differentiating visual factors. What this structure of differences means in practice is that highland residents often can identify readily the municipal origin of particular *traje* pieces and equate the wearer with the worn. Thus, for example, Tecpanecos in the marketplace (or in any other situation where a large number of the individuals present are not known) hesitate little in identifying the town origin of a particular *traje* or part thereof and, in most cases, the probable town allegiance of the wearer. This latter claim is always more tentative for reasons which will become apparent soon. On other occasions, the close tie between the municipal inhabitants and their clothing is reason enough to prompt contests, shows, and classroom descriptions of Maya dress in terms of its municipal affiliations.

A good example of this is seen in national and regional-level Indian queen competitions. For these events, representatives of the various highland towns appear dressed in their most beautiful municipal *traje*. However, unlike non-indigenous competitors who wear evening gowns in similar pageants, contestants in *traje* do not necessarily have to wear satin ribbons pinned across their chests, each ribbon announcing a girl's home town. For the competitors in *traje*, the mere appearance of an individual in indigenous dress specifies the municipality being represented and the supposed home town of the girl. Further identification is redundant for those who have the cultural knowledge to see clothes and equate town.

Another example of the town-*traje* tie can be seen in traditional *traje* competitions such as the one held in 1980 for the secondary school girls of Tecpán. On that occasion, contestants were asked to appear in the indigenous dress of a particular highland town. Perhaps not surprisingly, Tecpán was represented by over half the contestants. Whenever it was possible, they used very old pieces (or newer ones which preserved the "look") of the style of dress which is considered the most "sacred" or most in touch with the heart of what it means to be Indian from a particular *municipio*. Music, Mayan language, and props were also used to evoke the spirit of the municipality represented and to sum up a feeling for a town by means of dress.

As a final example, I want to mention the activities of September 15, Guatemala's Independence Day. On that day, town festivities are organized which primarily emphasize allegiance to the nation, but which also encourage a sense of municipal pride. As part of the holiday events, students from all the local schools march in the large town parade, the majority of them in

new school uniforms. Because Indian girls in all of Tecpán's schools (except the Evangelical one) are not required to wear uniforms, for the Independence Day parade they don their best traditional dress (figure 1). The girls usually seize the opportunity to wear, not just any local *huipil*, or Indian blouse, but one of the latest in traditional fashion. In 1983, the "newest" fashion took the form of the *xilón*-style *huipil*, a style of woven blouse which had fallen into disuse in the past several decades but which began reappearing in the early 1980s in a much more elaborate form.[3]

In each of these three instances, *traje* can be seen to have an important municipal function; that is, the wearing of indigenous dress is supposed to tell the viewer that the wearer is (or is meant to be) from Tecpán. This message comes across to the viewer even though the Tecpán women in each of these examples wear what would seem, on the surface, to be very different clothing. Described in terms of distinct styles of blouses, Tecpán entries in the queen's contest wear brand-new and especially beautiful blouses of the *huipil de Tecpán* sort while, in the traditional dress competition, the contestants wore *sobre huipiles* ("over blouses") of handspun brown cotton, many of which were very old and supple from years of use. Finally, the girls in the 1983 Independence Day parade wore brand-new articles of dress, including the "new" style of *xilón* blouse.[4]

But surely a *xilón*-style *huipil* would do as well as a handspun brown cotton *sobre huipil* for announcing the wearer's municipal affiliation, if that is all that is intended in a particular situation. The answer is that municipal affiliation is never all that is intended. In a national Indian queen's competition, the object not only is to be immediately recognized as from a particular town, but also to appear pretty, youthful, and *bien preparada* (that is, "well prepared," with the added sense of being "on the ball"). Hence, the particular *traje* pieces which the girl wears not only should be easily identifiable in terms of town affiliation for a non-local audience but should also function to establish other important dimensions of her being. For example, in order to be crowned the National Indian Queen, a girl not only must represent a municipality but also display a knowledge of her culture and respect for her Maya ancestors.

In the traditional *traje* competition, on the other hand, the emphasis is on the historical dimensions of dress and *costumbre* ("traditional custom"). For such an occasion, *sobre huipiles*, *morgas* (an old style of Indian skirt), and sandals (all items associated with old people and old styles of dress) are perfect for accenting ties with one's Maya ancestors. Particularly

fine examples of the above emphasize that the young person is demonstrating her knowledge of and commitment to keeping alive Indian history.

Finally, in the case of the Independence Day parade, Indian school girls are aware that they are marching in front of a local audience, one that has a ready knowledge of the history of municipal *traje*. In this instance, a school girl's attempt to accent her personal beauty, poise, and sophistication may take the form of appearing in the latest in *traje* fashion. What is more, in the case of the updated version of the older *xilón*-style *huipil*, the play on history is not lost on the crowd. Because of the attention paid to Indian heritage, the particular girls (and, by extension, all youth) are seen as active, innovative members of the indigenous community but also ones who remember their roots.

Further Spatial Considerations
While the use of *traje* to signal municipal ties is an extremely important function of dress, it is not always the most important function. One's town *traje* is neither a necessary uniform nor uniformly worn at all times and by all local *traje* wearers. The "municipal mode" (wearing indigenous dress from one's home town) is but one of the many functional or communicative aspects of traditional clothes that can be highlighted or emphasized through wear. In order to play upon other possible modes, residents of Tecpán may purposely select articles of *traje* which originate in and/or are associated with other highland *municipios*, and they do so for very particular, culturally motivated reasons.

Accounting for the range of *traje* pieces found in use in any given municipality is like getting an ethnographic snapshot of the factors that unite and divide the indigenous people of Guatemala. Marriage between individuals from different towns, for example, is a widely occurring and generally accepted event. Under such circumstances, it is the woman, ideally, who goes to live in her husband's town and, often, with his family (especially during the first years of marriage). However, despite the move across town lines, the woman commonly retains the regular use of *traje* from her birthplace, though she is likely to dress her children in the *traje* of their father's town. This was the case with a number of women I knew in Tecpán who wore *huipiles* from Comalapa and Patzún in a more or less regular fashion and who claimed they did so because of natal ties. When I asked people why particular women living in Tecpán wore non-Tecpán *traje*, the answer that respondents would give most quickly and with the greatest

confidence was that the individual in question was from another municipality.

Among the other reasons given for choosing to wear other-than-local *traje* are economic factors (cost), weather (heat or cold), a general pride in being Indian, and what I will call the "*al gusto*" response. Asked why a particular person wears the dress of another town, the response was often "*Es al gusto de uno*," "It is a matter of one's personal taste." While not meaning to shun the subject of individual taste, I will concentrate on some of those elements of choice that are guided by broader, socially defined parameters, namely, economic aspects, climatic considerations, and what I see as a growing awareness of access to the larger world based on greater educational opportunities, better transportation, and improved communications.

The Economic Factor

Cost figures prominently in most decisions to acquire a new article of *traje*. For example, the prices of Tecpán *huipiles* and *cortes* (Maya skirts) averaged Q30.00 per piece (where one quetzal [Q] equalled one dollar in 1980); however, the majority of Tecpán Indian family incomes fell in the Q2.00 to Q8.00 per day range. Given the economic situation, it is little wonder that many people seek less costly routes to acceptable traditional dress. Conceivable solutions are many: actual solutions are fewer in number, owing to the limitations of what is acceptable within any particular municipal context. In Tecpán, for instance, cheaper municipal *huipiles* are still handwoven (i.e., woven on backstrap looms) but feature fewer, less complex, and more crudely woven figures. In neighboring Comalapa, these types of cheaper, handwoven items are also available. In addition, it is common to find women wearing *huipiles* made by the faster and cheaper treadle loom process. In both cases, the basic structure of visual elements of the Comalapa *huipil* style is preserved to a point that is acceptable to the buying public.

People also look to town-external solutions for cheaper but satisfactory indigenous wear. Totonicapán and Quezaltenango, for example, are two major suppliers of the more reasonably-priced *huipiles* sold in Tecpán.[5] Produced on treadle looms, these pieces are faster to make and contain only common cotton thread, factors which are reflected in their Q11.00 to Q20.00 selling price.

Of course, price alone is never a reason to buy a particular item, and Tecpán families balance several timely considerations when a purchase is made. For example, some women simply do not care about weaving or

handwoven clothes and are more likely to choose the treadle loomed varieties of *huipiles*. Instead, they express a preference for spending time and money on their homes and housekeeping (one woman equated weavers with poor housekeepers), other craft projects (needlework, crochet, knitting, etc.), or celebratory efforts. "Indianness" is expressed in a multitude of ways and even the strong tie between a Tecpán Indian woman and handwoven municipal dress can be violated and the person's commitment to her ethnic roots not disputed.

Another instance where the less costly *traje* pieces are used concerns mothers, particularly non-professional women with marriage-aged daughters. These women are likely to buy the cheaper *huipiles* and wear their blouses and skirts for longer periods of time in order to save money for the purchase of more expensive handwoven items for their daughters. They see this as important because the young women are at an age when they want to attract suitable *novios* ("boyfriends" or "fiancés") and to establish themselves as poised, *bien preparada*, and fastidious adults. Good grooming plus impeccable outfits bode well for a young woman's future prospects, whether these be through matrimony or a professional job. Whatever the case, the mother who makes the sacrifice generally is beyond needing to worry about either in her own life.

Climatic Considerations

While the noontime temperatures in Tecpán fluctuate little throughout the year, climatic factors do play some small role in dress. Climate in Guatemala is determined largely by altitude, not latitude; and, lying at seventy-five hundred feet, Tecpán falls in a moderately cold weather zone. This means that December and January nighttime temperatures can drop to the freezing point even though the daytime ones regularly approach seventy degrees. The hottest temperatures are in March and April, just before the arrival of *invierno* ("winter" or the wet season), with its cooling afternoon rains and cloud cover. Yet even in the heat of a March day, the thermometer is only temporarily driven into the eighties. It is for this hotter weather, in particular, that people claim that *blusas* ("blouses"), such as those traditionally produced in Cobán and San Cristóbal Totonicapán, are ideal.

Consisting of factory-made cotton cloth embroidered with designs around the neck and armholes, *blusas* are familiar to every woman in Tecpán. While some claim their inspiration arises from the blouses typical of the aforementioned towns, most consider them to have evolved into a generic highland style now produced privately and commercially in a number of mu-

nicipalities. Because of their light weight, *blusas* are considered ideal attire for days of heavy housework and/or hours under a hot sun. Because they are cheap and easy to wash (especially when compared to thick, brocaded *huipiles*), *blusas* are also common attire for messy toddlers and active young children.

While it seems that "common sense" determines the use of the light *blusas* for hotter weather, climate is only one consideration. Each time a person wears *traje*, several functional dimensions of dress are called into expression and accommodated simultaneously. However, simultaneous accommodation is not always possible. Instead, priorities must be set and selections made to meet this ordering. Thus, for example, during my fieldwork I accompanied a group of women on a field trip to an area of Guatemala which is lower in altitude and, hence, warmer than Tecpán. Most of the Indian travelers had prepared for this change in climate by bringing lighter-weight "machine-woven" *huipiles* and *blusas*. However, one woman brought and wore only heavy Tecpán pieces. Asked why she did this, she replied that her husband wanted her to wear municipal *traje* so that all who saw her would know where she was from. A sense of community pride more than a consideration for the heat governed the husband's thought. The woman, going along with her husband's recommendation, showed that respect for her husband (plus an equal pride in community) was cause enough for her to wear hot, heavy *traje* pieces when lighter ones would have been cooler.

An Expanding Awareness of the World

The use of non-local *traje* also functions to signal that the wearer, in particular, and the local Maya community, in general, have a growing awareness of and access to the larger world. While familiarity with the *traje*, language, and *costumbres* of another Indian town decreases with its distance from Tecpán, Tecpanecos readily admit that greater educational opportunities, better transportation, and improved communications mean that people today are much more worldly than in years past. As far as *traje* is concerned, these modern developments take the material form of people being able to obtain items of *traje* (usually *huipiles*) from a number of towns located outside of the usual sphere of municipal activities. Alternately, a knowledge of the clothing of other towns can mean that aspects of Tecpán indigenous dress may be adapted to the styles of these distant places.

Because these markedly "foreign" pieces are not the ones commonly sold in the Tecpán market, they are either chanced upon or specifically

sought out outside of town. In either case, the use of "foreign" *traje* may signify the wearer's education, work experience, travel, family connections (often related to wealth), and *preparación* (again, referring to a certain knowledge and competence which often comes with schooling). Examples should help explain what I mean.

(1) Felipa[6] is the marriage-age daughter of an Indian family which has a transportation business. Well educated, she has completed twelve years of school, the last three in Guatemala City where she received a professional degree in home economics. Now working in Tecpán, she (as well as other members of her family) maintains an active interest in local and regional Indian events. When Felipa's male family members are away from home on business, they often buy her clothes in local markets. Wearing these imported pieces, she signals her appreciation for and awareness of indigenous *costumbres* from throughout the highlands.

(2) Teresa, too, is the marriage-age daughter of an Indian family and has the same home economics degree as her friend Felipa. Her uncle has a good job in the capital working for a wealthy foreign family and, as a consequence, has been able to travel throughout Guatemala. When he goes to different highland towns, he sometimes buys his niece *huipiles*. In instances where Teresa approves of her uncle's taste in clothes, she is pleased to wear these items that signal special access to sources of *traje* rare in the Tecpán area.

Even without her uncle's help, Teresa can tap into distant *traje* sources. Through her professional school connections, she has become friends with a number of young Indian women from around the highlands. Since graduating and starting a government job, Teresa has been able to save a portion of her earnings and, through her school friends, has arranged to commission articles of *traje* from the friends' hometowns. As she obtains new items, they become part of her work wardrobe and, given her position as teacher and role model for the young women with whom she comes in contact (*ladinos* and Indians alike), her dress is an expression of her own "preparedness" and pride in ethnicity.

(3) This final example is a second-hand report from two independent sources. Both claimed that when young Tecpán women go to the capital and take on jobs as domestic help in wealthy urban households, they often return home with significant alterations in *traje*.[7] The one change mentioned by both women was an increase in skirt length—something which can be done relatively easily by rearranging how much cloth is doubled over at the top. While, at first, I judged this change to be based on a current *ladino* fad,

I was promptly corrected when I offered this opinion. Contrary to my original suspicion, the length of one's *corte* is seen as yet another indicator of municipal affiliation. Both older women took the change to be influenced by the style of dress from San Cristóbal Totonicapán, and the actions of the young Tecpán women those of individuals on their own for the first time and eager to express their worldly ways.

As these examples show, the use of *traje* pieces from other highland communities can signal the wearer's special knowledge of and connections to distinct sources of materials and knowledge. While the appearance of "foreign" attire on a local resident can reflect negatively on the wearer if it is felt that she is trying to flaunt her privileged access to resources (e.g., by means of a well-connected work position or powerful acquaintances), the interpretation is generally more positive. The wearer is more likely to be understood as reflecting the local Indian population's growing awareness of the larger Guatemalan scene and a pride in cultural roots that goes beyond municipal bounds.

These particular aspects of what it means to wear non-local *traje* join the others presented earlier, in the sections on climatic and economic factors, as important (although, by no means, the only) functional dimensions of highland dress. That *traje* is capable of conveying several messages at once should be evident. Similarly, it is clear that all functional combinations are not possible (recall the "problem" of wearing Tecpán *traje* in warm climates) and that certain "looks" may elicit contradictory interpretations (e.g., particularly fine *traje* is capable of glorifying the worth of Maya tradition, on the one hand, and the over-inflated image of a self-centered wearer, on the other). This, however, simply points out the richness and complexity of *traje*'s expressive potential and the range of context-determined interpretations to which it is open.

Traje as an Expression of All Indian Culture

As we have seen, the residents of Tecpán selectively and purposively use *traje* from outside their municipality, as is more or less the case with indigenous residents from throughout the highlands. However, the "borrowing" of *traje* pieces across town lines is often asymmetrical and sometimes entirely unidirectional. For example, women from the neighboring town of Santa Apolonia have adopted the use of *traje* from Tecpán, San José Poaquil, and other local municipalities for regular use. I have no knowledge of Tecpán Indian women, however, taking on Santa Apolonia dress (even in cases where a Santa Apolonia woman marries and moves to

Tecpán). This asymmetry hints at a valuation of *traje*—a ranking of one as "better" or "worse," and, in fact, Tecpán women claim that the Santa Apolonia *huipil* is out of favor even in its own town because it is not as attractive as ones from other *municipios*. Attractiveness or beauty in this context is measured in terms of contemporary fashions in *traje* (such as the general propensity for elaborate weaving and a rich array of color, both of which are largely absent from the sparsely decorated, white *huipiles* of Santa Apolonia). But what does this say about the Santa Apolonia *traje* taken as a symbol for being Indian from that specific town? Or, what does choosing to wear a less costly blouse from Totonicapán rather than a more expensive one from Tecpán mean to a Tecpán woman living in a society where a higher price so often indicates that the object is "better" than a less costly one? Does this make one *traje* less "good" than another, or one community's traditional "worth" less valued?

The grounds for evaluation are shifting here and the exact terms need to be specified before going on. From the perspective of town pride and personal preference, there definitely are rankings of *traje*. But what if *traje* is considered as an expression of Indian culture—*all* Indian culture? Immediately the emphasis changes from an ordered, preference-ranked list of highland municipal dress to a uniform view of *traje* as Indian culture's quintessential visual statement. It is in this light that each municipal *traje* may be taken to be equivalent to the next as a valid representation of place and a way of life. Each reflects its roots in the Maya past, each tells of the active presence of indigenous people in Guatemala today, and each stands for the contrast between Indian and *ladino* constructions of the social world. Thus, for example, in the national Indian queen's contest, representatives from all over Guatemala compete for the crown in local *traje*. Once a queen is chosen, she continues wearing her town's particular dress; however, her presence in *traje* now is seen as a pan-Indian statement on the beauty and worth of all Guatemalan indigenous culture. In Tecpán, this perceived equality among *traje* styles (and, by extension, indigenous culture seen as *municipio*-specific) is given expression on a number of occasions, including a public presentation at the local fair which I describe below.

Each year for the week-long celebration for Saint Francis of Assisi, Tecpán's patron saint, a group of local Indian people plan a series of activities which focus on one aspect of indigenous culture. In 1980, the focus was *traje* (figure 2). To start off the week of events on this theme, planners scheduled a presentation of highland dress for which a dozen local Maya girls modeled as many different highland *trajes*. Commenting on their appearances were

two male emcees from the Instituto Indígenista Nacional (the National
Indian Institute), who spoke in Kaqchikel Maya to the largely Indian
audience. As the emcees explained, the purpose of this live presentation
(plus the week-long exhibition of traditional dress which accompanied it)
was to impress upon the audience not only the beauty of the individual towns'
trajes but the richness and variety of indigenous expression as a whole.
Along with direct claims to this effect, the speakers indirectly created a sense
of unity among Indians at the expense of non-Indians. The use of Kaqchikel,
for example, served not only to signal a pride in Indian language but to
exclude *ladinos* from the events. (Whether this was the case in fact is another
matter: many Tecpán *ladinos* understand Kaqchikel.) The use of this
"special" language enhanced the notion that indigenous customs (such as the
use of *traje*) are unique and meaningful only to Indians. That Indians should
preserve *costumbre* as theirs and theirs alone was emphasized again when the
emcees specifically admonished weavers not to teach non-Maya their craft.
The warning implied that indigenous culture could become diluted and
impure by contact with the non-Maya, and it helped to emphasize what is
seen as a sharp contrast between the two cultural systems.

**Widely Acclaimed in the U.S. and Abroad: Non-Maya Dress in
Guatemala**
> A: Where are you coming from?
> B: From New York.
> A: What did you bring?
> B: Something really nice.
> A: What letter does it start with?
> B: With ___ (names first letter of the object).
> (A then tries to guess the object)
> Children's game played in Tecpán

While the geographic reference points for *traje* are confined to the
highlands, in general, and to municipal units, in particular, those for the non-
Indian dress worn in Guatemala lie as far afield as Europe and the United
States. But how are the clothes of these far-flung spots tied to *ladino* dress
in the highlands? And how is it that the non-Maya population sees itself in
the same category as North Americans and Europeans?

As with *traje*, various categories of *vestido* can be conceived of with
reference to the point of inspiration (not to mention manufacture) of the
objects. While the inspiration for *traje* has been characterized as arising from
each highland town's equally valid production techniques and the expression

of its Maya identity, Western dress comes into being and is ranked in quite a different way. For example, *ladino* dress in Guatemala can be seen as having an outside source of inspiration which accounts for changes in dress and which gives definition to the notion of fashion. After one identifies the source of ultimate authority on dress, all other places which are significant can be arranged hierarchically below it in a fairly absolute fashion such that more status accrues to clothing which comes from places "higher up" on this scale, and progressively less to that of "lower" spots. Dress, in this case, carries with it the status of its place of origin, with "fashion" or "fashionability" here having to do with an association with the "best" or "latest" in offerings from the upper echelon of this scale.

Going along with this ordered ranking of sites are relational considerations such that any particular place may take on the role of the mecca of fashion relative to other, less privileged spots. In Tecpán, comparisons are made between locations in terms of how *civilizado* ("civilized") or *abandonado/retirado* ("abandoned"/ "distant") each is determined to be. Typically, these labels refer to relations between more or less urban (or rural) locations with their access (or lack thereof) to modern conveniences, material goods, and ideas. Thus, for example, a *ladino* woman from a village in the southeast of Guatemala,[8] told of her invitation to visit the home of a social worker whose family lives in Antigua, Guatemala's fashionable colonial capital. She never went, however, because she was embarrassed by the fact that she only had homemade clothes which she herself sewed. Nevertheless, she makes these clothes incorporating ideas she gets from fashion magazines and dress shop windows in a nearby town, and she considers herself and her teen-aged daughter to be quite fashionably attired when compared to other village members whose clothing is not so inspired.

The source of the ultimate inspiration for *vestido* is suggested by a "text", which is not directly related to clothing. It is an advertisement for pizza which appeared in a national newspaper. It announces:

> *It was born in New York; it triumphed in California;*
> *AND NOW IN GUATEMALA*
> > (*El gráfico* 28 February 1980)

As this piece suggests, the United States and Europe are the ultimate source of all worthiness and acceptability. They provide an absolute measure against which to compare the worth of any given item—a friend or a pizza, for example. Thus, in the advertisement, the life history of the product is

given in terms of the order of its appearance in the Americas, with the implication being that, while Guatemala is not New York or California, it is in direct line with the two. Proximity or accessibility to the desired wellspring places an item in a high (if not *the* highest) ranking.

And so it is with clothing. Media in Guatemala—television, radio, newspapers, and magazines—carry a wide variety of messages having to do with dress (and dress accessories) and places abroad. Associations with Europe and/or the United States (*"América"*) are regularly singled out and emphasized as being a particularly positive aspect of the article of attire. Thus, for example, we find the following newspaper advertisements (my translations):

> *FIORUCCI: everything in clothes with the stamp of Europe*
> [*El gráfico* 23 December 1980]

> *AMERICAN SWEATER WITH BUTTONS*
> [*El gráfico* 25 March 1980]

> *Skinflicks: AMERICAN DESIGN BATHING SUITS*
> [*El gráfico* 25 March 1980]

> *For this time of year, exclusive designs in sports clothes, imported directly from Europe and the United States*
> [*Prensa libre* 1 March 1980]

> *"Ellas" Boutique: European and American clothing from the best firms*
> [*El gráfico* 31 January 1981]

From here, particular geographic locations—cities or countries—are singled out for specific mention: Italy or France, London, Miami, or San Francisco. And, in lengthy, detailed articles, Paris, Milan, and New York are regularly featured as the centers of *haute couture* and the perennial sources of the best of the new fashion. Outfits are described, specific designers are interviewed, and the showings of new collections are reported as the seasons turn, even though the seasons turn differently in Europe or the United States and in Guatemala. Never mind. This is one way Guatemala participates in the international fashion scene and thereby signals its sophistication in such worldly matters.

Among Tecpanecos, however, I never got the slightest impression that Europe mattered: all emphasis was on the United States. There seem to be several reasons for this particular view. First, the United States figures in (and often dominates) much more than just clothing news. In the realm of politics, the United States has a persistent presence in activities, which regularly command media attention. Throughout 1980, U.S.-dominated news events included the U.S. hostage situation in Iran, the U.S. boycott of the Moscow Olympics, and the Carter-Reagan presidential race. Many Tecpanecos not only knew about these current events, they also held the opinion that some U.S. issues (foreign aid, for example) concern Guatemala directly and in a potentially adverse manner. This view was particularly prevalent among younger people and ones with more education, that is, just those most likely to associate the United States with the latest in fashion.

Apart from indirect and impersonal ties, several families have personal connections with the United States. At least two Tecpán families I knew had relatives living in the States; others had family members who had traveled there (as students, for professional reasons, and, in the case of one Indian man, as a government representative); and nearly everyone can lay claim to knowing someone who knows someone who has visited there at least once. Part of the reason for this frequency of travel is that the United States lies relatively close to Guatemala, as airline advertisements stress. Travel abroad is within the budget of very few but not unheard of in Tecpán. In fact, at the start of my field stay, a young professional woman from the department capital who worked in Tecpán had just returned from a trip to Miami. Her first account of activities abroad consisted solely of naming different clothing pieces which she had bought in discount stores at a fraction of the price being asked in the more fashionable Guatemala City boutiques, where only recently the items had become available.

Proximity, however, cannot be the only criterion for the appeal of the place or else Mexico and all the other countries of Central America would be equally (or more) enticing. Rather, the United States is seen as both categorically different from and better than the nations of Latin America. It is something of a fabled place where quality products of high technology and fashion are born (compare this with the children's game mentioned at the start of this section): it is the wellspring of progress and abundance, and the shape of things to come in Guatemala.

Referring to the last point, a visit to the United States can be considered a journey not only through space, but one through time as well. Traveling there, a person can almost literally leap forward months, if not

years, to buy the products of Guatemala's future. Many people are aware that when an item is popular in the United States, only mention of it arrives to Guatemala; and when that item finally reaches local markets, its fashionableness in the United States has probably already worn thin. This latter fact is not always a regrettable one. For the fortunate few who can travel to the United States, now-passé items are cheap and readily available, and, by merely carrying them home, the Guatemalan purchaser can transform them into scarce luxury goods. However, most people cannot take advantage of this time lag to tap into cheap sources of desirable objects. Instead, they are merely left with knowledge of this phenomenon, one which signals, once again, that Guatemala is in a subordinate position and, in effect, *abandonado* in the larger world.

When the rare Tecpaneco has the chance to travel abroad, he or she generally does so as the purchasing representative for whole families and networks of friends. Requests are many and orders are quite detailed in terms of brand names, styles, and prices. Among Tecpanecos, knowledge is generally restricted to smaller consumer pieces (such as clothing and small electrical appliances) which are within the price range of most people at some point in their lives. Within this class of products, strong opinions are common and reasons for buying one item rather than another quite detailed. That an item is purchased in the United States is an undeniably positive quality. However, that one feature is not the only thing to recommend it. Other aspects of the object's public presence need to be consciously considered in order for a person to achieve cultural maximization of his or her purchasing power.[9]

While foreign markets are preferred, access is rare; so Tecpanecos generally look to Guatemala City as the best spot inside the country to buy manufactured items such as Western clothing. Within the shops and stores of the capital, quality goods and foreign products are readily available, though often for a sizable price. However, given the choice between similar products—one local in origin and the other from the United States (or Europe)—the latter, with the foreign label, would generally be considered the preferable one. Capitalizing on such preferences, local manufacturers make use of plays on foreign brand names, either to imply a close association between the two products or in an effort to fool the unsuspecting buyer. Lifting an exact name and logo (such as a case I encountered of shoes fraudulently labeled with a U.S. brand name) is just an extreme version of this financially lucrative scheme.

U.S. manufacturers, likewise, turn cultural preferences into personal financial gains when they dump items which do not sell well at home onto third world markets. However, that America's cast-offs (in such shapes as John Travolta handbags and Pink Panther T-shirts) are good enough for Guatemala is seen locally as further evidence of the Central American nation's inferior status in the global hierarchical scheme.

After Guatemala City, Tecpanecos think of Chimaltenango, the department capital, as the next best location for goods and services. Chimaltenango, for example, is seen as "better" than Tecpán but not as "good" as Guatemala City for some services and supplies (e.g., schools, banks, government services, and medical facilities; medicines, fertilizers, and photographic supplies). However, as far as Western clothing goes, it holds relatively little status. Only some raw materials (e.g., cloth and knitting supplies) and selected finished items (e.g., shoes and shirts) are said to be found in slightly greater variety, with more attractive styles, and cheaper prices than in Tecpán. However, Tecpanecos generally do not think of making specific trips to Chimaltenango to shop for clothes and so, on this count, the city of fifteen thousand is pretty much ignored.

If one is left to look for *ropa corriente* in Tecpán, there are three principal options. Listed in the order of general preference, they are *ropa ya hecho* (readymade clothes with factory labels), tailor-made clothing, and homemade pieces. The first of these, the readymade items, are available in several of the small stores and shops in the center of town as well as from market vendors in the plaza on Thursdays and Sundays. In addition to these, Tecpán has a number of small clothing factories (a couple producing sweaters and another, men's shirts) which have local retail outlets. While the factory outlet shops offer a wide variety of goods within a very limited range, both the market stalls and permanent stores offer a few pieces of a wide selection of clothing. In either case, the buyer must be satisfied with what is available, do without, or make alternative plans.

Alternative plans for clothing often entail purchasing fabric and taking it (along with a picture or some sort of description) to an experienced tailor. Although the majority of the work of these craftspeople is in the routine construction of pants, jackets, skirts, and shirts, some are also quite capable of reproducing a radically different style. By commissioning skilled tailors to produce items in the mold of the latest styles, Tecpanecos signal their awareness of developments in the capital and abroad, if not their ability to locate and/or pay for the "real" item.

People who make their own clothing might also try to copy popular fashion items and succeed quite nicely. However, homemade clothing (which can look particularly "rough hewn" for a number of reasons) can also have very negative connotations growing out of its association with the lower class and the poorer, more "abandoned" areas of Guatemala. Thus, at times, the notion of the homemade dress may conjure up images of cheaper materials sewn together on treadle sewing machines, the result being an item which lacks tailoring and finishing touches. Thus while, in practice, a particular amateur seamstress's efforts might escape this characterization, the general feeling is that the homemade clothing which typically is associated with residents of rural villages is the least desirable of all *ropa corriente*.

Traje and *Vestido*

With the mention of homemade *vestido*, we reach the antithesis of "American" dress in the Guatemalan ranking of Western clothing. If manufactured items from the United States are considered the most desirable clothing, then homemade pieces produced in the hinterlands are the least. In this way, the ranking of Western dress may be taken to parallel a ranking of geographic locations and, by association, a ranking of the people who live in the various locales. Unlike municipal *traje*, which I have described as a system of local statements considered equally valid as expressions of Maya identity, *vestido* represents a ranked ordering, with the worth of a piece almost literally measured by the distance its place of origin is from the fashion hub. In this way, the two systems of clothing suggest two distinct systems of relations between wearers, one based on egalitarian principles and the other on hierarchical ones.

Traje and *vestido* also contrast on the sources of their inspiration. While the creators of *traje* look backwards in time and within their own world for the roots of municipal dress, wearers of *ropa corriente* look outside their immediate world and to the future for some unknown "look" which is perpetually in the making. The Maya ancestors, both those recently deceased and those long departed, are honored and their deeds recalled with each weaving and wearing of traditional dress, while non-Indians pay homage to contemporary designers who know nothing of local Guatemalan life and whose mortality is evident, not only because they are human, but because the passage of years and the appearance of new popular designers make all the earlier ones a little more obsolete.

Finally, while Indian dress is not a static entity which people reproduce exactly and endlessly in some eternally traditional mode, the real

emphasis for *traje* is on the traditional: Maya dress is consistently produced with a notion of continuity with the past in mind. Western dress, on the other hand, while not without its "traditional elements," nonetheless develops through time by means of contrasts and leaps. A significant characteristic of fashion in the Western world is that new styles negate the old, often by being as little like those of the recent past as possible. This means that success in clothing innovation in the West all too often is measured not so much in terms of how elements from the past are enhanced and (re)made meaningful in contemporary contexts, but how well an item can "convince" its wearer and the person who sees it being worn that the fashion idea is "new." Innovations in municipal *traje*, on the other hand, play with visual conventions, but do so most successfully when they reinforce and renew the continuous thread between the traditions of the Maya ancestors and their living relatives.

Endnotes
1. Most of my field research was carried out during thirteen months of work in highland Guatemala between October 1979 and February 1981. During the summers of 1983 and 1985, I returned to Tecpán for month-long visits, both to fill in gaps in my data and to note changes which had taken place during the intervening periods, especially in light of the violence which the area had suffered.
2. I have gained numerous insights on the functional conceptualization of dress from the work of Petr Bogatyrev. For example, in his book *The Functions of Folk Costume in Moravian Slovakia* (1971), Bogatyrev sets out to delimit the distinct roles or functions played by Eastern European folk dress in its social context, including what he calls the regionalistic function. Likewise, I make much use of semiological theory and combine it with the culture-specific examination of the functional aspects of dress. For example, according to the semiology of Ferdinand de Saussure, a sign is composed of a signifier and a signified, the relation between the two being conventional. Given this arrangement, "objects" (in the sense of "culturally recognized entities") can stand for or represent one another symbolically in a wide range of social contexts. *Traje* and municipal units regularly come together in just such a symbolic relationship, with *traje* generally the signifier and municipal allegiance or origin the signified. In fact, the matching of elements from these two realms has an extremely prominent role in highland

life, with people actively and explicitly employing objects from one realm to stand for or represent the other.

3. The *xilón* style of Tecpán *huipil* is characterized as having a white background and vertical bands of red, blue, and black. Figures identical to ones found on other styles of Tecpán *huipiles* are woven on the chest, shoulder, and back areas with supplementary weft threads.

4. A class of blouses which some refer to simply as *"huipiles de Tecpán"* is the most general or unmarked style of Indian blouse found in Tecpán in the 1980s. They may be characterized by their solid background colors and rows of designs which are of three principal types, each calling for a different weaving technique. *Palomas y colochos* ("doves and curls") and the related *estrellas* ("stars") and *sopladores* ("fans") are individual figures woven by laying in supplemental weft threads and working these from the back. *Geometricos* ("geometrics") are interlocking geometric shapes which are woven from the front of a piece, also from supplemental wefts. And, finally, *cruceta* ("cross-stitch") is formed by wrapping warp threads with supplemental weft threads and thereby creating highly realistic depictions of flowers and fruit.

5. Those from Totonicapán (or woven elsewhere in this style) are favored in Tecpán. My hypothesis as to why this is so is that the Quezaltenango *huipil*, while ready-to-wear without any additional adornment, is considered more finished with hand- or machine-embroidered flowers on its woven base. These additional elements, however, add greatly to the original cost of the piece. The Totonicapán *huipil*, however, is "finished" when it comes off the loom: it is not embellished further, aside from the usual addition of velvet at the neck and arms. This less costly but complete *huipil* from Totonicapán might be more appealing than one of equal value from Quezaltenango which is seen as less finished.

6. The four proper names used in these examples are pseudonyms, but ones chosen from a list of women's names considered to be "more Indian" than such "more *ladino*" names as Claudia, Irasema, Janet, Orfa, and Gladys.

7. Some Maya women give up wearing *traje* altogether after such experiences away from home. Though most do not take this extreme route, a portion of the young women wear Western dress—dresses and skirts, and (even more extreme) slacks—while in the city, but

switch back to *traje* before returning to their hometowns for Sunday visits or for good. Parents are generally against such changes and will discipline their daughters soundly, if the matter is brought to light.

8. In 1973-74, I worked as a volunteer home economics teacher for the Guatemalan Ministry of Agriculture in the municipality of Jutiapa. During my fieldwork in Tecpán and on subsequent visits to Guatemala I have kept up my ties to Jutiapa. Given that the population of the area is nearly 100 percent *ladino*, clothing data collected in Jutiapa serves as an interesting balance to what I learned in Tecpán.

9. I might note that Americans desiring Guatemalan goods also want high quality at low prices. In this case, however, the desired items are characteristically "low technology" pieces such as weaving and pottery. Given this, the buying patterns of the Guatemalan and U.S. tourists make an interesting statement about the relation between the two countries, one specializing in and renowned for its cheap, high technology goods and the other for its cheap, low technology goods.

Bibliography

Ajozal Xuya, José Francisco
 1977 Editorial. Tecpanidad 1:3.
Bogatyrev, Petr
 1971 The Functions of Folk Costume in Moravian Slovakia. The Hague: Mouton.
Martínez Peláez, Severo
 1979 La patria del criollo: ensayo de interpretación de la realidad colonial guatemalteca. San José, Costa Rica: Editorial Universitaria Centroamérica.
La Nación (Guatemala).
 1977 "Turismo." 26 August:16.

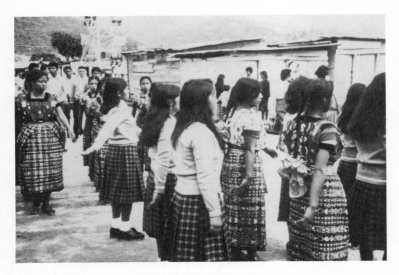

Figure 1. Indian and *ladino* girls marching in Tecpán's Independence Day parade. Photo by Carol Hendrickson 1980.

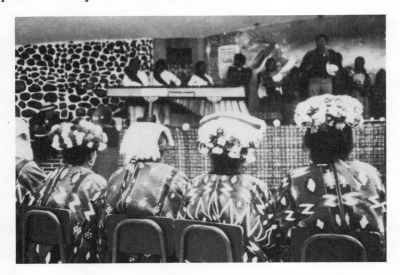

Figure 2. *Traje* presentation at the 1980 Tecpán fair, with Indian women who use *sobre huipiles* seated in front as honored guests. Photo by Carol Hendrickson 1980.

Chapter Six

Woman's Clothing as a Code in Comalapa, Guatemala

Linda Asturias de Barrios

Introduction

Guatemalan ethnographic clothing has been studied from different perspectives, ranging from extensive overview (O'Neale 1945), regional descriptions (Wood and Osborne 1966), textile techniques (Anderson 1978, Bjerregaard 1977, Sperlich and Sperlich 1980), and designs (Neutze de Rugg 1974) to change (Rowe 1981). [1.] The external, or etic, point of view (that is, the perspective of an outside observer), which permits comparisons between communities, has predominated. However, with some exceptions (e.g., Rodas and Rodas 1938, Pancake and Annis 1982), the internal, or emic, viewpoint (that is, the point of view from within the community) has been neglected until recently, resulting in a lack of information on the meanings woven by the Indian communities into their own clothing. In 1983, the Museo Ixchel del Traje Indígena in Guatemala began a series of annual publications of in-depth studies devoted to clothings of specific communities (Barrios 1983, Quirín 1984, Asturias de Barrios 1985, Mayén de Castellanos 1986). One of the goals of this series has been to uncover this network of meanings.

127

Thus the purpose of this chapter is to present the woman's clothing of Comalapa as a semiologic code used by the community to convey socially relevant information for interaction. Although the original research included the man's clothing, this article is limited to some basic woman's garments, with an emphasis on meaning rather than on textile details.

Theory

Clothing is a cultural product. Besides its adaptability to the environment, it serves as a code or vehicle of culturally relevant information, which, generally speaking, deals with the wearer's status in his community, his identity, and/or the occasion in which he is participating.

To decode the meanings encoded in a particular clothing system, researchers may find it appropriate to approach their study from an emic perspective. According to Pike (1966:152-63), emic cultural descriptions "provide an internal view, with criteria chosen from within the system. They represent the view of one familiar with the system, who knows how to function within it himself." Applied to clothing as a semiologic code, the emic approach implies discovering the system—signs and grammar—used by a community.

A semiologic code, like a linguistic code, is a system of signs. Each sign is composed of a signifier, which belongs to the level of expression, and a signified, which belongs to the level of content.

> The semiologic sign separates from the linguistic sign at the substance level. Many semiologic systems (objects, gestures, images) have a substance of expression whose being does not reside in meaning: frequently, they are utilitarian objects that society directs to transmit meanings: clothing serves for protection, food for nourishment, even though they also serve to signify (Barthes, 1974:33-34, my trans.).

Signs can be simple or composite. Simple ones cannot be divided into smaller signs; composites are sequences or arrangements of signs (Malmberg, 1982:18). The relationships among signs are given at two levels: syntagmatic and paradigmatic. A syntagma is a set of interrelated signs in a sequence or arrangement. A paradigm is a class of signs. Segmentation and classification are the analytic operations applied to syntagmata and paradigms respectively (Barthes, 1974:44). A garment such as a *huipil* is a composite sign that may be segmented into simple signs such as neckline

shape, pleats, and brocaded motifs. The different styles of neckline (slit, square, or V-shaped), for example, constitute a paradigm. The garments of a particular dress in a given situation constitute a syntagma.[2]

Location

Located in the central highlands of Guatemala, Comalapa is one of the sixteen municipalities in the department of Chimaltenango. With an area of 76 square kms., it has one town, eight villages, and twenty-two hamlets. Its population (20,422) consists of a majority of Cakchiquel-Maya Indians (96.5%) and a *ladino* (non-Indian) minority (3.5%). Contrasting with the typical demographic distribution of the department, its inhabitants are highly concentrated (56%) in the municipal capital, also called Comalapa. Agriculture, handicrafts, and trade are the main economic activities of the residents. Subsistence agriculture is focused on *milpa*, a crop complex combining maize, black beans, and squash. Wheat and other crops for exchange are grown on a smaller scale. Groups ranging from nuclear families to cooperatives produce handicrafts, an industry characterized by its diversity and growing importance among a predominantly agricultural population. The most important of these artisan products are textiles, such as *huipiles*, sashes, table runners, place mats, and coin purses, all of which are woven on backstrap or treadle looms. Agricultural and textile products as well as *panitos de feria* (small cookies sold in town fairs) are traded in local and regional markets. In addition, folk painting is a part- or full-time occupation for an increasing number of the population.

The *Huipil* and Its Meanings

Although most Indian men in the community have replaced their native clothing with Western-style garments, the women are very proud of their local clothing. The repertory of woman's garments includes a *huipil*, a *sobre huipil* (over-blouse) or *perraje* (shawl), sash, wrap-around skirt, and apron. *Huipiles*, *sobre huipiles*, and sashes are locally woven on either backstrap or treadle looms. *Perrajes* and ikat-patterned fabrics for skirts and aprons are woven on treadle looms in the departments of Quezaltenango and Totonicapan and sold in Comalapa on market days (see Asturias de Barrios, 1985:46).

As discussed previously, the *huipil* as a composite sign may be segmented into simple signs. The signifiers of these simple signs can be neckline shape, pleats, type of fabric according to loom employed, total design, brocaded motifs, fabric structures resulting from different weaving

techniques, and brocading yarns. The meanings associated with these signifiers are discussed below. For example, there are three types of neckline: square (figures 1 and 2), a slit between two breadths of the *huipil*, and V-shaped. Since these three types represent a chronologic sequence and women tend to conserve the styles worn in their youth, today neckline form indicates the wearer's age: a slit (mature or old woman), square (young woman), or V-shaped (very young woman).

Huipiles are made of two breadths. Some have a machine-sewn pleat, which tailors the garment to the body, at each side of the neck opening (figures 1 and 2). The absence or presence of pleats also conveys age: mature or old vs. young.

Huipiles woven on a backstrap loom (figure 1) are visually distinguished from those made on a draw loom (treadle loom with additional harnesses) (figure 2) by their brocading patterning and fabric edges. Furthermore, Comalapans compare them by using criteria such as weaver's sex, price of the garment, production time, and singularity of the product. A backstrap-loomed *huipil* is woven by a woman, expensive, produced in several months, and unique. A draw-loomed *huipil* is woven by a man, inexpensive, produced in hours, and identical to others. Thus the meanings assigned to each kind of *huipil* (high prestige vs. low prestige, or high economic level vs. low economic level) are respectively associated with these stated characteristics.

Huipiles are decorated by brocading a series of horizontal bands with different motifs called *figuras* (figures). The distribution and characteristics of these bands form a total design. According to peculiarities of this total design, Comalapans differentiate two types of *huipiles*, the "red one" or "pure Comalapan" and the "Sanmartinecan." The former, which has a red band at shoulder height, has traditionally identified the community (figures 1 and 4). The latter, which has been influenced in colors and distribution of bands by San Martín Jilotepeque, a neighboring municipality, has also been used for more than sixty years (figure 2). A comparison of the corresponding designs and a description of bands according to informants are presented in figures 1 and 2.

Wearing the Comalapan or the Sanmartinecan *huipil* depends on the family tradition transmitted from mother to daughter. The woman who has worn the Comalapan *huipil* from childhood will wear it until she dies. The same is true for the woman who wears the Sanmartinecan *huipil*. Therefore the total design conveys a matrilineal tradition in wearing clothing. (Outside this context, other principles of social organization, e.g.,

virilocal, tend to dominate.) Both the Comalapan and the Sanmartinecan total designs also communicate geographic origin, i.e., municipality of Comalapa.

Aesthetic sense is a characteristic combining textile quality and artistic expression. It is evaluated by examining the weaving density, the quality of brocading yarns, the number of different motifs, the distribution of motifs in a brocaded band, the combination of colors in a single motif, and prestigious motifs. According to these criteria, a *huipil* is classified as simple or special. A simple *huipil* may have several of the following features: low weaving density, inexpensive brocading yarns such as acrylic, few different motifs, relatively large spaces between motifs in a band, few colors in individual motifs, and non-prestigious motifs. Conversely, a special *huipil* has very dense weaving, expensive yarns such as silk, pearl cotton and rayon, several different motifs, minimal space beween the motifs in a band, three or more colors combined in individual motifs, and prestigious figures such as the parrot, macaw, and *rupan plato* (majolica-ceramic ceremonial plate). Since these two types of *huipiles* are worn in different social contexts, the former indicates a daily or ordinary occasion and the latter a festive one (e.g., birthday, wedding, town fair, or holiday.) In addition, the *huipil* may communicate the wearer's economic level, for poor people cannot afford special *huipiles*.

Weaving techniques inferred from fabric structures are also significant. For example, either *pajon* (continuous supplementary-weft float patterning done with the shed open and using two pick-up sticks to obtain a brick-like design) or *ka'i' ruchokoyil* (weft-faced plain weave) is usually employed to weave the red band of the Comalapan huipil. Since the *pajon* consumes less yarn than *ka'i' ruchokoyil*, these techniques may communicate the wearer's economic level. In addition, they may convey the weaver's ability, because women consider *pajon* easier than *ka'i' ruchokoyil*. *Medio marcador* (two-faced patterning with wrapped supplementary wefts) and *marcador* (double-faced patterning), two relatively recent techniques in the community, are known only by young weavers and also denote master weaving.

Total design and aesthetic sense are culturally ruled. Therefore all Comalapan *huipiles* in the red or Sanmartinecan style have features that identify them with this particular municipality. However, community weaving rules permit idiosyncratic expression. For example, the motifs placed in the center or any other band are chosen by the weaver from a large repertory. When a *huipil* is woven on a backstrap loom, the combination of motifs and

colors denotes the wearer's personal identity. This meaning is not applicable to *huipiles* woven on draw looms, because the same combination of motifs and colors is used for dozens of identical *huipiles*. In addition, the quality of a *huipil* woven on a backstrap loom, evaluated in terms of weaving, design and color, expresses its wearer's weaving ability. Since this is one of the features defining womanhood socially, the finer the huipil, the more prestige the weaver enjoys.

The *sobre huipil* is differentiated from the *huipil* by the way it is worn and its total design (figures 3 and 5). The *huipil* is tucked into the skirt, but the *sobre huipil* hangs like a cape over the *huipil*, so that the arms are covered. It is disappearing from the woman's wardrobe, for only mature and old women wear it. Young women have replaced it with the *perraje* (shawl). The total design of the *sobre huipil* is characterized by having two or more brocaded bands on the bottom (see details in Asturias de Barrios, 1985: 39-42). Unlike that of the *huipil*, its neckline form does not vary; it is always a slit between breadths.

As a composite sign the *sobre huipil* conveys information similar to that of the *huipil*. In some cases differences are found at the signifier level. For instance, the Comalapan total design varies from the *huipil* to the *sobre huipil*, even though its meaning in relation to matrilineal tradition is the same.

A special *sobre huipil* worn with a white commercial veil and a "mother" (big ceremonial) candle denotes religious office as *capitana* (head of the women's branch of a *cofradia* or religious confraternity). A similar clothing with two "daughter" (smaller) candles indicates a position as *primera mayordoma* (first assistant to the *capitana*). When the *sobre huipil* is in the Comalapan style, the favorite and most prestigious design is one with three main brocaded bands alternating with four "separators" or multicolor stripes (figure 3).

Other Garments and Their Meanings

Comalapans distinguish two types of fabric woven on treadle looms for skirts. *Morga* is of indigo-dyed cotton with units of white warp stripes (figures 4 and 5); *jaspeado* is weft or warp-and-weft *ikat* patterned (figure 5). The former conveys the wearer's very old age, since only a few old women still wear it. Most women have replaced it by the *jaspeado*, but the way it is worn, in terms of number and placement of pleats, varies according to age. For example, mature women use three to four pleats distributed in front, and teenagers use two, one on each side. Thus pleats provide more accurate information about the wearer's age than does the *ikat*-patterned skirt itself.

Frequently *ikat*-patterned skirts have appliqué on their lower edge, which consists of a lace or velveteen border. Sometimes soutache is used for additional decoration. Depending on the price of the fabric and amount and quality of appliqué, these skirts are also classified as simple or special, and their corresponding meanings are the same as those described above.

According to a chronological criterion, sashes are divided into old and modern. Old sashes (figure 4) have multicolor warp stripes similar to the "separators" of the Comalapan *huipiles* and *sobre huipiles* (figures 3 and 5). Their fabric structure is warp-faced plain weave. The modern sash is characterized by brocaded designs, which may be woven in horizontal bands on a separate breadth and then cut and sewn on to a striped sash or directly brocaded in the sash.

In addition to design and fabric structure, the size and manner of wearing distinguish the types of sashes. The old sash may measure 300-500 cms. long by 12-25 cms. wide, and the modern about 160 cms. by 3-4 cms. The old is worn loosely (figure 4), and the modern very closely fitted.

Three features may also indicate the wearer's age: type, size, and manner of wearing a sash. For instance, a long, wide traditional sash, loosely worn, is associated with old women, and a shorter narrower sash of the same type, worn more tightly, with mature women. Sashes, like other garments, may be simple or special, according to quality, price, and condition.

Discussion

The Comalapan woman's clothing is a semiologic code composed of several signs. Each garment (e.g., *huipil*, skirt, or sash) is a composite sign. As such it may be divided into simple signs. For example, let us consider a *huipil* woven on a backstrap loom in the Comalapan total design with square neckline, pleats, double-faced brocaded parrots in its central band, and pearl cotton and rayon as brocading yarns. Its simple signs are backstrap-loom weaving (high economic level, prestige); Comalapan total design (Comalapan provenance, matrilineal tradition); square neckline (young woman); pleats (young woman); double-faced brocading (very able weaver, festive occasion); parrots (festive occasion, prestige); pearl cotton and rayon (festive occasion, high economic level); and an idiosyncratic combination of colors and motifs (personal identity). Among these features are polysemous signs (e.g., total design and double-faced brocading) and synonymous signs (e.g., square neckline and pleats). Since these signs are related *in praesentia*, they constitute a particular syntagma.

Paradigms are constituted by signs related *in absentia*. For example, the three types of neckline (slit, square, and V-shaped) form a paradigm, for a *huipil* can have only one neckline shape. Similarly, the absence or presence of pleats as two separate signs constitutes another paradigm.

A particular *huipil* as a composite sign, communicates a specific message. However, generally speaking, the *huipiles* in Comalapa convey socially relevant meanings that help to locate their wearers in a set of geographic, economic and social positions (Pancake and Annis, 1982). These meanings include ethnic identity (Indian or non-Indian), geographic origin (Comalapa, Tecpán, etc.), economic level, matrilineal tradition (Comalapan or Sanmartinecan), female sex, wearer's age, prestige as a weaver, occasion in which the wearer is participating (ordinary or festive), and personal identity.

The semantic complexity of the *sobre huipil* is similar to that of the *huipil*. The skirt and the sash convey a smaller number of meanings. For example, the *ikat*-patterned skirt does not reveal geographic origin, for it is worn in most of the Indian communities in the country. The sash alone does not communicate matrilineal tradition in wearing clothes.

Among the different simple signs discussed in this paper, those dealing with wearer's age deserve special consideration. The specific age meanings encoded in neckline shapes, absence or presence of pleats and so on are valid for the present time. They will continue to change as wearers grow older and new styles are adopted by young generations.

Woman's clothing as a whole is therefore a syntagma that may be segmented into smaller syntagmata or composite signs (e.g., *huipil*, skirt or sash). The message of the whole may have redundant or ambiguous information. The economic level, for example, might be encoded in the *huipil*, the skirt, and the sash. On the other hand, the *huipil* might indicate one geographic origin and the sash a different one.

This combination of garments corresponding to different municipalities deserves further study at the national level, for costume has traditionally been a symbolic bond with the community where one lives, to which one belongs and identifies. What does wearing this combination of garments mean? Is it only a fashion or a search for wider regional or cultural identity? These and other questions dealing with the intricacies of Maya clothing will be addressed in future research.

Endnotes

1 Data and analysis are based on research sponsored by the Museo Ixchel and Tabacalera Centroamericana, S.A., the Guatemalan affiliate of the Philip Morris Companies Inc.

2 With the theoretic considerations stated above as part of a general framework, Comalapan clothing was studied by anthropologist Idalma Mejia de Rodas and the author in 1984 (Asturias de Barrios 1985). Four months were devoted to fieldwork. Data were collected by participant observation, observation protocols, questionnaires, and open interviews. Sixty records of women's costumes were completed, ten for each of the following age groups: teenagers (13-18), young women (19-40), mature women (41-60) and old women (61+). The questionnaires were answered by 117 students in the last two grades of primary education and the last three of secondary education in public and private school in the municipal capital. More than fifty interviews were conducted in Spanish, recorded, and later transcribed. Each interview lasted between fifteen and ninety minutes and took place in the home or workplace of the person interviewed. Men and women weavers, tailors, embroiderers, skirtmakers, silversmiths, painters, owners of yarn shops, market vendors, and civil and religious authorities were interviewed. In some cases photographs or paintings by Andres Curuchich were shown to elicit information about the past or to motivate those being interviewed. Some informants were also invited to come to the Museo Ixchel to describe certain textiles. Since several interviews contained Cakchiquel words and phrases, a Cakchiquel linguist, Margarita Lopéz, transcribed and translated these interviews into Spanish.

Bibliography

Anderson, Marilyn
 1978 Guatemalan Textiles Today. New York: Watson-Guptill Publications.
Asturias de Barrios, Linda
 1985 Comalapa: Native Dress and Its Significance. Guatemala: Museo Ixchel del Traje Indígena.

Barthes, Roland
 1974 Elementos de semiología. *In* La semiologia. Roland
 Barthes, Claude Bremond, Tzevetan Todorov and Chris-
 tian Metz. Third edition. Buenos Aires: Editorial Tiempo
 Contemporaneo.
Barrios, Lina E
 1983 Hierba, montañas y el árbol de la vida en San Pedro
 Sacatepéquez, Guatemala. Guatemala: Museo Ixchel del
 Traje Indígena.
Bjerregaard, Lena
 1977 Techniques of Guatemalan Weaving. New York: Von
 Nostrand Reinhold Company.
Malmberg, Bertil
 1982 Introducción a la linguística. Madrid: Ediciones Catédra.
Mayén de Castellanos, Guisela
 1986 Tzute y jerarquía en Sololá. Guatemala: Museo Ixchel del
 Traje Indígena.
Neutze de Rugg, Carmen
 1974 Diseños en los tejidos indígenas de Guatemala. Guate-
 mala: Editorial Universitaría.
O'Neale, Lila M.
 1945 Textiles of Highland Guatemala. Publication 567. Wash-
 ington, D.C.: Carnegie Institution of Washington.
Pancake, Cherri, and Sheldon Annis
 1982 El arte de la producción: Aspectos socioeconómicos del
 tejido a mano en San Antonio Aguas Calientes, Guate-
 mala: Mesoamérica 4:387-463.
Pike, Kenneth
 1966 Etic and Emic Standpoints for the Description of Behavior.
 In Communication and Culture. Alfred Smith ed. Pp. 152-
 63. New York: Holt, Rinehart and Winston.
Quirín Dieseldorff, Herbert
 1984 X'Balam Q'ue: El pájaro sol. Guatemala: Museo Ixchel
 del Traje Indígena.
Rodas, Flavio, and Ovidio Rodas
 1938 Simbolísmos (Mayas-Quichés) de Guatemala. Guatemala:
 Tipografía Nacional.

Rowe, Ann P.
 1981 A Century of Change in Guatemalan Textiles. New York: The Center for Inter-American Relations.
Sperlich, Norbert, and Elizabeth Katz Sperlich
 1980 Guatemalan Backstrap Weaving. Norman: University of Oklahoma Press.
Wood, Josephine, and Lilly de Jongh Osborne
 1966 Indian Costumes of Guatemala. Graz: Akademische Druck und Verlagsanstal.

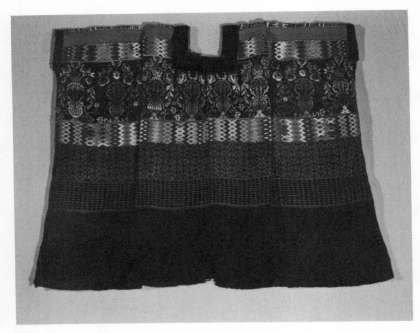

Figure 1. *Huipil* in the Comalapan total design, with *ka'i' ruchokoyil* red band. Comalapa. Backstrap loom. 130 x 75 cms. 1984. Museo Ixchel Collection # 4759. Photo by Rolando Rosito 1987.

Description of bands (from bottom to top):
1) plain cloth
2) small, spaced design
3) small, spaced star design
4) border of central figure
5) central figure
6) border of central figure
7) *creya* (red band)
8) figure on shoulder

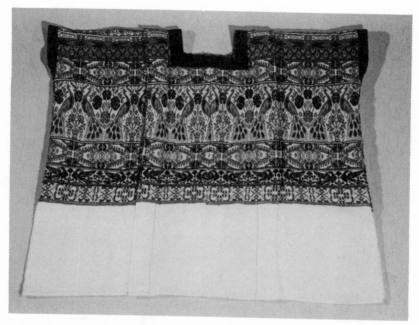

Figure 2. *Huipil* in the Sanmartinecan total design. Comalapa. Draw loom. 130 x 98 cms. 1984. Museo Ixchel Collection # 4656. Photo by Rolando Rosito 1987.

Description of bands (from bottom to top):
1) plain cloth
2) first design below border of central figure
3) second design below border of central figure
4) border of central figure
5) central figure
6) border of central figure
7) figure near the shoulder
8) figure near the shoulder
9) border of figure on shoulder
10) figure on shoulder

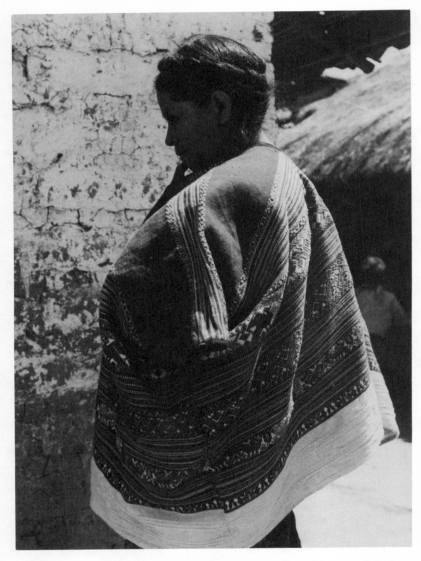

Figure 3. Woman wearing a *sobre huipil* in the Comalapan total design. Photo by Joya Hairs 1954.

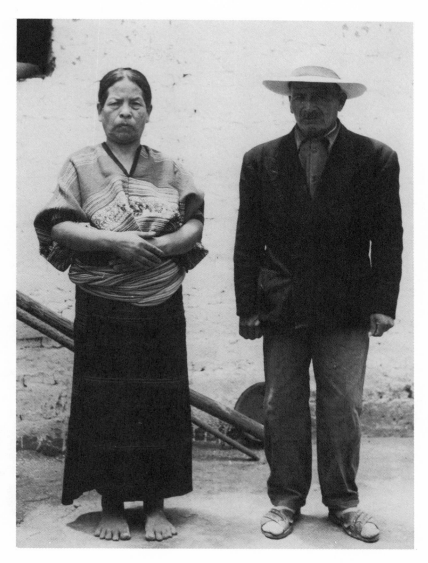

Figure 4. Andres Curruchich and his wife. Traditional woman's clothing (*huipil* in the Comalapan total design, loosely worn sash and *morga*). Photo by Joya Hairs 1955.

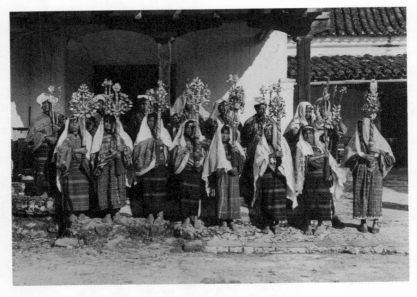

Figure 5. *Capitanas* and *primeras mayordomas*. Photo by Joya Hairs 1955.

PART THREE

CENTRAL ANDES OF
SOUTH AMERICA

Chapter Seven

We Are Sons of Atahualpa and We Will Win: Traditional Dress in Otavalo and Saraguro, Ecuador

Lynn A. Meisch

This chapter addresses a continuing concern among ethnographic textile researchers working in Latin America: whether traditional cloth will continue to be made and worn or whether its manufacture and use is disappearing. Does formal government-directed education, contact with outsiders and the production of cloth for sale inevitably lead to the abandonment of traditional dress? Too many discussions of social and cultural change are obituaries, lamenting any alteration of the status quo as heralding the group's demise. This view tends to treat indigenous communities as living museums which must remain frozen in the past. As Clifford has noted, "This feeling of lost authenticity, of 'modernity' ruining some essence or source, is not a new one" (1988:4). Clifford "proposes a new historical vision. It does not see the world as populated by endangered authenticities... Rather, it makes space for specific paths through modernity...." (ibid.:5).[1]

145

Andeans are not living in a static universe any more than we are. They are definitely forging their own way through the modern world, and they do not appear to be heading toward an homogenized monoculture. (It is hubris of the worst kind to assume that everyone wants to be like us, which is what predictions of monoculture usually imply.) More appropriate questions with regard to cloth include: What kind of change is occurring and controlled by whom? Is change (of any kind) initiated by the community or is it a response to outside pressure and discrimination? Who determines what is traditional? How do *indígenas* view their traditional dress, what kind of garments do they choose to wear, and when? Are there patterns of costume change?

A look at two communities in Ecuador, Otavalo in Imbabura Province in the north, and Saraguro in Loja Province in the south, provides some answers to these questions. Neither Otavalo nor Saraguro are homogeneous communities. In both places, but more so in Otavalo, there are differences in wealth and the opportunities money can buy, including education, travel and material possessions. The inhabitants of these communities refer to themselves as *indígenas, naturales* or *runa* (Quichua for people).

Many Ecuadorian *indígenas,* while quick to adopt certain material benefits of modern society (from watches and calculators to cars and trucks) are deeply conservative in matters of ethnic identity. And of the three main determinants of ethnic identity in Ecuador: language, residence and dress, dress is the most important. *Indígenas* can speak Spanish rather than Quichua and live in the city (or abroad) rather than in their natal communities, but, as long as they wear traditional dress, they are identified as *indígenas* in their own eyes and in the eyes of other Ecuadorians. As Whitten observes, "to be Indian in Ecuador...one must be known to be a native speaker of an indigenous New World language, or dress in a costume stereotyped as 'Indian'" (1975: 175). It is important to realize that by young adulthood dress is a matter of choice. A person can choose to dress as an *indígena* or as a white, or as one or the other depending on the occasion. Ethnic identity is malleable.

The Oxford English Dictionary defines a tradition as "something that has prevailed from generation to generation." Traditional *runa* dress has no name in Quichua but is called *"traje tipico"* (typical dress) or *"indumentaria"* (costume, manner of dressing) in Spanish. It refers to a particular kind of dress, from headgear and hairstyle to footwear, that is customarily worn by members of the community. Throughout Ecuador the boundaries of

traditional dress are fluid. Generally speaking, older people are more conservative than young people and women are more conservative than men. Younger, more prosperous *indígenas* close to the towns of Saraguro and Otavalo are usually the most innovative, stretching the definition of tradition until it encompasses change. The current concept of what constitutes traditional dress is largely unspoken, although people can articulate it when asked. Why talk about it, their attitude seems to be, when all you have to do is look around?

One pattern in the use of traditional dress that I have noticed in Otavalo and Saraguro is that of survivals, the continuity of an older trait through a period of change into a new era (Tylor 1920: vol I:71).[2] A particular kind of costume survival, which I term an archaic residue, is quotidian or fiesta dress from an earlier era that is now used only for such special occasions as religious and civic fiestas, market days, weddings, baptisms and similar events. The survivals in Otavalo and Saraguro traditional costume *(traje tipico)* suggest that there is not an inevitable progression of costume change from daily or fiesta use to only fiesta use to adoption of white-style clothing. Instead, there has been gradual change in these communities with the new eventually becoming the traditional, and in some instances, the traditional becoming archaic and then disappearing. But in both communities something new becomes defined as *"traje tipico"* so that there is always a distinct costume that identifies the group.

Otavalo

In the Otavalo valley, an area known for its production weaving for the national and international market, the women's dress is still close in form to Inca costume.[3] Based on this ethnic group alone it is impossible to argue that contact with outsiders inevitably brings the destruction of indigenous culture. And, in fact, Otavalo is not unique in this respect.[4] Economic factors in Otavalo strongly favor the preservation of traditional costume. As Otavaleños travel throughout Ecuador and South America wearing their *traje*, they are instantly identifiable to those who want to buy their textiles. The hundreds of tourists who visit the Saturday market in Otavalo like to buy from *indígenas* because they "look cute." One of the main attractions of the Otavalo market is the sight of thousands of *indígenas*, from grandparents to babies on their mothers' backs, all wearing their distinctive traditional dress.

Otavalo is the only indigenous Andean community I know of where there are written costume descriptions, paintings or photographs from every century since the Spanish Conquest. Certainly one reason that so little

research has been published on Andean costume change is that we have no records for most communities. In Otavalo we can track continuities and change over four centuries.

Ethnohistory

Otavalo is a market town of about 14,000 people (mainly *mestizos* and whites) situated in a fertile, green valley 9,200 feet high in the Andes, just sixty miles north of Ecuador's capital, Quito. Approximately 45,000 *indígenas* live in seventy-five communities throughout the valley, including the town of Otavalo. I estimate that another 5,000 to 8,000 Otavaleños live outside the valley in weaving and merchant colonies throughout Ecuador and as distant as Bogotá, Colombia, and Barcelona, Spain.

The peoples of the Otavalo valley, the Caraqui and Cayambi, fell to the Inca invaders of Ecuador in A.D. 1495, after fierce resistance. Their defeat came just three years after Columbus had landed on Hispaniola and seventeen years before Pizarro landed on the coast of Peru. While the Incas weren't in the region long, the extent of their influence can be seen in the Quichua names, if not the forms, of many Otavalo garments.

By A.D. 1534 the Spanish were marching through Ecuador and a year later land was being given out in the Otavalo valley. Large *obrajes* (weaving workshops) were operating in the area by the mid-1550s, resulting in the "merciless overworking of Indians in primitive factories" (Salomon 1973: 482). Ironically, *obraje* labor was probably a significant factor in the preservation of the kind of traditional dress worn today. Men rather than women are the weavers on both the backstrap and European-introduced treadle loom in the Ecuadorian sierra. In the colonial era the men working fourteen hours a day in the *obrajes* obviously didn't have time to weave their families' clothing on the backstrap loom. This time crunch coincided with the enforcement of sumptuary laws which prohibited *indígenas* from dressing like whites. The obvious solution was to use treadle-loom woven fabric for virtually all garments, so that in Otavalo the form and color, rather than specific weaving techniques became the essential ingredients of traditional dress.

From colonial times until the agrarian reform of 1964 many Otavaleños were *wasipungeros,* (serfs), weaving for the patron, and tied to the land in a condition of debt servitude. Therefore, most *indígenas* are accustomed to production weaving on the treadle loom, although backstrap loom weaving still survives in the region for such traditional items as belts and some ponchos, and for such tourist-trade items as scarves.

Because of the fear that backstrap loom weaving may be lost, especially in the more progressive, commercially-oriented communities of Peguche, Quinchuquí, Iluman and Agato, which are close to Otavalo, there is a movement started and led by *indígenas* to preserve these techniques. Carlos Conteron of Iluman teaches backstrap techniques as a professor in the Quinchuquí school system, visiting eleven local schools, while a group of weavers led by Miguel Andrango in Agato specialize in producing high-quality backstrap textiles for the tourist market. Basically, however, when we speak of weaving in Otavalo we are talking about use of the European loom, both foot-powered and electric.

The earliest description of Otavalo costume was written in A.D. 1582, just forty-eight years after the Spanish Conquest, by Sancho Paz Ponce de León, *corregidor* of Otavalo. He noted that before the Incas came the men wore a *manta*, or wrap, which encircled the body twice. After the Inca conquest the men wore a *camiseta*, or shirt. The women wore a square cotton wrap called an *anaco* around their bodies, held shut over the shoulders with pins of copper or silver called *topos*. The *anaco* was closed at the waist with a cotton *faja* (belt). This belt was elaborately decorated in several colors and was wrapped six or seven times around the waist. Women wore a smaller wrap called a *lliclla* over their shoulders, which was also held shut with a *topo* (my translation; Ponce de León's spellings of Spanish and Quichua words. Ponce de León 1964: 14-15).

The Incas introduced the Quechua language to Otavalo, but its general use was spread by priests as a lingua franca in the colonial period. Today, Quichua or *ruma shimi* (as the language is called) is the first language for most Otavaleños, and many speak Spanish as well.

Contemporary Otavalo Female Dress

The costume I am describing as contemporary is that worn by most *indígenas* throughout the 1980s, but keep in mind that this description is a snapshot, freezing a decade in time. The costume is changing slowly even as I write. Slowly is the word, however, because female dress in Otavalo is highly conservative, with many pre-Hispanic elements. All females, from tiny babies to elders, wear the same costume. Females never cut their hair but wear it pulled back and wrapped with a long ribbon *(cinta)*. Recently, some young women have cut bangs and have had them permanented but otherwise wear it in the manner described above. If enough women adopt this style and it persists over time, it will become traditional. This kind of innovation

gradually enlarges the boundaries of the traditional, and typically it is the young, wealthier *indígenas* who are in the vanguard of change.

The inner garment is a blouse and slip combination *(camisa con tela bajera)* made of cotton, or more commonly, synthetic fabric. The blouse is machine or hand embroidered, and lace *(encaje)* is attached in ruffles at the neck and sleeves (figure 1).

A white *(yurak) anaku,* a rectangular, waist-to-ankle length wrap skirt, is worn over the slip. It is wrapped with one big pleat, folded back to front at the side, with the opening on the opposite side. The dark blue or black *yana anaku* is wrapped over the white one with the pleat and opening on opposite sides from the first *anaku.* My *indígena comadres* and my goddaughters showed me various tricks for making and holding the pleats while the two belts are wrapped over the *anakus* to hold them up. My own efforts resulted in both *anakus* falling down and much hilarity, since this was something any six-year-old girl could manage. Today *anakus* are made from treadle loom-woven or commercial wool or acrylic cloth. Instead of the elaborate hand-picked *(pallay)* motifs found on similar garments worn in Bolivia (but made using pre-Hispanic technology), some Otavalo *anakus* have simple embroidery at the hem, a labor saving innovation that may date back to the days of the *obrajes.*

When both *anakus* are wrapped, a wide, red mother belt *(mama chumbi),* from three to six inches wide and about four feet long, is wrapped around the waist. The *mama chumbi* is woven on the backstrap and has a stiff *cabuya (agave)* fiber weft. It is held shut by the baby belt *(wawa chumbi),* which is about one and a half inches wide and nine feet long. The baby belt is wrapped over the mother belt very tightly and the end is tucked in. (Belts are rarely tied in Ecuador; the end is simply tucked in.) Baby belts are woven on the backstrap loom with various supplementary-warp motifs.

For footwear females wear locally made blue or black sandals *(alpargatas).* These are now considered traditional but have appeared since the 1940s. All females wear masses of beads around their necks, gilded glass beads from Czechoslovakia or Japan in most communities; thick red beads in some communities around Lago San Pablo. Both wrists are wrapped with a long string of red beads *(maki watana,* wrist wrap). Baby girls have their ears pierced, but no single style of earring is considered typical.

Females wear a white, blue or black cloth *(fachalina)* as a shoulder wrap, while a cloth with the same name, usually black or blue, is worn on the head in one of several styles. Formerly, the style indicated the woman's village, but this is no longer true. Some *fachalinas* woven

specifically as head cloths are weft-faced, with a white border at the top and bottom selvedges. Finally, for hauling burdens on their backs, women use a cloth called a *rebozo,* which can be deep red (the old style), turquoise, blue, green, black or white.

Community pressure militates against change that is too drastic. In the summer of 1989 a young woman wearing a green *anaku* was met by stares and murmurs of disapproval from other *indígenas* as she walked in Otavalo. The thought of "what will people say?" is a powerful mechanism for social control. Weismantel, writing of the *indígenas* of Zumbagua in central Ecuador notes that "old men call...young men *lluchu* ('naked' or 'skinned') if they dare walk publicly in the parish without poncho and hat" (1988:7).

Contemporary Otavalo Male Dress

Otavaleño males never cut their hair but wear it pulled back in a long braid *(shimba),* as do the men of Cañar and Saraguro in the south. In northern Ecuador, long hair is the sine qua non of Otavaleño identity. *Runa* men working on construction projects in Quito may wear blue jeans, T-shirts and sneakers, but they are identified as Otavaleño *indígenas* by their long braids. The father of one of our godchildren cut all his young sons' braids (but kept them wrapped up in a cloth in his mother-in-law's house in Iluman). The father, a widower, is working as a watchman in Quito and his boys were attending Quito schools. He was afraid they would face too much prejudice if they were seen as *indígenas.* In this case, *runa* identity has not been kind to the father, who was a serf on the Hacienda Pinsaquí as a child, brutalized and not allowed an education. Had he stayed among Otavaleños in the Otavalo area I doubt he would have cut his sons' hair, and he has kept his own braid. In this instance he was manipulating ethnic identity on his sons' behalf.

Otavaleños are also easily recognizable by their white pants *(calzon)* and blue poncho (also called a *ruwana).* These ponchos vary from single or double-faced ones of handspun wool woven on the backstrap loom to double-faced factory-made ponchos that are tan or gray plaid on one side and blue on the other. Again, color (blue poncho, white pants) rather than method of manufacture is considered significant. Pants have been getting longer; older men wear them mid-calf length and gathered into a tie band at the waist, while younger men wear ankle-length pants including white Levi's, with a belt that buckles. Any kind of shirt or sweater is worn, although a white shirt is more traditional. Males wear a white, tan, gray, brown or

black felt fedora *(sombrero;* or ones with a wider brim, *ascanta).* Many of the hats are handmade in Iluman from commercially-made felt which is bought in Quito. Most men wear white sandals *(alpargatas),* but others wear what they wish, including sneakers and name-brand running shoes.

Children are dressed like tiny adults, and one of the godparents' gifts to their godchild at baptism is a complete set of *traje.* Every single item of traditional dress can be bought at the Otavalo market.

While some families specialize in making a particular item (e.g., *fachalinas, alpargatas,* belts, blouses) they aren't producing just for their own use, but in quantity for sale. A family need not weave or sew at all to wear traditional dress but can buy it. In some families, women embroider their own blouses, or the men weave belts, but it is the norm, not the exception, to buy the family's clothing.

In most indigenous communities in the Andes, a weaver makes the clothing for his or her family, and "each textile...is made to create and maintain important social relationships" (Medlin 1986: 275). Textile production and marketing are the foundation of Otavalo's economy, and the importance of knowing how to weave (albeit on the treadle loom) is characteristically Andean. The Otavaleños' insistence on the importance of dress in defining ethnic identity is also typically Andean, but textiles are no longer made to create or maintain social ties with the eventual owner of each textile. The retention of pre-Hispanic style elements of traditional dress combined with a commercial system for their manufacture and acquisition is an example of the manner in which the Otavaleños are forging their own way in the modern world. A variation of this pattern is occurring in Chimborazo Province, where indigenous women are buying commercial cloth made in Quito, Guayaquil, or Otavalo for their *anakus* rather than using handwoven cloth.

Survivals

Because of the historical descriptions and depictions of Otavalo dress it is possible to note costume change and identify survivals. Since at least the 1860s (Hassaurek 1967) and until the 1950s (Parsons 1945; Collier and Buitrón 1949) the men's poncho was red in most communities. In Cotacachi the poncho was dark blue or black (Hallo 1981: 62, 97). There has been a gradual shift to dark blue ponchos throughout the valley for no reason I can discern. It may have had to do with the availability of certain dyes. Cochineal, for example, was formerly available around Ibarra, but none has been produced for at least sixty years.

Today when young men want to dress like the old days for such fiestas as San Juan and San Pedro they wear red ponchos, as do some groups which play traditional music. In the late 1970s I saw several old men wearing red ponchos and the old-style handmade hats, and a few backstrap loom-woven red ponchos were sold in the Saturday market. Now no one wears red ponchos daily; their use is a survival. The pull-over white cotton shirt with narrow tucks across the chest that was worn in the 1940s is no longer worn by *runa* men but has evolved into a tourist item and is sold in the market as the "Otavalo wedding shirt."

More significant is the disappearance of *ikat* ponchos (called *llamas watashka,* llamas wrapped)[5] because their loss also represents the loss of a textile technique (*ikat*). In the 1940s two varieties were worn, wool ones for daily use and more intricate blue and white cotton ones for fiestas. These latter ponchos were worn at certain major fiestas and by the groom at his wedding. They are illustrated in miniature dioramas at the Instituto Otavaleño de Antopología. The most distinctive feature of these *ikat* ponchos is a pattern of blue and white checks that covers most of the garment. Today they are occasionally worn at weddings by men whose families have kept them as heirlooms or by men who have rented from a family that owns one. I have seen such ponchos in private and museum collections, but I have never seen one worn.[6]

Ikat ponchos will probably disappear altogether when the existing ones wear out. Otavaleños have explained to me that *ikat* is extremely labor intensive and most weavers would rather do the more lucrative production weaving. An interesting trend with respect to ordinary, contemporary ponchos is that some young men are wearing jackets for daily use and ponchos for special occasions. This means that among a tiny segment of the population, the ordinary poncho is becoming a survival.

The young men wearing jackets are not rejecting Otavaleño identity, however, and insist on long hair, white pants, and frequently, white *alpargatas,* but find ponchos cumbersome for such activities as driving a car or truck, weaving on the treadle loom or working in their family's *artesanías* store (figure 2). Typically, it is the young men in the wealthiest weaving communities close to Otavalo who are redefining what is traditional. Most of them own a poncho which they wear on special occasions. When I attended an Otavaleño wedding in 1985 the groom, who usually wears a jacket, wore a dark blue wool poncho for the wedding.

The heavy, handmade felt hat *(sombrero* or *sumbru)* that was ubiquitous in photos taken in the 1940s has been replaced by lighter felt

fedoras for men. The women have abandoned the old hat altogether, describing it as "hot and heavy." They wore these hats over or under their *fachalinas;* now they just wear *fachalinas*. On rare occasions I have spotted an old woman in the market wearing the old-style hat.

The women have been so conservative in their dress that it is hard to find survivals. One example is the full-body *anaku,* which was worn as late as the 1940s. Collier and Buitrón wrote that:

> In place of the embroidered blouse and petticoat, Indian women in isolated communities often wear a cream-colored or beige rectangle wrapped around the body like a tunic and fastened at the shoulders with silver or copper pins. This tunic answers the description of pre-Spanish dress given by the early chroniclers (1949:66).

This full-body *anaku* has almost disappeared and along with it, the straight pin *(tupu)*. When the *anaku* was shortened and no longer pinned over the shoulders there was no need for pins, and by the 1940s the shoulder wrap was tied rather than fastened with a pin. Notice, however, that while the full-body *anaku* has almost disappeared, it has been replaced by something else defined as traditional, the blouse and slip combination and two half-*anakus*.

Survivals are also found in jewelry. The red beads females wear wrapped around their wrists, or as necklaces in some communities, pertain to an ancient tradition. In pre-Hispanic times, the beads were made from the spiny oyster shell *(Spondylus princips* or *calcifer)*. *Spondylus* is found around and to the north of Ecuador's Santa Elena peninsula (Marcos and Norton 1981: 136) and was traded widely throughout the Andes.

After the Spanish Conquest, red coral was imported from the Mediterranean. In her will, doña Lucia Coxilanguango, who died in A.D. 1606 and who was the wife of the Governor of the Repartimiento of Otavalo, lists eight different *sartas* or strings of beads: one of silver beads *(chaquiras de plata)* mixed with blue coral *(corales de azul);* one of silver, white and blue beads; one of silver, purple coral *(corales morada)* and pearls; one of blue coral and silver; two of purple coral and silver; and one of red coral *(corales coloradas)* and silver (Caillavet 1982:51).

The "blue coral" was possibly lapis lazuli brought up from Chile and the red and purple "coral" were probably *Spondylus princips* and *calcifer* since I don't think Mediterranean coral was imported this early.

(Dona Lucia's use of "coral" seems to refer to any beads that weren't silver.) The white beads were probably bone or shell. The point is that the red beads have long been prized and worn by women in the Otavalo region.

Throughout the centuries, as one kind of bead became rare or expensive, a new bead replaced it. The *Spondylus* beads were replaced by red coral. Red coral became so expensive by the early 1980s, costing up to U.S. $200 to wrap both wrists, that it is passed along as heirloom jewelry and worn on special occasions or by women from the wealthiest weaving and merchant families. Possibly as early as the nineteenth century red coral was partly replaced by red or coral-colored glass beads with a white center. Columbus, Cortés and Pizarro brought beads to the New World as trade items (Dubin 1987: 254), including such Venetian glass trade beads as red *cornaline d'Aleppo*, called white hearts among bead collectors, or *veintimilla* today in Ecuador. *Cornaline d'Aleppo* means carnelian from Aleppo, Syria, and these beads were probably made in imitation of real carnelian. The ones found in Ecuador are distinguished by an outer layer of red or coral-colored glass over a white glass core and range in size from tiny seed beads under 2mm long to 1 cm (measured parallel to the hole).

These beads have been excavated at Fountain of Youth Park in Florida dating to as early as 1580 but are most common at European-influenced sites in the Americas from the late seventeenth through the eighteenth centuries (Deagan 1987: 168, 172). They were also imported or became especially popular during the presidency of General Ignacio de Veintimilla (1876-1883) and are called *veintimilla*. Around this same time red and coral-colored porcelain beads *(porcelana)* were imported, probably from China. Both *veintimilla* and *porcelana* are now antiques and highly valued. They have been replaced by glass and even plastic beads for daily use. In a rather ironic twist, Mediterranean coral is now being imported again, perhaps by Otavaleños returning from Spain. It is sold in the market at prices that allow a woman to wrap her wrists for a total cost of U.S. $24.00.

Since no self-respecting Otavaleña wants to be seen without her wrists wrapped, she wears whatever she can afford. Rather than assume that she must abandon her *traje* if a certain kind of bead is unavailable, she has simply insisted that the beads be red or coral-colored, focusing on color rather than material, origin or method of fabrication.

The rosary *(rosario)* is another survival. Parsons (1945:29) described a common necklace as a "rosario of brass and red beads, coral and glass, with a large silver cross and ancient silver coins, and ... tupu." Today the use of *rosarios* is restricted mainly to weddings and to the male *prioste*

(sponsor of a fiesta) during such fiestas as Pendoneros on October 15th in communities along the south side of Lago San Pablo.

Children and young people, not just elders, proudly wear tradi-tional dress. When I asked nineteen-year-old Breenan Conteron, the sister of my goddaughter, to write about her traditional dress and why she wore it, part of her response was: "When I leave my village to visit other cities in my country of Ecuador I always wear this costume because in this way I value and respect my ancestors, who fought to maintain their culture, traditions and customs. And I am proud that through my inheritance and in my blood I am a bearer of this culture" (my translation from the Spanish). *Traje* is acceptable as a school uniform for *indígena* children (since it is a uniform of sorts) while white children must buy a special school uniform. Attendance at school is therefore compatible with ethnicity, and Otavaleños in tradi-tional dress are now found at every educational level including the univer-sity.

Increased prosperity among the Otavaleños through the produc-tion and marketing of textiles has strengthened ethnic identity and pride in traditional dress, which includes many pre-Hispanic elements and some survivals. At the same time the Otavaleños have adopted certain features of American-European culture that they deem useful, particularly technology. But instead of bulldozing their traditional lifeways and constructing an eight-lane expressway to the future, the Otavaleños are building a two-lane paved road that follows the contours of the land. As Salomon observes, "Otavalo contradicts the steamroller image of modernization, the assumption that traditional societies are critically vulnerable to the slightest touch of outside influence and wholly passive under its impact, devoid of a policy for coping beyond a futile initial resistance" (1973:464).

Saraguro

Saraguro is situated at 8,200 feet in the eastern cordillera of the Andes, one hundred miles south of Cuenca. I estimate the present Quichua-speaking population of the area at 15,000 to 25,000, most of whom live in small communities in the green, rain-swept mountains outside the town.

Ethnohistory

The Saragureños may be relative newcomers to Ecuador. Local lore says their ancestors were Peruvian Quechua speakers who were sent to Ecuador as Inca *mitmakuna* (administrators and colonists) after Tupac Yupanqui's conquest of the region around A.D. 1455. The *mitmakuna*

replaced the indigenous Palta who were removed to Bolivia, except for the residents of a few communities. There is no documentary historical evidence that the ancestors of the Saragureños were *mitmakuna,* however, so there is no way to confirm or deny their own accounts. It is prestigious in Ecuador to claim Inca ancestry, just as it is prestigious in the United States to claim ancestors who came over on the Mayflower. In both claims, final judgment on their validity must be reserved in the absence of definite proof.

Saraguro is the opposite of Otavalo in many respects. While Otavalo is visited by thousands of tourists annually, no more than ten or fifteen visit Saraguro and most never leave the town proper. Unlike the Otavaleños, the *indígenas* of Saraguro were never serfs on the haciendas or laborers in textile workshops. They have survived as farmers and cattle traders, supplying much of the beef for southern Ecuador. Because of a shortage of pasture in the Saraguro region the Saragureños practice transhumance, driving their cattle over the continental divide and down into the Oriente (jungle) around Yacuambi (the town is also known as 25 de Mayo). The cattle are fattened and driven back over the Andes to be sold at the Sunday Saraguro market.

The Saragureños value education and they are among the best educated *indígenas* in Ecuador with their own high school in Saraguro. As in Otavalo, *indígena* children are permitted to wear traditional dress as a school uniform. There are Saragureño students at the universities in Quito and Cuenca, and graduates of these universities have returned to Saraguro as grade and high school teachers and as physicians and nurses.

Contemporary Saraguro Female Dress

The costumes of both Otavalo and Saraguro combine elements of pre-Hispanic and Spanish colonial dress. But unlike Otavalo, Saraguro costume is still homemade. Almost every woman and girl spins sheep's wool with the hand-supported spindle *(puchikana sijsij)* and distaff *(waguna kaspi).* Unlike spinning in Bolivia and southern Peru, in Ecuador the spindle is always hand supported and never dropped. This kind of spinning was probably based on cotton technology (Meisch 1980a). When the spindle is held horizontally, an S-twist results. In Saraguro this is called *alliman* or *alliladu* (going right), and extremely fine yarn is spun in this fashion. When the spindle is held vertically, yarn with a Z-twist results, called *llukiman* (going left).

Generally, the fine S-twist yarn is used for garments woven on the backstrap loom *(awana, makana* or *kalluwa),* while the Z-twist yarn is used

for cloth woven on the floor loom *(telar)* (Meisch 1980a). The yarn is not plied for most textiles, except for about six warp yarns at each side selvedge of backstrap-woven pieces. The S-spun yarns are paired but not plied for the warp, while a single yarn is used for the weft, a characteristic which relates Saraguro textiles to the earliest known Ecuadorian textiles (Gardner 1979, Marcos 1979, Meisch n.d.) and to pre-Hispanic North Coast Peruvian textiles (Meisch op. cit., A. P. Rowe 1984, Vreeland 1986).

Females are the spinners and males are the weavers in this region, and a family makes most of its own clothing. For the most part, if a garment has a Quichua name and is of pre-Hispanic derivation it is woven on the backstrap loom, while if it has a Spanish name and is of post-conquest origin it is tailored from cloth *(bayeta)* woven on the treadle loom.

Saraguro women's costume has many pre-Hispanic elements but still contains more examples of European influence than does Otavalo women's costume. Certain garments are obviously pre-Hispanic in origin. The rectangular shoulder wrap *(lliglla),* wrap skirt *(anaku)* and belts *(chumbis)* have Quichua names and are woven on the backstrap loom. (Occasionally a shoulder wrap is made from *bayeta.)* The basic color of Saraguro dress is *yana,* dark blue or black (figures 3, 4).

Women never cut their hair but wear it pulled back and tied at the nape of the neck or in one long braid. Their gathered underskirt *(pollera)* is made from fabric woven on the treadle loom and was inspired by Spanish peasant costume. The hem is decorated with machine embroidery and sequins. The skirt has its own waistband *(reata)*, which is usually a machine-made tape from Cuenca. A belt called a *ñajcha chumbi* (comb belt) is wrapped over the *pollera.* (See Cason and Cahlander 1976: band 14; A. P. Rowe 1977: chapter 9 for details on the structure of this belt.) Next comes the *anaku.* It is a long rectangle woven on the backstrap loom, gathered into hundreds of tiny pleats and wrapped over the *pollera.* The pleats are sewn into a handwoven, plain weave waistband *(watu),* made from acrylic or handspun wool.

Yet another belt is wrapped over the *anaku.* This belt is called a *de la china* (of the female) and has supplementary-warp pick-up motifs. It is usually finished in a four-strand braid with several tassels *(sisas,* or flowers), which hang down the wearer's back. *De la china* belts have commercial cotton yarn for the ground and acrylic or handspun wool for the supplementary warps. Many Saragureños remember when the belts were made from handspun cotton that their grandparents obtained in raw form from Catamayo and Celica near the Peruvian frontier, and spun in Saraguro.

The most recent addition to the women's costume is an embroidered blouse *(camisa bordada)* made from commercial cotton or rayon. It is tailored on a treadle sewing machine and embroidered around the cuffs and neck. Various commercially-made blouses and sweaters are worn for daily use, a cardigan sweater sometimes replacing a *lliglla* around the house. Grandparents remember the garment that preceded the blouse. It was called a *tupullina* (to bring the *tupu* onto the body), and was woven on the backstrap loom. People differ on exactly how it was made (one web or two) and worn but agree that it was wrapped around the torso and pinned over the shoulders with *tupus* (shawl pins).

The *tupu* is still an essential part of female costume. Under Inca rule nobility wore pins of gold and silver, while common people wore pins of wood or bone. In Saraguro fine silver *tupus* are prized and are passed along from mother to daughter as heirlooms. Traditionally shawl pins have been mold made in Saraguro by white jewelers. One kind is made from Peruvian silver coins, last minted at the turn of the century, which are 900 parts silver, almost sterling. A silver shawl pin and chain *(cadena)* can cost up to U.S. $150. The second kind of shawl pin is more common. These are made from Ecuadorian coins minted in 1937 and 1946. Some are solid nickel, others are bathed in silver. These are considerably cheaper. About a century ago many Saragureños wore bone shawl pins, and occasionally an old woman from an outlying community will wear one to the Sunday market.

Earrings also are considered essential. Baby girls have their ears pierced and wear inexpensive earrings. But when girls get older they receive fine silver filigree earrings *(sarsillus)* that are of Spanish derivation. One kind is called *media luna* or half moons. The other is called *kurimolde*, a mixture of Quichua and Spanish meaning gold mold. No one can remember, however, when these were ever made of gold; they are always silver. Women wear two kinds of glass bead necklaces *(walkas)*, frequently both at once. One style consists of strands of beads. The other has joined zig-zag rows of beads, forming a collar which can be up to a foot wide. The colors of the beads and number of rows indicate the female's community.

Women and men wear identical headgear. The older style is a broad-brimmed, hand-felted *sombrero de lana* (wool hat). Local white families specialize in making these hats, and the dark spots on the brim, which result from the ironing and pressing, are considered an integral part of the design. These hats are being replaced for daily use by dark felt fedoras, or by white hats of *paja toquilla* ("Panama" hats), which are handmade in the Cuenca area.

Women and men used to wear handmade leather sandals, but now
the most common female footwear is plastic shoes bought at the market.

Contemporary Saraguro Male Dress

Like the men in Otavalo, Saragureño males never cut their hair
but wear it pulled back in a braid *(jimba)*. Their headgear is the same as the
women's, described above. Saragureños wear a garment called a *kushma*,
related to the Inca tunic. It is handwoven on the backstrap loom in two
different ways. Either two four-selvedge rectangles are woven, joined edge-
to-edge with a hole left for the head, folded in half along the weft and joined
at the sides with holes left for the arms, or the *kushma* is woven in one piece
with the neck slit woven in, then folded and sewn up the sides. The joins are
made in an embroidery stitch with colored yarns, which indicate community
affiliation. (This is also true for poncho joins.) Men frequently wear factory-
made shirts and sweaters in place of, or sometimes under, the *kushma*.

Kushmas are always worn belted. Formerly men used a belt
(mama chumbi), identical in structure to the women's *najcha chumbi*, but
wider. Today males wear a leather belt *(cinturon)*. One style is made in
Saraguro and comes with a small money purse and a sheath for the man's
machete attached.

The poncho is basically a wide *kushma* but not sewn up the sides.
It is woven on the backstrap loom in two sections that are later joined. The
poncho is a post-conquest garment that probably originated in Chile in the
early seventeenth century. Two kinds of ponchos are worn, a plain dark one
(figures 4, 5) or a poncho with several groupings of warp stripes (figure 3).
This two-colored poncho is called a *wanaku* (the same name as the wild
camelid, which is now extinct in Ecuador) and is said to be the older style.
The elders say that earlier *wanaku* ponchos were made of undyed, dark
sheep's wool with white stripes, but today these same garments are overdyed
with purple aniline, making them black with purple stripes. Other Sara-
gureños say the yarn is dyed before it is woven. It is possible both methods
are used; today ordinary dark ponchos are dyed before or after they are
woven, depending on the maker's preference.

Both *kushmas* and ponchos are woven of extremely fine hand-
spun yarn with paired warps, and much effort goes into them. Because the
ponchos suffer rough use during agricultural work, Otavaleño textile ven-
dors sell dark blue or black treadle loom-woven ponchos at the Saraguro
Sunday market. Families with many young boys frequently buy these

ponchos for them for daily wear. One Saragureño from the *barrio* (community) of Las Lagunas also weaves dark acrylic ponchos on his treadle loom to sell in the community.

Two other distinctive features of Saragureño male costume date from the colonial era. The Spanish forced *indígenas* to abandon the breechcloth and wear pants instead. The pants of that time were knee breeches, which is what Saragureño males wear today. The pants have a Spanish name, *pantalones cortos* (short pants) and are tailored from fabric woven on the treadle loom. Two kinds of fabric are made; plain weave, called *llano,* which means plain, and a balanced twill weave called *estameñado,* from *estameña,* meaning serge. Various details of the pants indicate the wearer's community. For example, men from Gañil and Matar wear pants with embroidery around the hem and up the sides, while other communities have a white, red, or purple vertical stripe, which is woven into the fabric. Pants from Jera and Oñacapac have a tricolored braid sewn along the hem. Sometimes commercially-made black or blue pants are cut off at the knees, but short pants in one form or another are considered to be an essential part of male costume.

The other male garment dating from colonial times is the *zamarro,* or cloth chaps (figure 5). The Saragureños don't associate the chaps with riding, but with status and prestige, probably because *indígenas* were forbidden to ride horseback in the colonial era. *Zamarro* are woven in one piece on the backstrap loom and then cut in half. It is unusual for a four-selvedge garment to be cut like this.

Footwear is called by its Quichua name, *ushuta.* Today this includes shoes and rubber boots bought at the Sunday market. Finally, as a carry-all men use cotton saddlebags *(alforjas),* which are woven on the backstrap loom throughout the region. Because the cultivation and use of coca leaves was eradicated in Ecuador in the colonial era, the coca bag has also disappeared and has been replaced by the saddlebag.

Children dress like miniature adults. Babies and toddlers wear a *pañuelo* (cowboy bandana) on their heads until they are old enough to wear hats. These bandanas are greatly in demand, and foreign visitors are always asked if they have any they would like to sell. Older children are allowed to wear traditional dress to school, as in Otavalo. The Ecuadorian government has also recognized the importance of long hair to *indígena* males, who are allowed to keep their braid when they serve in the armed forces.

Survivals

It is impossible to track costume change over the same time period as in Otavalo because of the absence of historical costume descriptions. The elders of the community told me what they remembered from their youth or what their grandparents told them, and I have been able to observe recent trends over the thirteen years since I first visited the town.

There is less uniformity in daily dress in Saraguro than in Otavalo, although in both regions the communities closer to the main market center (Otavalo or Saraguro) have been quicker to add commercially-made clothing to their traditional dress. There is also an age gradation in both regions, with the old more conservative than the young, as I noted earlier.

At the Saraguro market my *indígena* friends would point out people wearing survivals, explaining, "that is the old style." It quickly became apparent that people dressed differently for fiestas than they did for every day and that Saragureños had a definite sense of what formal or fiesta wear should be. I was frequently asked by Saragureños to take formal family portraits, which involved the parents rummaging around inside the house to find the appropriate costume.

One item which invariably appeared for formal portraits and fiestas was the handmade, wide-brimmed *sombrero de lana* (figure 3). It is now a survival. A few old people wear theirs daily, but most Saragureños wear dark felt fedoras or white *paja toquilla* hats daily. Every family, however, owns several old-style hats for fiestas and special occasions.

While most young boys and men own a *kushma,* it is becoming a survival. A few older men wear theirs daily, but most males reserve their *kushmas* for fiestas. The cloth chaps, which used to be worn for work in the fields are also becoming survivals and are worn mainly on special occasions. The striped *wanaku* poncho occupies a strange niche. Many Saragureños described it as an older style. It is worn daily by some males, and is not considered special fiesta wear, nor is it associated with any particular community. Solid blue ponchos predominate, but *wanaku* ponchos continue to be worn.

For as long as Saragureños can remember their costume has been dark colored. Today the clothes are dyed with indigo (when available) imported from El Salvador, or more commonly with aniline dyes. A century ago all clothing was made from undyed, dark sheep's wool and the Saragureños told me that they still believe "undyed ponchos are warmer." Some dark, undyed garments are still worn but this style is considered rustic. The Saragureños have many Quichua words to describe the different kinds of

undyed cloth. This system was inordinately confusing for me to learn because the name refers to the less prominent color or mottling in the cloth rather than to what I saw as the dominant color:

> *suku* - mottled light and dark yarn for both warp and weft *(suku* means light)
>
> *shanu* - white warp and black weft
>
> *uki* - dark brown warp and weft
>
> *zhiru* - one white and one dark yarn plied together
>
> *yana* - natural black warp and weft
>
> *pukailo* - from *puka hilo,* meaning brown yarn (Just as blue and black are classified as one color in Quichua—*yana;* red and brown are classified as one color—*puka.)*

A *kushma* or poncho can be made from any of the above kinds of cloth (called *pacha* if woven on the backstrap loom), except *zhiru.* Since aniline-dyed garments predominate today, the above kinds of cloth are increasingly rare.

For women, sterling silver earrings and shawl pins are heirlooms, passed along from mother to daughter and worn only on special occasions. Some Saragureños mentioned that *rosarios* were worn a century ago but could not give details, and the only one I encountered had red and blue painted wooded beads and a beautiful, handmade sterling silver crucifix.

In both Saraguro and Otavalo the women are more conservative than the men in regard to costume change. This is probably because the men have more contact with the outside world and are more likely to experience and react to the pressure to wear contemporary-style clothing. I have been with *indígena* men from Saraguro in Quito and Otavalo, where the local white people taunted them about their broad-brimmed hats and short pants. Ethnic pride in Saraguro (and in Otavalo) is so strong, however, that it is unlikely that traditional costume will be abandoned. It was in Saraguro that I heard a young *indígena* respond to an insult from a local white by saying, "We might be Indians, but we are sons of Atahualpa and we will win."

Traditional costume not only identifies *indígenas* to outsiders, but *indígenas* to one another. An Otavaleño traveling in Loja, or Caracas, Venezuela, or New York City, can recognize someone from home by his or her dress, and a Saragureño in the Oriente or at the university in Cuenca or Quito can recognize another Saragureño if he or she is wearing traditional dress. When thousands of *indígenas* gather for fiestas or markets, their costume enhances their sense of "we," mentioned by the young Saragureño above.

Conclusions

I have tried to address several concerns in this chapter. The first is that extensive contact with outsiders leads to the abandonment of traditonal dress, the loss of ethnic identity and a progressive homogenization of the world's peoples. We might all be in the same blender, but the ingredients are not mixing yet and may never do so. The Otavaleños, the Saragureños and other groups in Ecuador have rejected a one-way ticket to monoculture. They like who they are. The second concern is that the sale of textiles to outsiders is also detrimental to traditional dress. Again, the Otavaleños prove the contrary, although they are not selling laboriously handspun and backstrap-loom woven textiles (for the most part) but textiles that are mass produced on the treadle or electric loom.

Another concern is that education forces costume change. It need not. The Ecuadorian government's policy of allowing *indígena* children to wear their *traje* as a school uniform does not force them to choose between ethnicity and education. The government's policy of permitting young *indígena* males who serve in the armed forces to keep their braid is also important in establishing that ethnic group loyalty is compatible with a larger, national identity. The young *indígenas* on Ecuadorian university campuses, wearing complete traditional dress, also refute the notion that higher education inevitably means assimilation. In contrast, when I asked a young woman from Chincheros, Peru, who was attending the university in Cuzco in modern dress, why she didn't wear *traje* she said the university wouldn't admit her if she did. Unlike Ecuador, in Peru national policy has resulted in homogenizing the population, beginning with the requirement that all school children wear a commercially-made gray school uniform.[7]

Both Otavalo and Saraguro lay to rest the contention that costume change means costume extinction. It can. Costume change has always occurred, but at a slower rate in the Andes and in Mesoamerica than in Europe and North America, judging from archaeological evidence and the historical record compiled since the Spanish Conquest. Many contemporary writers (Dieterich, Erickson and Younger 1979, Ehlers 1987, Milrod 1980) have argued that costume change is lamentable, generally basing their judgment on our preference for the handmade and the old, and ignoring that what we now consider old and traditional was once probably new and non-traditional. A close look at historical documents often shows this to be the case. In the absence of written or visual records I urge researchers to attend fiestas to record the older costume traditions, since fiesta dress often contains survivals and thus provides information about costume change.

In Ecuador the essential definition of ethnicity is being made by the *indígenas* themselves through their decisions about what constitutes traditional dress for them and their determination to wear a distinctive costume in the face of prejudice. They base their decisions on concerns ranging from comfort, cost and convenience to a self-conscious, proud realization that a unique form of dress is a vital factor in their strength and coherence as communities. For the Otavaleños traditional dress has the additional force of being commercially advantageous because it allows people to recognize them as textile merchants.

We need to enlarge and redefine our concept of traditional dress, as the Otavaleños have done. For too long, we have focused on whether a garment was handspun and handwoven. (For a notable exception to this statement see Femenias, this volume.) While I admit to a preference for handmade textiles myself, this preference can blind us to trends. The Otavaleños' emphasis on form and color rather than on mode of manufacture has allowed them to retain traditional dress under the most trying circumstances.[8]

In Otavalo and Saraguro there are survivals in costume, items which may eventually disappear even for fiesta use. Yet something else, defined by the *indígenas* themselves as typical or traditional, will probably replace these items if present trends continue.

Endnotes

1. It is impossible to do sustained fieldwork without funding, and I would like to thank Fulbright Hays for my fellowship to do research on textiles in Ecuador in 1977-79. Thanks also to the Institute for Intercultural Studies for photography expenses and to the institutions I was affiliated with in Ecuador: C.I.D.A.P. and Banco Central del Ecuador, and their directors and staff, who went out of their way to be helpful. Thanks also to the people in Ecuador who welcomed me into their homes during my field research in visits between 1977 and 1989, who taught me to spin and weave, and who asked me to baptize their babies. Many of these friends, *compadres* and godchildren appear in the photos which accompany this paper. Finally, thanks to an anonymous reader and Ann P. Rowe for helpful comments on this paper, Earl and Shari Kessler, Jill and John Ortman of La Bodega Artesanías in Quito, and the late Dr. Lawrence K. Carpenter, who generously shared with me information on Quichua and his many contacts in Otavalo.

2. There are several kinds of survivals. A costume can be new but made in
the style of an earlier era and worn only for special events, or the
item itself can be antique. The best example of the latter was
documented by Arthur Tracht (n.d.) who described the extremely
old textiles (300 to 400 years) in the *q'epi* bundles of Coroma,
Potosí, Bolivia, which are taken out and worn only for the fiesta of
Todos Santos each year.

 I have previously described survivals in Cañar, Otavalo,
Cuenca, Chordeleg, Gualaceo and Saraguro, Ecuador (Meisch
1980b; 1980c; 1980-81; 1981-82; 1987), and in Tarabuco, Bolivia
(Meisch 1986). Adelson and Tracht (1983:87) illustrate survivals
in Bolívar, Bolivia, wedding costume, and the Franquemonts (pers.
com.) have described this phenomenon in Chincheros, Peru.
Medlin's work (1986 and this volume) on Calcha, Bolivia, illus-
trates a variation of the pattern of survivals I have described here,
and Miller's paper (this volume) on the *ikat* shawls of northern Peru
and southern Ecuador also concerns survivals.

 For Mesoamerica, W. F. Morris, Jr., (1984: 21) includes
a photograph from Chiapas, Mexico, with the caption "The Zin-
acantec bride wears not a Maya huipil, but an Aztec-style feathered
huipil," and A. P. Rowe (1981) describes survivals in the Guatema-
lan highlands. These are just a few examples; a careful reading of
the literature would reveal many more.

3. The closest in form to female Inca costume worn today is that of the
women of Tupe, Department of Lima, Peru. The Tupe costume
includes a full-body *anaku* pinned over the shoulders with *tupus,*
which is closer to Inca dress than the Otavalo blouse and half-
anaku. My assertion that Otavalo women's costume was the closest
to Inca dress was questioned by Ed Franquemont and Ned Dwyer,
but I would like to thank Lee Anne Wilson for sending me the Matos
(1984) article with photographs of Tupe. We all agreed that the
closest in form to Inca male costume worn today is that of Q'eros,
Department of Cuzco, Peru.

4. The *indígenas* of Isla Taquile, in Lake Titicaca, Peru, have preserved and
even enhanced their ethnic identity while controlling tourism to
their island (Healy and Zorn 1983). I have observed a similar
situation on Taquile's neighbor, Isla Amantaní. See also Lynn
Stephen's chapter on Teotitlán del Valle, Mexico (this volume).

5. The name *llamas watashka* (llamas tied) is a puzzle and I was unable to learn if it referred to a specific motif. The Otavaleño weaver who described these ponchos used the term to refer to *ikat* ponchos in general. Some *ikat* ponchos woven in Cacha Obraje, near Riobamba, Province of Chimborazo, have V-shaped motifs called llama *chaki* (llama foot) because the V resembles a llama's footprint.

6. My thanks to Rebecca Tolen, who sent me a contemporary photo postcard of what looks like a wedding in Quishinche, Province of Imbabura, Ecuador. The groom, who appears to be an Otavaleño, is wearing an *ikat* wedding poncho over his dark blue poncho. The *ikat* poncho has a ground of very small blue and white checks, with two stripes of an *ikat* floral-like design on each poncho half. The groom is also wearing a dark felt fedora, a commercial kerchief around his neck, mid-calf white pants, and a *rosario* around his neck. The bride may be an Otavaleña or a member of one of the other regional ethnic groups (some of whom are descendents of *mitmakuna* brought by the Incas). She is wearing a white fringed wedding shawl over a shiny, nylon-like blue shawl, a sky-blue *pollera* skirt and a dark fedora, but is carrying a headwrap *fachalina* over her arm. She is wearing a necklace of gilded glass beads and archaic-style earrings (shown in Collier and Buitrón 1949: 10) of gilded glass beads looped over her ears with string.

7. I am not arguing that any Ecuadorian government has had a pro-*indígena* policy. The situation seems more like one of benign neglect, or, perhaps in the case of military service, sheer desperation since *indígenas* so strongly resist cutting their hair. A comparison between the situation of *indígenas* in Ecuador and Peru is worthy of a dissertation, but it seems that the social climate is far more favorable to *indígenas* in Ecuador.

8. The ultimate trying circumstance is threat of death. In the Andes, the Spanish suppression of Inca-style dress following the collapse of Tupac Amaru's revolt and his execution in 1781 is well documented. More contemporary examples of costume change forced by violence include Peru, where indigenous people are under pressure from Sendero Luminoso and the Peruvian military; Guatemala, where there have been massacres by the military and killings by right-wing death squads; and El Salvador, where an uprising in 1932 led to the military's massacre of 30,000 *indígenas*

and peasants, who were identified as subversive on the basis of traditional dress and the use of indigenous languages.

Bibliography

Adelson, Laurie, and Arthur Tracht
 1989 Aymara Weavings: Ceremonial Textiles of Colonial and 19th Century Bolivia. Washington, D.C.: Smithsonian Institution Traveling Exhibition Service.

Caillavet, Chantal
 1982 Caciques de Otavalo en el siglo XVI: Don Alonso Maldonado y su esposa. Miscelanea Antropológica Ecuatoriana 2: 38-55. Quito: Museos del Banco Central del Ecuador.

Cason, Marjorie, and Adele Cahlander
 1976 The Art of Bolivian Highland Weaving. New York: Watson-Guptill.

Castañeda León, Luisa
 1981 Vestido tradicional del Perú. Lima: Museo Nacional de la Cultura Peruana.

Cieza de León, Pedro de
 1959 The Incas of Pedro de Ciezo de León [1553]. Harriet de Onis, trans., Victor Wolfgang von Hagen, ed. First edition. Norman: University of Oklahoma Press.

Clifford, James
 1988 The Predicament of Culture: Twentieth-Century Ethnography, Literature, and Art. Cambridge: Harvard University Press.

Collier, Jr., John, and Aníbal Buitrón
 1949 The Awakening Valley. Chicago: The University of Chicago Press.

Deagan, Kathleen
 1987 Artifacts of the Spanish Colonies of Florida and the Caribbean 1500-1800. Vol. 1: Ceramics, Glassware and Beads. Washington, D.C.: Smithsonian Institution Press.

Dieterich, Mary G., Jon T. Erickson, and Erin Younger
 1979 Guatemalan Costumes: The Heard Museum Collection. Phoenix: The Heard Museum.

Dubin, Lois Sherr
 1987 The History of Beads from 30,000 B.C. to the Present. New York: Harry N. Abrams.

Ehlers, Tracy Bachrach
 1987 A Guatemalan Town Ten Years Later. Cultural Survival Quarterly II(3): 25-30.

Gardner, Joan S.
 1979. Pre-Columbian Textiles from Ecuador: Conservation Procedures and Preliminary Study. Technology and Conservation 4 (1):24-30.

Guaman Poma de Ayala, Phelipe
 1980 El Primer corónica y buen gobierno. Jaime L. Urioste, trans., John Murra and Rolena Adorno, eds., México, D.F.: Siglo Veintiuno.

Hagino, Jane Parker, and Karen Stothert
 1983 Weaving a Cotton Saddlebag on the Santa Elena Peninsula of Ecuador. The Textile Museum Journal 22:19-32.

Hallo, Wilson
 1981 Imágenes del Ecuador del siglo XIX: Juan Agustin Guerrero. Quito: Ediciones del Sol.

Hassaurek, Friedrich
 1967 Four Years among the Ecuadorians [1867]. C. Harvey Gardiner, ed. Carbondale: Southern Illinois University Press.

Healy, Kevin, and Elayne Zorn
 1983 Lake Titicaca's Campesino-Controlled Tourism. Grass Roots Development: Journal of the Inter-American Foundation 6:2/7:1, pp. 3-10.

Marcos, Jorge G.
 1979 Woven Textiles in a Late Valdívia Context (Ecuador). *In* The Junius B. Bird Pre-Columbian Textiles Conference. Ann Pollard Rowe, Elizabeth P. Benson, and Anne-Louise Schaffer, eds. Pp. 19-26. Washington, D.C.: The Textile Museum and Dumbarton Oaks.

Marcos, Jorge G., and Presley Norton
 1981 Interpretación sobre la arqueología de la isla de la plata. Miscelanea Antropológica Ecuatoriana 1: 136-154. Quito: Museos del Banco Central del Ecuador.

Matos Avalos, Alejandro
 1984 Tupe, pueblo tradicional en la provincia de Yauyos. Boletín de Lima.36, año 6: 57-73.

Medlin, Mary Ann
 1986 Learning to Weave in Calcha, Bolivia. *In* The Junius B.
 Bird Conference on Andean Textiles. Ann Pollard Rowe,
 ed. Pp. 275-288. Washington, D.C.: The Textile Mu-
 seum.
Meisch, Lynn A.
 1980a Spinning in Ecuador. Spin-Off 4: 24-29.
 1980b The Cañari People: Their Costume and Weaving. El
 Palacio 86(3): 15-26.
 1980c The Weavers of Otavalo. Pacific Discovery 33(6): 21-29.
 1980-81 Costume and Weaving in Saraguro, Ecuador. The Textile
 Museum Journal 19-20: 55-64.
 1981 Paños: *Ikat* Shawls of the Cuenca Valley. Loveland,
 Colorado: Interweave Press Technical Paper.
 1981-82 Abel Rodas, the Last *Ikat* Poncho Weaver in Chordeleg.
 El Palacio 87(4): 27-32.
 1986 Weaving Styles in Tarabuco, Bolivia. *In* The Junius B.
 Bird Conference on Andean Textiles. Ann Pollard Rowe,
 ed. Pp. 243-274. Washington, D. C.: The Textile Mu-
 seum.
 1987 Otavalo: Weaving, Costume and the Market. Quito, Ecua-
 dor: Libri Mundi.
 n.d. Northern Peru and Southern Ecuador as a Textile Region:
 Weaving and Loom Styles and Pre-Inca Populations.
 Paper presented at the 21st Annual Meetings of the Insti-
 tute of Andean Studies, Berkeley, California, January
 1981.
Milrod, Linda J.
 1980 Introduction. *In* Woven Images: Bolivian Weaving from
 the 19th and 20th Centuries, by Roger Yorke. Halifax,
 Nova Scotia: Dalhousie Art Gallery, Dalhousie Univer-
 sity.
Morris, Jr., Walter F.
 1984 A Millennium of Weaving in Chiapas. San Cristóbal de las
 Casas, Chiapas, Mexico: Sna Jolobil Weavers Associa-
 tion.
Parsons, Elsie Clews
 1945 Peguche, Canton of Otavalo, Province of Imbabura, Ecua-

dor: A Study of Andean Indians. Chicago: University of Chicago Press.

Ponce de León, D. Sancho Paz
1964 Relación y descripción de los pueblos del partido de Otavalo [1582]. Otavalo, Ecuador:Instituto de Indio Americano.

Rowe, Ann Pollard
1977 Warp-Patterned Weaves of the Andes. Washington, D.C.: The Textile Museum.
1981 A Century of Change in Guatemalan Textiles. New York: The Center for Inter-American Relations.
1984 Costumes and Featherwork of the Lords of Chimor: Textiles from Peru's North Coast. Washington, D.C.: The Textile Museum.

Rowe, John Howland
1946 Inca Culture at the Time of the Spanish Conquest. Handbook of South American Indians. Vol. 2. Pp. 183-330. Bureau of American Ethnology, Bulletin 143.

Salomon, Frank
1973 Weavers of Otavalo. In Peoples and Cultures of Native South America. Daniel R. Gross, ed. Pp. 460-494. Garden City, N.Y.: Doubleday/The Natural History Press.

Tracht, Arthur
n.d. Q'epi: History, Function and Contents of a Sacred Textile Bundle from Potosí, Bolivia. Paper presented at the Junius B. Bird Conference on Andean Textiles, Washington, D.C., April 1984.

Tylor, Edward B.
1920 Primitive Cultures: Researches in the Development of Mythology, Philosophy, Religion, Language, Art and Custom. Two Volumes. New York: G.P. Putnam's Sons.

Vreeland, Jr., James M.
1986 Cotton Spinning and Processing on the Peruvian North Coast. In The Junius B. Bird Conference on Andean Textiles. Ann Pollard Rowe, ed. Pp. 363-383. Washington, D.C.: The Textile Museum.

Weismantel, Mary J.
1988 Food, Gender and Poverty in the Ecuadorian Andes. Philadelphia: University of Pennsylvania Press.

Whitten, Jr., Norman E.
 1975 Black Frontiersmen: Afro-American Culture in Ecuador
 and Colombia. Prospect Heights, IL: Waveland Press.

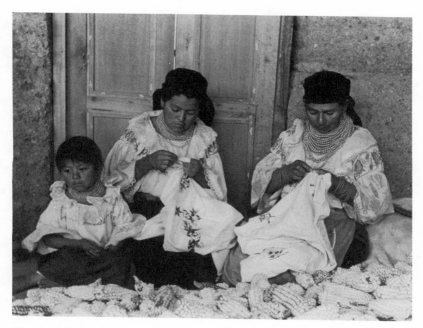

Figure 1. Rosa Elena de la Torre (right) and her daughter, Rosa Conteron, finish blouses while the youngest daughter, Gladys Rocio, watches. The women in this family machine-embroider and sew their own blouses. Iluman (Otavalo, Imbabura Province, Ecuador). Photo by Lynn Meisch 1984.

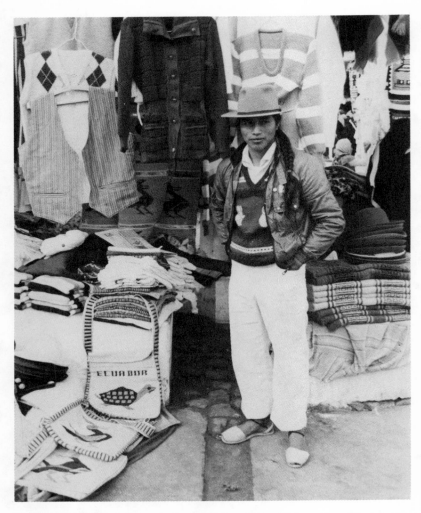

Figure 2. Daniel de la Torre in front of his and his wife's quarter-kiosk in the Otavalo, Ecuador, Saturday market. Like many young men, he is wearing a jacket instead of a poncho while he works but does use his poncho in cold weather and for special occasions. Photo by Lynn Meisch 1984.

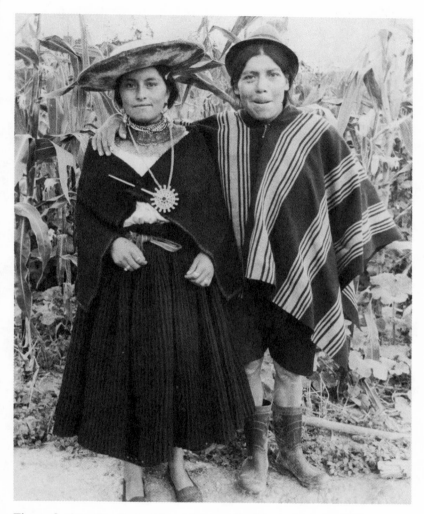

Figure 3. Angelita Cartuchi and her cousin, Manuel Cango, posing for a portrait. Angelita is wearing complete, formal Saraguro traditional dress, which she put on for the photo. (Compare her with the woman in everyday dress in figure 4.) Her cousin stopped working to get in the picture and is wearing a *wanaku* poncho. Gunudel (Saraguro, Loja Province, Ecuador). Photo by Lynn Meisch 1978.

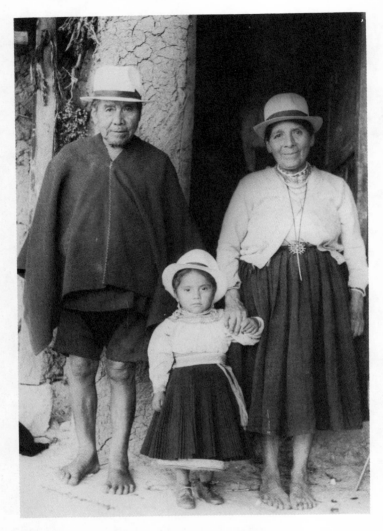

Figure 4. Raimundo Cango, his wife Maria Alegria Andrade, and their granddaughter. Taita Raimundo wears his *kushma* daily; the bottom can be seen hanging below his poncho. The family dressed the little girl for the portrait, then persuaded the grandparents to get in the photo, so they are wearing daily dress. Gunudel (Saraguro, Loja Province, Ecuador). Photo by Lynn Meisch 1986.

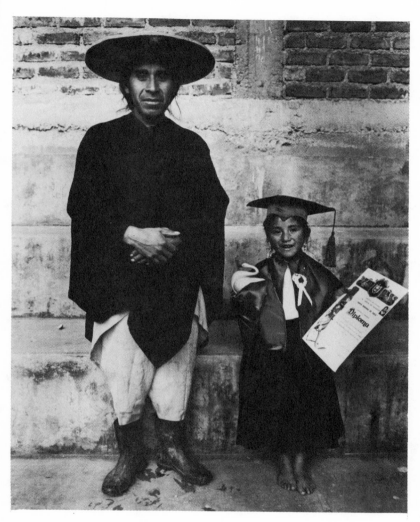

Figure 5. Manuel Andrade and his daughter, Juanita. Kindergarten gradu-ation at the school of Santa Mariana de Jesus in Saraguro, Ecuador. Manuel is dressed in formal wear including the old-style handmade felt hat and cloth chaps (*zamarro*) over his short pants. Photo by Lynn Meisch 1978.

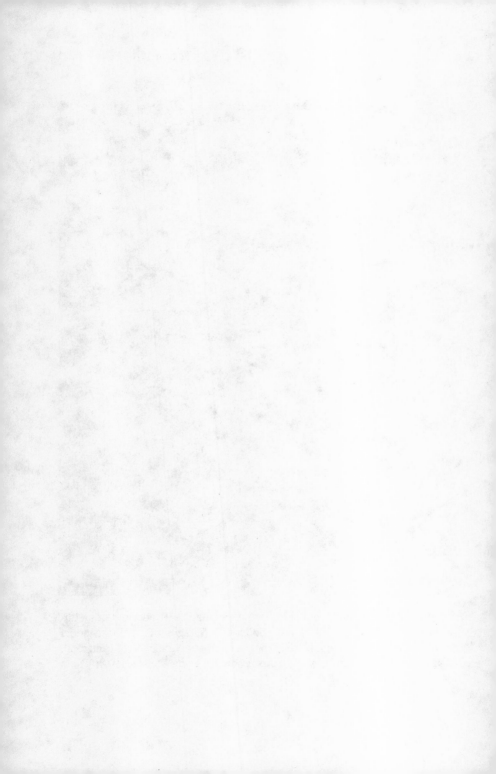

Chapter Eight

Regional Dress of the Colca Valley, Peru: A Dynamic Tradition

Blenda Femenias

Introduction

Every day of their lives, women of the Colca River Valley, Arequipa, Peru, wear elaborately embroidered clothing. The exquisite, unique Colca Valley costume is worn by about 10,000 people, yet it has not been studied. I first documented the contemporary use and production of embroidered clothing (*ropa bordada*) there in 1986.[1] Talking about clothing practices with valley residents, I asked them who wears *ropa bordada* and under what circumstances? How do they obtain it? Who makes it? What materials and techniques are used?

I found that men do not wear embroidered garments; the only traditional garment they retain is the poncho. Only women wear the costly embroidered clothing, and most wear it daily, not just for festivals. Semi-professional artisans in small workshops (*talleres*) use treadle sewing machines to embellish handwoven or commercially manufactured fabric.

Women's embroidered clothing has become more elaborate in recent years. The forms of women's dress, which resemble European folk dress of earlier centuries (see Snowden 1979), have probably remained stable; it is the materials and ornaments that have changed.

This chapter presents data about construction, decoration, and use of *ropa bordada*. Beyond that, however, it is a preliminary inquiry into the causes for changes in clothing, within a broader social context that includes social networks, gender and economics. Modernization, progress, and capitalist expansion have variously been proposed as causes for "traditional" societies to reject regional dress, as they need or desire to appear more modern. Adherence to tradition is seen as a hallmark of conservatism. The dominant trend in the Colca Valley does not bear out this generalization. There, dress has become not only more elaborate but also a more important component of local culture, in tandem with increased commercialization of the valley's economy. *Ropa bordada* eloquently expresses a uniquely regional cultural identity. It is the major craft in the lower valley (figure 1), where there is very little weaving and no other type of local artisanry such as ceramics. Workshops in three towns produce the clothing for the entire valley. They are located at the extreme ends of the lower valley, in Chivay and Cabanaconde, and near Chivay, in Coporaque (my field site). Embroidery of women's clothing on treadle sewing machines is an exclusively local art form that has changed over recent years with the advent of these machines. Even though "modern, commercial" garments[2] are available, not everyone has switched to wearing them. The availability of more modern technology and materials has encouraged residents to accentuate the distinctive appearance of their costume, and it has changed their social relationships, both internal and external.

In addition, although commercialization has changed traditional exchange networks between pastoral and agricultural areas, it has not dissolved them and has created new networks that may be as strong. Established social and political structures often favor men, so that women create their own alternative networks. Access to land and materials continues to be crucial for Colca Valley people, who continue to modify the vertical exchange system between ecological levels (Murra 1972, see also Mazuda et al., eds. 1985) as well as participating in the wider political economy.

Fifty years ago, the Colca Valley was touted as a "forgotten valley" when it was "rediscovered" by U.S. aviator-explorers (Shippee 1934). Recently, the valley has been the site of numerous field investigations in the physical and social sciences.[3] In 1985, the Peruvian government designated

the area a micro-region for appropriate or "low-tech" development. Research into all aspects of Colca society is therefore of practical as well as academic interest at this time.

The Setting

The Colca Valley is on the western slopes of the Andes, about 100 km. (or four-hour drive) northwest of Arequipa. This Quechua- and Spanish-speaking region comprises a variety of geographical areas; the towns are located at altitudes from 2,700-3,800 meters. A certain amount of geographic isolation and economic interdependence have led to cultural cohesion among valley residents, although there are rivalries between towns. Chivay (population 3,000) is the valley's largest town and commercial center. It is one point that divides the upper, pastoral zone from the lower, agricultural zone; the high slopes outside the towns are also used by herders. Residents are extremely aware of the vertical dimension; "above" and "below" are two of the most common words used to express location.

I focus here on the 30-mile-long lower zone, where *ropa bordada* is made and used. The ten towns where most of the 32,000 residents live were established as Spanish colonial *reducciones* in the late sixteenth century, and archaeological evidence of pre-Columbian occupation is widespread (Manrique 1985, Denevan ed. 1986, 1988). Historically this lower zone has been a very productive agricultural area, specializing in maize grown on terraces that line the valley (Treacy 1989). It is further divided by the Canyon of the Condors near Pinchollo.[4] Cabanaconde is the lowest town in this section.

The valley is the site of a mine and a large multinationally funded irrigation project. A new road was built to Arequipa, making daily bus service available. In addition to complete embroidered garments, items including commercial fabric, yarns, and trim are available in Chivay, the most "modern" town in the valley. In 1986, only Chivay had electricity, a permanent market building, and a load-bearing bridge over the Colca River. Later that same year, Cabanaconde was also wired for electric light.

The higher, pastoral zone "above" Chivay has its commercial center at Callalli. Raw wool, yarn, and woven goods such as bags, yardage, and blankets are produced there. Sale of alpaca and sheep wool products is economically vital to upper valley residents and has probably affected traditional exchange relations with the agricultural zone.[5]

At lower elevations and west of Chivay, the canyon divides zones of different embroidery style. There are distinctive aspects of *ropa bordada*

worn "below the canyon," that is, by women from Pinchollo, Tapay, and Cabanaconde. Although embroidery styles differ, the forms of embroidered dress are the same for the whole valley.

Form and Style in Colca Costume

Female costume (figure 2) consists of seven heavily embroidered garments: long-sleeved blouse (*camisa*), sleeveless vest (*corpiño*), long-sleeved jacket (*saco*) (figure 3), three ankle-length skirts (*polleras*), and hat. A *lliklla* (shawl/carrying cloth) sometimes has an embroidered border. Because the upper skirt is worn tucked up into the waistband, the entire waist-to-hem area appears covered with embroidery.

Except for the *lliklla*, an indigenous Andean garment, these garments have their origins in earlier Spanish forms, some dating to the sixteenth century. By about 1500, *camisa* (from Latin *camisia*) was either a man's shirt or woman's chemise; *corpiño* (or *corpecico*) meant a woman's small waistcoat or vest (Anderson 1980: 63, 182, 213). There is no published data stating when *saco* and *pollera* were introduced into Spanish dress nor of any of these items into Peru. However, I believe that twice during the colonial period major adjustments occurred in Andean costume form. The first was after 1532, the beginning of the Spanish conquest; the second after 1781, the execution of the rebellious *kuraka* Tupac Amaru II, when a Spanish proclamation officially extinguished all traces of Inka culture (Femenias 1984: 61). As usual, discourse and practice diverged. Andean people did not submit to the symbolic ethnicide of no longer wearing traditional dress and speaking Quechua as the proclamation mandated. However, the renewed Spanish emphasis on controlling indigenous culture did include "encouragement" for native people to wear Spanish clothing in the contemporary (late eighteenth century) style.

The skirt and shawl may be made of handwoven or commercially produced cloth; other garments are rarely handwoven. Cotton, wool, and synthetic fabrics are all commonly used, while velvet and chiffon are featured for festival dress. Embroidery is done with cotton floss; acrylic yarn is applied as well. *Bayeta*, handwoven plainweave wool fabric made by men on the two-harness treadle loom, was apparently standard for skirts and jackets in the past. Today, older women seem to favor *bayeta* skirts, while younger women use more commercial fabric. *Llikllas*, if handwoven, are made by women of wool or synthetic yarn on the staked native Andean loom, as are ponchos.

Local distinctions are apparent within the regional uniformity. The Canyon is the divider between two major styles. Above the Canyon, jacket and vest borders are about four inches wide (figure 3), and skirt borders about fifteen inches, reaching above the knee. A white straw hat with a wide, decorative band is typical; plain wool felt hats are sometimes worn, usually by older women. Below the Canyon, jacket and vest borders are about six inches, almost completely covering the front; only in this area is the Peruvian national escutcheon used as a motif. Skirt borders are very narrow, about four inches. The white straw hat is rarely used, and felt hats are heavily embroidered with designs found on the other garments.

All embroidery or appliqué is done on treadle sewing machines, not by hand. The earliest visual documentation I have located is one photograph in a 1934 *National Geographic* article (Shippee 1934), which shows Colca women whose skirts have several narrow rows of trim at the bottom, but details are not clearly visible.

Figural designs predominate, densely packed onto a band. Designs used, in order from most to least common, are flowers and flowering vines, birds, fish, and butterflies. One unidentifiable animal depicted may be a rabbit or a snail. Some floral-type designs may be stars or abstract geometric designs.

Although floral and animal motifs are far from unusual in Andean clothing, the curvilinear style and baroque impression of Colca embroidery are not typical of Andean woven textiles. I have yet to identify the stylistic source(s) of these motifs. The facades of colonial churches and casonas in the valley and in Arequipa are somewhat similar in style and motifs. However, ornate embroidery apparently began only with sewing machines; if so, it is puzzling that the carvings were not copied on costume for more than 300 years.

Many questions remain unanswered about Colca costume history. We know little about what the clothes were like before sewing machines and cannot easily find out. Few documents and photographs exist of Colca people. We can try to reclaim the lost history but discovering its contemporary significance is equally compelling.

Social Function

Cloth in the Andes symbolizes and reinforces a vital and ever-changing identity. Use and creation of distinctive dress represents the intersection of culture and individual. Andean cloth reinforces social relationships that pervade all other activities and, thus, demonstrates the dy-

namic aspects of the culture. Andean clothing is frequently but not necessarily handwoven.

The type of cloth and clothing used to express these functions is often called ethnic dress. However, I avoid using this term here for several reasons. First, detailed, cross-cultural studies of dress and ethnicity are seriously needed, because to date there is very little theoretical literature linking dress and ethnicity.[6] A notable exception is Mary Ann Medlin's (1983) study of traditional handwoven garments in Calcha, Bolivia, as vehicles for social interaction and symbols of ethnicity. Second, my own field study in Coporaque was brief, and I am hesitant to label Colca Valley people an ethnic group without sufficient justification. Because I know Colca costume is worn in a specific geographical area, I use the term "regional costume."

In the Colca, *ropa bordada* has important social functions. As the typical regional dress, it is worn daily and for special occasions including festivals.[7] The most obvious function is signing. The highly distinctive dress immediately signals to the informed observer that the woman who wears it is from the Colca Valley.[8] Clothing is also a sign of social position. It denotes special occasions, with garments that differ in quality, materials, and color from daily dress, but rarely in form or design. Women's dance clothing may even be worn by men.

Almost all adult women wear *ropa bordada*. Girls and teenagers often wear modern-style clothes, such as jogging suits, school uniforms, synthetic tops with skirts or pants, and shoes other than *ojotas* (tire-tread sandals). Small girls usually dress in western clothing until they receive their first *pollera* (skirt) at about age four, as a gift at festival time, which they then continue to wear. To an outsider, the full skirts seem cumbersome for doing agricultural work and especially for climbing the numerous stone walls (figure 4), but the top skirt is quite functional, looped up to one side to serve as a large pocket, which is handy for marketing, sowing seed, carrying lunch to the field, or women's numerous other jobs. Reasons that women give for not using traditional dress include discomfort from the weight of the skirts and the greater expense.

Colca Valley towns participate in numerous festivals. The summer festival cycle is from early December to the beginning of Lent (*Carnaval*). Coinciding with Catholic saint's days, Christmas, Epiphany, etc. about once a week one town sponsors Witite, a local festival, which lasts about three days and nights, followed by three or four days rest.[9] The Witite cycle is completed by mid-January; this is followed by a *tinkachiy* (blessing

ceremony) for cattle, held by each family the week before *Carnaval*, and then *Carnaval* (figure 1). Although probably historically distinct, Witite and *Carnaval* are now similar in format, characterized by dancing, band music, drinking, and a street market (*feria*). Witite has been incorporated into the Spanish vocabulary as a verb, referring to the dance as well as the festival. "Vamos a Wititear," say valley residents—"We are going to Witite." Religious events such as masses and baptisms also are held during these occasions. (Only two towns in the valley have resident priests who travel to the other towns as needed.)

Ideally, festival clothing is not just new daily clothing; more ornate garments are preferred (figure 2). I attended *Carnaval* in Coporaque and Cabanaconde and Witite in Achoma; the latter was reportedly the most elaborate in the valley that year. The Witite festival is sponsored by patrons, usually a young couple, whose *cargo* (responsibility) is to pay for the entire celebration one year. As such, one obvious function of the festival is to redistribute wealth. However, it also functions to display wealth. The Achoma Witite patrons were exceptionally well dressed, resplendent even among a crowd in which many women wore complete new outfits of luxurious, impressive *ropa bordada*, featuring velvet, chiffon, lace, and metallic braid. Such fabrics and trims are not used for daily dress, nor are the red, turquoise, or orange handwoven shawls with deep embroidered borders that were worn over the head in church or over the shoulders on the street.

Carnaval is the last opportunity to celebrate before Lent. In Coporaque, there was apparently no official patron. One of the organizers was Gladys, a successful merchant and a single woman in her mid-twenties, who does not wear *ropa bordada* daily. Her father, Sergio, has an embroidery workshop, which he uses more to display their wealth than to increase it, by providing Gladys with an incredibly elaborate festival wardrobe.[10] Gladys wore all new clothes during *Carnaval*. She had not just one set of luxurious *ropa bordada* but a complete new set of clothes each day for three days.

The future direction of Colca dress cannot be determined. Perhaps Gladys's pattern will become the rule rather than the exception, wearing modern clothes daily and regional dress for festivals. (See Medlin 1983 on Bolivia, Meisch [this volume] on Ecuador.) There is no clothing continuum with "traditional" dress at one end and commercial dress at the other. Partial use of both types is fairly common; even women who wear modern clothes always wear a traditional hat (white straw or dark wool felt, sometimes embroidered). Others wear a traditional jacket over a modern blouse and skirt or a cardigan sweater instead of jacket with a traditional outfit. Almost all

women use a *lliklla*. Traditional dress does not imply conservatism and isolation. Rather it seems to indicate awareness of various roles individuals must play in a changing world—roles that, for some, bring prosperity but for others barely guarantee survival.

Production: Organization, Techniques, and Materials

The production process consists of an organized workshop system, in which the designs are applied to garments using specific techniques on varied materials. All embroidery is done by men or women on treadle sewing machines. I observed no instances of hand-embroidered clothing being used or made and was consistently informed that there were none. (The agropastoral system by which the necessary wool or cotton is obtained is discussed briefly under "Distribution and Exchange" below but not the industrial system that produces commercial fabrics.)

In Coporaque, cloth production is distinct from clothing production. There, embroidery workshops (figure 5) do not prepare yarn or cloth; in fact, little cloth is produced. A few families have sheep, but wool is not the most common fiber used there for clothing, and I did not observe women spinning regularly.[11] Silvestre, a *bayeta* weaver, moved with his family from Callalli to Coporaque to rent farmland. He weaves *bayeta* in exchange for yarn, finished cloth, or money. Women who do spin their own yarn can bring it to Silvestre to weave. His fee is a percent of the yarn or cloth, which he can then sell, or barter cloth for more yarn to weave.

A woman with *bayeta* may take it to a workshop to be sewn and embroidered. Or, a woman without it can request it from the embroiderer. One workshop owner told me he does not use homespun, homewoven *bayeta* but purchases it. There is a wide range of custom-made to ready-to-wear garments available, depending on the customer's needs and the maker's schedule and inventory. A skirt uses the most material and labor and represents a substantial investment for buyer or maker.

An embroidery workshop is also a tailor shop. Garments are made following measurements; patterns are not used. Skirts are sold without a waistband; the fabric is gathered and handsewn onto a piece of trim by the woman who buys it.

There are at least fifteen workshops in the valley: five in Coporaque, five or more in Chivay, and five in Cabanaconde. In Coporaque, three are operated by young married couples; the other two by older, possibly single adults.[12] All make garments on commission or to sell ready made. No workshop owner relies exclusively on sale of *ropa bordada* to earn his or her

living; most people are farmers, and some have other property. Embroiderers disagreed about how they learned to embroider. I was told it had been hard or easy to learn; it took only a few weeks or more than a year. Understanding the workshop system makes it apparent that these views are not mutually exclusive.

Two or more individuals work in each workshop; at any given time, two or more similar garments are made simultaneously, using two or more sewing machines. Construction and embroidery are interrelated activities. No pattern is drawn onto the fabric to guide the embroiderer; the designs are done from memory. Usually, one individual "draws" the design outline in white thread onto the fabric. This highly skilled job requires familiarity with all the designs, some individual flair in executing them, and competence in handling the machine. Once this "drawing" or outlining is complete, a second person fills in the colors, one at a time. Another highly skilled job is applying yarn in a pattern, usually a large floral design, by securing down with thread (figure 6). Differing amounts of skill required for these tasks accounts for varied opinions about learning to embroider.

Wage laborers (*operarios*) are hired first as trainees, then as assistants as need arises; apparently in Chivay, workshops employ more *operarios*, and several who now work in Coporaque trained in Chivay. Any workshop may hire *operarios* to help out at a busy time, such as *Carnaval*. An *operario* may open his own workshop or assist his family. One *operario*, Valeriano, worked for two workshops in town, those owned by Rosalía and Sergio, who are older adults with adult children; some of Rosalía's daughters also work in her workshop. Rosalía had been a weaver as well as an embroiderer; she does little of either activity any more, owing to back problems but sells embroidered clothing throughout the valley.

In the family-run workshops, both husband and wife work at embroidery. Leonardo and Susana are a young couple who, in 1986, had a workshop for five years (figure 5). Susana's brother, an *operario* for a shop in Chivay, taught Leonardo and Susana to embroider. In Chivay larger workshops tend to hire more *operarios*. In Coporaque, two of three *operarios* that I spoke with were men. It may be that men are more likely to be hired than women as *operarios*, especially outside their families. In four of the five Coporaque workshops, women work on sewing machines alongside men on clothing construction and embroidery.

In terms of cloth production, however, gender division of labor is practiced. Only women make the handwoven shawls and ponchos on the native Andean staked loom, while men weave *bayeta*, handwoven wool plain

weave cloth. There are a few women weavers in Coporaque, but I could not document their procedures when I was there during January and February, which are peak agricultural months. Women were too busy, or it was too rainy for weaving to be practical. The one male weaver who specializes in *bayeta* was weaving sporadically then, but his output was affected by the limited availability of yarn.

Commercial materials are commonly used today for all garments. Only the skirt is at all likely to be made of handwoven cloth, but it may be from factory cloth. Even handwoven *llikllas* and ponchos may be of synthetic yarn. Cotton, wool, and synthetics are all commonly used, or, for festival dress, velvet or chiffon with lace and metallic braid trim. Wool is not as widely used now as it apparently was in the past. A woman who wants a *bayeta* skirt can bring her own cloth to the workshop or request it from the embroiderer.

The roots of the historical development of this production system can be traced to pre-Columbian systems and early Colonial changes, featuring dual production of two types of cloth by men and women. In the Inca Empire, and probably before, weaving was *the* quintessentially female activity (see Murra 1989). The Spanish established the *obraje* system; they introduced the treadle loom and conscripted men to weave in the sweatshops. Therefore, it is likely that purchased (or otherwise exchanged), non-home-woven cloth may have penetrated the local economy as long as four hundred years ago. There were *obrajes* in the Colca Valley (María Benavides, pers. com. 1984). Elaboration of that cloth into a distinctly local style of dress may well have been an individual domestic responsibility, but the possibility of a tailoring workshop system cannot be excluded.

Machine applied decoration is apparently a recent introduction. Various embroiderers told me that the sewing machine had been brought in between twenty to sixty years ago. Before that, people say, clothing was trimmed very simply by hand. It is unclear if this trim was woven, embroidered or possibly both. No one in the Valley wears this style today. Everyone I asked agreed that the forms of dress had not changed, only the style of decoration.

At first, sewing machines were apparently used to embroider simple designs on bands of fabric, which were then applied to the garments. The first sewing machines used were hand crank, not treadle, which meant only one hand could be used to guide the fabric under the needle. Later, the treadle machines left both hands free to guide the fabric, facilitating creation of more elaborate designs. Also, at some point, the technique changed:

artisans began to embroider the designs directly on to the fabric, after the garment was at least partly constructed, rather than sewing bands onto completed garments.

The question remains of how to explain this "chicken or egg" situation—which came first, commercial fabric (other than bayeta) and machine-embroidered trim or *bayeta* fabric with handmade trim? However, if we examine textile production processes cross-culturally and historically, numerous patterns of incorporation (or rejection) of "modern" fabrics and technologies are revealed (see analysis in Schneider 1987). For example, the elaborate *mola* tradition of the Cuna of San Blas, Panama, began with cotton factory cloth. In terms of embroidery specifically the case of Sicilian whitework trousseau textiles (Schneider 1980) may offer a suitable model for the Colca Valley. In the turn-of-the-century Sicily, a transition from patterned handwoven cloth to embroidered factory cloth was simultaneous with changes in agricultural production and access to other resources.

In addition, while Colca Valley people were probably never self-sufficient in clothing production, and participated in local and long-distance exchange, use of commercial cloth may mark their switch to new types of inter-regional exchange. These new exchange systems may be less advantageous to valley residents, especially to women, if they mean a loss of local control over materials, land, or other resources that women formerly controlled. Decreasing access to resources elsewhere has often decreased most women's status (see Etienne 1980 on the Baule, Ivory Coast), but some women are likely to have benefitted from marketing and production opportunities.

Distribution and Exchange

The Colca Valley has upper and lower areas that traditionally have been linked in a system of complementary, vertical exchange. Such an exchange system is both a social and an economic system, within which *ropa bordada* has a firm place. Complementarity and verticality have dominated a sector of Andean studies since John Murra's pioneering ethnohistorical studies (1972). As Salomon (1985) notes, vertical systems can be extremely dynamic, with small regional systems relating to larger systems; such is the case in the Colca Valley. As the conceptual aspects of the traditional system have combined with economic factors, often external to the system, numerous changes have recently resulted.

The region is an interdependent agro-pastoral complex, but it is not self-contained. The valley west, and at elevations lower than, the town of

Chivay is the agricultural zone, specializing in maize; at the lowest end, below the canyon, even such temperate products as fruit are grown. The area above Chivay, and at higher altitudes outside the lower towns, is used primarily for livestock, especially camelid pasture, with very little cultivable land. Vertical exchange between the zones is practiced, e.g., produce is exchanged for meat and wool. However, because residents of both zones demand other goods not produced in either zone, long-distance trade relationships also exist. Traders come from as far as Puno, Cuzco, or the Pacific Coast (Manrique 1985). In barter (*trueque*) exchanges of fleeces, spun wool, woven textiles, camelid meat, or even live animals have specific values in corn and other grains, legumes, etc. (Casaverde 1977, Gómez R. 1985). Other goods including commercial products can also be bartered.

Wool, yarn, and cloth were traditionally obtained from the upper zone or from the long-distance puna traders. However, these items are used less often now in the lower zone. Reduction in supply and in demand are both partially responsible for this decline. Traditional exchange alone cannot fill all needs; there is also a shortage of wool, and land use patterns have changed. Both upper and lower zones are externally oriented, possibly more so than toward each other. Money is now commonly used as an exchange medium, although barter continues. Traditional exchange now serves more as "a type of security, that reduces growing dependence on the market" (Manrique 1985: 222, my trans.), rather than as the principal means of obtaining products. Furthermore, dependence on the market impoverishes the peasantry, because the terms of exchange favor the city and the coastal industry. However, social differentiation may be increasing within Colca Valley peasants, as discussed below.

Alpaca products represent a significant part of Peruvian exports and many *alpaqueros* sell much of their wool. Colca pastoralists are organizing to become more competitive in selling alpaca wool (ADECALC 1985). The sheep wool market is not as important but still can be a source of income for herders.

In the lower Colca Valley, however, pasturing sheep is not a good investment: competition with high-altitude pastoralists would make it economically disadvantageous to sell wool and meat, but these items could satisfy domestic needs. Agriculture, on the other hand, includes the cash crops vital to the local economy. While corn, potatoes, and beans are local dietary staples, they are also sold to feed the burgeoning population of Arequipa. Barley is now an important crop, sold to the large Arequipa

brewery. Many people see cattle as a better investment and use some land to grow alfalfa for cattle fodder (on Colca Valley agriculture, see Denevan, ed. 1986, 1988; Treacy 1987, 1989; Guillet 1987).

Labor may be the decisive factor, in that processing wool and spinning yarn is probably the most labor-intensive part of textile production. Furthermore, intensification and commercialization of agriculture for cash crops requires increased labor input. This, coupled with increasing necessity to work for wages, has probably reduced the time available to women to spin yarn.[13]

A mine (Minas Madrigal) has also been economically important. It provided employment to people in the towns of Madrigal and Lari, although many miners have been brought from Puno and Cuzco. In 1986, after I left the valley, the mine closed operations because of low profits.

MACON, a large multinational project, has had a significant impact on the Colca Valley in recent years (Benavides 1983). This irrigation project was not intended to benefit valley residents directly. Its purpose was to divert water from the upper reaches of the Colca River, tunnel it down to the coast several hundred miles away, and use the water to irrigate the Pampa de Siguas. The project was headquartered in a modern "camp" just outside Achoma, which had electricity and indoor plumbing. The controversial MACON project has had direct economic impact on the valley. Many residents, especially in Achoma, were employed by the project; others sold land for the camp, the tunnel right-of-way, or to provide construction materials; and now, residents travel to the coast as owners of, or seasonal laborers on, the irrigated lands.

Wage labor opportunities are otherwise limited and many people of both sexes migrate to Arequipa or Lima to seek work. Military service often first removes men from their town for a long period.

Coporaqueños perceive Achoma and Madrigal as rich towns, while seeing themselves as financially deprived. Embroidery workshop owners believe that people in those towns have greater access to cash and are good potential customers. The workshop owners also travel to weekly markets above Chivay, where income from alpaca provides cash to purchase *ropa bordada*.

In the Colca Valley, traditional clothing is not associated with lack of resources, because modern clothing is usually cheaper.[14] The costs of embroidered clothing are significant. In 1986, a vest cost about $6, a skirt, about $30. The cost of a complete *ropa bordada* outfit was as high as $200,

by far exceeding that of western clothes. This cost represented between four and six months' wages, at an average minimum wage for laborers of about $1.00-1.50/day.

The economic function of *ropa bordada* is not to "save" money for the consumer. Given that a cash economy long since penetrated into the Colca, *ropa bordada* is one item that functions to recirculate money within the system. Several studies of Andean cloth have focused on objects produced for sale, especially to tourists (Salomon 1981, Healy and Zorn 1983, Zorn 1987). In these cases, objects are made for the express purpose of sale, to bring cash into the system, which is then used for other purposes. However, the Colca Valley situation is different in two major ways: first, sale is internal; second, materials are costly and must be purchased.

In the Colca Valley, dress functions to enforce relations between the upper and lower zones even though cash is involved, because it is produced in the lower zone and used in both zones. However, it also enforces extra-regional relations, because local goods must be sold for cash to buy garments that may have been traded in the past.

Operating an embroidery workshop and business can be a means of earning income while remaining in the village, and few such opportunities exist. Yet it is not a solution available to all. To open a workshop requires a commitment of time and resources for space, sewing machines, material, personnel, and local travel. It could require borrowing money or buying on credit. In Coporaque, both men and women run workshops, but I cannot say that both sexes benefit equally from the enterprises.

The differential effect of the increasingly elaborate *ropa bordada* on the women who wear it must be considered. Women's access to money and other resources (material and social), which they need to obtain clothing and other goods, is an important phenomenon. Today, women's clothing seems to have symbolic importance as expression of local identity and prosperity. Perhaps this symbolic aspect can be translated into economic and social advantage for women, or perhaps they will be marginalized by retaining an appearance that seems archaic compared to urban styles.

Furthermore, because of the high cost of *ropa bordada*, it seems indicative of the widening differentiation within the valley. By wearing *ropa bordada*, the Colca elite and *nouveau riche* assert not only their superior control of resources but also legitimate their participation in Colca society. How deeply this differentiation has permeated, and whether it can be characterized in class terms remains to be seen.

Conclusion

I have demonstrated that the Colca Valley has "modernized" somewhat in recent years with increased influx of technology and money and that women's costume has become more important, both as a symbol of cultural identity and as a significant expenditure.

I subtitled this chapter "a dynamic tradition," in light of the need to reconsider the meaning of tradition (Hobsbawm 1983) to encompass process in history. "Dynamic" implies change, not stasis, yet the changes occurring in the Colca are not all positive, such as the accentuated class and gender inequalities. *Ropa bordada* is important because it is the dress that Colca Valley people themselves have chosen as dress and because it indicates their participation in modern society, not their ignorance or rejection of it.

Endnotes

1. L. Castañeda discusses Colca Valley costume in *Traditional Dress of Peru* (1981: 151-53), terming it Chivay costume, but she never visited the area. In the line drawing, she represents a fiesta hat without labeling it as such. Much of the other information is by now outdated.

 The greatest supporter and contributor in my research was always John Treacy, my late husband. The 1986 research was funded by the School of Family Resources and Consumer Sciences and by a Cyril W. Nave Fund Research Travel Grant, both at the University of Wisconsin-Madison. Advice and encouragement were offered by the Ibero-American Studies Program staff of that year: Barbara Stallings, Director, Thomas Skidmore, former Director, Barbara Forrest, and Kate Hibbard as well as Frank Salomon and Donald Thompson, Department of Anthropology, University of Wisconsin, and Ann Stoler, now of the Department of Anthropology, University of Michigan.

 In Coporaque, the following artisans permitted me to interview them and to observe or photograph their work: Leonardo Mejía, Susana Bernal, Juan de Dios Choquehuanca, Onofre Málaga, Sergio Maqui, Valeriano García, Rosalía Valverde, Gerardo de Vilcasán and Felicitas Bernal, and Silvestre Mamani; and in Chivay, Guillermina Martínez. Background information was supplied by my compadres, Epifanio Condorvilca and Candelaria Bernal, and by Eric and Mary Ellen Kindberg, Antonia Kayser, and María

Benavides, and numerous other generous residents of the Colca
Valley.

I returned to the Colca Valley in 1989 for pre-dissertation
research. However, the research presented in this paper is based on
the 1986 research, unless otherwise noted.

2. No single, inclusive, satisfactory term has yet been proposed for clothing
mass-produced in imitation of contemporary American and Euro-
pean fashionable dress. I have settled on "western," "modern style,"
and "commercial" as acceptable terms for this type of clothing,
although I feel they are somewhat misleading.

3. The Colca Valley Project, directed by William M. Denevan, Department
of Geography, University of Wisconsin-Madison, brought a team
of United States and Peruvian geographers, archaeologists, and
pedologists to the valley in 1984 (Denevan ed. 1986, 1988).
Peruvian anthropologists working with DESCO projects are cen-
tered in Chivay (e.g., Manrique 1985).

4. The canyon is also significant because of its recent emergence as a tourist
attraction. This profound gorge, publicized as the world's deepest,
renders the river unnavigable, but is the natural habitat of the
Andean condor. Tourists take day trips from Arequipa to see the
condors and some "local color."

5. Since my concern is with *ropa bordada*, not with woven textiles, I will
discuss the upper zone only in relation to the lower zone. My
dissertation research will encompass the upper zone and the impact
of the alpaca trade.

6. One goal of my dissertation research, scheduled for 1991, is to inquire into
how Colca residents characterize themselves in ethnic terms and
specifically into the role of clothing in creating ethnic identity.

7. Not all special occasion clothing is for festivals. Mourning clothing is also
distinctive, at least in color. Two funerals were held in Coporaque
while I was there in 1986, and in both cases many women appeared
in black shawls, with blue or green stripes and sometimes black
skirts. Some older women wear black daily, but it is not a common
color. Men also appeared at funerals in mostly black ponchos,
whereas the daily poncho is brown or gray, sometimes with pink
stripes.

8. The signing function and its application to archaeology as well as cultural
anthropology has been discussed by Wobst (1977) based on Eastern
European hat styles.

9. On Witite, see Bernal Malaga's (1983) unpublished thesis on Colca Valley festivals.
10. When I returned in July 1989, Sergio had died and Gladys had a small baby; she was not an active participant in the festival celebrating Santiago (Coporaque's patron saint).
11. This may be partly attributable to the season in which I did fieldwork. I was there in summer, when women are busiest with agricultural tasks and sheep are not sheared.
12. In late 1986 one couple, Leonardo and Susana, moved to Chivay.
13. On substitution of machine-spun and/or purchased yarn for hand and/or homespun, see Zorn 1987, n.d.
14. Medlin (1983: 199) also found this to be true in Calcha, Bolivia.

Bibliography

ADECALC
 1985 Alpaqueros de Caylloma: Problemas y alternativas. (Asociación [formerly Comisión] Organizadora de Criadores de Alpaca de la Provincia de Caylloma. Lima: DESCO.

Anderson, Ruth
 1980 Hispanic Costume 1480-1530. New York: Hispanic Society of America.

Benavides, María A.
 1983 Two Traditional Peasant Communities under the Stress of Market Penetration: Yanque and Madrigal in the Colca Valley, Peru. Master of Arts thesis, University of Texas, Austin.

Bernal Málaga, Alfredo
 1983 Danzas de las etnías collaguas y colonias: Un estudio en la cuenca del Colca, Caylloma. Unpublished honors thesis, Universidad Nacional de San Agustín, Arequipa.

Casaverde Rojas, Juvenal
 1977 El trueque en la economia pastoral. *In* Pastores de puna: uywamichij punarunakuna. J. Flores-Ochoa, ed. Pp. 171-92. Lima: Instituto de Estudios Peruanos.

Castañeda Leon, Luisa
 1981 Traditional Dress of Peru/Vestido tradicional del Perú. Lima: Museo de la Cultura Peruana.

Denevan, William M., ed.
 1986 The Cultural Ecology, Archaeology, and History of Terracing and Terrace Abandonment in the Colca Valley of Southern Peru. Technical Report to the National Science Foundation and the National Geographic Society. Madison: Department of Geography, University of Wisconsin-Madison.
 1988 The Cultural Ecology, Archaeology, and History of Terracing and Terrace Abandonment in the Colca Valley of Southern Peru, Vol. 2. Technical Report to National Science Foundation and the National Geographic Society. Madison: Department of Geography, University of Wisconsin-Madison.

Etienne, Mona
 1980 Women and Men, Cloth and Colonization: The Transformation of Production-Distribution Relations among the Baule (Ivory Coast). *In* Women and Colonization: Anthropological Perspectives, Mona Etienne and Eleanor Leacock, eds. Pp. 214-238. New York: Praeger.

Femenias, Blenda
 1984 Peruvian Costume and European Perceptions in the Eighteenth Century. Dress, the Annual Journal of the Costume Society of America. 10: 252-263.
 1987 Andean Aesthetics: Textiles of Peru and Bolivia. Blenda Femenias, ed. Exhibition catalogue, Elvehjem Museum of Art and Helen Allen Textile Collection. Madison: University of Wisconsin-Madison.

Gómez Rodríguez, Juan de la Cruz
 1985 Tecnología del pastoreo en las comunidades del cañon del Colca. Arequipa: Central del Crédito Cooperativo.

Guillet, David
 1987 Agricultural Intensification and Deintensification in Lari, Colca Valley, Southern Peru. Research in Economic Anthropology 8.

Harris, Olivia
 1978 Complementarity and Conflict: An Andean View of Women and Men. *In* Sex and Age as Principles of Social Differentiation. Jean S. LaFontaine, ed. Pp. 21-40. New York: Academic Press.

1982 Labor and Produce in an Ethnic Economy, Northern Potosí, Bolivia. *In* Ecology and Exchange in the Andes, David Lehmann, ed. Pp. 70-96. Cambridge: Cambridge University Press.

Healy, Kevin, and Elayne Zorn
1983 Taquile's Campesino Controlled Tourism. Grassroots Development, Journal of the Inter-American Foundation 6:2/7:1: 3-10.

Hobsbawm, Eric
1983 Introduction: Inventing Traditions. *In* The Invention of Tradition, Eric Hobsbawm and Terence Ranger, eds. Pp. 1-14. Cambridge: Cambridge University Press.

Manrique, Nelson
1985 Colonialismo y pobreza campesina: Caylloma y el valle del Colca, siglos XVI-XX. Lima: DESCO.

Mazuda, Shozo, Izumi Shimada, and Craig Morris, eds.
1985 Andean Ecology and Civilization. Wenner-Gren Foundation for Anthropological Research Symposium No. 91. New York: University of Tokyo Press.

Medlin, Mary Ann
1983 Awayqa Sumaj Calchapi: Weaving, Social Organization and Identity in Calcha, Bolivia. Ph.D. dissertation, University of North Carolina.

Murra, John
1972 El "Control Vertical" de un máximo de pisos ecológicos en la economía de las sociedades andinas. *In* Visita de la provincia de Leon de Huánuco en 1562, Vol. 2. John Murra, ed. Pp. 427-68. Huánuco, Peru: Universidad Nacional Hermillo Valdizán, Facultad de Letras y Educación.

1989 [1962] Cloth and its Function in the Inka State. *In* Cloth and Human Experience, Jane Schneider and Annette Weiner, eds. Pp. 275-302. Washington, D.C. Smithsonian Institution Press.

Salomon, Frank
1981 Weavers of Otavalo. Revised ed. *In* Culture and Ethnicity in Modern Ecuador, Norman Whitten, ed. Pp. 420-49. Urbana: University of Illinois Press.

1985 Dynamic Potential of the Complementarity Concept. *In* Andean Ecology and Civilization. Shozo Mazuda, et al., eds. Pp. 511-531. Wenner Gren Foundation for Anthropological Research, Symposium Papers, No. 91.

Schneider, Jane
1980 Trousseau as Treasure: Some Contradictions of Late Nineteenth-Century Change in Sicily. *In* Beyond the Myths of Culture, E.B. Ross, ed. Pp. 323-359. New York: Academic Press.

1987 The Anthropology of Cloth. Annual Review of Anthropology 16: 409-448.

Shippee, Robert
1934 A Forgotten Valley of Peru. Photographs by George Johnson. National Geographic 65(1): 110-132.

Snowden, James
1979 The Folk Dress of Europe. New York: Mayflower Books.

Treacy, John M
1987 Building and Rebuilding Agricultural Terraces in the Colca Valley of Peru. *In* Yearbook, Conference of Latin Americanist Geographers 13, Martha A. Works, ed. Pp. 51-57. Baton Rouge: Department of Geography and Anthropology, Louisiana State University.

1989 The Fields of Coporaque: Agricultural Terracing and Water Management in the Colca Valley, Arequipa Peru. Ph.D. dissertation, Department of Geography, University of Wisconsin-Madison.

Wobst, H. Martin
1977 Stylistic Behavior and Information Exchange. *In* For the Director: Research Essays in Honor of James B. Griffin. C. Cleland, ed. Pp. 317-342. Madison: University of Michigan Anthropological Papers 61.

Zorn, Elayne
n.d. Society Weaving Weavers: Changes in Production and Use of Textiles in Taquile, Peru. *In* Runakunap Kawsayninkupaq Rurasqankunaqa: La tecnología en el mundo andino, tomo II. Heather Lechtman and Ana María Soldi, eds. (In Press, Universidad Nacional Autónoma de México).

1987 Encircling Meaning: Economics and Aesthetics in Taquile, Peru. *In* Femenias ed. Pp. 67-79.

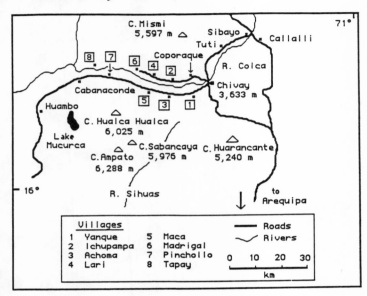

Figure 1. Map of the Colca Valley adapted by Blenda Femenias from John Treacy (1989).

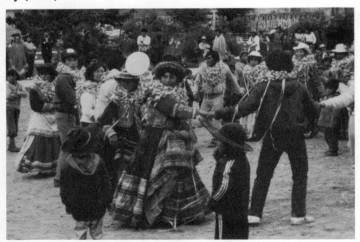

Figure 2. During the *Carnaval* dance in Cabanaconde, February 1986, women wore more elaborate embroidered clothing than for daily wear. Photo by Blenda Femenias 1986.

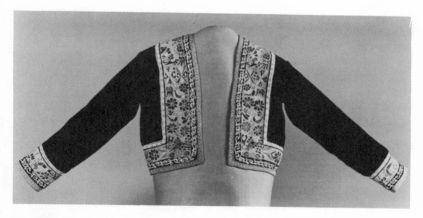

Figure 3. Woman's jacket (*saco*) from Chivay, Caylloma, Arequipa, Peru. Woven in twill weave of burgundy wool warp and weft; machine embroidered and appliquéd with multicolor cotton flosses and light blue, white, and silver cotton, acetate, rayon, and nylon fabrics; machine knit blue-green nylon trim. Helen Allen Textile Collection, University of Wisconsin-Madison 1984.11.1.

Figure 4. Candelaria Bernal climbing over a stone wall, Coporaque, Peru. She wears the embroidered clothing and white straw hat typical of the Colca Valley. The bundle she carries is a *lliklla* wrapped around supplies for a *tinkachiy* ceremony. (She carries an orphaned lamb so she can feed it.) The woman walking away uses a commercial *lliklla*. Photo by Blenda Femenias 1980.

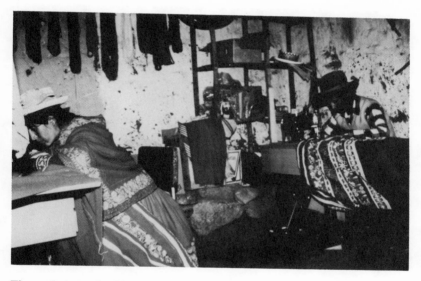

Figure 5. An embroidery workshop in Coporaque, Peru. Susana Bernal and Leonardo Mejía are embroidering skirts on treadle sewing machines. Skeins of yarn hang on the wall between them. Photo by Blenda Femenias 1980.

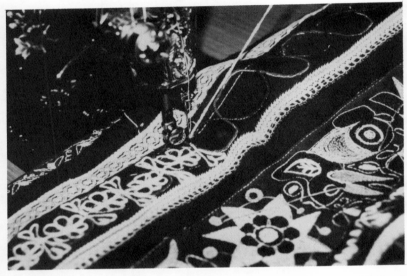

Figure 6. Leonardo Mejía applies acrylic yarn to a skirt in a small floral pattern. The cotton thread is threaded through the needle, while the yarn is held in tension around his neck. Photo by Blenda Femenias 1980.

Chapter Nine

Nature versus Culture:
The Image of the Uncivilized
Wild-Man in Textiles from the
Department of Cuzco, Peru

Lee Anne Wilson

"Le vêtement est l'instrument de la dignité de l'homme et le symbole de sa fonction humaine."

André Leroi Gourhan

Importance of Cloth and Clothing

Throughout history, clothing has had social, political, economic, and religious significance, signified group membership, occupation, point of origin, age, sex, and status, and celebrated such rites of passage as puberty, marriage, and death.[1] This paper focuses on concepts of group membership and definitions of the "other" as they are revealed in textiles produced near Cuzco, Peru, during the past one hundred to one hundred and fifty years. Drawing on published sources from the early chroniclers of the sixteenth and seventeenth centuries to contemporary ethnographies of the twentieth, this

chapter will demonstrate that a contemporary textile motif, the *ch'uncho* or wild man, dates back to Inca concepts of insider versus outsider, is closely related to pre-contact, culture-hero mythology, and ultimately reflects the insistent survival of a pre-Conquest world view.

Textiles have been important signifiers of membership and identity in the central Andes of Ecuador, Peru, and Bolivia for almost 5000 years. Today they still define both individual and group identity. For example, wearing specific textiles defines an individual's position by inclusion, while the lack of these same textiles defines the position of the "other" as one who is excluded. This is especially apparent among Quechua-speakers where one of the less complimentary terms for Europeans is *taksa k'ala* meaning "little naked ones" or individuals who have little influence within the traditional community (Arguedas 1957:188). Another translation for *k'ala* is "peeled" (Isbell 1978:81), suggesting that these individuals have "peeled off" traditional clothing, renouncing their membership in the process. In a similar vein, highlanders consider the jungle residents to the east culturally inferior because they do not wear clothes (Webster 1972:16).

The Textiles

This chapter discusses the image of a stylized human figure found on textiles produced and worn in the highlands around Cuzco (figures 2, 3).[2] The motif appears to be based on an X or hour-glass form with hair or headdress elements streaming up from the head and legs extending down from the body. A horizontal bar frequently emphasizes the lower portion of the body (figure 3), and additional appendages are occasionally attached to the shoulders. Although the majority of these images are identifiable representations of the human figure, more stylized variations exist. In addition, some images include elaborate headdress elements, small birds near the figure's shoulders, and zigzag or other geometric designs.

While naturalistic or realistic images are found on Andean textiles from the earliest appearance of fabrics to the present day,[3] the empire-building Incas who ultimately succumbed to Spanish domination rarely used naturalistic designs in their weavings.[4] In this sense, the figural motifs found on the textiles just discussed do not appear to be the direct descendants of Inca imagery and could have arisen out of Spanish-introduced concepts of visual narrative and naturalistic representation.[5] However, since realistic depictions of animals, plants, and humans do occur in other pre-Hispanic textiles, the use of figural images in historic textiles of the nineteenth and twentieth centuries does not necessarily imply only Spanish intervention. Until more

is known about the history of textile production during the seventeenth and eighteenth centuries, especially in the region around Cuzco, the precise antecedents of these motifs will remain unknown.

The figural motif being discussed occurs in long narrow bands on a variety of textiles including the man's poncho, woman's *lliclla* or shawl (figure 2), and coca bags or *ch'uspas*. In some styles these design bands (called *pallay*) are composed of only the hour-glass-shaped figure already described (figures 2 and 3),[6] while in other areas these figures alternate with other designs including plants, animals, and birds.[7] Within each band each individual motif is separated from the ones above and below it by a color change such that each motif appears to be in a separate rectangular box (figure 3). The bands in which the images are woven are also arranged in specific patterns, usually in a series of vertical stripes that are separated from each other by an area of solid-color plain-weave (figure 2). The individual units, usually square or rectangular in shape, are reminiscent of similar discrete design units (called *tocapu*) on Inca textiles (see the tunic in figure 4 for an example) that may have encoded specific information regarding the status of the wearer of the tunic.[8] These design units as well as similar ones found on both colonial textiles and wooden drinking vessels (*keros*) may be the antecedents of today's design units known as *pallay*. Information on both the *tocapu*-like designs of the *keros* as well as modern *pallay* motifs suggests that they were and still are important images that held specific meanings. For example, Cummins (1988) points out that within the three registers of designs found on the wooden drinking vessels, the middle section was composed of *tocapu*-like designs that would have been covered by the hand that held the vessel suggesting that the *tocapu* design bands were encoded with specific information that was not intended to be seen by the public.[9] Recent ethnographic studies suggest that textiles generally and *pallay* specifically probably reflect important concepts that are communicated visually.[10]

In addition, other studies indicate that a specific relationship exists between the figurative *pallay* bands and the areas of plain weave between them called *pampas*.[11] Using data collected from the Aymara community of Isluga in the Chilean highlands, Veronica Cereceda (1978:1030) suggests that the broad areas of solid color called *pampas* are diametrically opposed to narrower bands of color referred to as *chhurus*, the *pampas* standing for open, natural spaces, while the *chhurus* reflect closed, culturally-modified spaces. A similar type of opposition also may exist for textiles from Q'ero where solid-color bands, also called *pampas*, usually separate the stripes of

decorative *pallay* from each other (figure 2) (Cohen 1957:47).[12] While
conclusive answers await more specific evidence from field work, and the
textiles of the *Quechua*-speaking area around Cuzco cannot be directly
correlated to those of the Aymara-speaking community of Isluga, the
enclosed space of the *pallay* designs and their borders may reflect a general
attitude about man's culturally modified and subsequently enclosed spaces
in contrast to the open space of the plain-weave *pampa* and its relation to the
untamed and unbounded natural world.[13]

The *Ch'uncho* Figure: Historic Documentation
The basic hour-glass-shaped figure (figure 3) discussed thus far
generally is identified as a *ch'uncho* [14] or uncivilized inhabitant from the
jungle to the east of the Andes, an image that has existed since Inca times
(Taussig 1987: 225-6). Most sixteenth- and seventeenth-century chronicles
contain verbal descriptions of the *ch'uncho*, referring to them as living in the
montaña or jungle to the north and east of Cuzco in the quadrant known as
Anti Suyo. Acosta ([1590] 1940:305) referred to them as barbarians and
savages without laws, king, or any form of judgement and compared them to
the inhabitants of Brazil and Florida as well as to the Chichimecs of Mexico,
as did Cobo ([1653] 1979:45). Diego de Molina (in Pease 1982:210) referred
to them as warlike people from the hills, who, although they did not pay
tribute, did provide the Inca with coca, feathers, and other objects for
sacrifices. The native chronicler, Guaman Poma ([1615] 1980) not only
provided verbal descriptions of the *ch'uncho* but also visual depictions in the
form of pen-and-ink drawings. His verbal descriptions, like those of the
Spanish writers, referred to the *ch'unchos* as naked, bellicose, and heathen
inhabitants of *Anti Suyo*, the jungle to the northeast of Cuzco. He also
mentioned their cannibalistic tendencies as well as their white skin color like
that of the Spaniards (Guaman Poma 1980: 133, 147, 155, 298, 845, 888,
913).
While Guaman Poma's verbal descriptions varied little from those
of the Spanish chroniclers, his drawings have provided us with a great deal
more information. While he wrote that each region, including that of the
ch'unchos[15] had its own distinctive dress (Guaman Poma 1980:845), his
illustrations actually distinguished between the inhabitants of the various
regions, especially those of the four *suyos* or quadrants into which the Inca
divided the world. For example, Guaman Poma consistently depicted the
leader of each of the four divisions of the Inca empire or *suyos* as well as the
two divisions of Cuzco (*hanan* and *hurin*) with a distinctive identifying

headdress (Adorno 1979:80). For the inhabitants of *Anti Suyo* , the distin-
guishing headgear is a crown of upright feathers (figure 5).[16] Other Guaman
Poma illustrations include an individual completely clothed in feathers, as
well as men and women wearing loin cloths and associated with jaguars,
monkeys, and parrots, the latter image most closely resembling the verbal
descriptions of *ch'unchos*.

Later possible depictions of the *ch'uncho* include an eighteenth-
century carpet located in the church of Santa Clara in Cuzco. In this textile,
three pairs of human figures flank an elaborate thistle. The upper and lower
two pairs have short crowns or headdresses, plain striped tunics, and are
associated with a bird and a monkey as well as with llamas that carry the
words "*mani*" and "*romo*," or peanuts and yucca, on their backs suggesting
the jungle habitat associated with the verbal descriptions of the *ch'uncho*.
The two central figures wear tunics with diamond-shaped designs, have
elaborate flaring headdresses, possibly made of feathers, and carry staffs
(Mesa & Gisbert 1972:220 & fig. 283). The flaring feather headdresses
suggest these images also represent *ch'unchos* since similar headdresses are
found on depictions of *ch'unchos* on wooden drinking vessels and in
Guaman Poma's figures.

Despite the fact that sixteenth- and seventeenth-century written
descriptions rarely included a feather crown as one of the *ch'unchos'*
distinguishing trademarks, the feathered crown was frequently the favored
visual hallmark for the *ch'uncho*. Not only did Guaman Poma use it to
indicate the realm of *Anti Suyo* and the *ch'unchos*, but feathered crowns also
appeared in representations of *antis* or *ch'unchos* on the wooden drinking
vessels known as *keros*.[17]

A possible reason for the use of the feather headdress as the
distinguishing mark of the *ch'uncho* may come from early comparisons
between the *ch'unchos* and the Indians of Brazil (Acosta [1590] 1940:305).
As early as the first quarter of the sixteenth century, European artists were
depicting virtually all the inhabitants of the New World accompanied by
parrots and monkeys and wearing a feathered crown that was based on the
upright feathered headdress of the Brazilian Indians (Honour 1975a:53-55,
figs. 43 &44), an image that was to be used as an allegory for the New World
for the next 250 years.[18] In fact, as early as the first half of the sixteenth
century both the third Wise Man (Honour 1975b: ill. 43) and the devil
(Honour 1975b: ills. XI & 44) were depicted wearing feather headdresses,
indicating the two opposing images, noble savage and cannibal, that domi-
nated the European view of the New World. Since both Guaman Poma as

well as the artists who decorated the *keros* were aware of European pictorial conventions, they may have borrowed certain of their images as well. In this fashion, the image of the feather headdress may have gone from Brazilian Indian to Spanish artist, and back to the native artists of Peru, who, by internalizing it, succeeded in creating a new "traditional" image.

While little information exists on the *ch'uncho* figure between the writings of the sixteenth- and seventeenth-century chroniclers and the present-day, at least one travelogue from the nineteenth century mentioned these figures. Paul Marcoy, traveling throughout South America in the late nineteenth century, apparently witnessed a dance of the *ch'unchos* in Cuzco and described them as "great dark-skinned fellows, with floating hair, dressed in their ordinary manner, but wearing immense conical hats made of osier, and covered with feathers of macaws and perroquets" (Marcoy 1875:261-262). Marcoy's *ch'uncho* dancers appear similar to the the ones of today thus forming a possible link between the *ch'unchos* as described by the earlier chroniclers and their appearance today as masked and costumed dancers in fiestas in the central Andes.[19]

The *Ch'uncho* Figure Today

Today *ch'uncho* dancers appear at the fiesta of *Qoyllur Rit'i* celebrated in early-June around the Corpus Christi and *Inti Raymi* (winter solstice) festivals. [20] Large numbers of villagers from communities throughout the Department of Cuzco make the yearly pilgrimage to the valley of Sinakara in the shadow of the Ausangate mountains to celebrate the miraculous appearance of the image of the crucified Christ known as *El Señor de Qollyur Rit'i* (Ramirez 1969:61-68).[21] While the festival appears to be rooted firmly in Catholic theology, the worship of sacred rocks, such as the one on which the image of *El Señor* is now painted, was an important part of Inca religious rituals (Gow 1974:56-57). In addition, *Qollyur Rit'i* is celebrated just about the time of the return of the Pleiades which heralds the beginning of a new agriculture cycle, suggesting that the celebration may originally have been part of the Inca ceremonial calendar (Randall 1987:48-49).

Besides various pilgrimages, many of which are undertaken by moonlight, the appearance of masked and costumed dancers is an important part of *Qollyur Rit'i*. Among those dancers that appear each year are the *ukukus*, or bears, product of the union between a bear and a woman (Gow 1974:74); *ch'unchos* or jungle tribes from the Amazon basin below and east of the highlands; and *collas* or llama herders from the high, flat, windswept, treeless lands of the *puna* to the south (Randall 1987:43, 45).[22] While most

of the scholars who have studied *Qollyur Rit'i* simply discuss a generic *ch'uncho*, Gow (1974:72) lists three types of *ch'unchos*: the *q'ara ch'unchos* (naked *ch'unchos*), the *wayri ch'unchos* (wind *ch'unchos*), and the "foreign" *ch'uncho*, all three of which are illustrated in Pierre Verger's photographs (Verger 1945:figs. 80-85). Of these three types, the *wayri ch'uncho* appears to be the figure most often seen at *Qollyur Rit'i* and also the one that most closely fits Guaman Poma's illustrations and early chroniclers' descriptions, reaffirming continuity with earlier concepts.

While the costumes worn by the dancers vary depending on the location and group performing the dance, the *ch'unchos* always can be recognized by a feather headdress in the form of a circular crown of upright feathers. [23] It is this red-orange crown of feathers as well as long feathered streamers that trail down the dancers' backs that relates these figures to the jungle and also to Guaman Poma's drawings. However, the rest of the *ch'uncho* costume—shirt, vest, pants, shoes, poncho—does not fit the verbal description of naked savage. For example, in Paucartambo, the rest of the costume is composed of a heavily beaded and sequined vest and/or gorget and decorated knee-breeches for the head *ch'uncho* and shirts with crossed baldrics and fringed skirts for the remaining *ch'unchos* (Barrionuevo 1980:208-210). In Chincheros the *ch'uncho* dancers wear a single sash that runs from right to left over a white shirt above short black pants that reach just below the knee and white knee-socks with dark bands around the top (Yule 1984:photo 41). In addition, both the Paucartambo and Chincheros *ch'unchos* wear wire-mesh face masks with stylized European features, an item lacking in the *Qollyur Rit'i* and *wayri ch'unchos* but found on the "foreign" *ch'unchos* as photographed by Verger (1945:80-81). In some instances, the *ch'unchos* are described as wearing a feathered skirt with the arms and chest also covered with feathers (Varas Reyes 1976:90) and face or body paint like the tattoos worn by jungle savages (Portugal Catacora 1981:94). This feathered costume suggests a possible link with Guaman Poma's (1980:146) depiction of an *Anti Suyo* inhabitant completely clothed in feathers. [24]

Another important aspect of *Qollyur Rit'i* is the mock battle that takes place between the *ch'unchos* and the *collas*. In the past, the *collas* were llama and alpaca herders who came from the high, flat *altiplano* to the south of Cuzco (Randall 1987:49). As such, they were opposed to both the savage *ch'unchos* of the jungle as well as the agricultural *runa*[25] of the mountain valleys. Both Getzels (1984:177) and Randall (1987:49) suggest that a similar dichotomy still holds true today although the *collas* are now *mestizo*

merchants. However, the outcome of the battle between the *collas* and the *ch' unchos* is always the same: the *ch' unchos* always win in what seems to be a reversal of roles (Getzels 1984:177).[26] The *ch' unchos* are, after all, poor savages, while the *colla* are rich merchants, whose full title is *q' apac colla* or rich and powerful *collas* (Gow 1974:78). In fact, the victory of the *ch' unchos* over the *collas* can be understood only within the greater context of the concepts of *hanan* and *hurin*, the upper and lower divisions into which Cuzco was divided and which also encoded concepts of the Inca world view that continue to be important today.

The *Ch'uncho* Figure in Relation to *Hanan* and *Hurin*

In a very basic sense, *hanan* and *hurin* can be thought of as complementary mirror images. While *hanan* encoded the principles of the right side, masculinity and superiority, *hurin* implied the left side, femininity, and inferiority. This two-part division structured virtually all aspects of Inca society from religious rituals to city planning and created a basic thought pattern and associated worldview that has survived to this day.

Both the Inca empire and its capitol city of Cuzco were divided into four quadrants based on the concepts of *hanan* and *hurin* (Zuidema 1964, 1977). Guaman Poma graphically illustrated this quadripartite division of the empire in a classical *mapa mundi* as perceived from the Inca point of view. In Guaman Poma's map, Cuzco occupied the center—the Incas regarded it as the navel of the world—with the region of *Chinchay Suyo* to the left, *Colla Suyo* to the right, *Anti Suyo* above, and *Cunti Suyo* below. As Adorno (1979:79) notes, this view is not from the vantage point of the reader or viewer but rather from the point of view of the insider, so that the conceptual right is on the viewer's left, much as stage directions are from the point of view of the actor rather than the audience. Chart No. 1, based on Guaman Poma's map, illustrates this point.

The center position, occupied by Cuzco, represented the highest value, with right (*Chinchay Suyo*), upper (*Anti Suyo*), left (*Colla Suyo*), and lower (*Cunti Suyo*) following in order of descending value (Adorno 1979:79). Cuzco, the capitol city of the Incas, was divided similarly into four quadrants or *suyos* with *Chinchay Suyo* to the northwest, *Anti Suyo* to the northeast and so on. [27] In both the quadrant division of Cuzco, as well Guaman Poma's map, the quadrants *Chinchay Suyo* and *Anti Suyo* were *hanan* because they belonged to the upper moiety of Cuzco, while *Colla Suyo* and *Cunti Suyo* were *hurin* because they were part of the lower moiety (Zuidema 1964, 1977). At the same time, within the upper and lower groupings *Anti*

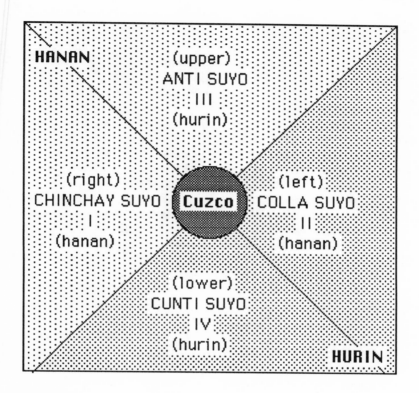

Chart No. 1
The four *suyos* surrounding Cuzco according to Guaman Poma's *Mapa Mundi* (circa 1615).

Suyo was *hurin* to *Chinchay Suyo* and *Colla Suyo* was *hanan* to *Cunti Suyo*, thus *Cunti Suyo* was *hurin* to all the others (Getzels 1984:192). In this fashion the *ch'unchos*, who inhabit the region of *Anti Suyo*, are *hanan* when compared to the *collas* from *Colla Suyo* and therefore must win the ritualized battle fought during *Qollyur Rit'i*. At the same time each of the dance groups has aspects of both *hanan* and *hurin* contained within them. For example, the darkness of the *ch'uncho* jungle is *hurin* in contrast to the sunlight *altiplano* of the *collas* (Getzels 1984:184). This constant pairing and re-pairing of *hanan* and *hurin* is essential to the Andean concept of order.

The *Ch'uncho* Figure and the *Inkarrí /Collurrí* Myth Cycle

The image of the *ch'uncho* also is closely related to a cycle of creation myths found in Q'ero and other Andean regions and based on a pair of figures called *Inkarrí* and *Collurrí* (Flores Ochoa 1973:302).[28] In some versions, *Inkarrí* and *Collurrí* were a husband and wife team responsible for the creation of the Andean landscape, foundation of cities, and introduction of agriculture and weaving,[29] while in other versions they were two brothers who perform similar feats.[30] The version in which *Inkarrí* and *Collurrí* were brothers suggests remnants of another myth in which *Wiracocha*, as culture hero/creator god, had two sons, *Imaymana Wiracocha* and *Tocapu Wiracocha*, each of whom was sent to specific regions to bring order in the form of edible plants (agriculture), curative herbs (medicine), and named rivers (fertility) (Molino [1573] 1947:20-21). Imaymana was sent to the *montaña*, which is also the region of *Anti Suyo* with its naked figures of *ch'unchos* living without laws or rulers, while *Tocapu* was sent to the *llanos* (plains or flatlands) or region of *Colla Suyo*, home of the *colla* pastoralists. Not only is a distinction made between the areas served by the two sons (low/high, jungle/plain), but their names also suggest specific and differing concepts. *Imaymana* appears to refer to all things created (Zuidema 1982:447), while *Tocapu* refers to the bands of designs found on specific Inca tunics or *uncu*. This seems to suggest that textiles, or textile designs, were considered to be of equal importance to the created world.[31]

In addition to the relationship between the *Inkarrí/Collurrí* myth cycle and that of *Imaymana/Tocapu*, *Inkarrí* also was often associated with the *ch'unchos*. For example, the inhabitants of Q'ero refer to themselves symbolically as both the "*ch'unchos* of the Andes" and "the children of *Inkarrí*"(Getzels 1984:175-177). In a myth collected in Puquio by Arguedas (1974:183), *Inkarrí* was the child of the sun and a "*mujer salvaje*" (savage woman or woman of the jungle), while in versions from Q'ero, *Inkarrí* emerged from the dark, chaotic jungle into which the previous race, the *ñawpa machu* (old or ancient ones), had fled after being badly burned by the newly created sun, suggesting that the *ch'unchos* are the descendants of the first human race in the Andes whose disappearance into the jungle was also responsible for spawning the creator-god/culture-hero *Inkarrí* (Getzels 1984:173, 177).

Comparing the *ch'uncho/colla*, *Inkarrí/Collurrí*, and *Imaymana/Tocapu* myths, it appears that we are dealing with at least three sets of opposing/combining forms, which can be related to the previous diagram depicting the relationship between *hanan* and *hurin* and the organization of

the Inca realm. Peter Getzels (1984) has demonstrated the interchanging roles of *hanan* and *hurin* within the *Inkarrí/Collurrí* myth. It seems that a similar phenomena can also be postulated for the *ch'uncho/Colla,* and *Imaymana/Tocapu* pairs. Thus, *ch'uncho, Inkarrí,* and *Imaymana* are all associated with quadrant III in the previous chart, while *colla, Collurrí,* and *Tocapu* are associated with quadrant II. However, as Getzels (1984:185-186) has pointed out, the relationship between *hanan* and *hurin* is a constantly changing dialectic. Thus, each member of the pair has both *hanan* and *hurin* aspects at different times and in different relationships to its complementary opposite.

Possible Interpretations of the *Ch'uncho* Motif on Textiles
 The constantly changing relationships between the *hanan* and *hurin* aspects of the *ch'uncho* image may give us some clues to the meaning of these figures when they are found on textiles and clothing. For example, the description of the *ch'uncho* as naked savage stresses the *hurin* aspect of the unclothed barbarian. However, the *ch'uncho* figure that appears on textiles from several regions around Cuzco is not naked, but clothed, resembling more closely the costumed *ch'uncho* dancer from the *Qollyur Rit'i* celebration, whose position of *hanan* (as an inhabitant of *Anti Suyo*) insures victory over the *colla.* The feather headdresses further stress the jungle origins (*hurin*) of the *ch'unchos,* while their clothes reveal the close link between the *ch'unchos* and the *runa (hanan)* of Q'ero. In this sense the figure of the *ch'uncho* defines both the member who belongs and the outsider who does not. At the same time the concepts of member/outsider are treated similarly to the concepts of *hanan* and *hurin.* That is, each contains aspects of the other. Thus, although the Q'ero consider themselves most comfortable in their highland homes, they also have contact with the jungle below them, planting and harvesting corn in the lower altitudes. While they do not like the jungle, referring to it as irrational and unreasonable, preferring instead the open spaces of the highlands above it, they not only make use of it but also define themselves in relation to it. In this fashion the jungle is a necessary complement to the highlands much as *hurin* is the necessary complement to *hanan.* To have order one must have balance and to have balance there must be at least two parts to the whole.[32]
 Further substantiating the relationship between the woven textile images and underlying cultural concepts is the manner in which the *ch'uncho* image itself is composed. For example, in all of the *ch'uncho* images, the figures are composed of two mirror-image triangles with their apexes

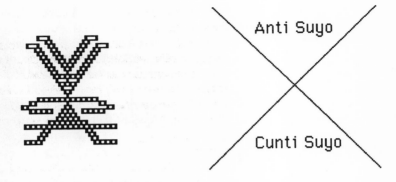

Chart No. 2 *Ch'uncho* figure compared to the organization of the *suyos* as found in Guaman Poma's *Mapa Mundi* (circa 1615).

meeting at the figure's shoulders. Comparing this form with Guaman Poma's map (see charts 1 and 2), it becomes evident that the basic outlines of the *ch'uncho* figure reflect the diagonal lines that structure the quadripartite Andean world, dividing it into areas of *hanan* and *hurin*.[33] Thus, the head of the figure, diagrammatically located in the region of *Anti Suyo*, also the homeland of the *ch'unchos*, is *hanan* in relation to the body and legs, which are in the section of *Cunti Suyo* and are *hurin*. In this sense, the woven designs themselves not only reinforce the basic concepts of *hanan* and *hurin* but those of belonging as well, reminding the inhabitants of Q'ero of their identity and firmly anchoring them within the larger Andean world view.

In conclusion, the hour-glass-shaped figure referred to as a *ch'uncho* represents the actual figure of jungle inhabitant as distinct from highlander. In addition, the *ch'uncho* figure also is related to both the *Inkarrí/Collurrí* and *Imaymana/Tocapu* culture-hero mythic cycles. Lastly, this image refers to the opposing yet inclusive concepts of *hanan* and *hurin* that structure the Central Andean world view much as the opposing yet inclusive bands of *pallay* and *pampas* structure textiles, the woven equivalent of the created world. In this sense, textiles (or the clothing which is made from them) represent the civilized world (*hanan*), while their lack stands for the uncivilized jungle (*hurin*), which in turn surrounds the civilized highlands (*hanan*) much as the plain-weave areas of *pampas* (*hurin*) surround the pick-up designs of *pallay* (*hanan*) on woven textiles (*hanan*). Not only are some sections of individual textiles *hanan* to the *hurin* of other sections of the

same textile, but individual design units may each contain elements of both *hanan* and *hurin*. Thus, it seems that neither the world, nor textiles are complete without the constant, yet fluid dialectic between the opposing yet combining forces of *hanan* and *hurin*.

Endnotes

1. This paper is dedicated to the memory of Douglas Fraser. I would also like to thank John Cohen and Lynn Meisch for sharing their insights into the *ch'uncho* figure, Tom Cummins for discussing his work on *kero* imagery, and Louise Stark for providing linguistic information. Funding for part of this research was provided by a Faculty Grant-in-Aid for 1985 and a Small Grant for 1986 from Arizona State University, Tempe, Arizona.

2. The villages of Cuyo Grande, Q'ero, and Pitumarka, the area of the Yanamao River, the upper Chilca River region, and the Lares area.

3. See Junius Bird, John Hyslop, and Milica Dimitrijevic Skinner 1985 for a detailed account of the very early Huaca Prieta textiles.

4. See Murra 1962 for the importance of textiles to the Inca. Virtually all Inca designs whether on ceramics, wood, metal, or cloth were geometric. Indeed, one of the identifying hallmarks of Colonial tapestry weaving is the use of realistic figures since these never appeared in Inca tapestry weaving. However, examples of animal figures, especially *llamas*, are found in other Inca weaving techniques such as those used to create belts and bags.

5. Tom Cummins (1988), in his study of the images found on wooden drinking vessels (*keros*) from the Colonial period, points out that narrative scenes, such as those found on the *keros* were not used by the pre-Conquest Inca, who preferred abstract, geometric designs.

6. As for example in Q'ero.

7. As for example in Cuyo Grande, the Pitumarka, and Lares regions.

8. See John Rowe 1979 for a more complete discussion of the styles of Inca tunics and the importance of the *tocapu* bands.

9. And coincidentally by the Spanish. My thanks to Tom Cummins (pers. com. 1987) for pointing out that the association between the central band of *tocapu*-like geometric designs on the *kero* and *tocapu* bands on textiles is substantiated by Gonzalez Holguin's definition of *chumpi qeru* as a cup with painted or relief bands or stripes around it (see also Rowe 1961:327) since *chumpi* means a woven belt.

10. See Franquemont 1986 and articles by Medlin, Meisch, and Zorn in Femenias 1987.
11. See Meisch 1985:6 and 1986:246, 248, Cereceda 1978:1030, and Zorn 1986:294 for specific examples and Femenias 1988:12-26 for a more general survey of design layout.
12. In addition, a border called *kerekin* (Cohen 1957:47; *"kiraqe"* in Nuñez del Prado 1984:114) or *puntas*, composed of alternating light and dark triangles (Nuñez del Prado 1984:114), may also surround the *pallay* stripes.
13. See Webster 1972: chapter 4 for a discussion of Q'ero settlement patterns. In addition, the idea of open versus closed space may also be related to local aesthetic concepts as well. For example, among the Navajo, traditional blanket patterns were continuous, non-bordered motifs that could be placed end to end to form a continuous pattern that reflected Navajo concepts of harmony and beauty. Borders, so prevalent in Navajo rugs today, were introduced to satisfy Victorian tastes for an enclosed space with a distinct boundary.
14. Alberto Miori, pers. com.1986; Cohen 1957: 46 and pers. com. 1987; and Medlin 1976 and pers. com.1987. However, Silvermann-Proust identifies a similar figure on Q'ero textiles as *Wiracocha*, the Inca creator/culture hero, and identifies yet another image, composed of two opposing series of V's radiating outwards from a central hourglass-shaped figure as the *ch'uncho* (1984a:88-98; 1984b:292-293, *ch'uspa* no. 2). There is virtually no information in the ethnographic literature to support Silvermann-Proust's claim, nor have other Andean textile scholars (Cohen, pers. com. 1987; Meisch, pers. com. 1987) found any ethnographic evidence for the *Wiracocha* attribution. Indeed, the area of Q'ero is dominated by the *Inkarrí-Collurrí* cycle of myths (see Morote Best 1984; Nuñez del Prado 1973; Getzels 1984) which Silvermann-Proust addresses in a later publication (1986b). Another meaning for *wiracocha* is Spaniard or non-Indian (van den Berghe 1974:15) and has been used in this fashion to distinguish a non-member of the community since the conquest (Cobo 1979:8). This, in fact, is most likely the meaning picked up by Silvermann-Proust, since the use of *wiracocha* to mean someone outside the local group is similar in connotation to the use of *ch'uncho* as an individual opposed to or outside of the civilized village group.
15. Also referred to as *antis* or inhabitants of *Anti Suyo*.

16. A fez-like turban with a crescent with the points turned upward indicated
 Colla Suyo (Guaman Poma 1980:171), a braided head-band with
 circular rosettes at each end and topped by a kylix-shaped object (a
 flower?) depicted *Cunti Suyo* (Guaman Poma 1980:173), and a
 cloth head-band with an upside down U-form surmounted by a
 feather singled out *Chinchay Suyo* (Guaman Poma 1980:167).
 Each of the two divisions of Cuzco, *hanan* and *hurin* also had dis-
 tinctive headdresses; a trapezoidal form for *hanan* and a circle for
 hurin (Guaman Poma 1980:366). In fact, headdresses appear to
 have been one of the most important means of identifying an
 individual's home region.
17. Where they are one of four figure types (Cummins 1988). See also Rowe
 1961:330, fig. 7; 334, fig. 10 and Gisbert 1980: ills. facing page 86
 for illustrations.
18. See illustrations in Honour 1975a & 1975b, also Chiapelli 1976, Boorsch
 1976, and Kohl 1982.
19. See Portugal Catacora 1981:92-97; Montes Camacho 1986:47-48;
 Barrionuevo 1980:208-210; Roel Pineda 1950; Varas Reyes
 1976:83-99; and Verger 1945 for descriptions and/or illustrations
 from Peru and Bolivia. In addition Lynn Meisch (pers. com. 1987)
 notes its appearance in Saraguro, Ecuador, and Judith Bettelheim
 (Nunley and Bettelheim 1988:79-83) illustrates examples of Amer-
 indian masqueraders from St. Kitts and Bermuda that are visually
 similar to contemporary *ch' uncho* dancers from the central Andes.
20. See Ramirez 1969; Gow 1974; Sallnow 1974; Randall 1982, 1987; and
 Getzels 1984 for descriptions of this celebration over the past
 twenty years.
21. See also Gow 1974:53-55, and Randall 1987:47-48 for other versions.
22. See also Sallnow 1974:107-108, and Gow 1974:71-74.
23. See Randall 1987:ills. p. 48; Ramirez 1969:84-85; Gow 1974:85;
 Sallnow 1974:107; Barrionuevo 1980:208, photo p. 209; Yule
 1984: photo 41; Silas Salinas 1982:106-107; Flores Ochoa and
 Nuñez del Prado 1984:foto 22 for illustrations.
24. To the south in Tarija, Bolivia, the costume of the *ch' uncho* is composed
 of a silk or rayon skirt or *pollerín* and a shirt with a silk shoulder
 cape. No mask is worn, but the dancer, instead, covers his face with
 a sequined veil (Varas Reyes 1976:90). During the Christmas
 celebrations in Saraguro, Ecuador, Lynn Meisch observed small
 boys costumed to represent the *Jívaros* of the jungle. Like the

ch' unchos they wear feather headdresses, and carry spears, but they also wear papier maché masks with painted designs that represent the face paint of the *Jívaros*. Meisch also points out that in Saraguro, as in Peru, "the Quechua-speakers had a kind of love-hate relationship with the jungle tribes, fearing and scorning them as uncivilized, yet trading with them" (Meisch 1987:letter of March 21).

25. Term used by Quechua-speakers to identify themselves, literally "the people."
26. See also Randall 1987:49, Gow 1974:77-78, and Ramirez 1969:81.
27. Brundage 1967; Zuidema 1977:233. See also figures no. 4 & 5 in Getzels 1984 for a comparison of the organization of Cuzco compared to the *Inkarrí-Collurrí* myths.
28. See also Silvermann-Proust 1986b: she and I simultaneously and independently applied the *Inkarrí* and *Collurí* myth cycle to the *ch' uncho* designs on Q'ero textiles. Other versions of the *Inkarrí* and *Collurí* myths can be found in Morote Best 1984; Nuñez del Prado 1973; Arguedas & Roel Pineda 1973; Ortiz Rescaniere 1973; and Getzels 1984.
29. Getzels 1984:172-173; Nuñez del Prado 1973:277, 279 and 1984:109; Arguedas 1974:184.
30. Morote Best 1984:159; Nuñez del Prado 1973:280.
31. In fact, Zuidema (1982:447) interprets the myth to mean that textiles were actual political symbols that represented local government.
32. While the ideas in this section are mine, I profited greatly from a discussion with Tom Cummins concerning the concept of *Anti/hurin* versus *Inca/hanan* as two parts of a whole and as part of the nature/culture dichotomy.
33. Recently working in the Cuzco area, I was told that an X-shaped design on textiles from Cotabamba represented the four *suyos,* while a similar design on Juli-style textiles represented all three levels of the world.

Bibliography

Acosta, José de
1940 [1590] Historia natural y moral de Las Indias. (Edition prepared by Edmundo O'Gorman.) Mexico: Fondo de Cultura Económica.

Adorno, Rolena
 1979 Paradigms Lost: A Peruvian Indian Surveys Spanish
 Colonial Society. Studies in the Anthropology of Visual
 Communication 5(2):78-96.
Arguedas, José María
 1957 The Singing Mountaineers: Songs and Tales of the
 Quechua People. Collected by José María Arguedas,
 edited and with an introduction by Ruth Stephan. Austin:
 University of Texas Press.
 1974 Mitos quechuas poshispánicos. *In* Realidad nacional,
 primer tomo, el mundo indígena. Julio Ortega, ed. Pp.
 182-193. Lima: Retablo de Papel Ediciones.
Arguedas, José Maria, and Josafat Roel Pineda
 1973 Tres versiones del mito de Inkarrí. *In* Ideología mesiánica
 del mundo andino. Juan M. Ossio A., ed. Pp. 301-338.
 Lima: Edición de Ignacio Prado Pastor, Colección Biblio-
 teca de Antropología.
Barrionuevo, Alfonsina
 1980 Cusco mágico. Lima: Editorial Universo, S.A.
Bird, Junius B., John Hyslop, and Milica Dimitrijevic Skinner
 1985 The Preceramic Excavations at the Huaca Prieta, Chicama
 Valley, Peru. Anthropological Papers of The American
 Museum of Natural History, Vol. 62, part 1.
Boorsch, Suzanne
 1976 America in Festival Presentations. *In* First Images of
 America: The Impact of the New World on the Old, Vol.
 1. Fredi Chiapelli, ed. Pp. 503-518. Los Angeles:
 University of California Press.
Brundage, Burr Cartwright
 1967 Lords of Cuzco. University of Oklahoma Press, Norman.
Cereceda, Veronica
 1978 Sémiologie des tissus andins: les talegas d'Isluga. An-
 nales Economiés, Sociétés, Civilisations 33(5-6):1017-
 1035.
Chiapelli, Fredi
 1976 First Images of America: The Impact of the New World
 on the Old. 2 Vols. Los Angeles: University of California
 Press.

Cobo, Bernabe
 1956 [1653] Historia del nuevo mundo. Madrid: Biblioteca
 de Autores Españoles, Vols. 91-92.
 1979 [1653] History of the Inca Empire. Translated and
 edited by Roland Hamilton. Austin: University of Texas
 Press.
Cohen, John
 1957 An Investigation of Contemporary Weaving of the Peru-
 vian Indians. MFA thesis, Art Department, Yale Univer-
 sity.
Cummins, Tom
 1988 Abstraction to Narration: Kero Imagery of Peru and the
 Colonial Alteration of Native Identity. University Micro-
 films, Ann Arbor, Michigan.
Femenias, Blenda
 1987a Andean Aesthetics: Textiles of Peru and Bolivia. Madi-
 son: University of Wisconsin, Elvehjem Museum of Art.
 1987b Design Principles in Andean Textiles. *In* Andean Aes-
 thetics: Textiles of Peru and Bolivia. Blenda Femenias,
 ed. Pp. 9-31. Madison: University of Wisconsin, Elvehjem
 Museum of Art.
Flores Ochoa, Jorge
 1973 Inkariy y Qollariy en una comunidad del altiplano. *In*
 Ideología mesiánica del mundo andino. Juan M. Ossio A.,
 ed. Pp. 301-338. Lima: Edición de Ignacio Prado Pastor,
 Colección Biblioteca de Antropología.
Flores Ochoa, Jorge A., and Juan V. Núñez del Prado B.
 1984 Q'ero: El último ayllu Inca. Cuzco: Centro de Estudios
 Andinos.
Franquemont, Christine
 1986 Chinchero Pallays: An Ethnic Code. *In* The Junius B.
 Bird Conference on Andean Textiles. Ann P. Rowe, ed.
 Washington, D. C.: The Textile Museum.
Getzels, Peter
 1984 Los ciegos: Visión de la identidad del Runa en la ideología
 de Inkarrí-Qollarí. *In* Q'ero: El último ayllu Inca. Jorge
 A. Flores Ochoa, and Juan V. Núñez del Prado B., eds.
 Cuzco: Centro de Estudios Andinos.

Gisbert, Teresa
1980 Iconografía y mitos indígenas en el arte. La Paz: Editorial Gisbert & Cia., S.A.

Gonzalez Holguin, Diego
1952 [1608]Vocabulario de la lengua general de todo el Perú llamada lengua Quichua o del Inca. Lima: Instituto de Historia, Universidad de San Marcos.

Gow, David
1974 Taitacha Qollyur Rit'i. Allpanchis 7:49-100.
1976 The Gods and Social Change in the Andes. Ph.D. dissertation, Anthropology Department, University of Wisconsin, Madison.

Guaman Poma de Ayala, Felipe
1980 [1615]El primer nueva corónica y buen gobierno. John V. Murra and Rolena Adorno, eds., Quechua translations by Jorge L. Urioste. Mexico: Siglo Veintiuno Editores, S.A.

Honour, Hugh
1975a The European Vision of America. Kent Ohio: The Kent State University Press.
1975b The New Golden Land: European Images of America from the Discoveries to the Present Time. New York: Pantheon Books, Random House.

Isbell, Billie Jean
1978 To Defend Ourselves: Ecology and Ritual in an Andean Village. Institute of Latin American Studies, Latin American Monographs, No. 47. Austin: University of Texas Press.

Kohl, Karl-Heinz, ed.
1982 Mythen der Neuen Welt: Zur Entdeckungsgeschichte Latinamerikas. Berlin: Verlag Frölich & Kaufmann GmbH.

Marcoy, Paul
1875 Travels in South America from the Pacific Ocean to the Atlantic Ocean. Vol. 1. Ilay—Arequipa—Lampa—Acopia—Cuzco—Echarati—Chulituqui—Tunkini—Paruitcha. New York: Scribner, Armstrong, & Co.

Medlin, Mary Ann
1976 The Shape of the Sun: Selected Aspects of Design in the

Weaving of Q'ero, Peru. MA thesis, University of North
Carolina, Chapel Hill.

1987 Calcha Pallay and the Uses of Woven Design. *In* Andean
Aesthetics: Textiles of Peru and Bolivia. Blenda Feme-
nias, ed. Pp. 60-66. Madison: University of Wisconsin,
Elvehjem Museum of Art.

Meisch, Lynn Ann

1985 Symbolism in Tarabuco, Bolivia, Textiles. *In* Andean
Studies Occasional Papers, Vol. 2. Pp. 1-26. Center for
Latin American and Caribbean Studies. Bloomington:
Indiana University.

1986 Weaving Styles in Tarabuco, Bolivia. *In* The Junius B.
Bird Conference on Andean Textiles. Ann P. Rowe, ed.
Pp. 243-274. Washington, D.C.: The Textile Museum.

1987 The Living Textiles of Tarabuco, Bolivia. *In* Andean
Aesthetics: Textiles of Peru and Bolivia. Blenda Feme-
nias, ed. Pp. 46-58. Madison: University of Wisconsin,
Elvehjem Museum of Art.

Mesa, José de, and Teresa Gisbert

1972 Escultura virreinal en Bolivia. La Paz: Academia Nacional
de Ciencias de Bolivia, Publicación No. 29.

Molino, Cristobál de

1947 [1573]Relación de las fábulas y ritos de los Incas. Buenos
Aires: Editorial Futuro S.R.L.

Montes Camacho, Niver

1986 Preceso íntimo del carnaval de Oruro. Oruro, Bolivia:
Editorial Universitaria.

Morote Best, Efrain

1984 Un nuevo mito de fundación del imperio. *In* Q'ero: El
último allyu Inca. Jorge A. Flores Ochoa and Juan V.
Núñez del Prado B., eds. Pp. 158-169. Cuzco: Centro de
Estudios Andinos.

Murra, John V.

1962 Cloth and Its Functions in the Inca State. American
Anthropologist 64:710-728.

Nuñez del Prado, Oscar

1973 Version del mito de Inkarrí en Q'eros. *In* Ideología
mesiánica del mundo andino. Juan M. Ossio A., ed. Pp.

275-280. Lima: Edición de Ignacio Prado Pastor, Colección Biblioteca de Antropología.

1984 El hombre y la familia: su matrimonio y organización político-social en Q'ero. *In* Q'ero: El último allyu Inca. Jorge A. Flores Ochoa and Juan V. Nuñez del Prado B., eds. Pp. 106-130. Cuzco: Centro de Estudios Andinos.

Nunley, John, and Judith Bettelheim

1988 Caribbean Festival Arts. The Saint Louis Art Museum in association with University of Washington Press, Seattle and London.

Ortiz Rescaniere, Alejandro

1973 De Adaneva a Inkarrí. Edición Retablo de Papel. Lima.

Ossio A., Juan M., ed.

1973 Ideología mesiánica del mundo andino. Lima: Edición de Ignacio Prado Pastor, Colección Biblioteca de Antropología.

Paredes Candia, Antonio

1976 Fiestas populares de Bolivia. Vols. I & II. La Paz: Ediciones Isla Y Librería-Editorial Popular.

Pease, Franklin

1973 El mito de Inkarrí y la visión de los vencidos. *In* Ideología mesiánica del mundo andino. Juan M. Ossio A., ed. Pp. 439-460. Lima: Edición de Ignacio Prado Pastor, Colección Biblioteca de Antropología.

1982 El pensamiento mítico. Francisco Campodónico F., ed. Lima: Biblioteca del Pensamiento Peruano, Mosca Azule Editores.

Portugal Catacora, José

1981 Danzas y bailes del altiplano. Lima: Editorial Universo, S.A.

Ramirez, Juan A.

1969 La novena del Señor de Qoyllur Rit'i. Allpanchis 1:61-88.

Randall, Robert

1982 Qoyllur Rit'i, An Incaic Festival of the Pleiades: Reflections on Time and Space in the Andean World. Lima: Bulletin del Instituto Francés de Estudios Andinos 11(2):37-81.

1987 The Return of the Pleiades. Natural History 96(6):42-53.

Roel Pineda, Josafat
>1950 La danza de los *ch'unchos* de Paucartambo. Cuzco: Tradición I(1):59-70.

Rowe, John Howland
>1961 The Chronology of Inca Wooden Cups. *In* Essays in Pre-Columbian Art and Archaeology. Samuel K. Lothrop, ed. Pp. 317-341. Boston: Harvard University Press.
>1979 Standardization in Inca Tapestry Tunics. *In* The Junius B. Bird Pre-Columbian Textile Conference. Ann Rowe, Elizabeth Benson, and Anne-Louise Schaffer, eds. Washington, D.C.: The Textile Museum and Dumbarton Oaks.

Sallnow, Michael J.
>1974 La peregrinación andina. Allpanchis 7:101-142.

Silas Salinas, Jorge
>1982 Bolivia. Barcelona: Ediciones Castell, S.A.

Silvermann-Proust, Gail Patricia
>1984a Los motivos Q'ero. *In* Q'ero: El último allyu Inca. Jorge A. Flores Ochoa and Juan Nuñez del Prado B., eds. Pp. 87-105. Cuzco: Centro de Estudios Andinos.
>1984b Los motivos de los tejidos de Q'ero: la descripción de los tejidos Cuzco: Revista del Museo e Instituto de Arqueología. Pp. 281-303.
>1986a Cuatro motivos Inti de Q'ero. Boletín de Lima 43:61-78.
>1986b Representación grafica del mito Inkarrí en los tejidos Q'ero. Boletín de Lima 48:59-71.

Taussig, Michael
>1987 Shamanism, Colonialism, and the Wild Man: A Study in Terror and Healing. Chicago and London: The University of Chicago Press.

van den Berghe, Pierre L.
>1974 The Use of Ethnic Terms in the Peruvian Social Science Literature. *In* Class and Ethnicity in Peru. Pierre L. van den Berghe, ed. Leiden: E.J. Brill.

Varas Reyes, Victor
>1976 San Roque: Torbellino de 'chunchos' y 'cañeros'. *In* Fiestas Populares de Bolivia. Antonio Paredes-Candia, ed., tomo II. Pp. 83-109. La Paz: Ediciones Isla y Librería Popular.

Verger, Pierre
 1945 Fiestas y danzas en el Cuzco y en los Andes. Buenos
 Aires: Editorial Sudamericana.
Wachtel, Nathan
 1973 Pensamiento salvaje y aculturación: el espacio y el tiempo
 en Felipe Guaman Poma de Ayala y el Inca Garcilaso de
 la Vega. *In* Sociedad e ideología: ensayos de historis y
 antropología andinas. Lima: Instituto de Estudios Perua-
 nos.
Webster, Steven
 1972 The Social Organization of a Native Andean Community.
 Ph.D. dissertation, Anthropology Department, University
 of Washington, Seattle.
Yule, Paul
 1984 The New Incas—los nuevos Incas. London: The New
 Pyramid Press.
Zorn, Elayne
 1986 Textiles in Herder's Ritual Bundles of Macusani, Peru. *In*
 The Junius B. Bird Conference on Andean Textiles. Ann
 P. Rowe, ed. Washington, D.C.: The Textile Museum.
 1987 Encircling Meaning: Economics and Aesthetics in Taquile,
 Peru. *In* Andean Aesthetics: Textiles of Peru and Bolivia.
 Blenda Femenias, ed. Pp. 67-78. Madison: University of
 Wisconsin, Elvehjem Museum of Art.
Zuidema, R. T.
 1964 The Ceque System of Cuzco: The Social Organization of
 the Capital of the Inca. Leiden: E.J. Brill.
 1977 The Inca Calendar. *In* Native American Astronomy.
 Anthony F. Aveni, ed. Pp. 219-259. Austin: University
 of Texas Press.
 1982 Bureaucracy and Systematic Knowledge in Andean
 Civilization. *In* The Inca and Aztec States 1400-1800:
 Anthropology and History. George A. Collier, Renato I.
 Rosaldo, John D. Wirth, eds. New York: Academic
 Press.

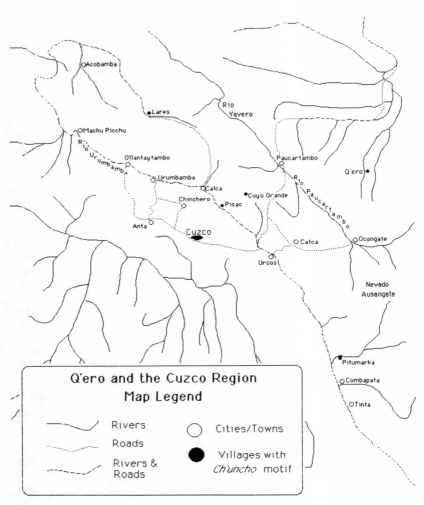

Figure 1. Map of Q'ero and the Cuzco region. Drawing by Lee Anne Wilson.

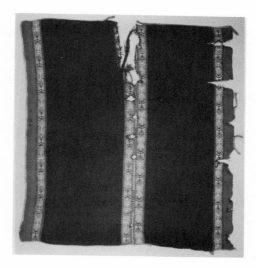

Figure 2. Q'ero, Department of Cuzco, Peru. *Lliclla* (woman's mantle) with designs depicting the *ch'uncho* figure, 19th-20th century. Collection of the Textile Museum, 1974.16.17, Washington, D.C. Museum photograph.

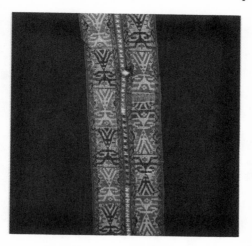

Figure 3. Q'ero, Department of Cuzco, Peru. *Lliclla* (woman's mantle) with designs depicting the *ch'uncho* figure, 19th-20th century. Detail of the *ch'uncho* image in figure 2. Collection of the Textile Museum, 1974.16.17, Washington, D.C. Museum photograph.

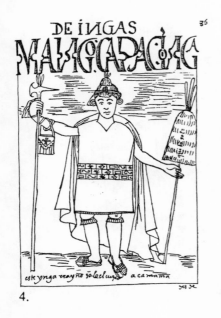

4.

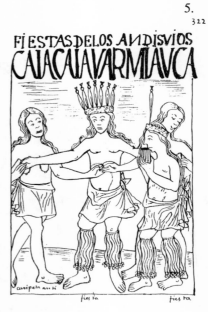

5.

Figure 4. Drawing of Manco Capac Inca by Guaman Poma de Ayala, circa 1615.

Figure 5. Drawing of Fiestas de los Anti Suyos by Guaman Poma de Ayala, circa 1615.

Chapter Ten

Clothes and Identity in the Central Andes: Province of Abancay, Peru

Raquel Ackerman

Introduction

Andeanists have concentrated their analyses of clothing on those materials and techniques that appear to have some continuity with pre-Columbian weaving.[1] The commonplace, essentially Western dress of the contemporary Andes, has been largely ignored in the literature. As a consequence, previous analyses have failed to consider the context in which textiles are used and the importance contemporary users attach to these items. Change in quality, material, and techniques may not be correlated exclusively with cultural change but also may reflect a degree of adaptation to present day economic conditions. Factory-made items have come to fulfill the social and ritual roles performed in former times by their hand-woven counterparts.

The province of Abancay, in the department of Apurímac, Peru, appears lacking in exuberance to the student of native textiles. Its churches are neglected and poor. Its inhabitants seem far more acculturated than those of neighboring Cuzco or Ayacucho. Even the local Quechua dialect, people

231

will argue, shows a high degree of Spanish interference. For these reasons, it is the ideal location to research continuity and change in use of clothing.

In this chapter, I attempt to make a synchronic analysis of contemporary clothing within the general context of life in the province of Abancay. The starting point for this analysis is the realization that, in Abancay, cloth is central to the definition of self. The use of clothing to mark social, cultural, and economic distinctions as well as its use in the marking of transformations in the development of the individual, will be reviewed. In Abancay, however, clothing surpasses the definition of self and enters into the realm of identity. It is used in death rituals to replace the individual and in "witchcraft" to harm the owner. Its symbolic potency extends to rituals pertaining to cattle and maize, where it is the indispensable mediator effecting the cosmic rearrangement required for fertility. Finally, at the level of the ontology of spiritual life, virgins, saints and *Apus* (mountain deities) are periodically dressed and redressed either physically or metaphorically. A review of all these realms will allow a first glance into the implicit discourse of everyday interaction.

Social Structure of Dress in Abancay Province

Abancay, as viewed by its surrounding countryside, is characterized by a sizeable variety of social actors. Each group has a very distinct way of dressing. Membership in a social class is expressed through the dress the individual wears. Aims and aspirations, as well as membership in different ethnic or religious groups, are also expressed by variations in the dress of the relevant social class. As can be imagined, clothing offers all the possibilities of expressing perceived changes in one's social status, such as the notion of "dressing up."

The basic social actors in the Abancay area are the city dweller, the *mestizo*, and the peasant. The city dwellers are the people who live in the city of Abancay or in the urban centers of the villages of Abancay province, and who have, at least ideologically, severed their links with the countryside. They take Lima and Cuzco as their political and social point of reference. By origin, city dwellers can be either Abancay born or migrants. By occupation they range from bureaucrats to merchants and proletarians. Increasingly composed of migrants, this sector of the population could be said to be better educated and either completely monolingual (Spanish speaking) or bilingual (Quechua-Spanish). Their higher literacy and technical skill allow them to occupy positions that are barred to the *mestizo* and peasant populations. Within the "city dweller" theme, there are several variations, serving as diacritics of occupational specialization and differences of wealth and

power. However, the description of such differences is beyond the scope of this chapter.

In the early twentieth century, the *mestizos* were the power élite of the rural communities of the province of Abancay. Within the local community they wielded higher prestige and power. Progressively, they have been displaced politically by the local version of city dwellers. Their social and political points of reference lie within their communities. Many *mestizos* have children and relatives who successfully have made the transition to city dwellers. Yet they refuse to move out. Even when they spend prolonged periods in the city, they maintain a house in their communities that they consider to be their primary dwelling. Traditionally they maintained good relations with the power élite of the department of Apurímac and provided brides and mistresses for the *hacendados* (large landowners). Today, they play a bridging role between the peasants and the city dwellers.

As opposed to the city dwellers and the *mestizos*, peasants do not share in power and prestige. They work their own plots of land and/or sell their labor to the haciendas and cooperatives in Apurímac and Cuzco and to the mines in Madre de Dios. Their presence in the cities is usually limited to periods of temporary wage labor. Even when they establish permanent residence in the city, they still identify themselves, and are identified by others, as peasants. They form a group apart from the local proletariat.

Beyond these three main categories of individuals in Abancay, there are several other types to which I will refer briefly. Among the city dwellers, there are several subtypes ranging from proletarians through peddlers to bureaucrats and store owners. Separate categories are provided by individuals returning from Lima and other coastal migrants. The first are considered as having lost their roots while the second are considered a link to the national government. Finally, shepherds, like peasants, have a transient presence in Abancay even when they establish themselves permanently there.

All these social differentiations are marked in clothing. It is through clothing that membership in one of these many groups is expressed. It is also through clothing that people make claims to a different social group from the one to which they had been originally assigned in this society. This section will consider the dress of women, as the greatest variation is exemplified in women's dress. This does not mean that men do not differentiate themselves by their way of dressing, but the local female dress is composed of more elements, giving the opportunity for a greater patterned variation.

Mestiza Dress

By far the most impressive dress is worn by the *mestizas*. Although there is a great deal of freedom in the choice of color, material and quality, *mestiza* dresses are structurally similar. The dress divides the body at the waistline and several superimposed layers of cloth cover the lower body (from the waistline down) and the upper body (from the waistline up). Dress below the waistline consists essentially of two different forms of skirts, each made of different materials, with an underskirt beneath each. Similarly, dress above the waistline consists of different forms of blouses of different textures and materials and a shawl.

Immediately covering the lower body a woman may wear underpants or *calzón* and a girdle or *faja*.[2] The innermost layer of skirts consists of a cotton underskirt or *fuste*. This is usually all white and is cut at the long waist and on the knee. The area below the lower seam has two layers of cloth bunched up. A woolen skirt or *centro de lana* is worn on top of the innermost underskirt. This is a solid-colored skirt, with a few optional parallel horizontal pleats on the lower half of the skirt. Regardless of whether it has adornments or not, the *centro* is always plain, gathered at the waist and fully ruffled. Layered on top of the *centro* is another underskirt (figure 1). This is a more elaborate version of the innermost one. It has the same seams, but each is sewn over with trimming laces. The area below the lower seam consists of two layers of embroidered organdy bunched up.

An elaborately adorned skirt (*pollera*) is worn on top of this second underskirt (figure 2). Its color should ideally match that of the *centro*, but otherwise this outer skirt is more elaborate. Its broad velvet waistband, hardly noticeable to observers, is closed with a silver clasp depicting a human or a bird couple. Clasps are often made of two melted old silver coins (*cinco décimos*, five-tenths, a term referring to the fifty percent of silver in them). The clasp represents two complementary opposites joining together: a man and a woman or a bird couple. While in ritual, the joining of two complementary opposites has a spatial manifestation and is intended to bring about fertility, it is interesting to remark that in the dress these opposites join a unity that the dress has artificially divided into an upper and lower half. Below the velvet waistband, a secondary waistband is formed by the bunching up of the skirt at the waist. This secondary waistband is made of the material of the skirt but, unlike the way it is made in the *centro*, the bunched up area is stitched over with several rows of stitches, forming a compact, lower, thinner and narrower waistband. Two layers of lining reinforce and unite the two waistbands: immediately against the exterior material there is a matching

lining on top of which is sewn a thick broadcloth, identical to that of the little shawl. Like the *centro* , this external *pollera* has a series of horizontal pleats on the lower half of the skirt. These pleats, however, are usually grouped in four distinct bundles intercalated with three trimming laces (one lace between each bundle) or with two trimming laces at both extremes and a series of embroidered flowers along the center. The hem is reinforced with the same velvet used to make the waistband (figure 2). The length of the skirts is quite variable and does not depend on age or status. Skirt length ranges from the mid-knee to a palm-width below the knee.

Immediately covering the upper body a *mestiza* wears a thin cotton blouse or *camisón*. A short-sleeve sweater covers the *camisón* and is, in turn, covered by a long-sleeve, thicker sweater. The exterior blouse or *saco* consists of two parts: an inner plain lining vest or *corpiño* or *chaleco* and an outer lace organdy blouse. The vest is sewn into the blouse becoming its lining at the back. In the front and sleeves there is an extra lining under the lace. The cuffs and the jabot are made of embroidered organdy with an extremely elaborate trimming lace between the embroidered organdy and the laced organdy of the blouse proper. A velvet bow is placed on each cuff, and three bows are placed on the jabot: one at the center and two on both extremes. The bows are made of the same velvet used for the waistband and at the juncture of each a large mother-of-pearl button is placed. The *saco* covers the velvet waistband concealing its silver clasp. The waistband itself, like the clasp, becomes the area where two opposed parts —the lower and the upper dress— are united.

A small stiff shawl or *llikllita* (Q.) covers the *saco* (figure 3). The *llikllita* is distinctively divided into three concentric rectangular zones. The outermost consists of a velvet stitched edge, made of the same material as the waistband of the *pollera*. The middle zone is made of embroidery or laced organdy. In either case it always involves white colored threads. Inconspicuous stitchings crosscut this area. Formerly, however, this zone used to be covered with brilliant colored threads. The center zone is made of a softer velvet, usually patterned. The velvet is thought of as a darker shade than the border. The transition between zones is always marked, either with a material of a different texture or with a different stitching. The entire *llikllita* has two linings: a heavy interfacing and a broadcloth (the same as that used for the waistband of the *pollera*). The *llikllita* completely covers the middle and upper back up to the top of the neck and two of its ends are fastened at the breastbone, ideally, with a silver pin with multicolored inlaid stones. From the back, the *llikllita* looks like a trapezium, while from the front it looks like

a trapezium closed in by two triangular flaps. It is said to be a kind of a packsaddle or *enjalma*. Ironically, packsaddles are understood as "warming" the backs of the animals. As will be seen below, on festive occasions bulls are dressed with packsaddles. Symbolic packsaddles are also placed on the back of the cosmic figurine presented as an offering to the spirits or *Apus* that inhabit the mountains.

Hats are recognized as distinctive regional wear. Andeans carefully scrutinize people's hats to determine their regional or ethnic affiliation. A woman wearing the complete *mestiza* outfit will most likely wear a white straw hat. Straw hats are custom-made. An individual's head diameter is measured and an imported natural straw hat (either from the northern coastal town of Catacaos, near Piura, or from the Andean town of Celendín, near Cajamarca) is molded to fit precisely above the ears to partially cover the forehead. The crown of the hat resembles a perfect cylinder. The entire hat is whitewashed, and a black band tied in a bow divides the brim from the crown. On rainy days an increasing number of women cover their hats with plastic bags or wear the more long-lasting felt fedora hats. Unlike the rest of the outer dress, straw hats are not exclusive to the *mestiza* dress. There is indeed a free choice as to which of the two styles of hats is favored. In general, however, although both fedora and straw hats are recognized as typical *abanquino* (from Abancay), *mestiza* dresses are associated with the whitewashed variety.

Few *mestizas* wear black-laced shiny boots up to the mid-shin, although they say it is the most appropriate footwear for this attire. In general, though a variety of shoe styles may be worn, the most salient feature is that a *mestiza* should never be barefoot.

A *mestiza* dress can be quite expensive, running well into the hundreds of dollars. The different materials that compose the dress come from France, Italy, Argentina, and Peru. The embroidered lace may come from Belgium, the velvet from France, the trimming lace from Italy, the mother-of-pearl buttons from Argentina, and the cotton linings from Lima.

Peasant Dress

The dress worn by peasant women or *mujer de pollera* is simpler though structurally similar to that of the *mestiza* (figures 1, 2, 3, 4, 5, 6). It also consists of several layers that echo each other. The main difference between both dresses is that the one worn by the peasant woman lacks ornamentation. Both underskirts are identical and have no lacework at-

tached. The *centro* and *pollera* could also be identical. A new skirt may be worn as a *pollera* on formal occasions or protected from the weather during rainstorms or agricultural labor. On the upper body, the vest, or *corpiño, chaleco*, is separated from the *saco*. A large apron covering almost the entire skirt and the front part of the blouse is often worn. The apron is made of thick cotton in a solid color with stitched pleats at different places. The length of the peasant woman's dress ranges from the mid-knee to almost above the ankle. Although classification as to age and status could be misleading, it seems that older women tend to favor longer skirts.

Instead of the *llikllita*, the back of the peasant woman is warmed with a Western-style sweater or *saco de abrigo*. Often, to give extra warmth to their backs, they also use a folded blanket held at the front with a large kilt pin. In fact, the *mujer de pollera* seems to be wearing Western clothes and elements in a non-Western way. Most of her clothes are not custom made but increasingly are ready made. The choice of hat is optional, and many women wear either type of hat depending on the occasion or on their taste. There is a wide range of footwear, though laced boots are never worn. Barefoot peasant women are not uncommon (figure 7).

There is a close correlation between style of dress and hair. Women wearing traditional clothes —the *mujer de pollera* and the *mestiza* — have their hair long, combed in two braids.

City Dweller's Dress

City dwellers wear Western-style dress in a single layer. The young may be seen wearing T-shirts and trousers, plain Western dress, sneakers, shoes or Indian sandals. They do not wear hats. Older women wear dresses or skirts, blouses and jumpers. On cold days they do not cover their bodies with shawls but use Western-style jackets or overcoats. In the city of Abancay, city dwellers do not wear hats. In the villages of the province they may wear fedora hats or unpainted straw ones. They follow the fashion of Cuzco and Lima. Dress does not necessarily divide their bodies into two parts. Those wearing Western clothes wear their hair loose, combed in one braid or short. In fact, the most drastic transformation in the process of acculturation of a *mestiza* or a peasant consists in cutting her long braids, changing the two-part dress into a single one, and abolishing the layers of clothes. Status and role are clearly reflected in clothing and, particularly in the city of Abancay, it is easy to distinguish occupation and wealth through clothing.

The *Lliklla*

Except for the city dwellers who live in the city of Abancay, all women, regardless of dress style, may wear a *lliklla* or large shawl. *Mestizo* women may at times wear *llikllas* on top of their *llikllitas*. *Llikllas* are multicolored square wool blankets. They are supposed to have a perfect lengthwise symmetry. Hence, they are made by manufacturing a long rectangular striped piece of cloth, which is cut across half of its length. The two resulting pieces of cloth are then sewn together alongside each other producing a square blanket. The design of the uncut cloth is always divided lengthwise into three parallel areas. The lateral areas have several stripes which may include one or more designs: in passementerie or *chichima* (Q.), or in half or full rhombs (*pallay* [Q.], a term referring to single rhombs and *mach'aqway* [Q.], a design which combines rhombs in a row). The center area is woven in a solid dark color. The seam is either terminated in a simple way or with a series of stretches of triangles, alternating in color. A piece of a different cloth is sewn along the entire contour of the *lliklla* to strengthen it. *Llikllas* are associated with the rainbow and like all multicolored objects they have a positive connotation.

Women do not weave their own *llikllas*, but they do generally process the purchased or bartered wool. They spin the wool on a spindle and then twist that of two spindles together into a single thread, rolling it up into a single skein. The wool is then dyed with a variety of natural and chemical dyes (the center part is usually dyed with natural dyes) and rolled up again. The spinner takes her wool to a weaver (usually male) and specifies the particular color pattern and design she desires (figure 8). *Llikllas* also may be purchased ready made from the inmates at the Abancay prison or purchased factory woven from the commercial establishments in the urban centers. The more intricate the design the more beautiful the *llikllas* are considered to be. Factory versions are looked down on. Each *lliklla* becomes an individualized possession and is considered a unique piece of craftsmanship. A woman may recognize a stolen *lliklla* a few decades after the loss. Women also identify each other's *llikllas* .

Women use *llikllas* to carry babies or objects on their backs, tying them up with a double knot at the chestbone. Men may occasionally also use *llikllas* to carry objects, though they tie them laterally, one side over the shoulder, the other under the arm. Though by function *llikllas* should be considered human packsaddles, they are not verbalized as such by the informants. They are part of the ritual paraphernalia so important in propi-

tiation of maize and cattle, in weddings, and symbolically in the offering to the *Apus*.

Change and Dress

In the villages of the province, slight variations in self-presentation become more significant than in the city. Subtle changes have been brought about by literacy, the arrival of non-Catholic religious sects, and increasing access to the capital city of Lima. In an area where until the past decades literacy was largely limited to the male population, few women made use of their reading skills. Although it is often the case that adult women belonging to the Evangelical sect can read, they are not the only ones to wear glasses. Only those who know how to read should wear eye glasses. Evangelical women dress like city dwellers and wear neither of the Abancay hat styles, but rather a natural straw hat that, although not exclusive to their sect, has become identified with them in the area. The place of residence for Evangelicals is not distinctive, as they may live in rural or urban areas. In all cases they have severed, at least ideologically, their ties with their communities.

Migrants who have moved to Lima and return for visits wear the most eclectic of clothes. They may often wear high heels, tight trousers, and colorful polyester blouses. They are referred to as *limacas*, a pejorative term, as opposed to *limeñas* or true Lima natives. In addition to this group there is another set of temporary migrants, who move to Lima and have retained Abancay province as their point of reference. When they return they bring back large quantities of appropriate clothes.

For instance, when José, a man in his early forties, came back to the village after working a number of years in Lima, he was wearing a two-piece suit with a nice white shirt, a new leather belt with a bright buckle with his J initial, a pair of black shiny shoes with socks and, contrary to local custom, was hatless. The next few days he showed himself off in the village, walking along the streets, talking to people and offering them beer. After a short time, however, there was no trace in his dress that reflected his long stay in Lima. He would wear his suits on social ritual occasions and during visits to town. José, however, had brought back with him enough clothes to last a lifetime: two dozen suits, four dozen shirts, several dozen sets of underwear, socks and shoes.

On the other hand, when Eulalia, a woman in her fifties, came back from Lima, she had changed her *mestiza* dress to an ankle-length solid dark color skirt. Her son in Lima was an entrepreneur and there she felt embar-

rassed by her traditional dress. Back in the village, she was criticized by her peers because they thought her change of dress made claim to a status which she did not merit. Unlike Eulalia, who dressed in either style, there are women who can no longer afford the *mestiza* dress. These women change parts of their clothing in an effort to represent their ideal of *mestiza* dress.

Wearing a single skirt for both the *mestiza* and the peasant is a sign of poverty. Saying that a woman is a *mujer de una sola pollera*, or a woman of a single skirt, is equivalent to saying that she is poor. The amount of clothes a woman may have accumulated in her lifetime is taken to be a reflection of her wealth. Women in their old age often keep acquiring clothes they may never wear. As will be seen below, all the clothes of an individual are displayed in the funerary ritual of "clothes washing" or *p'achat'aqsay* (Q.) and may be used later in the annual remembrance of the dead.

Clothing and the Rites of Passage

Transformations in the development of the individual are marked by changes in clothing. Each rite of passage prescribes a new or clean set of clothes. A newly born child spends the first four months wrapped up in a diaper or in a bandage, a *walt'ana* (Q.). The child then wears clothes that are not identified with either sex. On the child's first birthday the parents buy, according to their economic conditions, anywhere from one to four sets of new clothes, which the child will wear during the day of his first birthday. The new clothes are said to bring good luck. Another important part of the celebration is the serving of a whole roasted guinea pig to the child. As with the wearing of new clothes, the food presentation sets a pattern that will be repeated in all important ceremonies during the life of an individual.

The social persona of a child is established through two complementary rituals any time before the age of three (timing depends on social class). The first of these rituals, Catholic baptism, is aimed at providing the child with his first ritual kin (godparents) and reassuring the salvation of his soul. Whereas the second ritual, *chuqcharutuy* (Q.) or first haircut, provides the child with the first animal and land possessions and with first direct links with the spiritual world. Godparents provide the child with a complete new set of clothes to be worn at the ceremonies. In the ritual of *chuqcharutuy* the child sits on a chair, covered with a *lliklla*, as the different braids into which the hair has been tied are cut consecutively by all attendants. They deposit the braids among flower petals in a plate and make large donations of property, animals or money to the child. The clothes given to the child for the ceremonies are, at least in principle, the first ones to identify the child with the proper gender:

miniature adult clothes. After the haircutting, a male will wear his hair short, while a female will grow it long and wear it in two braids.

Marriage forms the second set of rites of passage where the wearing of new clothes is prescribed. Throughout the province *mestizos* and peasants undergo two different rituals: *tapukusqa* (Q.) or engagement and wedding, the first stage of the marriage ceremony and the Catholic ceremony. These rituals take place around age eighteen for the bride. At that time the couple establishes residence together. Only a few years later, when the union established with the *tapukusqa* turns out to be successful and the couple has several children, the Catholic wedding takes place. *Tapukusqa* is considered the last expense or *p'achamuday* (Q.), a change of clothes, the parents are going to make on behalf of their daughter. They buy her a completely new set of clothes. A colorful kerchief is pinned on the bride's new dress. The other end of the kerchief is held by the groom's mouth, and then bride and groom are held together by grasping two different ends of another colorful kerchief. They leave the bride's house and set out to the groom's, bound together by the kerchiefs. Upon their arrival they are greeted with flowers spread all along the road about one hundred and fifty meters from the house. At the entrance of the house they go through a colorful flower-arch. In Catholic weddings the couple and their would-be marriage godparents arrive at the church walking under a colorful arch or *k'illi* (Q.). The dictionary defines *k'illi* as a seam or border of a *lliklla* (Middendorf 1890:206). It is sewn together or attached to something (Gonçalez Holguín 1952:308). A *k'illi* is made of two long wooden sticks wrapped at the top-half with a white cloth and tied every twenty-five or thirty centimeters and ending at the top with palm leaves and small flags. The two sticks are connected at the top by a band of cloth from which hang bottles of cane alcohol and Coca-Cola, ring-shaped breads, several small plastic dolls, old silver coins and colorful ribbons. The couple stands in the center under the *k'illi* and at their sides, alternating sexes, stand their godparents. Within the scope of this chapter it should suffice to note that both arches and the colorful kerchiefs are symbolic representations of rainbows. Like the *lliklla*, which mediates the change of status of the child at *chuqcharutuy*, the rainbow is a mediating symbol between bride and groom at the *tapukusqa* and between the couple and their future ritual-kin at the Catholic wedding.

Death rituals, the last rite of passage of an individual, consists of three stages: wake, burial and "clothes washing" ritual or *p'achat'aqsay* (Q.). These stages aim at securing rest for the corpse by giving the living relatives a preventive purification of the contamination that the bad odor sent forth by

the corpse may have given them. These rituals reassure them of having provided the soul with a proper farewell to start its journey. Seen from the perspective of the living, it becomes a farewell in three stages. People prepare for death well ahead of time. According to their means, they set aside land and animals to pay for the ritual expenses, a set of their best clothes to be buried in and, in some cases, may have even made arrangements to purchase their own coffin. When relatives in charge of the burial fail to comply with the deceased's last wishes, they are severely criticized. The clothes the deceased are buried in should at least reflect their status during life.

At wakes the corpse is covered with a shroud, used as an undergarment, and with the best clothes the deceased owned. On the day following the burial the ritual of "clothes washing" takes place. Relatives, ritual kin and a few friends gather at the deceased's house. All the things made out of cloth that belonged to the deceased (heavy blankets—referred to as the "bed," saddlebags, sacks, clothes) are distributed by the closest kin to those who come to attend the ritual and do the washing. Careful note is taken of which clothes are given to whom. People volunteer to do the washing. Preferably, the washing is not done by the immediate kin but by ritual relatives. Ideally, due to differences in strength, men should wash the heavy belongings and women the lighter ones. However, there is no clear-cut division of labor for this purpose. The aim of this ritual is to rid the deceased's clothing of its smell, said to be dirty and full of perspiration. Actually, the odor of the dead spreads over to their clothes, and, by extension, these become a source of pollution for the living. The soul is disturbed when the clothes are left unwashed. The ritual has a double purpose. By securing the tranquility of the soul on its way to its new destiny, tranquility of the living also is secured. Disturbed souls and the odor left behind by the deceased are major causes of sickness.

Except for very old clothes, which are burned, all clothes are washed in a river. The ritual of "clothes washing" differs from regular laundering. It gathers people of both sexes to perform a task usually done by women: washing clothes other than one's own. The mood is usually merry, and while a bottle of alcohol is passed around, stories about soul apparitions on previous similar occasions are exchanged.

At "clothes washing," the soul of the deceased often makes an appearance for a last farewell. It presents itself in the unpredictable shape of some kind of small bird or flying insect, a bug or a butterfly. It comes and rests on one or two of the closest relatives. These apparitions, however, are not taken very seriously, and people do not show any special deference to the

insect. Under the strong highland sun, the clothes dry in a few hours, forming a display of the possessions of the deceased. Once dried, the best of each kind is selected. A *poncho* or a *lliklla* , in the case of men or women respectively, is spread on the earth. The clothes are placed with extreme care on top of it to reproduce the deceased figure faithfully, with all appurtenances he/she normally wore. Thus, if the deceased used to wear a wool hat under the straw one, or, if she wore a specific number of skirts, this is reproduced in the arrangement of the clothes. People say this act convinces those who have not attended the burial (relatives who have come from distant villages) of the death of the person. Furthermore, this is the last farewell.

One by one, those attending the ritual, who are by far less numerous than those at the burial, embrace the bundle of clothes shaped as a living person and talk to it as if it were alive. They recite the same prayers that were performed at the cemetery. The sacristan is brought in to recite some mixture of Latin and Spanish, probably ending with a speech in Quechua. Holy water is poured on the clothes following the sign of the cross: from head to feet and from left to right at the level of the chest.

Early that morning samples of all the food and drink favoured by the deceased are prepared by some of the women (ideally ritual kin). They place the food in a miniature saddlebag that they put on the back of a miniature stick horse or *q'aspiuywa* (Q.). The deceased's preferred drinks are poured into miniature bottles (small medicine bottles). Cigarettes and some fresh fruits are also included in this meal or *ofrenda* for the dead.

The *ofrenda* is placed in any small hole nearby, referred to as a small cave or *cuevita* or *grutita*. The miniature bottles in which drink had been poured are opened inside the cave to be drunk by the soul on the long journey. Lighted candles are placed next to the food, and the small cave is closed up with stones. The deceased's clothes are collected with no further ritual, and drink and cigarettes are distributed among all. Food and drink will be served back at the house of the deceased, as it is served at the end of any lay communal work day.

When asked, people do not state explicitly that the *ofrenda* is actually for the soul to eat and drink, and there is no consensus on the stages the soul has to traverse on its way to its final destination. Through stories narrated about deaths, harm and souls, and through commentaries about events that happened in the village during my stay, it is possible to affirm that there is a strong belief behind these practices. The soul, as any living human being who goes on a journey, needs its *kukavi* (Q.) or food for a trip. A story circulated about a man who, having died of a heart attack, resurrected hungry

and thirsty, since the food had not been placed in the tomb itself but, as is customary, in the *cuevita* next to the river. This *kukavi* is just the beginning of a series of offerings that will go on as long as there are living relatives who remember their dead. As with a child's first birthday, clothes and food set a pattern of future ritual activities.

The pattern of cloth laying at the ritual of "clothes washing" will be repeated again in a simplified manner at masses for the souls of dead people. This occurs in the church on the occasion of any major saint's day. Most priests outside of the city of Abancay still allow people to bring into the church a table which is covered with a black cloth or with a large blanket folded by peasant women and tied with a kilt pin. Ideally, on top of the cloth, the clothes of the deceased should be extended as in the *p'achat'aqsay*. In practice, few priests allow the bereaved to carry out the full ceremony. Only wreaths of white flowers resembling those at burials, a pitcher of holy water and lighted candles are placed on the cloth. The church is an impressive sight. The central space is filled with rows of tables. These are surrounded by the relatives of the deceased, who are dressed in mourning clothes. Illuminated by candles against a black and white background provided by the contrast of the flower arrangements and the black clothes covering the tables, it seems as if a big wake for the recently deceased were taking place. In fact, some of the souls for which tables are set have long ago abandoned the world of the living. A table is considered the best way to honor a deceased in church.

People in mourning wear black clothes: within each dress style black is used to mark mourning. Regardless of the style, full mourning is worn for a period ranging from one to three years, and half-mourning (only one element of the dress is black) is worn for a similar length of time.

The Clothing for the Person

In the *p'achat'aqsay* and the laying of clothes at the church, clothing replaces the person. However, the identity between clothing and person becomes clearer when we consider that the substitution can also be used in the manipulation of the realm of the spirits. Thus, it is not only a substitution to memorialize an absent one, but, due to the exigencies of the moment, it may also alter the life of living individuals.

The first instance of this type of substitution appears in "witchcraft." *Daños* are complex structures of multiple elements. They are considered as extremely polluting, dangerous self-contained wrappings that must be carefully tied, lest they let loose their harm and affect the wrong person. Their configurations are ancient. The elements used (which are recurrent in other

contexts) have a logic and a language of their own and are interpreted by a ritual specialist.

Daños are always homologous to the harm intended. Accordingly, to cause the sickness produced by *machus* (Q.), or pre-Columbian, uncivilized, non-Catholic spirits, the bones or mummified remains from a pre-Columbian burial site must be dressed with the victim's clothes. To invoke *daños*, ritual specialists often use frogs, bodily parings, and partially eaten food. The frogs may be dressed with a piece of cloth belonging to the person to be harmed, and thus take the place of the victim. Different combinations of these elements can produce varying effects.

The identified clothing also appears in healing and the contagion of ill fate. Often, to heal children from soul loss or *susto*, a cross is dressed with their clothes turned inside out. Large black blankets also cover the body of a sick adult, thus allowing the cloth to absorb all the evil, polluting essence of the disease. Ill fate is said to pass by contagion when one person wears another's clothing. There seems to be a consensus that it is easier to acquire bad luck through the use of another's clothes than through body-to-body contact. People prefer to wear their own old and often mended clothing rather than to accept second-hand gifts from others.

Two cases brought to my attention during fieldwork underscored the identification of people with clothing. The first case occurred when a *kamaqwaqlla* (Q.) was killed by his wife and her lover. As a *kamaqwaqlla* has a strong influence on the *Apus*, he was killed in several stages to prevent the revenge of his soul. First, his body was mutilated, his head was taken off his body and his tongue was removed, roasted, and eaten. The parts of his body were buried apart to prevent a proper burial. All his clothes, except for one set, were also scattered and buried apart to prevent a burial through the proper "clothes washing" ritual, *p' achat' aqsay* . Thereafter, a second, metaphorical killing took place. A lamb was dressed in the remaining set of clothes and burnt alive amidst forty-four ritual offerings to the *Apus*. The *kamaqwaqlla* was killed in this way to kill both his body and soul. The killing of the body ended up being a very simple affair. To kill the soul, however, the murderous couple had to go to extremes to dispose of it and to bribe the *Apus*. Central to this preventative activity was the use of the *kamaqwaqlla's* clothing and its proper destruction.

The second case was narrated to me in connection with the death of a woman who was said to have discovered a *tapado* or treasure. *Tapados* are treasures buried inside the earth that belonged to the *machus* . According to this story the woman who discovered a *tapado* died out of ignorance. She had

seen an area of the earth which was glittering and approached it. When there are hidden treasures in the earth, the area above them glows at night. Everybody knows, however, that a person who attempts to unearth such a treasure will die because of the "wind of the *machus*." This woman did not pay any attention to the warning and suffered the consequences. During that conversation, it was explained to me that the only way to avoid suffering the consequences of the "wind of the *machus*," was to take off any piece of clothing and drop it while fleeing. This action causes the "wind of the *machus*" to attack the clothing and not the person.

Symbolic Potency of Items of Dress

In the province of Abancay maize is the priveleged crop. The production of maize requires rituals at specific moments during the year. Its cycle marks the discrete division of the agricultural year. Cattle, on the other hand, are the privileged animal species whose care produces an annual cycle that also marks the life cycle. The observance of maize and cattle rituals in the villages coincides only at specific times. For most of the year they are mutually exclusive. Maize rituals make statements about social life, whereas those for cattle are associated with the natural conditions of humans. Cattle represent the ultimate source of vigor for humans but are a society apart. Furthermore, cattle are conceived of as the metaphorical maize of *Apus*.

Llikllas are used in rituals pertaining to maize and cattle. At the storage of maize, a ritual table or *mesa* is laid. The purpose of this ritual is to make invocations to *Apus* and thus ensure the protection of the crop until the next harvest. The maize *mesa* consists of placing two *llikllas* next to each other at one of the edges of the area where maize is drying. At the center of each *lliklla* special ritual stones, or *taqes* (Q.), a multivocal Quechua term that designates ritual stones and first-born females, are placed. These are dark stones that bulge in different areas and are extremely irregular and rough. They are said to resemble maize ears and have been found in their natural state. They represent permanence and are intended to keep the maize in its storage place throughout the year. These stones are rubbed and tied with objects (llama fat, flowers) that, in different contexts, represent fertility and reproduction. *Taqes* are surrounded by the best ears of maize of the harvest. At the furthest extreme, a bag full of coca leaves is placed between the *llikllas*. Towards the front is placed a bottle of cane alcohol. In front is placed a pitcher of maize beer (*chicha*) and two small wooden vessels used in rituals to drink cane alcohol. The configuration of the maize *mesa* thus presents two

symmetrical areas with the *taqes*, symbols of both reproductive fertility and maize, at the center. After libations are completed, the *llikllas* are used over and over to transport the real maize to a storage location.

In the dry season, while the fields are fallow, the feast of cattle or *wakamarkay* (Q.) takes place. People say *wakamarkays* aim at cleansing and regaling cattle. After the animals are marked, a cattle *mesa* is laid to invoke the cattle protector spirits. A *lliklla* is extended on the ground, and objects used throughout the ritual are carefully placed on top and outside the *lliklla*. Four seashells are placed at each corner, whereas at the center a large grass cross and another seashell are placed. On one side of the *mesa*, between two corner seashells, the scientific objects used to ensure the health of animals (syringe, medicine bottle, and pincers) are placed, and the horn tips cut during the ritual are carefully paired. The cattle stamps are situated on another side of the *mesa*. A jute bag containing coca leaves, incense, small wooden vessels, cut horns, tails, and condor eyes appears on the opposite side. Outside the *mesa* are placed all the objects used for marking the animals and those objects that had been used in the ritual enactment of cattle by humans. Although a complete analysis of the *mesa* is beyond the scope of this chapter, it should be sufficient to remark that the objects placed inside the area delimited by the *lliklla* represent the elements needed for the survival and health of the animals. Those placed outside are the elements necessary for the synecdochical and metaphoric relation with human beings.

In both *mesas*, *llikllas* are a symbolic universe. For example, in the cattle *mesa* the strength and vigor of the animals are spread out on the *lliklla* where the medical implements for protecting cattle health and sustenance appear. During the maize *mesa* rituals, the symbolic maize and all the elements associated with its multiplication are placed on the *lliklla*. In both cases, mediating elements are placed outside the *llikllas*. In the case of the maize *mesa*, the elements are libations to the spirits. In the cattle *mesa* the elements are those used in the ritual enactment of cattle marking. The laying-out of ritual elements resembles the offerings made to the *Apus*. These offerings, called *despachos*, make use of a flat delimited area where elements representing the universe are placed. Outside this area the symbolic objects representing human biological requirements appear. Interestingly, the flat object delimiting this area is a piece of paper containing threads of colorful wool that represents the rainbow. As mentioned before, the *lliklla* also is associated with the rainbow because of its color structure and designs.

There is one more ritual, a shamanic séance, which requires a *mesa*. The *mesa* is literally a table on which the elements required to communicate

with the spirits are placed. During the séance the spirits themselves appear and partake of these elements. Unlike cattle and maize *mesas*, no *lliklla*, or a representation of the rainbow, is required. This type of *mesa* does not contain a symbolic representation of the relevant universe. Unlike the other three rituals, the desired effect is not produced by its metaphorical representation. In this case, the spirits present themselves and the individual can relate directly with them through the use of language. When, however, the *lliklla* is part of the ritual, it symbolically envelops the whole universe. Contrary to other garments, the *lliklla's* primary referent seems to be in the realm of ritual, while its derived meaning is in the realm of everyday life.

Cattle are associated with another piece of cloth. In bullfights, which occur in the maize fields before ploughing, ritual confrontations between humans and cattle take place. The sponsors of the event wear luxurious packsaddles or *enjalmas* on their backs that are fastened at the chestbone with a pin. *Enjalmas* are pieces of fine cloth adorned with multicolored textile scraps or pieces of shiny paper. They are worn as if they were small *llikllitas*. The husband and wife sponsoring the event make libations to the *Apus*. They prepare the cattle before the fight by placing the *enjalmas* on the backs of the animals and pour and drink more alcohol. The *enjalmas* are then placed on stakes set in the field. After the bullfight, *enjalmas* are returned to the backs of the sponsors and the animals. Cattle are believed to be the epitome of vigor. In ritual, a metaphorical link between humans and cattle is created to ensure the contagion of vigor to humans. The ritual wearing of the *enjalma* as a *llikllita* reinforces this belief. *Enjalmas* are, as mentioned above, animal *llikllitas* that serve to warm the back of the animal. In the bullfight ritual, the relationship is emphasized by the fact that not only the cattle wear the "*llikllitas* ," but the sponsors also wear *enjalmas* as *llikllitas*. They are at that moment mirror images of the bulls because they wear the same clothing at the same time.

Dress of Virgins and Saints

In areas outside the city of Abancay, each village has a patron saint and a few other saints for whom celebrations are held every year on fixed calendrical dates. Since most villages lack permanent priests, it is on these occasions that priests travel to the villages to celebrate mass in honor of the saints, to bestow the sacraments of weddings and baptisms, and to say masses in honor of the dead souls. Despite the possible presence of the priests at other times, festivities are the favoured occasions to take sacraments and have the dead souls blessed. It is the presence of large numbers of people who

congregate near and in the Church on saints' days that give legitimacy to the rituals.

On the vesper of a saint's feast, the sponsors of the celebration must decorate the church or chapel where the mass will be held. This adornment of the church is referred to as *altarwatay* (Q.) or tie the altar. Ideally the sponsors of a celebration, the *carguyoq* (Q.), are a husband and wife. They bring flowers and colorful bands to decorate the church and hang them from the area of the altar. The bands are communal property and are stored throughout the year by an acting priest. Only those sponsoring a feast are entitled to borrow them. Flowers are placed in every niche, next to the images of saints and virgins, and on the altar. The church, otherwise neglected during the rest of the year, acquires a solemn but festive air. On the day of the mass the church is further adorned with flowers and lit candles brought in by devotees.

Celebrations are divided into several stages over a number of days and directed by different sponsors according to their personal associations with specific saints. The central point of the festivity, though not the most laborious one, is attendance at mass and procession of the saint. The sponsors are in charge. They appear in church dressed in their best attire. They walk slowly in procession holding flags, long wax multicolored candles, and a long cane decorated with bouquets of flowers. The women's bouquets are always smaller than those of their husbands. On the altar, these objects appear in mirror symmetry; the flowers and flags are placed on the ends of the altar. The candles are placed between the flags. After the celebration of the mass, the two candles at the sides of the altar are lighted. Family groups disperse and festivities continue on a personal level. For example, those who have been married will celebrate their weddings, and those that have a close relationship with the sponsors will attend the festivities in their house. The church is the only place where religious rites are observed.

On the eighth day following the church service, the *cargo* is over. The celebration ends with the *kacharpariy* (Q.), to bid farewell or to let loose, and with the transmission of the *cargo* to the next year's sponsor. First the altar of the church is dismantled—the *altarpaskay* (Q.) or untie the altar. The sponsors carefully bring down the bands that were placed over the altar and proceed to wrap themselves with them. They wear them transversally over the breast and back and tied at the waist. Several members of the sponsors' nuclear family may wear these bands. Then they transfer the *cargo* to the next year's sponsor. The departing ones take off their bands and place them over the new sponsors. The transfer of bands takes place between people of the

same sex (women hand them over to women, men to men). Both sets of sponsors, new and old, drink *chicha* and cane alcohol together and stroll around the village square, singing and dancing at each corner.

Ceremonial bands also are worn by political authorities. In the traditional political structure of villages in the province, the *varayoq* (Q.) and the *comisario* were the most powerful authorities within each community. The *varayoq*, who could be compared to the *carguyoq* in the *altarwatay/ altarpaskay* ceremonies, was elected at each New Year. He was invested with the symbols of authority: a staff and a band. By wearing the bands that were used to decorate the church and holding a flower staff throughout the *cargo*, the sponsor is similarly empowered. As previously demonstrated, cloth has the property of impregnating itself with the odor and fate of those who wear it. Hence, by wearing the bands used to decorate the church, the sponsors are impregnating themselves with the sacred essence of the church. In the transmission of political power, the staff and band, impregnated with authority, are physically transferred from the body of one temporal political official to another. In the case of the saints' feasts, the band impregnated with sacred essence and prestige also is transferred from one religious authority to another.

Besides the decoration of the church, the sponsors also take part in the dressing of the saint. If the image of the celebrated saint resides in the church, and hence belongs to the community, the sponsors may give it new clothing. Images of virgins and saints are not dressed like ordinary people but have elaborately embroidered garments in the most elegant Spanish eighteenth- and nineteenth-century fashion. Their dress consists of long, embroidered garments not comparable to any quotidian dress. It is never the case, for example, that sacred figures wear city dweller, *mestiza*, or peasant woman's dress. Moreover, their dress elements do not divide the body in two as in *mestiza* dress. The sacred figures never wear hats. The hair is loose, and the dress is covered by body-length cloaks. These images are handled with care and respect.

During Holy Week, the church and the sacred figures are dressed in mourning. Altars and niches which contain images of saints other than Christ and the Virgins Dolorosa and María are completely covered with dark purple cloths. The colorful dresses on the statues of the Virgins are replaced with black ones. White and purple flowers, *ñuqch'u* (Q.), which grow wild only at this time of the year, are brought into the church. Churches become mourning houses for Christ. The life-size image of Christ covered with black cloth is laid on a table in front of the altar. The statues of the Virgins in

mourning are placed to the left and right sides of the image of Christ. At this time of year, Christ is believed to be dead. In all villages, people are enacting a ritual of liminality. On each night of the week in the church, successive wakes are held for Christ. During this period the universe also finds itself in a liminal position. Nature is blessed and the *Apus*, witnesses of human action, are absent, confessing their own sins to God. Human actions are intended to help along the universe to pass through this difficult period. In contrast to the statues of the Virgins and the church itself, people dress normally.

On the feast of Santa Cruz the big crosses on the top of the mountains are brought into the villages. They are adorned with new shrouds and white garlands, the same flowers used in burials of adults. This feast is the enactment of the *via crucis* or the way of the cross. People say they are doing what Christ did when he was living on earth. The duration of the feast is variable and on each day the cross is taken to a sponsor's house. Devotees bring candles, which they light on a raised platform, and kiss the shroud. Structurally, crosses are placed in the same room and in a position similar to that of corpses during wakes. These wakes are, however, happy ones, and for most of the festivity the cross remains in its designated spot while people sing, dance, and drink. The feast ends when all the wakes are over. The cross is carried back to the top of the mountain, where it remains shrouded until the following year. Unlike the sacred bands of the saints' feasts, which pass to the new *carguyoq*, the shrouded crosses on the mountain tops have been polluted by human contact. The inverse process of contagion has taken place. People do not touch the new shroud in order to impregnate themselves with the sacred essence of the cross, but rather they come into direct physical contact with it to cleanse themselves. This is the Christ of the *Agnus Dei*. This transference of pollution to the cross is further emphasized when the crosses are brought into the village. They are not placed in the church, a sacred dwelling, but are carried from one private dwelling to another.

The *Despacho*, Messenger of the Gods

The *despacho*, or offering packet, represents the most complex interaction between humans and *Apus*. It is also the most complex of symbolic objects, composed of discrete units, each in its turn having a strong symbolic content. It has an inherent latent power that is only activated in ceremonial contact with the beneficiary. This inherent power resides in the order and combination of its constituent ingredients. It has two distinct configurations. The first one is formed by an initial ordering of the ingredients in a rectangular pattern along a central axis, on a flat surface (discussed

above). Most ingredients are kept apart in separate wrappings. The individual on whose behalf the offering will be made buys a *despacho* wrapped in newspaper and takes it to a shaman. During or after the séance the *despacho* is rubbed all over the beneficiary's body, from head to feet. The shaman, then, prepares the *despacho* for burning. This time, the ingredients are carefully unwrapped to be combined in a concentric configuration: some elements are placed directly on a figure made of llama fat. Other ingredients are placed along its circumference while still others are placed on both areas. The llama figure represents a snow-white creature dressed with jewels, buried in a garden of flowers, sparkling minerals, and gold and silver objects. Its body is covered with colorful beads, which, in its first configuration, represented gravel, the antithesis of the rainbow. In this second configuration, black, flat seeds are inlaid on its forehead and "shoulders" as "small wings." Gold and silver threads are placed around its "waist." Gold and silver sticks are set on the body. Llama wool threads, representing the rainbow, are placed on top and around the figure, partially covering it. Two half segments of condor feathers are placed "like wings" in the back sides of the "body." Finally, gold and silver leafs are attached to its body "like packsaddles."

The sight of the *despacho* is striking with its wealth of color and profusion of textures. It represents the sum total of all the goods that exist in the world. It is clothed in essentially metaphoric dress. A close examination of the figure indicates duplication of elements reminiscent of the structure of *mestiza* dress. There is an anti-rainbow (beads, associated with gravel on the road and the dry season) and a rainbow (wool threads), There also are small anti-wings, (flat, black seeds, associated with permanence) and metonymic ones (condor feathers, associated with flying away). Gold and silver threads are in opposition to the beads and represent a celestial road. Gold and silver sticks, associated with lightning, represent the anti-rainbow in a different sense than the beads. Lightning also is thought of as mediating between water and earth but is considered a negative mediator. Like humans and cattle, the llama figure wears *enjalmas*, albeit two of them. The offering packet is the messenger of the *Apus*. Thus assembled and impregnated with the body odor of a human being, it is burnt and will reach the *Apus* through smoke. Its destruction will restore the well-being of the individual on whose behalf it is offered.

Conclusion

> In the Andean region [in pre-Columbian times] the object of greatest prestige and, hence, the most useful one in the wielding of power, was the woven cloth (my trans.; Murra 1958:165).

Murra emphasizes the presence of cloth in every aspect of ritual, social, economic, and political life in different regions of the Andes. In this respect there has been an extraordinary continuity in this area. What is the reason for this widespread use? What follows is an attempt to give a synchronic answer to this question.

I approach the answer by reviewing the contexts in which clothing has appeared as a privileged medium. Clothing acts as a mediator between different realms. The type of mediation is of a very peculiar kind: contagion. Between the sacred and the profane, clothing is the means by which "sacralization," or becoming sacred, is received. This process occurs when touching the bands in the church. Sacred power also is transmitted through the *enjalmas* of the bullfight festivals and in the "clothes washing" ritual, the *p'achat'aqsay*.

Contagion is passed through clothing that links the profane realm with another realm that, for lack of a better word, I will call the anti-sacred. Here the clothing of the individual is taken and is used in the production of "witchcraft." Behind this action is the concept that the essence of the profane individual has passed to the clothing. This is actually expressed by the informants through the belief that the "odor" of the individual remains in the clothing.

Not all clothing, however, is used in this mediating role. The *lliklla's* mediation is not through contagion but is exercised in another manner. In the *mesas* for cattle and maize, we find the *lliklla* delimiting the sacred space upon which the symbolic statement will be laid out. The *lliklla* thus bridges the sacred and the profane by enveloping a symbolic universe. The total symbolic statement that will assure the multiplication of cattle and maize is included within it. A similar role is played by a symbolic replacement of the *lliklla* : the paper wrapping used in the *despacho*. This notion is re-emphasized because the *lliklla*, just as much as its alter-ego, the paper wrapping of the *despacho* , stands for the rainbow. Elsewhere, I have discussed how the rainbow is the necessary mediator if there is any transformation from the natural realm into the cultural one (Ackerman 1986).

Except for the *lliklla*, all mediation by clothing is mediation by contagion. Contagion, of necessity, implies the transfer of an abstract diffuse

essence. In all the mediations where the clothing originates in the realm of the profane, Abancay residents speak of an "odor" that remains in the clothing. As a manner of speaking, the totality of the individual remains with this "odor." In the more traditional area of contagion originating from the sacred, no such designation exists. The essence or power, transferred from one *varayoq* to another through the band of authority or through the church to one *carguyoq* and then to the other, is not concretized as any sensory stimulus.

To understand why clothing is so useful for rendering this corporeal abstract essence, we must review its use in everyday life. It is used to express differences not only of wealth but also of orientation and aims. Education and origin also find expression in dress differentials. Furthermore, the differentiation is not limited to minor items of clothing or simply to different materials used but extends to the use of radically different components to produce equally different wholes. For example, the dress of a *mestiza* has very little in common with that of a city dweller.

The referents behind the use of specific clothing styles are adhered to fiercely. Dressing inappropriately is considered an act of deception that is objectionable, not only because the people pretend to be something that they are not but also because the order of things is violated. An illiterate *mestiza* is an illiterate *mestiza*; no amount of Western dress will make her otherwise. Wearing glasses as a pretense of literacy is objectionable. Each thing has its proper place and violence to that order is an act of bad taste and bad manners at a cosmic level. As we saw above, society shames the transgressor.

Society identifies individuals by the dress they wear. In Abancay, furthermore, we see that this identification is hypostatized in the realm of spiritual beings. This hypostatization finds two expressions. In the human realm, the corporeal saints, virgins and other spiritual beings are carefully dressed and re-dressed according to the occasion but always in a style that is appropriate. At the more abstract level of interaction with spirits, the *machus* can be deceived into surrendering their human prey if the humans shed their clothing.

Once this identity of people with their clothing is experienced and talked about, it can serve to confront troubling unsolvable problems. Clothing can represent an already dead person in order that the living can bid the dead a last farewell and thus stop time for a necessary act of social politeness. It can also be used to take away the sins of the earth. Clothing may replace the sick when the *Apus* are invoked. It provides a substitute of the individual for sacred occasions. The dress of everyday life takes on symbolic dimen-

sions. The realm of the sacred is the stage whereon these symbols are manipulated through ceremonies. Not all clothing symbolism works in the same way. In the case of the *lliklla*, its original surplus of meaning derives from its symbolic function as mediator and as the envelope for the whole of the symbolized universe.

Endnotes

1. This paper has benefitted enormously from discussions with and insights of Daniel Levy. I am also most grateful to Dr. Stephen Hugh-Jones for his helpful criticisms. The data on which this paper is based was collected in the province of Abancay (Apurímac, Peru) between January 1981 and May 1982, in December-January 1984-1985, and in February 1986. A detailed analysis of the rituals, *despacho* and witchcraft referred to in the paper can be found in my Ph.D. dissertation, *The Muleteer of the Mountain Gods: Eschatology and Social Life in a Southcentral Andean Community,* Department of Social Anthropology, University of Cambridge, 1986.
2. Quechua terms are indicated with the initial Q.; all other foreign terms are Spanish.

Bibliography

Ackerman, Raquel
 1986 The Muleteer of the Mountain Gods: Eschatology and Social Life in a Southcentral Andean Community. Ph.D. dissertation, Department of Anthropology, University of Cambridge.

Gonçalez Holguín, Diego
 1952 [1608] Vocabulario de la lengua general de todo el Perú llamada lengua quichua o del Inca. Lima: Universidad Nacional Mayor de San Marcos.

Middendorf, E.W.
 1890 Wörterbuch des Runa Simi oder der Keshua Sprache. Leipzig: F.A. Brockhaus.

Murra, John Victor
 1975 La función del tejido en varios contextos sociales y políticos. *In* Murra, John Victor. Formaciones económicas y políticas del mundo andino. Lima: Instituto de Estudios Peruanos.

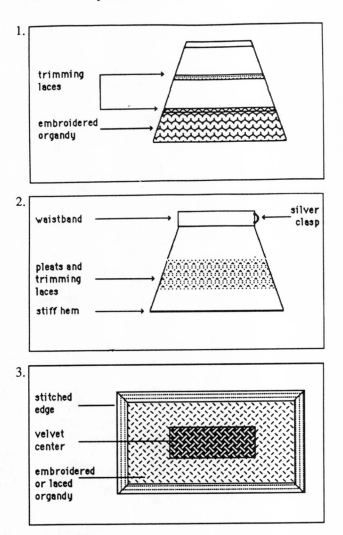

Figures 1, 2, 3. *Mestiza* dress elements. Drawings by Raquel Ackerman.

1. Underskirt (*fuste, fustan*).

2. Skirt (*pollera*).

3. Stiff shawl (*llikllita*).

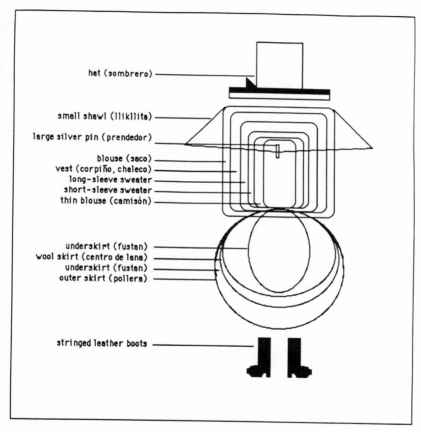

hat (sombrero)

small shawl (llikllita)

large silver pin (prendedor)

blouse (saco)
vest (corpiño, chaleco)
long-sleeve sweater
short-sleeve sweater
thin blouse (camisón)

underskirt (fustan)
wool skirt (centro de lana)
underskirt (fustan)
outer skirt (pollera)

stringed leather boots

Figure 4. *Mestiza* dress. Drawing by Raquel Ackerman.

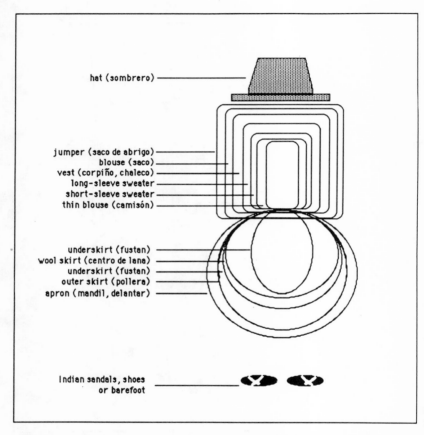

Figure 5. Peasant woman's dress (*mujer de pollera*). Drawing by Raquel Ackerman.

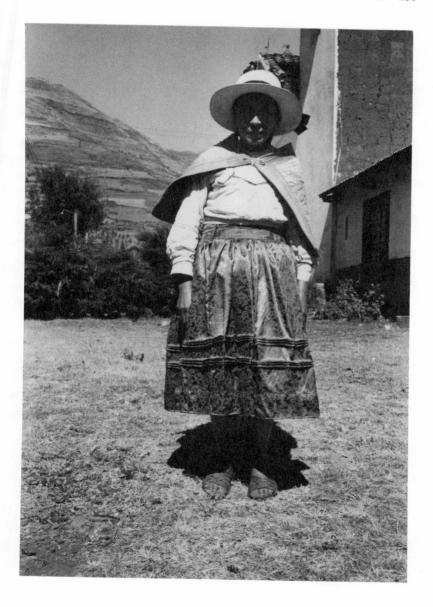

Figure 6. Woman in *mestiza* dress. Photo by Raquel Ackerman 1981.

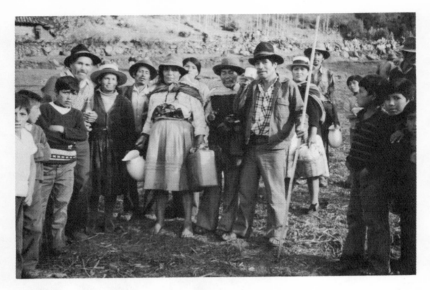

Figure 7. Sponsors of a bullfight in a rural community wearing packsaddles on their backs. Photo by Raquel Ackerman 1981.

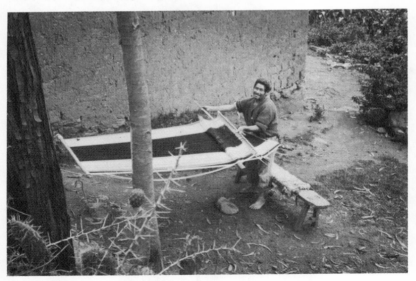

Figure 8. Man weaving a *lliklla*. Photo by Raquel Ackerman 1982.

Chapter Eleven

Ethnic Dress and Calcha Festivals, Bolivia

Mary Ann Medlin

Introduction

I have two strong visual memories from my fieldwork. During Carnival 1979, a young man of the Calcha ethnic group in the southern Bolivian Andes danced around a courtyard as he played the Carnival flute. It wasn't just a matter of drinking or partying. He was totally involved in the celebration. He wore a complete fiesta outfit when he went along with others from his hamlet to visit the home of the leader of the *ayllu*, the confederation of hamlets that shared ownership of land.

Just weeks before this event, he had returned to the Calcha hamlet where he had been born, after a year of Bolivian military service and two years of work as a temporary migrant in Buenos Aires, Argentina. He was at the age when young Calcha men begin to look for a wife and was a young member of a well-respected family in the settlement.

Dancing with others from his hamlet around the *ayllu's* leader's barrel of corn beer in the center of the patio, he was acting as a member of his hamlet, as a member of the *ayllu*, and as a Calcha, a member of a distinct ethnic group in Bolivia. Within two years of that Carnival he was a married adult ready to assume his responsibilities as the male head of a household.

A second image I have is from the last months of my fieldwork. In 1980, one evening my husband and I, with our baby, walked downriver to a small fiesta in honor of a hamlet's Virgin, represented there by a stone whose caretaker organized the music and dancing. The dancers and musicians wore Calcha fiesta dress and danced in a circle to music traditional to the ethnic group. The number of people attending was small but these activities were appropriate for a fiesta.

Another group of Calcha were off to one side of the patio where the celebration was taking place. They were young women and men of marriageable age. They danced to *huayño* music, recorded music popular in cities and towns, played on the large portable tape recorders held by several of the young male dancers. A straight line of men danced facing a straight line of women, everyone wearing manufactured clothing.

Two significant social aspects of Calcha fiestas are expressed through the use of fiesta dress during the two celebrations I have described. One is the expression of the common identity *ayllu* members from various hamlets share when they gather together. Dancing, singing, making music, and drinking are activities organized by members of the group, and the participation of the Calcha who attend strengthens the organization and identification of the group. At the same time another aspect of Calcha life is involved. The young people go to fiestas specifically to meet and interact with one another. Romances are begun and decisions to marry are arrived at on such occasions. Relationships essential for the physical reproduction of the group are often begun at these fiestas and then formalized later.

To live as a member of the Calcha ethnic group is a matter of choice, as is the decision to marry and have children. The Calcha select political leaders who organize their fiestas and the activities that must be carried out to meet state demands. Every Calcha at some point in his or her life is involved in this dual nature of fiestas, one involving personal relationships and the other concerned with local-level political activities. Both of these facets of fiestas require decisions about the use of Calcha ethnic dress.

The Calcha's use of cloth in fiestas is a fundamental part of the group's social reproduction. Individuals' fiesta dress not only represents their personal decisions about ethnic identity, but it also represents their family's internal organization and tentative decisions about possible alliances with other kin groups. Local leaders and their supporters use cloth to create and bolster social bonds within *ayllus* and to the larger ethnic group, which today is made up of six *ayllus*.

Calcha Cloth

Calcha cloth, because of its design and use of color, is distinctive from that of any other Andean ethnic group (Meisch 1986 and this volume, C. Franquemont 1986). Today, the Quechua-speaking Calcha who live in a valley in southern Potosi department in Bolivia number about 9000 (Medlin 1983, 1987). Their subsistence crop is corn; they trade for some needed goods, and buy others in semi-annual markets or in the city of Potosi. Most young men and now some young women travel to Argentina for temporary wage labor, and most families have some kin who have permanently moved there.

Until about twenty years ago, all Calcha wore their ethnic dress daily. Women wore black *bayeta* dresses covered by an *ajsu* or overskirt that they wove on four-staked looms. Bayeta is a fabric woven on the treadle loom. Men wore white *bayeta* pants, black *bayeta* shirts, and carried ponchos woven by their wives. Most Calcha have gradually changed to manufactured clothing for daily wear and reserve handwoven textiles for use in fiesta dress. Several things account for this: there is discrimination against Quechua-speakers who wear handwoven dress in Bolivian cities and at the Bolivian-Argentine border; the Calcha now have greater access to cash to purchase manufactured clothing; and males go to Argentina for wage labor leaving women in charge of more agricultural tasks and, thus, having less time for hand weaving (Medlin n.d.).

Weaving is still part of their subsistence productive system. Hand-woven cloth is a cultural necessity for proper social interaction at marriages, hamlet plantings of corn, and ethnic group celebrations. Women are able to weave only when there is not a more pressing need for their labor in the fields, with their small herds of goats, or after more immediate household tasks are completed.

Calcha Weaving and Social Relations

Calcha weavers are women who have learned their skills from their mothers, aunts, grandmothers, and sisters (Medlin 1986). Since she was a toddler, a woman has seen her mother and other female kin at a loom. Women within a hamlet, who are usually related by kinship or marriage, often share examples of designs either in finished textiles or in samplers.

Female kin teach young kinswomen to weave and supply them with necessary materials until the beginners can acquire their own. A young girl first weaves a few rows on a textile her mother is making and then uses her mother's yarn and loom to make her first *unkuña*, a small carrying cloth, or

wayaqa, a small bag. As she learns to spin a young girl makes more of her own yarn from fiber her mother has acquired in trade. A young woman in her teens may have a loom made by her father. She also may have received small gifts of cash from a brother that she can use to buy aniline dyes.

A family's resources influence a woman's weaving. Calcha families with greater access to resources continue to invest in high-quality weaving supplies and can afford to allow women more time at their looms. Good weavers in families with fewer resources often produce coarser cloth simply because they cannot acquire good-quality sheep's wool that can be finely spun. They may also spend more time at agricultural tasks and have less time to weave.

A woman whose own family resides in the hamlet where she lives after marriage may be able to continue to share tasks with her own female kin. As part of her husband's family's household, her marriage begins life-long relationships with female in-laws who have a vested interest in supporting her weaving. A marriage to a good weaver is judged to be a good marriage even though young women no longer make all of their husband's and children's clothing. Poor weavers are thought to make lazy wives.

A family's relationships with relatives and neighbors in their hamlet and with other members of their ethnic group requires the use of Calcha cloth. At the family's *mink' a*, a collective work group for the planting of corn, handwoven cloth must be properly used in serving food and drink to the kin and neighbors who exchange labor. During the interactions of local leaders and ethnic group members, it is Calcha cloth that both identifies those who share ethnicity and frames their interactions.

Calcha Fiesta Dress

Almost all adults still own an outfit of fiesta clothing and wear it when they attend fiestas (figure 1). Young women and men first acquire fiesta clothing when they start to take an interest in the opposite sex and to attend fiestas. A young woman of sixteen begins to weave the textiles required for her outfit, while a young man asks his mother or a sister to make the poncho and other articles he needs. At first, both sexes attend celebrations in outfits that include pieces borrowed from close kin, but later they are expected to acquire their own complete fiesta outfit.

Contemporary fiesta dress consists of clothing that reflects over four hundred years of contact with Europeans. Both the articles of clothing and their names show Spanish influence. Today the clothing is a combination of important textiles that Calcha women weave, some other items made of

bayeta cloth, and still other items crafted by people of nearby ethnic groups or in market towns.

The traditional fiesta dress (figure 2) for women consists of: *aymilla* (a Quechuaization of the Spanish word *almilla*), a dress; *ajsu*, an overskirt; *llijlla*, a mantle; *cañari*, a heavy underbelt; *chumpi*, a finely woven overbelt; and *wayeta* (a Quechuaization of the word *bayeta*), a head-cover. The *aymilla* for fiestas is a dress sometimes made of high quality black *bayeta*, woven by men on the Spanish-introduced treadle loom in western Chuquisaca department. *Bayeta* is bought or traded for in the market town, Vitichi. More often women now use *pañu* (a Quechuaization of the Spanish word *paño*), a manufactured black wool material. A brother or husband who has worked in Argentina may bring the manufactured cloth back as a gift to a wife or sister. *Pañu* is quite expensive, more than ten dollars a meter in 1980, and makes fiesta dress both costly and a display of accumulated wealth.

The *aymilla* has a very full skirt that comes to below the knees when bound with the belt. The bottom edge is decorated with machine embroidery. The dresses are cut and sewn by members of the rural population, some of whom do especially fine work for fiesta wear, while others do tailoring and embroidery suitable only for daily wear. The bodice is wide and only takes on form when bound by the belt. The long full sleeves are first covered with machine embroidery in white thread by the person sewing the dress and then filled in with colored yarn by the dress's owner.

The *ajsu* is a rectangular textile made of two seamed halves, worn with the warp horizontal. There is a wide band of design on the lower half of the skirt and a narrow one on the top half. This is the textile that is expected to be the best example of a woman's weaving. It is worn over the *aymilla* and also bound by the belt forming a space in which women carry small objects.

Young women do not like to use the *cañari*, the wide underbelt which adult women wear under their long narrow belt. They say they are uncomfortable. *Cañaris* are made by Calcha men who also make cinches for pack animals and rope. Fine *chumpis*, belts, some made of yarn almost as delicate as sewing thread, are made by women. The belt or belts are wrapped around the waist to define the profile of a woman: fullness at the bust, a small waist, and a wide skirt which swings as she walks or flies out gracefully when dancing.

When the weather is cool, or if a woman carries a child or burden on her back, she wears a *llijlla*. It can be worn as a mantle or folded to carry a baby or a burden allowing her hands to be free as she walks. The *llijlla* is made of two seamed halves that have a rotational symmetry of one hundred

eighty degrees in design. Women take special care in making *llijllas* to wear with fiesta dress. They should have broad black bands rather than the red, green, or wine band suitable for use with manufactured clothing. The *wayeta* is a rectangular cloth of purchased machine-woven wool, sewn along one edge to form a square that can be pulled over the head like a hood or worn covering the back. At weddings, the inner side, lined with yellow, green, and pink cotton fabrics, is worn turned out over the head of the bride, pulled so far forward that her face cannot be seen. The *wayeta*, with its embroidered side out, may also be used to cover the face of a baby sleeping in a carrying cloth on its mother's back. *Wayetas* are red, green, or purple and provide a touch of color complementing the brightly colored sleeves of the somber black of fiesta dress.

Calcha men's fiesta dress (figure 3) includes their *aymilla*, a black shirt; *calzones*, white pants; *señor*, a cummerbund; *cinturón*, a wide leather belt; *ufanta* (a Quechuaization of the Spanish word *bufanda*), a scarf; and *ch'uspa*, coca bag or *wayaqa*, small bag. The term *aymilla* is used for the men's shirt that is made of either black *bayeta* or *pañu* for fiesta use. The shirts have relatively wide straight-sided bodies with long sleeves. Like the women's *aymilla*, these are cut and sewn by members of the Calcha ethnic group. The shirts have machine embroidery along the edges of the sleeves and the neck.

Men's pants, *calzones*, are made of white *bayeta* with wide legs that reach almost to the ankles. The shirt is worn tucked into the pants, and the *señor* is wrapped around the waist. The *señor* is a long rectangular cloth handwoven as a single piece and machine embroidered around the edges with small floral motifs added in the corners. The waist and the cummerbund are bound by a *cinturón*, a thick belt of heavy leather doubled over to form a pocket in which cash or important papers can be carried. The *ch'uspa* or *wayaqa*, which holds coca leaves, is tucked between the belt and the *señor*. *Wayaqas* are more common than *ch'uspas* today, and coca leaves are seldom available to the Calcha.

Over his shoulder, a man carries his poncho and his *ufanta* or scarf. The poncho may also be worn across the back to carry a burden. A man's poncho, like the pocket formed by a woman's *ajsu*, may be the source of treats for the small children who await a grandfather's or father's return. A man's fiesta poncho is woven by a female relative for his use. It has two seamed halves and an added fringe.

There are three main poncho types found in Calcha fiesta dress: colored *panti listao poncho*, a black *yana listao poncho*, and the *poncho*

Boliviano with red, yellow, and green stripes in the same shades as the Bolivian flag. There is also the *luto poncho,* the black mourning poncho without woven design. The term *listao* may be derived from the Spanish word *listado* (striped); *panti* is the Quechua word meaning wine or deep red color and *yana* means black. All of these ponchos may have *pallay* (hand-picked design) bands and or stripes of *ikat.* The use and place of *pallay* and *ikat* have varied over time. Older ponchos may have both types of design or only bands of *ikat.* Newer ponchos may have only bands of *pallay.* The *viraqhocha ponchos* are said to be modeled on Argentine gaucho ponchos. They are entirely plain weave, often with a red ground and stripes of dark blue on each half, and are worn with manufactured clothing, never with fiesta dress.

Women and men both wear fiesta hats and sandals similar in style. The Calcha hat has a wide brim and a low crown and is available at markets in the nearby town of Vitichi. The hatmaker there can modify a hat from the department of Tarija or make an entirely new hat. The style of hat now most commonly used for fiestas is orange and is called a *sombrero Tarijeño.* Those who wear ethnic dress for everyday use white hats daily (they were worn only during fiestas in the past), and black ones for mourning. All hats are decorated with a grosgrain ribbon the same color as the hat, a buckle, a narrow black velvet ribbon, a band of rickrack, a narrow handwoven band with designs made of sewing thread warp and fine colored yarn weft, and another final band of rickrack. The band, *troqilla,* is handwoven by a female owner of the hat or a female member of the owner's family. The woven design has been simplified in the last twenty years.

For fiestas there are attractive leather sandals with thick soles of many layers held together with cactus thorn "nails." These are sold in Vitichi, especially on the Sunday before Carnival, the most important Calcha fiesta, and during the two biggest markets of the year. These are held at Espiritu, (technically Pentecost, eight weeks after Easter, but celebrated the last week of May), and San Andres, the 30th of November. Sandals are an essential part of a complete fiesta outfit.

The main difference between fiesta quality and daily ethnic clothing is in the material and the quality of workmanship. There are three classes of *bayeta* used in *aymillas.* The finest may serve as a substitute for the expensive *pañu* for fiesta dress. The coarsest *bayeta* is suitable only for daily wear.

Ethnic dress, while no longer common for daily use, is used by some people for trading trips outside of the Calcha's territory. Those who wear

ethnic dress on these trips say their dress informs members of other ethnic groups that there are Calcha present and advertises the specific kinds of goods they have to sell or trade. This explanation is parallel to that given for the value of ethnic dress by the Otavaleño weaver-merchants of Ecuador (Meisch, this volume). A few Calcha who wear ethnic dress daily take it off for trading trips. They maintain that they have been treated disrespectfully in urban areas when wearing traditional dress.

Changes in Fiesta Dress

When the Calcha discuss how weaving has changed, they talk about how designs have changed. They see their fiesta costumes as basically the same as those of the past but now including less skillfully woven textiles. Often families have some older textiles. For example, a grandmother's overskirt may have nine or eleven bands of distinct *pallay*, while only five or seven bands are used today. All Calcha also recognize that older textiles were finer (more threads per inch) than those woven today. There is now more use of white than red in the woven bands of design, a change that has taken place in the last twenty years.

Today women's fiesta dress is usually made of manufactured *pañu* and rarely of high quality *bayeta* cloth. The machine embroidery on the sleeves, the neck, and the edge of the skirt has become more elaborate (figures 1 and 2), and the white machine embroidery of the sleeves is filled in with synthetic yarn. Synthetic yarn often is used in the center seams and as edging on overskirts and *llijlla*.

The forms of the woven textiles and the cut-and-sewn men's shirts and pants have changed less. Men's shirts and *señors* are more elaborately decorated with machine embroidery than in the past. More young men throughout the ethnic group's territory now use the colorful *poncho Boliviano* rather than the more somber *panti* or *yana listao ponchos*.

Both women and men usually wear the bright orange hat rather than a white one. The items most often missing from a complete fiesta outfit are the leather sandals. Rubber tire sandals are now a common substitute. Women may use a number of collars crocheted of white cotton yarn today. In the last ten years Calcha women have also begun to crochet edging on men's scarves instead of purchasing the crocheted parts from town mestizos. An additional change for women's costumes at Carnival is that, while they continue to wear two *llijllas* crossed over their chests (figure 2), they no longer attach just the textiles that they have woven during the year. Now a number of purchased synthetic scarves are fastened to the female Carnival

costume. They are bright in color but are no longer a presentation of the weaving that a woman has done during the past year.

Calcha Fiestas

Handwoven Calcha dress is used during the fiestas and celebrations which reinforce the Calchas' shared identity. As already discussed, the most important fiesta for the Calcha is Carnival, the week of Ash Wednesday. Second in importance is San Pedro/San Pablo at the end of June. Other fiestas still celebrated include Reyes (Epiphany), January 6; Pascua (Easter); Corpus Christi, ten weeks after Easter; Santa Vela Cruz, May 3; San Juan, June 24; Santa Rosa, August 24; and Todos Santos, November 1. Half of the eight *kurakas*, the leaders of each *ayllu*, of Calcha take office on Reyes, and the other four take office on San Pedro and San Pablo.

Most fiestas include celebrations in the hamlets of sponsoring *ayllu* leaders, the *kurakas*, and at the ceremonial center, the town of Calcha. There is a bridge in town which people recognize as a boundary representing the dual division of the *ayllus* into two groups. This is a typical replication of the Andean division of societies into above and below, an ideological concept, not a geographical reference (see Wilson, this volume).

Until the 1960s, each *ayllu* had its own patio in town. Now *ayllu* leaders arrange to rent a house in the ceremonial center for the fiestas they organize. Previously each major fiesta had at least four *kurakas* who would sponsor musicians and dancers which were the focus of celebrations in each of the four corners of the town's central plaza. Today it is common for there to be only two groups sponsored by *kurakas*.

For all celebrations in the ceremonial center the leaders and their supporters wear ethnic fiesta dress. Fiestas centered in the hamlets require some use of fiesta dress by visitors from other hamlets. At Carnival, the visit of the *kuraka* to every hamlet in the *ayllu* includes household receptions of the *tata kuraka* and *mama kuraka* (father leader and mother leader), the male and female *ayllu* leaders, and their accompanying female dancers and male musicians all wearing Calcha daily dress. It is only when the hamlet members leave their own homes to visit the *kuraka's* home or the ceremonial center that they put on their fiesta dress.

Use of Fiesta Dress

Fiesta dress is put on the evening before leaving for a fiesta. Most young people arrive at the fiesta after dark, dance all night, and retire during the day, returning for the remaining nights of celebration. At fiestas in the

ceremonial center, young people dance in circles with members of the same sex; late at night they may form mixed couples.

Young people invest energy and resources in the preparation of their fiesta outfits. They are shy about appearing in public in ethnic dress, while adults publicly use fiesta dress in daytime activities at fiestas. Most people rest during the mornings of fiestas, but the married supporters of sponsors must see that the proper refreshments and activities are organized for *ayllu* members.

Kurakas wear complete outfits of ethnic clothing for fiestas. They own more than one poncho but no longer change to a new one each day of a fiesta as they did through the 1950s. In 1982, the wife of the *kuraka* of *ayllu* Pasla said she had woven nothing for her husband as *kuraka* because he had all the ponchos he needed. She recounted again, as she had in previous discussions with me, the ponchos she had woven for her husband. There were four, one *poncho Boliviano*, for use as ethnic fiesta dress, and three *viraqhocha poncho*, which are worn only with manufactured clothing. Until the end of the 1950s, a *kuraka* would have used at least three or four different fiesta ponchos.

Changes in Use of Fiesta Dress

Women in the southern part of Calcha territory no longer weave *listao ponchos* and younger men use only the *poncho Boliviano* for fiestas. The *listao ponchos* are more common in the northern part of the territory and most older men are likely to have them. Even *kurakas* are not expected to use both types of ponchos at fiestas today. Informants said that in the past people would say that the *kuraka* did not have a good wife or was from a family lacking in resources if he did not use several different ponchos during a celebration.

Today, as long as he has a poncho in good condition, a *kuraka's* wife need not weave specifically for his tenure as leader. Usually each *kuraka* has a poncho already woven by his wife for former subservient fiesta roles. Fewer textiles are woven for specific fiestas but a complete set of proper fiesta attire is still required of young people, *ayllu* leaders, and their supporters.

New ponchos are likely to be woven for Carnival simply because it is the most important Calcha fiesta and has the largest number of active participants. *Kurakas* expect their musicians and dancers to have complete outfits and be dressed in their best. Recently some male musicians, however, have used manufactured clothing. The *ayllu* leaders, *tata kuraka* and *mama*

kuraka, the *kamachis* (two helpers), and the female dancers continue to wear fiesta dress. In the early 1980s there was increased interest in complete outfits because some *ayllus* began to participate in regional folklore festivals.

The Meaning of Fiesta Dress

The Calcha have learned from their contact with outsiders that many in Bolivia consider people who use handwoven cloth in their dress to be uncivilized. In conversation, the Calcha themselves distinguish between members of the ethnic group who continue to use Calcha dress daily and those who use manufactured everyday dress as *Calcheños* and *civilizados*. They have been told by middlemen who come to Calcha to trade for ethnic cloth that handwoven cloth is *costumbre fea*, an ugly custom.

When I talked with people about why they no longer wear handwoven cloth daily, I was told that people were not treated with respect when they went to the city dressed as Calcha. In the past they were pushed off sidewalks and often were forced to work in the homes of city people against their will. They also were not allowed to cross the Argentine border to work in the sugar harvest of northern Argentina dressed in Calcha clothing. At first, men left their Calcha clothing behind at the border and put it on again when they returned. Eventually they stopped using Calcha dress daily as they gained access to sufficient cash to purchase manufactured clothes and as they brought back Argentine clothing.

It is not only the recent participation in folklore festivals that supports the Calcha position that fiesta dress is distinct from daily dress. They explicitly recognize that fiesta outfits require higher quality materials and are the best demonstration of a weaver's skills. They are aware of the high value of the considerable energy and resources invested in complete costumes.

More important is the implicit value of their textiles as a representation of Calcha identity. All Andean weaving is more than just clothing. Calcha fiesta dress, while it does cover one's body, is made to express membership in the ethnic group. Calcha cloth expresses the social relations necessary for its creation. It is a unique creation of an ethnic group, made by specific women for themselves and their close kin. It is made to be used when the Calcha work together in their hamlets or ceremonial center.

Fiesta dress always has been worn within the Calchas' territory when they celebrate shared ethnic identity. While the group is not continuously dressed in ethnic cloth, Calcha cloth is available only to the members who accept the responsibilities of Calcha adulthood including the required

political obligations. Calcha fiesta dress signifies adulthood and integration into the local groups whose political and economic activities determine the future of the ethnic group. The same textiles that represent the skill of the women who make them also embody the relationships that require such fine cloth.

Fiesta Dress and Adulthood

During three and a half years of fieldwork, the only time I saw children wear Calcha dress was when teachers organized a school presentation of folklore. Young people begin to take an interest in Calcha fiesta outfits as they prepare to take on adult roles. Young women weave their own *ajsu* and *llijlla* to use in fiestas and as young brides. Young men, when they develop a serious interest in marriage, begin to acquire their outfits by convincing their mother or a sister to weave for them. Calcha are not considered adults until they marry. It is not age or maturity that bring adult status but the assumption of the responsibilities of marriage and parenthood. Fiestas have always had an important role in courtship and marriage. Participation in fiestas is the first step from immaturity to adulthood.

The Calcha say that, until twenty or thirty years ago, marriages by kidnaping a young woman at a fiesta were more common. If she and the young man survived several days in his parent's household, they were considered to have taken the first step toward marriage. Those young women whether "kidnaped" or in a young man's home of their free will had their woven clothing examined, particularly by female in-laws, who made judgments on the probable value of the bride as a hardworking wife.

Today Calcha fiesta dress still displays young marriageable women's best weaving. Both women and men take an interest in the quality of weaving and make an effort to be seen in as fine a fiesta dress as possible. Their choice of clothing indicates their intention to assume adult roles and demonstrates that they have learned the skills necessary for the support of a new family. In addition, it shows that they have developed supportive social relationships that make it possible for a young couple to live together and work toward establishing a successful household.

Fiesta Dress and Local Politics

The *kurakas* of Calcha *ayllus* as mature leaders have access to the resources necessary to supply their families with ethnic fiesta dress. Leaders choose *kurakas* from families that can meet the economic demands of the office. The weaving of their households indicates their control of resources.

The male and female heads of the household, *tata* and *mama kuraka*, together perform the essential leadership tasks, gaining and organizing the support of *ayllu* members.

As leaders of their *ayllu* the couple entertains those who visit their houses and hamlets. They sponsor fiestas and call in support from those whom they have helped in the past. Their kin and neighbors recognize their obligations to provide help as needed. The *tata kuraka's* right and obligation to put on Calcha clothing when visiting within his territory demonstrate that the population continues to govern itself. It is only Calcha leaders and never State authorities who use ethnic dress in the performance of official duties. State authorities use manufactured dress for official appearances.

Kurakas take off ready-made daily clothing and put on fiesta dress for Carnival, conveying a message that there are local and unique resources essential to the group. Because of the social dynamic of Calcha cloth, a *kuraka's* Carnival dress expresses the idea that the relationships represented by textiles sustain the group in the daily activities that make the celebration possible. Those who do not themselves use Calcha clothing recognize that it fosters and reproduces *ayllu* identity, establishing a basis for a wider sense of ethnic unity. Carnival is the most important occasion for the use of ethnic dress by large groups and the *kuraka* and his supporters, who dance throughout the *ayllu's* territory. The members of the *ayllu* never gather together in a single location. By taking Calcha cloth from household to household within the territory, the *tata* and *mama kuraka* force the recognition of *ayllu* organization. This use of cloth strengthens the members' awareness of their group identity.

Rasnake, in an analysis of Carnival in Yura, describes how the *kinsa rey*, the staff of the authority couple, is taken on household visits during Carnival. Rasnake argues that the staff represents the group led by the *kuraka* while, at the same time, it is recognized as a locus of spiritual power (1986:669). In Calcha the couple in authority carry a staff, but it is not decorated with cloth like that of the Yura. In contrast to the Yura, the Calcha authorities themselves, together with their dancers and musicians, are dressed in the cloth, which represents the group and is a source of its power. Calcha cloth itself is a "model for" behavior (Geertz 1965) as well as a "summarizing symbol" (Ortner 1973). The cloth comprising fiesta dress is a powerful representation of group cohesiveness that presents Calcha to themselves and to outsiders.

Ready-made clothing, a representation of urban culture in Bolivia, is a part of everyday life. Today Calcha do not produce all their clothing and

have always traded for the *bayeta* from which parts of Calcha dress is sewn. The handwoven textiles of Calcha require raw materials from outside the group's territory. Calcha cloth both separates and ties the ethnic group and the larger Andean social world. The *kuraka's* use of Calcha cloth demonstrates the continuation of local organization and production.

Fiesta Dress, Ethnicity, and the Nation

In the fiesta when young people dance to *huayños* while the supporters of the *kuraka* dance to Calcha music, two uses of fiesta dress are separated; two ritual actions are distinguished. At the more important fiestas in the ceremonial center of Calcha, youths wear ethnic dress when they meet and dance to music supplied by *kurakas*. At the celebration with *huayños* the young people's concern about getting to know one another takes precedence over the affairs of the local political leader. An important initial step in the marriage process is separated from local politics. The *kuraka* supporters are distinguished by dress as well as by style of dance from the young people who dance together but are not yet ready to accept the political responsibilities of adulthood.

The Calcha are part of Bolivian society and know a great deal about its complex political and social structure. Their daily lives are influenced by the national economic system. Manufactured clothing is cheaper in value than is the labor of Calcha women (who wove more in the past). Due to male migration for wage labor, more women's labor is directed to ensuring their family's food supply. Calcha culture, like that of all Andean people, has been modified by the impact of larger societies.

Young people, however, continue to be interested in one another and in marriage, and the entire ethnic group continues to benefit from the leadership of the *kurakas*. Calcha fiesta dress, which is not identical to that used even fifty or a hundred years ago, remains an essential element in the processes through which young people become adults and as adults support local political organization.

The creation and use of Calcha fiesta dress represents an individual's acceptance of his or her reproductive role as part of a new married couple, as a member of the *ayllu*, and as a supporter of *kuraka* authority. Calcha clothing represents individual skill and knowledge, the family and kin support system, and the strength of the group that shares ethnic identity. In fiestas, ethnic dress mediates the relationships of young people with one another and their families. At the same time it represents the transformation of members of families and hamlets into the *ayllus* of the Calcha. Youths who

put on Calcha dress soon marry and become participating adult members of this unique society.

Bibliography

Franquemont, Christine
 1986 Chinchero Pallays: An Ethnic Code. *In* The Junius B. Bird Conference on Andean Textiles. Ann P. Rowe, ed. Washington, D.C.: The Textile Museum.

Geertz, Clifford
 1965 Religion as a Cultural System. *In* Anthropological Approaches to the Study of Religion. Michael Banton, ed. London: Tavistock Publications.
 1973 Religion as a Cultural System. *In* The Interpretation of Cultures. Pp. 87-125. New York: Basic Books, Inc.

Herro, Joaquin, and Frederico Sanches de Lozada
 1983 Dictionario Quechua-Español: Estructura semantica del Quechua cochabambino contemporaneo. Cochabamba: Centro de Education Financiada por Comunidad, Compañia de Jesus.

Medlin, Mary Ann
 1983 Awayqa Sumaj Calchapi: Weaving, Social Organization and Identity in Calcha, Bolivia. Doctoral dissertation, Anthropology, University of North Carolina at Chapel Hill.
 1986 Learning to Weave in Calcha, Bolivia. *In* The Junius B. Bird Conference on Andean Textiles. Ann P. Rowe, ed. Washington, D.C.: The Textile Museum.
 1987 Doña Juana and Doña Sara. *In* The Human Tradition: Latin America: The Twentieth Century. William H. Beezley and Judith Ewell, eds. Willminton: Scholastic Resources, Inc.
 n.d. Women and Agriculture in Calcha, Bolivia. Unpublished manuscript.

Meisch, Lynn A.
 1986 Weaving Styles in Tarabuco, Bolivia. *In* The Junius B. Bird Conference on Andean Textiles. Ann P. Rowe, ed. Washington, D.C.: The Textile Museum.

Ortner, Sherry
 1973 On Key Symbols. American Anthropologist 75:1338-
 1346.
Rasnake, Roger
 1986 *Carnaval* in Yura: Ritual Refections on *Ayllu* and State
 Relations. American Ethnologist 13:662-680.

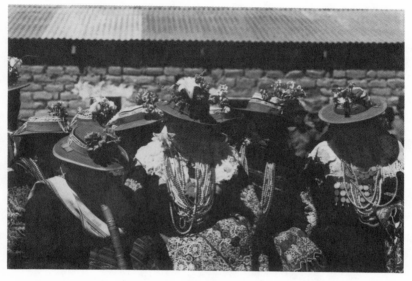

Figure 1. Women and men in fiesta dress dance together to celebrate fiestas. Women add crocheted collars and beads over the *aymilla* and *ajsu* and both sexes add flowers to their hats. These women are holding machine-embroidered *wayetas*. The male musician's *ufanta* is draped over both shoulders and his poncho is folded on his left shoulder. Photo by Mary Ann Medlin 1970s.

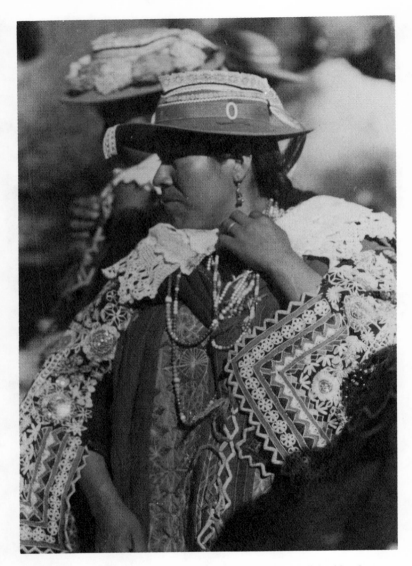

Figure 2. For Carnival, women attendants of the local political leaders wear *llijllas* crossed over their chests and backs and pin scarfs and *llijllas* over the crossed textiles. They are a walking display of their weaving skills. Photo by Mary Ann Medlin 1970s.

Figure 3. A local political leader uses fiesta dress at an important celebration before an audience that includes representatives of departmental and national agencies. The white bayeta pants and fine *aymilla* are worn with a *panti listao* poncho, folded and worn diagonally across his back. Photo by Mary Anne Medlin 1970s.

PART FOUR

WEAVING AND DYEING TECHNOLOGY

Chapter Twelve

Dual-Lease Weaving: An Andean Loom Technology

Ed Franquemont

Introduction

In most of the Peruvian Andes today, traditional cloth is produced on the simplest of looms with a labor-intensive process (figure 1). The loom itself is nothing more than a pile of shaped sticks organized into a two-lease system that will of itself produce only varieties of plain woven cloth. However, the pattern bands Andean weavers make through hand manipulation of the leases from this simple equipment are among the most complex and lovely fabrics made by hand anywhere in the world. These weavers are heirs to a rich textile tradition fostered by an elaborate society without writing, a culture in which cloth was the most important material commodity. For ancient Andean people, textiles offered a medium that not only conveyed status and expressed wealth but also served as an abstract model by which fundamental ideas such as mathematics and philosophy were studied and conceptualized (E. Franquemont et al. n.d., C. Franquemont 1986, Ascher and Ascher 1981). Because cloth has had such an expanded role in Andean

society, the perceptions, conceptions, and working methods of the Andean weaver are of great interest to those who hope to meet the Inca genius at work solving complex problems from a uniquely indigenous point of view.[1] The true equipment of Andean weaving is the mental agility of the weavers themselves, who find in the simple looms no mechanical limits to their creative vision.

Today, despite the general emphasis in the Andes on conceptual rather than technological solutions to fabric production and design problems, it is clear that pre-Columbian weavers at times used more elaborate hardware to make double cloth, gauze weaves and other fabrics (d'Harcourt 1962). There still are many complex loom systems in use among the traditional weavers of Bolivia (Cason and Cahlander 1976:16 left). But for most of the contemporary Andes, only a few minor fabrics, such as the *golon* skirt border[2] (Schevill 1986:89), are made with complex heddle arrangements. For this reason it was especially interesting when a new kind of complex weaving set-up came to light during a survey of Huancavelica, Peru, in 1978 (E. Franquemont 1983).[3] This new type of loom set-up uses four leases that are arranged in a completely different way, and results in a device that weaves simply and easily classic Andean complementary warp weaves with effects such as "pebble weave" (Cason and Cahlander 1976:58-63) and "intermesh" (Cason and Cahlander 1976:72-76). In a report on this weaving in 1983, I drew parallels with a lovely tubular binding that weavers from Chinchero, Peru, apply to the edges of their fancy cloth. Both are made with a forked stick to hold leases, and a second stick to temporarily hold complex picked up leases of yarn. At that time I was most impressed with this loom as a device for weaving symmetrically, since complex picks could be put into storage, or "reserved," on temporary sticks for re-use later in symmetrical designs. I borrowed a term coined by Anne Blinks (pers. com. 1982) to describe certain Amazonian ways of weaving and called this "Reserved Shed Pebble Weave."

Since that publication a great deal of new information has surfaced about this way of weaving that offers better understanding of its history, distribution, and fundamental nature. In this article I will describe this technology more clearly in order to demonstrate its reliance upon fundamental Andean concepts, and review the evidence to date about these "dual-lease" systems of weaving. I will argue that dual-lease weaving is not a rare and localized phenomenon but rather an important Andean technology that is ancient in origin and was widespread throughout the area in the past.

Principles of the Dual-Lease Loom

Standard four-lease weaving from European traditions works by dividing the entire warp one time into four parts. Although the four leases may have different roles in forming the structure of the cloth and can be used in combinations of one, two, or three leases at once, there are no threads that are in more than one lease. We can say that these European looms use exclusive leases.[4] In contrast, the essence of dual-lease weaving is that the entire warp is divided in half twice, that is, according to two different plans. Threads go into one of the two leases of the first division and also one of the two leases of the second division; these are non-exclusive leases, or more accurately, two sets of exclusive leases. The first division into two equal leases is held on a forked stick, which separates the yarns and establishes an order for pickup but does not allow access to the back lease except by pickup. The forked stick yields a static cross, since it is impossible to reverse the positions of the leases. In this division the yarns generally go through the cross alternately or in alternate pairs. Then, these same yarns are drawn together and divided in half a second time with a more complex order (figure 2). An applied string heddle is installed on each lease of the second division. Each warp thread goes through one of the two leases at the forked stick, and then onto one of the two heddles. There are two different two-lease systems at work simultaneously: a dual two-shed system. It is difficult to accommodate such a dual system to the treadle looms of European traditions, since the movement of the harness generally requires exclusive leases. In the Andes today, dual-lease systems apparently have inherent limitations since Andean weavers use the technology exclusively for belts.

Weaving with dual-leases proceeds by alternating one two-shed system with the other. The weaver begins work with the near side of the forked stick system, which in the example is black (figure 7B).[5] He inserts a shed sword, turns it on edge and clears the lease through the heddles; this results in a solid black pick (figure 7B row 1). After passing a weft, the weaver removes the shed sword and works from the heddle system. He raises Heddle 1, clears the lease to the woven edge and passes a weft; this results in a pick of mixed color that can be called a "pebble row" (figure 7B row 2). For the third pick the weaver returns to forked stick, and once again weaves a solid black pick (figure 7B row 3). The fourth pick is from the heddle system, and is achieved by raising Heddle 2. These four picks complete the cycle of work which can be summarized as: forked stick system—Heddle 1—forked stick system—Heddle 2. With the plan used in Huancavelica, this cycle produces an all-black field of a familiar complementary warp weave with three-span

floats in alternate alignment, the so-called pebble weave. To produce an all-white field, the weaver returns to the forked stick and picks up white threads to replace their black partners and places them on a holding stick (figure 4). Now the near side of the static cross is white. The weaver then repeats the same process exactly, with the only difference being that the yarns he brings forward from the forked stick are now white instead of black. To make patterns, the weaver simply works with a lease on the near side of the forked stick that is mixed in color, and reserves this mixed lease of yarns for future use or reference on the holding stick (figure 5). All pickup for patterns is done only at the forked stick, and the heddle sheds are always woven *khata*, without pickup. Since this is a semi loom-controlled weave, it is possible to describe a pattern, as did I in 1983 and Fra. Martín de Murúa in 1611 (Desrosiers 1986), only in terms of the configuration on the holding stick at the near side of the forked stick; the intervening heddle picks are loom controlled.

Andean Dualisms

Dual thinking is an important factor of Andean life and seems to have been so for thousands of years. Their ancient textile art heavily depends upon positive negative contrasts (d'Harcourt 1962), and so does the contemporary weaving. Indeed the essence of complementary warp weaving is the recognition of a two-thread set of balanced pairs (Franquemont and Franquemont 1988). There is much more direct evidence, however, for the importance of dual and bipartite organization in Andean thought. During the Inca period, social groups were divided into moieties of *hanan* (upper) and *hurin* (lower), and there is evidence that history was conceived as a flow in one direction balanced by a return in the other. This fluctuation of direction centered around critical points in time called *Pachakutij* (C. Franquemont 1984).

Andean communities today consist of two social halves and organize labor through various principles of reciprocal exchange. Dance groups, political meetings, and even soccer strategy depend upon recognition of mated opposites. Major textiles have two identical halves arranged symmetrically and are always built of two-ply yarns because " all things need their mates." In many Andean communities, only married men hold office because bachelors are not yet complete people. In this social environment, the discovery of a weaving procedure based on dual organization is not surprising, but the equipment and procedure are. Complexity of fabric is achieved not by a system with many parts but rather by repeated divisions

into two parts. These two-part systems are ranked and nested within each other. The loom is organized into two equal parts (the heddles vs. the forked stick), each of which also contains an internal division into two equal parts. Division of the warp into equal halves of contrasting colors is another independent dual dimension. The steps in weaving also require two-part alternation between parts of the loom. Hierarchical and nested systems of opposed halves represent a fundamental principle used by Andean people to organize complex information (E. Franquemont et al. n.d.). In this case, it serves to simplify the job of weaving by constantly presenting the work as a choice between two options.

Distribution and Antiquity of Dual-Lease Looms

In 1978, dual-lease weaving seemed especially exciting as an example of an unreported loom technology that had been lurking undiscovered in a forgotten corner of the Andes. However, follow-up work has shown that several researchers had come across similar systems before. Oscar Nuñez del Prado collected an example of this kind of weaving from the Department of Apurimac, Peru, in 1972; it is presently in The Textile Museum in Washington, D.C., and has been illustrated by Desrosiers (1986: figure18). Even earlier, Lila O'Neale published a loom from Huancayo that resembles a Textile Museum specimen with a similar dual-lease arrangement.[6] Cherri Pancake (pers. com. 1987) reports that dual-lease systems were a common way of weaving in Ayacucho during her years as a Peace Corps volunteer. The tubular edge the women of Chinchero weave onto their fancy cloth (Cahlander, Franquemont, and Bergman 1981) is a closely related weaving procedure that also uses a forked stick and holding stick, but curiously there are no heddles. This small loom uses only the first division of the warp and therefore has only the equipment of forked stick system of weaving. This evidence argues that in some way the two divisions of the warp can be considered to have independent functions and that dual-lease weaving actually does represent two different ways of working used in tandem. All of this related earlier work now has clearer significance in efforts to delineate the area occupied by dual-lease weavers and the implications of working with a dual-lease system.

There have been more reports of dual-lease systems since publication of the Huancavelica information in 1983. Gary Urton photographed a young girl in Pacarijtambo, Cuzco, weaving on a such a loom in 1984, and he collected a number of pieces from the town that were made with dual-lease looms. Catherine Allen knows dual-lease weavers from Sonqo, Cuzco, and

this kind of weaving seems to be common from there through Pisac and Lares, all to the northeast of the Urubamba River. This area contains many distinct local styles of weaving, yet virtually all weavers make a single style of *Misti Chumpi* (*mestizo* belt) with a forked stick and two heddles. One piece of this type, attributed to the Chaywantiri section of Pisac, has been illustrated by A. Rowe (1977:figure 90). Although the arrangement of yarns in the heddles or across the forked stick may differ from one of these areas to the next, the basic principles of loom organization and weaving procedure remain the same. A map of these localities (figure 3) demonstrates that dual-lease looms are found throughout a wide swath of the Central and Southern Andes of Peru. There is of course no reason to believe that this is an exhaustive mapping, and subsequent field reports will no doubt expand the area in which dual-lease weaving systems are found.

Although this map is provocative, at this point it is still difficult to be sure that the distribution of dual-lease weaving means that it was widespread in pre-Columbian times. Huancavelica, at the northern and western edge of the map, has had massive immigration of indigenous people who were brought from many parts of the Andes to work in the mines. As a result, the contemporary local culture is an amalgam that could derive from almost any Andean context. Sonqo, Lares, and Pisac lie at the other extreme of our map, and it appears that at least here this weaving may have been a fairly recent import. Although the people of Lares-Pisac weave in many different styles, they all make the *Misti Chumpi* alike and use this same name for the procedure (figure 6). The term *Misti* usually refers to things that were brought into the area by traders coming from the Arequipa area during the late nineteenth and early twentieth centuries. Perhaps the name derived from their association with the volcano El Misti that dominates the Arequipa landscape; or perhaps it is merely a contraction for the word *mestizo*. But in any case, the weavers of Lares make a strong distinction between this technology and their own ways of making complementary warp weaves with two leases. Despite the evidence for the importation of dual-lease weaving into the Cuzco area, the persistence of the technology in isolated pockets scattered over a wide area of south and central Peru does suggest that it may represent the remains of a way of work that was once more common.

The work of Desrosiers (1986) has demonstrated that dual-lease weaving is probably pre-Columbian in age. A remarkable bit of detective work allowed her to decipher a page of text written by Martín de Murúa in 1611 that contains actual weaving directions for dual-lease belts. The belts in question were made for women to wear during a maize festival that is

doubtless pre-Columbian in origin, and the scribe who recorded the directions was apparently watching the weaving procedure without understanding exactly how it was being done. Desrosiers initially hypothesized that the belts must have been double cloth since a standard complementary warp weave could not be made following these directions. Her later hypothesis argues that the directions are for dual-lease weaving, and this is probably correct. This position is bolstered by the discovery of a pre-Columbian belt in the collection of the American Museum of Natural History in New York that actually fits Murúa's directions; it has a fabric structure quite similar to that of the *Misti Chumpi*. It is still uncertain where Murúa encountered the directions for this belt, but much of his work took place around the north end of Lake Titicaca. His account not only adds time depth to our understanding of dual-lease weaving but also significantly expands the geographical area in which it has been reported.

Identification of Dual-Lease Weaving from the Finished Textiles

If dual-lease weaving systems have pre-Columbian antecedents and have been widely used across the Andes, it is probable that many museums and collections in the United States and Europe contain fabrics, ancient and contemporary, that have been made by some variant of this weaving procedure. It would be most interesting to develop a tool that would allow researchers to identify dual-lease products from the finished cloth and thereby extend our understanding of the history and development of this technology into the pre-Columbian era. This kind of inquiry is, of course, filled with uncertainty. For one thing, the area is far from homogeneous with respect to textile traditions and procedures. Even today, the Andes is a tapestry of small local cultures that know little of each other's ways and sometimes achieve the same effects through different procedures. In addition, the cloth from the ancient world that has survived is mostly associated with burial ritual and hardly represents the spectrum of techniques and tastes common to any pre-Columbian society. And finally, the great versatility of the contemporary weavers shows that technique and fabric structure are not so tightly connected as one might assume. It is always risky to speculate very precisely about weaving methods from the evidence of finished cloth. Keeping these caveats in mind, however, there are reasons to be optimistic that clues exist that allow a laboratory worker to be fairly certain that dual-lease systems were used to make a particular piece. At least three lines of reasoning present possibilities.

Structure. Dual-lease weaving uses a semi-loom controlled process, which has consequences for the structure of the cloth.

1). Heddle Rows. Since every other row is controlled by a heddle, they should be regular and identifiable. Furthermore, heddle control leads the weavers to use 2/2 horizontal color change instead of 3/1. This means that there is a heddle row between plain weave picks of contrasting colors. Weavers who work complementary warp weaves with a two-shed loom change colors by following one solid color pick with another (3/1 horizontal color change). Since any loom-controlled process, including adaptation for four-harness treadle looms, will favor 2/2 color change, this clue is interesting and provocative but certainly not conclusive evidence that dual-lease looms were in use. The evidence of color change is especially difficult to use for patterns that are not built of horizontal color change at all.

2). Regularity of Heddle Rows. Dual-lease woven cloth shows an overall regularity of heddle ("pebble") rows across the entire fabric. That is, the pebble rows are always the odd numbered rows or always the even numbered rows. In contrast, two-lease weavers organize pebble rows within each design block. In figure 7A row 6 is a pebble row in the black zone but a pattern row in the white zone. Row 7 is a pebble row in the white zone but a pattern row in the black zone.

3). Selvedge Structure. Most contemporary Andean belts have a band, however thin, of plain weave at the selvedge to make a firm edge. But it is actually quite difficult to make a flat over-under plain weave with a dual-lease system, so the treatment of the edge presents the dual-lease weaver with some special problems. Huancavelica weavers turn this quality to their advantage. By placing all of the edge threads in the heddles but not in the forked stick division, they are able to weave into their belts a lovely rolled edging; a similar edge is made by Lares Valley weavers. This is possible because the weft always passes through these edges from the same direction (figure 9). The rolled edging is very suggestive of a dual system but unfortunately cannot be considered completely diagnostic because Chinchero artisans weave the very same edging into their belts by a laborious and contorted hand procedure. Doubtless Chinchero people learned the edging from finished

examples, and not from weavers themselves, but nonetheless were able to copy the edging through a different technique. Other edge distinctions may also be possible with the dual-lease loom (see discussion of Challwawacho belts, below).

Errors. Dual-lease procedures allow characteristic errors that may provide visual evidence of the system's use.

1). Persistent Errors. Since it is semi-loom controlled, any errors made in threading the heddles persist throughout the fabric; in contrast, finger-manipulated procedures generally have short-lived, one-time-only errors. Repeating errors may also occur in the pattern leases formed from the forked stick because these leases are usually reserved on a holding stick for future re-use. Any errors made during the pickup of a pattern lease tend to persist until the pattern calls for those threads to be manipulated again.

2). Repeating Errors. A second type of error that is characteristic of a dual-lease loom is the repetition of a pebble row; that is, the inadvertent raising of the same heddle twice in a row. The fabric holds together fairly well despite this error but the pattern has problems caused by long floats. Similar repetition of a pebble row is also occasionally done intentionally by two-shed weavers in order to accommodate pattern design, but here the purpose is fairly obvious and contributes to the design.

Design. In any weaving system, aspects of the equipment may have an influence on design choices and decisions. Because our understanding of dual-lease weaving is still rather sketchy, it is difficult to know very precisely how the technique affects design. Our present understanding is that two different but related kinds of complementary warp weaves are made on dual-lease looms.

1). Dual-lease with Alternate Paired Warps ("Pebble Weave"). In Huancavelica, weavers produce complementary warp weaves built of warps aligned in alternate pairs, which has been called "pebble weave" (figures 7A and 7B). Those who work designs with paired warp plans tend to avoid horizontal color change as much as possible, probably because the horizontal lines are quite ragged. Their designs are chiefly laid out along diagonals, which has the added advantage of allowing each pattern lease pickup to be figured by adding or subtracting threads from the lease held in reserve. Instead of counting threads, the weaver knows

which threads to pickup and drop by their relationship to the pattern lease reserved on the holding stick. This can be illustrated by examining the triangular motif at the top in figure 7B. Row 11 is made by picking four black threads in the center of a white lease; this configuration is placed on a holding stick. After raising Heddle 2 and weaving row 12, the weaver returns to the holding stick to form the pattern lease for row 13. He simply replaces two white threads with black partners on either side of the existing black block. Here the weaver is able to work by visual inspection or gestalt knowledge rather than by time-consuming thread count.

　　2). **Dual-lease with Single Warps ("Intermesh").** The museum specimens illustrated by Desrosier as well as contemporary pieces from Pacarijtambo, Pisac, and the Lares Valley use a similar weave built of single threads in alternate alignment. Cason and Cahlander have called this "intermesh" (figure 7C). Those who make dual-lease weaves based on single threads ("intermesh") seem less concerned with the problem of the 2/2 horizontal color change.

　　3). **Two-Shed Design Considerations.** Compared to any dual-lease weaver, however, those who make complementary warp weaves on a two-shed loom have far greater freedom of design (figure 7A). The need to pickup all the "pebble rows" by hand in the two-shed system allows the weaver to accommodate their patterns through accidentals and other variations from the idealized plan of alternating colors. The use of 3/1 horizontal color change also allows weavers to repeat a "pebble row" without any obvious repercussions on the pattern (figure 7A, rows 13 and 16). This freedom of design comes at the cost of speed of work. Since each thread must be manipulated by hand in every pattern lease, there is no dramatic advantage in speed for one pattern over another.

　　Evaluation of potential laboratory tools. The most important and potentially useful laboratory tools to identify dual-lease weaving from finished cloth lie in the structure of the fabric. Any plan of pebble rows that is consistent throughout an entire fabric probably indicates loom control over these rows, while pebble plans that are independently organized within the various motifs strongly suggest manual control over the weaving process. Identification of distinctive weft selvedges offers another good clue that dual-lease procedures were in use despite the fact that Chinchero weavers can copy the rolled edging by other means. Special edge treatments may well

be consequences of the technology, although it is certainly possible to create rolled edgings with a more standard four harness arrangement.

The character of the horizontal color change is a less convincing tool but still interesting. 2/2 horizontal color change does seem to be indicative of some kind of loom control over the "pebble rows," but the structure can be easily accomplished by hand. Rowe, for example, reports that certain fabrics from Tarabuco, Bolivia, have 2/2 color change (Rowe 1977: figure 94), while Meisch (1986: figure 3 and 17) shows weavers from the area making similar fabrics with a two-shed system and 3/1 color change. Consequently it is not possible to conclude that a pre-Columbian fabric like one illustrated by Rowe (1977: figure 79) was made with a dual-lease system despite its overall similarity to Chaywantiri belts (Rowe 1977: figure 90) that are known to be made on a dual-lease loom.

Challwawacho Belts: A Test Case

As an exercise to test the problems and power of observations like these to identify dual-lease looms from the evidence of finished cloth, I looked at some of the beautiful belts from the Challwawacho area of Cotabambas (figure 8). Their homeland in the Department of Apurimac, Peru, is difficult to get to and no direct field observations of weavers at work have been reported, yet enough of the products have found their way into the markets of Cuzco to provide a significant body for study. At least three distinct styles seem to be represented, but the range of design canons, color schemes, and techniques indicate that the belts are probably made over a fairly broad area. These belts make good test candidates for several reasons. First of all, this is the only contemporary style that has preserved certain three-color weaves that were in use in pre-Columbian times, and for this reason they comprise a bridge of sorts between ancient and contemporary techniques. I was especially intrigued because after ten years of effort I have not been able to find a satisfactory way of accomplishing some of the woven effects with standard two- and four-shed weaving systems. Second, several examples show rolled edgings like those made in Huancavelica. One especially lovely example has an integrated tubular edge with *ñawi,* or eyes, reminiscent of the edge bindings made by Chinchero weavers with a forked stick. In addition, there are other unusual selvedges suggesting that the edge threads were woven only on alternate picks of weft. Third, although there are as yet no reports of the methods used to make these belts, there are still hundreds of active weavers producing them and doubtless more complete information will be available in the near future to check our laboratory observations. And

finally, two looms in progress that I collected in Cuzco in 1985 have forked sticks in place.

An examination of twenty-eight Challwawacho belts and two bags in my collection and in the collection of the Haffenreffer Museum of Anthropology, Brown University, found no two-color complementary warp weave bands that had 2/2 horizontal color change; all used 3/1 color change. Some individual motifs were built of pairs of warps in alternate alignment, while others in the same bands showed single warp floats in alternate alignment. According to the criteria outlined above, there was no loom control over the "pebble rows" in these fabrics. But there is a distinctive edge treatment. Four examples, including the one shown in figure 8, had rolled edges achieved by weaving the selvedge threads only on alternate picks. All the other belts had a distinctive two-span float at the weft selvedges, which also suggests some kind of procedure executed on every other pick (figure 9). The two bags in the sample, however, were different from the belts. They had plain woven selvedge bands underneath an applied edge binding. The evidence of the edges argues that either a separate procedure was used for the bags or that the weaving system had more flexibility than would normally be found with either a dual-lease system or a two-shed system of work. In either case, the technology allowed the edge threads to be woven on alternate picks easily but did not inhibit the weaver from making a plain weave if so desired. The examination of these Challwawacho textiles themselves was therefore inconclusive: they do not show the defining characteristics of other known dual-lease fabrics, yet they suggest that some of the procedures may have been in use.

We can turn to the looms in progress for another kind of evidence, but the forked sticks found in place on the looms in progress are not such strong evidence as they might appear. Both looms have most likely been disturbed. On one loom, lines of stretched places in the warp suggest that heddles had been applied but have been removed. It is impossible to know how many heddles there might have been or what configuration they had. On the second loom, the cross itself on the forked stick is hopelessly disordered, indicating that all shedding devices have been removed and carelessly replaced by a forked stick. A third loom in progress has neither heddles nor forked stick. There is a static two-shed cross held by a shed loop and lease rod, and a third lease rod has been installed to separate the threads of the three color sections. According to my informant, a Chinchero woman who collected the loom and observed it in use, all patterns are picked up by hand following the warp order

established by these three devices. But even considering all of these reservations, the looms were traded to contacts in Cuzco with forked sticks in place, an indication that these weavers are probably conversant with some of the equipment, if not the same dual-lease technology.

Conclusions

Dual-lease weaving is an Andean technology that is indigenous, ancient, and probably widespread. It is difficult to know if the range in which it is found today reflects that of pre-Columbian times, since indigenous textile technologies have hardly been static in the past five hundred years, and innovation and diffusion of new ideas continue in spite of the increasing marginalization of the weaver by the money economy (E. Franquemont n.d.). Despite evidence that dual-lease weaving may have been introduced to some parts of Cuzco fairly recently, the survival of similar unusual equipment and even the same forms of looms over a wide area argues that this technology was probably more prevalent in the past than it is today. The still-vibrant tradition of belts from the Challwawacho area shows a technology that does not really fit our expectations for the dual-lease looms we now know, yet it does not fit comfortably into any other known technology and seems to share some equipment and design features with belts that are known to be woven with dual-lease procedures. It would not be surprising to find that Challwa-wacho weavers harbor another distinct technological tradition that is related in some ways to the *Misti Chumpi* and other dual-lease belts. The clues currently available for laboratory examination of finished products can help frame this problem but as yet provide no really definitive answers. This argues the need for more direct field work among weavers who are known to use dual-lease looms, a clearer definition of the technological character-istics of their work, and perhaps some hands-on experimentation with the procedure by good weavers in the United States and Peru. Of course, a few direct observations of Challwawacho weavers are also in order at this point.

Like most textile arts in the Andes, dual-lease weaving offers us a material window into more esoteric matters. While contemporary Andean people (and perhaps ancients as well) prefer to solve problems by developing the concepts, intellect, and physical skills of individuals rather than mechani-cal contrivances, the internal organization of these looms into two sets of two satisfies a fundamental Andean logic, a way of dealing with complexity through repetitious doubling and halving that lies at the heart of Inca thought (Franquemont et al. n.d.). These principles are still at work today in many

other contexts ranging from traditional dance to social organization and even soccer strategy. Andean people, heirs to a direct intellectual and kinetic legacy from the Inca past, still study and learn about these ideas without words and through their fingers by working with looms such as these. Doubtless there are still many other ingenious techniques and procedures waiting to be discovered in the Andes, waiting to teach us more about what thread can do; Challwawacho may well be the home to some of these techniques. No other people in history put so much cultural energy into fiber arts as the Andeans. Even though the superlative weavers of the contemporary Andes are only the impoverished reminder of a far more brilliant past that is gone forever, cloth remains the quintessential Andean art and the best forum to enter into a dialogue with the remarkable Inca mind.

Endnotes
1. I use the word Inca to refer to contemporary Quechua-speaking people as well as pre-Columbian Andean people.
2. This fabric is of European origin, derived from the braided silk and cotton galloons used on ecclesiastical vestments.
3. The work was funded by the Cia. de Minas Buenaventura of Lima, Peru.
4. Martha Stanley has pointed out that European-tradition weavers do occasionally use non-exclusive leases with long-eyed heddles in a system called "compound shaft mounting"; see e.g., Worst (1924:205-229).
5. Most weavers of traditional Andean fabrics are women; however, the Huancavelica weavers observed using this system were men.
6. I am indebted to Ann Pollard Rowe of The Textile Museum in Washington, D.C., for bringing this reference to my attention in the course of a stimulating commentary on my earlier draft. Her observations have been of great help in preparing this paper for publication.

Bibliography
Ascher, Marcia, and Robert Ascher
 1981 Code of the Quipu. Ann Arbor: University of Michigan Press.
Cason, Marjorie, and Adele Cahlander
 1976 The Art of Bolivian Highland Weaving. New York: Watson-Guptill Publications.

Cahlander, Adele, Ed Franquemont, and Barbara Bergman
 1981 A Special Andean Tubular Trim. The Weaver's Journal 6 (3): 54-58.

d'Harcourt, Raoul
 1962 Textiles of Ancient Peru and Their Techniques. Seattle: University of Washington Press.

Desrosiers, Sophie
 1986 An Interpretation of Technical Weaving Data Found in an Early 17th-Century Chronicle. *In* The Junius B. Bird Conference on Andean Textiles. Ann Pollard Rowe, ed. Washington, D.C.: The Textile Museum.

Franquemont, Christine
 1986 Chinchero Pallays: An Ethnic Code. *In* The Junius B. Bird Conference on Andean Textiles. Ann Pollard Rowe, ed. Washington, D.C.: The Textile Museum.
 1984 Pachakutij: A Quechua Name Class. Unpublished manuscript.

Franquemont, Christine, and Edward M. Franquemont
 1991 Learning to Weave in Chinchero. *In* Técnologia andina, Vol. 2. Heather Lechtman and Anna Maria Soldi, eds. Mexico City: Universidad autonoma de México.
 1988 Learning to Weave in Chinchero. The Textile Museum Journal 26:55-78.

Franquemont, Edward M.
 1983 Reserved Shed Pebble Weave in Peru. *In* In Celebration of a Curious Mind. Nora Rogers and Martha Stanley, eds. Pp. 43-53. Loveland, CO: Interweave Press.
 n.d. Change in Chinchero Textiles. Unpublished manuscript read at Annual Meeting of Institute of Andean Studies, Jan. 1984. Berkeley.

Franquemont, Edward M., B.J. Isbell, and Christine Franquemont
 n.d. Awaq Nawin: the Weaver's Eye. *In* An Andean Kaleidoscope. B. J. Isbell, ed. Salt Lake City: University of Utah Press.

Meisch, Lynn
 1986 Weaving Styles in Tarabuco, Bolivia. *In* The Junius B. Bird Conference on Andean Textiles. Ann Pollard Rowe, ed. Washington, D.C.: The Textile Museum.

O'Neale, Lila M.
 1946 Mochica (Early Chimu) and Other Peruvian Twill Fabrics. Southwestern Journal of Anthropology 2 (3):269-294.

Rowe, Ann Pollard
 1977 Warp-Patterned Weaves of the Andes. Washington, D.C.: The Textile Museum.

Schevill, Margot Blum
 1986 Costume as Communication. Rhode Island: The Haffenreffer Museum of Anthropology, Brown University.

Worst, Edward F.
 1924 Foot-Power Loom Weaving. Milwaukee: The Bruce Publishing Co.

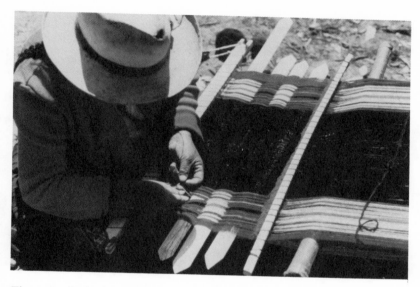

Figure 1. Andean loom at work. Most indigenous weavers of the Peruvian Andes make complex cloth on extremely simple looms through adroit manual pickup of design bands. Photo by E. Franquemont 1970s.

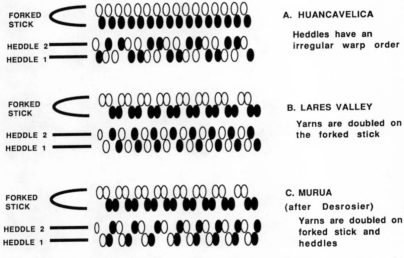

Figure 2. Tie-ups for dual-lease weaving. Different distributions of yarns in the forked stick and the heddles have been reported from different areas. Drawing by E. Franquemont.

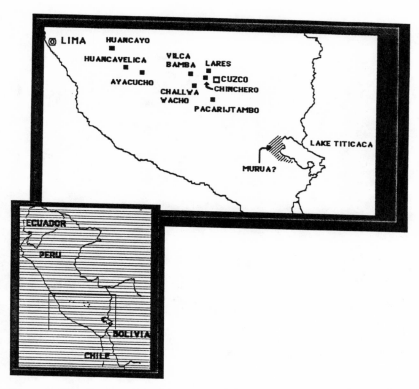

Figure 3. Distribution of dual-lease looms or products. Preliminary information shows a wide distribution of these looms in the central and southern Andes of Peru. Drawing by E. Franquemont.

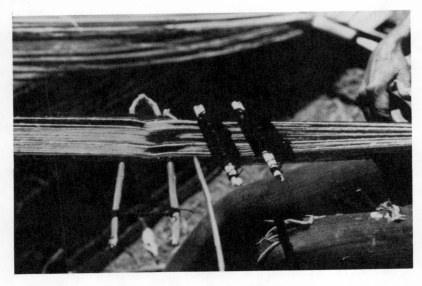

Figure 4. Dual-lease loom with holding stick in place. Pattern leases, once formed, are held in reserve on the holding stick for future repeats or for use as a template from which subsequent pattern leases may be formed easily. Photo by E. Franquemont 1970s.

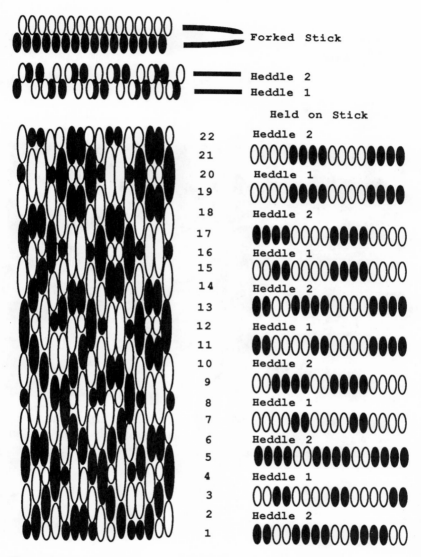

Figure 5. Pattern drafts/reserved configurations. Different patterns or effects are accomplished through changes in the configuration of the yarns at the near side of the forked-stick system. Drawing by E. Franquemont.

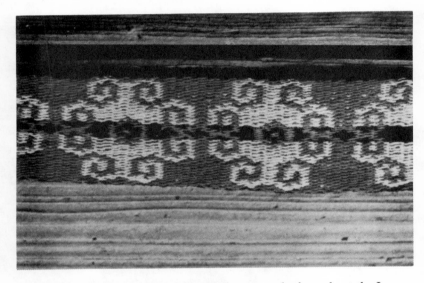

Figure 6. *Misti Chumpi*. Dual-lease belts are made throughout the Lares-Pisac area of Cuzco under the same name and with a fairly uniform design plan, suggesting recent introduction from outside. Photo by E. Franquemont 1970s.

Figure 7. Comparison of weaves. Drawings by E. Franquemont.

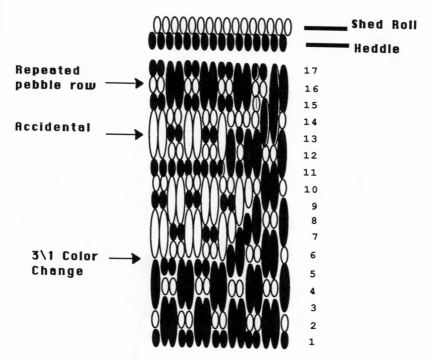

A. Two-shed loom fabric. Characteristics of complementary warp weave with three-span floats aligned in alternate pairs ("pebble weave") made with a two-lease system. Note 3/1 horizontal color change at rows 6, 11, and 14. Row 13 contains an "accidental" in which a single-yarn three-span float appears, while row 16 repeats the same "pebble" scheme as row 14.

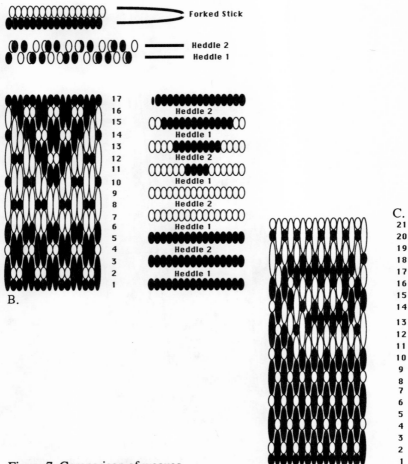

Figure 7. Comparison of weaves.
Drawings by E. Franquemont.

B. Dual-lease loom fabric. Characteristics of complementary warp weave with three-span floats aligned in alternate pairs ("pebble weave") made with a dual-lease system. Note 2/2 horizontal color change at row 6.

C. Dual-lease loom *Misti Chumpi*. Characteristics of complementary warp weave with three-span floats aligned in alternate single threads ("intermesh") and some two-span floats in pattern areas. 2/2 horizontal color change.

Figure 8. Challwawacho belts. Weavers from this part of Apurimac, Peru, have preserved an ancient weave in belts that also show an integrated rolled edging. Haffenreffer Museum of Anthropology collections, Brown University. Photo by Danielle Toth 1985.

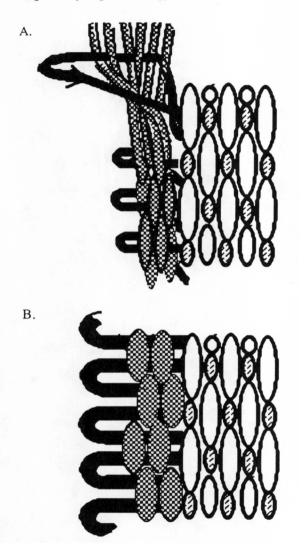

Figure 9. Selvedge details. Drawings by E. Franquemont.

A. Huancavelica belts have a tubular rolled edging made by passing the weft through the selvedge from one direction only.

B. Challwawacho belts show an unusual two-span float flat selvedge made by unknown means.

Chapter Thirteen

Resist Dyeing in Mexico: Comments on Its History, Significance, and Prevalence

Virginia Davis

Resist dyeing, patterning cloth by preventing dyestuff from penetrating portions of the material, occurs worldwide in many forms.[1] In Mexico, the ubiquitous *rebozo* is the principal textile created by this process.

The *Rebozo* and Its History

The *rebozo* is a multi-functional long shawl worn by women in Mexico. The Spanish word *"rebozar"* means "to muffle up." "The *rebozo* serves not only to cover the head or to cross over the breasts for adornment. It is also a temporary cradle for children of the poor, a kerchief with which women dry their tears, an improvised basket in which Indian women carry vegetables to the market, a cover for the infant who tranquilly sleeps by his working mother. It covers a pot of tamales for sale on a street corner. Its fringe, twisted on the head, becomes a stand for a basket of fruit."[2] While the Spanish *rebozo* is the size of a handkerchief, the Mexican *rebozo* varies in

width from twenty-four to thirty-four inches and in length from six to twelve feet. Of the length, approximately three-quarters is woven and the remainder is fringe, usually elaborately worked in one or a combination of half hitching, overhand knotting, or finger weaving. The yarn, the color and design of the weaving, the style and technique of fringe finishing, and the manner in which the *rebozo* is worn communicate significant information. These features serve to indicate where the *rebozo* was made and the probable status and home of the wearer.

Currently, there are four principal types of *rebozos*:

1. wool or cotton *rebozos* in solid colors or stripes, not *ikat* dyed, woven on a backstrap loom in home or village;
2. *rebozos* similar to category (1) produced on a treadle loom;
3. *rebozos* similar to category (1) produced on a power loom;
4. *rebozos* that are *ikat* dyed, using commercial cotton, produced on a treadle or backstrap loom.

The cotton used in type (4) is commercially spun, ranging in number from the coarsest, #80, to the finest, #200. The finer grades are sometimes called *de bolita* perhaps referring to the packaging in balls.

The central topic of this chapter is the warp *ikat* cotton *rebozo* from Tenancingo in the state of Mexico. *Ikat* is the name given to the process of resist dyeing a pattern on threads before weaving, and by extension, the term is applied to the textile woven using such threads.[3] The popularity in Mexico of the overall *ikat* patterning may have originated with its resemblance to the mottled patterning of a snake's skin. It has been suggested that the attraction to this design has its roots in the pre-Hispanic cult of the serpent (Martinez del Rio 1971:8). Other pattern names suggest a mottled pattern and color, e.g., *canario* (white-speckled yellow), *coyote* (white-speckled brown). The *rebozo* in Mexican culture has a strong semiotic significance in terms of national identity and religion. One of the most popular colors is the *paloma* (dove), which is white-speckled blue (Peñaloza 1979:72). Today in Mexico this type of *rebozo* is worn so universally and depicted so frequently in Mexican art, that it could be characterized as the national garment for women. Mexican textile scholar Dr. Atl (Gerardo Murillo) suggested that this kind of *rebozo* should be the national flag of Mexico (Martinez del Rio 1971:9).

There is definite evidence that other resist techniques, namely *plangi* (resist created by stitch or tie compression) and batik, were used in pre-contact Mesoamerica (Johnson 1954:137; Mastache de Escobar 1974:251-

52). Although it is possible that *ikat* was also known, this must remain speculation. The existence of such resist techniques in pre-contact Andean cultures could point to diffusion via trade either from the south to the north, or vice versa. When speaking about cloth and garments, post-contact observers and travelers use general terms and do not discuss the nuances of technique. Bernal Díaz del Castillo writes of seeing in the Texcoco market in 1524: "many sorts of spun cotton in hanks of every color, and it seems like the silk market at Granada, except that there is much greater quantity" (Díaz del Castillo 1956:213-16).

Considering the vast reduction in the size of the indigenous population after the Spanish conquest and a life expectancy under fifty years (Gibson 1964:6), the artisans working at the end of the sixteenth century would have been the grandchildren or great-grandchildren of people whose products were seen by Díaz. A new syncretic culture began to emerge. The pre-conquest heritage could be seen in such a subtle touch as the incorporation into Mexican decorative art of the "S" symbol, *ilhuitl*, which in Nahautl means "day of the week" or "festival to be observed." Religious practice particularly tended to contain a subtext from pre-conquest belief and ceremony (Lafaye 1976:7-139). The significant image of the Virgin of Guadalupe first appeared in 1531 imprinted on the *tilmatl* (a traditional cloak of pre-conquest origin) of a poor Indian, Juan Diego. In 1582, an ordinance of the Royal Audiencia of New Spain forbade *mestizos*, Negros, and mulattos from wearing Indian dress and was probably responsible not only for the preservation of indigenous Indian costume but also for the development of *mestizo* dress (Martinez del Rio 1971:9). Thus, the *rebozo* and other *mestizo* garments evolved to fill the vacuum that this social policy had created. These garments, typically home produced, were made from backstrap-woven cloth that was cheaper than commercial cloth.

The Spaniards introduced sheep and the use of wool. In the *obraje* (workshop), with its foot-powered looms and dismal working conditions, described so poignantly by Alexander von Humboldt (1977:188-89) at the end of the eighteenth century, coarse cotton for *mantas* (cloaks) was woven. Cotton, which in pre-Conquest times had been a luxury material, was now the fiber for garments of the lesser classes. *Obrajes* did not compete with backstrap weaving by skillful weavers at home. There were parallel systems, "factory" and home (Gibson 1967:154; Keremitsis 1973:1-3). Juan V. de Güemes who discussed eighteenth century *rebozo* production, which often illegally evaded the guild system, remarks that the natives did not need all the machinery of the *obraje*, only four sticks with which they did admirable

weaving in colors and *jaspeados* (*ikat* patterns) (Nuñez 1917:21-22). At specific centers such as Oaxaca, Puebla, and Tlaxcala, there were guilds of silk weavers, which by 1600 were using Chinese silk (Borah 1943:89). In Puebla, *paños* of silk were woven as early as 1539. By 1731, a silk guild complained that the cotton weavers were using silk threads in their *paños de rebozo*. Silk weavers were enjoined from using cotton, but the cotton guilds had no such restriction (Bazant 1973: 495-499). Von Humboldt mentions the presence of many individuals of Asiatic origin in the late eighteenth century in Mexico and specifically notes Malays working in Puebla *obrajes* (Von Humboldt 1977:45). The Manila galleons, 1565-1815, plying trade between Manila and Acapulco, brought an influx of Asiatic slaves, in particular from Malacca, Molucca Islands, China, and the Philippines, beginning around 1580. It has been suggested that these slaves were wearing *ikat* shawls from India (Martinez del Rio 1971:7-8). This may be the source of the popular mottled designs and the specific refinements of *ikat* technique (Martinez del Rio 1971:7; Miller, this volume).

Another possible source might be Bagobo (a tribe from Mindanao, Philippines) *ikat* which is similar in *ikat* motif, technique, and size to that of Mexico. The long narrow rectangular shape of the *rebozo* is more characteristic of garments from Southeast Asia than of either the Indian sari or the European shawl (Cordry and Cordry 1968:130). A pre-contact *ikat* tradition in Mesoamerica would have provided the foundation for the adaption of more complex techniques necessary for the overall mottled designs (Miller, this volume). From 1565 on, the China trade via Manila brought silk in every stage of manufacture and every variety of weave and pattern (Robinson 1987:65). There were *lampotes* (gauze) and *mantas* (blankets) from the Philippines, Chinese and Persian rugs, and fine cotton from Bengal and the Coromandel coast. It would be interesting to examine shipping lists, but since both goods and slaves were smuggled, this might not be definitive (Schurz 1959:32-50, 182). *Mantónes de Manila*, square embroidered silk shawls with long fringes, originally from China, were popular trade items. Perhaps the Chinese *mantón* contributed its embroidery style, use of gold and silver threads and long knotted fringe to the development of the *rebozo* (Martinez del Rio 1971:87).

In looking to possible Spanish antecedents of the *rebozo*, we may note that, in the Andévalo region of Huelva, there is a small cloth worn under a hat covering the face and head as extra protection against the sun, which is called a *rebozo*. More relevant is the *rebocillo* of Mallorca, customarily worn as a headcloth framing the face, going around the shoulder and crossing on

the breast. *Ikat* is not a feature of the *rebocillo* of Mallorca, although there is a continuing tradition of *ikat* in Mallorca. But none of these Spanish garments had the dimensions of the Mexican *rebozo* (Foster 1960:98-99). Early dictionaries provide some clues as to the development of the *rebozo*. In Captain John Stevens' *Dictionary of Spanish and English*, 1726, we find the *reboço* or muffler, a veil or hood worn over the face to avoid being known. The oldest Spanish language dictionary in Mexico, produced by the *Academia Española* in 1737, defines the *rebociño*—a mantilla or short head-dress which women use to cover their mouth (*bozo*). And the small illustrated Larousse dictionary (de Toro y Gisbert 1967:873) defines *rebozo* as "*modo de llevar la capa o manta cubriéndose con él el rostro*" (a manner of wearing a cloak or shawl so that it covers the face). These definitions are consistent with the theory that the *rebozo* developed from the need for a head covering in church. It may not be mere coincidence that the very popular typical *rebozo*, blue with a white overall speckled pattern known as *palomas* (dove) or *palomitas*, has both the color and imagery of the Virgin. Thomas Gage, an English Dominican traveling in the New World in 1624, described a mantle of cotton of "divers" colors, worn instead of a mantilla. Later, in 1625, he mentioned a silk shawl-like band thrown over the left shoulder and held by the right hand, which also replaced the mantilla (Lechuga 1986:166-67). However, the mantle he placed on the *mestiza* was of fine white muslin or cambric with lace. It was worn over the shoulders or head, crossed over the breast with one end over the left shoulder. Sometimes the ends hung free. This garment, from the 1620s, was worn like the *rebozo*, and had roughly the same dimensions (Gage 1969:111). Francisco de Ajofrín, a Capuchin friar, commented in 1763 that almost every woman, even if she follows Spanish fashion, will have a *paño de rebozo* (Ajofrín 1964:65-66). By 1794, in his report to the Crown, Viceroy Juan Vicente de Güemes Pacheco de Padilla said of *paños de rebozo* (Martinez del Rio 1971:88):

> ... the women wear them without exception, nuns, the highest born and richest ladies and the most unfortunate and poorest women of the lowest class. They use them as shawls, as shoulder cloaks, in public buildings, in promenades and even in bed. They wrap themselves in them and tie them around their waists ... Some are woven of cotton and others of cotton mixed with silk and some have stripes of gold and silver threads and the richest ones are embroidered with other metals and colored silks ...

Although the end of the Viceregal period (1821) marked the beginning of Mexican national independence, identification with a distinctively "Mexican" culture had been developing since the end of the seventeenth century. Sometimes this took the form of romanticization of the "Indian" and disregard of *mestizo* elements. But by the nineteenth century, if the *rebozo* was not the mode of stylish women looking to European fashion, it was firmly recognizable as an element of female folk costume throughout the population, with an accompanying place in folk dance and poetry. One of Frances Calderón de la Barca's (1982) first impressions of Mexico in 1839 is of the women of Veracruz wearing *rebozos*, "long colored cotton scarfs, thrown over the head and crossing the left shoulder." However, she says that ladies wore mantillas. In describing the *poblana* (woman of Puebla) costume, she says "overall is thrown a *rebozo*, not over the head but thrown on like a scarf" (Calderón 1982:40-63). Later, when Calderon de la Barca attempts to go to a costume ball dressed as a *poblana*, following the upper-class tradition of adopting servant or folk garb for play, she is dissuaded by a committee of local people who convey to her their perception of this costume as that of the demimonde (Calderón 1982:88-89). However, during the nineteenth century, the *china poblana* dress gained stature as a national costume (Dewar 1963:18-19). Both for *mestiza* and for Indian women, the *rebozo* was firmly entrenched as a Mexican folk garment. It appears in folk dances, particularly the *Jarabe Tapatio* (Mexican hat dance). The *rebozo* acquired a patron saint, *"El Señor del Rebozo"* (Martinez del Rio 1971:88). The following poem by A. León Ossorio (n.d.) illustrates the use of the *rebozo* as a symbol of femininity in popular art :

How pretty looks my brunette
Wrapped in her *rebozo*
Hanging from its fringes
Are the hearts of a hundred *charros* (Sayer 1985:108).

An account from 1851, published in Guadalajara by D. Vicente Munguia on the origins and fabrication of the *rebozo*, is somewhat self-serving. Seeking to justify a grant for the exclusive production of both knotted pattern dyed and false (brocade patterned) *rebozos*, Munguia says only that he learned from a foreigner in 1819 and practiced the technique long and hard (Munguia 1851:8-11). An indication of the popularity of the *rebozo* throughout the nineteenth century was the appropriateness of a fine silk *rebozo* in its inlaid box as a wedding gift. An accessory was a brush for the

fringe. Unfortunately, surviving nineteenth-century *rebozos* are rare and eighteenth-century examples even more so. The persistence of this garment to this day is truly remarkable—even more so if something is understood of the arduous, meticulous, time-consuming process of production of the warp *ikat rebozo*.

Elsie C. McDougall: *Ikat* Resist-Dyeing Documentation and Collection

The Elsie McDougall Collection at the American Museum of Natural History carefully documents resist techniques as practiced fifty years ago. It provides a valuable point of departure in evaluating subsequent developments.[4] Elsie C. McDougall focused on the resist-dyeing techniques of *ikat* and *plangi* (stitch and thread resist patterning) and also sought evidence that wild silk was woven in pre-contact times. She was a self-taught ethnographer and a perpetual student. In a 1986 interview, one of McDougall's friends, Mrs. Peggy Bird,[5] described her as "independent, strong-minded and meticulously organized." Born in London in 1883, she was trained as a teacher at Stockwell College. In 1926, she made her first trip to Mexico and Central America and returned with textiles. Throughout the 1930s, McDougall made collecting trips, visiting places that were then quite remote, traveling by horse or mule and coping with arduous conditions. Entire winters were spent establishing personal contacts with the Indians, collecting, and photographing (Start 1948:9; Grossman 1955:6-7). She worked with translators, because often her informants spoke only the indigenous languages, such as Otomi or Nahuatl. According to J. Eric Thompson, she had the "ability of making friends with the Indians and winning their confidence" (Thompson 1962:205-206).

She was particularly interested in the warp *ikat rebozo*. She collected *rebozos* and documented *ikat* technique in *rebozo* construction in Teotla, a weaving quarter of Tenancingo, Estado de Mexico, in 1935. There are, in the collection, four rare extremely fine examples of the type of warp *ikat rebozo* known as *doscientos* made in the late nineteenth century in Tenancingo.[6] One of the *rebozos*, with the date 1890 represented in knots in the fringe, has over ten thousand hair-like warps with over three hundred warp ends per inch.[7] These four are indeed fine *rebozos* with a silk-like feel and drape.

It is important to note that the design of the *ikat* patterning of the Mexican *rebozo* has very special properties. The resist patterning is created vertically in a warp-faced textile but, after dyeing, the motifs read horizontally in the finished weaving. The design of the patterning is almost always one of two types: (1) an overall misty pattern, sometimes called *llovisna* or

(2) an overall geometric pattern of very fine scale. These two typical categories of design existed in Tenancingo *rebozos* not only in the late nineteenth century but also in the 1930s and indeed continue to exist. One of the nineteenth-century *rebozos* collected by McDougall has a block-like geometric pattern called *Aztecas*. To accomplish this pattern requires an incredible number of resist bindings. I estimate that 10,000 to 12,000 resist ties placed on the warp before dyeing and weaving are needed to create this pattern. The *Aztecas* pattern was known in the 1930s but was woven in a larger scale that is less labor intensive. From the collection of the San Diego Museum of Man, another *rebozo* of uncertain provenance but dated late 1920s or early 1930s has the *Aztecas* design.[8] Currently, there are designs similar to the *Aztecas* but enlarged and simplified even more.

In February and March 1935, McDougall was in Teotla with the aim of documenting the *ikat* process from start to finish. At that time, she commissioned a number of complete *rebozos* as well as two deliberately partially woven and left on backstrap looms. In addition to thorough field notes and photographs, she acquired artifacts used in the process, including a starched warp that had been tied but not dyed, an *ixtle* brush (bound, stiff twigs from the *yucca aloifolia*) for starching, a set of pattern-marking sticks, and a small ceramic marking paint container that hooks over the finger. These objects, plus a partially woven *rebozo* still mounted on the backstrap loom, and a completed *rebozo* of the same pattern, augmented by the photographs and description, give a fairly good idea of the entire *ikat* process in Tenancingo at that time.

Production observed in the 1930s was quite specialized. There were men who marked the pattern on the warp (*pintores*), men and boys who tied the resist bindings, weavers, dyers, and women and boys who made the fringe. At that time, there were only two or three dyers who could read and write and keep accounts. These dyers also served as middlemen. The prepared warps were accumulated at the dyers' house until there were enough for a dyeing session. McDougall counted as many as seventy-eight on one occasion. The dyers' family also wove and helped with the dyeing when necessary. The weavers were usually given credit and were in debt to the dyers. Apparently, production was done on a backstrap loom one garment at a time. Women of Teotla commonly referred to their *rebozos* as *tilmas* (Nahuatl: *tilmatli* = cape). In 1935, McDougall noted that many Nahuatl terms for loom parts were still in use and that, to her knowledge, only two women were weaving *rebozos*; the weaving was done mostly by men on backstrap looms. Generally, in Mexico, male weavers have not used back-

strap looms. Perhaps McDougall observed *rebozo* production at a time of transition from women's production in the home to men's production in the workshop. Today, the typical mode of *rebozo* production weaving in Tenancingo is by men on counterbalance treadle looms in workshops (Fundación Cultural Televisia, AC.:1986; Imanari 1983:132).

McDougall's observation of the steps of the process of preparing an *ikat* warp and setting the warp for a *rebozo* on a backstrap loom is thorough (McDougall 1935a, 1935b).[9] In the *ikat* process, usually ties are placed in patterned sequences on groups of threads, which are then dyed. The dye does not penetrate the area under the tie. When the ties are removed, the patterned sequence is on the group of threads in the original color of the thread. The pattern alternates with the dyed color of the threads. An outline of highlights of the process as distilled from McDougall's notes follows. I have selected sequential steps in the process that I consider crucial and distinctive to *ikat rebozo* weaving as practiced in Tenancingo in 1935.

The skeins of yarn are prepared by being wound tightly from post to post in the weaver's yard. If elasticity is removed, the yarn will not stretch as much during the tying of the *ikat* pattern. Bobbins are wound. The number of bobbins is one-half the number of threads in a vertical stripe having an *ikat* design. (For each weaving, the weaver determines the number of warp threads in a unit by the thickness of the yarn in relation to the desired pattern unit.) If one starts with four bobbins, then a warping bout (the back and forth, over and under, route of the threads) consists of eight threads. This is the number of threads in a vertical *ikat* pattern unit. Each bout gets a little twist to distinguish it. These little twist (*torcalito*) bouts are *ikat* pattern units (figure 1). Every three or four little groups of eight are put together in a larger twist unit. In 1935, a routine count in winding the portion of warp for the patterned *ikat* stripes was 264 small twist units, each consisting of eight threads combined into sixty-six large twist units (264 divided by 4). Each large twist unit consists of thirty-two threads. The warp is about eleven feet long.

The next step, the most difficult and crucial, requires great concentration. The threads from each little twist group that are to have the same design component in each *ikat* stripe will be grouped together. The eight threads of the *ikat* pattern unit will have one design component of the pattern unit on the first two threads; the second design component on threads three and four; the third design component on threads five and six; and the fourth design component on threads seven and eight (figure 1). Therefore, when the warp is stretched out, with a cross at both ends, the weaver arranges the

threads sequentially and divides them into sixty-six large twist units. The weaver then begins with the first of these large twist units (it will have four groups of small twist pattern units, each with eight threads) and takes the two first design component threads from group 1. At this point, if the *last* two design component threads from group 2 are selected, then the two first design component threads from group 3 are selected next, and finally, the last two design component threads from group 4 are selected. A design that is bilaterally symmetrical will emerge on this group of threads after marking, tying, and dyeing. These eight threads constituting a design component are held together by a cord or sometimes by a board with spaces between nails (figure 2). The weaver proceeds with the regrouping, going to the two second design component threads from group 1, etc. When the first large twist unit is finished, the weaver proceeds sequentially through the remaining sixty-five large twist units. At this point, there are sixty-six large twist units, each of which contains four smaller pattern units that were regrouped on the basis of having identical design components.

Now, a further amalgamation occurs. Beginning with the first six large twist units, the groups having like design components are bound together: these six large twist units become four groups, each group containing forty-eight threads and a different design component of the pattern unit. This is repeated, so that finally there are eleven portions of the warp, each of the eleven having the four groups corresponding to the four separate components of the design. The eleven groups are then starched with *atole* (corn starch) until they are rigid and then marked. Marking, which was completed swiftly, and tying were done by a low paid *pintor* (marker). The marking fluid was agave waste saturated with *añil* (indigo) dye, and carried in a small container hooked over the thumb. The marker made light strokes across a set of cords. Patterns had been learned from a *maestro* (teacher). Often patterns were a combination of motifs, with no strict vertical repeat.

The Tenancingo style *rebozo* always has two elements: the *ikat* stripes (*jaspe*) and the solid color warp stripes (*fondo*). The *fondo*, which alternates with the *ikat*-dyed pattern unit stripes, is warped and dyed separately. These stripes have different compositions. While, in the simplest instances, they are one color, frequently there is a central unit of one or two threads in a contrasting color. Particularly in more contemporary *rebozos*, the color of the *fondo* often makes a counterchange with the *ikat* pattern.

McDougall believed that many of the designs in the mid-1930s represented a simplification from previous geometric designs. These simplified designs require less labor-intensive tying. This can be seen readily: in the

mid-1930s, there were more solid color stripes interspersed, and alternate color rows, resulting from alternate color threading in a dense warp-faced weave, substituted for a check *ikat*-dyed design. In 1935, with the pattern greatly simplified and the texture of the cloth relatively coarse, the total warp count probably averaged 4,000 ends compared with the 10,000 ends of the superfine *rebozos* from the end of the nineteenth century. McDougall estimates approximately 8,000 ties in the fine *rebozo* she commissioned from Mariano (see below). A more common *rebozo* of 1935 would have had about 2,500 ties for which the reported wage was approximately twenty cents (United States currency).

Although some vegetal dyeing was done in 1935, chiefly synthetic *añil* (indigo) imported from Germany was used. After dyeing and drying, the warp was stretched, the ties of *ixtle* fiber cut off, and the warp groups restored to their original position, of four small twist groups composing a large twist group—sixty-six of these large twist groups across. Ties across the width of the *ikat* warp at intervals of about a hand span kept the pattern aligned while the warp was integrated with the solid color stripes during the mounting of the warp. A refinement in the backstrap loom used was a split back bar. The lower half had a groove where the warp fit. The two pieces of the back bar were placed together over the warp and fixed with a spiral lashing that went around each grouping of a solid and an *ikat* stripe. Heddles were constructed from #3 cotton. Two quadrupled picks formed the beginning and finishing selvedges. The weaving was heavily battened. After weaving, the *rebozo* was folded in half and then in quarters lengthwise. Then the fringes were brought together, making an eightfold. *Rebozos* are still folded in this traditional manner. The fringe was dipped in cold dye for a uniform color and taken to be knotted. Knotting, at that time, was the low-paid work of women; sometimes young boys were impressed into service.

A typical fine *rebozo*, commissioned by McDougall in 1935, was woven by Mariano, a weaver of Teotla, Tenancingo. The yarn of this rebozo is a very fine machine spun cotton ("Z" ply, about 80/2). The sett is about 176 ends per inch. For the execution of the *ikat* pattern of this *rebozo* at least eight thousand ties would have been required. The finished woven length is 200 cm (6.5 ft.); with the fringe of 32 cm, the total length is about 9 feet. The width is 81 cm (approximately 32 inches). The pattern is a popular one called *cocoles* (diamond shape). The colors are white, brown (from a bark dye), and indigo. This *rebozo* seems to be typical of those produced at the time, indeed, not too different from the *fino* (best grade) produced in Tenancingo today.

In 1935, McDougall also commissioned an unusual *rebozo* from Augusto Mendoza (figure 3). His work seems to stand apart stylistically, not only from Tenancingo *rebozos* but also from Mexican *rebozos* in general. The commissioned *rebozo* showed the kinds of motifs that Mendoza had learned as a youth in the course of apprenticeship with his *maestro*. At the time of McDougall's research, there were two *pintores* in Teotla. In 1933, Mendoza had made a *rebozo* for his daughter, Sabina. The name, "Sabina Mendoza," a *jarra* (jar) motif, and a Greek key figure in the border, appear in warp *ikat* in this *rebozo* (figure 4). Through the daughter, McDougall met the aged father who gave her the information that, in his youth, his *maestro* could represent any familiar animal, domestic fowl, plant, etc., in *ikat*. McDougall asked Mendoza to remember what his *maestro* had taught and to make a *rebozo* with plant and animal motifs.

Mendoza made a *rebozo* of this style in 1935. This specimen is now part of McDougall's collection at the American Museum of Natural History.[10] It depicts lizards, centipedes, and conventionalized plant forms, *jarras* (jars), and unidentified forms ranging in size from one and a half inches to six inches. The warp motifs on cotton are white on a dyed black background. Another unusual feature of this *rebozo* is the purple (or light blue) rayon stripes, in widths varying between approximately one-eighth and three-eighths inches. They alternate with solid color dark blue stripes and the motif-bearing stripes to give an optical effect. The solid color rayon stripes are a type of yarn formerly known as *sedalina*. The cotton of the darker blue and the motif bearing stripes is *hilo algodón*, #120, known as *de bolita*, possibly because of the packaging (pers.com. Irmgard W. Johnson, 1987). This *rebozo* was warped at about 150-160 ends per inch. It is roughly eighty inches long and twenty-four to twenty-six inches wide, somewhat smaller than what was typical at that time. The fringe is about nine inches. McDougall has the following note about the fringe: "The fringe was knot netted (finely) in distant Temascaltepec, one of the ancient towns of Toluca Valley, a weaver community there ended in about 1931 [McDougall more plausibly says 1914 elsewhere] when in civil war, rebel troops on the march burned and destroyed the dwellings—the weavers scattering."[11] McDougall further pinpoints the place where the fringe was done. Weavers in Teotla had relatives in San Simon de Guerrero, a tiny hamlet near Temascaltepec. The Mendoza *rebozo* was taken there to have the fringe finger woven by a dyer's wife. This woman also remembered the use of vegetal indigo (McDougall 1935a). The figurative motifs in warp *ikat*, particularly of animals, fowls and insects, and purple and black stripes present a puzzle. The style of this *rebozo*

definitely seems anomalous in the context of Mexican *ikat rebozos*.[12] Are these designs for *ikat*, the creation of the isolated folk artist Mendoza, the unique legacy of his apprenticeship with his anonymous *maestro* or may we hope to find other examples embodying the same tradition?

Another *rebozo* was sent to the Lowie Museum in 1905 by Zelia Nuttall, acting as a field representative for the Crocker-Reid Research Fund.[13] This *rebozo*, of typical size, 32 inches wide and about 8 feet long, bears no designation other than "Southern Mexico." At each edge there are four brown stripes with a white square dot *ikat* pattern. The predominant *ikat* patterning consists of stylized *muñecas* (doll figures), floral and geometric motifs. The colors are dark blue and white. However, because the background has been resisted, the motifs are dark on a white field. The fringe is 5 inch-long triangles in overhand knotting. It is dark blue and incorporates the brown and white stripe. The yarn is a "Z" ply of six strands of cotton; the loom is warped at 128 ends per inch.

The Nuttall and Mendoza *rebozos* seem atypical in the context of Mesoamerican *ikat rebozos*. Are there others in existence that would place them in a broader context? Perhaps future research will shed light on this.

Documentation of Other Resist Techniques

McDougall, seeking evidence that resist techniques had existed in pre-Hispanic times among peoples of Otomian stock, researched *plangi* and *ikat* in remote parts of Hidalgo in 1936-37 (McDougall 1936). Although the practice of *plangi* was vanishing, apparently it was still known to several weavers in that area. The type of *plangi* done by these weavers is sometimes called *tritik*. A design is stitched on the cloth. Then the stitching is pulled to compress the cloth. The compression creates undyed pattern areas when the cloth is dyed. At the little Otomian village of Ranchito Guadalupe between Ixmilquilpan and Zimapan, McDougall documented work in *ikat* and *plangi* by Romuala Olgún, an elderly woman, who spoke only Otomi (figure 5). She dyed with indigo, cochineal, logwood, mesquite pods, and iron sulphate. This weaver produced a backstrap-woven, twill double-weave cloth (a piece of a *quechquemitl*, a triangular woman's shawl) simulating a warp *ikat* pattern. The yarn is a coarse handspun, "Z" twist, rather tight. Señora Olgún, on commission, made a warp with *ikat* patterning, done with maguey fiber ties for a *jerga*, a garment for men and boys. McDougall suggested that the *jerga* was the descendent of the Aztec *tlcuipilli*. Altogether, McDougall commissioned three *plangi* pieces from Señora Olgún. Working together with her daughter, Señora Olgún created a stitch-resist cochineal dyed

322 *Weaving and Dyeing Technology*

delantal, a two-piece apron. Each piece is twenty-seven inches by twenty-seven inches, handwoven homespun, thirty-two ends per inch, twenty-six picks per inch. Using a maguey thorn needle, she stitched and tied with maguey fiber of different weights. She did not mark the design on the cloth first. A third example is dyed with cochineal but still compressed. It has petals, diamond, and vine motifs.

Another piece worth noting, by an unknown hand, bears the date "1930" incorporated in *tritik*. This clearly contradicts the assertion by one commentator that the practice of tie-dye in Mexico ceased in the 1920s (Parrott 1957:274). Irmgard W. Johnson (1986:27) has documented a tie-dyed skirt from Vizarron, Queretero, acquired in the 1950s. Ruth Lechuga and Marta Turok encountered an interesting old Otomian woman, Doña Dolores Aguilar, in Chavarria in a remote area of the Queretero mountains in the late 1970s (Lechuga 1986:206). She had not done tritik for twenty years but remembered the process, when encouraged, and created a skirt patterned with flowers.[14]

The Contemporary Tradition in *Ikat Rebozos*

There seems to have been no systematic study of *rebozo* production through the decades. In various regions of Mexico there is a marked preference for a specific type of *rebozo* (Lechuga 1986:167-170). In the state of Oaxaca, the typical dark blue cotton with flecks of white is popular, but most of the weaving is done elsewhere. In 1935, McDougall observed, in the city of Oaxaca, a weaving quarter south of the marketplace where all i*kat rebozo*-weaving was done on treadle looms. Indian youths from the village of Cajonas did the marking and tying, learning Spanish at the same time. Her opinion was that the work was coarse and the patterning insignificant, although some of the patterns had the same names as those used in Tenancingo (McDougall 1935b). Although production in Oaxaca continued into the 1960s, by the 1980s *ikat rebozo* weaving there seemed at a standstill. Anita Jones (pers. com. 1989) wrote about an old weaver, Manuel Palancares, in the barrio Xochomilco, who still makes very coarse and small i*kat rebozos*.[15]

Rayon, for the most part, has replaced silk in another type of *ikat rebozo*, yet to be thoroughly studied. A very interesting rayon *rebozo* from Tehuantepec,[16] collected in 1963 by Anita Jones, is said to be worn about the shoulder or tied about the waist. In my observation of *rebozos* worn in the Yucatan, the preference seems to be for rayon *rebozos* from Santa Maria del Río in colors that match their *huipiles*. Nowadays, most rayon *rebozos* are

woven in Santa Maria del Río, San Luis Potosi, although Santa Maria also has an ongoing history of weaving silk *ikat rebozos*. In 1953, Dr. Daniel Rubin de la Borbolla, then director of the Museum of Popular Arts in Mexico City, concerned that *ikat* weaving was dying out, founded an *Escuela de Artesañias* and brought weavers from Tenancingo to Santa Maria to teach young women and men the art of weaving *ikat rebozos* on backstrap looms (Irmgard W. Johnson, pers. com. 1987). The school still exists.

Production of cotton-warp *ikat rebozos* in Tenancingo continues today. Around 1948, most production shifted to workshops with male weavers using counterbalance looms (Hewitt 1957:19-20; Imanari 1983:129-133; Fundación Cultural Televisia, AC.:1986).

Even though there are changes from the nineteenth century, the type of *ikat* patterning and techniques for achieving them are similar. Design quality in the 1980s has been interesting and sophisticated. In Tenancingo today, the practice is to put a *fondo* warp of 225m on the principal beam of a counterbalance loom. This is enough length for 84 *rebozos*. Each *ikat* warp is 75m, enough for 28 *rebozos*. The new *ikat* warp is successively added, separately tensioned, and woven. Techniques of pattern selection, marking, and tying are still those of 1935. Stamping the design on the warp and tying is the work of families. The wage is about $60 (money amounts are in United States currency) for a 75m warp. The wage of the weaver (male) in 1983 was about $2 per *rebozo*; the fringe maker (female) received about $16 per *rebozo* for her labor-intensive task. The life of *rebozo* makers is hard. In 1983, the retail price of a *rebozo* ranged from $32 to $48 (Imanari 1983:133).

The continuing commercial production of such a high-quality, beautifully crafted, labor-intensive object for internal mass consumption is quite remarkable. An in-depth study of the economic and social history of the *rebozo* in the last fifty years might provide some interesting insights into its surprising persistence in Mexican culture. As it is, the *rebozo* exists as a garment worn throughout Mexican society by women of all social classes. The *rebozo* has significance as a symbol of Mexican woman and as a unifying element in expressing national identity.

Endnotes

1. See (Larsen 1976) for a general presentation of this subject.
2. With this quotation from Dr. Atl, pseudonym of Gerardo Murillo, noted Mexican artist and folklorist (Murillo 1922:1), I dedicate my paper to the women who wear *rebozos*.
 Except where otherwise indicated, material in this paper derives

from the Elsie C. McDougall Textile Collection and Archive which is the property of the Department of Anthropology of the American Museum of Natural History and is stored in the Ethnographic Textile Collection Room. During 1985 and 1986, I had the opportunity of organizing and working with this archive. I would like especially to thank Lisa Whittall, whose knowledge, interest and patience, greatly aided this project. I am also indebted to Irmgard Johnson for her research help, careful reading and important corrections of earlier versions of this article. Many people have given help and encouragement: Patricia Anawalt, Joanne S. Brandford, Mrs. Peggy Bird, Barbara Conklin, William Conklin, Martin Davis, Sandra Harner, Dr. Craig Morris, Pam Scheinman, Marc Scheinman, Louis Slavitz.

3. *Ikat*, from the Indonesian word *mengikat*, to bind, is the standard word used for this process and cloth (Burnham 1980:72). Conceptually this process provides a good example of non-verbal mathematical manipulation of groups of threads and of sets of such groups.

4. Elsie McDougall is characterized by those who knew her as a keen observer who was exceedingly generous with her knowledge and artifacts and very encouraging to other researchers. Her collections were given or sold at low prices to museums (Thompson 1962:205; Irmgard W. Johnson, pers. com., 1986). Failing health and eyesight curtailed her travels. She spent a good deal of time cataloguing her collection, revising her notes, and corresponding on points of research. Laura Start, in preparing the catalogue of McDougall's collection at the Pitt Rivers Museum of Oxford, was aided by McDougall's photographs, drawings, and notes. This catalogue, published in 1948, is a major source of knowledge about her extensive collection of textiles and looms from many regions in Mexico and Guatemala. The catalogue describes many of the forms and techniques from these areas (Start 1948). McDougall resided in Bearsville, New York, and was introduced by Louis Slavitz to Junius and Peggy Bird in 1948, as was noted in a telephone conversation with Louis Slavitz in March 1986 and in a letter from Peggy Bird dated April 6, 1987. She died in 1961. The American Museum of Natural History, the Pitt Rivers Museum of Oxford University, the Peabody Museum of Harvard University, the Whitworth Gallery of the University of Manchester, the Horniman

City Council Museum of London, and the Southwest Museum, Los Angeles, house her collections of textiles and related materials. The American Museum of Natural History has the largest portion: one hundred and forty-two Mexican and fifty-one Guatemalan textiles and looms, with the Pitt Rivers next, having thirty Mexican and twenty-three Guatemalan items. Archival material at the American Museum of Natural History consists of her copious field notes, drawings, and photographs, often of process. There are twenty-three basic techniques represented in the collection by Grossman's count. Grossman says, "The quality and the extensive documentation of every specimen distinguish this collection making it valuable both as exhibition material and as a study collection and not merely a hodgepodge of isolated curiosities" (Grossman 1955:9).

5. Wife of Dr. Junius Bird.
6. "*Doscientos*" refers to *rebozos* woven in a hair-like fine English cotton, number 200. This thread was extremely rare in 1935, but McDougall found a few bobbins, unused and rotting away, on a shelf of a weaver's house. There is an adage, true or not, that "*un rebozo de doscientos puede que pasar para* (sic) *una sortija*" (perhaps a *rebozo* of 200 can pass through a ring). A note with this adage in McDougall's handwriting is attached to 65/5183. All four *doscientos* mentioned here are located in the Ethnographic Textile Collection Room, Department of Anthropology, American Museum of Natural History: 65/5183, 65/5184, 65/5185, 65/5186.
7. American Museum of Natural History: 65/5183.
8. San Diego Museum of Man: 1970-22-86.
9. McDougall's description is very exact, however I have used Miller's terminology: pattern unit and design component because these are very accurate terms and allow the reader to compare Tenancingo *ikat* process with the *ikat* process of Tacabamba, Peru (Miller, this volume).
10. American Museum of Natural History: 65/5181.
11. Label, written by McDougall, 65/5181. Also McDougall (1935a, 1935b).
12. Irmgard Johnson consulted with Teresa Pomar, Director of the Popular Arts Museum, Mexico, D.F. Dr. Pomar expressed the opinion that the knotting style of the fringe resembles that of Moroleón, Guanajuato. Dr. Pomar has a large collection of over one hundred *rebozos*. She and Dr. Johnson concluded that the Mendoza *rebozo* is puzzling; so far no similar one is known. One would perhaps

expect one from Mendoza's *maestro*. They suggest inquiry at other museums and collections (Irmgard W. Johnson, pers. com. 1987).
13. Lowie Museum of Anthrolopogy, University of California, Berkeley, CA.: 3-555.
14. Sayer, Chloe. *Costumes of Mexico*. (Austin:University of Texas Press, 1985:182-83). Ruth Lechuga (1986:206) describes the very interesting resist process done by Doña Aguilar. She wrapped, using a needle, some of the already twill woven threads of a jerga to create a resist before dyeing the garment. Toraja, Indonesia is the only other locality where I have noted a technique similar to this. In this kind of gauze-woven cloth, called *pewo*, the resist binding is placed on some of the threads after weaving and before dyeing the entire piece.
15. On a trip to Oaxaca in June 1990, I found that although Manuel Palancares was long since dead, *rebozos* were still being produced by his stepson Fidel Diaz Valencia and are known locally as coming from the Palancares workshop.
16. San Diego Museum of Man: 1964-27-8.

Bibliography
Ajofrín, Francisco de
 1964 Diario del viaje que hizo a la América en el siglo XVIII.2 Vol. México, D.F.:Instituto Cultural Hispano-Mexicano.

Anawalt, Patricia R.
 1981 Indian Clothing before Cortés. Norman: University of Oklahoma Press.

Bazant, Jan
 1973 Evolución de la industria textil poblana 1544-1845. Historia Mexicana 13:473-516.

Bird, Junius B.
 1960 Suggestions for the Recording of Data on Spinning and Weaving and the Collecting of Material. The Kroeber Anthropological Society Papers 22: 1-9.

Borah, Woodrow
 1943 Silk Raising in Colonial Mexico. Ibero-America 20. Berkeley, CA: University of California Press.

Boyd, E.
 1974 Popular Arts of Spanish New Mexico. Santa Fe: Museum of New Mexico Press.

Burnham, Dorothy K.
 1980 Warp and Weft: A Textile Terminology. Toronto, Ontario: Royal Ontario Museum.

Calderon de la Barca, Frances
 1982 Life in Mexico. Berkeley and Los Angeles, CA: University of California Press.

Codex Mendoza
 1984 Commentary, Kurt Ross. Reproduction, London: Regent Books.

Cordry, Donald, and Dorothy Cordry
 1968 Mexican Indian Costumes. Austin: University of New Mexico Press.

de Toro y Gisbert, Miguel
 1967 Pequeño Larousse ilustrado. Revised and enlarged by Ramón García-Pelayo y Gross. Larousse, Paris.

Dewar, John
 1963 The China Poblana. Los Angeles County Museum Quarterly 2/2.

Díaz del Castillo, Bernal
 1956 The Discovery and Conquest of Mexico, 1517-1521. Translated by A.P. Maudslay. New York: Farrar, Straus and Cudahy.

Foster, George M.
 1960 Culture and Conquest: America's Spanish Heritage. Chicago: Quadrangle Books.

Fundación Cultural Televisia, AC
 1986 Mexican Textiles: Line to Color. Video Recording. Mexico, D.F.

Gage, Thomas
1969 [1620] Travels in the New World. Edited with introduction by J. Eric S. Thompson. Norman, OK: University of Oklahoma Press.

Gibson, Charles
 1964 The Aztecs under Spanish Rule. Stanford, CA: Stanford University Press.
 1967 Tlazcala in the Sixteenth Century. Stanford, CA: Stanford University Press.

Grossman, Ellin F.
 1955 Textiles and Looms from Guatemala and Mexico: The

Elsie McDougall Collection. Handweaver and Craftsman 7: 6-11.

Hewitt, T.H.
1957 Rebozos of Tenancingo. Handweaver and Craftsman 8(3): 19-20.

Imanari, Tomami
1983 Kasuri (*ikat*) of *Rebozos*. (In Japanese.) Senshoku no Bi 24:129-133.

Johnson, Irmgard W.
1954 Chiptic Cave Textiles from Chiapas, Mexico. Journal de la Société des Américanistes. Nouvelle Serie XLIII:137-48. Paris.

1970 A Painted Textile from Tenancingo, Mexico. Archiv für Völkerkunde 24:265-73. Vienna.

1986 El textil mexicano: Técnicas de producción. *In* El textil mexicano: Linea y color. Exhibition Catalogue, Museo Rufino Tamayo. México, D.F.

Keremitsis, Dawn
1973 La industria textil mexicana en el siglo XIX. México, D.F.: Sep-Setentas.

King, Mary Elizabeth
1966 Village Costumes of Guatemala and Mexico. Exhibition Catalogue, Textile Museum, Washington, D.C.

Lafaye, Jacques
1976 Quetzalcóatl and Guadalupe: The Formation of Mexican National Consciousness, 1531-1813. B. Keen, trans. Chicago: University of Chicago Press.

Larsen, Jack Lenor
1976 The Dyer's Art: Ikat, Batik and Plangi. New York: Van Nostrand Reinhold.

Lechuga, Ruth D.
1982 La indumentaria en el Mexico indígena. México, D.F.: Fonart.

1986 El traje indígena de México. Third edition. México, D.F.: Panorama S.A.

McDougall, Elsie C.
1935a Rebozo Construction, Teotla, Toluca Valley, Mexico. Ethnographic Textile Collection Room, Department of Anthropology, American Museum of Natural History.

1935b *Rebozo*. Ethnographic Textile Collection Room, Department of Anthropology, American Museum of Natural History.

1936 *Plangi*. Ethnographic Textile Collection Room, Department of Anthropology, American Museum of Natural History.

Martinez del Rio, Marita, et al.
1971 El rebozo. México, D.F.: Artes de México.

Mastache de Escobar, Alba Guadalupe
1974 Dos fragmentos de tejido decorados con la técnica de plangi. Anales del INAH. Mexico.

Mexican Folk Art from the Collection of Nelson A. Rockefeller
1984 Exhibition Catalogue. New York: Center for Inter-American Relations.

Mompradé, Electra, and Tonatiúh Gutiérrez
1981 Indumentaria tradicional indígena. México, D.F.: Editorial Hermes, S.A.

Munguia, D. Vicente
1851 Del orígen, uso y bellezas del traje propio de las mejicanas conocido bajo el nombre de rebozo. Guadalajara: Camarena.

Murillo, Gerardo (Atl, Dr.)
1922 Las artes populares de México. México: Editorial Cultura, Secretaría de Industria y Comercio.

Norman, James
1959 In Mexico. New York: Wm. Morrow Co.

Nuñez y Dominguez, Jose J.
1917 El rebozo. México: Departo. Editorial de la Dirección General de las Bellas Artes, Monografías Nacionalistas.

O'Neale, Lila M.
1945 Textiles of Highland Guatemala. Washington, D.C.: Carnegie Institution.

Paalen, Isabel de Marin
1976 Historia general del arte mexicano etno-artesanias y arte popular. México, D.F.:Editorial Hermes, S.A.

Parrott, Allen
1957 A Rare Tie-dye Skirt from Mexico. El Palacio 64: 274-5.

Peñaloza, Porfírio Martinez
 1979 Popular Art of Mexico. Mexico, D.F.: Ediciones Lara, S.A.

Robinson, Natalie V.
 1987 Mantónes de Manila: Their Role in China's Silk Trade. Arts of Asia 17(1):65-75. Hong Kong.

Sayer, Chloe
 1977 Crafts of Mexico. New York: Doubleday.
 1985 Costumes of Mexico. Austin: University of Texas Press.

Schurz, William Lytle
 1959 The Manila Galleon. New York: E.P. Dutton & Co.

Start, Laura E.
 1948 The McDougall Collection of Indian Textiles from Guatemala and Mexico. Oxford: Oxford University Press.

Thompson, J. Eric
 1962 In Memoriam. Ethnos 1-4: 205-206. Stockholm.

Von Humboldt, Alexander
 1977[1811] Political Essay on the Kingdom of New Spain. John Black, trans. New York: Knopf.

Figure 1. Pattern unit, Mariano's *rebozo*, 1935. Drawing by Virginia Davis 1989.

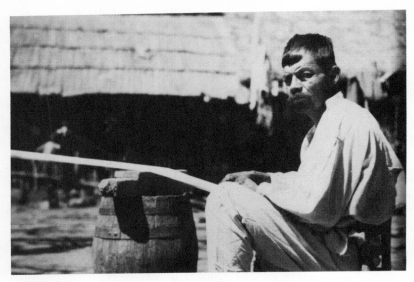

Figure 2. Mariano putting similar design component warp yarns in the spaces between nails on a board. Elsie McDougall Archives, Ethnographic Textile Collection Room, Department of Anthropology, American Museum of Natural History, New York. Photo by Elsie McDougall 1935.

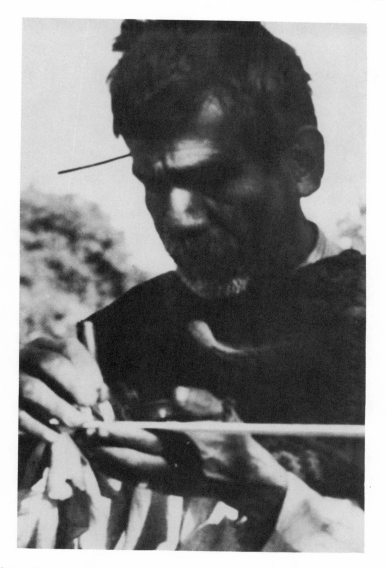

Figure 3. Augusto Mendoza marking a warp. Elsie McDougall Archives, Ethnographic Textile Collection Room, Department of Anthropology, American Museum of Natural History, New York. Photo by Elsie McDougall 1935.

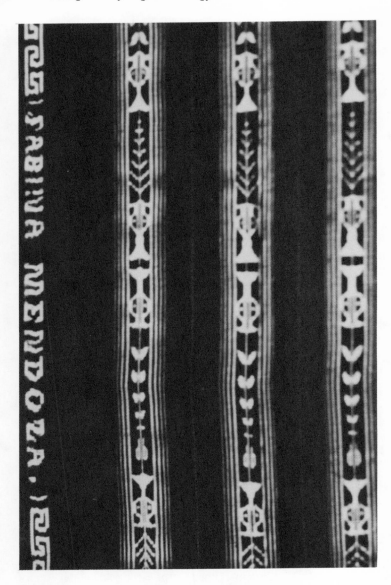

Figure 4. *Rebozo* for Sabina Mendoza. Elsie McDougall Archives, Ethnographic Textile Collection Room, Department of Anthropology, American Museum of Natural History, New York. Photo by Elsie McDougall 1935.

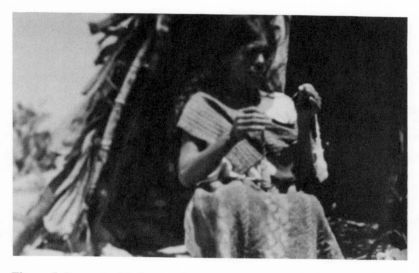

Figure 5. Romuala Olgún, wearing a *tritik* (stitch resist) *delantal* (apron). Elsie McDougall Archives, Ethnographic Textile Collection Room, Department of Anthropology, American Museum of Natural History, New York. Photo by Elsie McDougall 1936.

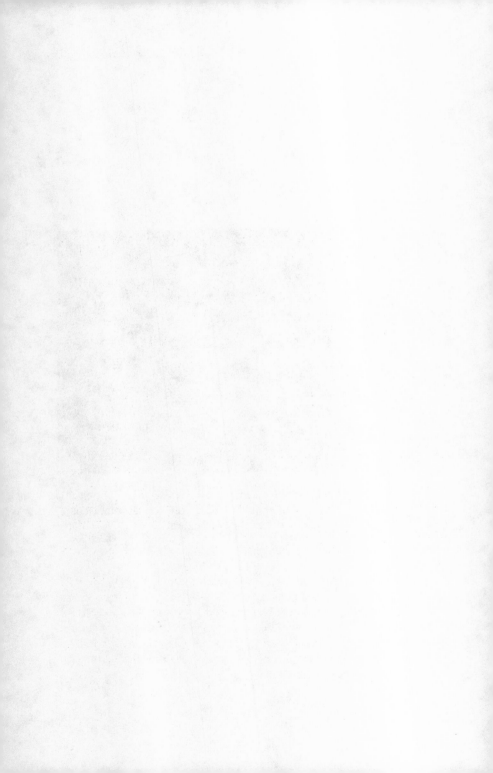

Chapter Fourteen

The *Ikat* Shawl Traditions of Northern Peru and Southern Ecuador

Laura Martin Miller

Introduction

After living six months in the Gualaceo region of southern Ecuador, I had grown used to the sight of old women coming to town on market day wearing their finest *paños*, or shawls. The oldest of these *ikat* shawls had indigo blue designs on a white background. Other *paños* were pink on black; both types were finished with long, elaborately knotted fringes. In Gualaceo, traditional dress, including the *paño*, is rapidly being displaced by factory-made clothing. Production is currently geared towards the tourist market and urban dressmakers.[1]

Arriving in Bambamarca, Peru, for the Sunday market, I was amazed to see almost all of the women, both old and young, wearing *pañones*, the *ikat* shawl of Northern Peru. Most of the shawls were blue with white designs, and a few women wore white shawls with blue designs. In the Cajamarca Department, traditional dress is maintained by the majority of the peasant population. Production is geared to the local market, and there is virtually no tourist trade in *pañones*.

Although strikingly similar in design, the *paño* and the *pañon* are made with different *ikat*, or resist dye, techniques. In this chapter, I will consider the technical differences and discuss the trade connections between the two areas. I hope to raise some questions about the fate of the *ikat* technique after the Spanish conquest and about origin of this style of *ikat* shawl in the Northern Peru and Southern Ecuador.

The *Ikat* Technique

Evidence suggests that the blue on white *paño* design came from San Miguel de Pallaques (Hualgayoc Province, Cajamarca Department, Peru) and was subsequently adopted in Gualaceo (Azuay Province, Ecuador). However, several differences in technique—pattern unit component grouping and loom style—merit description and raise questions about the origin and spread of *ikat* technique in the region. It seems remarkable that radically different techniques exist in such a relatively small geographic area and produce such similar textiles.

The *Pañones* of Tacabamba, Peru

Currently in Peru, *ikat* shawls or *pañones* are produced only in Tacabamba, a small town in the Chota Province of Cajamarca. Tacabamba lies about twenty-five kilometers from Chota, the provincial capital, and the trip takes about two hours by truck. I spent a week there in October 1986 observing and documenting *pañon* production.

In Tacabamba, the various processes of *pañon* production are done by different women. A single shawl may pass through the hands of as many as five women—the warper, the resist tier, the dyer, the weaver, and the knot tier. Most women know all of these arts (with the exception of dyeing, which is the jealously guarded secret of only a few women), but they specialize in only one trade. Their weekly labors are usually a combination of paid work on *pañones* owned by someone else and work on a *pañon* for which they invested in the materials. Naturally, there is more profit for the artisan when she has invested in the materials. In her "own" *pañon*, she pays other artisans to do the processes that she does not specialize in.

In Tacabamba *ikat pañones*, designs are created on the warp with fiber resist ties prior to dyeing in indigo. This process is the same whether the resulting *pañon* is white on blue or blue on white. Generally, *pañones* are composed of warp-parallel lines of pattern units in ABAB order. A pattern unit is composed of a given number of components (figure 1). Each

component is made up of a fixed number of warp threads determined by the artisan based on the design to be created and the thickness of the thread.

Before resist tying can begin, the weaver must make the warp on the warping frame or *urdidora*, a rectangular wooden base from which rise five posts. Unlike weaving in other Andean areas where the warping sticks also function as loom bars, in Tacabamba the *urdidora* posts are fixed to the base. The warper manipulates two threads while warping. When the warp is completed, she transfers it to an interim loom set-up. One end of the warp is tied to the *cungalpiu* (Q),[2] or notched loom bar, nearest the artisan. The end farthest from the weaver is firmly lashed to a special shorter notched loom bar, approximately half of the length of the *cungalpiu* nearest her. The artisan then places the shorter loom bar in the *chamba* (Q), or hanging device, and puts tension on the warp by leaning against the backstrap. Slack is left in the heading cord at the artisan's end allowing room to manipulate the threads. She then begins to count out the components of each pattern unit.

The artisan starts at the right edge of the warp and begins to count out the components. In the *pañones* that I saw, each component was comprised of three pairs of warp threads. After she counts out the number of components required for the pattern unit, she laces a fiber through the components and knots the end, thus defining the pattern unit (figure 2). This work is often done by the artisan's children. She tells them the number of threads in each component and the number of components in each A and B pattern unit. Pattern units in Tacabamba usually consist of five to nine components, for a larger number would be unwieldy later. The counting and lacing process is repeated across the warp until all the threads are counted. The fiber used for lacing the pattern unit is generally a few strands of the same plant fiber used for resist tying. This fiber is akin to that of the *Agave Americano Latino* that is used in Ecuador, and comes from a similar, but smaller, plant. Hanks of this fiber are always abundant in the weaver's house.

After counting out the components and defining the pattern unit, the next step is to separate the A pattern units from the B pattern units, so that the A components can be grouped and resist tied separately from the B components. To separate the A's from the B's, the *putij* (Q), or shed rod, stick is used. The weaver places the A pattern units above the stick and the B's below it.

The analogous components of all the A pattern units must be grouped together, similarly, all the analogous components of the B pattern units must be grouped together. In a simple five-component pattern unit, the

weaver uses the spaces between her fingers to group the analogous compo-
nents (figure 3). She picks up the first pattern unit at the right edge of the warp
in her left hand and with that hand, she places the first component in the space
between the thumb and index finger of her right hand. Then the second
component is placed between her index finger and middle finger. The fifth
component falls free below the little finger. The weaver repeats this process
from right to left across the warp with each of the A pattern units.

When the weaver finishes, the space between the thumb and the
index finger holds all of the first components of all of the A pattern units.
Similarly, the space between the index finger and the middle finger holds all
of the second components of all of the A pattern units. She then loosely laces
a thick clump of plant fibers through the five ordered groups, using the same
lacing pattern seen before in figure 2. Each of these groups is called a *tira* in
Tacabamba. Thus each *tira* contains all of the analogous components from
design units across the width of the warp.

The weaver turns the warp side over and repeats this process with
the B pattern units. When this is completed for both the A and the B pattern
units, the groupings or *tiras* are established for the entire length of the warp.

The weaver removes the end of the warp that was tied to the longer
notched loom bar, compresses the warps that had been spread out along the
heading cord and lashes it to a shorter loom bar. With the shorter loom bar
at both ends of the warp, she stretches it on a frame, the *templadora*. One
loom bar fits on the underside of the long rectangular frame and the other
loom bar is firmly lashed to the opposite end of the *templadora*. This device
keeps the warps under tension and prevents them from shifting their relative
position during the resist tying process. In resist tying, the artisan creates the
design on the *pañon* by tightly wrapping with plant fiber each area of the *tira*
to be kept free of dye. She sees each group of five *tiras* as a unit, and the
placement of each resist tie on the *tira* is dictated by its place in the overall
design.

The Tacabamba component counting and pattern unit grouping
system for *ikat* is essentially limited by the number of fingers on the human
hand. Pattern units of up to nine components are created, but the hand is still
the basic limitation. To form a nine-component bilaterally symmetrical
pattern unit, nine components are counted out, and a few strands of fiber are
laced through them. When the artisan places the components on her hand, the
first five components are placed in the spaces between the fingers as
previously described. Then, the sixth component is placed with the fourth,
the seventh with the third, the eighth with the second and the ninth with the

first. Thus, component number five is a pivot point or the line around which the mirror image is formed. This technique is called *la retapada* or the recovered.

Weavers in Tacabamba told me that designs with more components can be made, but it is very time consuming and they simply do not have the time to spend creating new, more complex designs when they must produce in order to feed their families.

After resist tying is done, the shawl is dyed in indigo. I found one dyer who was willing to give me some information about her craft. She buys the indigo in cakes from the intermediaries who supply most of the weaving materials in Tacabamba. The dyestuff is not locally grown or processed. When dyeing, she first wets the *pañon* warp so that the dye will penetrate evenly. She prepares the dye the night before she is to use it by heating and adding lye made from ashes, lime, and plants. Each *pañon* warp is dipped in dye twice and dried. When dry, she takes off the resist ties and returns the piece to the owner. Details on dyeing are rather sketchy, for relatively few elderly women know this trade and are not willing to share their secrets.

Pañones in Tacabamba are woven on the backstrap loom; each end of the warp is lashed to a notched loom bar over a heading cord. One loom bar is hung from a secure position above the ground, and the other is placed at the weaver's waist. The weaver leans back on the backstrap to give her the tension required to manipulate the threads. In contrast to the circular-warp Ecuadorean loom, in Peru, the weaver weaves the warp toward the upper loom bar, always rolling up the created textile.

Although the loom technology is quite different in Ecuador, there is an odd similarity. In both Tacabamba and Gualaceo, Ecuador, when setting up the loom, the weaver uses a short length of bamboo around which she makes the heddles. Essentially, it measures the heddles to the same length. In Gualaceo it is called the *juka* (Q) and in Tacabamba, the *canutito*. In both places, the artisan simply loops the heddle cord around the warp and the bamboo—it is exactly the same movement and process in both areas.

After weaving, the fringe is knotted. An overhand knot is used, as in Gualaceo. Currently in Tacabamba, the *blonda* or fringe rarely exceeds twenty centimeters. Common designs include flowers—carnations and dahlias—and zigzags. An elderly woman told me that old *blondas* measured a *vara*, or thirty-eight centimeters, in length and included a wider variety of elements, such as animals and birds.

The *Paños* of Gualaceo, Ecuador

In the Gualaceo area, there is a strict sexual division of labor in *paño* production; women prepare and dye the warp and knot the fringes, and men weave the shawl. Often married couples work together in *paño* production—the husband weaves while the wife prepares the warp and dyes it. Fringe knotting is usually done by women who specialize in this aspect of the production.

In Ecuador, the warp is made on the *banco*, or warping board, which consists of a base board and with the *tactis* (Q), or two thick posts, at either end and two *sarines*,[3] or dowels, in between them. When warping, the thread passes from the left dowel and goes from front to back around the left end post. It passes along the warping board face opposite the warper and comes from back to front around the right end post. It passes in front of the right dowel and behind the left dowel. The warper then reverses direction, and the warp thread passes in front of the left dowel and behind the right dowel. The warp passes around the right end post from front to back and runs the length of the warping board. It then comes from back to front around the left end post and passes behind the left dowel. The warper reverses direction and places the warp around the left end post from front to back. This process is repeated until sufficient warps for the *paño* are in place.

The left dowel or *sarin* A can be called the dovetail stick. Both the initial and the terminal warp ends hook around it. With the dowel in place, the warp forms a tube, and the textile is woven with the dowel, or the string replacing it, in position. When the dovetail stick or string is removed, the warp end loops separate and the weaving spreads out into a flat rectangle. Since the warp threads are in order on the dovetail stick, it is essential for component counting and pattern unit selecting.

In Ecuador, the components and the pattern units are determined before the warp leaves the warping board. This complex and efficient system is based on the *cuendas*—a set of auxiliary strings, usually thick cotton. The *cuendas* are used both to separate the counted components from other components in the same pattern unit and to later unite the analogous components in all the pattern units. It is important to note that while in Tacabamba the artisan looks at the warp lashed to the *cungalpiu* and extended vertically before her, the Gualaceo artisan looks at the warps horizontally while they are still on the warping board.

In the Gualaceo area, when the artisan has finished warping, she begins to put the *cuendas* in place (figure 4). She starts at the "bottom" of the warp, with the first warps that she placed on the warping board. She selects

a certain number of pairs of warps and ties a series of *cuendas* to these threads, starting at her left. These warps serve as a base upon which to tie the *cuendas*. She uses as many *cuendas* as there are components in the pattern unit. Eventually, the warp threads that the *cuendas* were first tied to are released. Depending upon the overall design that the artisan has decided upon, these base threads can be included in the resist tied pattern or excluded. If excluded, these threads will appear in the final shawl as plain parallel warp stripes.

The artisan then looks at the dovetail dowel, where the warp pairs can be easily distinguished, and she counts out the number of threads for the first component of the first A pattern unit (in figure 4, the base warps where the *cuendas* are tied will be released and appear as warp parallel stripes). She passes the *cuenda* behind those threads and then pulls the *cuenda* toward her again, so it ends up on her side of the warp. The next component is counted and the second *cuenda* passes behind the warps that comprise the first and second components and then passes toward the artisan. Likewise, the third *cuenda* passes behind the warps that comprise the first, second, and third components, and then it passes toward the artisan. Thus the *cuendas* maintain the separation between the counted components. The process continues until the desired number of components of the first A pattern unit is completed.

Gualaceo *paños* are composed of warp-parallel lines of pattern units in ABAB order, like the Tacabamba *pañones*. One set of *cuendas* governs the A pattern units while another set of *cuendas* governs the Bs. Thus, once the components of the first A pattern unit have been counted with the *cuendas*, another set of *cuendas* are tied on, and the artisan uses these to count and select the components for the B pattern units.

When she finishes counting and selecting the components for B pattern units, she returns to the *cuendas* that govern the A pattern unit and begins to count out the components for second A pattern unit. Again, the first *cuenda* passes behind the first component, and the second *cuenda* passes behind the first and second components of the A pattern unit. In this fashion, the artisan completes the second A pattern unit and continues to the second B pattern unit.

When this has been done for all the warp threads, the artisan then uses the *cuendas* to group the analogous components of each of the units. She unties the *cuendas* from the original base and frees those threads. She then ties the top end of each *cuenda* to its bottom end. Starting on her left with the first A *cuenda*, she gathers all the warp threads that are contained in this *cuenda* loop and makes a single bundle or *soga* as it is called in the Gualaceo

344 Weaving and Dyeing Technology

region. The *soga* in this area is similar to the *tira* in the Tacabamba region. After forming each *soga*, the artisan laces a fiber around the bundle so that the painstakingly-achieved separation will not be lost. This is the same kind of lacing as seen in figure 2. The second *soga* is formed from all the components contained by the second *cuenda*. The process continues for all the *cuendas* of pattern unit A and then is repeated for all the *cuendas* of pattern unit B. A thick bunch of fibers is laced through the *sogas* so that the order is maintained. Only when this fiber is in place are the *cuenda* loops untied and removed.

When this process has been completed for all the warp threads, each *cuenda* has served a double purpose: it maintains the separation of each component from its fellows in the pattern unit and serves to unite all the analogous components of all of the A or B pattern units. Therefore, the number of components in Gualaceo *ikat* pattern units is not limited by the number of spaces between the fingers but can be as large as the number of *cuendas* that the artisan uses and the number of *sogas* that she wants to tie with the resist wrapping. Some complex designs in Gualaceo require up to twenty-four *sogas*.

The fiber used for resist tying comes from the *Agave Americano Latino*, or *cabuya* as it is known in the region. The fronds are cut and the thorns are removed from the sides and tips. Then cuts are made longitudinally in the frond, and the fibers that run its length begin to separate. After splitting, the fibrous strips are tied in bundles and allowed to soak in stagnant water for a week. This fermentation process helps depulp the fibers. After soaking, the bundles are removed and beaten against rocks to remove all excess pulp. The fibers are then rinsed with clean water and stored until needed. Artisans emphasize that the *cabuya* must be especially clean to be used for a white-ground shawl. This is not as crucial for the more common pink-ground shawls.

After resist tying, the *paño* is dyed. Currently in the Gualaceo area, the pink and black shawls are most commonly made, and these use aniline dyes. The yarn is first dyed in pink, then resist tied and then over-dyed in black. For these *paños*, the fringe is kept out of the dye bath and remains pink.

In Ecuador, the warp encircles the loom bars, in contrast to the northern Peruvian type loom in which the warp is lashed to the rectangular notched loom bars. In Ecuador, as the weaver works, he simply slides the unwoven warp and the textile around the loom bars, thus maintaining the warp to be woven a comfortable distance away from his body. The Ecuadorean loom is more efficient than the Peruvian, for the painstaking task of

lashing the heading cords to the loom bars is eliminated. The warp is a tube, and when the dovetail stick or string is slipped out, the textile becomes a rectangle.

It may take only a week to warp, tie, dye, and weave the actual textile, but fringe knotting can take up to three months, depending on the complexity of the design and the fineness of the knots. Knotting is also the most poorly paid of all of the parts of *paño* production. In Mexico, knotting is better paid; in 1983 in Tenancingo, male weavers earned around two dollars per shawl, while female fringe knotters received sixteen dollars for their work (Davis, this volume). However, it must be remembered that knotting is the most time-consuming process of shawl production.

Recent History of the *Ikat* Traditions

The striking similarity in Peruvian *pañones* and Ecuadorean *paños* is by no means a coincidence. The style called *estilo peruano* in the Gualaceo region was adapted from Peruvian *pañones* seen by Ecuadorean *ikat* weavers. Early twentieth-century trade connections played a key role in the spread of this style of *ikat* shawl.

There is documented evidence of *pañon* weaving in northern Peru in the late nineteenth century. In a 1977 thesis, three Peruvian anthropology students reported that elderly women in San Miguel de Pallaques (Hualgayoc Province, Cajamarca Department) had learned the technique from their mothers and that *pañon*-weaving was "el oficio del pueblo,"—the trade of the people (Quiroz et al. 1977:24). Generally, rural women dyed and wove the *pañones*, while women who lived in the town of San Miguel warped, did the resist-tying, and knotted the fringes.

In 1925, *pañones* were woven in San Miguel and in Tacabamba (Cajamarca Department) and in Huancabamba (Piura Department). The weaving tradition seems to have extended no further south than San Miguel. In San Miguel during the 1960s, *ikat* weaving was replaced as the "oficio del pueblo" by a kind of over-shot blanket (ibid.:27).

In February 1957, John Cohen documented *ikat* shawl production in San Miguel. The technique used in producing these *mantas*, as they were called, is significantly different from what I observed in Tacabamba. The San Miguel technique allows more complex designs than those currently seen in Peru. He reports that the warp was made on a warping board similar to that described for Tacabamba. Before removal from the warping board, the warps were separated into component groups of eight threads, and those groups were maintained by lacing. Then the warp was transferred to an interim loom

set-up, and the artisan began to form the pattern units. Instead of using her fingers to group the analogous components of the pattern unit, the San Miguel artisan used a tool called the *escogidor*.[4] This comb-like device had twenty slots into which component groups were placed. In the *manta* John Cohen documented, only seventeen of the twenty slots were actually used.

Starting at one side of the warp, the artisan placed warp components into *escogidor* slots in sequential order. After filling all the slots once, she returned to the first slot on the *escogidor* and continued to place the components. When finished, the warp was divided into seventeen groups; each group contained analogous components from the entire width of the warp. A string was laced through these groups to maintain their separation. Thus a seventeen-component pattern unit was created.

Then the warp was returned to the warping board where it was placed under tension between two posts. Four ply yarn was used for resist tying and it was wound around a *quichu* (Q), or bobbin, so that it could be easily manipulated around the warp. Artisans reported that it could take up to three days to complete the tying on a fine white-ground *manta*.

After tying, the warp was removed from the warping board, and the fringe ends wrapped in paper and cloth to protect them from the dye. The dyer that John Cohen interviewed lived on the outskirts of San Miguel and told him that she bought imported Central American indigo in a store in town. She reported grinding the indigo between stones and cooking it with water and ashes. She dyed the *manta* warp by dipping it in the dye bath, stirring it, and periodically lifting it out of the bath to snap it. The snapping action helped the dye to penetrate the small areas between resist ties (J. Cohen, pers. com. 1987).

The San Miguel style was characterized by *ikat* designs in blue on white. There were:

> flowers, snails, little birds and little pots, distributed evenly on the body of the shawl. About fifteen to twenty centimeters above the fringe, a border design [warp-perpendicular] was made during the *ikat* dyeing process. It is a combination of figures, either larger or smaller than the design on the body of the shawl to make it visually pleasing (Quiroz et al. 1977:24).

San Miguel artisans created warp-fringe designs in overhand knots at either end of the textile. This part of the shawl—the *randa*—is about forty to fifty

centimeters long, followed by twelve centimeters of free fringe. *Randa* designs include "little birds, landscapes, letters and national seals, all chosen by the woman ordering the *pañon*" (Quiroz et al. 1977:25). The most elaborate fringes depicted the Peruvian and Ecuadorean national seals. Poems were also worked in the fringes. The Peruvian anthropology students documented two poems worked in the fringes, both of which merit attention:

Al pie de la lima verde	At the foot of the green lime tree
Donde nace el agua clara	Where the clear water flows,
Entregué mi corazón	I gave my heart
A quien no lo merecía.	To one who did not deserve it.
Aguila del valle andino,	Eagle of the Andean valley
Parte para el Ecuador	Takes wing to Ecuador
Llevando la labor	Taking the works
Del pueblo San Miguelino.	Of the people of San Miguel (ibid.:26).

The latter is most interesting in tracing the shawl trade and the spread of designs from northern Peru to southern Ecuador. San Miguel area weavers brought their shawls to town during local festivals, such as La Fiesta del San Miguel Arcangel in September, San Juan in June, and La Virgen del Arco in December. There they met travelling salesmen from Piura and Monsefu. These men bought *pañones* to sell in other parts of Cajamarca and sold their wares, including shoes, cloth, and hats (ibid.:27).

How and when did the San Miguel type shawl arrive in Gualaceo, Ecuador? Oral history collected in 1986 sheds light on how the "*estilo peruano*" arrived and on the dynamics of *paño*, production in Gualaceo in the early twentieth century (Miller et al. 1986).

The *paño* style in Ecuador called "*estilo peruano*" corresponds closely with the description of the San Miguel *pañon*. These shawls have blue designs on a white ground and include a white on blue warp-perpendicular *guarda*, or border design. Common designs in the body of the *paño* and the *guarda* include birds, butterflies, plants, dogs, curls, and flowers.

The *fleco*, or fringe, of the Gualaceo *paños* is elaborately knotted, like the San Miguel *pañon*. Some Gualaceo-area weavers stated that the national emblem fringe design was a local innovation. Information from Peru contradicts this. Nonetheless, fringes in Ecuador are elaborate and give us a good idea of what San Miguel *pañon* fringes must have been.

Simple, low-quality *ikat* shawls were made in the Gualaceo area, (specifically the communities of Bulcay and Bulzhun), before Peruvian *ikats* arrived in the early twentieth century. Currently, these shawls are made in the technique described for the Gualaceo *paño*. They are considered low quality because the thread is thicker and the designs are less complex. Within the memory of seventy- to eighty-year old men and women, every year *pacotillas*, or low-quality shawls, were taken to Loja for the Fiesta de La Virgen del Cisne on the eighth of September. One elderly man told us:

> There (in Loja) the young ladies of the countryside usually go out dressed in the little shawls we made. They didn't have this style in Loja, but in the countryside around Loja (Miller et al. 1986:22).[5]

Paños pacotillas were taken from the Gualaceo area to Loja by both individual weavers and intermediaries. Much of the weaving throughout the year was done on an informal commission basis, but in the months before the Fiesta de La Virgen del Cisne, artisans produced on consignment for the intermediaries. A woman who knotted *paño* fringes as a young girl told us:

> I knotted [the fringe of the shawl] for them to take to Loja. I did birds, deer, doves and all kinds of things. I was a worker...I put myself to doing the *paños* that they took to Loja to sell. They offered to pay 6 or 7 *reales* for each one, and they offered a *real* more for every one, to be paid on return from Loja (ibid.:24).[6]

Another man told us of *mingas de tejidas*, or communal work parties, to weave *paños* for the trip to Loja. These *mingas* were organized by the intermediaries.

> I worked in weaving work parties. A long time ago, the travelers (the intermediaries) had weaving work parties, five, six weavers, that's how we'd weave in parties for those who were traveling. In one house, there'd be a work party. Some of us would go at four in the morning. Some at five in the morning, to work, to weave. Some had their *paños* all set up to go and just weave them there. The travelers took this on their trip, 100 *paños*, 200 *paños*, 150

paños, all according to the amount of their influence. Some people have money, they went with a lot. Others don't have as much influence, they took only a little (ibid.:24-25).[7]

One old weaver who made the trip to Loja as a boy told us of the journey.

The trip was 5 days going, and 5 days back, and with the five days spent at the fiesta, the round trip was 15 days. And there we traded with the Peruvians. (We went on mule back), yes, on muleback. I went as just a kid (ibid.:25).[8]

When in Loja with their wares for the Fiesta de La Virgen del Cisne, weavers from the Gualaceo region saw Peruvian shawls. It is highly unlikely that they met up with Peruvian weavers, since *pañones* were sold to intermediaries in the Peruvian towns. For experienced weavers, however, examination of the textile itself is enough to inspire innovations in style. As one elderly weaver told us:

They said that they'd seen Peruvians, here are the Peruvian shawls. We made Peruvian [shawls]....Many Peruvians went to Loja. The Peruvians went to Loja to sell all kinds of things. The travellers from here brought back Peruvian goods. They'd go with *paños pacotillas* to sell there (ibid.:23).[9]

Another elderly weaver stated:

These weavings they say they knew in Peru first. Then here we began to do the so-called "Peruvian tying"...They say it came when I was a boy....In Peru they make *paños*, they'd say. So, little by little, knowledge grew here among the people (ibid.:23-24).[10]

Dynamics of Production

The two shawl styles that we see today in Tacabamba and Gualaceo stem from the same source, the early twentieth-century Peruvian *pañones* seen and copied by Ecuadorean weavers. The geographical and cultural

similarities of the two areas are striking as well. Yet from a similar origin, the two traditions have taken different paths.

Pañon Production in Tacabamba

In Tacabamba today, the designs of both the *pañon* and the *blonda* are simpler than those of early twentieth-century San Miguel shawls. Elderly people in Tacabamba told me that when they were young, the *blondas* were longer and more detailed. I was told of one woman—now deceased—who used to make *pañones* with twenty *tiras*. It is possible that shawls were made in Tacabamba using the same technique that Cohen observed in San Miguel. While the *ikat* technique died out in San Miguel in the 1960s, it could have been simplified in Tacabamba at some point during the past fifty years.

Although simplified, the *pañon* tradition is thriving in Tacabamba today. Young girls learn the technique from their mothers, grandmothers, or neighbors. *Pañon* production is the *oficio del pueblo*, or trade of the people, in that town. Often, the women who live in town have the capital to invest in materials for *pañones*. They pay an artisan for her labor in each part of the production process, from warping to knot tying.

The regional market is strong. Every Sunday, at the weekly market, women bring their *pañones* neatly folded over their shoulders for sale. Middlemen come to Tacabamba to buy *pañones* for resale in Bambamarca, Cajamarca and Celendin, Cajamarca Department; in Chachapoyas, Amazonas Department; in Rioja and Moyobamba, San Martin Province; and in Yurimaguas, Loreto Department. However, the women do not earn much from their work, and the middlemen have the upper hand, since they also sell the raw materials needed for the *pañones* on their shawl-buying trips. Local organization of artisans does not exist.

Every year as the September 14th Fiesta de Nuestro Senor de la Misericordia approaches, artisans feverishly produce *pañones*. The best *pañones* of the year are available at the celebration. The same dynamic was seen in San Miguel de Pallaques in the early twentieth century. In addition, women also told me that many contraband Ecuadorean goods were available at the fiesta. They mentioned blenders, radios, and plastic goods with enthusiasm. Thus the cross-border trade still thrives and is linked to the celebration of local fiestas.

Paño Production in Gualaceo

In the Gualaceo region, around World War II, the cotton supply disappeared and artisans began to weave wool *paños*. Wool is easier to dye

than cotton, and they began to make shawls with pink designs on a black background. This style is by far the most popular today. Cotton and indigo have become prohibitively expensive.

From oral history, we know that production in the Gualaceo region in the past was akin to what we see in Tacabamba now. Production was geared to the local market and also linked to the yearly Fiesta de La Virgen del Cisne in Loja. Elderly women in Bulcay, a *paño*-producing community in the Gualaceo region, told me that they used to go to market with their "*paños al hombro*" (their *paños* on their shoulders) in hope of selling their work. The weekly shopping depended on this income.

In the Gualaceo region, pressures are stronger to abandon traditional dress in favor of factory-made clothing. Gualaceo is closer to the urban center of Cuenca than Tacabamba is to Chota or Cajamarca. The highway is much better, and electricity has made television and radio fairly common in the homes of the *paño* artisans and other rural people. Under these influences, the traditional culture of the region is rapidly disappearing and, along with it, traditional *paño* production. In addition, other trades, like shoemaking, are better paid and are thus more prestigious.

Paño production has not died out, but design and the dynamics of commercialization have changed. Although traditional pink and black *paños* are still made, many artisans weave scarves, belts, and small shawls for the tourist market. A much greater variety of colors are used, including purple, green, turquoise, yellow, orange, and brown. Some artisans still use traditional designs, but new designs, such as triangles and leopard spots are also woven now.

This cloth is destined for dressmakers in Cuenca and in Quito, who produce dresses and jackets for the local elite and for export. In the past few years, the weavers have developed direct contacts with the urban dressmakers, which is a healthy change from an earlier situation in which a single individual controlled both access to prime material and sale of the *paños*.

The Gualaceo-area *ikat* shawl production has lost its local market due to changes in dress and attitudes over the last ten to twenty years. In contrast, the *pañon* production in Tacabamba is linked to the local peasant economy and is not heavily affected by urban dress. The paths of these two traditions have merged and diverged over the course of the twentieth century, each changing in response to local conditions.

Directions for Future Research

What was the *ikat* tradition in these areas before the Spanish Conquest? What happened to the technique after the Conquest? Where might the late nineteenth-century Peruvian style have originated?

Prior to the Spanish conquest, the *ikat* technique existed in both Peru and Ecuador. Ann Rowe cites fifteen examples of pre-Hispanic cotton warp *ikat,* most of them coastal, from the Pacasmayo, Viru and Chicama valleys in Peru (Rowe 1977:18). They are probably of Chimu origin. The warm, wet conditions of the Ecuadorean coast do not lend themselves to textile preservation. However, some eighty-five textile fragments were preserved in a burial urn excavated in 1961 at the La Compania site in the Los Rios province of Ecuador. The burial dates from the Late Milagro Period in Ecuador, from A.D. 1200 to 1500. Several of the specimens were decorated with metal bangles; copper mineralization products from the bangles probably helped preserve the cloth. Conservator Joan Gardner states: "the Los Rios *ikats* were presumably dyed brown on tan yarns. The patterning in these fragments is geometric with stepped and diamond and latch-hook motifs, among others" (Gardner 1979:29).

Today *ikat* exists in a variety of textiles, many of them garments introduced by the Spanish. Did the technique die out, to be later reintroduced by the Spanish, or did weavers adapt local *ikat* traditions to decorate Spanish garment styles?

How was a style and technique introduced if there was not a pre-existing knowledge of the art? *Ikat* weaving is complex and time-consuming. I do not believe that an *ikat* sample from another part of the world could give enough information for even the most experienced weaver to replicate it if he or she did not already have some kind of an *ikat* system.

Did the Spanish have an economic motive to introduce such a time-consuming technique? I believe not. Indeed, the major textile technique that the Spanish introduced was the treadle loom, which allowed greater production in the forced-labor *obrajes* than would have been possible with pre-Hispanic textile techniques. *Obraje* production included woolen and cotton cloth for export and for the southern mines.

In both areas, the pre-Hispanic style backstrap loom is used to produce modern *ikats*. The use of the Ecuadorean circular-warp backstrap loom follows the lines of pre-Incaic Palta occupation, which extended as far south as Jaen in northern Cajamarca. The heading-cord loom of Tacabamba is probably one of the northernmost uses of the Peruvian loom (Meisch 1981:4). In both areas, even though Spanish is spoken by the peasantry, loom

terminology is primarily *Quechua* or *Quichua*, suggesting that pre-Hispanic weaving traditions continued in areas where Hispanic culture and styles were assimilated.

The *paño* is a nonindigenous garment introduced by the Spanish. The *lliglla* (Q), or a rectangular shoulder cloth, held closed at the neck by a *tupu* (Q), or pin, is its pre-Hispanic equivalent. The *paño* is an important part of women's traditional dress in *mestizo,* Spanish-speaking highland areas. More information about early colonial settlement patterns in both Azuay and Cajamarca is required in order to understand how *paño*-use could reflect ethnic background. There is, however, a strong correlation between *paño* use and a predominantly *mestizo* peasantry.

The *paño* style was adopted in northern Peru first. By the early twentieth century, it had spread to southern Ecuador where it was adopted by the *mestizo* peasantry, who already had an *ikat* tradition.

Yet where did the style originate? Research must be done on colonial weaving techniques and styles, and on weaving in Spain, Mexico, and Guatemala. An intriguing historical fragment has led me to suspect that *ikat* shawls may have been inspired by imported goods from the Philippines. In his 1927 travelogue, *A La Sierra—distrito de Santa Cruz...en la provincia de Hualgayoc, departamento de Cajamarca*, in the section on local customs Dr. Juan Ugaz mentions that "until a few years ago, the Manila shawl for women and wool cape for men were *de rigeur*" (Ugaz 1927:70). From the tone of this document, it appears that he is speaking of the local peasantry and not the elite. This suggests that, at some point, shawls imported from the Philippines were available for local weavers to copy. The historical data on the diffusion of design from Peru to Ecuador indicates that, with the existence of an *ikat* tradition, the examination of another style of *ikat* is all that an accomplished weaver needs in order to copy that garment.

The two regions have radically different techniques for *ikat* component and pattern group selection, but the resulting textiles are almost identical. It is almost impossible to decipher the technique used when looking at modern ethnographic textiles from these regions. Yet we can look at the number of components in each pattern unit to make an educated guess about the technique. If there is a small number of components—from three to nine—the textile is likely to have been done in the modern Tacabamba technique. If the designs are more complex, the technique from Gualaceo or San Miguel could have been used. Shawls made with the Gualaceo *cuenda* system or the San Miguel *escogidora* system are virtually indistinguishable.

Perhaps the difference in *ikat* technique follows the same ethnic boundary that divides the southern territories, where the Peruvian heading-cord loom is in use, from the northern areas where the Ecuadorean circular-warp loom is used. More research must be done to determine such boundaries.

The research presented raises many questions and answers only a few. Some of the answers may be impossible to obtain due to lack of historical evidence. Ethnographic information on the spread of techniques in other areas could shed light on the fate of *ikat* in the Andes after the Spanish Conquest.

Endnotes

1. Funding for this investigation was provided by the Fulbright Commission of Ecuador which supported my research from 1984 to 1986. I would also like to thank the staff of CIDAP (Centro Interamericano de Artes Populares) for logistical support during the youth oral history project. I thank Morton S. Miller for preparing the illustrations in this chapter.

2. When (Q) follows the initial use of a term, it is of Quichua origin. Other foreign words are Spanish, unless otherwise noted.

3. I am unsure of the origin of the word *sarin*. It could be of pre-Incaic origin.

4. I am grateful to John for his generosity in sharing his field research notes with me.

5. Endnotes five through ten present the original Spanish text of oral history gathered in 1986.

 Ahi (en Loja) acostumbran las señoritas de parroquias salir tapadas con el pañito hecho de nuestras manos, una moda que no había en mismo Loja, sino en las fronteras de Loja.

6. *Yo amarraba para que vayan llevando a Loja. Hacía pájaros, venados, palomas y todas cosas. Yo era obrera...yo me ponía a amarrar los paños, que se llevaban a Loja a vender. Ofrecían pagar en cada precio creo que era 6 o 7 reales y ofrecían un real más para que, para dar el pago a la vuelta del viaje a Loja.*

7. *Yo he trabajado en mingas de tejidos. Antes había los viajeros que hacian mingas de tejidos, cinco, seis tejedores asi hemos tejido en mingas (para que llevan de viaje). En una sola casa, minga de tejer....Ibamos algunos a las 4 de la mañana íbamos. Algunos a las 5 de la mañana, para pichar,* a tejer. Algunos parados los paños, para ir no más*

y a tejer allá. Con eso (los viajeros) iban de viaje, con 100 paños,, 200 paños, 150 paños, 200, segun la influencia del individuo. Algunos sonindividuos de plata, van llevando bastante. Algunos pequeños deinfluencia, poco llevaban.

*Pichar refers to the action of strumming the warp so that the shed-rod shed rises.

8. *El viaje era de 5 días de ida, y 5 días de regreso, y los 5 días que se estaba allí en la fiesta, es que el viaje redondo era de 15 días...Y allá se comerciaba con los Peruanos...(Fuimos en mular), sí, en mular. Yo me fuí huambrito.*

*Huambrito is a Quichua word that has passed into rural Ecuadorean Spanish meaning young person.

9. *Decían que han venido viendo a los peruanos, aquí están los paños peruanos. Peruanos haciamos...De Perú viene a Loja bastante. Salían los Peruanos a Loja a vender toda cosa. De allí traían los viajeros que van de aquí. Con paños, paños pacotillas iban a vender allá.*

10. *Estos tejidos en primer instancia dicen que saben en Perú... Entonces aquí tambien empezamos a hacer dicho amarrado peruano...Dice que venía cuando yo era niño...En Perú hacen paños decían. Entonces así, poco a poco, fueron inspirando sabiduría aquí en la gente.*

Bibliography

Gardner, Joan S.
 1979 Pre-Columbian Textiles from Ecuador: Conservation Procedures & Preliminary Study. Technology and Conservation 4:24-30.

Meisch, Lynn Ann
 1981 *Paños: Ikat* Shawls of the Cuenca Valley. Loveland, Colorado: Interweave Press White Paper.
 n.d. Northern Peru and Southern Ecuador as a Textile Region: Loom and Spinning Styles and Pre-Inca Populations. 21st Annual Meetings of the Institute of Andean Studies at Berkeley, California, 1981.

Miller, Laura M., and Youth Oral History Project in Gualaceo
 1986 La caja ronca: Historia oral de los artesanos del cantón Gualaceo. CIDAP (Centro Interamericano de Artesanias y Artes Populares), Cuenca, Ecuador.

Murra, John
 1946 The Historic Tribes of Ecuador. *In* Handbook of South American Indians, Vol. 2.

Penley, Dennis
 1988 Shawls of Gualaceo Done in *Ikat* Technique. CIDAP (Centro Interamericano de Artesanias y Artes Populares), Cuenca, Ecuador.

Quiroz, Haydee, Elena Rivas, and Gladys Guerra
 1977 La artesania textil de San Miguel de Pallaques. Seminario de Historia Rural Andina, Universidad Nacional Mayor de San Marcos, Lima, Perú.

Rowe, Ann Pollard
 1977 Warp-Patterned Weaves of the Andes. Washington, D.C.: The Textile Museum.

Rowe, John Howland
 1957 The Incas under Spanish Colonial Institutions. The Hispanic American Historical Review 37(2):155-199.

Ugaz, Juan
 1927 A la sierra, distrito de Santa Cruz: Inmensa hoya donde nace el rio Lambayeque, en la provincia de Hualgayoc, Departamento de Cajamarca. Chiclayo, Perú: Imprenta Mendoza.

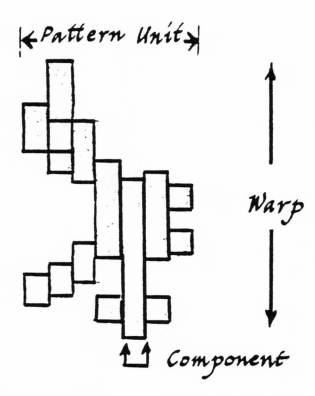

Figure 1. Bird design from a Gualaceo *paño*. Drawing by Morton Miller.

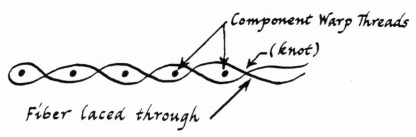

Figure 2. Component lacing: Tacabamba *pañon*. Drawing by Morton Miller.

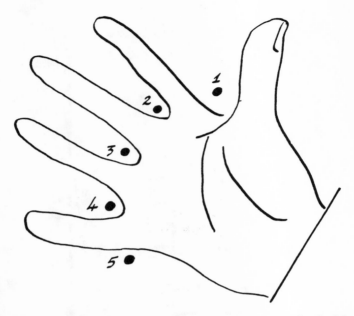

Figure 3. Components on the hand: Tacabamba *pañon*. Drawing by Morton Miller.

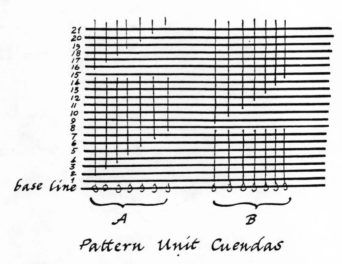

Figure 4. The Gualaceo *cuenda* system. Drawing by Morton Miller.

Chapter Fifteen

The Dyes Used in Guatemalan Textiles: A Diachronic Approach

Robert S. Carlsen and David A. Wenger

Introduction

This study is an attempt to establish accurate guidelines about the use over time of the major dyes utilized in Guatemalan textiles.[1] It has been undertaken because of the problematic nature of the literature on Guatemalan textile dyes. Simply stated, much of what is in print has been founded on conjecture. As a result, the literature contains both accurate and inaccurate information. It is our position that if approached with a proper methodology and if analyzed with correct testing procedures, these dyes offer a valuable tool for improving our knowledge of Maya culture.

Primary to this study is the understanding that the dyes in textile yarns are more than merely color producers. While taxonomies based on color can be of use, the utility of such taxonomies is limited. Not only is color identification influenced by culture (Berlin and Kay 1969), but colors are typically subject to change over time. Specifically, what might be recognizable as a "pink" yarn in an older textile may well have had an entirely

359

different appearance at the time of manufacture. Hence, the use of color source offers a more powerful classificatory device than does color. If the dye in a single yarn sample can be distinguished from the myriad of other dyes, there exists the potential to address significant research questions. With different dyes used at different times and in different places, their potential as a tool for "fingerprinting" is evident. Dye analysis can be useful in the determination of origins and dates of manufacture of textiles. Moreover, it has potential applications beyond simple material culture studies. For example, results from dye testing can be used in the determination of the economic and political conditions of manufacture, something of value to numerous disciplines.

In order to optimize the identification of the dyes used in the ethnographic textiles three conditions generally must be met. First, a data base comprised of a corpus of well-documented textiles must be available. Second, the researcher must have adequate techniques to conduct dye testing. Finally, data from the dye tests must be properly interpreted. This essay, based on ongoing research at the University of Colorado Museum in Boulder, is organized according to the above design. After a description of the collections from which yarn samples were analyzed, a brief explanation is made of the methodology and testing procedures used. Results from the project are then detailed. As this study reflects work in progress it is not intended to be conclusive. To date, efforts have been directed toward testing of the red, purple, and blue yarns used in Guatemalan textiles. Moreover, research has been restricted to textiles dating from before 1945.

The Data Base

Of primary importance in this project has been the nature of the collections from which yarn samples were taken. While it would certainly have been preferable to have tested a significant number of yarns taken from pre-Hispanic Guatemalan textiles, this was impossible. Despite the lengthy tradition of weaving in the Maya area, examples of pre-Columbian Maya textiles are extremely rare. In fact, the inventory of such textiles discovered to date includes only the Maya Early Classic period textile fragments from Rio Azul (Carlsen 1986, 1987), the Maya Post Classic fragments dredged from the *cenote* at Chichén Itzá (Haury 1933) and a few cave fragments from Chiapas. Of these fragments, only those from Rio Azul have been tested for colorants.[2] Beyond the scant inventory of pre-Columbian textiles, the earliest known Maya textiles are those collected by the Maudslays and described below. Unfortunately, even the Maudslay collection was assembled nearly

thirty years after the invention of synthetic dyes by Perkin in 1856. In spite of this limitation, the present study has benefited from the fact that museums in Europe, the United States, and Guatemala house various well-documented and well-dated collections of ethnographic Guatemalan textiles. A brief description of the collections utilized in the present study follows.[3]

1. The earliest collection of ethnographic Guatemalan textiles is housed at the Victoria and Albert Museum (designated VA in this study) in London. It was collected in the 1880s by the "father of Maya archaeology," Alfred Maudslay and his wife Anne and includes some thirty pieces. Unfortunately, provenience data on the collection is scant. In fact, several of the pieces appear to be of Mexican origin.

2. Housed in the American Museum of Natural History (AMNH) in New York City is a very important collection of Guatemalan textiles. The earliest documented pieces in this collection date from the 1890s and were collected by Father Henry Heyde. As with the Maudslay collection, there are problems in the provenience of this material. In many cases, the locations assigned to the individual textiles are incorrect. Nonetheless, the collection offers an extremely valuable source of data for the early dyes. In addition to the Heyde collection the AMNH contains weavings collected by several other individuals. Of particular interest are those collected by Gustavus A. Eisen in 1902 for the Lowie Museum (subsequently exchanged with the AMNH), the textiles collected by the archaeologist Herbert Spinden in 1917, and the collection of Elsie McDougall dating from the 1930s and 1940s.

3. The Peabody Museum of Archaeology and Ethnology (PMAE) at Harvard University contains a large and superb collection of Guatemalan textiles. The earliest examples in the Peabody Museum were collected in 1901 by George Byron Gordon. Unfortunately, as seems axiomatic for the early collections, provenience data is problematic. Collection information provided for the Gordon collection indicates that all the pieces are from Quezaltenango, which is clearly not the case. In addition to the Gordon textiles, the Peabody Museum contains some excellent Guatemalan weavings collected by such individuals as Samuel Lothrop (collected in 1917), Edith Ricketson (collected in 1932), and Howard Tewksbury (collected 1935-1940).

4. A Guatemalan textile source of considerable importance is the collection at the Lowie Museum of Anthropology (LMA) at the University of California, Berkeley. Of primary importance is the collection of Gustavus A. Eisen assembled in 1902 while Eisen was in Guatemala to locate the source of native jade. The Eisen material was made famous by Lila M.

O'Neale's (1945) study of Guatemalan textiles. Additionally, the Lowie Museum houses the textiles brought back from Guatemala by O'Neale in 1936.

5. The University of Colorado Museum (CUM) keeps a small, but important, collection of textiles. This collection was assembled by Earl Morris between 1914 and 1930 while he was director of the excavations at Chichén Itzá, Mexico.

6. The collection at the Middle American Research Institute (MARI) at Tulane University contains considerable important material. Included are pieces collected by such notable figures in anthropology as Franz Blom and Oliver LaFarge. However, the largest block of this collection was assembled in the early 1930s by Matilda Geddings Grey.

7. The Taylor Museum (TM) of the Colorado Springs Fine Arts Center contains approximately three hundred and fifty Guatemalan textiles collected in the early 1930s by Edith Ricketson, an archaeologist for the Carnegie Institution. This well-provenienced collection includes pieces from numerous villages in Guatemala, many of which were new at the time of collection. Of particular benefit to the researcher is that this collection is comprised of a balanced combination of both fine and everyday textiles.

8. The University Museum (UM) at the University of Pennsylvania houses a collection of more than a thousand Guatemalan textiles. While there are a few G. B. Gordon pieces in this collection (collected in 1901), the largest segment was assembled by the noted collector and scholar of Guatemalan textiles Lilly de Jongh Osborne in the mid to late 1930s. In addition to the Osborne material, the University Museum contains a very fine collection assembled by Howard Tewksbury (1930s). While not as large a collection as that of Osborne, Tewksbury's is equally impressive. In fact, these two individuals were friends and shared each other's expertise.

9. The Museum of International Folk Art (MIFA) in Santa Fe is home to the large collection of textiles assembled by the archaeologist Edwin Shook. This collection is well provenienced but unfortunately is made up largely of pieces that were antique at the time of collection. Dating of this collection is therefore problematic. Nonetheless, certain pieces were new at the time of collection and can be dated to the early 1940s.

10. Finally, the single finest collection of Guatemalan textiles in the world is housed in the Museo Ixchel de Traje Indígena (M.I.) in Guatemala City. Although much of this collection has been assembled in recent decades, the collection contains numerous pieces that have dates brocaded or embroidered onto the weaving. Obviously, working with this category of textile

provides the most secure method of dating.[4]

Methodology and Testing Procedures

Were the goal of this study merely to find out what dyes have been used in Guatemalan textiles, then dating of the yarns tested would not be important. However, this study has been designed to find out more than just this. It has been our goal to determine when the various dyes were used. Additionally, this study has sought to explore reasons why changes in dyeing patterns may have occurred. To this end a research design has been followed that provides a method for the dating of yarns. To start with, only collections with well-documented dates of collection have been utilized. Within the limitations of the various collections, a standard sampling procedure has been followed; yarn samples taken in a descending order of preference. (1) First, those textiles onto which the weaver had either brocaded or embroidered dates were used. (2) Second, weavings unfinished at the time of collection were sampled. (3) Third, yarns were tested from textiles which appear to have been new at the time of collection. (4) Next, testing was performed on textiles demonstrating minimal wear. (5) Finally, certain pieces, despite showing considerable wear, were sampled. While there is a likelihood for some error in this method, the large sample size has rendered the significance of these errors minimal.

In addition to the difficulty in the dating of yarns to be analyzed, problems inherent to dye testing have added to the complexity of this project. For instance, the destruction of material required by virtually all testing methods led us to forgo testing textiles that lacked suitable loose yarns. Beyond this, limitations to dye analysis that affected the study include the fact that no single method works on all types of dyes, or that no method of dye analysis simply surrenders the name of a dye being tested. At best a particular method is made workable by comparing the result of a test to that conducted on a known dye (otherwise known as a "standard"). Moreover, there are advantages and disadvantages to all dye-testing methods. For this reason, at the University of Colorado Museum we rely on the selective use of several analytical methods. In those situations in which one technique may be limited, another can be used. A brief description of the methods used in this study follows.

Solution Spectrophotometry

Solution spectrophotometry requires that approximately one cm of the yarn to be tested be dissolved in a solvent. (These solvents can be as

diverse as water or various acids.) This solution is then placed into a transparent quartz cuvette, which in turn is placed into the spectrophotometer. Inside this instrument, light (visible and/or ultraviolet) is passed through the cuvette, with some light transmitted and some absorbed by the sample. Scanning the calibrated light range, the instrument measures absorbance, producing a spectrum that is unique for each sample.[5] To determine results, spectra from unknown samples are compared to those of standards.

Chemical "Extraction" Tests

The chemical "extraction" method used at the University of Colorado Museum is actually a series of separate tests. These tests were developed in large by Dr. Helmut Schweppe of the B.A.S.F. laboratories in Ludwigshafen, West Germany (1988). While these tests are diverse, for the purpose of classification we have settled on the somewhat unsatisfactory term "extraction" to designate this body of methods. Using these tests, determination of the unknown dye is often arrived at through a process of elimination, the results of each test narrowing the potential number of dyes into which an unknown might fit. An example of one of these tests would be if after boiling an unknown red yarn sample in water the solution turns red, it can be assumed that the dye is synthetic. Other tests are more complicated. For instance, vat dyes can be tested by reducing the yarn to a water-soluble form. In this form, vat dyes (as well as certain other dyes) will lose their color. Determination of a vat dye is possible upon reintroducing the yarn to oxygen. If dyed with a vat dye the color will return to the yarn within minutes.

Thin-Layer Chromatography (TLC)

Prior to the actual TLC procedure, it is necessary to extract and concentrate the unknown dye from a yarn sample. The most common method of extracting dye from yarn is to boil the sample in 10 percent sulfuric acid. The acid must then be separated out so that the solution can be dessicated. This is achieved by adding ethyl-acetate, and subsequently shaking the mixture. The solution will settle into two layers, the acid and water on the bottom and the dye and ethyl-acetate on the top. The ethyl-acetate/dye layer is siphoned off and subsequently dessicated over a steam bath.

With this step completed, the actual TLC process can begin. First, the dye dissolved in a small amount of ethyl-alcohol is applied with a micro-pipette to a pre-prepared TLC plate. The plate is then put into a TLC tank, or glass jar, into which has been placed the appropriate solvent. (The choice of solvents depends on the type of dye being tested for.) Over a period of an hour

or two, capillary action will cause the solvent to rise on the plate, its components separating out at varying levels in the form of colored spots. To determine the source of the unknown dye, the color of the spots and the level at which they separate are compared to the characteristics of known dyes. The characteristics of separation can be computed into a factor called an R_f ratio, this allowing for the comparison of data.

Project Results

Central to the interpretation of data in this study has been the understanding that significant changes in dye use do not happen independent of other factors. Instead, these changes invariably represent underlying conditions such as the availability or the cost of a dye. By way of example, the European invention of synthetic dyes in 1856 and the subsequent havoc to Guatemala's cochineal-reliant economy,[6] ultimately led to that country's switch to a coffee economy (McCreery 1986:103). That situation is evident in Guatemalan Indian textiles of the day not only in the almost immediate presence of synthetic dyes but in a copious use soon thereafter of silk. Silk, a costly imported fiber, became readily available to native weavers through the transfer of indigenous economies to a cash orientation; this the result of forced Indian labor on the coffee plantations. Clearly, textiles have the potential to be read as indicators of national and international political, economic, and technological realities. The model utilized in this study to interpret dye analysis data exploits this potential.[7] Findings are presented according to yarn color, the categories of color subdivided into fiber type (see figure 1).

Purple-Dyed Yarns

In her book *Modern Primitive Arts of Mexico, Guatemala and the Southwest*, Catharine Oglesby states:

> Guatimaticos [sic] use on their ceremonial gar-
> ments a rich, soft purple made from mollusks. The men
> gather them. It is said that the fish live only seven years and
> that it is best to gather them in the spring when the moon
> is full. The men go down to the streams, rub one animal
> against the other, and in this way a saliva is extracted from
> a gland in the gill. Strands of wool are dipped into the
> excretion, and this dye renders a peculiar seaweed odor
> and a salty taste. The mollusk is then returned to the water

and not annoyed until the next season (1939:181).

This statement by Oglesby typifies much of what is in print about the dyes used in Guatemalan textiles—a few facts, and a bit of fiction, all hung together with assumptions. Although Osborne (1935:51) corroborates Oglesby on the seemingly untenable position about the moon and therefore that claim must be grudgingly accepted, the yarns dyed with mollusk-derived purple dye were not wool but cotton. Additionally, the mollusk that produces the purple dye is definitely not riverine. Moreover, how disappointing that garments colored with this much-celebrated purple dye, that colorant that Perkins and Everest (1918:15) called "the dye most esteemed above all others," tend to exhibit the odor and the taste of cloth, not seaweed![8]

Cotton: The belief that mollusk-dyed purple yarns have the odor and the flavor of seaweed is not the only rumor attached to this dye. One of the more commonly held myths about dyes in Guatemalan textiles deals with a cotton yarn that has come to be called *morado falso* or false purple. The clearest articulation of this comes from Rowe (1981:24) in an otherwise outstanding work. She speaks of a yarn found in textiles from before 1940 which imitates the uneven appearance of true mollusk-dyed purple. According to this description, the *morado falso* can be easily distinguished from the true mollusk purple through its three-ply construction. The basis of assumptions about the *morado falso* is to be found in O'Neale (1945:11-12). That author mentions a mauve yarn called *morado* found throughout the Guatemalan highlands, a yarn which "simulates as closely as may be the purple extracted from shellfish." The source of this yarn, which O'Neale says costs as much as eight times more than other yarns, was said to be Honduras. The truth is that there is nothing at all "false" about this purple yarn. Numerous tests on soft purple cotton yarns exhibiting striations in color confirm that these yarns are invariably colored with the dye from the mollusk *Purpura patula*. On this, our findings confirm a statement by Osborne (1965:63), and pointed out to us by Yuri Saldyt, that Guatemalan weavers used both commercial and handspun yarns dyed with this mollusk dye.

Certainly not all early purple cotton yarns were dyed with *Purpura*. While yarns dyed with *Purpura* were prized by highland Maya weavers, there were times when they chose to use other types of purple cotton yarns. For example, a Totonicapán *huipil* from the Maudslay collection (VA T34-1931) contained a (burgundy) cotton yarn which was dyed with a combination of alizarin (see below) and some unknown dye. Importantly, in this same *huipil* another yarn was dyed with *Purpura*. While the decision by a weaver

whether or not to use *Purpura*-dyed yarns was no doubt influenced by cost, the desire to broaden the palette must also have been a factor.

Although it is not known what dyes, other than *Purpura*, might have been used to impart purple hues to cotton prior to the invention in 1856 of synthetic dyes, brazilwood certainly may have been used. It should be noted, however, that to date we have yet to detect brazilwood in any Guatemalan textile. Nonetheless, this dyewood is native to Guatemala and may well have been used as a dye material for cotton and/or wool. Regardless of which other dyes might have been utilized, *Purpura* was commonly used to dye cotton until the late 1930s. At that time synthetics came to be utilized almost exclusively. Nonetheless, *Purpura*-dyed cotton yarns were used sporadically for some years thereafter. We have seen weavings with stylistic elements characteristic of the 1950s that have contained *Purpura*. Weavings of this type may have been woven with yarns that had been stored. While we do not possess data as to why the use of *Purpura* was abandoned, the answer probably stems from its high cost in relation to that of synthetically dyed yarns.

Silk: Of the natural dyes used to obtain purple in silk, our research indicates that only cochineal was used. (While cochineal is often thought of as a dye for red, the use of varied mordants can impart a wide range of hues, including purple.) In making this statement, we differ from Pettersen (1976:88) who claims that silk was sometimes dyed with *Purpura patula*. Not only has our testing failed to detect any *Purpura*-dyed silk, but the high cost of that dye makes it unlikely that such dyeing was ever done. It must be realized that cochineal, a dye that is considerably less expensive than *Purpura*, can impart the same color as the mollusk-produced dye.

Our research indicates similar temporal and spatial patterns for the use of cochineal as a dye for both red and purple silk. As the number of early red and purple silks from the museum collections was small, for the purpose of this study we have combined them into a single section. The reader is directed to the section on red silk for a detailed description of our findings.

Wool: The use of purple-dyed wool in Guatemalan textiles is rare. The primary exceptions are as supplementary weft yarns in weavings from such towns as Todos Santos, Chichicastenango, and Comalapa, and in Momostenango blankets. To date, all tests that we have performed on purple-dyed wool have shown the dye to have been synthetic. However, it is our expectation that further testing may demonstrate that natural dyes such as brazilwood were used as dyestuffs to obtain purple wool. Both Osborne (1935:54) and O'Neale (1945:28) cite brazilwood as having been used.

O'Neale (1945:28) adds that cochineal and indigo were sometimes combined to obtain a purple for wool yarns.

Blue-Dyed Yarns

Of the dyes used in Guatemalan textiles to obtain blue, only indigo is easily identified. Though the presence of indigo can be determined using any of the three dye-testing categories outlined above, we prefer spectrophotometry. Our research demonstrates that the presence of indigo in Guatemalan textiles is widespread. This dye was used in the pre-contact period (Rossignon 1859:43-53), the colonial period, and in the modern period.[9] In fact, the use of indigo in Guatemalan textiles remained common until quite recently. It is important to note however that the more recent usage of indigo has been with the synthetic form of this dye, which in Guatemala is commonly referred to as *tinte aleman*. Unfortunately, testing methods do not presently exist to differentiate synthetic from natural indigo.

Currently, the use of both natural and synthetic indigo is rare in Guatemala. *Jaspe (ikat)* dyers in the dyeing center of Salcaja cite the cost of the *tinte aleman* as the primary reason for abandoning its use. In that town, dyers have by and large switched to dyeing their *jaspes* black instead of blue. A factor underlying the cessation of natural indigo dyeing in Guatemala has been the civil war in El Salvador, since that country was the source of most of Guatemala's indigo.

Cotton: The occurrence of indigo on cotton is common. In fact, the use of this dye on cotton has been so prevalent that it is difficult to place data on its presence into a meaningful context. Quite simply, if a Guatemalan textile contains a medium to dark shade of (non-mercerized) blue cotton, it has likely been dyed with indigo. The most common exception to this is a pale blue cotton, which unfortunately is difficult to confirm. This dye is found commonly on textiles from before 1930. This dye may be *sacatinta* (from the *Jacobinia spicigera* plant), a plant which Osborne (1965:37) indicates was used as a laundry bluing, as well as a dyestuff. Although this plant has been called an indigo (García Lara 1981:11), our testing indicates otherwise. As well, it might be what Italo Morales (1984:68) identifies as *cuajatinta*. Further work with this dye using the TLC process may produce meaningful results.

Wool: Blue-dyed wool is not overly common in Guatemalan textiles. Only blankets from the weaving center of Momostenango, and the *q'uul* (men's shoulder blankets) from Chichicastenango, constitute notable exceptions. Within the limited occurrences of blue wool, indigo is a common

dye. However, in the museum collections sampled, the earliest textiles containing blue-dyed wool were colored with synthetic dyes. These yarns came from the well-known and enigmatic Totonicapán serapes in the Eisen collection (LMA 3-1, 3-3, 3-4). Other early blue wools tested were dyed with indigo. These include a man's jacket from Chichicastenango (LMA 3-154), an early twentieth-century Chichicastenango *q' uul* (TM 616), and a Momostenango blanket (CUM 25138). Two testings on blue wool yarns taken from Momostenango blankets, said by their Momostecan sellers to have been woven in 1985, revealed the dye to be indigo.

Silk: As opposed to wool and cotton, on which indigo dyeing was the norm, in the existent collections indigo dyed silk is rare. Only one sample, an undocumented Nahualá sash (AMNH 65-5753) appears to have been dyed with indigo. Another blue dye, found on certain older textiles (e.g., TM 607), is unknown. This dye exhibits characteristic striations, individual yarns fading from light blue to light green. Most blue silks, even from the older documented collections, appear to have been dyed with synthetic dyes. The data do not allow the determination of the predominant pre-synthetic blue dyes for silk, however, it may be assumed that the usage of indigo was common.

Red-Dyed Yarns

Cotton: One of the more common myths about the dyes used in Guatemalan textiles is that early red cottons were dyed with cochineal (Osborne 1965:40, Conte 1985:30). The fact that this insect-derived dye is native to Guatemala, and that at the time of the advent of synthetic dyes in 1856, Guatemala was the world's largest producer of cochineal, has no doubt led to this assumption.

Based on the literature, we were initially surprised that our testing revealed no cochineal-dyed cotton. Even the oldest pieces in the Maudslay collection lacked this dye. Instead of cochineal, our research demonstrated the early red cotton yarns from the museum collections to have been dyed with alizarin. In fact, *without exception* tests performed on red cotton yarns from textiles dating to the period of approximately 1875-1927 tested positive for alizarin. Far from being a natural dye at all, the dye utilized by the Maya during this period was synthetic, and its source was dye works in Europe.

Alizarin is the primary component in madder, both dyes giving nearly identical spectra. Alizarin was patented simultaneously in both Germany and England in 1871. But what of the period before this date? Could not cochineal have been used then? As dyers will attest, cotton is difficult to

dye. With cochineal this is especially true. Although the process is possible, the method is complex. The fact is that a large scale use of cochineal for dyeing cotton has seldom, if ever, been done anywhere in the world (H. Schweppe, pers. com. 1985). That the Maya were exceptions is unlikely. But the problem remains: how did the Maya dye cotton red prior to the invention of alizarin? Could it be that until synthetic red dyes became available, the Maya were without a satisfactory dye for cotton? Evidence presented in the following paragraphs supports this hypothesis.

The acceptance by Guatemalan weavers of alizarin was almost immediate. Within just a few years of its invention in Europe this dye was being used commonly throughout the highlands of Guatemala. Such a revolution in the native dyeing could only have occurred under ideal circumstances. The lack of a dye capable of dyeing cottons red would have provided just such a condition for change. Additionally, the absence of a red dye for cotton serves to explain certain of the patterns demonstrated in the early ethnographic collections. First, it offers an explanation as to why the older textiles contain no red cotton dyes other than alizarin. As well, it explains why the oldest textiles in the oldest documented collections lack red cotton altogether. Moreover, if red cottons were not available until the latter decades of the nineteenth century, this would explain why weavers in certain villages switched to the large-scale use of red cotton in certain garments around this time. Witness the late nineteenth-century transition of blue *cortes* (skirts) to red in Santiago Atitlán or the rapid transformation shortly thereafter in Chichicastenango from white to red *tzutes* (ceremonial cloths).

To put this situation into a better perspective it should be realized that the potential number of dyes with which the Maya might have obtained a pre-synthetic red were few. The literature (Osborne 1965:48; García Lara 1981:11) mentions *annatto* as a dye used by the Maya to obtain red cotton. However, aside from the fact that this plant dye imparts hues that are more orange than red, testing has failed to demonstrate its presence in Guatemalan textiles. Another red dye plant, *relbunium*, grows in Guatemala (Donkin 1977:7). Nonetheless, there is no evidence that the Maya ever exploited it as a colorant. Yet another possibility is brazilwood. Osborne (1935:54) mentions brazilwood as a dye for both wool and cotton. Our own investigations, however, indicate that brazilwood does not impart a true red color on cotton. Instead, depending on the mordant, it gives hues in the pink to lavender range. One more option would be that the Maya may have used madder. Plants of the genus *Galium*, the genus which produces madder, grow in Guatemala (D. Breedlove, pers. com. 1985). However, the occurrence of the Guatemalan

variety is restricted enough that its widespread exploitation would quickly have brought the plant to extinction. What is more, few *Galium* varieties actually produce madder. All told, it is unlikely that the Maya ever used madder.

As mentioned, research demonstrates that the pre-Columbian Maya obtained a red cotton using paint (Carlsen 1986, 1987). However, paints are a quite different category of colorant than are dyes. It is known that in the pre-contact period the Maya's neighbors, the Aztecs, spun rabbit wool (*to-chomitl*) into their cotton yarns to attain a reddish color, the rabbit wool taking the cochineal (P. Anawalt, pers. com. 1987). Perhaps as the Maya had no true red dye for cotton they too had to "fool" the cotton to get a dyed red.

Regardless of its antecedents, or the lack thereof, when alizarin finally appeared in Guatemala its popularity went unchallenged for more than half a century. Osborne (1935:55) mentions an "aniline"-dyed red cotton popular with the Indians for over fifty years. Osborne states that this cotton, called *crea* by the Indians, was imported from Manchester, England. In fact, this cotton was not actually aniline dyed, it was dyed with alizarin (Osborne's statement probably reflects the common mistake of referring to all synthetic dyes as "aniline").

Of the red cottons tested from textiles that can be documented to have been woven before 1930, only one sample contained other than alizarin. This sample, which came from a *huipil* (blouse) collected new in 1927 in San Mateo Ixtatán by Oliver LaFarge (MARI G.5.2 41-488), was dyed with some other type of synthetic. Interestingly, this textile also contained a red cotton that was alizarin-dyed, the combined presence of red dyes forewarning the transition that was soon to come. After 1930 the use of alizarin in Guatemalan textiles faded almost as fast as it appeared. Of more than twenty tests performed on red cotton from the Taylor Museum, yarns dating from around 1930, only three were dyed with other than alizarin. By 1935, however, based on yarns from the University Museum collection, approximately half of the red cotton used in the Guatemalan weavings was dyed with non-alizarin red. And by 1940, based on tests on yarns from textiles in the collection of the Museum of International Folk Art, the transition away from alizarin was complete.

The alizarin period in Guatemalan textiles lasted for over fifty years. Why did it come to an end? One possibility is that around 1930 the Indians came to have access to less expensive dyes than alizarin. Given the marginal economic position of the Indians, as well as the regional effects of the worldwide economic crisis (see McCreery 1986), such a factor would

have been significant. Another possible explanation would be that the deteriorating political climate in Europe between 1930 and 1940 caused a disruption in the Indian's supply of the red dye. (It must be remembered that the two sources of alizarin were Germany and England.) Finally, were the situation in Europe to have even partially disrupted dye supplies, the result in Guatemala would have been a smaller supply, thus higher prices. Such a climate would have been ideal for the introduction of alternative dye types. Research shows that alizarin was replaced by numerous other synthetic red dyes.

Wool: Unfortunately, not enough well-documented red wools were available to establish definitive patterns of dyeing. Nevertheless, some conclusions can be suggested. An authoritative description by O'Neale (1945:29-30) of cochineal use in Guatemala in 1936 establishes the fact that this dye still enjoyed popularity at that late date. Based on scattered testings of red wools (mostly from undocumented textiles) dating to the approximate period of 1935, our findings conform to O'Neale's observations. Although the few red wool samples taken from Momostenango blankets (CUM 25138, MIFA 71.9-158) have been dyed synthetically, more extensive sampling would probably reveal cochineal. Of four undocumented *q'uul* from Chichicastenango, all were dyed with cochineal.

Silk: As opposed to cotton, the use of cochineal on silk is fairly common in ethnographic Guatemalan textiles. Although the earliest documented silks go back only to the Maudslay collection (1880s), one can safely suppose that cochineal-dyed silk has a lengthy history in Middle America. However, in spite of rumors of pre-Columbian silk use in this region (Osborne 1965:31), it seems that this fiber was not used by the Indians until after the Conquest (see Borah 1943). Of historical interest is that Hernan Cortés was apparently one of the pioneers of silk raising in the New World (Borah 1943:10). The conqueror of Mexico stated that he both raised and dyed silk with cochineal. By 1628 a thriving silk raising industry is documented in Guatemala (Vasquez de Espinosa 1942:224). For economic, as well as climatic reasons, the Middle American silk-growing industry was to have a rather short tenure. Within a few centuries of the Conquest, it is certain that all but a small amount of "wild" silk was imported (Borah 1943).

Although it is not possible to determine the exact patterns of Middle American silk dyeing, it is known that in Mexico, both silk and cochineal were raised in Oaxaca, Puebla, Michoacan, and probably Chiapas (Donkin 1977:21). Certainly, at least in these regions, some silk was dyed with cochineal. However, during the time in which Osborne did her research in

Guatemala she never saw silk being dyed by the Indians. In fact, it was her opinion that "silk seems always to have been bought pre-dyed from stores" (1935:53).

Our research indicates that at the time that Maudslay made his collections (1880s), cochineal remained the predominant dye for red silk. Five silk samples from the Maudslay collection were tested—three of them silk floss and two of them twisted silk. All three of the silk floss samples tested positive for cochineal, as did one sample of the twisted silk (V A T37-1931). The other sample of twisted silk was synthetically dyed. (Of more than twenty-five tests performed on twisted silk during the course of this project, the Maudslay sample was the only one to have been naturally dyed.)

Tests performed on yarns from turn-of-the-century textiles demonstrate a tendency towards the use of synthetic dyes for silk. Of eleven tests performed on silk samples taken from this time period (eight floss and three twisted silk), only three were dyed with cochineal, all of them floss. This tendency continued during the period 1910-1935. Seventeen tests performed on yarns from this period showed but four to have been dyed with cochineal. Interestingly, all four were from the town of Quezaltenango (out of a total of six from that town). In spite of Osborne's belief that silk was not dyed in Guatemala, the predominance of cochineal-dyed silk from Quezaltenango indicates a local source. By 1930, though, it appears that the use of cochineal to dye silk has all but ceased. Of twenty-one samples from the Taylor Museum dating to this period, all but one (TM 674: cochineal-dyed from Quezaltenango, and included in the above data) were synthetically dyed.

It is interesting to note that our survey of the museum collections demonstrates the period of approximately 1930-1935 to have been the time of the maximum use of natural silk in Guatemalan textiles. Remarkably however, by 1940 there is only minimal use of this fiber. It was replaced by rayon, an artificial silk, and by mercerized cotton. Although rayon, a fiber invented in 1855, and mercerized cotton make their appearance in Guatemalan textiles by 1930, the use of these fibers at that time was still minimal. About rayon, O'Neale states that in 1936 "few inroads had been made into the textiles woven by Indian women for their own use" (1945:19). She cites the use of this fiber by weavers in Nahualá and in Olintepeque. The rapid transition from real to artificial silk indicates a radical disruption of supply during this period. Once again, the deteriorating political climate around this time, both in Europe and in the Orient, might account for this disruption.

Conclusion

While human existence in most climates, including that of Guatemala, necessitates the use of clothing, there is nothing that requires clothing to be colored. Instead, the coloring of cloth is a way of making it more beautiful, of adding to a weaver's creativity, and in some cases of expressing symbolic meaning (see, for instance, Prechtel and Carlsen 1988). But, other factors operate. As has been demonstrated in this study, the use of cloth as expression is influenced, even dictated by certain local, national, and international considerations. Changes in color not only represent a weaver's experimentation as the palette of available colors expands. These changes are also based on the availability of dyes and/or yarns as well as the cost of these items.

However, lest this conclusion seem overly culturally materialistic, the Guatemalan case presents another important consideration. In spite of the Guatemalan Indian weavers' vulnerabilities to materially-based realities outside of their control (McCreery 1986), and in spite of their marginal economic position, many have chosen to make changes when necessary rather than to lay down their looms, even when there were economic incentives to do so. In Guatemala, costume serves as both a statement of ethnic identity and as a tool of cultural survival. That the Indian weavers of Guatemala have been willing to make changes in order to stay the same reflects the tenacity by which that country's Indian population resists acculturation.

Endnotes

1. The authors would like to thank the following for their help in the compilation of this study: Jonathan Batkin and Cathy Wright of the Taylor Museum, Linda Asturias de Barrios and Flor de Maria Aguilar of the Ixchel Museum, Frank Norick and Barbara Busch of the Lowie Museum of Anthropology, the University of California at Berkeley, Nora Fisher of the Museum of International Folk Art, Joe Ben Wheat of the University of Colorado Museum, Lisa Whittal of the American Museum of Natural History, Victoria Swerdlow of the Peabody Museum at Harvard, Pamela Hearne of the University Museum at the University of Pennsylvania, Marjorie Zengel of the Middle American Research Institute at Tulane University, and Linda Woolley of the Victoria and Albert Museum. Special acknowledgment is extended to Helmut Schweppe for sharing his

extensive knowledge in the field of dye analysis, to Mary Ballard of the Smithsonian Institution for sharing various publications on dye testing as well as for her insightful comments on our preliminary manuscript and to Virginia Ahrens of the University of Delaware for her help and encouragement.

2. Of the five distinct textiles found at Rio Azul two were colored. Testing determined the colorant to have been mercuric-sulfide, a red mineral-based pigment otherwise known as "cinnabar." It is important to note that mercuric-sulfide is not a dye but instead is applied as a paint.

3. Interested readers may want to look at the publications by O'Neale (1945), Rowe (1981), and Conte (184) for representative photographs from many of the collections described below.

4. Even textiles with dates included as decorative motifs must be approached with caution. For instance, a dye test performed by the authors on one textile with a brocaded date of 1827 revealed the brocade yarn to have been colored with a synthetic dye. Synthetic dyes were not invented until 1856. Moreover, our research has turned up textiles onto which, for one reason or another, dates were embroidered many years after the actual weaving of the garment.

5. The instrument used at the University of Colorado Museum is a Beckman model DU 7.

6. Cochineal is an insect-derived red dye native to the New World. Prior to the 1856 invention of synthetic dyes by Perkin, cochineal was the world's primary red dye of commerce for wool and silk. At the time of Perkin's invention, Guatemala was the world's largest producer of cochineal.

7. The model used in this study makes an interpretation of history. As the interplay of factors that underlie this history is often complex, we have included only what we consider to be the most salient factors. Some of our interpretations are preliminary. As such, we invite scholars to expand on these findings.

8. Until washed several times, yarns dyed with shellfish purple do exhibit a peculiar odor. However, this odor is much closer to garlic than to seaweed.

9. See Vasquez de Espinosa (1942:235-37) for a description of early seventeenth-century indigo dyeing in Middle America. O'Neale (1945:24-25) details the process in 1936.

Bibliography

Berlin, Brent, and Paul Kay
 1969 Basic Color Terms: Their Universality and Evolution. Berkeley: The University of California Press.

Borah, Woodrow
 1943 Silk Raising in Colonial Mexico. Ibero-Americana Series No. 20. Berkeley: University of California Press.

Carlsen, Robert
 1986 Analysis of the Early Classic Period Textiles Remains— Tomb 19, Rio Azul, Guatemala. *In* Rio Azul Reports Number 2, The 1984 Season, Richard E. W. Adams, ed. San Antonio: Center for Archaeological Research, The University of Texas at San Antonio.

 1987 Analysis of the Early Classic Period Textile Remains— Tomb 23, Rio Azul Guatemala. *In* Rio Azul Reports Number 3, The 1985 Season, Richard E. W. Adams, ed. San Antonio: Center for Archaeological Research, The University of Texas at San Antonio.

Conte, Christine
 1984 Maya Culture and Costume. Colorado Springs: The Taylor Museum.

Donkin, R. A.
 1977 Spanish Red: An Ethnogeographical Study of Cochineal and the Opuntia Cactus. Volume 67, Transactions of the American Philosophical Society. Philadelphia: The American Philosophical Society.

García Lara, Fernando
 1981 Situación actual del uso de colorantes naturales en la artesianía guatemalteca. Guatemala: Subcentro Regional De Artesanías Y Artes Populares.

Haury, E.W.
 1933 Maya Textile Weaves. Unpublished report on the textile fragments from the *cenote* of Chichén-Itzá.

McCreery, David
 1986 An Odious Feudalism: *Mandamiento* Labor and Commercial Agriculture in Guatemala, 1858-1920. Latin American Perspectives 13: 99-117.

Morales Hidalgo, Italo
 1984 La situación del jaspe en Guatemala. Guatemala: Subcen-
 tro Regional de Artesanías y Artes Populares.
Oglesby, Catharine
 1939 Modern Primitive Arts of Mexico, Guatemala, and the
 Southwest. New York: Whittlesley House.
O'Neale, Lila M.
 1945 Textiles of Highland Guatemala. Carnegie Institution of
 Washington Publication no. 567. Washington, D. C.
Osborne, Lilly de Jongh
 1935 Guatemala Textiles. Middle American Research Institute
 Publication no. 6. New Orleans: The Tulane University of
 Louisiana.
 1965 Indian Crafts of Guatemala and El Salvador. Norman:
 University of Oklahoma Press.
Perkins, Arthur George, and Arthur Ernest Everest
 1918 The Natural Organic Colouring Matters. New York:
 Longmans Green and Company.
Pettersen, Carmen L.
 1976 The Maya of Guatemala: Their Life and Dress. Guatemala
 City: The Ixchel Museum.
Prechtel, Martin, and Robert S. Carlsen
 1988 Weaving and Cosmos amongst the Tzutujil Maya. Res
 15:122-132.
Rossignon, Julio
 1859 Manual del cultivo del añil y del nopal. Paris.
Rowe, Ann Pollard
 1981 A Century of Change in Guatemalan Textiles. New York:
 The Center for Inter-American Relations.
Schweppe, Helmut
 1988 Practical Information for the Identification of Dyes on
 Historic Textile Materials. Washington, D.C.: Smith-
 sonian Institution.
Vasquez de Espinosa, Antoni
 1942 Compendium and Description of the West Indies. Smith-
 sonian Miscellaneous Collections, Vol. 102. Washington,
 D.C.: Smithsonian Institution.

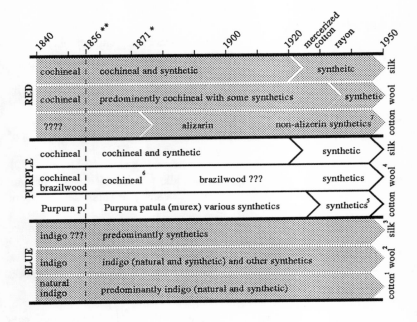

1. Cotton has a lengthy history in the Maya area. The roots of this use go back to the pre-classic period.
2. While the use of sheep wool in the Maya area is no doubt limited to the period after European contact, the pre-contact Maya may have used wool from other animals. It is known that the Maya's neighbors, the Aztecs, utilized rabbit wool.
3. In spite of rumors to the contrary, it seems as if the use of silk in Middle America is post-contact.
4. Purple dyed wool is somewhat rare in existing Guatemalan textiles. To date all tests on purple wool have determined the dye to have been synthetic. However, it is expected that future testings will reveal the use of brazilwood.
5. The patterns for dye use in existing purple cottons show that shellfish purple dye was used commonly as were synthetics.
6. While cochineal is often thought of as a dye for red, with proper mordanting it can also impart purples.
7. To date the earliest non-alizarin red cotton that we have tested was woven in ca. 1927.

* alizarin patented in Europe ** Perkin's invention of synthetic dyes

Figure 1. Summary of Guatemalan dye project results.

PART FIVE

THE MARKETING OF TEXTILES

Chapter Sixteen

Export Markets and Their Effects on Indigenous Craft Production: The Case of the Weavers of Teotitlán del Valle, Mexico

Lynn Stephen

Macroeconomic theories of development and underdevelopment tend to describe the impact of capitalist development including craft production for export in terms of third-world peasant dependency on first world capital.[1] Such an approach does not examine capital accumulation at the local level in craft-producing populations or clarify the community-level impact of economic development stimulated by the growth of national and foreign markets (Cook 1984a, 1984b). In order to evaluate the impact of foreign markets on craft-producing communities, we must look at local economic relationships and community cultural investments in craft production as well as international economic ties. Specifically, community control of resources, capital, and labor relations, both within the community and with foreign clients, and the relationship between local ethnic identity and the production of particular craft items should be examined.

Here these issues are explored in relation to the Zapotec community of Teotitlán del Valle, Oaxaca, Mexico where local weaving production has been reoriented towards export. In this chapter, I will illustrate why the internal dynamics of local institutions have had as much to do with the current organization of weaving production in Teotitlán as the external structures of export markets and the demands of foreign importers. I will first outline the development of national and foreign markets for Zapotec weavings, touching on the development of similar markets for indigenous crafts from other parts of the world. I will then discuss the development of the merchant sector in Teotitlán, the organization of weaving production, and current differences in merchant and weaver control in the production process. I conclude that craft production can lend itself to a higher degree of community control under certain conditions than other types of economic development because it is strongly tied to local ethnic identity (Stephen forthcoming).

Markets for Craft Goods

The creation of a market for "neo-traditional" items, for "new products made according to traditional methods," is ironic (Cook 1984a:13). As Cook citing Shrumpeter (1950) points out, the development of capitalist industry has eventually destroyed handicraft industry. A resurgence of consumer desire for hand-produced commodities can only come about because such commodities no longer are readily available and stand in sharp contrast to uniformly produced factory products. Part of the appeal of buying handicrafts is knowing that they come from a part of the world where old ways live on. For consumers, buying the "old ways," the traditional culture, is often as important as buying the products themselves.

Scholars studying the development of markets for indigenous crafts suggest that many indigenous artists and communities are producing for a set of intersecting markets, not for one standard market. In a study of tourist art in the Ivory Coast, Zambia, and Kenya, Jules-Rosette (1986:12) found that artists produce for four tourist markets including the village market, the "conventional" urban market, the curio trade, and galleries. Usually these markets are foreign. She suggests that artists need to be able to switch artistic codes and genres across these different markets.

Suzanne Baizerman (1987) suggests that tourist art, as a modern form of a culture's craft, is inseparable from outside markets. Rather than identifying different types of markets, she proposes that any art produced by

an ethnic group, whether sold to tourists or galleries, be considered as part of a larger body of art produced by that particular group. She suggests the term "boundary art" to describe art produced through a process whereby two cultures meet. She seems to imply that all types of markets contribute to the content and form of boundary art.

Studies of craft production by Baizerman (1987), Good (1988), Jules-Rosette (1984, 1986), Morris (this volume), and others suggest that the development of foreign markets and specific production techniques geared towards outsiders is an interactive process between producers and consumers. Indigenous craft producers are not "corrupted" by foreign influences but pick and choose design, color, and style elements that simultaneously please them and have positive economic returns. In this volume Meisch and Medlin emphasize how contemporary indigenous crafts retain artistic continuity not through their content but through their form. The Zapotecs of Teotitlán have followed this pattern, continuing to produce a particular form of weaving but altering its content and design in response to consumer demands.

Historically, Teotitlán was part of a weaving complex which included the neighboring communities of Díaz Ordaz (Santo Domingo) and Santa Ana. The three communities wove for local consumption as well as for tribute payments to the Aztec state before the arrival of the Spaniards. At the turn of this century, the three communities continued to weave, with each specializing in a particular type of blanket. Díaz Ordaz artisans wove a cheaper blanket, called a *pelusa*, that is a mixture of animal hair and cotton (Vargas-Barón 1968:46). Santa Ana wove second-class wool blankets with little or no design of a looser weave. Teotitlán wove first-class, tightly woven woolen blankets with designs.

Until 1890, the sales and distribution network for blankets from Díaz Ordaz, Santa Ana, and Teotitlán extended only to the markets of Oaxaca and Tlacolula (Vargas-Barón 1968). From 1890 to 1920, this network expanded to include other valley markets in the area such as Ocotlán, Etla, and Miahuatlán. The peak in demand for *pelusa* blankets was from 1910 to 1930. After 1930, competition from factory-produced cheap blankets cut into the market for *pelusa* blankets. After 1930, a steady decline occurred in the number of weavers from Díaz Ordaz.

The period between 1920 and 1950 saw significant growth in the industry, particularly in the production of high quality, tightly woven first-class blankets. Teotitlán and Santa Ana began to export first- and second-class woolen blankets to the Sierra Júarez and to Chiapas from 1920 until 1950. During the late 1940s and 1950s, national distribution of Oaxacan

weaving began to expand (figure 1). Exported first to classic tourist stops such as Acapulco and Mexico City, first-class blankets began to appear in many tourist stops in Mexico after 1950. During the 1960s and 1970s, distribution reached the United States and Europe. In Teotitlán in the late 1960s, a Frenchman who owned a store in Oaxaca began commissioning tapestry versions of Picasso prints from the weavers. Since then, clients from all over the world visit Teotitlán to commission everything from tapestries made with imported wool to 2000 identical rugs to be sold in department stores. As the market evolves, the range of distribution becomes ever wider, and Teotitlán increasingly becomes the hub for the distribution of all production. Now most weaving from Santa Ana and Díaz Ordaz (as well as San Miguel which started weaving about ten years ago) passes through the hands of Teotiteco merchants. Teotitlán's advantageous position as a marketing and distribution center may be related to its previous position as district capital until Mexican Independence in 1821. As a district capital the community developed extensive ties with a wide range of local communities.

The success of Teotiteco textiles as consumer products is reflected in the extent of a market that now has four levels. At the high end of the market are original tapestries or reproductions of art pieces that each involve six months to one year of labor. These textiles cost up to $10,000. These are made by about fifteen artisans with international reputations. An original tapestry by one of these artisans is now in the permanent collection of the Museum of Modern Art in New York City.

The second level is for original designs in limited quantities using high quality wool and dyes. These pieces are usually sold to U.S. middlemen, who then broker them to department stores, craft shops, and interior decorators. These pieces are usually produced by merchants who farm part of the work out to trusted employees and continue to do some of the weaving themselves.

The third level is for mass-produced pieces, usually five by seven feet, that feature several popular designs; Navajo designs currently dominate. These pieces are bought by smaller-scale Mexican and U.S. distributors who run their own businesses. This is the largest sector of the market in Teotitlán and is the sector where most piecework operations are concentrated.

The fourth level is for mass-produced smaller rugs, bags, and jackets made with poor-quality wool or wool-cotton mixes and cheaper dyes. Few weavers in Teotitlán produce this type of commodity, but merchants in Teotitlán commission them from weavers in the neighboring communities of

San Miguel and Santa Ana. The weaving industry of San Miguel is based almost entirely on the production of cheaper products. Part of the reason why San Miguel has entered the weaving market at this level is that production of smaller products made with synthetic fibers requires little capital investment. The community is significantly poorer than Teotitlán, and both merchants and weavers there have little capital. It is most convenient for them to produce large numbers of cheap products that have a high turn-over rate, providing a small amount of capital to reinvest in the next lot of cheap textiles.

In contrast to the African situation described by Jules-Rosette (1986) where individual artists and entire communities produce for a variety of markets, each Zapotec weaving community tends to produce for a more specific market. Weavers from Teotitlán focus on the high-end market, producing high-quality, labor-intensive goods. The neighboring communities of Santa Ana and San Miguel produce lower-quality production for cheaper markets such as border souvenir shops, flea markets, and low-end department stores in the United States. Teotiteco merchants have commercially colonized these neighboring communities through a monopoly on distribution networks in both Mexico and the United States. While people in Teotitlán are willing to sell the lower-quality products of other communities to American tourists and importers, they strive to maintain a reputation as first-class artists and craftsmen by only producing the finest quality blankets. Because the community does not have a problem with capital accumulation, its members are able to define themselves artistically through the use of expensive primary materials and labor-intensive forms of textiles associated with a "traditional" weaving product.

The intense contact that foreign importers have had with Teotitecos has a strong influence on the designs and colors of textiles produced in Teotitlán. Most Teotitecos can describe in detail how American taste has changed over the past twenty years. Images of Mexican indigenous idols and Picasso designs were selling well in the 1970s (figure 2). The 1980s were marked by a surge of orders for Navajo designs, traditional geometrics, and reproductions of modern artists, particularly Escher (figure 3). The 1980s also saw a return to natural dyes and subtle pastel colors. Many Teotitecos comment that they do not understand American taste, but they want to produce what sells. When asked what they themselves consider to be an attractive blanket, most cite classical Zapotec designs or designs adopted from other indigenous cultures of Mexico. Their preferences reflect an identity historically linked with weaving.

According to Jules-Rosette (1986:28), artists develop "ethnoaes-
thetic standards for evaluating their work" that are influenced by the
marketplace, by the artists' awareness of their skills, and by requirements for
craftsmanship. Both artists and consumers have their own ranking of specific
forms of art, and each may consider a specific art form to be superior or
inferior. Teotiteco weavers continue to produce a superior ethnic product by
incorporating elements of foreign design, color, and content into their work.
At the same time, however, they continue to value traditional elements of
style, design, and color that may not sell well in the current marketplace.
Even though they may not be mass-producing traditional designs, such
designs are still maintained in the community's repertoire.

Contemporary Weaving: The Household Division of Labor

The complexity of the designs produced by Teotitecos is mirrored
in the organization of production. There is a flexible division of labor within
each household by age and gender that organizes the basic tasks of carding
wool, spinning, dyeing, weaving, and finishing the ends of a blanket.
Weaving production includes all household members.

During the 1960s, when people in Teotitlán began to use factory-
spun yarn, women's spinning labor was freed. As demand for rugs continued
to grow, demand for weaving labor also grew. Within a few years of the
introduction of factory-spun yarn, significant numbers of Teotitlán women
and young girls began to weave. Today, the majority of women under
twenty-five know how to weave and all are learning. Many married women
between twenty-five and forty also have learned to weave as have widows
who have no other means of support. A random-sample survey I carried out
in Teotitlán in 1986 of 154 households found that approximately 66 percent
of the weavers are male and 34 percent are female (figure 4).

The fairly recent introduction of factory-spun wool has increased
therefore the flexibility of the traditional sexual division of labor associated
with weaving, particularly with regard to women. In general, women have
been associated more than men with carding, spinning, and dyeing activities.
Young children have handled small preparatory tasks involved in weaving
such as winding skeins of yarn, winding yarn onto bobbins for spinning,
tying up the ends of finished textiles, and helping with carding. Men
traditionally have put most of their labor into warping looms and weaving.

Age also influences roles in weaving work. In general, people over
forty have a much wider knowledge of weaving processes than do people
under forty. In large part, this is due to the fact that people over forty learned

to weave in a period when carding, spinning, and dyeing were all done by hand. Everyone learned how to do all aspects of the work. At that time, because weavers used hand-spun yarn much faster than it was produced, many men as well as women worked as spinners and dyers. Since the introduction of factory-spun wool, spinning and dyeing has increasingly become women's, particularly older women's, work.

Older people have a wide knowledge of dyeing processes. While most serapes from Teotitlán are made with "vegetable colors" (i.e., the colors of vegetables), they are not made with vegetable dyes. The majority of yarn is colored with synthetic dyes. Many young people do not know how to use natural dyes or how to find proper dyeing plants. Older production processes also included washing the dyed wool and then washing the finished blanket. In order to speed up production, these traditional methods are no longer practiced.

Exceptions to the use of synthetic dyes can be found. In the 1970s, a local weaver studied ancient dyeing processes and encouraged Teotitecos to use natural dyes. The materials often used include: cochineal (producing reds, pinks, and oranges), indigo (blues and greens), rock lichen (yellow), acacia beans (black), pecan shells (tan), and the dodder vine (yellow). Unfortunately, the cost of dyes such as cochineal, over U.S. $100 per pound, is prohibitive to all but the most high-quality weavers.

Merchants and Weavers: Control over the Production Process

In 1986, Teotitlán had a population of 1039 households or approximately individuals. One hundred twenty-five of these households are merchant households, and a majority of the remaining 914 are weaving households. Merchants are distinguished from weavers because they purchase weavings for resale and are employers of weavers. A majority of merchants (about 95 percent) act as employers either through piecework contracts with weavers, hiring people to labor in their workshops, or commissioning complex pieces in advance. Most of the weaving work in Teotitlán today is available through merchants. While merchants purchase rugs, the act is symbolically understood and described by Teotitecos as the merchant purchasing the "work" or the "time" of the weaver. Merchants are identified not only as "resellers" but also as people who "have workers" (Stephen 1991).

While these two groups do not correspond with absolute wealth differences in the community, their differing positions in relation to the accumulation of capital, the structuring of labor relations, and direct access

to foreign markets often results in merchants having a larger determining role in the overall organization of production than weavers. Elsewhere I describe merchants and weavers as class-based occupational groups (Stephen 1991). Because of a labor shortage, however, weavers also have some leverage in determining their working conditions and wages.

Since 1980, the prevalent mode of production in Teotitlán has been piecework. Almost all merchants are involved in some type of piecework operation and a majority of weaver households spend part of their labor time in piecework contracts. The piecework system places merchants as intermediaries between local weavers and foreign importers and tourists. In this position, merchants are vulnerable to the terms offered by importers and to seasonal fluctuations in the market. At the same time, however, merchants also have a good deal of control in setting the terms for piecework contracts within the community because they are the major source of employment in Teotitlán. Merchants often utilize nonbusiness ties with laborers to negotiate an advantageous contract.

Merchants in Teotitlán accumulate capital to invest in their weaving operations. Data on total household expenditures collected over ten months from six merchant and six weaver households reveal that, in general, the relative income of merchant households is higher than that of weaver households (as indicated by the level of household expenditures) and that a higher proportion of cash expended in merchant households goes toward weaving-related costs than in weaver households (45 percent as opposed to 25 percent) (Stephen 1991).

Data on merchant expenditures indicate that some merchants use their capital to purchase larger and more specialized looms. More than ten merchant households now have oversize looms (up to three and a half meters long) for weaving one-piece, carpet-sized rugs. Some merchants continue to provide the looms for their workers, usually when weavers come to work in merchants' households. The standard of living in the community has recently risen enough, however, so that almost all weavers now own their own looms (figure 5). What remains difficult for weavers to finance is the purchase of primary materials—wool, yarn, and dyes.

Steep inflation pushes weavers into long-term piecework contracts because they do not have to continually spend their earnings on primary materials. Many merchants in Teotitlán now go directly to yarn factories in the textile area of Tlaxacala and purchase undyed yarn in bulk to distribute to their workers. Yarn factories will also deliver large orders directly to Teotitlán. Many merchants also sell yarn to weavers who want to work

independently. When local yarn shortages occur, merchants push the price up. Several merchants have hoarded yarn and raw wool and sold it at high prices when local demand was high. By serving as the major distributors of primary materials as well as the major source of employment in Teotitlán, the merchant sector maintains a significant degree of control over the structure and organization of production.

Organization of Weaving Production

Like other export-oriented craft industries in Oaxaca, the weaving industry in Teotitlán is characterized by a diversity of production units, with the majority of people concentrated in piecework operations.

The four basic types of production units found in Teotitlán include:

(1) *independent weaver household workshops:* All weavers in this production unit are household members. They are not paid for their labor. Such households own the means of production and provide their own wool, yarn, and dyes. Weavers produce textiles in their own homes that are sold to tourists, importers, or to local merchants. Both men and women will weave in this type of production unit.

(2) *merchant workshops with hired laborers:* Labor in this type of production unit includes both hired weavers from weaver households and unpaid merchant household members. Hired weavers who work on-site at merchant workshops do not own the means of production nor are they responsible for providing yarn or dyes. Hired weavers are paid by the piece by merchants who own the workshops. Paid laborers are usually male, although they may be single young women as well. Unpaid merchant household laborers often include women and children. They may be weaving and/or supervising paid weavers. The paid weavers here appear in a straight labor/capital relationship with merchants.

(3) *merchant workshops with pieceworkers* : Labor in this type of production unit can include both unpaid merchant household members and contracted weavers in pieceworker households who are working in their own homes. Pieceworker weavers usually own their own means of production but often are not responsible for providing inputs such as yarn and dyes. They usually are given materials and weave finished products that are paid for by the piece by contracting merchants. This production unit usually includes men and women.

(4) *pieceworker households:* Weavers work in their own households and utilize their own means of production. Yarn and dyes are usually supplied by a merchant. Merchant households pay weavers by the piece. This

production unit only includes people from the weaver class and may involve men, women, and children who weave at home. As pieceworkers, women are much more likely to weave at home than in a merchant's household because they can combine weaving with other domestic duties as described below.

While most households primarily are part of one type of production unit (independent weaver household workshops, merchant workshops with hired laborers, merchant workshops with pieceworkers or pieceworker households), laborers from one household may be involved in two or more types of production units simultaneously. They may, for example, work part of the time at home as part of an independent household workshop and part of the time at a merchant's house as part of a workshop with hired laborers. Similarly, if one follows the trajectory of a household over time, the household will most likely be the basis of more than one type of production unit. Cook's work demonstrates that in other craft industries in Oaxaca, most merchants were once independent artisans or pieceworkers (Cook 1982: 20, 1984a).

The basic types of household-based production units in Teotitlán are typical of those found in other types of craft production in Oaxaca. Cook states the following about their organization:

> Most of these industries engage people of both sexes, and of a wide range of ages at some stage in the production or circulation of their prospective commodities. They display varying mixes of family labor and hired labor with different forms and scales of production organization (1984a:12).

The Influence of Ritual and Kin Ties in the Production Process

A careful examination of the relations of production in the weaving industry reveals that people working together have close family and *compadrazgo* (ritual kinship) ties.[2] Extended family ties and the *compadrazgo* system organize the people of Teotitlán into social groups that may function as units or networks for weaving production, agricultural production, and ritual participation. Ritual kinship and family ties require people to work together on ritual occasions in tasks such as cooking, animal slaughtering, and wood gathering. These same relationships are used for other types of labor recruitment as well, particularly for procuring laborers outside of the household unit. The existence of these stable family and *compadrazgo* social groups guarantees cooperation in the weaving system as well as a high degree of cohesiveness between the production system and the ritual system.

Recruiting laborers through the ritual kin network is an extension of practices carried on among biological and affinal kin. Many merchants have their godchildren working for them as pieceworkers in a system where *padrinos* (godfathers) and *madrinas* (godmothers) provide materials and *ahijados* (godsons) and *ahijadas* (goddaughters) produce finished weaving products in their homes. Merchants often have more godchildren than weavers. This is due to their greater ability to shoulder the heavy costs of godchild sponsorship. Respect is so inculcated into the godparent-godchild relationship that the godchild is in a weak position to refuse a labor request from godparents. Because merchant godparenting relationships often have heavy obligations, they may be able to lean on their godchildren more than weavers who do not have cash to loan and work to offer their godchildren. From the perspective of the godchild, having a godparent with significant financial resources also makes it possible to ask for a loan in a time of financial need. Heads of weaving households often seek out merchants as godparents for their children in the hopes that the merchants will be able to help their children economically.

Weavers often receive interest-free loans and primary materials from merchants. Because there is a shortage of weaving labor due to high market demand, weavers often have more work than they can handle. In deciding which work to do, weavers give priority to requests from relatives or *compadres*. If the *compadre* is not willing to pay the wage a weaver wants, however, the weaver will quietly go elsewhere to work. As long as there is a labor shortage, merchants cannot take too much advantage of their position as godfathers or *compadres*.

Craft Products as a Source of Ethnic Identity

Analyses of textile production in Mexico and other parts of Latin America (Meisch this volume, Morris this volume) suggest that weavings are not just produced for exchange—they are also symbolic statements of ethnicity. Textiles, whether produced for local use or for tourists, are intricately linked to indigenous concepts of ethnic identity. As pointed out by McCafferty and McCafferty (this volume), weaving can also be linked to gender-specific aspects of ethnic identity. While foreigners and social scientists often mourn the demise of a particular culture through the loss of tradition, an examination of contemporary indigenous textiles demonstrates how local populations synthesize different cultural elements, their own and others, to reconstitute ethnic identity and social organization in response to historical and economic changes.

In Oaxaca, ethnicity is defined at the local level through sets of self-defined characteristics maintained through continual interaction and contrast with other local ethnic groups (Barth 1969). It is not constructed as part of a Pan-Indian or tribal identity (see Chance 1986:25, Taylor 1979:24, Whitecotton 1977:4-7). In the case of the Teotitlán Zapotecs, ethnicity is based on a claim to local historical autonomy ("we are the original Zapotecs") and on specific cultural traits that are emphasized as a primary source of identity. These include speaking Teotitlán Zapotec, participating in social and cultural institutions that reproduce kinship relationships, maintenance of distinct ritual forms, and being the first people in Oaxaca to produce wool weavings (Stephen 1991). Teotitlán Zapotecs use elements of production and ritual as origin-based symbols to claim a place in the polyethnic stratification system of Oaxaca, which includes other indigenous groups and *mestizos* of mixed Spanish and Indian blood (Hawkins 1986).

While the Mexican government, travel agencies, and airlines have appropriated weavings as symbols of the "Indianness" of Mexico, Teotitecos claim their textiles as proof of their legitimacy as Zapotecs of Teotitlán. Weaving is indelibly linked with Teotiteco identity. Oral history proclaims that Teotitlán was the first Zapotec population site in the Oaxaca Valley. While current archaeological evidence invalidates this claim, it is still a widely held belief. In pre-Hispanic times, part of the tribute payment Teotitlán made to the Aztecs was in the form of woven cotton mantles (Acuña 1984:335, Barlow 1949:123, Codex Mendoza (d) 1938: leaf 44). According to local history, in a move that changed the community's future, between 1535 and 1555, Bishop Lopez de Zarate not only gave the Teotitecos sheep but also provided them with their first treadle looms. While Teotitecos historically were subsistence farmers, they also were known as first-class weavers throughout the Colonial period. The fact that they continue to weave and produce traditional designs with basically the same technology and materials links the commercialized weaving production of today with the long tradition of weaving for local use.

Activities and products associated with weaving are an important part of the package of cultural traits used by Teotitecos to validate and market their local ethnic identity. Textiles as rugs and blankets are important origin symbols because Teotitlán is known to be the original site of treadle-loom production in the Oaxaca Valley. Because Teotitecos have been able to turn the ethnic symbol of a textile into a major source of income the physical object has been reified by local culture. The wool textile is simultaneously

the bread of the community and a major symbol of the uniqueness of Teotitlán.

As suggested by Zorn (1987), textiles can be viewed as communicative systems that evoke, express, and constitute an identity for their creators. The very process of weaving can be viewed as an ongoing activity of ethnic and social reproduction, even as textile content, designs, and colors change in response to the interaction between creators and consumers. Jules-Rosette (1986) also suggests that tourist art be viewed as a system of communication, similar to Baizerman's idea of boundary art (1987). Jules-Rosette maintains that the sign value of a work of art is converted into a symbolic exchange when a particular genre finds a new audience (1986:10). In the case of Teotitlán, weaving and distributing rugs not only produces and markets desireable commodities but reproduces and markets Zapotec ethnic identity as well.

Ethnic Crafts and Business Negotiations

While the meaning of the ethnicity woven into Zapotec textiles is different for Teotitecos and U.S. consumers, the fact that the textiles are ethnic products is a major selling point. Their legitimacy as craft items hinges on the fact that they are produced in an indigenous village using traditional weaving techniques. This fact sets some of the terms for the organization of production and distribution as well as guaranteeing Teotitecos a market for their product.

Of primary importance is the fact that U.S. importers must travel to Teotitlán to purchase textiles and arrange business deals. By coming to the community, they are forced to adjust to the local rhythm of production and deal with an indigenous community where ritual obligations often have a higher priority than weaving production. Many North American importers complain of the difficulty of trying to do business with Teotitecos. Their complaints have to do with price fluctuations and the inability of the Zapotecs to produce the correct type and quantity of textiles ordered within the time frame specified. Many complain that ritual events interfere with production schedules. Most accept this as a consequence of doing business with the Zapotecs, but a few comment bitterly that it is impossible to "help the Indians" if they cannot deliver their products on time.

In their role as intermediaries between foreign importers and weavers, Teotiteco merchants must negotiate the territory between the internal life of the community and the demands of their clients. While this

position gives them a definite advantage over weavers in setting up the terms of production, because negotiations about the distribution and marketing of textiles are conducted in Teotitlán by people who also have ritual and kinship responsibilities in the community, the institutional priorities of the community do have an effect on the overall organization of production and distribution of textiles. Importers eventually adapt to the loose production schedule of the community or cease doing business with Teotitecos.

Conclusions

Craft production, variably known as simple commodity production and petty commodity production (Marx 1881/1967; Morishima and Catephores 1975), has been described as small-scale, supposedly independent production operating under the domination of the capitalist mode of production. Bartra (1974), Meillassoux (1975), and Wolpe (1972, 1980) describe petty commodity production as a mode of production which coexists with capitalism, and serves, through the maintenance of an underpaid labor force, as a strategy for capital accumulation in the capitalist sector. The case of Teotitlán as well as the examples of other craft-producing communities in Latin America (Cook 1984a, 1984b; Cook and Binford 1986; Goode 1988; Littlefield 1976; Meisch this volume; Morris this volume) contradict these characterizations of craft production.

As pointed out by Cook (1984a:78), craft production can serve as either a haven from or source of capitalist development. The case of Teotitlán points out the importance of examining the internal dynamics of economic development in peasant communities before judging the overall effects. While regions such as Oaxaca definitely remain in a subordinate position in relation to the national economy of Mexico and to the international economic system, local economics and historical circumstances also have an important impact on the effects of capitalist development in Mexico.

The commercialization of weaving production in Teotitlán has been controlled to a significant degree by indigenous people in their own community. While Teotitecos did not create the market for their product, they did respond to it in creative and effective ways. They were able to use migration to the United States to finance growth in family workshops and to gain information about how to deal with Americans in a business relationship. They have been successful in maintaining significant control over the production and distribution of their product.

Such control, however, is distributed unevenly in the community. Merchants, who provide the majority of employment opportunities and

control the distribution of primary materials, have a stronger hand in structuring the organization of production than do weavers. Nevertheless, because of a weaving labor shortage and the existence of family and ritual kinship ties that underlie all relations of production, weavers can exert a measure of control over working conditions and wages.

At a larger level, the case of craft production for export is a particularly interesting one because of the ethnic content of many craft products. In the case of Teotitlán, because weavings are made with traditional technology in a system of production organized largely along family and fictive kinship lines, commercialization of weaving has not isolated weaving production from traditional community institutions. The relations of production, the act of weaving, and the product itself—a Zapotec textile—are laden with multiple meanings: economic, ethnic, familial, and communal. The weaving industry cannot be reduced to an economic institution. In sum, both the ethnic content of weaving and the economic reality of capital accumulation in Teotitlán point to the important roles of community institutions and local historical processes in shaping the structure and organization of craft production in third-world peasant communities.

Endnotes

1. This research was supported by grants from the Inter-American Foundation, the Wenner-Gren Foundation for Anthropological Research (4645), and the Arthur and Lena Damon Award of Brandeis University. Research took place between 1984 and 1987, primarily for a doctoral dissertation.
 See Cockcraft 1983, Frank 1967, Furtado 1969, Kay 1975.
2. *Compadrazgo*, known as ritual co-parenthood, ritual kinship, or godparenthood is a Spanish institution that is now a distinctive feature of Latin American social structure. It is a lifelong relationship between the biological parents of a child, the ritual godparents, and the godchild him or herself. The relationship begins with a ritual and obligations continue throughout the lifetime of all participants. See Foster 1953, 1969; Kemper 1982; Nutini and Bell 1980; Sault 1983.

Bibliography

Acuña, Rene ed.
 1984 Relaciones geográficas del siglo XVI, Antequera. Tomo Primero. Mexico City: Universidad National Autónoma de México Instituto Investigaciones Antropológicas.

Baizerman, Suzanne
> 1987 Textile Tradition and Tourist Art: Hispanic Weaving in Northern New Mexico. Ph.D. Dissertation, Department of Design, Housing and Apparel, University of Minnesota.

Barlow, Robert H.
> 1949 The Extent of the Empire of the Culhua Mexica. Ibero Americana 28. Berkeley: University of California.

Barth, Frederick
> 1969 Introduction in Ethnic Groups and Boundaries, F. Barth, ed. London: Allen and Unwin.

Bartra, Roger
> 1974 Estructura agraria y clases sociales en México. Mexico City: Ediciones Era.

Chance, John
> 1986 La dinámica etnica en Oaxaca colonial. *In* Etnicidad, y pluralismo cultural. La dimánica etnica de Oaxaca, A. Barabas and M. Bartolome, eds. Pp. 143-172. México D.F.: Instituto Nacional de Antropología e Historia.

Cockcraft, James
> 1983 Immiseration, Not Marginalization: The Case of Mexico. Latin American Perspectives 10:86-107.

Codex Mendoza
> 1938 James Cooper Clark, ed. London: Waterlow & Sons Ltd.

Cook, Scott
> 1982 Craft Production in Oaxaca, Mexico. Cultural Survival Quarterly 6(4):18-20.
> 1984a Peasant Capitalist Industry. New York: University Press of America.
> 1984b Rural Industrial Commodity Production, Social Differentiation and the Contradictory Dynamics of Provincial Capitalism. Latin American Perspectives 2 (4):60-85.

Cook, Scott, and Leigh Binford
> 1986 Petty Commodity Production, Capital Accumulation, and Peasant Differentiation: Lenin vs. Chayanov in Rural Mexico. Review of Radical Political Economics 18 (4):1-30.

Foster, George
> 1953 Cofradía and Compadrazgo in Spain and Spanish America. Southwestern Journal of Anthropology 9:1-28.

1969 Godparents and Social Networks in Tzintzuntzan. South-
 western Journal of Anthropology 25: 261-278.

Frank, Andre Gunther
1967 Capitalism and Underdevelopment in Latin America.
 New York: Monthly Review Press.

Furtado, Celso
1970 Economic Development of Latin America. Cambridge,
 England: Cambridge University Press.

Gay, Jose Antonio
1881 Historia de Oaxaca. 2 vols. Mexico City: Imprenta del
 Comercio de Dublán y Cía.

Good, Catharine
1988 Haciendo la lucha: Arte y comercio nahuas de Guerrero.
 Mexico City: Fondo de Cultura Económica.

Griffin, K.
1969 Underdevelopment and Spanish America. London.

Hawkins, John
1986 Inverse Images: The Meaning of Culture, Ethnicity, and
 Family in Post-Colonial Guatemala. Albuquerque: Uni-
 versity of New Mexico Press.

Jules-Rosette, Bennetta
1986 The Ethnoaesthetics of Tourist Art in Africa: Some Theo-
 retical and Methodological Implications. Paper presented
 at the 85th Annual Meetings of the American Anthropo-
 logical Association, Philadelphia, Penn. Dec. 3-7, 1986.
1984 The Messages of Tourist Art: An African Semiotic Sys-
 tem in Comparative Perspective. New York: Plenum
 Publishing Corporation.

Kay, G.
1975 Development and Underdevelopment. London: Macmil-
 lan.

Kemper, R.V.
1982 The *Compadrazgo* in Urban Mexico. Anthropological
 Quarterly 55:17-30.

Littlefield, Alice
1976 The Hammock Industry of Yucatan, Mexico: A Study in
 Economic Anthropology. Ann Arbor: University Micro-
 films.

Marx, Karl
 1881/1967 Capital. 3 vols. New York: International Publishers.
Meillassoux, Claude
 1975 Femmes, greniers et capitaux. Paris: Libraire Francois
 Maspero.
Morishima, M., and G. Catephores
 1975 Is There an "Historical Transformation Problem"? Eco-
 nomic Journal 85 (38):309-328.
Nutini, Hugo G., and Betty Bell
 1980 Ritual Kinship: The Structure and Historical Develop-
 ment of the Compadrazgo System in Rural Tlaxcala, Vol.
 1. Princeton, New Jersey: Princeton University Press.
Sault, Nicole L.
 1983 The Transmission of Godparenthood Ties in a Zapotec
 Village of Oaxaca, Mexico. Paper presented at the 82nd
 Annual Meeting of the American Anthropological Asso-
 ciation, Chicago, Illinois, November 16-20, 1983.
Shrumpeter, J.A.
 1950 Capitalism, Socialism and Democracy. New York: Harper.
Stephen, Lynn
 Forthcoming. Culture as a Resource: Four Cases of Self-Man-
 aged Indigenous Craft Production in Latin America.
 Economic Development and Cultural Change.
 1991 Gender, Class, and Ethnicity in the Lives of Zapotec
 Women. Austin: University of Texas Press.
Taylor, William
 1972 Landlord and Peasant in Colonial Oaxaca. Stanford: Stan-
 ford University Press.
 1979 Drinking, Homicide and Rebellion in Colonial Mexican
 Villages. Stanford: Stanford University Press.
Vargas-Barón, Emily
 1968 Development and Change of Rural Artisanry: Weaving
 Industries of the Oaxaca Valley, Mexico. Ph.D. Disserta-
 tion, Stanford University.
Whitecotton, Joseph W.
 1977 The Zapotecs: Princes, Priests and Peasants. Norman:
 University of Oklahoma Press.

Wolpe, Harold
 1972 Capitalism and Cheap Labour Power in South Africa: From Segregation to Apartheid. Economy and Society 1: 425-456.
 1980 Introduction. *In* The Articulation of Modes of Production: Essays from Economy and Society. London: Routledge, Kegan, and Paul.

Zorn, Elaine
 1987 Encircling Meaning. Economics and Aesthetics in Taquile, Peru. *In* Andean Aesthetics: Textiles of Peru and Bolivia. B. Femenias, ed. Pp. 67-78. Madison: University of Wisconsin, Elvehjem Museum of Art.

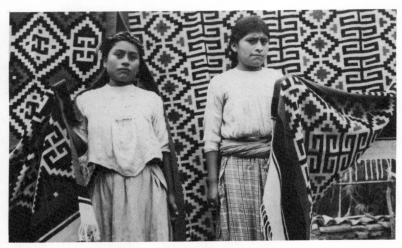

Figure 1. Two young women from Teotitlán sell serapes decorated with Zapotec designs in the market of Oaxaca. Photo courtesy of Foto Rivas, Oaxaca 1950s.

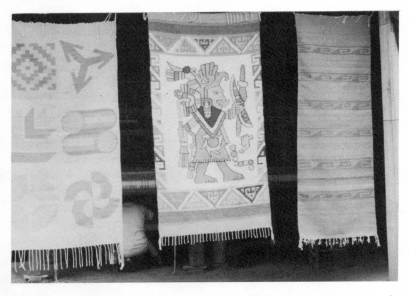

Figure 2. Abstract geometrics and indigenous religious idols were popular subjects for Teotitlán textiles. Photo by Lynn Stephen 1970s.

Figure 3. The 1980s saw the conversion of the first municipal food market into a textile market for tourists in Teotitlán. Photo by Lynn Stephen 1980s.

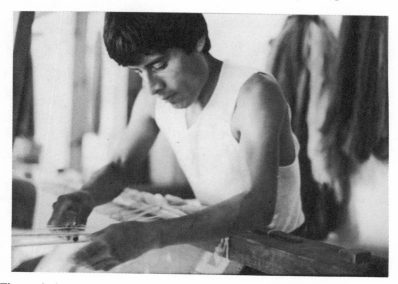

Figure 4. A young male weaver attends to a design detail. Photo by Lynn Stephen 1980s.

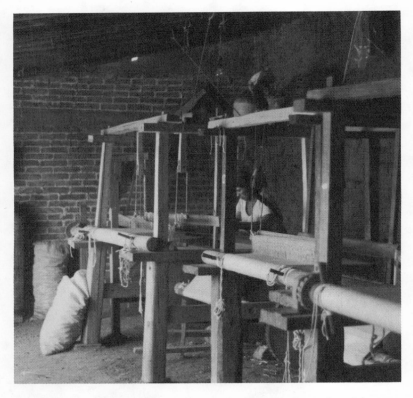

Figure 5. A woman weaves at the standard treadle loom found in many weavers' households. Photo by Lynn Stephen 1980s.

Chapter Seventeen

The Marketing of Maya Textiles in Highland Chiapas, Mexico

Walter F. Morris, Jr.

Introduction

Very few Maya weavers have been able to profit from their work in the centuries since Columbus first landed in the New World. Maya textiles were once highly valued and traded throughout Mexico and Central America. In their search for the Orient, one of Columbus's ships in the Caribbean pulled alongside a Maya canoe that was full of textiles for sale in Honduras. The market has changed since that first contact. The Conquistadores organized a system of forced labor called *repartamiento* that, among other things, compelled the Maya to sell, below cost, their thread and cloth, which was then sold back to them at inflated prices. Spaniards and later *mestizo* merchants generally disdained to use the native textiles themselves and instead wore cloth imported from Europe and Asia.

The sale of Chiapas Maya textiles to non-Indians began in earnest in the 1970s when the expansion of tourism created a new demand. Local merchants and entrepreneurs began to find ways to fulfill this demand, and various Mexican government agencies developed programs for organizing

artisans and selling their goods. One of the most successful native organizations to develop in this period is known as Sna Jolobil, which means Weaver's House in Tzotzil Maya. This is the largest organization of weavers, with over six hundred members from a number of communities within Chiapas. It has the greatest sales and the highest prices of any local textile operation. And Sna Jolobil has been the most active in seeking out and recreating old traditional weaving techniques and designs. This last aspect of Sna Jolobil is not a secondary activity: their focus on the traditional is also the key to organizational and financial success, as I shall discuss in this chapter.

The Maya have been weaving some of the most beautiful and elaborate textiles of the Americas for over two thousand years. Many costumes and designs woven in the highlands of Chiapas maintain a tradition that is as old as the Maya culture itself, for weaving (unlike most ancient Maya art forms) survived the collapse of Classic Maya society in the tenth century, and the Spanish Conquest in the sixteenth century. The ceremonial costume of the ancient and modern Maya is woven with designs that symbolize their vision of the cosmos and the beings that bring rain and life to the world (Morris 1984). The rectangular garment known as the *huipil* or blouse envelopes the weaver in a diagram of the world about to flower (figure 1). Radiating from her head are diamonds that depict the sun's movement through the sky and underworld. Along the edges of the brocade the musicians of rain, the toads, dance with the Earthlord who creates the clouds and reigns over the flowering plants that appear in growing rows of designs that cover the sleeves. A weaver may include depictions of the ancestors, the patron saints, the people of the first world who became monkeys, the monsters defeated by the Earthlord, and the animal spirits with their jaguar lord. She interweaves these designs and the power they symbolize into a harmonious vision of the world renewed in flower.

This rich tradition of symbolic weaving has been the focus of my research since 1973.[1] Sna Jolobil has received a great deal of support from many people and institutions. Members of Sna Jolobil would ask for help in specific projects and would solicit funds for programs the cooperative organized but would refuse any support that would give financial control over any aspect of Sna Jolobil to outside people or organizations. The Mexican government, American museums and institutions, and interested individuals have given their time, knowledge, and financial support to the weavers.[2] This group of supporters has helped maintain the political stability of the organization by defending them from outside jealousies and helping

to resolve internal disagreements while giving the financial and artistic support necessary to innovate new programs.

Sna Jolobil did not develop overnight; textiles were being sold before the cooperative began in 1977. The market for weaving was dismal, however, and it is important to understand the historical situation before describing Sna Jolobil's solutions.

The Local Market

Within a Maya community, a woman may ask a relative or neighbor to weave a garment for her, although this is not a common practice. Ceremonial costume may include garments that are made of weaves or designs known only to a few specialists who are commissioned to make these textiles. In Zinacantán, for example, only two or three weavers can make the feathered bridal gown, which must then be specially ordered or rented for the wedding.

In a few cases, the ritual costume must be obtained from a weaver in another community. The *huipiles* worn by the statue of the patron saint of the community of Santa Marta are made by a weaver in the neighboring community of Magdalenas. Religious officials from Santa Marta visit the Magdalenas weaver, offer her presents, and ritually request the garment in the name of their patron saint (figure 2).

The weaving of ceremonial garments is not so much an economic venture as much as it is a way of gaining prestige and security within the community. The weaving of a saint's *huipil* for another community is a political act that binds or separates neighbors. When Santa Marta and Magdalenas were disputing a few years ago, the weavers of Magdalenas were told not to weave for Santa Marta.

In contrast, the marketing of woolen goods by Chamulan weavers is done more for profit than prestige. Chamulan women produce most of the woolens of the highlands. Some are ceremonial robes that are made on commission with due ritual. Most, however, are standard items: wool shawls, belts, and tunics that are sold on the open market. The weaver walks through the market with the piece draped over her left arm to announce its sale. These woolen garments are essential parts of the costume that are not made by local weavers, so normally they sell quickly. Since the weaving and felting of wool is a particularly arduous task, and other communities feel that sheep grazing destroys the environment, most highland Maya prefer to buy their woolens from Chamula.

The internal market is then composed of specialists who can weave intricate ceremonial textiles and Chamulans who are willing to do the physically difficult tasks of weaving wool. The sale of textiles and raw materials made outside of highland Chiapas, even those made by Maya weavers in Guatemala, is dominated by *ladino* or *mestizo* merchants.

The Non-Indian Market

Some garments are purchased from non-Indians even within the Maya communities where most women weave. The blue skirt material worn throughout the highlands, for example, is woven on looms in Barrios Mexicanos of San Cristóbal de Las Casas. The cloth is not sold directly to Maya women but lent to merchants from Barrio Cuxtitali who sell the cloth in small, remote markets and buy pigs with the proceeds. The pigs subsequently are slaughtered and made into sausages. Finally, with the profit from that sale, the skirt material is paid for.

Raw materials, commercial cotton cloth called *manta,* cotton thread and acrylic yarns are all bought and sold by local *ladino* merchants. These materials are generally produced in Puebla and are routed through middlemen before reaching Maya consumers. Even the *manta* woven in the textile factory in San Cristóbal is sent to Mexico City where it is distributed to wholesalers. They, in turn, sell it to designated local merchants who then sell it to small-scale *ladino* merchants for final sale in the San Cristóbal markets.

The local textile market is dominated by non-Indians or *ladinos*, as it has been since the Spanish conquest. The huge profits reported for the resale of tribute cloth in the seventeenth century continues in a somewhat diminished form in the twentieth century.

Maya weavers may sell a garment to a relative or for the clothing of a saint's statue, but the raw materials come from *ladino* merchants. As factory-spun cotton and aniline dyes replaced local sources in this century, the influence of *ladino* merchants in the internal market has increased. The one exception has been woolen goods where, as we have seen, the Maya produced both the raw materials and the finished products. *Ladinos*, who shunned most Maya textiles, would buy woolen coats, blankets, and felt pads, produced by Maya weavers in Chiapas and Guatemala, because, until recently, no alternative warm textiles were available. Although producing woolens is not extremely profitable, this direct access to raw materials is probably how native weavers could eke a minimal profit for their work.

The Tourist Market

The small shops along Calle Real de Guadalupe in San Cristóbal de las Casas specialize in the sale of weavings and crafts to tourists. There are a dozen tiny stores with piles of textiles spilling off the shelves and a few gaudy blouses hung on the door to attract customers. This street, running from the central plaza to Guadalupe church on top of a hill at the eastern entrance to the town, has probably always had stands of goods to sell to the Maya as they approached the market square. These stores were once a kind of trading post, according to Donald Cordry who visited San Cristóbal in 1940. He states that "in the picturesque Calle Real are shops owned by *ladinos* (*mestizos*) who buy textiles, bags, and baskets from Indians to sell to other Indians who do not make these particular items themselves" (Cordry and Cordry 1968:340).

With the expansion of tourism in the 1960s and 1970s, Guadalupe Street became the center of the trinket and textile trade in the Chiapas highlands. Goods that sold for under $10 were those that sold the quickest. Since the merchants' goal was to turn over stock as quickly as possible, these stores were soon filled with piles of cheap woven bags and blouses sold, by merchants, who had little understanding or interest in the goods, to tourists. The weaver's profit for sales was truly minimal. In 1973, I found that most weavers were selling their textiles at near the cost of the raw materials that went into making the cloth. Smart weavers were reducing their manufacturing time by simplifying the design and were also using the least expensive raw materials available.

The Guadalupe Street merchants had become the unwitting agents of the destruction of the culture that they were selling. When these stores sold textiles to the Maya, as Cordry describes, both the producer and consumer understood how to distinguish quality and the stores were simply conduits of an established trade. Tourists who streamed through San Cristóbal in the 1970s had little time and less opportunity to learn about the goods they were purchasing. To combat this ignorance, one can either educate the tourist through exhibits and publications or educate the weaver to produce more westernized goods. The latter has been the more common goal of most people who work with artisans.

The weaving store on Guadalupe Street, La Segoviana, was one of the first to innovate with local textile design. Don Hernan sold weavings and machetes, as the other stores were to do after him, but he also made a collection of traditional dress in order to study Maya designs. Later he built a textile factory with colonial treadle looms. The weavers of Barrios

Mexicanos knew the basic techniques for dyeing yarns and weaving plain cloth on a treadle loom. Don Hernan expanded on this knowledge and trained a work force to do all the dyeing and to weave intricately brocaded designs taken from local weaves as well as European sources. Most of the goods were sold wholesale outside of the state. The business has fluctuated, with the main difficulty the expense of raw materials and the fact that the supply is often interrupted by scarcity and hoarding during periods of high inflation.

Using local labor to produce goods with European designs for export has been practiced since early in the Colonial period. In 1627, Thomas Gage described Zoque weaving: "Indians make it their great commodity to employ their wives in working towels with all colors of silk, which the Spaniards buy, and send into Spain. It is rare to see what works those Indian women will make in silk, such as might serve for patterns and samplers to many school-mistresses in England" (Thompson 1958:148-49). It is doubtful that an English schoolmistress would teach her students how to embroider the Earthlord; in Colonial documents, only those weavings made with European designs were recorded as being sold to non-Indians.

Fashion

The entrepreneurs who now make fashionable clothes out of native cloth have added a new twist to this technique, as they use local motifs on clothing they design and tailor in an occidental fashion. There are currently half a dozen San Cristóbal fashion designers operating who sell locally in their own shops or sell to stores in major cities in Mexico and the United States. In all of these operations, the production is organized in basically the same manner: the Maya are paid by the piece to embroider according to the layout given to them by the fashion designer. The cloth and yarns are often supplied as well. About 10-20 percent of the retail cost is paid to the embroiderer.

The generally low wages, piece-work payments, and mass production of certain designs are reminiscent of sweat shops. Unlike La Segoviana's foot-loom factory workers who are paid minimum wage and receive social security benefits, the embroiderers have no benefits, no job security, and a wage determined by the magic of the free market.

The fashion designers, with rare exceptions, use embroidered designs rather than brocade because it gives them more control over the design. (Brocade is woven into the cloth, while embroidery is applied to the finished cloth.) The garments that are embroidered are not made of locally manufactured textiles: Guatemalan treadle-loomed cloth is commonly used,

as is Mexican commercial cloth. One designer has cloth woven to her specifications in Oaxaca. These textiles are generally more colorful and less expensive than local cloth of comparable quality. The designers are using a manual skill that produces at lower cost than neighboring artisans. Although the final product may be sold as "ethnic art," the end result is actually a melange of various Maya cultures with Western culture predominating in every aspect of the design. A particular designer may be personally helpful to certain artisans, but the fashion trade as a whole tends toward a fracturing and obliteration of local culture while exploiting local labor. The Zoque Indians who adopted European designs in order to weave cloth that could be exported to Spain, as reported by Gage, in the end left no trace of autochthonous patterns even in their own costume.

The exploitation of labor is inherent in any plan to adapt local production to outside markets because the designer of the cut of cloth, of the woven patterns, and of the colors of the fabric, will be an outsider who understands the market. It is no accident that, just as the buyers of Zoque weavings were Spanish, the founder of the treadle-loom factory and all of the fashion designers are not Maya, nor were any of them born in Chiapas; most are, in fact, foreigners. The remolding of local crafts into goods made for an outside market will always depend on an intermediary who can deal with both cultures and who will be the only person who will fully profit from the exchange.

To a lesser degree, this is also the main problem in any attempt by local artisans to export their goods. The paperwork involved in export licenses and shipping is beyond the capabilities of most Maya at present, so any exporting must still be done through intermediaries. The Mexican government agencies that attempted to help artisans took on this role of intermediary for exporting goods to national and international markets. Although this was normally more economically beneficial to the weavers than selling to local merchants, these programs tended to be short lived.

Government Folk Art Programs

Folk art became one of the bases for post-revolutionary national identity, primarily due to Dr. Atl, a landscape artist and teacher, who energetically promoted the first major exhibit of Mexican folk art in 1921 and published in the same year the first work on Mexican popular art (Atl 1980 [1921]).[3] Chiapas was too distant to be affected by federal programs until 1972 when the National Indian Institute (INI) created a fair and contest of state weavers in San Cristóbal. The prices were set five times higher than the

local norm, which outraged the Guadalupe Street merchants and benefitted only a very few weavers. Although it was supposed to be a yearly event, it was never repeated.

That same year, a group of local *mestizo* women, supported by Banfoco (an artisans' fund) and Prodesh (State/UNICEF development agency), and led by the Mexican anthropologist Marta Turok, formed an organization known as Sakil Na to aid and promote local weavings (Turok, n.d.). Sakil Na was conceived as a source of raw materials on credit for artisans and a non-profit store for finished goods. The project was innovative, but by early 1974 internal disputes, poor sales, and a reduction in governmental support killed the project. The experience was important, however, as this was the first attempt to organize weavers and create a local outlet for their goods. The lesson from this —that even well-meaning outsiders should not run the artisans' business— took years to learn.

In mid-1974 Banfoco was replaced by the Foundation for the Promotion of Folk Art (FONART), which opened a local office in San Cristóbal to purchase artisanry. FONART formed production groups in eighteen communities, supplied raw materials at cost and on credit to artisans, and bought enormous quantities of textiles and pottery. These goods, along with those from the rest of the nation, were sold in FONART stores in Mexico City and along the U.S. border. FONART was the largest of the dozens of government programs in the early 1970s promoting folk art.[4] Although each program was unique and sometimes in conflict with others, all had the same basic methods. Crafts and textiles were bought directly from the artisans (or through a local organization that the agency directed) and then sold through the agencies' own stores. To promote sales, exhibitions of folk art were made in the store and at fairs in tourist centers. These exhibits emphasized that such crafts were authentic examples of Mexican culture.

Although the results were not as beneficial to the artisans as might have been hoped, this approach of emphasizing the authenticity of the crafts in general helped to maintain the culture. This particular aspect of the government programs was clearly more beneficial than the fashion designers and the Guadalupe Street merchants. As an economic proposition, however, many were outright disasters, and few were able to sustain themselves as political interest in folk art waned by the late 1970s. The government had set itself up as an enlightened intermediary, but the sale of folk art simply could not support the bureaucracy that formed around each program. Artisans never had direct access to the market, and when government policy changed, the artisans were left where they had started.

Sna Jolobil

The members of FONART's regional office in Chiapas in 1975 could see a parallel problem forming.³In the previous year, we had organized three thousand weavers and embroiderers into production groups in eighteen communities. Elected representatives of each group were responsible for gathering the textiles we had ordered, which would be brought to the central office for purchase. The textiles were then shipped to Mexico City to be distributed and sold to FONART stores throughout Mexico. Since FONART was intended not only to sell artisanry but also to give infusions of cash to remote communities, it was heavily subsidized. As certain goods began to fill the warehouses, it became obvious that the subsidies would not last forever. We thought that if the artisans ran their own store, maybe they could survive the crash that was about to happen. In December 1975, we asked that representatives of each group come to the San Cristóbal office to discuss their future. They did not believe our prognostications but agreed to organize an independent artisans' organization called *Tiangus* or marketplace in Nahuatl, the language of the Aztecs. Space for the store in the ex-convent of Santo Domingo was ceded to the weavers by the municipality of San Cristóbal. The weavers were not very interested in this experiment at first, as FONART continued buying for another year. For this reason, the store was run by outsiders like ourselves. Consequently it was plagued by administration problems until 1977 when the artisans took over the organization and running of the local store which they renamed Sna Jolobil.

Sna Jolobil began with about fifty of the more active members of FONART's production groups (which had collapsed as soon as the money dried up). As their store increased its sales, the active members of Sna Jolobil had increased to over six hundred, with perhaps another thousand weavers who occasionally produced something they would like to sell. There are now a dozen weaving and embroidery groups in as many communities that send representatives to San Cristóbal to leave goods at the store and to participate in meetings. These groups are subdivided into hamlet organizations where weavers can easily get together to discuss finances and study designs. Hamlet representatives bring the finished goods to the community center, pick up threads and other raw materials for their group, and participate in the community meetings. The community representative is delegated to bring all of the hamlet's various goods to the store since the trip to San Cristóbal is time consuming and expensive. In practice, the hamlet representatives occasionally come themselves to see how things are going. Individuals are discouraged from bringing their weavings directly to the store, as this

undermines the authority and function of the representatives. Yet individuals are free to visit, and to attend meetings. If a number of women do come with complaints, then the officials of Sna Jolobil will go to their hamlet, discuss the problem, and if necessary, oversee the election of a new leader.

One of the main jobs of the representatives is to see what is selling in the store and report back to the groups' members. Weavers often complained about what they felt were capricious buying practices when FON-ART was selling all their goods in distant stores. One production group of three hundred women attempted to coerce FONART into buying some of each type of traditional garment of their community. Long explanations of buyers' tastes and why foreigners would buy shirts but not skirts failed to convince the women. The group, deciding that FONART was being unreasonable, disbanded. In Sna Jolobil, if a group feels that their skirts will sell, they are free to put a few in the store and see what happens. If the skirts are still sitting on the shelves after a month, the representative can see for herself that these items are not the best to produce for sale. If there is a serious disagreement over pricing, the store will allow the group or an individual who has woven an outstanding textile to put her own price on the piece. If it moves quickly, then that becomes the standard price. If not, the weaver is asked to lower the price. Having a local store has settled a lot of arguments. Even if an artisans' organization was producing all its goods for export, I would recommend creating a local outlet to show the artisans how the marketplace works.

Sna Jolobil has a president, treasurer, and other officials who are elected yearly. Their roles are to oversee the operations of the store, visit the community groups to settle any grievances, and organize exhibits, weaving contests, and workshops. They also maintain a working relationship with the government institutions that occasionally support their activities. The store is run by full-time Maya employees who receive and pay for the goods, keep the books, maintain the store, and sell the textiles. Men were the first leaders and store workers, but women now run the store. Most of the men who are involved with the cooperative are accountants. The store's gross yearly sales in 1977 were about $1,000; by 1981 they sold approximately $100,000 worth of weavings.

As Sna Jolobil grew more successful, other weaving organizations were formed with the support of patrons such as the Mexican Communist Party, the Catholic church, and the American government. Despite the political differences of their supporters, each organization had remarkably similar ideas on how to sell folk art. They all put up a small store, which, like

Sna Jolobil's first effort, sold weavings in direct competition with Guadalupe Street. But they never moved beyond this, and here is a problem.

The advantage of just operating a small shop and ignoring export or fashion is that, although the local market may be small, it is fairly easy to work with. A small store involves little overhead, the paperwork and accounting are relatively simple, and the sales personnel need not be specially trained in international marketing or fashion trends. The shop owners' problem, however, is that they have not distinguished themselves from the other weaving shops in either quality or type of merchandise and therefore must sell their goods within the same low price range as the merchants with whom they are directly competing. These organizations can not raise prices without losing sales, and so they offer a weaver pride with little profit.

Sna Jolobil decided to ignore the competition and focus on producing the finest traditional *huipiles*. These would be expensive and could not be sold as just another local craft. Sna Jolobil weavers had to sell their textiles as art. A $500 weaving is an absurdly expensive craft item, but a relatively inexpensive work of art. Tourists were willing to pay such prices if they could recognize the quality of the work. Sna Jolobil promoted exhibits and publications on Chiapas textiles to educate the buyers' eyes so that they could see the details that indicated skilled workmanship and creativity. To maintain quality, weavers studied examples of textiles from the nineteenth century, revived the use of natural dyes, and ran periodic contests where weavers could see and critique each other's work. Just like learning how to make fashionable clothes or mastering the intricacies of export, promoting textiles as art and improving quality are on-going processes, and a great deal of work. What distinguishes Sna Jolobil from the other cooperatives is that its prices have risen dramatically. Unlike weavers who work with fashion designers or produce special goods exclusively for export, the weavers of Sna Jolobil run their own business.

Raw Materials

The basic problem in creating fine textiles is to find good raw materials. This is not an easy task in Chiapas, where cotton goods are sold only through intermediaries and silk and wool yarns are commercially unavailable. Since 1975, all Mexican factories that used to produce woolen yarns switched over to the production of acrylic yarns. Acrylics feel like the plastics from which they are made and have colors that many tourists find overpowering. Weavings made with acrylic yarns would never be recog-

nized as art or sold at more than the market rates, so Sna Jolobil's problem was to find a substitute for commercial yarns.

One solution is to use natural dyes. Unfortunately, the use of plants to dye wools had all but disappeared when chemical dyes became readily available in the 1950s. Home-spun and dyed yarns were becoming a distant memory when acrylic yarns appeared on the market in the 1970s. In order to revive the craft of natural dyeing, Amber Past spent years interviewing elderly women about dyes and experimenting with local plants to recreate the old techniques.

The first weavings made with natural dyed wools sold extremely well, but the weavers were not excited about the earthy colors their natural dyes produced. Even though the women of Sna Jolobil can now, after ten years of study, make bright naturally dyed colors, the women still prefer to use brilliant acrylic yarns for their own clothing. We tend to view natural dyes as an integral part of the weaver's tradition, while in fact most Chiapas weavers have always purchased the brightest possible yarns for brocading their *huipiles*. In the nineteenth century, *huipiles* were made with Chinese silk. Early twentieth-century *huipiles* were made with natural dyed wool and Guatemalan cotton, and modern *huipiles* are made with acrylics dyed as bright as possible to satisfy the local demand. The reason we worked so hard at reviving natural dyes was not to save a tradition that didn't want to be rescued but to give the weavers access to better and cheaper raw materials.

A *huipil* woven with plastic yarns has a low retail value and is expensive to produce. Acrylic yarns sold in small batches by the local merchant are very costly. Weavers were taught how to use chemical dyes. Chiapas, however, is remote, and the supply of dye was erratic, expensive, and of inferior quality. Natural dyes take time to collect, but the supply is local and the quality is controlled by the dyer. The use of natural dyes is, ironically, the only concession that weavers have made to foreigners in order to sell their work as traditional art.

In 1976 there was one dyer in Chamula, Maria Tzu, who had learned from Amber Past and invented on her own a wide range of natural dyes. A short film on Maria Tzu and her dyes was made for Sna Jolobil. This was shown in various highland communities and created some interest in the dyes.[6] In 1978 Amber Past organized the first dye workshop (supported by UNICEF), where women from a dozen communities stayed together and studied dye techniques for a week. A small group of women decided to become dye specialists and worked with Amber on a bilingual (Tzotzil/Spanish) book on dye plants and techniques. By 1980, the dyers were

organized enough to be able to buy a small house in San Andres Larrainzar that could be used for meetings and as a dye workshop.[7] Dyers shared pots, mordants, lowland wood dyes, etc., and produced enough dyed wool for the rest of the cooperative. Open workshops are held yearly for women who wish to learn how to make their own dyed yarns.[8] Foreigners who are knowledgeable about dye techniques are invited to share their skills with the workshop.[9] The dyers are now experimenting with dyes for silk and cotton.

Natural dyes have helped to define Sna Jolobil's textiles as something special. The other raw materials, which have to be purchased (cotton thread, embroidery floss, *manta,* dye mordants, raw silk, and wool), are bought in bulk directly from the producer or factory.[10]

Weavers often do not have the cash to buy the materials they need, so Sna Jolobil distributes raw materials to groups in each community to be repaid when the groups are paid for the textiles left in the store. Sna Jolobil does not demand that all the raw materials loaned to weavers be used for goods sold at the store for the simple reason that this is impossible to control. Since it is difficult and costly to procure these materials, methods of control have been tried. But attempts to gain even minimal control always created administrative procedures that were both autocratic and unworkable. It was decided to let the weaver choose what she will do with her yarns.

Traditional Design

Most weavers only make a few kinds of textiles. A woman from San Andres, for example, will weave her husband's red-sleeved shirt and red belt, her children's long shirts, her striped shawl, working blouse, and perhaps a red brocaded *huipil.* All of these can be sold, but the market can only absorb so much of each. Sna Jolobil sells about five San Andres men's shirts and ten *huipiles* a month. Two weavers working almost full time could fulfill the entire demand for men's shirts. A weaver can only produce three or four *huipiles* in a year, so it would take thirty or forty weavers to keep up with the demand for *huipiles.* One reason Sna Jolobil promotes expensive complicated *huipiles* is because this supports more members.

The weavers, of course, do not churn out the same article over and over. They tend to do a few easy pieces and perhaps make a sampler of designs while working on something difficult. A greater variety of textiles and styles of weave will attract more customers and therefore sell more goods, for almost every buyer wants "something different." Since Sna Jolobil is dedicated to preserving traditional weaves, it would seem that the weavers are doomed to offering a few staid styles. Fortunately, tradition is

a lively affair—every community has its own style of dress, color combinations, and designs. There is variety within each community's style, as each weaver creates her personal vision of what is beautiful. Woven records of historical changes and forgotten fashions appear as ceremonial costumes and the clothing of the saint statues. This immense range of styles and designs can, theoretically, be studied, reproduced, and used as a source for innovations. In actuality, a woman learns the designs of her mother and mother-in-law. If they do not know how to brocade, then she must pay a weaver who does in order to learn the basic designs before she will begin to innovate her own variations. Occasionally a woman has a dream that the saint has asked for a new *huipil,* so she will study the old *huipiles* worn by the statue of the saint and then weave an even more elaborate version (Morris 1986). In Tenejapa, a woman is selected every year to weave a new set of clothes for the Virgin of Banabil Lake, where the Virgin once appeared and asked for proper clothing. [11] In Tenejapa, the weaver's materials and food are paid for by the whole community. Weavers in other communities are also occasionally given food while weaving sacred clothing.

Few women are supported by their community to weave or can spend the leisure time dreaming about the saint's *huipil.* Sna Jolobil, therefore, gives grants to weavers to study brocaded designs. These textiles are either religious costumes from the weaver's community or old examples of brocade from Sna Jolobil's own study collection. Receiving a grant gives a certain prestige to the weaver whose goals and methods are recognizable to the Maya community. The orthodoxy now attributed to grants is the result of an unorthodox method of collecting.

From 1974 to 1978, I collected some four hundred distinctive styles of weaving for a museum in Chiapas. [12] Whenever a rare style was located, weavers would be asked to make copies for other museums. [13] I thought that I had invented something new until a meeting with the keeper of the ceremonial clothing of Chamula, Mol Domingo. When asked about purchasing a garment, he said "No, but I can sell you a copy." There was only one brocaded *huipil* left, but three were needed for the ceremony so Domingo had copies made of the original.

They were terrible copies. No one in Chamula knew how to brocade, and Domingo did not have any understanding of such matters, so he had a woman from a neighboring community embroider the reproductions. Garish colors and embroidered designs appeared where the brocade should have been. Mentioning some of the problems with his copies, I asked if a friend could look at them. Rosha Hernandez is one of Sna Jolobil's best

weavers and has woven for the saints statues (figure 3). She founded the San Andres weaving group because she noticed that young women were not learning what she strongly feels is a sacred art. After Rosha inspected the original and Domingo's copies, she quietly informed him that he had been derelict in his duties and that the saints would surely not look kindly upon those who wore travesties of the clothing given at the beginning of the world to the Maya, the True People. Domingo looked very relieved when Rosha took the original home to study.

A few months later, Rosha came back with a *huipil* that duplicated every detail of the antique weave. Seeing a good reproduction the Chamulas, like everybody else, could recognize the value of the work. They later asked Rosha to reproduce the *huipil* of Santa Rosario to replace the one that had been worn by the statue for over one hundred years. The original was given to Sna Jolobil for the study collection. The reproduction, that is now worn by the saint, should survive another hundred years, giving the Chamula time to decide if they want to revive the art of brocade within their own community.

A dozen more *huipiles,* the only surviving examples of a style, subsequently were located. Women were given grants by Sna Jolobil to re-create these *huipiles,* to teach others how to make them, and to study others which had interesting modern variations of style and design. Sna Jolobil also has gathered its own collection for exhibitions and to loan to weavers for study. This allows weavers free access to old designs. Traditionally, a weaver would have to pay another weaver to help her if she wanted to study motifs outside her family's repertory. It was particularly helpful to those young women from families who no longer knew how to brocade at all.

One of the most effective methods of getting the weavers interested in creating traditional textiles, surprisingly, has been weaving contests. National and state-wide contests held in Mexico are rarely effective, for few artisans can travel to the capitol cities where they are held. Moreover, the winners are given large prizes and proclaimed to be special, which often causes them problems in their communities where egalitarianism is valued over individualism.

When M. Teresa Pomar became Director of the Museo Nacional de Artes e Industrias Populares in 1977, she began to organize another form of contest in many parts of Mexico, including Chiapas. These proved to be more appropriate. These contests were held in the artisan's own community so that everybody could participate, examine their neighbor's work, and socialize. The prizes were small but numerous, and the basis for judging was not purely aesthetic but also emphasized the traditional and the technical quality. Sna

Jolobil participated in a number of these contests and decided to invite Pomar to help judge local contests that they organized. They also slightly modified the contest by including in the judging panel Mexican government officials, foreigners who collect textiles, people who work in the store, and weavers from communities other than the one being judged. The long, confusing, and often loud debates on the value of each weaving by the judges give the weavers, who, for the most part, never leave their community, a sense of the process outside buyers use to place a value on the work. The weaver-judges get a real understanding of how arbitrary the process of deciding between first and second prize can be. This softens the social impact of their decision. They also give out awards and honorable mentions for many categories. The community of weavers can see that although the judges may miss what the weavers themselves consider excellence, prizes are not given to poor work, and the most traditional weave is the one most likely to win. So weavers try to produce the finest and most traditional weaves for the store and next year's contest.

The weaving contests also act as a yearly general assembly in each community. Normally only the group representatives go to the monthly meetings in Sna Cristóbal to present their group's problems and ideas. During the contests, all the members of the weaving group get the opportunity to talk to the leaders of Sna Jolobil, to air grievances with those that work in the store, and to talk about their group's organizations with representatives from other communities. During a contest, the weavers, who have been given a grant or worked on their own to study pieces from their grandmother or Sna Jolobil's collection, have the opportunity to show their work to the whole community. Since it is these women who most often win, their weavings are carefully examined and often copied by other weavers.

Giving grants, making a study collection, and producing weaving contests are expenses that take a significant amount of Sna Jolobil's scant resources. Commercially, as well as culturally, the investment has paid off, as Sna Jolobil can now offer a wide range of textile designs and weavings that can not be found elsewhere. Their weavings are clearly distinguishable from those of the small tourist shops, so Sna Jolobil is not trapped into competitive pricing. One can not go to a Maya community and find a nineteenth-century *huipil*. Sna Jolobil is the only source for museums and tourists of antique-style textiles.

The focus on historical textiles also has enlivened the weaver's art by making tradition a conscious source of inspiration from which the weaver can draw when creating a new style. Moreover, this source is not controlled

by a foreigner as it would be if the weavers were trying to create fashionable clothing. Finally, the act of reviving a forgotten style has an emotional power that is part of the glue that binds the cooperative together. Weaving is a sacred act that reaffirms and makes manifest one of the teachings of the ancestors. In a society that believes that the Golden Age is in the past, bringing back and revitalizing the past is considered to be a step forward toward greatness. The Maya communities would lose something vital if they forgot how to weave. There is a spirit, a sense of purpose, that Sna Jolobil experiences from the revival of traditional textiles that the weavers would not feel if it were just a store.

Publicity

All this would be in vain if the weaver could not support herself or at least profit from selling traditional textiles. As I have said, the market offered options that were barely viable. The Maya themselves only purchased woolens and ceremonial costumes from other weavers. The local *mestizo* population would buy a few practical pieces or operate stores that bought and sold folk art at the lowest possible price. The export and fashion market was controlled by those with education and experience, which meant government agencies, cosmopolitan Mexicans, and foreigners. Sna Jolobil had to create a new market if it was to succeed.

Sna Jolobil distinguished itself from other organizations by focusing on developing traditional fine textiles. But to sell these goods, the buyers had to be made aware of Sna Jolobil's existence, educated on how to distinguish quality, and taught to appreciate the culture expressed in the weave. Finally, the buyer had to be convinced that Chiapas textiles were a legitimate art form worth far more than woven trinkets.

There were two formidable problems at the beginning. Chiapas textiles were virtually unknown outside the area, and Sna Jolobil's store was hidden in a building that tourists did not normally visit. Sna Jolobil needed advertising that made people aware of its existence and the unique quality of its textiles. Since Sna Jolobil was going to sell art, the advertising had to be creative, well-crafted, and therefore expensive, if it was to give the image that Sna Jolobil wanted to project. There were virtually no funds available for an advertising campaign, so Sna Jolobil had to innovate some new approaches.

Sna Jolobil began by printing flyers which, like the other cooperatives, emphasized the store as an artisan-run organization. These were left at hotels and tourist agencies. One improvement on this basic format was to include a bilingual (Spanish/English) explanation of the cooperative and a

good map of the city that a tourist would not be likely to discard. Flyers are inexpensive but to do more, Sna Jolobil had to find ways to make the publicity pay for itself.

The first idea, and one of the best, occurred in 1977 when Antonio Turok, a local photographer whose family was in the postcard business, decided to print some black-and-white postcards of his own. Sna Jolobil asked him, for a small fee, to put their name, logo, and address on the back of his postcards. He agreed. Sna Jolobil also received postcards on consignment for sale in their store. These quickly paid back the minor costs of the advertising. The publicity was spectacular, as over a quarter of a million postcards labeled "Sna Jolobil" were sold in the first five years and mailed all over the world.

Using postcards as advertising has the advantages of distribution, recoverable cost, and even occasional profits. Another positive side effect is that, in order to sell publicity, the printing and design must be of reasonable quality. The caliber of the advertising medium must be good to promote an art form.

Postcards grew from an advertising ploy to a business as Sna Jolobil gradually emerged as one of the important postcard distributors in San Cristóbal de Las Casas. Sna Jolobil now works with five photographers who produce color postcards, posters, and calendars. Sna Jolobil is no longer dependent on a single outsider to produce publicity. It now has the capital to buy postcards wholesale and to pay for the printing, which increases its share of the profits.

Since every little store in Mexico orders personalized calendars to be given to its best customers, printing Sna Jolobil's calendar was a natural advertising idea. The Maya have their own ancient calendrical system, which is no longer widely used in Chiapas. Since 1979, Sna Jolobil has printed calendars that include the Tzotzil and Tzeltal Maya dates along with the Western ones. This preserves tradition as well as promotes the cooperative. Calendars are given to weaving group representatives, Maya and Mexican government officials, and are sold in Mexico City and the cooperative store to recover the printing costs. As with the postcards, Sna Jolobil works with local artists who will produce calendars in return for a small payment— normally copies of the calendar and a textile. These partnerships with non-Maya artists have not only given Sna Jolobil publications a better quality than they could have produced on their own but also have forged links with the local artists' community.

Books

Up to 1970, most books on Mexican textiles and folk art did little more than mention Chiapas. The state is remote and even now is more difficult to travel to than most parts of Mexico. If these weavings were to be taken seriously, it was essential to have some publications that would identify the textiles and describe their symbolism and history. Sna Jolobil had to publish its own material.

In 1979, Pedro Mesa M., a member of Sna Jolobil, and I put together the pamphlet *Luchetik: El lenguaje textil de los altos de Chiapas / The Woven Word from Highland Chiapas,* now in its third printing (Morris and Mesa 1979). Design symbolism was chosen as the first topic. I had studied it for years, and Pedro Mesa had made drawings of over fifteen hundred different brocade designs.[14] A pamphlet on designs seemed to be the most effective way of getting people interested in Chiapas textiles. In talking with tourists, we found that people who know nothing about weaving are not as interested in technique as in the symbolism of the woven designs. The intricate designs are tiny, and one must look very closely to see them. The designs draw the viewer into the weave. Only then does one notice the amount of work involved. Once the buyers could identify common motifs, they had something to talk about when they showed their purchases to friends.

Amber Past worked on a pamphlet, *Bon: Tintes Naturales,* with participants in the natural dye workshop. The plan was to publish it in Spanish and Tzotzil and thus make people aware of the work that went into each colored yarn. The pamphlet could be useful to those teaching natural dyes, as *Bon* would be one of the few books available on the subject in Spanish.[15]

These publications were eventually profitable, but the initial investment was too high for the cooperative to continue publishing new books for a number of years. Instead, Sna Jolobil has been distributing new works on Chiapas weaving produced by the Instituto de la Artesania Chiapaneca and others. Like the postcard business, book selling should grow more profitable with more volume and experience. More capital will help Sna Jolobil to produce more sophisticated books in cooperation with local artists.[16]

Pamphlets are informative but not very impressive. To sell art, one needs polished presentations of the sort that Sna Jolobil could never afford on its own. The weavers realize that almost any publication or publicity about Chiapas textiles will help improve sales, so they are willing to work with photographers, writers, and television crews to get their work known. In Chiapas, this is an unusual stance, as most Maya refuse to have their pictures

taken and do not welcome foreigners into their homes. The rationale for these attitudes may relate to distrust of cameras and the knowledge that photographs of the Maya have monetary value elsewhere. The Sna Jolobil weavers will cooperate, however, if the photographs are associated with weaving and will be published. Since practically no other indigenous peoples in Chiapas will work with photographers, Sna Jolobil is in a good position to get fair treatment and good press.[17]

Exhibitions

Publicity will get people interested in purchasing weavings. The price they are willing to pay, however, will depend on whether the textiles are seen as ethnographic curios, peasant costumes, fine weavings, or works of art. If these textiles appear in museums and art books, the perception is quite different than in postcards. Chiapas textiles had to be "legitimated" through the proper institutions.

In 1975, few museums had collections of Chiapas weaving. I helped a number of museums acquire weavings at cost. To provide them with information, I published a catalogue of Chiapas textiles (Morris 1979). This had no immediate effect, but I made this an early project, knowing that the information would take time to digest and "ageing" the textiles in the storerooms would only increase their value. In fact, it took a dozen years before either the museums or Sna Jolobil were ready to mount an exhibit.

In the meantime, a number of temporary exhibitions were mounted in San Cristóbal to make people aware that textiles do exist in Chiapas. In 1979, a textile exhibit room was created in the only museum of San Cristóbal, Na Bolom.[18] This small exhibit was meant as a temporary measure until a museum to house the Pellizzi Collection of Chiapas Textiles was completed. That museum is now almost finished.

The museum was first conceived as a resource for weavers. In the museum design, one important area was the study room where a weaver could set up her loom and examine textiles from the adjoining storeroom. Weavers also were trained in textile conservation and maintenance in the hope that they would manage the collection and exhibit. That has proven to be difficult. The work has not been wasted, however, as Sna Jolobil has learned how to conserve its own collection which weavers can study. The cooperative has taken on some of the original functions of this museum.

The first exhibit will explore the historical roots of Chiapas weaving, a topic chosen because weaving would not be accepted as an art unless it had a history. In 1984, during a frantic episode when it seemed that the

museum would soon open, a guide book to the exhibit was printed and distributed. Several thousand English and Spanish copies of *A Millennium of Weaving in Chiapas* (Morris 1984) have already been sold, so the exhibit has had some effect even before it opens.

A local exhibit forces the locals, Maya and non-Indian alike, to reexamine the familiar objects that are now in the spotlight and to try to understand why they deserve special attention. It disturbs the status quo, which explains the museum's delay, even though the subsequent increase in tourism would be even more profitable to hotel and restaurant owners than to weavers. More textiles would be sold, and the buyers would become more discerning. The local museum will establish weaving as an important part of the cultural landscape, but if Chiapas weaving is to gain a broader recognition, it must appear in a broader context. It took a few years to discover the proper context in which to exhibit weaving as art.

Ethnographic Museum Exhibits

If exhibits are to be effective for marketing, it is important that the pieces be displayed as art, not as ethnographic curiosities. In 1978, the Science Museum of Minnesota created a beautiful, extensive permanent display on daily life in Zinacantán. It included a thatched-roof house with all the furniture, utensils, and costumes of that Chiapas community, along with examples of weaving from other communities. When the exhibit opened, we hoped that people would be encouraged to buy Chiapas weavings. A local Minnesota store, "Maya Market," bought a number of textiles from Sna Jolobil, but the public showed little interest. Even the museum shop could not sell their textiles. It became clear that anthropology museums are not the place to display textiles as art.

The problem could have been that the few textiles on display are lost among all the other "ethnic oddities." In 1984, a new approach was attempted. The result was another exhibit dedicated to Sna Jolobil and entitled "Flowers, Saints, and Toads: the Textile Art of the Chiapas Maya."[19] Once again, it did not stimulate the sale of any textiles in museum or local stores. The anthropological context sometimes creates a distance from the general public.

Museum stores, located in non-profit institutions that could be sympathetic to native organizations, appear to be good places to sell folk art, especially that of an ethnic cooperative. The stores are adjacent to exhibits that explain the cultural context of traditional arts. With the exception of a few expensive pieces that sell slowly, museum shops mostly sell inexpensive

items like plastic dinosaurs and t-shirts. Their low-cost high turn-over market is very similar to that of the Guadalupe Street merchants from which Sna Jolobil has been trying to distance itself.

Despite their limitations, anthropology museums are among the few institutions open to having folk art exhibits. The "Flowers, Saints, and Toads" exhibit at least established that Chiapas weaving exists. To get beyond this existence as an ethnographic curiosity, the textiles had to appear in other contexts, in other types of museums.

Craft Museum Exhibits

Craft museums are a little more appropriate, and "Flowers, Saints, and Toads" traveled to a number of them. Being considered a craft, however, has some serious disadvantages. "Good craftsmanship" is a phrase that normally describes utilitarian objects of reasonable value. The price of crafts reflects these preconceptions and ranges from dismal to fair. One advantage of craft museums is that they present textiles as desirable items.

The Textile Museum in Washington, where "Flowers, Saints, and Toads" was exhibited in 1985, has been instrumental in promoting textiles as art. Although the Textile Museum exhibit was very helpful in exposing the fine craftsmanship of Chiapas weaving to the public, the weavings would have to be exhibited in a museum of modern art if their makers were to be considered as artists.

Art Museum Exhibits

The Rufino Tamayo Museum in Mexico City, a private modern art museum of international standing, organized an exhibit in 1986 of Mexican textiles and their influence on modern artists, "El Textil Mexicano: Linea y Color" (Vexler 1986). The Tamayo Museum had never exhibited folk art before and had no examples in their collection. They had to ask for loans. Many textiles were borrowed from Sna Jolobil.[20] It was a breakthrough. For the first time Chiapas textiles were not treated as curiosities or crafts but as art on a par with the permanent collection of paintings, photographs, wall hangings, and sculptures.

The publicity was excellent and sales increased almost immediately. A large number of weavings, especially the most expensive ones, were quickly sold in the museum store. It was a refreshing contrast with earlier exhibits. A single exhibit, even one that tours, can not establish Sna Jolobil's reputation, but it is a good beginning.

In the Tamayo exhibit, Sna Jolobil also sidestepped one of the traps of exhibiting in art museums. The Tamayo Museum exhibited the Chiapas textiles, not as the work of individuals but of a cooperative. The role that artists play in Maya and Western society is very different—the portrayal of a Maya woman as an "artist" would destroy her place in her own society. Artists in the Western tradition are rebellious individuals who strive to create a new vision that will enliven the culture. If society accepts their vision they will be honored, but, until then, financial renumeration is not forthcoming. Among the Maya, like most traditional societies, the artist is one of the pillars of society. Their work reaffirms that the culture has not strayed from the path set down at the beginning of time by the ancestors. Artists are not special people; poets, clowns, shamans, and weavers are also farmers and house-wives. Any special talent is attributed to hard work and divine intervention. Poverty is all too common and has no special grace.

Many Native Americans, who have been promoted as artists, left their communities because of envy of their new wealth and suspicion over their close ties to outsiders. Once artists leave, they not only lose contact with the source of their inspiration but must also adapt to a new culture and compete with other artists for support. Staying in the community can be a more dangerous alternative: one Chiapas potter who was becoming famous survived an assassination attempt only to be shot to death a year later. It was important for the Tamayo Museum to accept Chiapas weaving as the work of a cooperative rather than of individuals. In the future Sna Jolobil will have to be careful that its members do not fall into the trap of individualism.

Sale Exhibits

One of the best ways to learn about the dangers and possibilities of exhibits is to organize them. Sna Jolobil cannot organize a major exhibit, just as it cannot produce art books alone. It can organize small exhibits, especially self-supporting ones. Sna Jolobil's first experiments began in an art gallery in 1979 when a room in La Galeria, the only art gallery in San Cristóbal, was offered to the cooperative. The goal was to display the finest *huipiles* in the same manner as the art in the adjoining room. The artisans enjoyed seeing their art well displayed. As a side effect, the quality of the presentation in the Sna Jolobil store improved shortly after the gallery opening. This exhibit and another in 1984 were not commercial successes, as Sna Jolobil found that it was competing with itself by having two outlets in the same town. When Sna Jolobil had to deal with museums, the experience gained from these and other exhibits proved useful.

Sna Jolobil plans to convert one room of its meeting house in San Cristóbal into a museum-gallery. It would function as a study room for weavers, a place to display the collection, and a salesroom for the finest pieces. Here the weavers can continue to experiment and learn about lighting, mounting, conservation, and selection of objects for display. Their education will be supported and tested by the sale of "museum quality" textiles in their gallery. Since the meeting house is right next to the store, the gallery will function as an annex, and Sna Jolobil will not be competing with itself again.

Outside of Mexico, art galleries offer an opportunity to mount small exhibits that Sna Jolobil could manage on its own. These gallery exhibitions attract more interest if they open at the same time as a museum exhibit on some related topic. In recent years a number of exhibits on the pre-Columbian Maya, Mexican or Maya textiles, and Mexican folk art have toured the United States and Europe. By curating its own exhibit, Sna Jolobil could enjoy the publicity generated by these anthropological exhibits, while presenting the work of the cooperative in a different light. The weavers could also sell more expensive textiles without bothering with museum stores. They will learn what museum visitors buy in their own country (which is quite different from what they will purchase while on vacation in Chiapas), and to gain knowledge of other export possibilities for Chiapas textiles.

In October of 1985, Sna Jolobil had its first exhibit in the National Arts Club in New York. It was a lovely exhibit that did not sell due to overpricing, lack of publicity, and general confusion. The second exhibit, at the Evelyn Siegel Gallery in Fort Worth in May of 1986, was less chaotic and financially more successful. This exhibit coincided with the opening of a major exhibit of Classic Maya art, "The Blood of Kings," at the Fort Worth Art Museum, which aided in publicity. [21] Almost enough weavings were sold to cover the costs. It will take three or four exhibitions before Sna Jolobil can manage the packaging of mounts, labels, and types of textiles without outside assistance. It should be remembered that the store was a failure until the weavers took it over and ran it themselves. These gallery exhibits have potential for a bright future.

Conclusion

Developing an art market for Maya textiles has not been easy. It will be even more difficult as the weavers try to negotiate directly with galleries and museums. So why bother? The principal reason, as the weavers are quick to respond, is money. In the decade that Sna Jolobil has been in operation, the price of a good textile (taking inflation into account), has risen 500 percent-

1,000 percent. A second reason is independence from outside control. The cooperative does not have to price its work according to the local craft market nor is it dependent on a designer for new styles or an exporter for sales. The weavers' only work with outsiders relates to gallery exhibits or books. If a particular project fails to materialize, no one in the cooperative is hurt. The third reason is that the weavers are artists, not factory workers, and the culture and traditions of the weavers are the main resource of the cooperative. To ignore the truly ancient roots of this art form, along with the creativity of the individual weaver, would cheapen her role in the community as well as the value of her labor.

An old, experienced weaver is respected in the cooperative even though she can not understand what some foreigner wants her to produce. A young weaver can show off her skills and wealth by weaving a spectacular piece. In each generation, women reweave the *huipiles* worn by the saints in their church. They are never exactly the same as before but always woven within the rules of composition and design that were first established by Classic Maya weavers a millennium ago. Chiapas textiles can easily be deformed into local trinkets or cheap peasant clothing, but the weaver will never receive fair profit for her work until her textiles are recognized for what they are: works of art.

Endnotes

1. This research was supported by the Smithsonian Institution, the National Geographic Society, and the MacArthur Foundation. I have always felt that research alone is sterile and must be combined with working with the people one studies. For this reason I have given as much time as possible to helping the weavers survive and continue their art. I was fortunate in being introduced to Maya weaving by two Mexican authorities, Marta Turok and M. Teresa Pomar. They have shown in their work that anthropology can be a valuable tool for social and cultural development. Working with weavers on their problems became the best way to solve my own questions. Weavers were much more willing to discuss the esoteric mysteries in the cloth if I could teach them about export licenses, brand name recognition, duo-tone printing, and other esoteric matters of my own culture. Although development work can be very frustrating, my work with the weavers has, more often than not, been exciting and taught me more about the culture than any

research program. The weavers' interest in my work also carried me through long periods when no one seemed very concerned about the results of my research. I can only feel sorry for those anthropologists who have ignored their best audience. Who else is passionately concerned about the esoteric details of a people's mythology and history if not the people themselves?

2. Mexican governmental institutions such as FONART, INI, Culturas Populares, as well as UNESCO, have all funded Sna Jolobil programs such as natural dye workshops, weaving contests, raw materials funds, and education programs. The Science Museum of Minnesota has dedicated its Chiapas textile exhibit to Sna Jolobil. Cultural Survival Inc. helps solicit funds for Sna Jolobil programs. M. Teresa Pomar and Ruth Lechuga offer the support of their museum and their counsel based on thirty years of experience. Amber Past spent five years working with weavers to recover the techniques of natural dyes. Francesco Pellizzi supported the establishment of a textile museum with INAH. Antonio Turok, Mica McGuirk, and Jeffrey Foxx all helped Sna Jolobil produce postcards. Patricia Morris and Elisabeth Ross made the drawings for their calendars, and many more people have helped Sna Jolobil in large and small ways.

3. Gerardo Murillo used the pseudonym of Dr. Atl.

4. Forty-two agencies, departments, or institutions of the government were involved in folk art in 1975 according to Novelo (1976: Appendix).

5. Luis Contreras was the regional director. Amber Past, Alejandra Alverez, and I were staff, and M. Teresa Pomar was then the sub-director of FONART under Tonatiuh Gutierez.

6. *Sk' op Santa Rosha,* a 16mm., 30-minute film made by Lorenzo Pellizzi.

7. The Instituto Nacional Indigenista and the State of Chiapas helped finance the purchase of the house and the weavers paid for its reconstruction.

8. Culturas Populares documented the 1985 workshop and gave financial support.

9. Mollie Richie has worked with the dyers since 1985.

10. Learning how to do this was difficult and would have been impossible, if at least one of the members did not have some formal education to be able to handle the paperwork and negotiations. A few members, who work in the store in San Cristóbal de Las Casas, also have been able to attend the local high school (there are none in the

Maya communities). The president of Sna Jolobil now is attending university. Other support comes from the Museo Nacional de Artes e Industrias Populares which has specialists who procure raw materials for artisans.

11. Sna Jolobil published *Santa Lucia: Weavers tales from Tenejapa* in Tzotzil, Spanish, and English. This includes a woman's story of weaving the garments for the Virgin of Banabil.

12. The Pellizzi collection is documented in Morris 1978. Mexico's Instituto Nacionál de Antropologíae História will exhibit these textiles in the Sala Pellizzi of the Centro Comunitario de San Cristóbal de Las Casas when the building is rehabilitated.

13. The Museo Nacional de Artes e Industrias Populares in Mexico City and the Science Museum of Minnesota acquired the largest collections outside of Chiapas. I felt that having the most important pieces in triplicate and in three different institutions would help insure their future against unforeseen disasters.

14. The research and drawings were made with the support of the Smithsonian Institution and the National Geographic Society.

15. Unfortunately the pamphlet never was produced.

16. Sna Jolobil is producing a book on the history and mythology of Tenejapa weaving, and a book on Sna Jolobil itself with the help of Mica McGuirk, a local photographer.

17. Over the years Sna Jolobil has been featured in Mexican television shows, two audiovisuals, a dozen magazine articles including one in National Geographic, and in recent books on Mexican folk art. Some of these presentations focused on Chiapas textiles without specifically mentioning Sna Jolobil, but lately the cooperative has been explicitly cited in regard to beautiful textiles (Vexler 1986).

18. Na Bolom is a study center and home of Gertrude Duby Blom. Francesco Pellizzi donated the funds to Na Bolom to create the exhibit room.

19. Dr. Louis B. Casagrande of the Science Museum and I were co-curators. The MacArthur Foundation supported, in part, the exhibit's creation. It toured the United States through 1987.

20. Sna Jolobil was initially asked for just a few pieces, but when the curator, Jill Vexler, visited Chiapas and saw the cooperative's textiles, the exhibit plans were changed.

22. In both New York and Texas, Jeffrey Foxx's photographs of the Maya were an important part of the exhibits. The exhibits were funded, in part, by InterCultura, Inc.

Bibliography

Atl, Dr. (Gerardo Murillo)
 1980 "Las artes populares en México" (1921). Reprinted in Serie Artes y Tradiciones Populares No. 1. México: Instituto Nacional Indigenista.

Cordry, Donald, and Dorothy Cordry
 1968 Mexican Indian Costumes. Austin: University of Texas Press.

Morris, Walter F. Jr.,
 1979 A Catalogue of Textiles and Folk Art of Chiapas, Mexico. 2 vols. San Cristóbal de las Casas: Publicaciones Pokok.
 1984 A Millennium of Weaving in Chiapas. San Cristóbal de Las Casas: Sna Jolobil.
 1985 Flowers, Saints, and Toads: Ancient and Modern Maya Textile Design Symbolism. National Geographic Research 1(1):63-79. Washington, D.C.: National Geographic Society.
 1986 Maya Time Warps. Archaeology 39(3):53-59.
 1987 Living Maya. New York: Abrams Co.

Morris, Walter F. Jr., and Pedro Mesa M.
 1979 Luchetik: The Woven Word from Highland Chiapas. San Cristóbal de Las Casas: Sna Jolobil and Editorial Fray Bartolome de Las Casas.

Novelo, Victoria
 1976 Artesanía y capitalismo en México. México: Instituto Nacional de Antropología Historia.

Thompson, J.E.S., ed.
 1958 Thomas Gage's Travels in New Spain. Norman: University of Oklahoma Press.

Turok, Marta
 n.d. Handicrafts. Manuscript, Harvard University Chiapas Project files, 1972.

Vexler, Jill
 1986 El textil mexicano: linea y color. Mexico City: Museo Rufino Tamayo.

Wasserstrom, Robert
 1977 White Fathers, Red Souls: Ladino Indian Relationships in Chiapas, 1528-1973. Ph.D. Dissertation. Department of Anthropology, Harvard University.

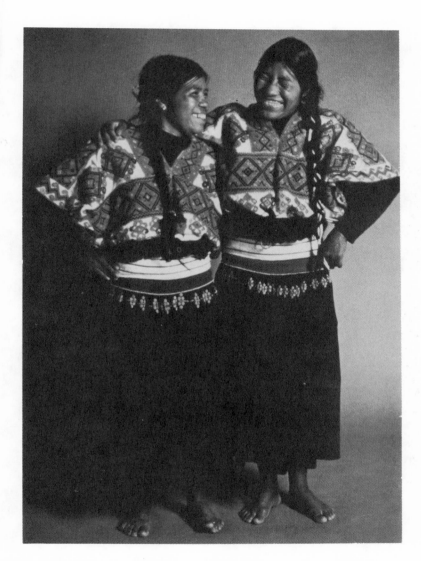

Figure 1. Women from Tenejapa wearing Tenejapa-style *huipiles*. Photo by Jeffry J. Foxx 1970s.

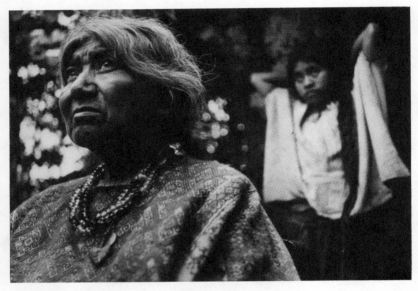

Figure 2. Me'Abrila, the weaving teacher of Magdalenes. Photo by Antonio Turok 1978.

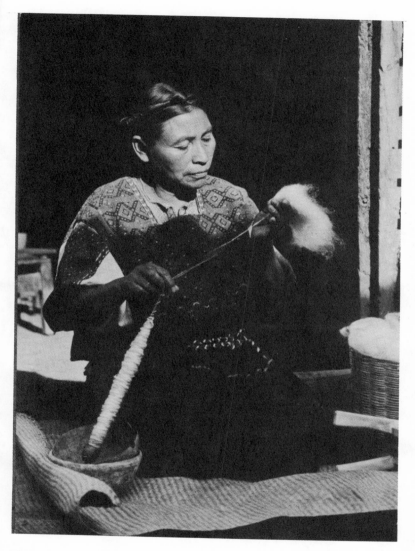

Figure 3. Rosa Hernandez, the leader of the San Andres weavers' group. Photo by Antonio Turok 1979.

CONCLUSION

Chapter Eighteen

Beyond *Bricolage*: Women and Aesthetic Strategies in Latin American Textiles

Janet Catherine Berlo

Introduction[1]

Historians of ethnographic art and anthropologists are currently redefining our relationships with other cultures and re-examining the biases and premises upon which these disciplines have been built.[2] In this on-going dialogue about the nature of culture, self, other, tradition, and change, the study of cloth has moved closer to center stage than ever in the past. Finally, cloth is being recognized as fundamental to studies of gender, social identity, status, exchange, and modernization (Schneider 1987, Schneider and Weiner 1986). In social anthropology, dynamics of textile production and exchange have been overlooked in favor of studies of kinship and social structure, agriculture, warfare, and trade (Weiner n.d:3). In the history of art, the textile medium has been eclipsed by painting, sculpture, and architecture. This has been true even within the realm of ethnographic arts, where these distinctions among media are much less clear cut than in the Euro-American tradition.

It is no coincidence that the re-evaluation in the 1980s of cloth's central role in culture directly follows upon the heels of a feminist critique of the androcentric biases of both anthropology and art history.[3] In both fields, male domains have received much more attention than female domains. While cloth production is by no means limited to females, in most parts of the world women play a central role in textile arts. Nowhere is this more true than in the Americas. While some of what I say applies to Latin American male artists and weavers as well, I am focusing on women because too often their roles as active agents of culture have been ignored or minimized.

Previous generations of textile scholars focused principally on technology and taxonomy. They were primarily concerned with documenting weaving techniques and classifying regional differences in dress. Some researchers continue to pursue these investigations, but others are delving deeper into areas of meaning, examining the multivalent roles of cloth and clothing. Economics, semiotics, diachronics, aesthetics—all of these avenues of investigation are providing us with a much richer picture of the place of cloth in native culture than we had even fifteen years ago.[4]

To this web of cloth's multiple meanings, I shall add a strand: an examination of women's aesthetic strategies in cloth production in Latin America. Under the rubric of "aesthetic strategies" I include the diverse ways by which women invest meaning in textile arts. These arts eloquently express women's concerns with tradition, transmutation, modernism, and a host of other topics. In the following sections I shall examine some of these themes. Though I shall draw examples from a number of different ethnic groups, my main focus will be on Maya women of highland Guatemala and Chiapas, Mexico.[5] In comparison to the peoples of many other regions (especially in the Andes), a great deal is known about the modern Maya, in terms of textiles as well as the larger cultural arena. However, many of the processes I describe for the Maya have occurred in textile systems throughout Latin America.

For many years I thought that indigenous, post-colonial Latin American textiles were prime examples of *bricolage*. Often constructed with more creativity than grace, they compose a fragmented stratigraphy of influences: wool and wild cotton; acrylic and metallic yarns; indigo and aniline dyes, yard goods from a host of international sources as well as rickrack, ribbon, and lace; gauze and polyester; indigenous brocade and *pallay* as well as embroidery and machine stitch. As Levi-Strauss defined it, inherent in bricolage is the notion of making do: the *bricoleur* works with a

heterogeneous assortment of materials, within mediums composed of the fragmentary and limited possibilities at hand. (S)he is a jack of all trades rather than a scientist (see Levi-Strauss 1966:16-29). Increasingly it is apparent to me that all of the cultural cross-currents and overlays in the textile art of Latin America are not, however, simply a "making do." They are not merely a passive, defensive response to five centuries of colonialism. "Beyond bricolage" suggests a new way of examining the act of female creativity in Amerindian societies. As I shall argue later in this chapter, the improvisations and appropriations in women's textiles are deliberate (and sometimes culturally subversive). They are the essence of the indigenous textile aesthetic.[6]

The topics I consider not only comprise elements of an indigenous textile aesthetic, they also (not coincidentally) resonate with meaning for many areas of contemporary indigenous culture. Textiles, as a mode of self-presentation, assert personal, ethnic, religious, and economic identities. Textiles are eloquent texts, encoding history, change, appropriation, oppression, and endurance, as well as personal and cultural creative visions. Their study should be part of the current scholarly dialogue about post-colonial modes of expression and representation.[7] For indigenous Latin Americans, especially women, cloth has always been an alternative discourse. Only recently have we really begun to listen.

Women, Work, and Cultural Creativity

The strictures of our own society can blind us to the meanings of events in other societies. In the modern Western world, both textiles and women are marginalized. *A priori* assumptions about textiles and women allow otherwise sensitive investigators to delimit women's activities in the following fashion:

> Cuna women ideally are involved in making *molas* in almost all of their leisure time, and the division of labor and organization of duties allows women ample leisure. (Sherzer and Sherzer 1976:28)

> [Shipibo] women wear beautiful native dress daily. Textile and pottery making take up much of their spare time. (Bergman 1980:82)

These quotes are representative of widespread scholarly attitudes about indigenous women and work. In opposition, I shall argue for the centrality of textiles as meaningful and essential *work* in indigenous American cul-

tures; they are not the stuff of leisure time. In many regions, textile work is central to being female. It is the arena where a woman's individual creativity and technical expertise join to express cultural norms. Examples from three groups, the Kuna,[8] the Maya, and the Shipibo, show that cloth makes manifest deeply held cultural values that may otherwise be imperceptible. In fact, it may be women's very crucial job to translate these ephemeral values into material objects. Examining women's actions and arts in this way shifts them from marginalized and epiphenomenal activities ("leisure") to dynamic, fundamental aspects of culture.

In a number of Amerindian societies, men's arts are oral while women's are, literally, material: men speak, women make cloth. Hierarchical codes within our own word-obsessed culture dictate that the public, the verbal, is the area of status, autonomy, importance. But this is not so clear within the indigenous systems, most of which recognize multiple, cognate paths to creativity.

The most clear-cut dichotomy between the expressive roles of men and those of women occurs among the Kuna Indians of Panama. In Kuna society, the ideal male is an eloquent public speaker. Two types of communal gatherings, or *congresos*, are a vital part of Kuna life. In secular gatherings of men, economic decision-making and adjudication take place (Howe 1986:31; Sherzer 1983:99). At these meetings men gain status and prestige through public displays of their verbal fluency. Only the most eloquent men rise to positions as village chiefs who conduct sacred gatherings attended by both men and women. In this forum, chiefs display their consummate verbal skills through chanted dialogues that cover sacred history, politics, and a host of traditions.[9] The Kuna sacred gathering encapsulates the aesthetic ideals of the Kuna universe: the chiefs, arrayed at the center of the gathering house, engage in verbal discourse. They are surrounded by rows of women, dressed in their finest garments, who work on textiles while the chiefs chant. Around the outside of the circle, sit the rest of the men (Howe 1986:figure 1a).

In the female arena, visual fluency and mastery of a body of knowledge is demonstrated by making fine *molas*: multi-colored panels of appliqued cloth worn on both the fronts and backs of Kuna women's blouses (figure 1).[10] Painstakingly cut and sewn from yard goods, *molas* use imported materials to express indigenous cultural values (even though the pictorial images on the *molas* may well be foreign), an issue to which I shall return later in this essay. They are eloquent expressions of women's creativity. Helms observes that women

are not literally outspoken in the public domain, but I suggest that by long and arduous hours of *mola* production, by the display created by *mola* wearing, and perhaps in the symbolism contained in *mola* designs, they assist the community in the furtherance of these ends by creating a form of "silent oratory" that publicly expresses, with form and vibrant color, the same views of the "world-as-event" and the same concepts of group cohesion and morality as are proclaimed by the spoken oratory of the men. By sound and sight, then, these messages pervade Cuna daily life, the fleeting elusiveness of men's ritual words at evening countered by the stable persistence of the complex visual record worn by women by day. (1981:64)

There is some evidence that a similar pattern of men's verbal and women's visual modes of expression occurs among the highland Maya. Ranking male members of the native religious hierarchy (*cofradía*)[11] use a style of speech in which repetition, metaphor, and patterns of parallel syntax are common (Gossen 1974:65-68). Furthermore, in many Maya communities, men engage in verbal sparring replete with puns and double entendres. Gossen reports on such word play in Chamula:

To know how to speak well and persuasively is greatly valued by Chamulans, and the ability to joke in this genre serves as a fairly dependable index of a man's social maturity, linguistic competence, intelligence, and political potential.(1974:106)

In contrast, Maya women's virtuosity in complex modes of representation occurs in the realm of textiles. A woman's *servilleta* or utility cloth from Chichicastenango provides a fine example of such visual fluency. It may combine *ikat* warps, plain red, blue, white, and beige warps, and thicker two-color plied warps. All of these are arranged in stripes of varying widths. The resulting complexly patterned ground cloth serves as the backdrop to a visually syncopated brocade of cotton, silk, and wool figures of human and animals. I suggest that the fine nuances, repetitions, and rhythmic yet asymmetrical color and design patterns characteristic of Maya women's backstrap-loomed textiles serve in the female arena as the equivalent of Maya men's complex verbal play.

Maya women not only weave items of daily dress but also the items that demarcate the suspension of ordinary existence: the textiles used in the community *cofradía* rituals. Men's *cofradía* roles are seemingly more important, for they are more public. But the significance of woman's role is signaled by the fact that generally only married men can rise in the *cofradía* hierarchy (see, for example Guiteras-Holmes 1961:71,95). The main reason for this is that husbands and wives have isomorphic roles to play. He conducts the rituals, but she weaves the textiles that allow those rituals to take place: the *cofradía* garments that demarcate both husband's and wife's rank within the religious hierarchy, the altar cloths and candle cloths, the garments that the statues of the saints demand for their coffers and ritual bundles. Indeed, textiles are among the most visible signs of sacred space and sacred role in Maya Christianity, as I shall discuss.

Among the Shipibo of Eastern Peru, women work in clay and fabric. On their plain weave hand-loomed cloth or on purchased muslin, they paint and embroider geometric designs (figure 2). Similar designs are painted on their bold ceramic vessels (see Gebhart-Sayer 1985:color plates). Shipibo men do not make art but are more likely than women to become shamans. Shamanic roles complement female artistic ones: a shaman manipulates the visionary design patterns that pervade the universe and that saturate each individual's spirit (Gebhart-Sayer 1985:12-13). Shamanic designs used in healing are usually invisible, although they sometimes manifest themselves as songs. Eminently visible are the ubiquitous designs with which women adorn water pots, food vessels, and skirts. These designs replicate the numerous skin patterns of *Ronin*, the cosmic serpent (Gebhart-Sayer 1984:7). (In previous generations such patterns articulated men's clothing and sha-man's robes too, but these items are passing out of fashion.)

While no studies directly address the relationship of Shipibo narrative to the visual arts, there is some evidence that the complementarity of verbal and visual modes demonstrated for the Maya and Kuna is appli-cable here as well. Shipibo poetic song is a highly structured narrative, replete with repetition and syntactic parallelism (Levy, n.d.:13,16). The syntax is simple, but complex figurative expressions (principally the meta-phoric use of nouns) abound (Levy, n.d.:14).[12] The aesthetic principles of Shipibo painting seem similar: a very simple "syntax" of straight and curved lines is formed into complex visual patterns. Each is unique, although it abides within a generally articulated notion of the correct geometry of design structure (see Roe 1980:57-62).

Each of these three examples illustrates that women's textile work embodies the deeply held values of society. Kuna *molas* display aesthetic fluency and ethnicity. Maya textiles define daily role and ritual role. Shipibo textile painting and embroidery make manifest the multitude of designs inherent in the structure of the universe.

A closer analysis of details from the Maya world reveals that textiles permeate all areas of indigenous life. They are multivocal markers: they can demarcate areas that are principally women's domain; they can mark women's presence in what otherwise appears to be men's domain; and they can link the human world with the world of the gods. I shall briefly consider aspects of each of these here. Later in this chapter I shall discuss the ways in which textiles link the indigenous and the external worlds.

Textiles and Women's Domain

In addition to weaving, childbearing, and food preparation are two key areas of women's sphere of action. Materials and metaphors of weaving permeate both. Weaving (resulting in cloth) and parturition (resulting in babies) both display women's generative capability. Tzutujil Maya use anatomical terms for loom parts (i.e., head, bottom, ribs, heart, umbilical cord), indicating that weaving is equivalent to giving birth (Prechtel and Carlsen 1988:124).[13] Corroborative clues to this linkage appear in diverse contexts. In myths collected in Santiago Atitlán, some of the original female mythic characters (called Marias) wove their bird and animal children, while the ancestral grandmother/sorceress spun her progeny (Tarn and Prechtel 1986:176-7). In the context of human childbirth, Chenalho midwives may tie off a baby's umbilical cord with a newly-spun cotton thread (Guiteras-Holmes 1961:108). Midwives in Santiago Atitlán bind a pregnant woman's belly with the long hair ribbons that Atiteco women wind around their heads. These mimetically regulate the uterus's snake-like coils to correctly position the baby for delivery (Tarn and Prechtel 1986:184).

The spheres of food and weaving intersect in concepts concerning textiles and nourishment. Warp threads in many areas are sized by "feeding" them with a maize mixture. Guiteras-Holmes reports "I have seen beans or maize fed to the ball of already carefully measured thread before it is placed on the loom in order that it will be long enough" (1961:307). Textiles are also offered to lakes as a kind of symbolic food for the Virgin Mary, who owns the water. In Chenalho, fine *huipiles* are thrown into the nearby lake when women dream that the Virgin needs this nourishment (Guiteras-Holmes

1961:166-67, 203). In a kind of reverse of this process, humans can be spiritually nourished by drinking the water in which a saint's garments have been washed (Vogt 1969:107).

Textiles in Male Domains

I have already mentioned that Maya women weave the textiles that enable male *cofradía* rituals to occur. The use of such textiles at every level of ritual activity is a constant reminder of women's presence. Many objects are "clothed" in Maya ritual—not only the statues of saints, but candles, fireworks, and staffs of office all have ritual cloths. Ritual tables are covered with woven cloth before ceremonial items are arrayed on them. Vogt remarks that in Zinacantán, the woven tablecloth (which is similar in color and design to women's shawls) as well as the food placed upon it are reminders of female presence in the ritual (1976:41,102). In some communities, female *cofradía* members are responsible for changing the saints' clothing; in others, like Chenalho, men dress the male saints and women dress the female ones (Guiteras-Holmes 1961:96). *Cofradía* cloth has inherent power. Not only does it lift those who wear it from the quotidian world to the world of the sacred, but it can cause acts of transformation as well. Mendelson (1958:123) describes that in Santiago Atitlán the saints are clothed in cloaks of green to induce rain, or red to bring on sunshine. Moreover, in Atiteco legend, mythic brothers don the shirts of the statue of Saint Martin and destroy nearby Antigua. How powerful the women who can weave such clothing!

Textiles Linking Human and Supernatural Realms

Of course, all clothing worn by saints and used in *cofradía* ritual link the human sphere with that of the gods. But Maya women and female saints are linked in other ways as well. Some female saints have weaving equipment in their coffers. Manuel Arias of Chenalho told Guiteras-Holmes:

> Now the Virgin [the Virgin of the Rosary], she has all that pertains to women: the *tsutsun* [bodkin], the rope for the loom, all the loom sticks, everything that a woman handles and makes. I saw it all because I was invited to count the saint's clothes (Guiteras-Holmes 1961:197).

Textile items are also linked with the supernatural powers of shamans and sorcerers. In Santiago Atitlán myth, a sorceress/grandmother can work her magic by spinning: "Batz'bal can make people crazy with spinning. She can

drill holes into muscles and bones; she ties off the extremities of cloths and other objects to kill" (Tarn and Prechtel 1986:177). In the same town, female shamans use loom parts for good, as well, to assist in the delivery of babies (Prechtel and Carlsen 1988:124).

Of course, women's arts in any community are part of a larger communicative sphere that embraces religion, song, history, town planning, healing, and myriad other activities. Looking at these complementary cultural texts affirms the centrality of textile traditions in indigenous life.

Intertextuality: the Permeable Boundary

The Maya epistemological system encompasses an ever-expanding matrix of meanings. A seemingly heterogeneous assortment of objects or ideas may form a unified *gestalt* by means of a system of correspondences and metaphors (see Prechtel and Carlsen 1988; Vogt 1976; Gossen 1974). Diverse yet complementary cultural texts work together in such a system. Until recently, neglected texts included those that encode women's aesthetic categories, such as textiles. Barbara and Dennis Tedlock are perhaps the first to stress the fundamental place of textiles in a Maya system of knowledge (1985), although supporting evidence for this can be found in many studies, as I shall indicate.

The Tedlocks suggest that the opening lines of the *Popol Vuh* (the Quiché Maya's ancient sacred text) have two possible translations:

> This is the beginning of the Ancient Word, here in this place called Quiché. Here we shall inscribe, we shall implant the Ancient Word.

They propose that the second line may also read

> Here we shall design, we shall brocade the Ancient Word

thus affirming a fundamental congruence among the realms of writing, agriculture, and weaving (1985:126). This multivocal translation suggests that the Maya recognize these three realms as diverse yet congruent paths to knowledge.

Barbara and Dennis Tedlock persuasively argue that intertextuality is key to understanding Quiché Maya symbolic modes, linking the arts of music, weaving, oratory, architecture, and agriculture. This concept of intertextuality gives insight into the permeability of the boundaries between different domains of knowledge. For brevity, I shall focus only on those

domains linked in the opening lines of the *Popol Vuh*: agriculture, writing, and weaving.

Weaving and Agriculture

Among the highland Maya, to be male is to plant maize. To be female is to weave. The acts of agriculture and weaving, as the defining work of the two genders, have a fundamental isomorphic relationship. Just as the Quiché text of the *Popol Vuh* indicates that to brocade and to plant are synonymous, in other Maya languages to brocade (i.e., to add supplementary weft threads to the basic web) is to "plant the thread" (Linda Asturias de Barrios, pers. com. 1988).

Salient in both weaving and agricultural work is their generative function: both are linked to birth. When men plant with their digging sticks, maize is born (and, indeed some Maya agricultural rituals link the spilling of semen or blood from male genitals to crop fertility). In one story from Santiago Atitlán, an old lady combs her hair (symbolizing the warp threads) with a batten, and rather than cloth, she produces corn cobs (Tarn and Prechtel 1986:176), thus bringing the weaving/generative cycle back to maize. One of the most powerful cloths kept in the coffers of *cofradía* San Juan has three faces (called "three corn girls"), as well as ribbon attachments that represent both umbilical cords and the tendrils of plant and lineage (Tarn and Prechtel 1986:175).

There are linguistic links between weaving and agriculture elsewhere in Latin America too. Among the Quechua of Chinchero, Peru, the word "pampa" refers both to the agricultural plain and to the large single color sections of handwoven textiles. *Khata* is a furrowed field ready for planting as well as the textile warp configuration ready for pattern formation:

> We can therefore think of the "pampa-*khata*" situation as that of a broad plain broken by fields and ready to plant or of the broad plain-colored expanse of the textile broken by the design sections in their raw form; the harvest in either case is the *pallay*. The word can literally be translated as "to pick up" but is used almost exclusively to refer to the process of harvesting potatoes or to the process of forming a design from the *khata* of a textile. (Franquemont and Franquemont 1987:70)

To work the earth and to work the loom: these processes provide life's fundamentals—food and clothing. That there are profound conceptual, linguistic, and religious links between the two should not be surprising.

Weaving and Writing[14]

There are, of course, many ways in which cloth can serve as historical text. It can be an alternative means of encoding cultural information. Aspects of ethnicity, economic relationships, and personal data are all proclaimed in cloth and clothing, as many essays in this volume demonstrate. Here I shall mention only two aspects of the intertextuality of weaving and writing: an underlying aesthetic that joins their creation, and the actual use of written elements in weaving and other textile arts.

Cloth may share an aesthetic structure with verbal or literary modes. I have already mentioned the correspondences between Maya verbal and woven genres, both of which feature rhythmic yet varied repetitions. A similar aesthetic of variation within repetition has been observed in Kuna verbal and visual arts. Both *molas* and men's oratory display parallelism— the repetition of themes with slight variations (Sherzer and Sherzer 1976:32). In Kuna verse, this is achieved through lexical variation in repeated stanzas. In *molas*, front and back blouse panels display closely corresponding but not identical designs. Both genres employ artistic "fillers." In orations, these are verbal fragments which link verses and lines. In *molas*, these are small triangles and slits that fill the background to achieve a vibrant, busy, all-over patterning (figure 1).[15] In the *mola* illustrated here, an English text is integral to the image used by the artist for her *mola* design. Kuna women often appropriate imagery from foreign products, advertising, sporting events, and other external sources (see Parker and Neal 1977). The use of alphabetic elements stresses the mastery of the foreign that is part of the Kuna aesthetic (see Sherzer 1983:231).

Sometimes texts are a structural part of the fabric, incorporated into supplementary weft or *ikat* stripes. In San Antonio Aguas Calientes, Guatemala, babies' names sometimes are woven as supplementary wefts into the fabric of their protective caps. When asked why she was selling her son's outgrown cap rather than keeping it for the next child, the weaver replied, "Because it has his name on it. The other one can't wear it." San Antonio Aguas Calientes has the highest female literacy rate of any Indian village in Guatemala (Annis 1987:27), so it is not surprising that the incorporation of supplementary weft texts is more common there than elsewhere.

Better known, and more plentiful, are the *ikat* fabrics of Guatemala, in which warp and/or weft threads are bound and dyed in complex patterns prior to weaving. Sometimes these are woven by men on treadle looms, sometimes by women on backstrap looms. Here, intertextuality proclaims technical virtuosity: while all *ikats* are time-consuming ventures because of the need to line up threads precisely, alphabetic *ikat* require even greater care to ensure readability. Alphabetic *ikats* generally position the textile either in geographic or sacred space. Women's shawls in Totonicapán may have the word "Totonicapán" woven into them in *ikat*; small altar cloths marked "recuerdo," designate the item's use in *cofradía* house or church.

Text embroidered on Maya cloth usually denotes ritual cloth. Often, altar cloths, shirts, and *huipiles* for the statues of the saints are embroidered with the maker's name and the date of the gift. These serve as a *recuerdo* (remembrance) of the weaver's time served as a *cofradía* official and are usually offered at the end of her year of service.[16] Many saints' *huipiles* from San Pedro Sacatepéquez, for example, are embroidered with the date October 7 (of various years), the feast day of the Holy Virgin of the Rosary (see Robbins 1986:figs.11-14). The *cofradías* in San Pedro Sacatepéquez have rich coffers of textiles that belong to the saints, as well as a strong tradition of embroidering names and dates of such textiles. Miniature statues of the Virgin Mary are tended by female *cofradía* officers who change the statues' layered *huipiles* every fifteen days (Barrios 1983:59). Today, the large image of the Virgin Mary in the church wears a floor length *huipil* in contemporary style. One exquisite *huipil* that was woven for this saint early in this century records the names of more than a dozen female *cofradía* officers who commissioned its design.[17]

Such *recuerdos* are useful to scholars for precise dating of textiles. Moreover, because they are the only older textiles for which we know the weavers' names, they pierce the veil of anonymity in which Maya weavers until recently have been shrouded. They record actions undertaken by individuals at precise moments in time. To the Maya, both weaving and writing give authority to those actions they commemorate. Conjoined, text and textile form powerful documents, drawing legitimacy from several realms of human endeavor.

In Zinacantán, Holy Elders keep notebooks that record the names of men who request positions of ritual office. These notebooks are records of who will serve as far as twenty years into the future. Having one's name inscribed in such a manner is validation enough for an individual to define himself as a person of a particular ritual category (Vogt 1969:262). The

notebooks bestow legitimacy and purpose on the future of the religious system and on the men who will build that future. Maya sacred inscribed textiles, such as those discussed for San Pedro Sacatepéquez, bestow legitimacy and authority on the past, and on the women whose woven vestments and embroidered words record the interactions of *cofradía* members and saints.

I have examined the permeability of the boundaries between weaving and other endeavors such as writing and agriculture, all of which serve as cultural texts. An examination of the intertextuality of these diverse modes of action emphasizes the multivocality of the Amerindian aesthetic. Intertextuality is a well-established part of that aesthetic rather than a colonial product; its roots extend into the distant past. In Classic Maya art and writing, for example, the boundaries between text and image were permeable; verbal and visual puns accentuated this (Berlo 1976, 1983; Miller and Houston 1987). Visual puns and conflations (which doubtless have verbal analogues) also extend into the Early Horizon of Andean antiquity (Rowe 1962:14-17). In ancient times, this intertextuality crossed cultural boundaries as well, allowing Maya, Aztec, and Inca peoples to appropriate from the symbolic realms of neighboring polities.

Barbara and Dennis Tedlock point out that for the Quiché Maya, intertextuality extends beyond the realm of their own culture to include elements of foreign cultures, too, for the Quiché value dialogues with other cultures. The Tedlocks term this "intercultural intertextuality" and describe its process:

> The intercultural dimension of Quiché intertextuality is not simply the end product of events that took place in the murky colonial past. It is not reducible to an unconscious fusing or blending of elements whose disparate origins have been forgotten—the kind of thing that has gone under the name "syncretism"—but results from a continuing creative process that is fully at work in the present day. (1985:142)

In art, this crossing of cultural frontiers results in a continual give and take that we might call reciprocal appropriation.

Reciprocal Appropriations

If intertextuality describes the processes that permeate media boundaries, what about those processes that transgress cultural boundaries?

In the realm of cloth and clothing, we find that materials and styles are appropriated not only between town and hamlet, or interregionally, but also between modern Western culture and indigenous cultures. Textiles have played a prominent role in exchanges between the West and indigenous peoples throughout the world. Complex flow charts would be needed to map the multi-directionality of such exchanges, for raw materials and finished goods flowed in both directions, the flow changing course according to varying economic and political conditions. One thinks of Chinese silk fibers and New Zealand flax destined for European factories, while in the opposite direction, European machine-spun thread flooded West Africa and the Americas to be used in indigenous hand-weaving traditions. European finished goods inundated the indigenous world, too. Hudson Bay blankets to the Pacific Northwest, cotton damask to West Africa, European cloths to the American Southwest. In the Americas, the directional path of finished textile goods has been mostly one way until recently. With a few notable exceptions (such as Navajo rugs) it is only in the second half of the twentieth century that Amerindian textiles have found a ready market in the West.

One of the most interesting aspects of the reciprocal flow of textiles and fibers is the ingenious use to which the native artist puts so-called finished European textiles. Hudson's Bay blankets cut and festooned with imported Chinese buttons were fashioned into the inventive "button blanket" of the Tlingit and Kwakiutl. European wool and flannel cloth was unraveled and rewoven into Navajo rugs. Kuna and Maroon women took European yard goods and totally refashioned them into indigenous products.

Among the Maya, some clothing styles and yard goods were adapted into native dress. Synthetic dyes were appropriated by weavers soon after their invention in Europe in 1856 (see Carlsen, this volume). In many regions of Guatemala, even the most remote, machine-spun and dyed threads have been available for a century, and have been predominant for over seventy-five years. Indeed, Guatemala's first cloth and thread factory was founded in 1876 in Cantel, in the western highlands (Schevill n.d.:45). Today vivid rayon and acrylic replace the fine silk of previous generations in Guatemalan brocades. Scholars and collectors frequently decry the adoption of machine-spun thread, bright synthetic dyes, and acrylic yarns, as well as the modification or repudiation of distinctive ethnic garb. But from the point of view of the indigenous artist, these trends are the logical outcome of personal choices made at particular historical moments.

To take just one example, the time advantages for the artist in using pre-dyed, pre-spun threads are enormous. To my knowledge, no detailed

time studies have been conducted that analyze the stages of Maya weaving from cotton processing and spinning to the finished garment, but several other studies are germane. A Navajo weaver who spins and dyes her own yarn spends 72 percent of her time on these preliminary steps and only 28 percent of her time on the actual weaving process (Gallagher 1981:27). A Shipibo weaver takes two weeks to spin the cotton for the skirt it takes her one week to weave (Bergman 1980:188). Quechua weavers in Chinchero, Peru, spend 56-78 percent of their textile production time on yarn preparation (all steps, from shearing to spinning and plying) (Franquemont 1986:312). It is no wonder that many weavers eagerly embrace machine-spun and dyed yarns where they are available! Today, among the Maya handspinning is confined to the short fiber *cuyuscate* or wild brown cotton that is favored for ceremonial textiles in some villages. (In the next section I shall discuss other uses of handspinning.) In some areas, adoption of commercially spun and dyed thread seems to have caused a proliferation of brocading. With less time spent on initial stages of preparation, the weaver has more time to devote to time-consuming brocade patterns. In recent years, the introduction of inexpensive and vivid acrylic yarn has caused startling fashion shifts in some villages. In Santa Catarina Palopó, for example, older (or more conservative) women wear the red and white striped *huipil* with moderate brocading, while younger (or more innovative) weavers brocade their garments so richly with acrylic that no ground cloth is visible (compare figures 3a and b; for an earlier example, see O'Neale 1945:fig 87a). In many other towns the bright and long-lasting colors of acrylic yarns are causing style changes too. Such experimentation with style, color, format, and technique has always been a part of the Maya weaving tradition (see Rowe 1981).

Other appropriations in Maya women's dress (as well as the dress of many other Amerindian women) include the use of imported rickrack, ribbons, metallic threads, variegated embroidery floss, and velvet edgings on hand-loomed garments. All of these can be seen as inventive free-play on the part of the indigenous artist.[18]

In a few Maya villages in Guatemala today, large brightly patterned bath towels replace woven shawls as the newest marketplace fashion. These are imported from nearby El Salvador, which also exports such bath towels (some of them patterned into Navajo rug and Kuna *mola* designs) to Bloomingdale's, taking the link of appropriations full circle.

While we think of ceremonial garb as being inherently conservative, displaying the "survivals" that Lynn Meisch describes (this volume), Maya saints statues are by no means immune to the modern. Some wear

traditional garb, including *huipiles* that are generations old (Morris 1986:56-57), while others wear festive imported clothes. In Chichicastenango, for example, the saints parade through the streets on the town's feast of St. Thomas (December 21) honored by the luminosity and richness of imported cloth, metallic gold rickrack, and paper currency.[19] In Santiago Atitlán, we might ponder the reciprocal threads of appropriation when the visiting textile scholar covers her shoulders with a Maya *ikat* scarf to enter the Church where she finds a saint wearing layers of cloths, both indigenous and imported, including one costly Hermes scarf patterned with gold rings.

In our typically ethnocentric fashion, we position ourselves as the collectors, the active agents. But ethnic artists have been collecting and adapting aspects of our dress for over 450 years. (Maya and Quechua dress, for example, are a stratigraphic profile of influences and appropriations from the West.) Only for the last hundred years have we been collecting their dress, and only for a scant twenty years has wearing their products been widely acceptable in our culture. Today, we appropriate ethnic textiles in numerous ways. North Americans and Europeans wear Guatemalan *huipiles* and Andean ponchos, and use ethnic cloths on our tables and walls. Wealthy Guatemalan women wear "sweater-*huipiles*" designed by the artist David Ordoñez; these incorporate hand-loomed *huipil* panels into a blouson-type sweater, costing over $100 in Guatemala City's most stylish shops. Within the past decade, as Latin American archaeological arts become scarcer and more high priced, some collectors have turned to twentieth-century textiles, making them a valued commodity in the upper economic ranges of the art market.

American and European textile designers freely take from native sources, proclaiming as their own those designs drawn from Navajo, Paracas, Maya, Kuna, and Aymara originals.[20] Maya *huipil* designs are offered as "Vogue original" sewing patterns (Lambert 1977:fig 5). North American quilters are given step-by-step instructions on how to make their own *molas* for quilts, pillows, and dresses (Patera 1984). And so, the impulses of appropriation come full circle again: Kuna *mola* makers take our cloth which they cut, sew, and refashion into *molas* which we take and fashion into our own clothes. As James Clifford reminds us, "art collecting and culture collecting now take place within a changing field of counterdiscourses, syncretisms, and reappropriations, originating both outside and inside 'the West'" (1988:236).

To interpret some of the transactions of the past 450 years as reciprocal appropriation is not to deny or minimize the oppressive heritage

of colonization and conquest suffered by Latin American peoples. This story is familiar to us all. But the concept of reciprocal appropriation positions indigenous people as active agents of their own artistic styles, not simply passive recipients of a hegemonic culture which constantly erodes and undercuts their own so-called "traditional" culture.

The contemporary indigenous textile aesthetic is, in many regions, an aesthetic of appropriation and accumulation. Culture is refreshed and re-created by periodic transfusions of goods, techniques, and materials. A Maya saint—or a Maya woman—who wears both indigenous garments and foreign ones sends a compelling visual message about the comprehensiveness of her world view: all can be taken in, mastered, and made part of the cultural order. Seen in this way, appropriation is not necessarily a prognosticator of a tradition's demise but can be instead the emphatic display of a culture's strength.

Appropriative strategies run concurrently with strategies that deal with the past and the Other in various ways. It is these I shall consider in the next two sections. But first, a final metaphor on reciprocal appropriations: in Maya textiles, the joins between two woven panels are often the focus of articulation and elaboration. Often, the seam itself is not rendered unobtrusive as it is in our apparel. Instead it is emphasized by silk or rayon stitching of bold color and emphatic form. This is called the *randa*. This occurs on head cloths, women's skirts, *huipiles*, and other garments. So too, in the indigenous world, seams of cultural articulation are often emphasized and highlighted. Attention is called to the diverse materials and influences that have been incorporated into the native domain.

Replication, Revival, and 'Staged Authenticity'

Each morning, European and American tourists leave the town of Panajachel, Guatemala, by boat. They cross Lake Atitlán in search of an "authentic" Maya village. An hour later, they arrive at Santiago Atitlán, a Tzutujil Maya community of over 10,000 habitants. This is, indeed, an authentically Maya community, where both women and men wear distinctive native dress, women weave and embroider, and men use the local volcanic stone to construct sweatbaths of ancient Maya style in their house compounds. Yet embedded in the daily life of this village are "pseudo-events" of staged authenticity[21] that link the Maya past with the modern touristic present. In Santiago Atitlán, after the 9 a.m. boat arrives, older women will pose picturesquely in their doorways and courtyards with spindles and baskets of raw, wild brown cotton. As visitors approach, the

women will begin to spin by hand (figure 4). Concurrently they exhort the tourists "Take photo! Take pitch!" Occasionally, for a visiting group, a woman will demonstrate the beating of raw cotton with forked sticks.

The traveler is overcome at her good fortune in capturing this moment of authentic Maya practice, blithely unaware that in Santiago Atitlán hand spinning cotton for clothing passed out of fashion several generations ago. The traveler assumes that the artist will make a fine ceremonial textile out of this hand-spun *cuyuscate* (although that has not been the custom for many years in this particular village). It is more likely that the woman of Santiago will sell for a few dollars a hank of hand-spun cotton as a souvenir to the next tourist and begin the process anew, purchasing more raw *cuyuscate* in the nearby Sololá market for thirty cents a kilo.

Such moments of staged authenticity are satisfying to Maya and *Gringa* alike; to the Maya, the satisfaction is economic, for she insists on payment of about forty cents for the privilege of taking her picture. For the *Gringa* the satisfaction is aesthetic, for she has witnessed an ancient and authentic way of working with fibers. Each is pleased with the exchange. Each brings back to her culture what she most wants from the other. In Santiago Atitlán, handspinning has taken on a new function, unconnected to weaving. It is a fragment of the past, offered up for the outsider's delectation and providing one small part of an economic base for the present.

In a different, but related fashion, Maya weavers in Chiapas, Mexico, have brought some of the past into the present to form a firm economic base for themselves as Morris details elsewhere in this volume. With the help of outsiders such as Morris, Maya women have successfully tapped into our perpetual fascination with the Maya.[22] Chiapas weavers have developed co-operatives and international markets for their fine and highly priced textiles. I suspect that most buyers of $800 Chiapas textiles would prefer to remain ignorant of the canny marketing strategy that underlies their purchase—from the deliberate use of antique-style materials and patterns to the careful positioning of the item in the correct marketplace sector, as described by Morris.

Yet this is another instance, like that in Santiago Atitlán, where both parties emerge satisfied. The buyer's purchase is legitimized by the exhibitions and publications that proclaim the importance of these textiles. The seller's ideology affirms that weaving is a fundamental way of being Maya; this kind of weaving allows her to be an economically self-reliant Maya. Most economic transactions between fourth-world artist and first-world

patron have been staggeringly weighted in favor of the patron. It is a pleasure to see in Chiapas at least some small redress of this imbalance. It is also a pleasure to see the weaver herself profit from fine-quality work.

The situation that Morris describes for the Chiapas Maya is a far cry from what has occurred in Guatemalan Maya handweaving. Guatemalan textiles have been in the public arena far longer than Chiapas textiles. Yet few Guatemalan weavers have arenas in which to sell their textiles for high prices. (Co-ops and other programs that foster economic self-determination for indigenous peoples are suspected by Guatemala's repressive government as being centers of communism; participation in such programs is dangerous).[23] In the past decade, older Guatemalan textiles have brought high prices at auction and through private dealers (Sotheby's 1982). This has led to the deliberate falsification of some Maya textiles (Berlo and Senuk 1985).[24] It is a particularly schizophrenic kind of falsification, however, when contemporary Maya women who can do exceedingly fine-quality work are making old-style *huipiles* on commission for middlemen who are misrepresenting their work as antique. American and European collectors will eagerly pay $1500 for a fine textile that they believe to be 50 years old, yet no such price is ever paid for a modern textile, no matter how fine. The weavers who are making these exquisite 1930s-style garments have no arena in which to sell such work as their own "revival-style" weaving, and yet we continually decry the decline in quality of most modern Maya weaving for which we pay $35-$100!

In the last few years, many weavers have begun to recognize that knowledgeable visitors prefer older styles and patterns. Many now make modern versions of old-style *huipiles*, and try to sell them as "antiques."[25] Generally of both intermediate price and quality, such replicas are not easily mistaken for the real thing. But one result of this phenomenon is that women weave a more diverse repertory of styles than in the past. Such processes of replication and revival bring past into present. People rework the past in a variety of ways that are most useful and meaningful for their present.

On History, Interpretation, and the Uses of the Past

"The pasts we alter or invent are as consequential as those we try to preserve," observes the historian David Lowenthal (1985:xvii). Remaking, altering, and inventing history is an on-going human preoccupation. Multiple histories compete for prominence for the Maya, as for many human groups. Each Maya community has its own particular way of understanding the events of antiquity and the colonial era. These modes of interpretation are

often at odds with our own. Moreover, our own are not necessarily the most accurate, for they, like those of the Maya, are circumscribed by various agendas. As George Kubler has pointed out, in examining the past each scholarly generation sees its own mirages (1977:23). One mirage, or at least one scholarly preoccupation, of the current generation is to link the contemporary Maya with their Classic period ancestors of a millennium ago as if by so doing, we are discovering the "real" Maya, the authentic Maya.[26]

While it is true that scholars recently have been finding many more ideational correspondences between modern and ancient Maya than previous generations of scholars thought possible, such discoveries must not lead us to view the colonial era as simply an overlay, a stratigraphic layer that can be removed to excavate the richer pre-Columbian lode beneath.[27] As James Clifford reminds us, modern third- and fourth-world peoples "invent their culture within and against the contexts of colonial history and the new nation" (1988:12). This is true in regard to textile traditions as well as other historical traditions.

Much scholarly and public interest has been generated by Walter Morris's recent assertions of the antiquity of some Maya textile symbols and the complex mythic meanings behind certain abstract design elements in Chiapas *huipiles* (1984; 1985a, 1985b, 1986, 1987a, 1987b). Of continuity of form and meaning in Maya textiles, Morris writes:

> The embodiment of time and space in a field of diamond-shaped designs has been a sacred concept since the Classic Maya period. Lady Xoc of Yaxchilan wore this same motif in AD 709 when she performed the bloodletting ritual described previously. The ritual and the gods have been suppressed in the last twelve hundred years of Maya culture, but the Maya world and the Maya image of the universe that is woven into the cloth have remained unchanged. (1987a:108)

Of the contemporary *huipil* he eloquently proclaims:

> The *huipil* is a mirror of the universe and a portal to the Earthlord's cave. Toads surrounded by flowers wait on the border, the Earthlord stands amid snakes and thunderbolts, and the weaver, like the Earthlord's daughter, has prepared her cotton for dramatic transformation. The Earthlord may hesitate, but the weaver has placed among the flowers a scorpion to prod the lightning into creating rain

clouds. The *huipil* is a woman's personal declaration that she has survived the evils that brought the Flood, has preserved the wisdom of the saints, and added life and color in their design. (1987a:119)

Morris also sees Maya calendrical numerology brocaded into Chiapas and Guatemalan *huipiles* (1985a:320, 1985b:71, 1987b:8,14,16) though he admits that "weavers have never explained to me the reasons for the repetitions of designs" that he sees as calendrical notation (1985b:71).

One wonders if such overzealous interpretation is perhaps one more aspect of the marketing strategy Morris describes in "The Marketing of Highland Maya Textiles from Chiapas, Mexico" (this volume). Such interpretations feed into our desires to link the modern Maya with their Classic period ancestors and read a literal text in Maya brocaded textiles. Indeed, Morris does provide such a line-by-line translation, neatly woven into a narrative textile-text (1987a:110). Yet the reader who closely analyzes Morris's compelling prose for evidence that this is a native weaver's exegesis will not find such evidence. Indeed, an occasional footnote reveals just the opposite:

> What I refer to as the rain god and the earth lord are actually called *santo* or "saint" by Magdalenas weavers. My belief that these designs are representations of Christian-Maya deities (*Anhel* and *Yahval Balumil*) is based on a comparison of similar designs from the neighboring Tzotzil communities of Chenalho and San Andrés that imply these meanings more explicitly. (1987b:20)

Without doubt, Maya textiles have a richness and depth of meaning that we are just beginning to plumb. But scholars of our generation must be careful to avoid imposing complex interpretations where they may not belong, no matter how satisfying these may be for our own sense of the Maya. This, too, can be seen as yet another act of cultural appropriation that mutes the native weaver's own message.[28]

Twentieth-century scholars may find significance in areas of the past that are relatively inconsequential in the minds of the Maya, as we have just seen. Conversely, Maya weavers claim legitimacy through channels we would be mistaken to think of as epiphenomenal. Moreover, their understanding of the origins of weaving varies from community to community.

Cakchiquel Maya in San Andrés Semetabaj, Guatemala, say that Jesus Christ gave each of the saints a town and field for cultivation (Warren

1978:49). For that reason, each Maya town today has a patron saint. But the Maya credit the Spaniards for giving each municipality distinctive costumes to replace their native animal skins and feathers (Warren 1978:40). From pre-Columbian paintings and sculptures, it is clear that a fine textile tradition existed for at least two thousand years prior to the arrival of the Spanish. The Maya were by no means wearing rude skins and feathers. But our knowledge of their history is irrelevant to the web of meaning that the Maya have constructed.[29] Tzotzil weavers in Magdalenas, Chiapas, say that in antiquity after the flood, the saints organized the different communities. Mary Magdalen came to their area, climbed a tree and set up her loom. She surveyed the land, pronounced it without fault, and commenced to brocade herself a *huipil* (Morris 1987a:112-113).

In Santiago Atitlán, a series of "Marias" (who seem to be aspects of the Christian Mary as well as being daughters of grandmother, the moon) are associated with the genesis of weaving (Tarn and Prechtel 1986). A Quiché Maya shaman in Chichicastenango (informant to Ruth Bunzel in 1931-1932), in his long litany of prayers, invokes on behalf of his wife unnamed "mistresses of weaving and embroidery, mistresses of the loom, mistresses of the needle; and also perhaps mistresses of prosperity and wealth; mistresses of dimes and quarters" (Bunzel 1952:308). The ancestors, saints, and other "mistresses" of textile arts are numerous, complex, diverse, and not well studied. In the historical traditions of Maya weavers, access to textile arts came through many different conduits. There are no easy, linear explanations.

In summary, the Maya take a weaving tradition that has been theirs for several millennia, and say that Christian saints or Spaniards taught them, though our version of history says that these figures have been part of their world for less than five hundred years. Telescoping time and history into their own world view, the Maya would be surprised that we think of Christianity as an "overlay."

The indigenous textile artist's reading of her history must teach us that the features we continue to insist on reading as "overlay," "introduced," or "acculturated" are in fact elemental to the fabric of indigenous life. Do we still distinguish within our own culture among those things that were introduced to us four hundred, or one hundred years ago and those that are "indigenous"? The time has come to stop trying to separate the strands of "traditional," "indigenous," "Hispanic," and "touristic," as if these are still, after 450 years of colonialism, separate fibers. On the indigenous Latin American loom, the warp is indeed pre-Hispanic, but the weft always has

been continual change, innovation, and appropriation. Neither warp nor weft stands alone; together they are a strong and flexible cultural fabric.

Women's relationships to the production and use of cloth in Latin America vary widely as all the essays in this volume illustrate. In some areas where machine-spun thread is unavailable (such as parts of the Andes), women may control all aspects of production from harvesting the raw materials, to spinning the thread and weaving the finished cloth. In other areas, like the Maya villages of southern Mexico and highland Guatemala, a wide range of production strategies co-exist. Elsewhere, as among the Zapotecs of Tehuantepec, Mexico (see Scheinman, this volume) and the Kuna of Panama, imported materials are transformed into "traditional" dress, which should remind us that the arbitrary categories of "traditional" and "introduced" that we use to make sense of the ethnic world make no sense to ethnic peoples themselves.

While it has been customary in the past to discuss ethnographic textile production in terms of the erosion of traditional practices, contemporary scholars (including those represented in this volume) increasingly take a more dynamic approach to the aesthetic, economic, and semiotic multiplicities inherent in ethnographic textile production. In this essay I have tried to demonstrate that the many strategies at work in contemporary indigenous textiles are in fact the component parts of a native textile aesthetic. Of course this aesthetic varies from region to region. Yet enough components of it are recognizable throughout the Americas that, I would argue, it represents a widespread, shared indigenous aesthetic system. While some aspects of this aesthetic system are clearly a response to colonialism, other aspects have ancient roots.

Beyond *Bricolage*: Toward an Indigenous Textile Aesthetic

At the beginning of this chapter, I proposed that native textiles do not fit the Levi-Straussian construct of *bricolage* for the randomness and haphazard ingenuity characteristic of the *bricoleur* is only one aspect of their production, an aspect insufficient to their definition. Instead, I have offered evidence that such textiles move beyond *bricolage*, that their many features form a deliberately multivocal aesthetic. Not merely constructed of the cultural flotsam and jetsam of the West overlaid on a native ground, these works are purposeful collages. From this point of view, we can read such textiles as active texts in an on-going intercultural dialogue about gender and history, as well as cultural hegemony and self-determination. From this point

of view, we acknowledge their makers as active creators of their own culture and acknowledge women's place in such culture-building.

Indigenous aesthetic strategies have a number of salient features. I have outlined some of these, such as appropriation and intertextuality, in some detail. The native artist also employs strategies of accumulation, improvisation, and deliberate diachronicity in her work, along with an individualistic artistic vision.

Accumulation.

Primary among the aesthetic features of Latin American textiles is the notion of accumulation. This multi-referential concept embraces both meanings and materials. Textiles accumulate meanings in their relations to numerous spheres of action, as discussed in the section on intertextuality. Visually, textiles are inherently an accumulative medium, with additions of weft, brocade, embroidery, trim, and appliqué increasing the sum of meaning, power, value, and visual display.

Improvisation.

Materials are often used in surprising and original ways. Maya women may sew zippers into the chests of their *huipiles* to make breast feeding easier. They may wear vivid bath towels as shawls and head covers. Color, pattern, and weaving technique can all be used in an improvisational manner. Visually syncopated color rhythms, virtuosic play with *ikat,* side-by-side use of double-faced and single-faced brocade (as in San Antonio Aguas Calientes)—all of these demonstrate the improvisational skill of the weaver. Anyone who has visited a Maya marketplace even just once, or who has compared a dozen *huipiles* from the same village, is indelibly impressed with the improvisational brilliance of color, pattern, and material in women's dress.

Parsimony and extravagance.

These seemingly contradictory concepts coexist in Latin American textiles. A Shipibo woman buys several yards of muslin, and paints her improvisational geometric designs on it with mahogany bark, clay, and ash.[30] She wears this as a skirt until it shows signs of wear and the designs begin to fade. To be frugal, she renews it, rather than making another: she dyes the whole thing dark brown with mahogany bark and clay, and reworks the geometric designs, this time with imported embroidery floss (figure 2). The chain stitching she works on the fabric uses up a great deal of embroidery floss but also makes the fabric stronger for another period of use. Extravagance in materials or means of production also occurs in Tehuana blouses, where scores of successive rows of machine stitching build up a richly

accumulative pattern (see Scheinman illustrations, this volume), and in those Maya brocades that use two-faced, double-faced, or soumak techniques.

Optics.

The optical effects of indigenous Latin American textiles are remarkable. They range from the subdued to the brash. The subtle color harmonies of a Quechua poncho (Schevill 1986: plate 11) contrast with the bold dissonance of the zigzag brocade stripes of yellow, orange, and purple in a *huipil* from Almolonga, Guatemala. The optics of the Almolonga *huipil* are further enhanced by its use with an *ikat* shawl, a multicolor *ikat* skirt, a machine-sewn apron, and a black-and-white hair ribbon. Together they form a stunning personal display.

In many communities, the boldly saturated colors made possible by synthetic dyes are the most valued. Women enjoy the color collisions of hot pink and acid green, or purple and yellow. Acrylic and metallic yarns are making their way into Maya skirts, multiplying the visual complexities of the already busy *ikat* patterning. Weavers in Comalapa, Guatemala, choose acrylic yarn for brocading *huipiles* in part because of what they refer to as *vista*—its intensely saturated color that reads vividly (Asturias de Barrios 1985:39). Nahualá weavers use bold shiny rayon yarns in their *huipil* brocade. Hot reds, pinks, greens, and blues vie for visual dominance. But in Nahualá, women abrogate this optic contrast of high color against white ground to some extent by deliberately choosing a red rayon that runs and soaking the brocaded cloth to produce red splotches in the white ground cloth (Anna Blume, pers. com. 1988). Regardless of temporal or regional variability, the optic properties of textiles seem always to be uppermost in the mind of the indigenous Latin American weaver, whether she was using natural dyes fifteen hundred years ago[31] or metallic and acrylic threads today.

Diachronicity.

As Annette Weiner observes:

Cloth disintegrates and therefore it cannot be classified as an object of permanence. Yet cloth as a valuable does last for a certain period of time and usually continues to have value when it becomes frayed and torn. In societies where cloth as an exchange object has an extended life trajectory, cloth may become the material documentation of the histories of social and political interactions. Through its physical nature of being plaited or woven, of being unravelled, or of rotting, cloth brings to these histories the reality of incompleteness and the danger of loss and death. (n.d.:7)

Cloth links different historical eras, both those of long and short duration. Style, material, and use all play into this. When donning ritual dress, in many communities one wears garments that refer to an older era. In Magdalenas, Chiapas, when St. Martha wears in procession the first weavings of young girls and a garment woven for her nearly 100 years ago (Morris 1987a:unpaginated color plate insert before p.153), she displays both the antiquity and the vitality of women's textile traditions. The past is ever renewed in the present. Cloths with inscriptions, such as the embroidered saint's garments of San Pedro Sacatepéquez, are palpable witnesses to the successive rounds of time: when the Virgin of the Rosary's garments are counted at the passing of the *cofradía cargo*, the dated and inscribed textiles stand as material testimony that generations of Cakchiquel Maya have served their saints in a ritually impeccable manner.

Appropriation: Using Art to Capture the World.

Cloth not only bridges time but disparate social realms, even continents, as discussed in the section on reciprocal appropriation. By incorporating the *meanings* of different social and temporal realms (as in ritual textiles), cloth makes manifest these meanings. By incorporating the *materials* of different cultural realms (as in Kuna *molas* and Maya *huipiles* using imported materials) cloth demonstrates its ability to digest and encompass these external realms.

In many ethnographic reports, one finds the truism that men seem to be the cultural innovators while women are the cultural conservators, resisting foreign language, dress, and customs longer than their male counterparts. This is expressed in passages such as this:

> Is it not plausible that [in Mesoamerica] the male-dominated public arena has been the active assimilator of new codes (language, economic systems, political authority systems, state religions) and, thus, seemingly able to respond quickly, even apparently capitulating to the winds of change; while the female-dominated domestic sector, simultaneously guards the older order (native languages, agricultural ritual, curing knowledge, ancestor cults, shamanistic knowledge) for present and future reference and security? (Gossen 1986:6)

In opposition to Gossen, I propose that although women might seemingly be the cultural conservators in many regions, this particular male/female

dichotomy is more apparent than real, and has more to do with our preconceptions about men and women, work and culture. I suggest that one of women's fundamental roles is to creatively transform alien objects, influences, materials, and ideas in order to appropriate them into indigenous culture. Native women in Latin America do this primarily through the medium of textiles. As we have seen, textiles play out the dialogue between conservatism and innovation, between continuity and transmutation. Men may be in the strategic position of bringing in wealth in the form of foreign goods (as among the Kuna, where men's coconut farms provide the cash that buys the cloth that Kuna women need). But it is women who are the agents of transformation. In the material realm, they incorporate otherness and make it indigenous. Native textile artists, through their inventiveness and visual wit, digest the past and the Other, and create a vision of indigenous culture that balances both. This is a subversive act, for it co-opts the hegemonic tradition that views the third world as a dumping ground for our products. As Maya, Tehuana, Kuna, and other native women appropriate, transform, and assimilate alien products into their textile traditions, they demonstrate through the strength and vitality of their fabric the durability of the fabric of their culture.

Endnotes

1. This article was written while I was a Visiting Associate Professor of the History of Art at Yale, teaching a seminar on "The Female Artist in the Native New World" during the Spring of 1988. Dialogue with the students in that class helped in developing the ideas expressed here. I would particularly like to thank my graduate students Anna Blume, Barbara Mundy, and Sarah Taylor for our on-going discussions on women and art. I am grateful to my colleagues Ellen Smart, Anna Blume, Rebecca Stone, and Aldona Jonaitis who commented on a draft of this essay.

 Since my own graduate student days at Yale, I have been influenced, both intellectually and affectively, by Robert Farris Thompson's work on African and Afro-Caribbean aesthetic and cultural systems. I dedicate this work to him.

2. For the most eloquent and far-reaching of these critiques, see Clifford 1988, Clifford and Marcus 1986, and Fabian 1983.

3, In anthropology, see for example, Reiter 1975, Rosaldo and Lamphere 1974. For a detailed review of the art historical literature, see

Gouma-Peterson and Mathews 1987. It is noteworthy that, in 1989, the College Art Association held two symposia on cloth and dress as part of the program of its annual national meeting, for the history of fiber arts has been ignored by this organization for many years. A brief version of this paper, entitled "Textiles and Intertextuality in Contemporary Native Cultures of the New World" was presented at one of these sessions, *The Fiber Arts in Context*, chaired by Rebecca Stone.

4. Schneider (1987) provides a useful world-wide overview of the recent literature on cloth. Examples of textile studies with a technological or taxonomic focus include O'Neale 1945, Emery 1966, Cason and Cahlander 1976, Rowe 1977, Bjerregard 1977, Sperlich and Sperlich 1980, and Pancake and Baizerman 1980-81. In addition to the essays in this volume, economic meanings of textiles are considered by Pancake and Annis 1982, and Zorn 1987; semiological by Cereceda 1986, Asturias de Barrios 1985, Mayén de Castellanos 1986, and Schevill 1986; diachronic by Rowe 1981, Schevill 1985, Mejía and Miralbes 1987, Mayén de Castellanos 1986; aesthetic by Tedlock and Tedlock 1985, and Femenias 1987.

5. Throughout this essay I present information drawn from a number of Maya communities in Mexico and Guatemala. It is imperative for the reader to recognize that, while there are many cultural similarities among all these communities, there are also appreciable differences in language, textiles, tradition, myth, *cofradía* organization, and so forth. Examples drawn from one community should not necessarily be construed as representing the views of other communities. While a great deal of fieldwork has been conducted among the Maya during the past century, most has been ethnographic research within one particular community rather than comparative studies across a number of communities. Therefore, in many instances we do not yet have a clear picture of the myriad differences and similarities among communities. My remarks here on the Maya should in every case be understood as examples of what *some* Maya do and think, not as statements of an unvarying Maya belief system or practice.

6. In regard to women's arts of the Euroamerican tradition, Meyer and Schapiro have termed a similar aesthetic impulse "femmage" and characterized it as combining aspects of collage, assemblage, improvisation, recycling, and personal history, all within the con-

text of a woman-centered art form (1978). Feminist art historians and literary critics of the past two decades have been interested in exploring the notion of a female aesthetic that is separate from the dominant, patriarchal culture. This has, of course, been a controversial enterprise. Although for the most part, these inquiries have been defined for and by the arts and letters of white Euroamerican women, there is the occasional recognition that such an aesthetic has a wider application: "What we here have been calling (the) female aesthetic turns out to be a specialized name for any practices available to those groups—nations, genders, sexualities, races, classes—all social practices which wish to criticize, to differentiate from, to overturn the dominant forms of knowing and understanding with which they are saturated" (DuPlessix 1985:285).

7. For a small sample of this dialogue, see Parry 1987, Penley and Ross 1985, and Clifford 1988. Their bibliographies provide further examples.

8. In the literature on the Kuna, the name of this ethnic group is spelled sometimes with a K and sometimes with a C. Except when quoting from published sources, I follow the spelling preferred by the Kuna themselves.

9. See Sherzer 1983, especially chapters 2 & 3.

10. While much has been written about Kuna *molas,* the best and most thorough studies are those of Salvador 1978, Sherzer and Sherzer 1976, Parker and Neal 1977, and Helms 1981.

11. For a concise synthesis of the *cofradía* system, see Mayén de Castellanos 1986:13-20 and Cancian 1967.

12. Yet among at least some Shipibo groups, song is not limited to men. See Lathrap, Gebhart-Sayer, and Mester 1985:96.

13. Elsewhere in Latin America, the loom is anthropomorphised as well. See Meisch 1986: 248,269, Cereceda 1986, and Reichel-Dolmatoff 1978:11.

14. I am construing "writing" here as a broad category that includes verbal modes that have only recently been written down. March's (1983) study of women's weaving and men's writing among the Buddhist Tamang of Nepal provides interesting parallels here as well as some insightful comments on gender complementarities.

15. Sherzer and Sherzer (1976:35) see this as part of a Kuna aesthetic that decrees that all space should be well-filled, a notion that applies to village planning, seating at public meetings, *mola* design, and oratory.

16. A textile may be offered on other occasions, to commemorate recovery from an illness, for example. In a North American private collection, a miniature San Pedro *huipil* with the word "grippe" embroidered on it gives thanks to the saint for recovery from influenza.

17. This garment is now in the collection of Bertold Nathusius, owner of the Sombol shop in Guatemala City. It was given to him by the *cofradía* in thanks for his financial help in rebuilding San Pedro's church after the 1976 earthquake (B. Nathusius, pers.com. 1981). See also Barrios 1983:58 for a similar *huipil*.

18. They also reveal the complex economic system that permeates a Maya community. For example, Hendrickson points out that native weavers in Tecpán, Guatemala, have their choice of embroidery floss from Spain, Mexico, England, France, or Colombia (1986:49).

19. Elsewhere in Guatemala, in response to the current climate of political violence, images of the saints wear military garments. See Simon 1987:91.

20. In this they are part of a long artistic tradition in the West. Twentieth-century masters of modernism such as Picasso, Leger, and Klee appropriated African sculptural forms in similar fashion. See Foster 1985 and Clifford 1985.

21. The term "pseudo-event" was coined by Daniel Boorstein (1961:77-117) in reference to tourist attractions in America. Dean MacCannell uses the term "staged authenticity" to refer to the packaging of real events for touristic consumption. See MacCannell 1976: chapter 5.

22. In another context, Cecelia Klein has called this our "Mayamania" (1988).

23. The on-going political trauma endured by the Maya in Guatemala, especially in the departments of Huehuetenango and Quiché, has taken a large toll in lives and in cultural traditions. See Simon 1987.

24. See Zorn (1987) for comments on similar processes among the Aymara.

25. This phenomenon is common throughout the world's ethnic art-producing regions. To cite just one example, a recent New York Times article documents the faking of West African masks (Brook 1988).

26. Ethnographic film maker Trinh Minh-ha sees this search for lost authenticity as central to the anthropologist's quest (Penley and Ross 1985:88).

27. See D. Tedlock (1986:77) for a critique of such attitudes in regard to Maya literature.

28. This is a common pitfall in studies of ethnographic arts and symbols.

Earlier generations of scholars were eager to unlock the symbolism of Western American Indian baskets and Pueblo pots. In both instances, it was discovered that women who wove baskets and painted pottery had widely varying names for design elements but no complex symbol system (Bunzel 1929, O'Neale 1932). Most scholars believe the same is true of most Maya brocaded textiles.
29. In the Andean world, competing views of history caused the native chronicler of the colonial period, Guaman Poma, to say that in ancient times they were wild, unclothed, when in fact archaeology demonstrates that the ancient Andeans had one of the most complex textile traditions of antiquity.
30. For a discussion of the painted patterns on Shipibo women's skirts, see Roe 1980. My information on the process of painting and reuse comes from discussions with Mariann Dunne, who worked with the Shipibo from 1980-85.
31. For excellent studies of the optic properties of ancient Huari textiles in Peru see Rebecca Stone 1986, 1987.

Bibliography
Alpers, Svetlana
 1977 Is Art History? Daedalus. Summer:1-13.
Anderson, Marilyn
 1978 Guatemalan Textiles Today. New York: Watson-Guptill.
Annis, Sheldon
 1987 God and Production in a Guatemalan Town. Austin: University of Texas Press.
Asturias de Barrios, Linda
 1985 Comalapa: Native Dress and Its Significance. Guatemala: Museo Ixchel del Traje Indígena.
Barrios, Lina
 1983 Hierba, montañas, y el arbol de la vida en San Pedro Sacatepéquez, Guatemala. Guatemala: Museo Ixchel del Traje Indígena.
Bergman, Roland
 1980 Amazon Economics: The Simplicity of Shipibo Indian Wealth. Ph. D. dissertation, Department of Geography, Syracuse University. Ann Arbor: University Microfilms.

Berlo, Janet Catherine
 1976 Punning in the Madrid Codex: An Interaction of Text and Image. New Mexico Studies in the Fine Arts 1:26-28.
 1983 Conceptual Categories for the Study of Texts and Images in Mesoamerica. *In* Text and Image in Pre-Columbian Art. J.C. Berlo, ed. Pp.1-39. Oxford: BAR International Series 180.

Berlo, Janet C., and Raymond E. Senuk
 1985 Caveat Emptor: The Misrepresentation of Historic Maya Textiles. Archaeology 38 (2): 84.

Bjerregard, Lena
 1977 Techniques of Guatemalan Weaving. New York: Van Nostrand, Reinhold Co.

Boorstein, Daniel
 1961 The Image: A Guide to Pseudo-Events in America. New York: Harper and Row.

Brook, James
 1988 Faced with a Shrinking Supply of Authentic Art, African Dealers Peddle the Illusion. New York Times National Edition. Sunday, April 17, 1988. P.H47.

Bunzel, Ruth
 1929 The Pueblo Potter. New York: Columbia University Press.
 1952 Chichicastenango: A Guatemalan Village. Seattle: University of Washington Press.

Cancian, Frank
 1967 Political and Religious Organizations. *In* Handbook of Middle American Indians. Robert Wauchope, ed. 6:283-98. Austin: University of Texas Press.

Cason, Marjorie, and Adele Cahlander
 1976 The Art of Bolivian Highland Weaving. New York: Watson Guptill.

Cereceda, Veronica
 1986 The Semiology of Andean Textiles: The Talegas of Isluga. *In* The Anthropological History of Andean Polities. John Murra, Nathan Wachtel, and Jacques Revel, eds. Pp. 149-173. Cambridge: Cambridge University Press.

Clifford, James
 1985 Histories of the Tribal and the Modern. Art in America. April:164-177.

1988 The Predicament of Culture: Twentieth-Century Ethnography, Literature, and Art. Cambridge: Harvard University Press.

Clifford, James, and George E. Marcus, eds.
1986 Writing Culture: The Poetics and Politics of Ethnography. Berkeley: University of California Press.

DuPlessix, Rachel Blau
1985 For the Etruscans. *In* The New Feminist Criticism. Elaine Showalter, ed. Pp. 271-291. New York: Pantheon Books.

Emery, Irene
1966 Primary Structures of Fabrics. Washington, D.C.: The Textile Museum.

Fabian, Johannes
1983 Time and the Other: How Anthropology Makes Its Object. New York: Columbia University Press.

Femenias, Blenda
1987 Andean Aesthetics: Textiles of Peru and Bolivia. Madison: Elvehjem Museum of Art, University of Wisconsin.

Foster, Hal
1985 The "Primitive" Unconscious of Modern Art. October 34: 45-70. Cambridge: MIT Press.

Franquemont, Christine, and Edward Franquemont
1987 Learning to Weave in Chinchero. The Textile Museum Journal 26:55-78.

Franquemont, Edward
1986 Cloth Production Rates in Chinchero, Peru. *In* The Junius B. Bird Conference on Andean Textiles, 1984. Ann P. Rowe, ed. Pp. 309-324. Washington, D.C.: The Textile Museum.

Gallagher, Marsha
1981 The Weaver and the Wool: The Process of Navajo Weaving. Plateau 52 (4): 22-27. Flagstaff: Museum of Northern Arizona.

Gebhart-Sayer, Angelika
1984 The Cosmos Encoiled: Indian Art of the Peruvian Amazon. New York: Center for Inter-American Relations.
1985 The Geometric Designs of the Shipibo-Conibo in Ritual Context. Journal of Latin American Lore 11(2): 143-175.

Gossen, Gary
 1974 Chamulas in the World of the Sun. Cambridge: Harvard
 University Press.
Gossen, Gary, ed.
 1986 Symbol and Meaning beyond the Closed Community:
 Essays in Mesoamerican Ideas. Institute for Mesoameri-
 can Studies. Albany: State University of New York.
Gouma-Peterson, Thalia, and Patricia Mathews
 1987 The Feminist Critique of Art History. The Art Bulletin 69
 (3): 326-357.
Guiteras-Holmes, Calixta
 1961 Perils of the Soul: The World View of a Tzotzil Indian.
 New York: Free Press of Glencoe.
Helms, Mary W.
 1981 Cuna Molas and Cocle Art Forms. Working Papers in the
 Traditional Arts 7. Philadelphia: Institute for the Study of
 Human Issues.
Hendrickson, Carol
 1986 Handmade and Thought-Woven: The Construction of
 Dress and Social Identity in Tecpán, Guatemala. Ph.D.
 dissertation, Department of Anthropology, University of
 Chicago.
Howe, James
 1986 The Kuna Gathering: Contemporary Village Politics in
 Panama. Austin: University of Texas Press.
Klein Cecelia
 1988 "Mayamania:" The Blood of Kings in Retrospect. Art
 Journal 47(1) 42-46.
Kubler, George
 1977 Aspects of Classic Maya Rulership on Two Inscribed
 Vessels. Studies in Pre-Columbian Art and Archaeology
 18. Washington, D.C.: Dumbarton Oaks.
Lambert, Anne
 1977 Textile Transposal: Guatemala in Interchange with Out-
 side Markets. *In* Ethnographic Textiles of the Western
 Hemisphere. Irene Emery Roundtable on Museum Tex-
 tiles, 1976 Proceedings. Irene Emery and Patricia Fiske,
 eds. Pp. 143-153. Washington, D.C.: Textile Museum.

Lathrap, Donald, Angelika Gebhart-Sayer, and Ann Mester
 1985 The Roots of the Shipibo Art Style. Journal of Latin American Lore 11(1): 31-119.
Levi-Strauss, Claude
 1966 The Savage Mind. Chicago: University of Chicago Press.
Levy, C. Daniel
 n.d. Histrionics in Culture. Unpublished manuscript on Shipibo poetics.
Lowenthal, David
 1985 The Past Is a Foreign Country. New York: Cambridge University Press.
MacCannell, Dean
 1976 The Tourist: A New Theory of the Leisure Class. New York: Schocken Books.
Mainardi, Pat
 1973 Quilts: The Great American Art. Feminist Art Journal 2 (1).
March, Kathryn
 1983 Weaving, Writing, and Gender. Man 18(4): 729-44.
Mayén de Castellanos, Guisela
 1986 Tzute y jerarquía en Sololá. Guatemala: Museo Ixchel del Traje Indígena.
Meisch, Lynn
 1986 Weaving Styles in Tarabuco, Bolivia. *In* The Junius B. Bird Conference on Andean Textiles, 1984. Ann P. Rowe, ed. Pp. 243-274. Washington, D.C.: The Textile Museum.
Mejía de Rodas, Idalma, and Rosario Miralbes de Polanco
 1987 Cambío en Colotenango: traje, migración y jerarquía. Guatemala: Museo Ixchel del Traje Indígena.
Mendelson, E. Michael
 1956 A Guatemalan Sacred Bundle. Man 170: 121-126. London.
Meyer, Melissa, and Miriam Schapiro
 1978 Waste Not, Want Not: An Enquiry into What Women Saved and Assembled—FEMMAGE. Heresies 4:66-69.
Miller, Mary Ellen, and Stephen Houston
 1987 The Classic Maya Ballgame and Its Architectural Setting: A Study of Relations between Text and Image. Res 14: 46-65.

Morris, Walter F., Jr.
 1984 A Millennium of Weaving in Chiapas. San Cristóbal: Sna
 Jolobil.
 1985a Warped Glyphs: A Reading of Maya Textiles. Fourth
 Palenque Roundtable. M.G. Robertson and E.P. Benson,
 eds. Pp. 317-23. Austin: University of Texas Press.
 1985b Flowers, Saints, and Toads: Ancient and Modern Maya
 Textile Design Symbolism. National Geographic Re-
 search 1 (1): 63-79.
 1986 Maya Time Warps. Archaeology 39 (3): 52-59.
 1987a Living Maya. New York: Abrams Co.
 1987b Symbolism of a Ceremonial Huipil of the Highland Tzotzil
 Maya Community of Magdalenas, Chiapas. Notes of the
 New World Archaeological Foundation 4. Provo, Utah:
 Brigham Young University.

O'Neale, Lila M.
 1932 Yurok-Karok Basket Weavers. Publications in American
 Archaeology and Ethnology 32. Berkeley: University of
 California.
 1945 Textiles of Highland Guatemala. Washington, D.C.:
 Carnegie Institution.

Pancake, Cherri, and Sheldon Annis
 1982 El arte de la produccion: Aspectos socio-económicos del
 tejido a mano en San Antonio Aguas Calientes, Guate-
 mala. Mesoamérica 4: 387-413. Antigua, Guatemala:
 CIRMA.

Pancake, Cherri, and Suzanne Baizerman
 1980-81 Guatemalan Gauze Textiles: A Description and Key to
 Identification. Textile Museum Journal 19-20: 1-26.

Parker, Ann, and Avon Neal
 1977 Molas: Folk Art of the Cuna Indians. Barre, Mass.: Barre
 Publishing Co.

Parry, Benita
 1987 Problems in Current Theories of Colonial Discourse.
 Oxford Literary Review 9(1-2): 27-58.

Patera, Charlotte
 1984 Mola Making. Piscataway, N.J.: New Century Publica-
 tions.

Penley, Constance, and Andrew Ross
 1985 Interview with Trinh T. Minh-ha. Camera Obscura: A Journal of Feminism and Film Theory 13-14: 87-111.

Prechtel, Martin, and Robert Carlsen
 1988 Weaving and Cosmos amongst the Tzutujil Maya of Guatemala. Res 15: 122-132.

Reichel-Dolmatoff, Gerardo
 1978 The Loom of Life: A Kogi Principle of Integration. Journal of Latin American Lore 4(1): 5-27.

Reiter, Rayna R., ed.
 1975 Toward an Anthropology of Women. New York: Monthly Review Press.

Robbins, Carol
 1986 Maya Miniatures and Other Textiles for the Saints. Dallas: Dallas Museum of Art.

Roe, Peter
 1980 Art and Residence among the Shipibo Indians of Peru: A Study in Microacculturation. American Anthropologist 82: 42-71.

Rosaldo, Michelle Z., and Louise Lamphere, eds.
 1974 Women, Culture, and Society. Stanford: Stanford University Press.

Rowe, Ann P.
 1977 Warp-patterned Weaves of the Andes. Washington, D.C.: The Textile Museum.
 1981 A Century of Change in Guatemalan Textiles. New York: The Center for Inter-American Relations. Distributed by the University of Washington Press.

Rowe, John
 1962 Chavin Art: An Inquiry into Its Form and Meaning. New York: The Museum of Primitive Art.

Salvador, Mari Lyn
 1978 YER DAILEGE! Kuna Women's Art. Maxwell Museum of Anthropology. Albuquerque: University of New Mexico.

Schevill, Margot Blum
 n.d. The Persistence of Maya Indian Backstrap Weaving in San Antonio Aguas Calientes, Sacatepéquez, Guatemala. Master's Thesis, 1980. Department of Anthropology, Brown University.
 1985 Evolution in Textile Design from the Highlands of Guatemala. Occasional Papers No. 1. Berkeley: Lowie Museum of Anthropology.
 1986 Costume as Communication: Ethnographic Costumes and Textiles from Middle America and the Central Andes of South America. Bristol, RI: Haffenreffer Museum of Anthropology.

Schneider, Jane
 1987 The Anthropology of Cloth. Annual Review of Anthropology 16: 409-48.

Schneider, Jane, and Annette B. Weiner
 1986 Cloth and the Organization of Human Experience. Current Anthropology 27(2): 178-84.

Sherzer, Dina, and Joel Sherzer
 1976 Mormaknamaloe: the Cuna Mola. *In* Ritual and Symbol in Native Central America. Philip Young and James Howe, eds. Pp. 23-42. Anthropological Papers 9. Eugene: University of Oregon.

Sherzer, Joel
 1983 Kuna Ways of Speaking. Austin: University of Texas Press.

Simon, Jean-Marie
 1987 Guatemala: Eternal Spring, Eternal Tyranny. New York: Norton Co.

Sotheby's Fine Pre-Columbian Art. June 12, 1982. Auction Catalogue. New York.

Sperlich, Norbert, and Elizabeth K. Sperlich
 1980 Guatemalan Backstrap Weaving. Norman: University of Oklahoma Press.

Stone, Rebecca
 1986 Color Patterning and the Huari Artist: The "Lima Tapestry" Revisited. *In* The Junius B. Bird Conference on

Andean Textiles, 1984. Ann P. Rowe, ed. Pp. 137-149. Washington, D.C.: The Textile Museum.

1987 Technique and Form in Huari-Style Tapestry Tunics: The Andean Artist, AD 500-800. Ph. D. dissertation, Department of History of Art, Yale University.

Tarn, Nathaniel, and Martin Prechtel

1986 Constant Inconstancy: The Feminine Principle in Atiteco Mythology. *In* Symbol and Meaning beyond the Closed Community: Essays in Mesoamerican Ideas. Gary Gossen, ed. Pp. 173-184. Institute for Mesoamerican Studies. Albany: State University of New York.

Tedlock, Barbara, and Dennis Tedlock

1985 Text and Textile: Language and Technology in the Arts of the Quiché Maya. Journal of Anthropological Research 41(2): 121-146.

Tedlock, Dennis

1986 Creation in the *Popol Vuh:* A Hermeneutical Approach. *In* Symbol and Meaning beyond the Closed Community: Essays in Mesoamerican Ideas. Gary Gossen, ed. Pp. 77-82. Institute for Mesoamerican Studies. Albany: State University of New York.

Vogt, Evon

1969 Zinacantán: A Maya Community in the Highlands of Chiapas. Cambridge: The Belknap Press of Harvard University Press.

1976 Tortillas for the Gods. Cambridge: Harvard University Press.

Warren, Kay

1978 The Symbolism of Subordination: Indian Identity in a Guatemalan Town. Austin: University of Texas Press.

Weiner, Annette B.

n.d. Why Cloth? Reflections on the Meaning of Cloth as Object of Exchange. Paper presented at the conference "Cloth and the Organization of Human Experience," Wenner-Gren Foundation, 1983.

Zorn, Elayne

1987 Encircling Meaning: Economics and Aesthetics in Taquile, Peru. *In* Andean Aesthetics: Textiles of Peru and Bolivia. Blenda Femenias, ed. Pp. 67-80. Madison: Elvehjem Museum of Art, University of Wisconsin.

Figure 1. Kuna *mola* depicting "Parrot Safety Matches" matchbox design.
Collection of and photo by Janet Catherine Berlo 1970s.

Figure 2. Detail of Shipibo painted, dyed, and embroidered woman's skirt. Collection of and photo by Janet Catherine Berlo 1970s.

a.

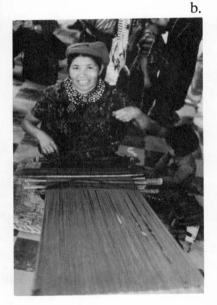

b.

Figure 3a. Weaver wearing a 1970s-style moderately brocaded *huipil*.

Figure 3b. Weaver wearing a 1980s-style all-over acrylic brocaded *huipil*. Santa Catarina Palopó, Guatemala. Photo by Janet Catherine Berlo 1988.

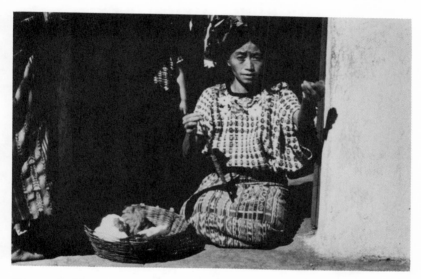

Figure 4. Woman hand-spinning wild brown cotton. Santiago Atitlán, Guatemala. Photo by Janet Catherine Berlo 1980.

Additional References

Altman, Patricia B., and Caroline D. West
 1992 Threads of Identity: Maya Costume of the 1960s in Highland Guatemala. Los Angeles: Fowler Museum of Cultural History, University of California.

Asturias de Barrios, Linda, and Dina Fernández García, eds.
 1992 La indumentaria y el tejido mayas a través del tiempo. Guatemala City: Ediciones del Museo Ixchel del Traje Indígena de Guatemala.

Barnes, Judith, and Joanne B. Eicher, eds.
 1992 Dress and Gender: Making and Meaning. Providence, RI, and Oxford, England: Berg Publishers, Inc.

Carlsen, Robert S.
 Forthcoming Bibles, Bullets, and the "Venerable Grandchild": On Conquest and Adaptation in a Highland Mayan Community. Austin: University of Texas Press.

Eicher, Joanne B. T.
 1995 Dress and Ethnicity: Change across Space and Time. Washington, D.C., and Oxford, England: Berg Publishers, Inc.

Hendrickson, Carol
 1995 Weaving Identities: Construction of Dress and Self in a Highland Guatemala Town. Austin: University of Texas Press.
 1996 Selling Guatemala: Maya Export Products in U.S. Mail-Order Catalogues. In Commodities and Cultural Borders. David Howes, ed. London: Routledge.

Meisch, Lynn Ann
 1987 The Living Textiles of Tarabuco, Bolivia. *In* Andean
 Aesthetics: Textiles of Peru and Bolivia. Blenda Feme-
 nias, ed. Pp. 45–59. Madison: Elvehjem Museum of Art,
 University of Wisconsin–Madison.
 1992 "We Will Not Dance on the Tomb of Our Grandpar-
 ents": 500 Years of Resistance in Ecuador. Latin Ameri-
 can Anthropology Review 4(2):55–74.
 1995 Gringas and Otavaleños: Changing Tourist Relations.
 Annals of Tourism Research (Special Issue on Gender in
 Tourism) 22(2):441–462.
Morris, Walter F., Jr.
 1995 Hand Made Money: Latin American Artisans in the Mar-
 ketplace. Washington, D.C.: Organization of American
 States.
Nash, June, ed.
 1993 Crafts in the World Market. Albany: State University of
 New York Press.
Randall, Jeanne L., and Edwin M. Shook
 1993 Bibliography of Mayan Textiles. Guatemala City: Edi-
 ciones del Museo Ixchel del Traje Indígena de Guatemala.
Rowe, Ann P.
 Manuscript Cloth and Costume in Highland Ecuador. Includ-
 ing articles by Lynn Meisch and Laura Miller.
Schevill, Margot Blum
 1994 The Communicative Nature of Indigenous and Mestizo
 Dress in Mexico and Guatemala. *In* Cloth and Curing:
 Continuity and Change in Oaxaca. Grace Johnson and
 Douglas Sharon, eds. San Diego Museum Papers No. 32.
 San Diego Museum of Man.
 1993 Maya Textiles of Guatemala: The Gustavus A. Eisen
 Collection, 1902. Austin: University of Texas Press.
 Forthcoming Innovation and Change in Maya Cloth and
 Clothing. *In* The Maya Textile Tradition. Margot Blum
 Schevill and Linda Asturias de Barrios, eds. New York:
 Harry N. Abrams, Inc.
Seibold, Katherine E.
 1992 Textile and Cosmology in Choquecancha, Cuzco, Peru.
 In Andean Cosmologies through Time: Persistence and

Emergence. Robert V. H. Dover, Katherine E. Seibold, and John H. McDowell, eds. Pp. 166–201. Bloomington and Indianapolis: Indiana University Press.

Stephen, Lynn
 1991 Zapotec Women. Austin: University of Texas Press.
 1994 Hear My Testimony: Maria Teresa Tula, Human Rights Activist of El Salvador. Cambridge, MA: South End Press.
 Forthcoming Power from Below: Women's Grassroots Organizing in Latin America. Austin: University of Texas Press.

Weiner, Annette B., and Jane Schneider
 1989 Cloth and Human Experience. Washington and London: Smithsonian Institution Press.

Glossary

Unless otherwise indicated italicized words are Spanish. Abbreviations are as follows: Q., Quechua or Quichua; M., Maya; N., Nahuatl.

Agave. A species of monocotyledonous plants with fibrous leaves; includes several varieties producing fibers with either smooth or harsh, prickly characteristics.

Ajsu **(Q.).** See *aksu.*

Aksu **(Q.).** A wraparound skirt.

Alforjas. Woven saddlebags.

Alizarin. Tar-based synthetic red dye.

Alliman. Going right, S-twist.

Almilla **(Q.).** Shirt worn by men and women, also a dress.

Alpaca. Domesticated animal, native to the Andes, with long and lustrous hair used for weaving cloth; member of the camelid family.

Alpargatas. Sandals.

Altiplano. A high flat plain.

Amaranth. An edible plant used by the Aztecs to make flour.

Anaku **(Q.).** A wraparound skirt.

Aniline. A derivative of benzene used in making dyes.

Antis. See *ch'uncho.*

Appliqué. A technique for decorating cloth by stitching pieces of cut and shaped material onto the ground fabric.

Artisela. Artificial silk.

Atole. A drink made from corn; also used to stiffen warp threads.

Awana **(Q.).** A loom.

483

Awasqa (Q.). The cloth woven by Inca commoners for their own daily clothing, probably warp-patterned cloth.

Awayo (Q.). Term used in Bolivia for a woman's shoulder wrap and/or a carrying cloth for food, babies, or firewood. See *llijlla*.

Ayllu (Q.). A social unit within a town or village, formed by geographic and genealogical rules.

Aymilla (Q.). See *almilla*.

Backstrap loom. A weaving apparatus with a continuous warp supported by two bars: a front bar tied to a support, and a back bar attached to a strap around the weaver's waist. Tension is controlled by the movement backward or forward of the weaver's body.

Balanced plain weave. Using either identical or approximately equal warp and weft yarns when weaving the simplest possible interlacing of warp and weft.

Banco. Warping board.

Bast. The stem fibers of dicotyledonous plants, such as apocynum and milkweed, also fibers extracted from beneath the bark of certain shrubs or trees such as willow.

Bastitores. Frames or stretchers.

Bayeta. Yardage woven on European treadle looms by Quechua and Aymara men.

Beat. The movement of forcibly pressing the last-inserted shot of weft into position before passing the next shot of weft in a newly formed shed. Most often done with a batten or sword.

Belt loom. A smaller version of a backstrap or staked loom used for producing narrow textiles.

Biyetta. A term used to describe embroidered bayeta cloths.

Blonda. Fringe.

Blusa. A European-style blouse.

Bolsa. A bag or shoulder bag.

Bordado. Embroidery.

Bricolage. The art of fixing or repairing as practiced by a nonexpert or handyman.

Brocado. A term used for supplementary weft brocading when done on a backstrap loom. Sometimes this is confused with *bordado*.

Cabuya. See agave.

Calzones. Shoes.

Cam. A moving piece of machinery such as a wheel or a roller.

Camelid. Any of several South American animals related to the camel, but without a hump: alpaca, llama, vicuña, guanaco.

Camisa. Shirt worn by men and women, European-style.

Cañari **(Q.).** Wide underbelt worn by adult women in Calcha, Bolivia.

Capacho. A large bag used to carry almost anything.

Capixay. An element of male costume used in Mesoamerica; a long overgarment resembling a cape or tunic, sometimes with sleeves.

Cargador. A large cloth used to carry children, firewood, and other material.

Carguyoq **(Q.).** Sponsor of a religious ceremony.

Cinchon. Girth for pack mule.

Cinta. A narrow belt or hair ribbon.

Cinturón. A belt.

Cinturón guaguito walt'ana. A combination of Spanish and Quechua terms used to describe a swaddling cloth.

Coca. The plant, *Erythroxylon coca*; the leaf is chewed daily by Andean Indians and is an important element in social and ceremonial life.

Cochineal. An insect which feeds on the the cacti *Opuntia* and *Nopalea* and which is used to obtain a range of red dyes; used throughout Middle America and in the Central Andes.

Codex. Native illustrated manuscript.

Cofradía. Religious organization requiring special costume and accessories.

Colera. A tunic. See *chamarro* and *ehuatl*.

Collas **(Q.).** Llama herders.

Compadrazgo. Fictive kin relationship of godparents to real parents and godchildren.

Complementary-warp weave. A compound fabric structure with two sets of warp (interlacing with the weft) that are complementary to each other. The two sets of elements play equivalent and reciprocal parts on each face of the fabric. The weave is double-faced with complementary sets of warp. Two and three colors can be utilized.

Contagion. The belief in the transference of an emotion, idea, or spell by touching.

Corte. A wraparound skirt.

Costal. An all-purpose bag, woven in many sizes; *costalito* refers to a small version.

Costumbre. Custom, habit.

Cotón. A man's jacket, cut in the European manner; also refers to a woman's under blouse.

Counter-spinning. S- and Z-spun threads are placed side by side as warp; when woven a subtle herringbone effect is created.

Crochet. A single-element technique in which a single hooked needle is used to interloop the yarn vertically and horizontally through two previously made loops.

Crossing. The movement of an element or group of elements across a textile, as a step in upward braiding; warps can be crossed to create tubes as in slings.

Cungalpiu **(Q.).** Notched loom bar.

Cuyuscate. Tawny, brown cotton, native to Guatemala; also called *ixcaco* (M.).

Chaleco. Man's vest, worn on fiestas.

Chalina. A shawl, also called *rebozo* or *perraje.* In the Andes it refers to a neck scarf worn by headmen.

Chamarro. Short tunic, open on the sides like an *ehuatl.*

Chaqueta. A man's jacket, European-style.

Chaquiras. Pre-Hispanic beads.

Chhurus. In weaving, narrow bands of solid color.

Chichicastle. A bad woman; also a fiber used in Mexico for weaving.

Chullo **(Q.).** Man's knit earflap hat.

*Chumpi***(Q.).** A belt, worn by men and women; varies in length, width, and motifs.

Ch'uncho **(Q.).** A wild man from the eastern slopes of the Andes.

Chuspa **(Q.).** Pouch for coca leaves, carried by virtually all Indian men in the Andes.

Delantal. An apron, European-style.

Departamento. A term used in Middle America and the Central Andes for a geographically defined political unit, like a U.S. state.

Doscientos. Rebozo of fine cotton.

Double cloth. A compound fabric in which the two separate weave structures (usually plain weave) are interconnected only where they exchange faces.

Double-faced. Term used for compound weaves whose faces are structurally identical, as contrasted with two- or single-faced.

Draw loom. A treadle loom with extra harnesses which allow for lifting groups of warps separately from other warps and for lifting them in any order required for a design; see *falsería.*

Eccentric weft weave. A pattern created by wefts that deviate from the horizontal and from their normal right-angled relation to the warps; achieved by the use of tapestry technique.

Ehuatl (N.). A tunic; a pre-Columbian dress form; see *chamarro* and *colera* and *unkhu*.

Enagua. A woman's skirt with waistband of European origin.

Enagua de holón. A woman's skirt with a ruffle of heavily starched lace or tulle worn at the hem.

Encomienda.. System whereby Indians were bonded to Spanish settlers, or *encomenderos* after the Conquest.

Enredo. A skirt.

Escogidor. Comb-like weaving device.

Faja. Wide belt used by men and women.

Falsería. See draw loom.

Finca. A large farm, ranch, or plantation.

Fleco. Fringe.

Float. A warp or weft thread which passes over or under more than two threads of the opposite element.

Frame loom. A simple loom in which the loom bars are secured to a wooden frame in a variety of ways.

Frazada. A blanket.

Gabán. Small serape with head opening for men.

Gauze weave. One in which the odd-numbered warps are crossed over the even-numbered warps and held in this position by a passage of the weft, thus creating a line of openwork.

Golón. A strip of complex balanced weave used as a trim for Andean costume.

Gorra. A baby's cap.

Ground weave. Any weave, but usually plain weave, on which supplementary warps and/or wefts float to provide a pattern.

Guarda. Border design.

Hakima. A narrow strip of cloth used as a strap or for tying.

Harness. A long narrow frame which holds the heddles.

Heading cord. One that is inserted in the endloops of the warp. The loom bar is then lashed to this cord, rather than to the warps, making possible a four-selvedge textile.

Heddles. Wire, twine, or flat pieces of steel with holes or eyes in center through which warp ends are threaded.

Heddle stick or rod. One with heddle loops attached.

Herringbone pattern. A type of weave with zigzag lines running horizontally from side to side of the cloth.

Hilo. Thread or yarn.

Honda. A sling. See *waraka.*

Horizontal ground loom. One that is staked-out in the ground with four posts; warp bars are bound near the top of the stakes; warps are fastened to a heading cord and then to the warp bars; string heddles are attached.

Huata **(Q.).** Hair tie.

Huipil **(N.).** A blouse made of rectangular pieces of backstrap- or treadle-loomed cloth without sleeves.

Huipil grande. A blouse or miniature dress of white lace worn as a headdress.

Ikat. A word of Malay origin; describes a method of resist or tie-dyeing done by binding warps or wefts at designated intervals then immersing them in dye. When bindings are removed, patterns result from areas of yarns not penetrated by dye. Four kinds of *ikat* patternings are possible; warp, weft, double, and complex.

Indigo. A dark-blue dye obtained from plants of the *indigofera* genus.

Ixtle. A plant with fibrous leaves of the agave species.

Jabón. A waist-length jacket.

Jacquard loom. A mechanized weaving apparatus; patterning is controlled by a series of punched cards that succeed one another with each treadling.

Jaspé. Warp and weft yarns dyed using *ikat* techniques. See *ikat.*

Jaspeado. Cloth woven with ikat patterns. See *ikat.*

Jerga. Broken twill weave. A word for treadle-woven twill cloth used in Guatemala.

Joronga. See *gabán.*

Kalluwa **(Q.).** A weaving tool to beat down wefts, a beater.

K'eparina **(Q.).** An all-purpose carrying cloth.

Kilim. A rug woven in tapestry technique which may include slits or openings created by discontinuous wefts.

Keros. Wooden drinking vessels.

Knitting. An interlooping technique using a single element in a series of loops. Pointed rods or needles are utilized.

Kuraka **(Q.).** Headman or town leader.

Ladino, Ladina. A Guatemalan person of mixed Indian, African, and/or Spanish ancestry who does not belong to one of the indigenous cultural groups. See *Mestizo.*

Lampotes. Gauze-weave cloths.

Lease. Crossing of warp threads during winding between warping posts to keep them in order during threading.

Lease sticks. Two thin sticks used in the cross or shed to keep the threads in order; also called shed sticks.

Listones. Ribbons.

Loom bar. One of the two bars of the simple two-bar loom, such as the backstrap or horizontal loom, between which the continuous warp is stretched.

Lustrina. Mercerized cotton embroidery yarn having shinier texture and more brilliant colors than ordinary mercerized cotton yarn.

Llama. A member of the camelid family. See camelid.

Llautu (Q.). A term used in Inca times for headband.

Llijlla (Q.). A woman's shawl.

Lloq'e (Q.). S-twist yarn; meaning left; associated with magical practices.

Llukiman (Q.). Going left or S-twist.

Máchina de gasa. Miniature treadle model Singer sewing machine.

Macramé. Fringe or trimming of knotted thread.

Mantones de Manila. Manila shawls.

Mesa. Ceremony.

Mestizo. See *Ladino.* Term used in Mexico, Peru, and Bolivia for a person of mixed genetic or cultural ancestry.

Milpa. A field used to grow corn, beans, and squash.

Mink'a (Q.). Work party in labor exchange.

Mish. A Guatemalan brand of mercerized cotton esteemed by weavers for its strength, fine color, and low cost.

Misti. A term for *Mestizo.*

Monedas. Coins.

Montera. A hat worn by both men and women.

Morga. A wraparound skirt; see *corte.*

Multiloop heddle. A group of heddles tied together without a stick to support them.

Muñeca. Doll.

Ñawi (Q.). Eye; used to describe the dots of opposite color that appear in a complementary float weave.

Oblique loom. A frame loom used in a semivertical position in Bolivia; similar to the horizontal ground loom but the loom bars are lashed to two long poles and propped against a roof, wall, or ceiling beam.

Obrajes. Workshops set up by the Spanish.

Off-loom. Those techniques such as knitting, netting, or twining that do not require a loom.

Ombré. See space-dyed.

Overdyed. A process of redyeing a natural or already dyed textile in the same color; i.e. natural black yarn overdyed black creates a darker color.

Pacotillas. Low-quality items.

Pajón. Continous supplementary weft-float patterning.

Pallay (**Q.**). To pick up; either an object, or threads to create warp patterns. The pattern thus made.

Pampa. A plain, or an empty, unoccupied space. Also refers to areas of single color plain weave in textiles.

Pampas. In weaving, solid-color bands.

Pañon. Shawl.

Pantalones. Men's knee or full-length pants.

Pañu (**Q.**). See *pañon.*

Pañuelo. Little handkerchief.

Pasamontaña. Means literally to pass the mountain; a face cap.

Pepenado. A supplementary weft brocading pattern used in Guatemalan weaving.

Pepita. See *pepenado.*

Perraje. A shawl.

Pick. A term for wefts per inch or centimeter or a single weft pass.

Pickup. Use of fingers or a pickup stick to select warps or wefts for a pattern. See *pallay.*

Pickup stick. A small pointed stick used to aid in picking up warp or weft yarns; could be made of wood or bone.

Plain weave. The simplest possible interlacing of warp and weft in unvarying alternation over and under. It may be balanced, warp-faced, or weft-faced.

Plangi. A technique for tie-dyeing woven cloth.

Ply. A verb meaning to twist; in 2-ply, two single threads have been twisted together.

Poc (**M.**). Head or shoulder cloth.

Pollera. A full gathered skirt.

Ponchito. A small poncho; see *rodillera.*

Poncho. Square or rectangular overgarment worn by men, usually consisting of two pieces of handwoven cloth sewn together with a slit in the center for the head.

Pot (**M.**). See *huipil.*

Puka (**Q.**). Red.

Pulque. An alcoholic beverage made from agave.

Puna. In the Andes, a high treeless plain. See altiplano.

Puric (Q.). Common person.

Purpura patula. A purple dye extracted from a mollusk.

Putij. Stick or batten.

Q'ompi (Q.). Pre-Columbian finely woven cloth, most often in tapestry-techniques.

Quachtlis (Q.). Woven cloths.

Quechquémitl (N.). Women's cape-like shoulder garment; a pre-Columbian dress form survival.

Quetzal. A bird with iridescent green plumage and long tail feathers; the national symbol of Guatemala; also a unit of national currency.

Quichu (Q.). Bobbin.

Quipu (Q.). A knotted string device for recording numbers.

Randa. A hand-stitched joining with embroidery yarn of two pieces of cloth.

Rebozo. See *perraje.*

Refafo. An underskirt.

Repartamiento. A distribution of Indians as property to Spanish settlers shortly after the Conquest.

Resist dye. A form of dyeing in which skeins of yarn have string bindings tied at intervals to protect from the dye portions necessary to create the pattern.

Ribbon loom. A four-harness counterbalance treadle loom with a backstrap apparatus used for making belts.

Ribete. A tubular edging used to trim *llijllas*, ponchos, *unkhuñas*, and *aksus*.

Rigid heddle loom. Also known as the hole-and-slot heddle: used in a backstrap arrangement; warps are threaded in the holes of the heddle set in the reed; slot threads are free to slide up and down; the rigid heddle reed is also used as a beater.

Rodillera . A woolen blanket that men wear over their trousers; also called a poncho.

Ropa corriente. Everyday dress.

Runa (Q.). Quechua-speaking people.

Rupan plato. Majolica-ceramic ceremonial plate and the name of a design.

S-twist yarn. Composed of two or more plies that are twisted together so as to trend in the same direction as the diagonal center bar of the letter "S" when the yarn is held in vertical position.

Saco. Tailored jacket worn by women.

Sarin. Dowel.

Seda. Silk.

Sedalina. Silk-like yarn: pearl cotton with a high gloss due to heavy mercerizing.

Señor . Cummerbund.

Serape. A blanket, often with an opening for the head.

Sett. Weaver's term for warp and weft count.

Shed. Opening formed in the warp, by raising or depressing harnesses, through which the shuttle is passed.

Shedding device. Any of various devices used to separate warps to make a shed such as a rigid heddle reed, a batten or sword, or a shed rod.

Shuttle. A device to hold the weft and carry it through the shed.

Single. A single-ply thread, sometimes used in unplied pairs or multiples when doing supplementary weft brocading.

Single-faced. In supplementary weft brocading, this term applies to the patterning that appears on one side of the textile only.

Sobre huipil. A special *huipil* worn over the everyday one.

Soga. Bundle of yarn or rope.

Soutache. Design element sewn onto a costume.

Space-dyed. Yarn is dyed in blocks of color creating a thread of many shades; see *ombré*.

Spindle. A straight shaft used for spinning. The spindle is weighted with a round whorl and is rotated rapidly to twist aligned fibers into thread, which are then wound around the spindle.

Spindle whorl. The round weight on the bottom of a spindle used to steady the rotating motion of the spindle while spinning thread.

Substitution. A simple technique in which two or more sets of elements exchange interlacing and floating functions to create a pattern.

Supplementary warp weave. Extra wefts are used for patterning in addition to the ground weave; these wefts are not essential to the structure of the cloth.

Suyos. Imaginary lines radiating from the Inca city of Cuzco, which geographically divide the world into segments.

Sword. A weaving implement of wood used to create sheds and for beating; also called a batten.

Tablera. A coat with tails worn by men.

Tejido. Handwoven cloth.

Telar de palitos. See backstrap loom.

Templadora. Tenter, a stick used to maintain uniform width of fabric.

Tension. Tightness or looseness of warp yarns.

Tenter. A device to help maintain an even width in the finished cloth. It is a stick placed crosswise on or under the fabric being woven, and has pegs, thorns, or nails at the ends which are pushed through the edges of the cloth.

Terciopelo. Rayon velvet commercial cloth.

Terminal zone. The area of a four-selvedge cloth which is woven last. Weaving becomes difficult in this area because there is not enough unwoven warp slack to produce a shed. The weft is inserted on bobbins of decreasing size, finally on a needle. This area is visible on a textile for patterning is usually abandoned and the texture of the cloth changes.

Teueuelli **(N.).** A sacrificial shield.

Tiangus **(N.).** Marketplace.

Tie-dye. See *ikat*.

Tipica. A term used for traditional clothing in Guatemala, also known as *traje*.

Tira. Group of warps.

Tocapu **(Q.).** In Inca weaving, units of geometric design.

Torcalito. Bout, an *ikat* pattern unit.

Traje. Traditional costume as worn by the Maya.

Treadle loom. An upright, stationary wooden structure for weaving, introduced by the Spaniards. Warps extend over back and front beams and are held at a rigid tension.

Tritik. A resist dye technique; sewing rather than tying protected areas of cloth.

Troquilla. Hat band.

Tulma **(Q.).** Braid ties worn by women.

Tupu **(Q.).** Silver or nickel shawl pin used to pin a *llijlla* over a woman's shoulders.

Twill weave. Twill weaves are float weaves characterized by a diagonal alignment of floats for which a minimum of three warp groupings is essential.

Two-faced. In supplementary weft brocading, this term applies to patterning that floats on the reverse side between pattern areas forming an inverse of the design on the other side.

Tzute. A head or shoulder cloth used by both men and women; see *poc*.

Uncu, unkhu **(Q.).** A tunic.

Unkhuña **(Q.).** A small cloth used for a woman's coca leaves and food stuffs; also used as a groundcloth for ceremonial offerings.

Urdidora. Warping frame.

Vara. Roughly three feet.

Vela. Candle.

Vestido. Ladino or mestizo clothing.

Vicuña. A member of the camelid family with especially fine wool.

Waraka (**Q.**). A sling; see *honda*.

Warp. Vertical or fixed loom threads that form the web of the textile.

Warp-faced. A fabric structure characterized by the close set of the warps, completely covering the wefts.

Warp-predominant. A fabric in which warps outnumber the wefts but do not entirely conceal them.

Wayaqa (**Q.**). A coca bag.

Wayeta (**Q.**). A hood of commercial cloth.

Web. The basic structure of the textile created by warps and wefts.

Weft. The horizontal or free threads that are interlaced with the warps to form the web.

Weft-faced. A fabric structure that results when wefts are closely compacted over more widely spaced warps and warps are not visible.

Xicolli (**N.**). A sleeveless male garment with a front-opening jacket and a closed tunic; a pre-Columbian dress survival.

Yana (**Q.**). Black.

Z-twist yarn. Composed of two or more plies that are twisted together so as to trend in the same direction as the diagonal center bar of the letter "Z" when the yarn is held in vertical position.

Index